THE WRITER'S *Brush*

THE WRITER'S *Brush*

Paintings, Drawings, and Sculpture by Writers

Donald Friedman

With essays by William H. Gass and John Updike

MID-LIST PRESS
Minneapolis

Mid-List Press publishes books of high literary merit and fresh artistic vision by new and emerging writers and by writers ignored, marginalized, or excluded from publication by commercial and mainstream publishers. Mid-List seeks to increase access to publication for new writers, nurture the growth of emerging writers, and increase the diversity of books, authors, and readers. Mid-List Press is a tax-exempt, 501(c)(3), not-for-profit literary organization.

Distributed to the trade by Welcome Books®, an imprint of Welcome Enterprises, Inc.
6 West 18th Street, NY, NY 10011; tel. (212) 989-3200; fax (212) 989-3205; www.welcomebooks.com

Printed in China
First printing: September 2007
11 10 09 08 7 6 5 4 3 2

Library of Congress Cataloging-in-Publication Data
Friedman, Donald, 1943–
 The writer's brush : paintings, drawings, and sculpture by writers / Donald Friedman ; with essays by William H. Gass and John Updike.
 p. cm.
 Includes bibliographical references.
 ISBN 978-0-922811-76-2 (hardcover cloth edition : alk. paper)
 1. Authors as artists. 2. Authors—Biography. I. Title.
N8356.A9F75 2007
704'.0888—dc22

2007011535

Interior and cover design: Lane Stiles

Acknowledgments:
"Femme" by Pablo Picasso; copyright © Estate of Pablo Picasso/Artist Rights Society (ARS), New York
"*La maison d'en face* or That Other Art" by William H. Gass from *The Dual Muse;*
 copyright © 1997 Washington University Gallery of Art, St. Louis; used by permission of the author
"Writers and Artists" from *Just Looking* by John Updike; copyright © 1989 by John Updike;
 reprinted by permission of Alfred A. Knopf, a division of Random House, Inc.

CONTENTS

Apologia, Acknowledgments, and Alternative Reading Paths IX

Introduction XIII

Writers Ordered by Year of Birth XXI

Writers

Acker, Kathy 2

Æ (George Russell) 4

Agee, James 6

Alberti, Rafael 8

Andersen, Hans Christian 10

Anderson, Sherwood 12

Apollinaire, Guillaume 14

Arp, Jean (Hans) 16

Artaud, Antonin 18

Bagnold, Enid 20

Ballantyne, R. M. 22

Baraka, Amiri 24

Barlach, Ernst 26

Barnes, Djuna 28

Baudelaire, Charles 30

Beck, Julian 32

Beerbohm, Max 34

Belloc, Hilaire 36

Bemelmans, Ludwig 38

Bennett, Arnold 40

Bentley, Nicolas 42

Berger, John 44

Bishop, Elizabeth 46

Blake, William 48

Breton, André 50

Breytenbach, Breyten 52

Brontë, Charlotte 54

Brontë, Emily 54

Buck, Pearl S. 56

Bukowski, Charles 58

Burroughs, William S. 60

Carroll, Lewis 62

Cary, Joyce 64

Cassill, R. V. 66

Chesterton, G. K 68

Churchill, Winston 70

Clowes, Daniel 72

Cocteau, Jean 74

Collins, Wilkie 76

Conrad, Joseph 78

Cookson, Catherine 80

Corso, Gregory 82

Coupland, Douglas 84

Crane, Hart 86

Cummings, E. E. 88

Darger, Henry 90

Davenport, Guy 92

Del Paso, Fernando 94

Donleavy, J. P. 96

Dos Passos, John 98

Dostoevsky, Fyodor 100

Du Maurier, George 102

Dumas, Alexandre *fils* 104

Duncan, Robert 106

Dunlap, William 108

Dunnett, Dorothy 110

Durrell, Lawrence 112

Dürrenmatt, Friedrich 114

Edson, Russell 116

Eisner, Will 118

Elytis, Odysseus 120

Emshwiller, Carol 122

Faulkner, William 124

Feiffer, Jules 126

Ferlinghetti, Lawrence 128

Finkel, Donald 130

Fo, Dario 132

Ford, Charles Henri 134

Fromentin, Eugène 136

Gao Xingjian 138

García Lorca, Federico 140

Gautier, Théophile 142

Gibran, Kahlil 144

Gilbert, W. S. 146

Ginsberg, Allen 148

Goethe, Johann Wolfgang von 150

Gogol, Nikolai 152

Goncourt, Edmond de 154

Goncourt, Jules de 154

Gorey, Edward 156

Grass, Günter 158

Greenaway, Kate 160

Greger, Debora 162

Grillparzer, Franz 164

Hardy, Thomas 166

Hartley, Marsden 168

Hawthorne, Julian 170

Hearn, Lafcadio 172

Henry, O. 174

Hesse, Hermann 176

Highsmith, Patricia 178

Hodgson, Ralph 180

Hoffmann, E. T. A. 182

Hong Kingston, Maxine 184

Hopkins, Gerard Manley 186

Horgan, Paul 188

Hugo, Victor 190

Hunter, Evan (Ed McBain) 192

Huxley, Aldous 194

Ibsen, Henrik 196

Ionesco, Eugène 198

Jacob, Max 200

Jarry, Alfred 202

Johnson, Charles 204

Jones, David 206

Justice, Donald 208

Kafka, Franz 210

Kees, Weldon 212

Keller, Gottfried 214

Kerouac, Jack 216

Kingsley, Charles 218

Kipling, Rudyard 220

Knight, Eric 222

Kokoschka, Oskar 224

Kubin, Alfred 226

Lasker-Schüler, Else 228

Lawrence, D. H. 230

Lear, Edward 232

Lermontov, Mikhail 234

Lethem, Jonathan 236

Levi, Carlo 238

Lewis, Wyndham 240

Lindsay, Vachel 242

Lofting, Hugh 244

Loti, Pierre 246

Loy, Mina 248

Lucebert 250

Masefield, John 252

Mayakovsky, Vladimir 254

McClure, Michael 256

McCullough, Colleen 258

Mérimée, Prosper 260

Michaels, Leonard 262

Michaux, Henri 264

Michener, James A. 266

Miller, Henry 268

Minot, Susan 270

Moore, Marianne 272

Morris, William 274

Musset, Alfred de 276

Nabokov, Vladimir 278

Nissenson, Hugh 280

O'Casey, Sean 282

O'Connor, Flannery 284

Odets, Clifford 286

Patchen, Kenneth 288

Peake, Mervyn 290

Perelman, S. J. 292

Plath, Sylvia 294

Poe, Edgar Allan 296

Potter, Beatrix 298

Prévert, Jacques 300

Proust, Marcel 302

Pushkin, Alexander 304

Rexroth, Kenneth 306

Riley, James Whitcomb 308

Rimbaud, Arthur 310

Rosenberg, Isaac 312

Rossetti, Dante Gabriel 314

Ruskin, John 316

Sacks, Peter 318

Saint-Exupéry, Antoine de 320

Sand, George 322

Sansom, William 324

Saroyan, William 326

Schulz, Bruno 328

Sexton, Anne 330

Shaw, George Bernard 332

Simic, Charles 334

Smith, Patti 336

Spiegelman, Art 338

Steadman, Ralph 340

Stevens, Wallace 342

Stevenson, Robert Louis 344

Stifter, Adelbert 346

Stowe, Harriet Beecher 348

Strand, Mark 350

Strindberg, August 352

Tagore, Rabindranath 354

Tarkington, Booth 356

Thackeray, William Makepeace 358

Thomas, Dylan 360

Thurber, James 362

Trevor, William 364

Twain, Mark 366

Updike, John 368

Valéry, Paul 370

Vandewetering, Janwillem 372

Vercors (Jean Bruller) 374

Verlaine, Paul 376

Vigny, Alfred de 378

Vonnegut, Kurt 380

Walcott, Derek 382

Waugh, Evelyn 384

Weiss, Peter 386

Welch, Denton 388

White, T. H. 390

Wilbur, Richard 392

Williams, Tennessee 394

Williams, William Carlos 396

Witkacy (Stanislaw I. Witkiewicz) 398

Wolfe, Tom 400

Yeats, W. B. 402

Among the Missing 405

La maison d'en face or That Other Art
William H. Gass 413

Writers and Artists
John Updike 429

Selected Bibliography 431

Apologia, Acknowledgments, and Alternative Reading Paths

When struggling with the conception of this book, I got advice—some asked for—from editors, scholars, and interested friends. I concluded that the ideal book about the writer-artist would not be just about the writer-artist; rather, it would include artist-writers as well, and musician-writer-artists, and multiple, if not universal, geniuses in general. I also concluded that even if the book were to be limited to the writer-artist, as this book is, it shouldn't, as this book does, exclude writers who didn't write at least some poetry or fiction.

Moreover, the anthology would arrange its subjects logically, making sensible academic discriminations, perhaps separating them by literary movement—grouping the Classicists, Romantics, Pre-Raphaelites, Symbolists, Modernists, Dadaists, Surrealists, and so on. It would place its main focus on writers in the supposed canon, or, given its visual emphasis, on those writers who were serious about their art, or at least on prolific artists and not just dabblers or untrained amateurs. It would divide the painters and the sculptors. It would cover more than the last two centuries and not be limited to western writers. It would put the writers in chronological order. Finally, it would be written as a narrative, so that it could comfortably linger on Æ, Arp, Barlach, Blake, Cocteau, Fromentin, Gao, Hartley, Hoffmann, Hugo, Jones, Kees, Kokoschka, Kubin, Lewis, Miller, Sand, Strindberg, and Thackeray—and the other figures equally accomplished in literary and visual disciplines—and hurry past the lesser lights; and it would fully incorporate into discussions of the individual writer-artists the larger themes presented in the essays that preface and follow their biographies.

The process of unearthing the writer-artists was not orderly; and much of the fun of a given discovery came from its serendipity and the frequently incongruous juxtaposition of a new find with a previous one—coming across Yeats's artwork after Odets's, for example; Acker's after Bennett's; or Thurber's after Lawrence's. Wanting to share this pleasure with the reader, I decided on a randomized placement of the writers and their art. First applying a random number generator to create an unsorted two hundred integer set, I realized that chance positionings were equally achieved by alphabetizing—with the added benefit of creating a searching tool. Since the biographies reference with bold-faced names other writer-artists whose stories and art are included in the book, this organization allows a curious reader to quickly pursue her own links.

Taking a cue from Julio Cortázar and his multipath novel, *Hopscotch*, I also offer readers who prefer a less Dionysian approach a listing of writers organized by year of birth. (The attempt to categorize by literary movement turned out to be an exercise in arbitrariness.) Although writers are identified by race, gender, nationality—and where pertinent, by sexual orientation and religion—I think there is no sound reason for grouping them as blacks, women, Jews, French, Swiss, or German. As for nonliterary skills, even if they were not composers (as Hoffmann, Kees, Justice, and Sansom were), many of our authors had musical talent. There is also among this small universe of writer-artists a remarkable propensity for law—at least eighteen studied or practiced it. Other professions are represented as well. Breton, Levi, and W. C. Williams were physicians; Goethe, McCullough, Nabokov, Potter, and Valéry were scientists. The lure of the sea gave careers to Conrad, Corso, Loti, Masefield (albeit briefly), Michaux, and Rimbaud; Ferlinghetti, Hodgson, Hunter, and Michener did tours in the navy; Vandewetering traveled in a lobster boat. On a darker note, a number of our authors were imprisoned: Corso, Hawthorne, O. Henry, and Verlaine for crimes (and Lermontov for dueling); Beck, Breytenbach, Dostoevsky, Levi, and Mayakovsky for political acts (Gao was sent to a Maoist "re-education" camp); Grass and Vonnegut were prisoners of war; and Cummings suffered wartime internment. The overwhelming majority of the writers experienced life-altering physical or emotional traumas, but a variety of injuries so frequently overlapped in a single individual as to make categorizing by trauma nearly impossible. (Lermontov, for example, lost his mother before he was three and was abandoned by his father, who died when his

son was seventeen; Lermontov endured a physical disfigurement, which led classmates to refer to him as a frog or hunchback, and spent years in military combat.) A most surprising group are Dunlap, du Maurier, Hearn, Huxley, and Thurber, all of whom produced artwork despite the loss of sight in an eye (and for all but du Maurier, impairment of the other), and Lear and O'Casey, who managed with deteriorated vision in both eyes.

The larger themes of writers' art alluded to earlier lead in many directions at the same time. They include the differences and similarities between the literary and plastic arts, the representation of reality, and the nature and source of creativity. Although touched on in my introduction, and in the essays of William Gass and John Updike, in-depth discussion of these topics would require a knowledge of psychology, biology, philosophy, art, and semantics that is likely beyond the reach of any one person. I've chosen to show the great diversity of writers who expressed themselves visually and the wondrous variations of their work, and to point out some of the interesting questions raised.

Following the admonition to writers to write the book they want to read, after years of reading works on writers' art that only talked about it, I have first of all put at least one example of each writer's art on display—and excluded writers whose art was not available. I have included biographical material that tells something of the writers' experiences in the visual arts, as well as information about their personal and literary lives. Wherever possible, there are statements by the writers about their art and the meaning it held for them. Since I am not a scholar, I wrote for the nonscholar. I tried to create a book that would appeal to and be accessible by the vast audience of readers of literature. At the same time, I hope that what I have assembled will be of use to students and teachers with backgrounds in the fields touched upon.

In sum, this far-from-perfect book is too small for its subject and raises many more questions than it answers. It was assembled by a dilettante who makes arbitrary distinctions, who naively sees a sameness in the creative impulses of the great and small, the famous and the unknown, whose ideas are derivative, and whose choices for inclusion—of both writers and artwork—are in some cases obvious and in some cases arguable. I confess here my satisfaction in including writers once fashionable but no longer well known, resurrected only because of their peculiarity in

expressing themselves in visual mediums. The effect is an accidental "Exhumations littéraires," as Théophile Gautier called his reintroduction of centuries-old, marginalized writers. (Later, he changed the title to *Les Grotesques*.)

With new writer-artists constantly emerging, this book was out of date the day it appeared. As its uncredentialed, unqualified author, I take courage from Eugène Ionesco's declaration as he was about to do a painting while being filmed: "I've done worse paintings than the one you are about to see."

I owe many people for their help in bringing this book into being. Foremost, I was blessed to have the friendship and consistent support of Robert Walsh. Unassumingly erudite— Robert has read all these writers and the scholarship about them— and a consummate editor, he answered gently and patiently my endless, frequently naive questions about literary and art matters. Robert identified writer-artists I didn't know about and, in a number of instances, supplied me with examples of their art. He was an invaluable, unstinting resource on the many occasions when I needed to find specialized help. He caught many of my innumerable mistakes and made countless suggestions for improvement. Any lingering weaknesses and errors are entirely mine. This book is dedicated to Robert.

No one could have wished for better assistance than that which I got from Peter Perrone, Michelle Memran, and Robert Kimmerle, who not only provided indispensible research but were unflaggingly enthusiastic, frequently suggesting new writers and paths to pursue. Robert also translated French texts and assisted in my communications with French agencies and institutions. Jeremy Countryman and Michael Lang contributed research to several of the author biographies. Winnifer Skatebol, a professional researcher with an incomparable generosity of spirit, regularly over a period of six years identified writer-artists, supplied me with research references, and brought relevant exhibits to my attention entirely out of the goodness of her heart. The book was significantly improved by having had the services of the gifted and perfectionistic young photographer Jason Brownrigg in shooting much of the original art in private hands. Fred Courtright, AKA the "permdude," ferreted out many of the difficult-to-find permissions, and Leslie Ann Dutcher did the same with a number of images. Dave Guida at Livingston Camera Mart spent endless

indispensable hours making sure that the artwork was formatted for quality reproduction.

For their willingness to provide examples of their art, to be interviewed, and in some cases to provide writings about their personal experiences as artists and the broader perspectives of writer-art, I thank, in no particular order, the illustrious writer-artists John Berger, the late Kurt Vonnegut, Lawrence Ferlinghetti, Ralph Steadman, Derek Walcott, Jules Feiffer, Peter Sacks, Charles Johnson, Mark Strand, Richard Wilbur, Charles Simic, Debora Greger, Donald Finkel, the late Donald Justice, the late Guy Davenport, Susan Minot, Jonathan Lethem, Amiri Baraka, the late Evan Hunter, Tom Wolfe, Hugh Nissenson, Michael McClure, Janwillem Vandewetering, Russell Edson, Patti Smith, and Breyten Breytenbach.

I thank the late Artine Artinian, French scholar and collector extraordinaire, for allowing me access to the art of dozens of French writers in his collection and to photograph and reproduce my selections without charge. Like thanks to Bradford Morrow, novelist, essayist, and editor, for his enthusiastic support and for permitting me to photograph and reproduce from his collection.

My thanks to the great institutions whose helpful staffs personalized them and gave them faces: the Newberry Library, especially to Diana Haskell for letting me in; the Beineke Library of Yale University, especially to the vastly knowledgeable Patricia Willis, Director of Special Collections; to Jenny Lee of the Rare Book and Manuscript Library at Columbia University; the Berg Collection at the New York Public Library; the Harry Ransom Center for the Humanities at the University of Texas, Austin; the Lilly Library at the University of Indiana; the Rosenbach Museum and Library, Philadelphia, and especially Dr. Karen Schoenewaldt, Registrar.

For providing the foundations on which this book is built: Rue Winterbotham Shaw, who curated the 1971 show *A Second Talent: An Exhibition of Drawings and Painting by Writers* at the Arts Club of Chicago and whose records, correspondence, and catalog were a gold mine of source material; the giant of literary talent and scholarship William Gass, who convened the 1997 symposium *The Dual Muse: The Writer as Artist, The Artist as Writer* at Washington University in St. Louis, who allowed the reproduction here of his brilliant essay "*La maison d'en face* or That Other Art," and who graciously gave me his time and invaluable introductions; Norman Holmes Pearson of Yale University, who assembled the collection he called "Art for the Wrong Reasons"; Walter Sorell, author of *The Duality of Vision* (1970); and Kathleen Hjerter, author of *Doubly Gifted* (1986). Their collations of the multiply-talented were basic checklists for me.

Finally, I extend my heartfelt appreciation to Mid-List Press and to its selfless toilers in the cause of literature, Marianne Nora and Lane Stiles, for believing in this project and for transforming my dream, and the efforts of those I've named here, into the book you are holding. Special thanks, too, to poet William Reichard for his polishing edits; to Myles Thompson, without whose belief in the project I wouldn't have started; and to Lena Tabori and her creative team at Welcome Enterprises, Inc. for enhancements in design and for getting the book to a place where you could buy it.

All avenues to clear copyright were pursued, but in some instances no copyright holder to reproduced work could be found. If any exist, please contact the publisher.

INTRODUCTION

"There is no such thing as 'Art.' There are only artists," is the first thing E. H. Gombrich tells us in *The Story of Art*. In the case of the two hundred nineteenth- and twentieth-century artists whose approximately four hundred works are reproduced here, they are also, astonishingly, all writers, many of them among the greatest names in western literature. Blake, Pushkin, Hugo, Poe, Dostoevsky, Proust, and Kafka are just a few of the pantheon. They are Classicists, Romantics, Pre-Raphaelites, Symbolists, Modernists, Dadaists, Surrealists, and Beats. Every Nobel laureate in literature who expressed himself in art is represented—from Yeats, Tagore, Kipling, Faulkner, Churchill, Shaw, Buck, and Elytis, to Hesse, Grass, Walcott, Fo, and Gao.

Weldon Kees—a writer, artist, musician, and filmmaker—would probably not have been surprised: "No doubt the majority of painters and writers could turn to either medium if they liked. Most of them, I think, are forced by society to do one thing and, consequently, in some cases, they become narrower and narrower. They get over-specialised. They're in a trap and they can't get out."

Of course, not all are equally gifted. But those with smaller talents in the visual arts do not seem to value their painterly efforts any less than do the twice-blessed, museum-collected minority (such as Arp, Barlach, Blake, Fromentin, Jones, Kokoschka, Lewis, Rossetti, and Strindberg), for whom each morning was apparently a coin toss to determine whether the day would be spent standing in a smock or seated with a pen. What these writers all seem to prize is the pleasure derived from arranging colors on paper and canvas; it is what distinguished the experience from writing and made it worth their while.

Strindberg equated the sensations he felt as he did his first painting to a hashish high. Hesse described the "entirely new joy" he discovered at forty: "Painting is marvelous; it makes you happier and more patient. Afterwards you do not have black fingers as with writing, but blue and red ones." The normally cynical Twain acknowledged the transformative effect creating art had on him: "I am living a new and exalted life of late," he wrote. "It steeps me in a sacred rapture to see a portrait develop and take soul under my hand." "All my life," said D. H. Lawrence, "I have from time to time gone back to paint because it gave me a form of delight that words can never give. Perhaps the joy in words goes deeper and it is for that reason more unconscious. The conscious delight is certainly stronger in paint."

Although Kees emphasized the creative nature of writers when he posited their desire and inherent capacity to paint, there is also a natural urge in most people to do something different from what they do routinely. "It's just perfectly ordinary for writers to do this," said Kurt Vonnegut, alluding to his painting and prints. "I mean, I might have been a writer and a golfer, too! Imagine being two things at once!"

Indeed, some writers insisted there was no essential difference between using words and pictures. "For half a century, I wrote in black on white," said Colette, "and now for nearly ten years, I have been writing in colour on canvas." Drawing, Jean Cocteau used to say, was just a "different way of typing up the lines."

But text and image do not function the same way. Words, as anyone knows who has tried to describe the face that makes his heart bang in his chest, or a landscape that inspires hosannas, are imprecise and abstract. Images are specific and concrete.

A few years back, bluenose Florida legislators exhausted 328 words attempting to define the area of the buttocks they considered indecent to expose. The first clunking bit read:

> The area at the rear of the human body (sometimes referred to as the glutaeus maximus) which lies between two imaginary lines running parallel to the ground when a person is standing, the first or top of such line being one-half inch below the top of the vertical cleavage of the nates (i.e., the prominence formed by the muscles running from the back of the hip to the back of the leg) and the second or bottom line being one-half inch above the lowest point of the curvature of the fleshy protuberance. . . .

Who wouldn't prefer Picasso's elegant capture of the forbidden zone with a few sure lines in *Femme:*

Picasso

Even if we concede the legislators' language an accuracy to meet constitutional standards of fair notice when the police appear (with rulers and T-squares drawn), we still have no mental picture of a real-world butt. Are we being protected from the sight of a gym-hardened, sun-tanned glut, a steatopygous traffic-stopper, or a dimpled white jiggle of flesh needing a surgical lift?

Which leads to the semiotic—the words, images, sounds, and movements that carry meaning to be interpreted by another—in this case, the way the less specific but more colorful descriptives used above do their work. (They begin by representing one person's perception or memory, then presumably summon images in the reader's mind that stand for other images or ideas in her memory that, in turn, stand for others once perceived, until something suggestive of "a real-world" buttock or the idea of a real-world buttock arises.) Or the way a couple of graphite lines on paper or acid-etched in metal do something similar.

The Greek word *graphos* meant something written as well as something drawn or painted. Although no landscape or portrait rendered in words can have the specificity of one captured in oil, scratched in copper, or carved in marble, and while ink, metal,

canvas, and stone do not permit a character or place to evolve over time, or allow more than a suggestion of dialogue or interiority, there is a connectedness between the written and plastic forms. Obviously, both use implements on a surface to communicate an idea, an emotion, or an image. Fernando del Paso says the earliest drawings he can remember making were the alphabet. And, historically, letters were drawings first—and to some extent, innumerable generations after the hieroglyphs and ideograms of the ancients, they remain so. Henri Michaux, for example, turned the alphabet into hallucinogenic figures. There are artists employing word shapes in their paintings and sculptures everywhere.

Cave pictures were there to say something about the scenes or events our preliterate ancestors chose to memorialize. But not only was painting essential to communication before letters were invented, even when words supplanted images as the primary means of unspoken informational exchange, language remained essential to art. We see this in the "long line of poet-painters," who were, William Carlos Williams wrote, "all of them artists for whom the text portrays, the picture speaks."

Drawing, painting, and sculpture partake of the physical world and are sensory, while writing is conceptual. This distinction blurs, however, when one considers that there is pleasure in rhyme, rhythm, and meter, which is musical, somatic, and sensual enough to provoke physical response. How pleasantly does writer-artist-jazz musician William Sansom's "So though with others smokes and girls might sound a stronger vice" splash around the palate. The deaf carve poetry out of space with their hands. The blind absorb stories through their fingers. The Greeks grouped poetry with the healing arts of medicine under the aegis of Apollo.

Yet, if poets and painters are part of the same family in their common use of images and language, their union has been viewed by some as unhealthily incestuous. According to this point of view, when the boundaries soften, the purity of each form is threatened. "I developed these principles to the rejection of all detailed description," wrote William Butler Yeats, "that I might not steal the painter's business, and indeed I was always discovering some art or science that I might be rid of and I found encouragement by noticing all round me painters who were ridding their pictures, and indeed their minds, of literature." Wyndham Lewis declared that keeping the literary out of his consciousness was the way to

achieve purity in painting. Conversely, he "recommended the construction of as abstract an alphabet as possible."

For Dante Gabriel Rossetti, "picture and poem bear the same relationship to each other as beauty does in man and woman: the point of meeting where the two are most identical is the supreme perfection." It was the creative sensibility that united word and image, not the forms themselves. Rossetti made poems for pictures and pictures to accompany poems. But the poem's purpose was not to describe the pictures: "I should particularly hope it might be thought . . . that my poems are in no way the result of a painter's tendencies—and indeed no poetry could be freer than mine from the trick of what is called 'word painting.'"

Poems about pictures were never to be "merely picturesque," but to clarify and enlarge understanding—as advertisers today do so successfully on every page, screen, bus, and billboard. Image and text were to maintain their separate forms. For Pound, the "point of meeting" was to be found in "Vorticism," the English avant-garde art movement founded by Lewis, which Pound took beyond its Cubist and Modernist roots. Pound's conception was of an "aesthetic which carries you through all of the arts." But for Pound, a common meeting ground for the arts did not mean that their forms should not be maintained or that all forms satisfy all needs. "We go to a particular art for something which we cannot get in any other art," he wrote.

> If we want form and colour we go to a painting, or we make a painting. If we want form without colour and in two dimensions, we want drawing or etching. If we want form in three dimensions, we want sculpture. If we want an image or a procession of images, we want poetry. If we want pure sound, we want music.

Did Pound really conclude his declamation on the division between the visual and literary arts by saying we go to poetry for images? Are the borders so muddy?

The "supreme perfection" that Rossetti located at the meeting point where picture and poem are "most identical" is not easily found. But for some creative souls, there exist realities whose representation seems beyond the capacities of word or image, at least in their traditional forms as picture or poem.

Annette Lemieux's four-and-a-half-by-twelve-foot painting *Hell Text* (1991) consists of thirteen lines of even, cursive, lowercase script—part of a first-person narration that describes the rounding up and transportation of the narrator in a boxcar to a "hell on earth" where the "black smoke" of the crematoria subdues the light. Lemieux, the writer, seems to be telling us that the hideousness she wishes to describe must be got from the victim's own hand, that it is too real, too intimate for the cold impersonality of type, and that it is a horror too enormous for the largest page. Lemieux, the artist, is intimating that the Holocaust is beyond art's powers of depiction. Her painting offers images that can be seen only in one's mind, conjured out of words or, more precisely, the ideas the words represent, rather than directly from pigment or ink.

An extreme example of the violation of the boundaries of form is Christine Borland's *The Monster's Monologue*, invisibly exhibited in 2000 on a wall of the Walker Art Center in Minneapolis. It consists of a flush-mounted loudspeaker out of which comes the voice of a child reading an excerpt of Mary Shelley's *Frankenstein*. The "visual" images produced by the artist are all generated by the mind of a listener.

These are only two of innumerable examples of language taking a plastic or physical form. (There are more than fifty thousand such pieces in the Sackner Archive of Concrete and Visual Poetry in Miami.) Yet, however brilliant the premise and however beautifully executed, such nontraditional expressions hold no appeal to the writer-artist who believes in the integrity and distinctiveness of artistic mediums and forms. Goethe admonished two centuries ago: "One of the most striking signs of the decay of art is when we see its separate forms jumbled together." For Eugène Ionesco, "Literature and painting have nothing to do with each other even as they express the same anguish, the same games, the same questions." The language of painting should not be confused with the language of words, he said: "The title of a picture should be another picture."

The artwork presented here preserves the traditional forms of each discipline, even though it may occasionally be captioned, accompany text, or interweave words and images. It is the work of writers who jumped—either once or repeatedly—from one artistic territory to another, and for almost as many different reasons as there are writers.

Some were artists or art students who either abandoned art for writing or pursued parallel literary and fine arts careers. A number illustrated their work or cartooned. Some were "Sunday painters"—dabblers, doodlers—or experimenters, like Victor Hugo, who made artworks out of his morning coffee grounds, ashes, and matchsticks. Others migrated to art when words failed them. Typically, creating art was play, it was fun. "Art isn't art, actually. . . . Art starts as sort of fucking around," was how Allen Ginsberg explained it.

There is a tradition of writers keeping picture diaries for the most pragmatic of reasons: They create aides de memoires of the nouns—a weathered native in the Otavalo market with a basket of crawling, supposedly edible larvae; young monks walking past a prostitute on a Rome street; suited businessmen arm-in-arm in front of a crumbling, stucco church wall—that will later conjure the verbs that turn stuff into story. A picture of the subject is the starting point for these writers' extrapolations from face, bridge, or wheelbarrow to character, motive, intention, action, and plot—and ultimately, to some social, psychological, or philosophical truth. "Nothing we can learn about an individual thing is of use unless we find generality in the particular," declared Rudolph Arnheim.

Other writers claim that it's the sensory connection they need, the feeling of physicality produced by an image, which enables them to produce words. For Sylvia Plath, such grounding was essential: words came only when stimulated by visual perception, even if she had to draw what she would write about. (As a journalist for *The Christian Science Monitor,* she wrote articles to accompany her illustrations.) Maxine Hong Kingston says that at the beginning of a book she gets her sense of where it's going by drawing pictures: "I draw a blob and then I have a little arrow and it goes to this other blob and then I have a little arrow and it goes to this other blob." And then the "blobs" become words. "Sometimes I draw my plays before I write them," says Dario Fo, "and other times, when I'm having difficulty with a play, I stop writing so that I can draw out the action in pictures to solve the problem." Dostoevsky sketched portraits of Myshkin and Karamazov on his manuscript pages. Jorie Graham develops a poem with "almost always a sense perception of some kind"— frequently an image she's drawn herself. "I draw to make myself try to keep the act of looking physical—bodily. So you're not looking

with your brain, you're looking with your body, to get it." In this she echoes Plath's account of how drawing the Pont Neuf enabled her to know the view "through the fiber of my hand." According to Arnheim, one "who paints, writes, composes, dances . . . thinks with his senses."

Yet, however helpful generating their own images may be to some writers, J. R. R. Tolkien, for one, argued against the practice. Despite having beautifully illustrated his fantasy stories, he insisted that the particularizing nature of pictures is detrimental to the reader. "The problem with any art that offers a visible presentation," said Tolkien, "is that it imposes one visible form. Literature works from mind to mind and is thus more progenitive. It is at once more universal and more poignantly particular. If it speaks of bread or wine or stone or tree, it appeals to the whole of these things, to their ideas; yet each hearer will give to them a peculiar personal embodiment in his imagination."

Plato taught us that we have only the idea of "tree" (or "bread" or "wine" or "stone"), that the world contains only specific trees— the two-thousand-year-old olive tree whose fruit may have fed Christ himself and which the Israeli road detours deferentially around, the new blue spruce flatbedded into my yard to screen my neighbors, the African leadwood up which the leopard hauls her kill, the dangerous baobabs Saint-Exupéry drew for us in *The Little Prince*—each unique as a snowflake. And it is perhaps these Platonic ideals embodied in words like "tree" that enable us to talk about trees in the abstract, and other chimeras like "perfection" or "democracy" or "Saviour." "I trust the world to speak for itself. If I write *rose*, there are roses to stand me good," said Guy Davenport.

But there are all kinds of roses, and countries where no roses grow, and a world filled with flora and fauna—not to mention ideas—for which we have no words (at least as of yet). Languages, after all, express the experiences unique to the societies that fashioned the language. When the writer picks up a brush rather than a pen to speak to us, he presumably avoids such problems, although, as Tolkien observed, the particularity of his drawn image may, paradoxically, defeat the universality of the image drawn in word.

If, as contemporary neuroscience tells us, seeing and thinking are one overlapping brain function, perhaps images are merely encoded language. We can think, and use language, without

images (and, as Helen Keller showed us, without sound either); but do we need a capacity for language to understand image? Social and political caricaturists have long been using image and word complementarily to create instantaneous comprehension. For Henry James such caricature was "only journalism made doubly vivid." If journalism was "criticism of the moment," he wrote, caricature was "that criticism at once simplified and intensified by a plastic form." Cartooning, which Will Eisner and Art Spiegelman elevated into the accepted literary form of the graphic novel, tells its stories in word and picture, showing more directly the influence of cinema and television than traditional literature. Gabriel García Márquez says his childhood cartooning was how he learned narrative. E. T. A. Hoffmann, S. J. Perelman, Tom Wolfe, Charles Johnson, O. Henry, Flannery O'Connor, John Updike, James Thurber, Jules Feiffer, and Jack Kerouac all cartooned. Perelman said, "I drifted into writing principally because my cartoon captions became longer and longer and longer."

Is a writer painting, drawing, or sculpting as natural to his creativity as Kees suggested? Even if it is ordinary, as Vonnegut said, to do more than one thing, there's still the question: why art and not golf—or orchids, or origami? Perhaps the writer is trying to create without the limitations of her chosen form. Or maybe it's that she seeks to bring forth her ideas with less artifice.

The appeal for the writer and the reader of these secondary, spill-over creations is at least partly that the artworks are frequently less accomplished, less subjected to the imposition of craft, and thereby perhaps closer to the inner self of the writer than her writings. We want to know about the unrevealed parts of our favorite writers. If the tabloids covered Nobel and poet laureates, we'd reach for them in the supermarket line.

When we consider the writer's artwork, we look for connections to what we know already. We expect to see André Breton and Jacques Prévert's Surrealist images, the Classical painting of Goethe and William Dunlap, and the casual self-portrait of Dylan Thomas in his cups. But what a surprise to see gothic Flannery O'Connor as a light-hearted cartoonist, Joseph Conrad doing pen and inks of sexy girls, or the pessimistic Charles Bukowski emerging from his private hell to produce childlike renditions of airplanes, cars, and dogs. There is consistency in, for example, the tattooed, sexually obsessed Kathy Acker illustrating

her work with line drawings of genitalia, both the romantic and agit-prop aspects of Lawrence Ferlinghetti's personality appearing in his paintings, and Nabokov rendering his fictions and butterfly drawings with the same scientific precision. But how to make sense of William Faulkner's clean-lined drawings of flappers, Henry Miller's cheery watercolors, or silly Edward Lear's imposing landscapes? In their artwork, writers frequently give us a different side of themselves. "Art," wrote Max Jacob, "is the will to exteriorize oneself by one's chosen means."

Knowing that the artwork was inhabited by the spirit (if not necessarily the talent) of the writer may not only yield insights into his writing but tell us something about the writer as a person. We want to rummage through his psyche, as we would his drawers, diaries, and private correspondence, to know about his life and loves. Using artwork as our probe is, however, problematic. Art used therapeutically for the mentally ill helps them express thoughts and emotions that would otherwise remain hidden and unarticulated, as Hesse employed art after his breakdown. But the connection between the art and the artist's mind is far from clear. Freud himself readily admitted that understanding the mind of the artist did not deepen the understanding of his work: "It must be confessed to the layman, who may possibly expect too much of analysis in this respect, that it does not throw any light on two problems which probably interest him most. Analysis has nothing to contribute to the explanation of the artist's gifts, nor is it competent to lay bare his method, his artistic technique."

Mentally ill people have produced interesting and beautiful art—a type of art French critics in the 1930s labeled "l'art des fous." Painter Jean Dubuffet, who advanced the idea of an art brut (which gave a home to mad Henry Darger), rejected the idea that art by the mentally ill was qualitatively different from any other form of art. "There is," he said, "no more 'art des fous' than there is art of dyspeptics or of those with bad knees." The same may be said about an art of writers.

Still, one may legitimately ask whether the impulse to produce artwork is the same one that impels the writer's literary expressions. In the broad sense, poetry and painting manifest the creativity that historically was first ascribed to God, then to imagination—to an individual's unique psychology—and more recently to the successful tapping of the subconscious, the

exploitation of chance, and even the theory of sexual selection (in which poetry and painting are viewed as a demonstration of quality, evolved, like the peacock's tail, for no utilitarian purpose beyond attracting a mate). But given the trouble-fraught lives of the great majority of the writer-artists anthologized here, their creative abundance may best be understood as an attempt to master trauma. The lives of the two hundred subjects of this book reveal most of them to have been injured—by physical ailments (including at least a half-dozen cases of severe vision loss or blindness in at least one eye), by mental illness, by the abandonment by or death of one or both parents or the death of a close sibling before adulthood, by poverty or social ostracism, by oppressive or brutalized upbringings, by war or Holocaust experiences—and many with a combination of afflictions.

Wilkie Collins made up stories to appease a childhood bully and, years later, realized that it "was this brute who first awakened" his narrative powers. John Updike wrote of the humiliation he felt from his chronic psoriasis, and the social and economic failures of his father. He was driven to "avenge all the slights and abasements visited upon my father." Because of his skin condition, Updike eschewed "presentable" jobs, determined to become "a craftsman of some sort, closeted and unseen—perhaps a cartoonist or a writer, a worker in ink who can hide himself and send out a surrogate presence, a signature that multiplies even while it conceals." T. H. White explained his extraordinary creative, scholarly, and physical achievements as a product of the insecurity, inferiority, and anxiety engendered by the breakup of his parents' marriage when he was fourteen: "Compensating for my sense of inferiority, my sense of danger, my sense of disaster, I had to learn to paint, and not only to paint—oils, art and all that sort of thing—but to build and mix concrete and to be a carpenter and to saw and screw and put in a nail without bending it." Donald Justice, who had endured a childhood of near poverty, osteomyelitis, the death of a close young friend, and mistreatment by adults, was articulate about the way creating enables one to deal with pain and loss: "The terror or beauty or, for that matter, the plain ordinariness of the original event, being transformed, is fixed and thereby made more tolerable. That the event can recur only in its new context, the context of art, sheers it of some risks, the chief of which may anyhow have been its transitory character."

Some of our writers had happy lives, and some of the unhappy were not, in the end, saved by their art. "My fans think I got well, but I didn't: I just became a poet," said Anne Sexton, who did a self-obliterating portrait before eventually taking her life. In her suicidal company were Hart Crane, Weldon Kees, Vachel Lindsay, Vladimir Mayakovsky, Sylvia Plath, Adalbert Stifter, and Witkacy (Stanislaw Ignacy Witkiewicz). This reflects a suicide rate for the writer-artists included in this book that is more than two hundred times greater than the general suicide rate in the United States.

Rudyard Kipling's legendary mistreatment in childhood made him the central argument for Edmund Wilson's thesis in *The Wound and the Bow* that trauma shapes the creative soul. Believing success as a writer or artist resulted from a knowledge of the trade in the same way stonecutters, seamen, and cabinetmakers knew theirs, Kipling found his childhood abuse a benefit to his craft: "Nor was my life an unsuitable preparation for my future, in that it demanded constant wariness, the habit of observation, and attendance on moods and tempers; the noting of discrepancies between speech and action; a certain reserve of demeanour; and automatic suspicion of sudden favours."

Many of our writer-artists are entitled to make the same boast of sadly acquired gifts of observation and characterological insight. They also needed to dodge blows or prove themselves deserving of ordinary love after their parents abandoned them—by dying (or, more explicitly, by killing themselves), by becoming drunks or divorcing, by deserting them or placing them in the care of unloving others, or, perhaps worst of all, by keeping them, as Beatrix Potter was stowed in the attic, in their own unloving care.

This relationship between emotional wounding and creativity has been the subject of much psychological study in recent decades: a 2005 search of the American Psychological Association database yielded 346 books and articles on the subject, most produced since 1970. "Traumatic experiences which occur in early childhood and which are later repressed often find expression in the creative works of painters and poets," wrote psychoanalyst Alice Miller, adding that "society is to a great degree unaware of this phenomenon, as are the artists themselves."

Painting and writing appear to be the means by which the damaged souls who are our subjects were able to address their guilt, anger, affection, despair, and other loss-generated

emotions—the way they salvaged meaning from pain. Through their art they could wall off the hurt so it did not metastasize and debilitate. Each poem, each drawing, is a layer of callus—or, more accurately, given the attention to aesthetics, of pearl—over the preserved but encapsulated memory. Dissatisfied with the world presented to them, injured writers and artists create their own, using words and paint—one that they can control, one that follows their rules of perspective and color, of narrative and voice, one peopled with characters of their invention, who move to their choreography in settings they've designed. It is a world that can be rewritten or painted over.

Thus, much of the artwork displayed here may be seen as born out of a matrix of pain and genius, a stew of life experience recorded algorithmically in the brain, undifferentiated as word or image, then, impelled by the mind, perhaps after being provoked by some catalyzing scene or face or snatch of conversation, to manifest itself, at last, in some medium as color, shape, sign, or symbol. That the ideas or images exist in a preconscious soup of sensations is suggested by every writer's use of metaphor and by synesthetes, for whom city noises are colored and scenery is story—Franz Grillparzer, for example, who would place an engraving before him and play it as if it were a piano score, or E. T. A. Hoffmann, who discerned a melody in a chrysanthemum's aroma.

The art may as easily (and consistently) be viewed as glimmers of God. And whether the paintings, drawings, and sculpture contain seriously or unseriously intended or unintended messages, whether they emanate from the conscious or subconscious or the left or right brain, whether they are the products of genetically transmitted talent or of neurochemical switches synthesized from individual or collective experience, whether they are well rendered or amateurish, they seem to have in common having been created in pleasure and, of equal importance, giving pleasure to their viewers.

I conclude then with no grand theory, no overarching paradigm to offer beyond these summarizing lines of Yeats from "Art and Ideas":

> Nor had we better warrant to separate one art from another, for there has been no age before our own wherein the arts have been other than a single authority, a Holy Church of Romance, the

might of all lying behind all, a circle of cliffs, a wilderness where every cry has its echoes. Why should a man cease to be a scholar, a believer, a ritualist before he begin to paint or rhyme or to compose music, or why if he have a strong head should he put away any means of power?

1749	Goethe, Johann Wolfgang von	150	1828	Rossetti, Dante Gabriel	314	1871	Valéry, Paul 370
1757	Blake, William	48	1830	Goncourt, Jules de	154	1872	Beerbohm, Max 34
1766	Dunlap, William	108	1832	Carroll, Lewis	62	1873	Jarry, Alfred 202
1776	Hoffmann, E. T. A.	182	1834	Du Maurier, George	102	1874	Chesterton, G. K 68
1791	Grillparzer, Franz	164	1834	Morris, William	274	1874	Churchill, Winston 70
1797	Vigny, Alfred de	378	1835	Twain, Mark	366	1876	Anderson, Sherwood 12
1799	Pushkin, Alexander	304	1836	Gilbert, W. S.	146	1877	Hartley, Marsden 168
1802	Hugo, Victor	190	1840	Hardy, Thomas	166	1877	Hesse, Hermann 176
1803	Mérimée, Prosper	260	1844	Hopkins, Gerard Manley	186	1877	Kubin, Alfred 226
1804	Sand, George	322	1844	Verlaine, Paul	376	1878	Masefield, John 252
1805	Andersen, Hans Christian	10	1846	Greenaway, Kate	160	1879	Lindsay, Vachel 242
1805	Stifter, Adelbert	346	1846	Hawthorne, Julian	170	1879	Stevens, Wallace 342
1809	Gogol, Nikolai	152	1849	Riley, James Whitcomb	308	1880	Apollinaire, Guillaume 14
1809	Poe, Edgar Allen	296	1849	Strindberg, August	352	1880	O'Casey, Sean 282
1810	Musset, Alfred de	276	1850	Hearn, Lafcadio	172	1882	Lewis, Wyndham 240
1811	Gautier, Théophile	142	1850	Loti, Pierre	246	1882	Loy, Mina 248
1811	Stowe, Harriet Beecher	348	1850	Stevenson, Robert Louis	344	1883	Gibran, Kahlil 144
1811	Thackeray, William Makepeace	358	1854	Rimbaud, Arthur	310	1883	Kafka, Franz 210
1812	Lear, Edward	232	1856	Shaw, George Bernard	332	1883	Williams, William Carlos 396
1814	Lermontov, Mikhail	234	1857	Conrad, Joseph	78	1885	Lawrence, D. H. 230
1816	Brontë, Charlotte	54	1861	Tagore, Rabindranath	354	1885	Witkacy (Stanislaw I. Witkiewicz) 398
1818	Brontë, Emily	54	1862	Henry, O.	174	1886	Kokoschka, Oskar 224
1819	Keller, Gottfried	214	1865	Kipling, Rudyard	220	1886	Lofting, Hugh 244
1819	Kingsley, Charles	218	1865	Yeats, W. B.	402	1887	Arp, Jean (Hans) 16
1819	Ruskin, John	316	1866	Potter, Beatrix	298	1887	Moore, Marianne 272
1820	Fromentin, Eugène	136	1867	Æ (George Russell)	4	1888	Cary, Joyce 64
1821	Baudelaire, Charles	30	1867	Bennett, Arnold	40	1889	Bagnold, Enid 20
1821	Dostoevsky, Fyodor	100	1869	Lasker-Schüler, Else	228	1889	Cocteau, Jean 74
1822	Goncourt, Edmond de	154	1869	Tarkington, Booth	356	1890	Rosenberg, Isaac 312
1824	Collins, Wilkie	76	1870	Barlach, Ernst	26	1891	Miller, Henry 268
1824	Dumas, Alexandre *fils*	104	1870	Belloc, Hilaire	36	1892	Barnes, Djuna 28
1825	Ballantyne, R. M.	22	1871	Hodgson, Ralph	180	1892	Buck, Pearl S. 56
1828	Ibsen, Henrik	196	1871	Proust, Marcel	302	1892	Darger, Henry 90

1892	Schulz, Bruno 328	
1893	Mayakovsky, Vladimir 254	
1894	Cummings, E. E. 88	
1894	Huxley, Aldous 194	
1894	Jacob, Max 200	
1894	Thurber, James 362	
1895	Jones, David 206	
1896	Artaud, Antonin 18	
1896	Breton, André 50	
1896	Dos Passos, John 98	
1897	Faulkner, William 124	
1897	Knight, Eric 222	
1898	Bemelmans, Ludwig 38	
1899	Crane, Hart 86	
1899	García Lorca, Federico 140	
1899	Michaux, Henri 264	
1899	Nabokov, Vladimir 278	
1900	Prévert, Jacques 300	
1900	Saint-Exupéry, Antoine de 320	
1902	Alberti, Rafael 8	
1902	Levi, Carlo 238	
1902	Vercors (Jean Bruller) 374	
1903	Horgan, Paul 188	
1903	Waugh, Evelyn 384	
1904	Ionesco, Eugène 198	
1904	Perelman, S. J. 292	
1905	Rexroth, Kenneth 306	
1906	Cookson, Catherine 80	
1906	Odets, Clifford 286	
1906	White, T. H. 390	
1907	Bentley, Nicolas 42	
1907	Michener, James A. 266	
1908	Ford, Charles Henri 134	
1908	Saroyan, William 326	
1909	Agee, James 6	
1911	Bishop, Elizabeth 46	
1911	Elytis, Odysseus 120	
1911	Patchen, Kenneth 288	
1911	Peake, Mervyn 290	
1911	Williams, Tennessee 394	
1912	Durrell, Laurence 112	
1912	Sansom, William 324	
1914	Burroughs, William S. 60	
1914	Kees, Weldon 212	
1914	Thomas, Dylan 360	
1915	Welch, Denton 388	
1916	Weiss, Peter 386	
1917	Eisner, Will 118	
1919	Cassill, R. V. 66	
1919	Duncan, Robert 106	
1919	Ferlinghetti, Lawrence 128	
1920	Bukowski, Charles 58	
1921	Dürrenmatt, Friedrich 114	
1921	Emshwiller, Carol 122	
1921	Highsmith, Patricia 178	
1921	Wilbur, Richard 392	
1922	Kerouac, Jack 216	
1922	Vonnegut, Kurt 380	
1923	Dunnett, Dorothy 110	
1924	Lucebert 250	
1925	Beck, Julian 32	
1925	Gorey, Edward 156	
1925	Justice, Donald 208	
1925	O'Connor, Flannery 284	
1926	Berger, John 44	
1926	Donleavy, J. P. 96	
1926	Fo, Dario 132	
1926	Ginsberg, Allen 148	
1926	Hunter, Evan (Ed McBain) 192	
1927	Davenport, Guy 92	
1927	Grass, Günter 158	
1928	Sexton, Anne 330	
1928	Trevor, William 364	
1929	Feiffer, Jules 126	
1929	Finkel, Donald 130	
1930	Corso, Gregory 82	
1930	Walcott, Derek 382	
1931	Vandewetering, Janwillem 372	
1931	Wolfe, Tom 400	
1932	McClure, Michael 256	
1932	Plath, Sylvia 294	
1932	Updike, John 368	
1933	Michaels, Leonard 262	
1933	Nissenson, Hugh 280	
1934	Baraka, Amiri 24	
1934	Strand, Mark 350	
1935	Del Paso, Fernando 94	
1935	Edson, Russell 116	
1936	Steadman, Ralph 340	
1937	McCullough, Colleen 258	
1938	Simic, Charles 334	
1939	Breytenbach, Breyten 52	
1940	Gao Xingjian 138	
1940	Hong Kingston, Maxine 184	
1946	Smith, Patti 336	
1948	Acker, Kathy 2	
1948	Johnson, Charles 204	
1948	Spiegelman, Art 338	
1949	Greger, Debora 162	
1950	Sacks, Peter 318	
1956	Minot, Susan 270	
1961	Clowes, Daniel 72	
1961	Coupland, Douglas 84	
1964	Lethem, Jonathan 236	

THE WRITER'S *Brush*

KATHY ACKER

Kathy Acker illustrated her body with tattoos and her books with tattoo-like line drawings of genitalia, dreamscapes, and maps of imagined locales. The connection was not happenstance: Acker identified writing with the body, saw the body as the source of language. Moreover, her texts—composed of fragments of material borrowed from other writers, cut up and inserted in different contexts within her own writing—were non-linear, indeed, nonrational, more visceral than mental. Her illustrations, especially the "dream maps" in her novel *Blood and Guts in High School* (1986), presented as faithful manifestations of her fantastic reveries, are an ironic imposition of structure on emotional chaos.

Consistent with her Surrealist influences (**André Breton** by way of **Jack Kerouac**), Acker drew the dream maps immediately on waking, reflecting her belief in the unconscious as a creative source. She once explained the parallel between drawing on her body and writing with others' texts:

> When you're dealing with tattooing . . . you're going in and listening to the body, and it's not so much remaking the body as it is finding out about the body, finding out what's there, and the two processes come together in the same process called tattooing. . . . For me, it's like writing, using other texts the way I do now. It's changed over the years. To learn to work a text is partly to learn to listen, so that it's not just me having my little autobiographical story, and stamping it on everything that comes along, but it's me going into **Faulkner** or **Rimbaud** and trying to listen to them. When I emerge, I'm some kind of conglomeration between them and me.

Phil Baker, writing in the *Times Literary Supplement*, suggested Acker's "chameleonic attempt to assume the identity of other people . . . recalls both the 'primitive' or 'magical' thinking of voodoo invocation and the more sophisticated thinking of New York 'appropriation' artists like Cindy Sherman and Sherrie Levine."

Acker said she became interested in the problems of plagiarism and appropriation because "[a]rtists my age were working with appropriation. It was a reaction against modernism, against the idea that as a creator you're god: the one who decides everything."

Born in 1947 in New York City, Acker was the daughter of Donald Lehman and Claire Weill Lehman, wealthy New York German Jews who separated when her mother was three-months pregnant. Acker grew up without ever meeting her father, although her mother remarried and she was raised with a stepfather. When Acker was thirty, her mother committed suicide. In an interview with "R. U. Serius" for *io* magazine, Acker connected her urge to write with visceral satisfaction, and both with childhood misery:

> When I was a kid, my parents were like monsters to me, and the world extended from them. . . . So the only time I could have any freedom or joy was when I was alone in my room. Writing is what I did when I was alone with no one watching me or telling me what to do. . . . So writing was really associated with body pleasure—it was the same thing. It was like the only thing I had.

Acker studied classics at Brandeis University and the University of California, San Diego, working as a secretary, stripper, and performer in sex shows and pornographic films before becoming a writer, art critic, and adjunct professor at the San Francisco Art Institute. She died of breast cancer in Tijuana, Mexico, in 1997, leaving behind a body of angry, disjointed, deliberately plagiaristic writing that was informed by Kerouac and **William S. Burroughs** and embodied the punk sensibility. Extremely prolific, Acker wrote plays, screenplays, opera libretti, and journalistic articles in addition to her many works of fiction.

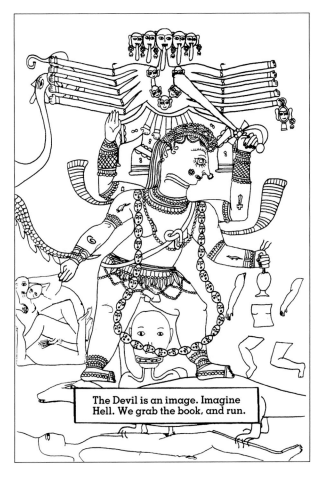

The Devil is an image. Imagine Hell. We grab the book, and run.

Kathy Acker. The Devil is an image. Imagine Hell. We grab the book, and run.

4–1/2 x 3 inches. From *Blood and Guts in High School*. Original artwork, Box 9, Kathy Acker Papers, Rare Book, Manuscript, and Special Collections Library, Duke University, with the kind permission of the estate of Kathy Acker

Æ (GEORGE RUSSELL)

"Seek on earth what you have found in heaven."

As a young teenager Æ—then still George Russell—began to question Christianity, specifically challenging God's right to hold him accountable for things he hadn't agreed to. He had visions of figures he recognized as ancient Irish gods and became preoccupied with spiritual issues. In 1888, Russell took the name "Æ," an abbreviation of "Aeon," meaning an eternal being that is an intermediary between the world and the supreme being of whom it is a part. He attended the Metropolitan School of Art in Dublin at a time when his visions—powerful, cosmic imaginings—intruded on and possessed his everyday life:

> I remember how pure, holy and beautiful these imaginations seemed; how they came like crystal water sweeping aside the muddy current of my life. . . . The visible world became like a tapestry blown and stirred by the winds behind it. If it would raise but an instant I knew I would be in Paradise.

Russell's art reflected his mysticism. **William Butler Yeats**, Russell's classmate at Metropolitan, lifelong friend, and intellectual adversary ("the antagonism that unites dear friends" in Æ's words), recalled Russell as an art student:

> He did not paint the model as we tried to, for some other image rose always before his eyes (a St. John in the Desert, I remember), and already he spoke to us of his visions. One day he announced that he was leaving the Art schools because his will was weak and the arts or any other emotional pursuit could but weaken it further.

Æ, often referred to as that "myriad-minded man," was a poet and mystic, a leader of the Irish literary renaissance, and an economist who organized agricultural cooperatives. He was born George William Russell in Lurgan, County Armagh, Ireland, in

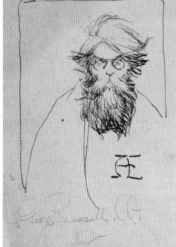

1867, and died in Hampshire, England, in 1935. From 1890 to 1898, Æ, who had joined Yeats's circle of Theosophists, lived in the Theosophical Lodge in Dublin while working in a drapery store during the day and devoting himself to the faith at night. Despite his declared abstemiousness in both art and love, he painted murals on the lodge walls (signed jointly with Yeats) and published poetry and prose, starting with *Homeward: Songs by the Way* in 1894.

Æ's plans for a celibate life were sabotaged when he fell in love with Violet North, another Theosophist, whom he later married. Æ left the Dublin Lodge in 1898 and joined the Hermetic Society, another group of Theosophists, which he led until 1933. A number of young Irish writers, including James Joyce, whom he met in 1902 and introduced to Yeats, brought him their work, and Æ supported and encouraged them. He was a cofounder—with Yeats, Lady Gregory, and George Martyn—of the Irish National Theatre Society, which produced his play *Deirdre* in 1907; but he had a divisive quarrel with Yeats that same year.

In addition to his many volumes of verse, most notably *The Divine Vision* (1903), *The Candle of Vision* (1918), and *Midsummer Eve* (1928), Æ's writings included books on economics and religious philosophy. He edited the nationalistic magazine *Irish Homestead* from 1904 to 1923 and its successor, *The Irish Statesman*, from 1923 to 1930.

At the same time, Æ continued his art, sketching, drawing, and painting landscapes of Ireland as well as his inner visions. Late in life he boasted that every British cabinet member had an Æ painting on his wall, but twenty years after his death his work was virtually unsaleable. "[I]t is said," wrote editor Colin Smythe, "that at an auction on the Dublin Quays, one of his pictures failed to sell at 2/6d. even with a coal-skuttle added to the lot." Today, however, Æ's work is again popular, and his portraits, landscapes, and visionary images are shown and promoted by Dublin's Oriel Gallery.

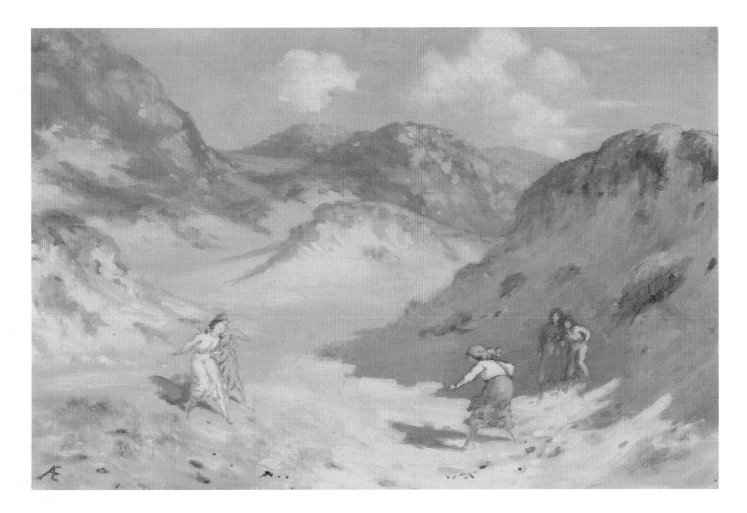

Above: Æ. Children on the Irish Dunes

Oil. 29 x 39–3/4 inches. YCAL at The Beineke Rare Book and Manuscript Library, Yale University. Reprinted by permission of Russell & Volkening as agents for the estate of George Russell

Opposite: Æ. Self-portrait

Pencil and ink. 5–1/8 x 7–1/2 inches. Berg Collection of English and American Literature, The New York Public Library, Astor, Lenox and Tilden Foundations. Reprinted by permission of Russell & Volkening as agents for the estate of George Russell

JAMES AGEE

James Agee's importance in modern literature, writes Victor A. Kramer in the *Dictionary of Literary Biography*, rests in part on his "revealing what others had not usually taken time to see." A letter in which Agee talks about his drawing suggests that his efforts in visual art made a direct contribution to his literary eye:

> At night I'm starting to draw heads of Alma and copies of postcard American city streets. I would never have known how much even a little of it sharpens your eye and gives you more understanding and affection for even some small part of a human or architectural feature. . . . I now "possess" and "know" Alma's face and a Brooklyn street in 1938 as if they were a part of me, as much as my hand.

The effort to capture the concrete details of reality as he perceived them permeated Agee's writing and was the polestar of his literary aesthetic. His goal, he said, was "to write of nothing whatever which did not in physical actuality or in the mind happen or appear; and my most serious effort will be, not to use these 'materials' for art, far less for journalism, but to give them as they are and as in my memory and regard they are."

It was his concern for how things are that undoubtedly led Agee to write his legendary film criticism, distinguished by its educating audiences in how to look at movies. And it is his film criticism that justified the canonization of his writings in a two-volume set by the Library of America. Film was the natural medium for Agee since it was all about seeing. The great potential of film-making, to him, lay in the scrupulously handled camera, and his screenplays were extraordinary in providing detailed photographic instructions to the director:

> The camera can do what nothing else in the world can do: can record unaltered reality; and can be made also to perceive, record, and communicate, in full unaltered power, the peculiar kinds of poetic vitality which blaze in every real thing and which are in great degree, inevitably and properly, lost to every other kind of artist except the camera artist.

Agee, a poet, novelist, influential film critic, screenwriter of, among other films, the Academy Award-nominated *The African Queen* (1951) and *The Bride Comes to Yellow Sky* (1952), was the author of the lyrical *Let Us Now Praise Famous Men* (1941), a book about the sharecroppers of Alabama illustrated with the photographs of Walker Evans. Perhaps his most famous work is the posthumously published, Pulitzer Prize-winning novel *A Death in the Family* (1957), inspired by the loss of his father in a car accident when Agee was only seven. The novel was adapted for the stage and screen.

James Rufus Agee was born in 1909 in Knoxville, Tennessee. After the death of his father, Agee was boarded at Saint Andrews School, and although his mother lived nearby he was allowed limited access to her, so that he felt—and ultimately expressed in *A Death in the Family*—the loss and loneliness of an orphan. Agee went on to Phillips Exeter Academy, and then to Harvard, where he edited the literary magazine *Harvard Advocate*. Subsequently he wrote for *Fortune* and *Time* and was film critic for both *Time* and *The Nation*. In 1934, he published *Permit Me Voyage*, a collection of poems. He and Walker Evans went to live among the share-croppers in 1936. Robert Fitzgerald edited *The Collected Poems of James Agee* (1968) and *The Collected Short Prose of James Agee* (1968); Paul Ashdown edited *The Collected Journalism of James Agee* (1985). Agee died in 1955, in New York City.

Above: James Agee. Rooster head

C. 1939. Ink wash on newsprint. 9 x 7 inches. Harry Ransom Humanities Research Center Art Collection, The University of Texas at Austin, with the kind permission of The James Agee Trust

Right: James Agee. Head of Alma

C. 1939. Ink wash on newsprint. 9 x 7–1/4 inches. Harry Ransom Humanities Research Center Art Collection, The University of Texas at Austin, with the kind permission of The James Agee Trust

Opposite: James Agee. Rat

C. 1939. Ink wash on newsprint. 9 x 7 inches. Harry Ransom Humanities Research Center Art Collection, The University of Texas at Austin, with the kind permission of The James Agee Trust

RAFAEL ALBERTI

"In the very beginning," wrote Rafael Alberti, "I looked to painting as the medium for addressing concerns in shapes and colors. Then it was poetry where these concerns found expression through the medium of word and metaphor." Alberti's poetry has a distinctly visual orientation, and at least one critic sees the direct influence of Cubism in its structures. "Without doubt I am a poet whose eyes are the hands of his poetry," Alberti acknowledged. Both painter and poet inhabited Alberti throughout his life, and when he declared a longing for lost power in his visual art, he expressed it as a wish for "the madness I had then, to paint painting with the brush of poetry."

When Alberti was fifteen, his family moved to Madrid and, cut off from the familiar seascape of his early childhood, he became morose. He credits the Prado with rescuing him. The adolescent Alberti spent hours there copying masters, as well as painting outdoor scenes and experimenting with Cubism. He exhibited with a group of avant-garde painters and then, at twenty, in a one-man show at the prestigious National Autumn Hall in Madrid.

In his lifetime, Alberti had hundreds of exhibitions of his artwork throughout Europe and Latin America, and a show of artwork owned by his daughter in Cuba toured the United States in 1999. Besides paintings in tempera and watercolor, he created collages, engravings, and lithographs, drew illustrations for his books and those of other writers, illustrated campaign and bullfight posters and record covers, and decorated furniture and household objects.

In his collection of poems about painters and about the colors and tools of the artist, *A la pintura* (1997), Alberti reconciled his two arts: "pintar las poesia con el pincel de la pintura" (painting poetry with the painter's brush). In the title poem, Alberti gives homage to the artist's materials: "To you, flax in the field. To you, expanse / of surface for the eyes. . . . To you, heroic paintbrush, wax or stone, / obedient to style or manner," to the image, to "the dream reality," made out of palpable materials, and finally, "To you, the hand, painter of Painting."

Poet, playwright, artist, and translator, Alberti was born in 1902 near Cadiz, Spain. He was only twenty-two when his first collection of poems, *Marineo en tierra* (1924), won Spain's National Prize for Literature. Despite poor health from tuberculosis, Alberti aspired to become a matador; however, he gave it up in his debut bullfight, as he was terrified of the bull.

Alberti would publish more than sixty-five books, bringing him a host of honors, including Spain's National Theater Prize in 1981 and the Cervantes Prize of the Spanish Royal Academy in 1983. A member of the Generation of 1927—which included such Spanish luminaries as **Federico García Lorca**, Juan Gris, Salvador Dalí, and Louis Buñuel—Alberti, with other avant-garde colleagues, was forced to flee Spain because of his opposition to Franco, although he was able to return in 1977 and lived there until his death, in Cadiz, in 1999. During the Spanish Civil War he was the organizer of an international congress of antifascist writers and intellectuals, served in the Republican Air Force, and personally evacuated the Prado's paintings. He was a friend of Miguel de Unamuno, and a lifelong friend of Pablo Picasso.

Above: Rafael Alberti. Untitled (abstract image of two birds)

Right: Rafael Alberti. Untitled (abstract image with hearts)

HANS CHRISTIAN ANDERSEN

Hans Christian Andersen, who gave us "The Ugly Duckling," "The Emperor's New Clothes," "The Princess and the Pea," and "The Little Mermaid," was friendly with some of the leading artists of his day, including the Danish sculptor Thorvaldsen, and made his own visual art in the form of paper and cloth découpages. Andersen apparently acquired an interest in such art after his mother forced him to take a job in a cloth mill when he was only eleven. "My mother," Andersen recalled, "thought this good practice for becoming a tailor." The cutout images shown here are from the Andersen collection of Denmark's Odense City Museum, which also holds Andersen's drawing notebooks and a large screen collage. Other collections of his "paper cuts" can be found at the Royal Library of Denmark.

The style of Andersen's cutouts range from the elegantly detailed to the intentionally crude, and his imagery from the light-hearted to the frightening. They were made as story illustrations, independent works of art, decorations (including Christmas tree ornaments), and gifts to children and adults.

Andersen was born into miserable circumstances in 1805 in Denmark, the exact location of his birth unknown. In three autobiographies, Andersen concocted a version of his life as a fairy-tale hero, a poor boy—the child of two loving parents, with a talented and poetic father—who, thanks to the intercession of a loving God, was turned into the success he became. The reality was that his father, a lowly cobbler, and his mother, a coarse, illiterate laundress who had already given birth to an illegitimate daughter, were married only two months before he was born and could not earn enough to support the family. His father enlisted in Napoleon's army as an escape from poverty and died shortly after, when Andersen was only eleven.

A reclusive, homely child, Andersen made up plays and designed costumes in which to act out his fantasies. After his father's death, his mother, in desperate straits, sent him off to work in a factory. At fourteen, he set out for Copenhagen, a society of rigid class division, arriving in the midst of a period of anti-Jewish rioting. He sought a career at the Royal Theater, where he found patrons to pay for his schooling and, at seventeen, received a scholarship to a private school. Although humiliated by being placed with eleven-year-olds and constantly disparaged by the headmaster, Andersen was already manifesting his ambition to be a great writer. At the same time, as a result of a family history of insanity, he was plagued by an ongoing fear that he would end up in an asylum. At the University of Copenhagen, Andersen published an **E. T. A. Hoffmann**-influenced fantasy tale that gave him his first success.

In 1992, Andersen scholar Johan de Mylius published analyses of twenty-one of Andersen's most famous paper cuts, relating the circumstances of their making and offering biographical and literary connections to their images. The two men on the swans depicted opposite are Pierrots—a recurring figure in Anderson cutouts. De Mylius points out that the swan appears in Andersen's fairy tales as a symbol of purity, and argues that the Pierrot is not only the clown but the artist, and actually bears a likeness to Andersen. The large, elaborate, blue cutout is inscribed "For Mrs. Melchior, née Henriques, 1874." De Mylius explains that the Melchiors were a Jewish family in Copenhagen who became Andersen's adoptive family during the last ten years of his life and cared for him until his death there in 1875.

The man whose name is linked forever to the fairy tale achieved fame in his lifetime as the respected avant-garde author of six novels and numerous short story collections—Andersen wrote more than 175 fairy tales and stories—about 50 plays and 800 poems, as well as essays and travelogues.

Top left:
Hans Christian
Andersen. Untitled
(Pierrots dancing on
swans)

Paper cut. 3–1/2 x 5–1/2 inches.
The Hans Christian Andersen
Museum, Odense, Denmark

Bottom left:
Hans Christian
Andersen. "For Mrs.
Melchior, née Henriques,
1874"

Paper cut. 16–1/2 x 10–1/2
inches. The Hans Christian
Andersen Museum, Odense,
Denmark

Right:
Hans Christian
Andersen. Untitled
(clown)

Cloth cut. The Hans Christian
Andersen Museum, Odense,
Denmark

SHERWOOD ANDERSON

At nineteen, Sherwood Anderson had given his occupation as "painter" when enlisting in the Ohio National Guard in 1895. After moving to Chicago following the Spanish-American War, he was exposed to Cubist and post-Impressionist art by his brother, Karl, who had participated in the mounting of the Armory Show. The result was a "letting go" in Anderson's artwork, which included sculpting as well as painting. He never sculpted or painted, wrote his biographer Kim Townsend,

> without being able to laugh at himself, but at the same time, he remained absolutely committed to what he was doing. Before he was through he was grinding clay in an old coffee grinder in order to be able to have some to work with back in Chicago; and, not surprisingly, he was playing with a fantasy of teaching others how to sculpt and paint and feel what he had felt.

Anderson attended one art class and never took another, considering his lack of drawing skill to be an advantage. His goal was to express himself in art freely and extemporaneously, as he believed black people expressed themselves musically. Trying to paint objects before him he found too constraining. "All he wanted," said Townsend, "was lines and space and then colors 'to lay into them.'"

> Though brandishing his brush Anderson might have whispered Gauguin or Expressionism to himself, what emerged were relatively awkward, realistic renderings of a tree trunk or a black man's head, or landscapes that one might conceivably label Fauvist were the colors (ironically) not so tepid. The way their subjects sometimes fill out their compositions, and the quality of an occasional patch of color may make one think of Georgia O'Keeffe, who reportedly liked his work. But he was not trying to paint or be like others.

Anderson had a couple of shows, one in Chicago at the Walden Book Store and one in New York, about which he wrote: "There are certain images that haunt the human mind. They cannot be expressed in words except through the poet who occasionally raises the power of words beyond the real possibility of words."

Anderson's short stories transformed the genre by rejecting the formulaic plot in favor of portraying the real experiences of real people, written in a style based on everyday speech. He influenced and supported Hemingway, **Faulkner**, and many other writers of their generation. Anderson was born in 1876, in Camden, Ohio. His father was a failed harness maker who became a drunk, and Anderson, one of six children, had to leave high school and work to help support the family. His mother died when he was eighteen. After going from one unskilled job to another and serving in a non-combat role in the army in Cuba during the Spanish-American War, he ended up in Chicago writing advertising copy. In 1910, in an unhappy marriage and financially strapped, he began writing novels. In 1912, while working as a paint manufacturer in Ohio, Anderson had a mental breakdown, disappearing suddenly from his offices in Elyria and showing up several days later in Cleveland, confused and disheveled. He later claimed the event as a conscious act designed to get him away from business and into literature full time.

While known primarily for his short stories and most famously for the collection of related stories *Winesburg, Ohio* (1919), Anderson also wrote novels, autobiographical sketches, and essays. He was elected to the National Institute of Arts and Letters in 1937. He died in 1941, in Colon, Panama.

Sherwood Anderson. Leaves and Fronds

Watercolor. 13–3/4 x 19–3/4 inches. The Newberry Library Special Collections and with the kind permission of Harold Ober Associates Incorporated as agents for the Sherwood Anderson Literary Trust

GUILLAUME APOLLINAIRE

*G*uillaume Apollinaire applied the aesthetics of Cubism to literature. He eschewed a realistic approach to writing while simultaneously attempting to capture worldly experience in visually imaginative expression. He wrote prose with no punctuation in *Alcools* and—long fascinated with Chinese ideograms and the idea of conveying the meaning of a word through its shape—poetic text in the shape of objects in *Calligrammes.* (His poem "Il Pleut," for example, is laid out in vertical lines of raindrops.) He doodled on his manuscripts and painted, mainly in watercolor.

Paintings were the subjects of many of his poems, and he was planning, when he died, to bring out a collection of poems he had written that had been inspired by his painter friends Picasso, Braque, Rousseau, Derain, Dufy, and Duchamp.

Comparing art forms, Apollinaire observed that "in painting everything is represented at the same time, the eye can wander over the picture, come back to a certain colour, look first from top to bottom or do the opposite: in literature, in music, everything is successive and one cannot return to this or that word or sound just as one wants." Trying to achieve in words the instantaneous effects of painting, he attempted "typographic simultaneity" in his poetry, an idea first suggested by Villiers de L'Isle-Adam and Mallarmé.

Here are examples of "calligrammes" from his poem "Voyages," later set to music by Poulenc:

The words *télegraphe oiseau qui laisse tomber ses ailes partout* ("telegraph bird that drops its wings everywhere") arranged in the image of a bird.

The words *Adieu amour nuage qui fuis et n'a pas chu pluie féconde refais le voyage de Dante* ("Farewell love, cloud that flees and that did not shed fertile rain; retake the voyage of Dante") arranged in the shape of a cloud.

The words *Óu va donc ce train qui meurt au loin dans le vals et les beaux bois frais du tender été si pale?* ("Where, then, is that train going that dies in the distance in the valleys and beautiful cool woods of such a pale tender summer?") arranged in the shape of a train. The question mark in this calligramme appears as engine smoke in a sky dotted with letter stars.

As early as 1899, when he was only nineteen, Apollinaire was using the word "ideogrammes" in his notebook, fascinated by the idea of conveying the meaning of a word by its shape: "We present the object without idle commentaries, we make an image of it and the emotion is in this way released."

Apollinaire was highly conscious of the importance of his revolutionary experiments, writing, "There have been errors, and they were inevitable, but the effort that they have cost will serve the future developments in art." Apollinaire (Guillelmus, or Wilhelm, Apollinaris de Kostrowitzki), who lived only thirty-eight years—born in 1880 in Rome, he died in 1918 in Paris—managed, in his brief life as poet, playwright, short story writer, novelist, and art critic, to shape the course of the early twentieth century movements of Futurism, Cubism, Dadaism, and Surrealism. His play *Les Mamelles de Tirésias,* staged in 1917, he termed *surréaliste,* applying the descriptive he had coined in writing about **Jean Cocteau** and Erik Satie's ballet *Parade.*

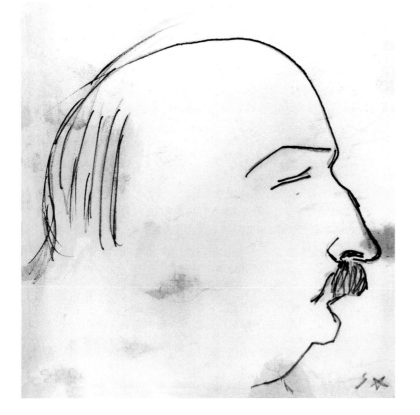

Above: Guillaume Apollinaire. Portrait sketch of Jean Royère

C. 1911. Ink and watercolor wash on paper. 4–7/8 x 4–3/4 inches. Harry Ransom Humanities Research Center Art Collection, The University of Texas at Austin

Right: Guillaume Apollinaire. Les oiseaux chantent avec les doigts (The birds sing with fingers)

1906. Ink and watercolor on paper. 6–1/4 x 4–1/4 inches. MP3588. Photo: Jean-Gilles Berizzi. Musée Picasso, Paris, France, Réunion de Musées Nationaux/Art Resource, New York

JEAN (HANS) ARP

Jean (Hans) Arp was a poet, painter, printmaker, and one of the most influential abstract sculptors of the twentieth century. He dropped out of high school at thirteen to study painting at the Strasbourg Academy of Art, but soon left to study privately. In 1904, at seventeen, he entered the Academy of Fine Arts in Weimar, and within three years his work was exhibited in Paris alongside paintings by Matisse and Signac. In 1908 he studied at Paris's Académie Julian. Distressed by teaching that required students to imitate, Arp retreated to a solitary life in the mountains of Switzerland, where he read intensively and worked on developing an art that did not depend on copying or describing what already existed. As Walter Sorell observed:

> Arp wanted to "produce," not "reproduce," and produce "directly and not through interpretation." . . . Out of shreds of images and the sequences of nonsequiturs he creates a world of irrational freedom and paradoxical ties, a world in which the descriptive sentence, painting an idea or feeling in time, is as non-existent as a legible concept of space in his visual art.

On receiving the International Sculpture Prize at the Bienniale Exhibition of Venice in 1954, Arp was asked what his choice would have been if he had had to choose between sculpture and poetry, and he responded he would have chosen poetry. He once said his collages were "poetry made with plastic means." Consistently, his drawings suggested writing or Chinese ideograms, and Arp sometimes referred to them as calligraphy or "écriture":

> For me words have always kept their newness, their mystery. I handle them like a child playing with blocks. I feel them, I mold them—like sculptures. I attribute to them a plastic volume independent of their meaning.

In both his poetry and art, Arp tried to create a tension by introducing opposites. In his poetry he utilized compound words that contained contradicting ideas and juxtaposed unrelated words. In his visual art he frequently used oval shapes because of their dual focal points. Arp's idea was adopted by the Surrealists as "biomorphic abstraction."

Harriet Watts says of Arp:

> The organic inspiration and the irrationality of his Dada poetry and art, Arp characterized as a form of natural that goes beyond reason, a "without sense" that is not nonsense, a mode expressive of nature's operations, which can never be comprehended within the narrow limits of human logic.

Eventually, Arp began to characterize both his poetry and art as an "object language."

Arp was born in the Alsatian city of Strassbourg, France, in 1887 and, equally at home in French and German, wrote his prose and poetry in both languages. He died in 1966 in Clamart, France. Associated with virtually every major avant-garde movement of his time, Arp published poetry and illustrations in the periodicals of the Expressionists in Munich and Berlin, of the Dadaists in Zurich (where he was a founder), of the Surrealists and of the Constructivists in Paris. Seeing his work as ever-evolving, he continually rewrote his poems, finding new meanings in new variations.

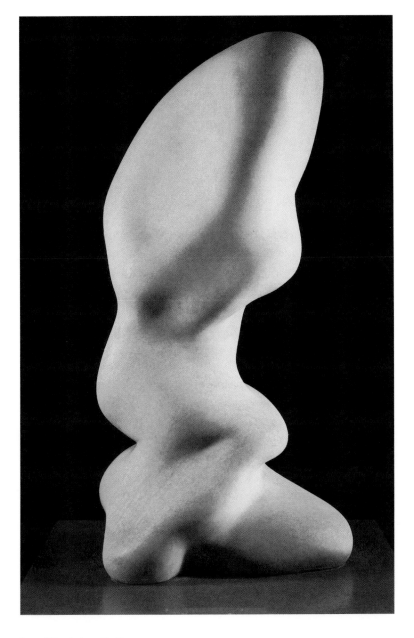

Jean (Hans) Arp. Dancers

Jean (Hans) Arp. Pistil

ANTONIN ARTAUD

Antonin Artaud was preoccupied with the nature of word and image, and the relationship between them. In *The Theater and Its Double* (1958) he wrote:

It has not been definitively proved that the language of words is the best possible language. And it seems that on the stage, which is above all a space to fill and a place where something happens, the language of words may have to give way before a language of signs whose objective aspect is the one that has the most immediate impact on us.

In his "Manifesto in a Clear Language," Artaud began by asserting that his aesthetic is destructive, "because for me everything that proceeds from reason is untrustworthy." He declared his preference for the heart—for a world outside reason—and claimed to believe

only in the evidence of what stirs my marrow, not in the evidence of what addresses itself to my reason. . . . That which belongs to the realm of the image is irreducible by reason and must remain within the image or be annihilated. . . . Nevertheless, there is reason in images, there are images which are clearer in the world of image-filled vitality.

For Artaud, drawings and poems shared the same communicative function, and he referred to his work as "written drawings." He also considered them to be as vital as his own breath: "I say / that for ten years with my breath / I have been breathing forms hard / compact, opaque, / frenetic, / forms without curves / . . . / Such are in any case the drawings with which I constellate all my notebooks."

Drawing and writing were linked throughout Artaud's life:

And since a certain day in October 1939 I have never again written

without drawing / / Now what I am drawing / these are no longer themes of Art transposed from the imagination onto the paper, these are not affecting figures / these are gestures, a word, grammar, an arithmetic, a whole Kabbala and which shits at the other, which shits on the other / no drawing made on paper is a drawing, the reintegration of a sensitivity misled, it is a machine that breathes / this was first a machine that also breathes / It's the search for a lost world / and one that no human language integrates / and whose image on the paper is no longer that world but a decal, a sort of diminished / copy / For the true work is in the clouds.

Although much of Artaud's art is in private hands, he is also well represented in the collections of the Musée National d'Art Moderne—Centre de Création Industrielle, the Centre Georges Pompidou, Paris, and the Musée Cantini, Marseilles.

Artaud—who despaired that he was never fully in possession of his own mind and whose radical notion to eliminate plot and carefully scripted dialogue in favor of audience-shocking effects altered the theory of modern drama—was an essayist, poet, novelist, dramatist, screenwriter, and actor. He was born in Marseilles in 1896, saw most of his siblings die in childhood, suffered a permanently debilitating attack of meningitis at four, and was afflicted with a stammer, chronic depression, and opium addiction. He died in Ivry-sur-Seine in 1948, leaving behind a twenty-volume *Oeuvres complètes*. Yet critic Susan Sontag described his legacy as "a broken, self-mutilated corpus, a vast collection of fragments." His bequest, she wrote, "was not achieved works of art but a singular presence, a poetics, an aesthetics of thought, a theology of culture, and a phenomenology of suffering. . . . Nowhere in the entire history of writing in the first person is there as tireless and detailed a record of the microstructure of mental pain."

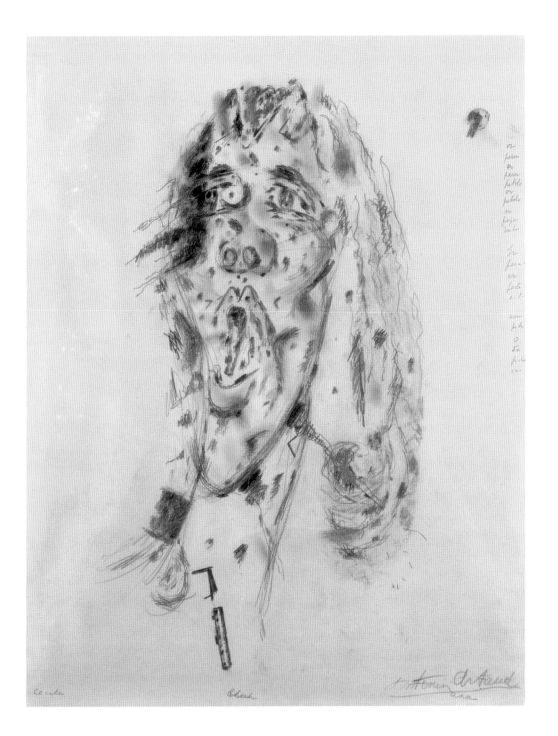

Antonin Artaud. La tête bleue
(The blue head)

1946. Graphite/wax crayon. Réunion
des Musées Nationaux/copyright ©
2007 Artist Rights Society (ARS), New
York/ADAGP, Paris

ENID BAGNOLD

In 1914, when she was twenty-five, Enid Bagnold recorded in her journal that she had met the fifty-five-year-old artist Walter Sickert (charged by crime novelist Patricia Cornwall in 2002 with being Jack the Ripper) at the home of Lady Ottoline: "One day as I was sitting folding my Red Cross dress to put it away in the chest of drawers whose handles he loves to draw Sickert leant over my shoulder and I turned my face and he kissed me." The thrill she felt resulted in her studying painting and drawing with Sickert. But even as the relationship was developing, she admitted that "the drawing is better than the kisses."

In her journal entry for April 4, 1914, Bagnold wrote:

> Sickert has been making me draw and teaching me to etch. It occupies all my days and makes me happy. Morbid wretch that I am, I know it's not right. I ought not to be happy. I ought to be writing, straining, miserably and wearily to write. I've heaps to say and I can't say it and I shall go down into my grave with it unsaid. Much loss that'll be! Yes, it will. I think of beautiful things that people would take pleasure in reading if only I could trouble to learn to use the medium.

As much as she enjoyed art, Bagnold saw it merely as a way to poetry:

> Sickert's given me a real gift, given me back my love of drawing, my perceptions, my talents, and through the drawing I hope again to write poetry. It would be a fine thing to be the finest painter in the world, but I would sooner be a little poet! I have a much longer vision in poetry and writing than in drawing. It's nearer life. You can't let off all the steam of living in pictures, whereas every misery and every love is material for self-expression in writing.

Bagnold was a novelist, poet, playwright, and translator, remembered mainly for *National Velvet* (1935), her classic story of a courageous, horse-crazy girl, and for her award-winning play *The Chalk Garden* (1955). She was born in Rochester, Kent, England, in 1889 and died in Rottingdean, Kent, in 1981. Her wealthy father, a colonel in the Royal Engineers, was remote and severe. "I didn't get to know him," Bagnold wrote, "and he didn't mind that. He wanted discipline." He moved the family to Jamaica when she was nine, and, Bagnold said, it was the first time beauty hit her. "This was the first page of my life as someone who can 'see.' It was like a man idly staring at a field and suddenly finding he had Picasso's eyes. In the most startling way I never felt young again. I remember myself then just as I feel myself now."

After an education back in England and on the Continent, Bagnold served as a nurse during World War I until she was fired for authoring an exposé of hospital conditions. She spent the rest of the war as an ambulance driver in France. Among her literary awards are the 1951 Arts Theatre Prize for *Poor Judas* and an Award of Merit from the American Academy of Arts and Letters for *The Chalk Garden*.

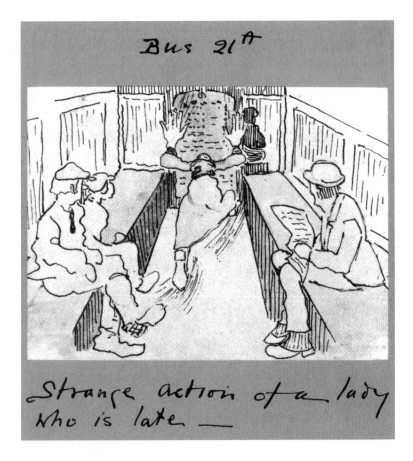

Above: Enid Bagnold. "Strange action of a lady . . ."

Ink on paper. From Enid Bagnold's *Autobiography*. With the kind permission of the estate of Enid Bagnold

Opposite: Enid Bagnold. Pennywhistle

C. 1911. Pen and ink on paper. 12–1/2 x 8 inches. Collection of Victoria Jones. With the kind permission of the estate of Enid Bagnold. Photo by Rosalind Michahelles

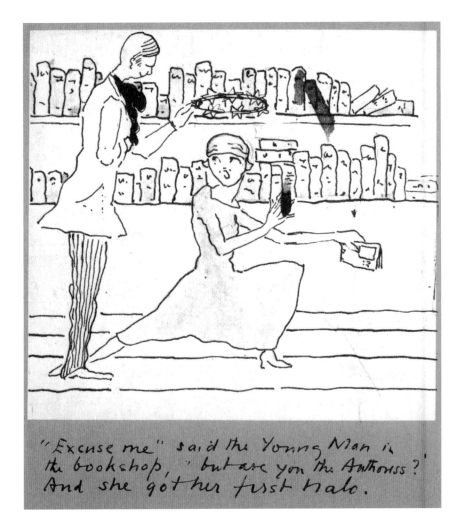

Above: Enid Bagnold. "Excuse me" said the Young Man . . ."

Ink on paper. From Enid Bagnold's *Autobiography*. With the kind permission of the estate of Enid Bagnold

R. M. BALLANTYNE

R. M. Ballantyne, who illustrated many of his nearly one hundred books and had his watercolors exhibited by the Royal Scottish Academy, came from an artistic family. A painting by his brother John hangs in Britain's National Portrait Gallery, and Ballantyne sketched, painted, and made woodcuts as a pastime. Still, his skill as an artist is surprising, considering that, because of a dramatic financial reversal in his childhood, he was forced to leave school at twelve and was tutored at home before being sent away to work at the age of sixteen.

In 1864, Ballantyne hiked from London to Edinburgh with the intention of writing a book about his twenty-eight day adventure—only to learn on arrival that an American had already done the same thing. However, besides writing notes (contained in letters sent to his brother John's wife, with whom he was having an affair) he painted his impressions of the trip in twenty-two watercolors, and they survived with the letters and were sold at auction in 1999. Other paintings by Ballantyne are represented in private galleries.

The attention to detail in Ballantyne's imaginative but precise illustrations parallels the text they accompany, for although he wrote romantic tales he sought to ground them in reality and to educate his reader about other peoples and cultures, science and geography. This insistence on accuracy was the result of an error he'd made in his most famous, never out of print, adventure tale of boys wrecked in the South Seas, *The Coral Island: A Tale of the Pacific Ocean* (1858). Having constructed the island largely out of his imagination, Ballantyne was greatly embarrassed by having his characters survive, impossibly, by piercing coconut shells with a small penknife. Ballantyne resolved to get the details right in future works, and he traveled to locales and experienced occupations firsthand before writing about them. This meant, for example, visiting South Africa before writing about its settlement, West Africa before his attack on its slave trade, Algiers before a book about its pirates, and Norway for another about Norse warriors. For verisimilitude, he also went diving, lived on light ships, and worked in a post office.

The Coral Island influenced countless other writers. It became the prototype for **Robert Louis Stevenson**'s *Treasure Island* (he dedicated it to "Ballantyne the Brave"), for J. M. Barrie's *Peter Pan* (Barrie wrote that "Ballantyne was for long my man" and that he waited for the next of his approximate one hundred books "as for the pit door to open"), and William Golding's *The Lord of the Flies* (whose characters refer to and take names from Ballantyne's story).

Robert Michael Ballantyne was born in Edinburgh, Scotland, in 1825, the ninth child of a musical father who, with his publisher brother, invested all their money with their friend Sir Walter Scott. Scott's bankruptcy ruined the Ballantyne family, and Robert's childhood was shadowed by financial distress. He had only two years at Edinburgh Academy, and four years later his father placed him with the Hudson's Bay Company in Canada, where he worked first as a clerk and, later, as an Indian trader. He returned to Scotland at twenty-two, where he learned that his father had died. Ballantyne took a succession of jobs in business to help support the family. In 1848 he published his first book, the autobiographical *Hudson's Bay*, and by 1856 was supporting himself entirely by writing and lecturing. In 1866, when Ballantyne returned to Scotland from a lecture tour, he was determined "to let nothing deter me from writing & painting & painting & writing until I have completed a sea-picture in oils worthy of a palace wall & have at last seen the final page of my new book crossed & dotted & delivered!" The plans were briefly set aside in favor of pursuing the twenty-one-year-old woman who became his wife, although he quickly returned to and continued his prolific literary and artistic output until he died, in Rome, in 1894.

TWO LEVIATHANS AT THE CABLE.—Page 100.

AN ELECTRIFIED TIGER.—Page 310.
Frontispiece.

R. M. Ballantyne. Two Leviathans at the Cable.
Illustration from *The Battery and the Boiler*

R. M. Ballantyne. An Electrified Tiger. Illustration from
The Battery and the Boiler

R. M. Ballantyne. Illustrated title from *The Battery and
the Boiler*

AMIRI BARAKA

Amiri Baraka has been painting and drawing since childhood when his mother, anxious to encourage her children in any of the arts, sent him for lessons. His paintings, often of jazz musicians and frequently containing verses or verse fragments, have been exhibited often, most notably at the Aljira Gallery in his hometown, Newark, New Jersey.

A poet, playwright, novelist, essayist, music critic, actor, political activist, and the leading figure of the Black Arts movement in the United States, Baraka was born in 1934 and known until 1968 as LeRoi Jones. Baraka's father was a postman, his mother, a social worker, and he was raised with middle-class values, although, as one of only a few black students in a white high school, with a strong sense of personal alienation. His social discomfort persisted as a student in the white culture of Rutgers University, so in 1951 Baraka transferred to Howard University, where he earned a B. A., but felt further alienated by what he perceived to be Howard's promulgation of a self-destructive, black bourgeois sensibility.

After a stint in the air force as a gunner on a B-36—and a dishonorable discharge for communist sympathies—Baraka moved into Greenwich Village and, with the support of **Allen Ginsberg**, immersed himself in the Beat scene. In 1958 he married Hettie Cohen and with her founded and edited the avant-garde literary magazines *Yugen* and *Totem Press,* publishing Ginsberg, **William Burroughs**, **Jack Kerouac**, Philip Whalen, and others.

In 1961 Baraka's first collection of poetry, *Preface to a Twenty Volume Suicide Note*, marked him as a new and distinctive voice in American poetry. That same year, following a trip to Cuba sponsored by the Fair Play for Cuba Committee, he published *Cuba Libre*, offering his views of political activism. In 1965, divorced from Hettie Cohen, he relocated to Harlem where he founded the Black Arts Repertory Theatre/School, which for a short time produced plays for black audiences. He soon moved back to Newark and in 1967 married Sylvia Robinson, now known as Amina Baraka. His angry declaration in his poem "Black People" that blacks cannot succeed "unless the white man is dead" and his call to black people to "get together and kill him" was quoted at his sentencing on a later-overturned conviction for possession of a weapon during the 1967 Newark riots. In 1968 he became a Muslim and changed his name to Imamu Amiri Baraka, but in 1974, after adopting a Marxist philosophy, he dropped the spiritual title "Imamu" along with his emphasis on black nationalism. In 2002, while serving as Poet Laureate of New Jersey, he was widely criticized for a poem that accused Israel of being behind the September 11 attacks on the United States and suggested that Jewish workers at the Twin Towers had had prior warning and had stayed home.

Baraka has published some thirteen volumes of poetry, two novels, and nine nonfiction works, including the highly polemical *Blues People: Negro Music in White America* (1963). Among his awards and honors are the Longview Award for *Cuba Libre*, the Obie Award for his play *Dutchman* (1964), a Guggenheim Fellowship (1965–66), a Doctorate of Humane Letters, Malcolm X College, Chicago (1977), and election to the American Academy of Arts and Letters (2000).

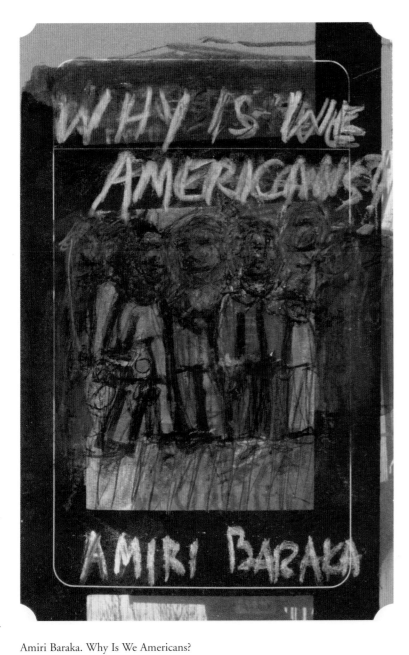

Amiri Baraka. Why Is We Americans?

2000. Watercolor. 13 x 10 inches. Collection of the author, courtesy of the artist.
Photo by Jason Brownrigg

Amiri Baraka. Anaocronobienord

2000. Watercolor. 5–1/4 x 3–1/2 inches. Collection of the author, courtesy of the artist. Photo by Jason Brownrigg

ERNST BARLACH

To understand Barlach's greatness as a writer and artist, his art, his prose, and his drama must be evaluated together," argues scholar Ursula R. Mahlendorf. "They are different aspects of the same concern, each aspect illuminating the others." For Ernst Barlach, however, maintaining distinctive forms was essential. In a 1926 letter he explained:

I am convinced that for me significant work was possible only after my abilities had attained separate forms of expression in both sculpture and writing. As long as I let myself be moved to creative activity by a general emotional urge—or more accurately, as long as I allowed anything to take form that wanted to take form—nothing but vagueness would ensue. Even now I must struggle not to let the one medium obscure the other.

In his autobiography, *A Selftold Life* (1928), Barlach elaborated:

Form—mere form? No. A mighty realisation burst upon me, and this is what it was: To you it is given to express, without reserve, all that is within you—the uttermost, the innermost, the gentle gesture of piety and the rude gesture of rage—because for everything, be it paradise, hell, or one in the guise of the other, there is expressive form.

Describing his series of woodcuts titled "The Transformations of God," Barlach said: "Experience shows that there is always one certain direction in which we can expand ourselves to the fullest degree, and in the Transformations, I am a maker of woodcuts." Deploring the labeling of his works as "cultist" and "mystic" and the implication of critics that he was deliberately obscurist, he wrote:

I desire nothing whatsoever but to be an artist pure and simple. It is my belief that that which cannot be expressed in words can be conveyed to others through Form. It satisfies both my personal desire and my creative urge to hover and to circle again and again over the problems of the meaning of Life and the grand mountain peaks in the realm of the spirit.

Barlach was born in Wedel, Germany, in 1870. His father, a country doctor, took the boy on rounds, giving him an early introduction to sickness and death. The institutionalization of his mentally ill mother when Barlach was only thirteen and the death of his father the following year impoverished his family. Despite this, Barlach was able to complete high school and attend art school, first in Hamburg, then in Dresden, where he studied sculpture and went on to achieve renown for his carvings, especially his heavy wood, "modern Gothic" figures.

During his lifetime Barlach's best-known works were World War I memorials in Hamburg and Magdeburg and religious figures in Lubek's Church of Saint Katherine. His pieces were removed from museums and public places and his publications were banned after he spoke out against political and racial intolerance as Hitler was coming to power. Barlach died in 1938 in Gustrow, Germany. Today, his sculptures, drawings, and prints are displayed in his studio/museum in Gustrow and at the Ernst Barlach House in Hamburg.

A leading playwright of the German Expressionist movement, Barlach was also lauded for his posthumously published, unfinished novel, *Der gestohlene Mond* (The Stolen Moon), which has been compared with **Franz Kafka**'s *The Castle* and Robert Musil's *The Man Without Qualities*.

Ernst Barlach. Frierende Alte
(Freezing Old Woman)

1937. Wood. 24.2 x 16.5 x 19 cm.
Copyright © Ernst und Hans Barlach
GbR Lizenzverwaltung Ratzeburg and
the estate of Ernst Barlach

DJUNA BARNES

Djuna Barnes's primary ambition was to be a poet, and her first poems were published in *Harper's Weekly* in 1911, when she was just nineteen. She then took art classes briefly at the Pratt Institute in Brooklyn and the Art Students League in Manhattan. By 1915 her illustrated chapbook *The Book of Repulsive Women* was published by avant-garde champion Guido Bruno, who wrote: "Djuna Barnes is one of the few young American artists who walk their own way. Not willing to make concessions to publishers and art editors, she is using her pen to earn her livelihood as a newspaper woman, and permits herself the luxury of being an artist just to please herself."

Barnes's drawings were greatly influenced by art nouveau—Bruno called her "the American Beardsley." Her plays, poems, and stories appeared in notable magazines and in a 1923 collection titled *A Book*, accompanied by line drawings. Her drawings, which included sketches of such luminaries as Robert Frost, Eugene O'Neil, **Mina Loy**, and Gertrude Stein, were published both with her articles and by themselves, and sometimes broke social taboos. Mary Lynn Broe writes in *Silence and Power: A Reevaluation of Djuna Barnes*:

> Urination, bare buttocks and spanking are popular themes in Barnes's drawings. In addition to this drawing of a woman urinating in "April" of *Ladies Almanack*, there are two illustrations of women peeing in Ryder. . . . [T]hese drawings are the visual equivalent of Barnes's apparently sexually free writing. Like the writing, however, they seem more like adolescent sexual humor than the bawdiness of sexual pleasure which is comfortable with itself.

More than sexual, however, Barnes's pictures and her writings tend to the morbid. When Bruno once asked her why, she replied:

> You make me laugh. This life I write and draw and portray is life as it is, and therefore you call it morbid. Look at my life. Look at my life around me. Where is this beauty that I am supposed to miss? The nice episodes that others depict? Is not everything morbid? I mean the life of people stripped of their masks. What are the relieving features?

Barnes published more than 350 drawings, some of which are reproduced in Douglas Messerli's *Poe's Mother: Selected Drawings of Djuna Barnes* (Sun & Moon Press, 1995). Messerli notes the equal weight Barnes gave to text and drawing, and the very visual nature of her writing:

> Particularly in *Nightwood*, but in varying degrees in all her work, Barnes creates a hierarchical world—not unlike that of "The Great Chain of Being"—conveyed in linguistically constructed visual images that determine her characters' moral conditions and structurally engage her characters through their physical positions.

Barnes was a poet, short story writer, playwright, artist, illustrator, and novelist—most famous for her 1937 masterpiece, *Nightwood*. She was born in 1892 in Cornwall-on-Hudson, New York, where she was educated at home by her father—a watercolorist who first taught her to draw—and paternal grandmother, and was the victim of incestuous sexual abuse. Barnes's heavy drinking led her to be hospitalized for a series of breakdowns beginning in the 1920s. She lived as a recluse in Manhattan for over forty years, and died there shortly after her ninetieth birthday.

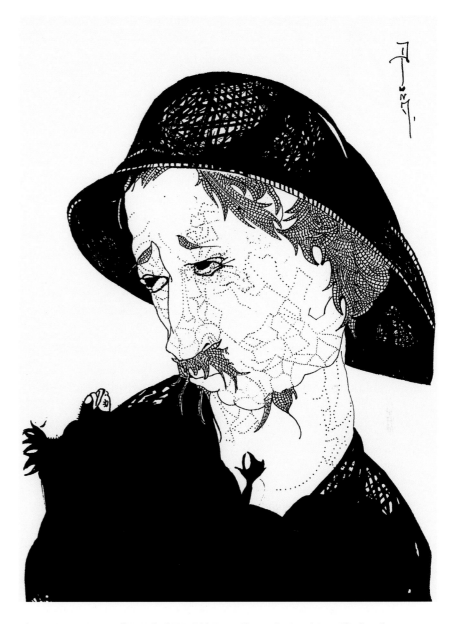

Above: Djuna Barnes. Untitled (drawing of shepherdess)

Private collection, New York City. Copyright © The Authors League Fund as literary executor of the estate of Djuna Barnes. Photo by Jason Brownrigg

Opposite: Djuna Barnes. Aries

Private collection, New York City. Copyright © The Authors League Fund as literary executor of the estate of Djuna Barnes. Photo by Jason Brownrigg

Above: Djuna Barnes. "He Lifted His Old Eyes, Almost Squinted into Blindness"

New York Morning Telegraph Sunday Magazine, September 2, 1917. From *Poe's Mother: Selected Drawings of Djuna Barnes* (Los Angeles: Sun & Moon Press, 1995). Copyright © The Authors League Fund as literary executor of the estate of Djuna Barnes

CHARLES BAUDELAIRE

Charles Baudelaire often spent time in the studios of, and corresponding with, Delacroix, Manet, and Daumier, and at the Louvre with his artist friend Emile Deroy. He wrote art criticism and a short biography of Delacroix. Seeing a poetic nature in painting and a literary genius in the artist, Baudelaire wrote:

[P]oetry is not the immediate aim of painting; when it happens to be mingled with painting, a work is all the better for it, but poetry cannot hide a picture's weaknesses. To make a point of straining after poetic effect in the conception of a picture is the surest way not to find it. It must come without the painter's being aware of it. It is the result of painting itself; for it lies deep in the spectator's soul, and genius consists in awakening it there. Painting is interesting only by colour and form; it resembles poetry only in so far as the latter awakens in the reader ideas of painting. . . . [T]he great painters, whose instincts are always a sure guide, have borrowed from poets only highly coloured and image-making subjects. Thus they prefer Shakespeare to Ariosto.

[. . .]

The artist who paints contemporary scenes is a genius of mixed nature—that is to say, a genius with a considerable component of literary ability. Sometimes he is a poet; more often he has a kinship with the novelist or the moralist; he is the painter of the occasion, and also of all its suggestions of the eternal.

The embrace of beauty evoked in Baudelaire a pleasure that intensified to the point of despair: "What delight, to drown one's gaze in the immensity of sky and sea! Solitude, silence, the incomparable purity of the azure!" Such is the immediate experience; but then the things he sees—a sail, the surf—"all these think through me, or I think through them. . . . [T]hey think, I say, but in music and picture, without arguments, syllogisms or deductions." And, the thoughts, he says, "whether they issue from me or spring from objects, soon become too intense."

Now, of a sudden, the depth of the sky appalls me, its limpidity exasperates me. The insensibility of the sea, the lack of movement in the whole spectacle, revolts me. . . . Must I everlastingly suffer, or must I everlastingly flee from beauty? Nature, pitiless enchantress, ever-victorious rival, give me peace! Cease to provoke my desires and my pride! The study of beauty is a duel in which the artist cries out with fear before he is defeated.

Baudelaire, author of the notorious *Les Fleurs du mal* (1857), the most influential poetry collection in nineteenth-century Europe—for which he, along with the printer and publisher, was prosecuted for impropriety—was born in Paris in 1821 and lived there until his death in 1867. His father was a former priest and an undistinguished poet and painter who died when Baudelaire was only six. Before his death, though, his father introduced the boy to what he later referred to as "the cult of images."

During his life Baudelaire suffered from syphilis, dissipated finances, and excessive alcohol and opium consumption. The portrait he drew of his enduring love, Jeanne Duval, appears opposite.

Charles Baudelaire. Jeanne Duval, Baudelaire's mistress

1865. Iron-gall on paper. Réunion des Musées Nationaux/Art Resource, New York

Charles Baudelaire. Self-portrait

1843. Ink on paper. Réunion des Musées Nationaux/Art Resource, New York

JULIAN BECK

Julian Beck's artist's eye was invaluable in his work with the Living Theatre, the legendary, New York-based, avant-garde company he founded with his wife, Judith Malina. Of the organic, personal way in which he did stage design—the art of "using the eyes to heighten understanding"—he wrote:

I trained by looking at the world, the perspective of cities, the harmony of all things, the ornaments, I collected mental images, kept an archive in my head, gathered odd pieces of wood, plastic trophies from the garbage dumps, and saved them in my studio for the right time, the right play.

[. . .]

I worked directly on the stage, relating to the space like a sculptor or painter. Many, many times I would make something, or a whole set, and then take it down and start again, and often again and again and again, I would sit silent in the theatre staring at the stage, searching for the solution: How to make the set say what the play wanted it to say.

Beck saw a common obligation to originality in both the writer and artist:

To the student of poetry (we are all students of poetry) I say: When you sit down to write a poem you must try to write what you have never heard before, and better yet, what has not been heard before. I say this as well to the painter, the philosopher, the musician—paint what you have never seen before, think what has not been thought before, make the sound till now unheard—to all those whose accomplishments keep humankind from falling into the pit. The pit where banality buries us alive.

A poet, playwright, essayist, actor, and artist, Beck was born in 1925 in New York, where he died in 1985. His father, Irving, was a businessman; his mother, Mabel Blum, a teacher. Beck attended Yale and City College. Founded in 1947 and influenced by the theatrical philosophies of **Artaud** and Brecht, the Living Theatre was shocking in its realism and became a controversial forum for social criticism and consciousness-raising about the poor. The group brought audiences into their efforts, sometimes pulling them out of their seats into their performances, and later bringing their theater into the streets and other public places.

Beck and Malina angered governments on several continents for their stands against Vietnam, the Cold War, and a range of economic and social injustices. They were frequently arrested. Plays by authors as diverse as Picasso, Auden, **Strindberg**, and **Cocteau** were put on in the troupe's first decade, but it was not until 1959, when Jack Gilbert's hyperrealistic play about drug addicts, *The Connection*, stunned theatergoers, that the company became widely known.

Beck and Malina created with others in a collective effort that Beck described in his book *Life of the Theatre:*

We sit around for months talking, absorbing, discarding, making an atmosphere in which we not only inspire each other but in which each one feels free to say whatever she or he wants to say. Big swamp jungle, a landscape of concepts, souls, sounds, movements, theories, fronds of poetry, wildness, wilderness, wandering. Then you gather and arrange. In the process a form will present itself.

Beck's abstract paintings were exhibited at Peggy Guggenheim's gallery in New York and were used at least once as a backdrop for his plays. More recently they have been shown at New York's Janos Gat Gallery.

Julian Beck. Romeo and Juliet

1957. Oil, pastel, pencil, and ink, 40 x 22 inches. Courtesy
of the Janos Gat Gallery and the estate of Julian Beck

MAX BEERBOHM

Sir Max Beerbohm was a serious, self-taught artist—a renowned caricaturist—as well as a writer. Modest about his gifts, Beerbohm said, "I've used them very well and discreetly, never straining them; and the result is that I've made a charming little reputation." While still an Oxford undergraduate, Beerbohm published articles and drawings in several noted periodicals, and, after leaving without a degree, his work—both caricatures and essays—appeared in the *Savoy,* the *Saturday Review,* and the *Yellow Book.* At twenty-three, he published his first book, a small collection of seven articles, which he entitled *The Works of Max Beerbohm, with a Bibliography by John Lane.*

Beerbohm was lightheartedly malicious in both his writing and drawings, deflating pretension wherever he found it. Of **D. H. Lawrence**, he once said: "He never realized, don't you know—he never suspected that to be stark staring mad is somewhat of a handicap to a writer." However, Beerbohm felt he was more brutal in his caricatures. "As a writer, I was kindly, I think—Jekyll—but as a caricaturist I was Hyde."

Indeed, Beerbohm believed that malice was integral to caricature. He distinguished caricature from writing, explaining that caricature "eschews any kind of symbolism, tells no story, deals with no matter but the personal appearance of its subject."

Over the years, he had to rely more and more on words. As Ann Adams Cleary observed in the *Dictionary of Literary Biography,* "Captions took on an increasingly important function in Beerbohm's art: words compensated for his public's growing unfamiliarity with visual clues. . . . His pictures became wordier and his prose less wordy."

At fifty-eight, after producing thousands of such works, he stopped, feeling that he was softening toward his subjects and that his caricatures were becoming likenesses: "I seem to have mislaid my gift for dispraise. Pity crept in. So I gave up caricaturing, except privately."

Born Henry Maximilian Beerbohm in London in 1872, he became known, thanks to **George Bernard Shaw**, simply as "the incomparable Max." Beerbohm succeeded Shaw as theater critic for the *Saturday Review* in 1898, and over the next twelve years contributed 453 reviews, while drawing and holding four exhibitions of his art during the same period.

At Oxford, Beerbohm and his friend Oscar Wilde lived a dandified life, which he drew upon in his popular and highly regarded satiric novel *Zuleika Dobson* (1910). Also in 1910, Beerbohm married Florence Kahn, an actress from Tennessee, and moved to Rapallo, Italy, where he was a neighbor of Ezra Pound. Following the success of *Zuleika Dobson,* Beerbohm used his literary skills to express his talent for ridicule, publishing *A Christmas Garland* (1912), a compendium of parodies of the writings of **Belloc**, **Chesterton**, **Conrad**, **Hardy**, **Kipling**, and others.

Beerbohm had produced a ten-volume collection of satiric stories, poetry, essays, and a novel before he died in 1956 in Rapallo. He received honorary degrees from Oxford and Edinburgh, and he was knighted in 1939.

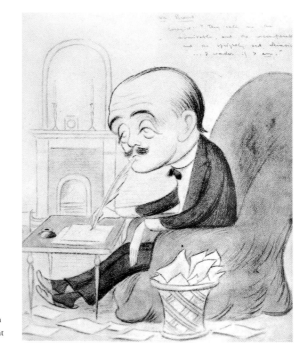

Max Beerbohm.
Self-portrait

Watercolor. CORBIS.
Copyright © Estate of
Max Beerbohm,
reprinted by permission
of London Management

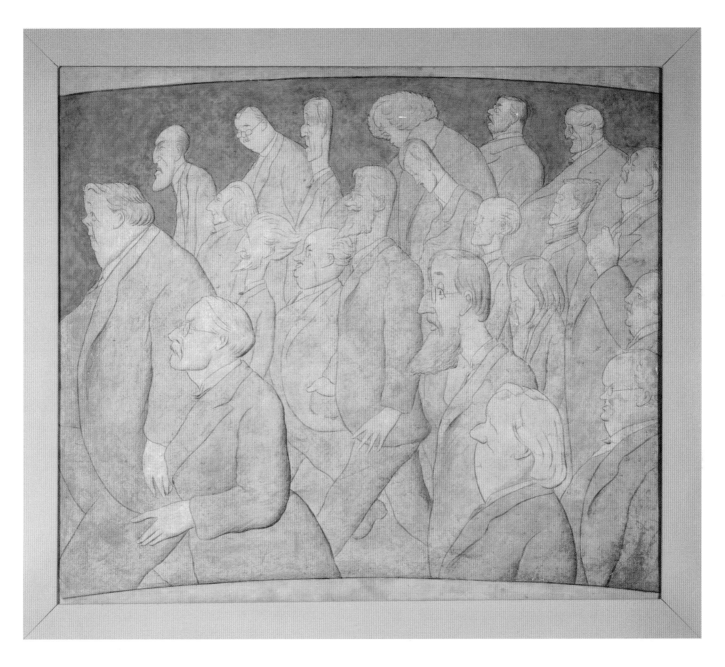

Max Beerbohm.
Twenty-one
Literary Figures

C. 1922. Tempera on
gesso ground on canvas,
affixed to board. 41 x
47–1/2 inches. Harry
Ransom Humanities
Research Center Art
Collection, The
University of Texas at
Austin. Copyright ©
Estate of Max
Beerbohm, reprinted by
permission of London
Management. These
notables include three
writer-artists included
in this collection:
George Bernard Shaw
ninth from the left), G.
K. Chesterton (tenth
from the left), and John
Masefield (eleventh
from the left).

HILAIRE BELLOC

ilaire Belloc painted and drew throughout his life, filling sketchbooks and illustrating entries in his diaries with landscapes and portraits. His grandfather, also named Hilaire Belloc, had been an art teacher and a museum-collected artist, and the young Belloc seems to have inherited his grandfather's artistic proclivities. To encourage her son in that direction, Belloc's mother took him to museums and exhibitions. From earliest childhood he illustrated his letters and as a five-year-old drew detailed maps. At ten he wrote excitedly from school: "The drawing master is taking an interest, and showing me how to work." His textbooks were filled with drawings of real and imagined figures and scenes. Biographer Robert Speaght recounts this almost mystical encounter by the fifteen-year-old boy:

> One day, as [Belloc] was sketching on the quais, an old man looked over his shoulder and remarked: "Your work has great interest to me, for I see in it a trick of perspective I have never come across in anyone else, except my old teacher." "And what," asked Belloc, "was his name?" "His name was Hilaire Belloc." "And that is my name too," the boy replied. "He was my grandfather."

Joseph-Pierre Hilaire Belloc was born in 1870 in La Celle-Saint-Cloud, France. His father, Louis, died when Belloc was only two, and his mother withdrew into a chronic depression.

After military service in France, Belloc went to Oxford, graduated with first-class honors, married Elodie Hogan of California, became a British subject in 1902, and won a seat in Parliament in 1906. He had left school at seventeen, and before he was twenty-two he had, in his own words, "learnt to plow, reap, and sow, shot a lot, went off to America from east to west, walked all over California and Colorado, went into the French Artillery and got into Balliol." He was very glad for the experience: "Since then I have done nothing and those are the only years in which one lives; for one has no duties and no accursed conscience."

Belloc became one of the most versatile of English writers, producing more than 150 works, acquiring wide fame as a poet, novelist, essayist, historian, and as a political and social commentator. His early volumes of light verse—*The Bad Child's Book of Beasts* (1896), *More Beasts (For Worse Children)* (1897), *The Modern Traveller* (1898), and *A Moral Alphabet* (1899)—were all greatly successful. *The Bad Child's Book of Beasts* sold out in only four days, and Belloc was compared favorably to **Lewis Carroll** and **Edward Lear.**

Upon his election to Parliament, Belloc accepted the post of literary editor of the *London Morning Post.* Over the next four years, while serving in both capacities, he produced two novels, a book of poetry, two travel books, a biography, and four volumes of essays. He died in 1953 in Guildford, Surrey, England.

Right: Hilaire Belloc. Untitled (seascape)

C. 1893–1894. Watercolor. 5 x 3–1/2 inches. University of Notre Dame Archives. By kind permission of the estate of Hilaire Belloc and the Hilaire Belloc Papers (CBEL)

Opposite: Hilaire Belloc. Untitled (seascape)

C. 1893–1894. Watercolor. 3–1/2 x 10 inches. University of Notre Dame Archives. By kind permission of the estate of Hilaire Belloc and the Hilaire Belloc Papers (CBEL)

LUDWIG BEMELMANS

*L*udwig Bemelmans loved to draw as a child, continued drawing during his various employments and in the army, and painted scenes on the walls of his New York restaurant. Biographer Edward J. Jennerich explains how Bemelmans' decorating his apartment walls was the catalyst for his becoming a writer:

> He wanted his home to reflect the taste and furnishings which he could not afford, so he painted these objects on the walls and window shades. At a dinner party in his apartment, May Massee, a frequent customer at the Hapsburg House and children's book editor at Viking Press, was one of the guests. She was captivated by his humor and style, and she suggested that he might try to write and illustrate books for children.

Bemelmans' lively, impressionistic illustrations had a great deal to do with the success of his children's books, which garnered many awards, including a Newbery Honor Book for *Golden Basket* (1936), the Caldecott Medal runner-up for *Madeline* (1940), and the Caldecott Medal for *Madeline's Rescue* (1954). Although he had four children's books to his credit when he wrote *Madeline,* it took five years to get it into print—publishers apparently believing it was too sophisticated.

Major exhibitions of Bemelmans' paintings were held at the Galerie Durand-Rual, Paris, in 1957 and at the Museum of the City of New York in 1959. Bemelmans compared the efforts of writing and painting:

> When writing, one writes mainly about oneself, for the pen is held by the writer. The same is true in other forms of expression, for instance in painting—if you know the artist, you will see him always in his pictures, even if they be landscapes. The more definite the personality the more the identification. Goya is, Picasso is, Dali is, Renoir, Van Gogh—in writing it is less evident for writing is a projection beyond the immediately visible.
>
> Putting down words on paper is a terrible, painful process. It is a search for words, for form, for telling a story in images that you cannot draw like a child but must project.
>
> The projection must always be (this is my personal conviction) an exaggeration, to be true to life. An exaggeration of the usual fact as it exists, either in your mind or in nature. . . . I can invent only from the model—I have a potato in front of me—and I can make it sprout, with some work and turn the sprouts into lilies or thistles. But I have to have the potato and the Idea.

Bemelmans was a novelist and essayist, as well as a children's book writer and illustrator, best remembered for giving us Madeline, the little misadventuring Parisian girl.

Born in 1898 in Meran (now Merano, Italy), Bemelmans had his own misadventuring youth in the Austrian Tyrol. His father, a Belgian painter, was largely absent from the boy's life, and Bemelmans, a poor student with authority problems, was sent away—first to a boarding school and, after failing there, to work in family-owned hotels.

The sixteen-year-old Bemelmans got into a fight with and shot a hotel manager. Threatened with reformatory, he left for New York and got a job there as a busboy. He enlisted in the United States Army at the start of World War I. After the war, Bemelmans became a U.S. citizen and New York restaurateur. He died in New York in 1962.

Ludwig Bemelmans. Flower wagon on Brooklyn Bridge

1959. Oil. By kind permission of the estate of Ludwig Bemelmans

Ludwig Bemelmans. Wall Street

1959. Oil. By kind permission of the estate of Ludwig Bemelmans

ARNOLD BENNETT

Arnold Bennett claimed his lifelong interest in the arts arose so early in life that he was not even aware of it. "When I was young," he wrote, "I had no consciousness of being interested in the arts, yet I was. Before I went to school, I was a feverish water-colourist. I painted lovely moss roses on glossy white cards, and then, discovering that moss roses and white cards were commonplace, I went into sepia and landscapes and drawing-blocks."

He and his siblings were also given basic musical training: "Some relative taught us our notes, and no more, and we were left free with a piano and a popular book of instruction." They found they had a natural aptitude playing duets as soon as they sat down to try. "We were exquisitely staggered by our own gifts, our parents rather more so, and even our parents' friends not less so."

Bennett credited visual and performing arts with giving him the education he needed to write:

> [W]hat more than anything else helped me to help myself in education was the frequenting of artists in other arts: painters, designers, sculptors, musicians. These friends and acquaintances unconsciously indicated to me other ways of seeing and feeling than the ways employed in literature. They enlarged the boundaries of my vision, my emotions, and my curiosity. I have learnt little from the companionship of authors. Indeed, up to the age of forty, I knew very few authors and few journalists.

At sixteen, Bennett left school to pursue a legal career, starting as a clerk in his father's office. Five years later he flunked the bar—twice—and began to write for local newspapers. He read voraciously in a program of self-education. Bennett learned to write, he said, "by writing and writing and writing," by taking "each word by itself, examining it as you would examine a criminal, and by avoiding ready-made phrases." Bennett remarked that the common regard of a picture "as a story first and a work of art afterwards—is not as indefensible as it seems, or at least not so inexcusable. In the attitude of the perfectly cultured artist himself, there is something of the same feeling—it must be so. Graphic art cannot be totally separated from literary art, nor vice versa. They encroach on each other."

Bennett augmented the text in his travel diaries with illustrations, such as the one presented here, of the places he visited. He did not ascribe his skill to any formal training. "I had supplementary lessons in 'art,'" he wrote, "being taught to 'draw' by the copying of elaborate Renaissance designs in pencil! There was absolutely nothing in the curriculum to stimulate the imagination or the faculty of observation."

A hugely popular writer of more than one hundred books—novels, stories, journalism, and critical essays—Bennett was born in Hanley, England, in 1867. He grew up in the grim industrial towns of the pottery district of England, which he used as settings for a number of his stories. His father began in the pottery trade but became a pawnbroker and then, studying at night, qualified as a lawyer.

Bennett was so beloved that as he lay dying in London in 1931, the city covered the streets near his home with muffling straw so he would not be disturbed by noise.

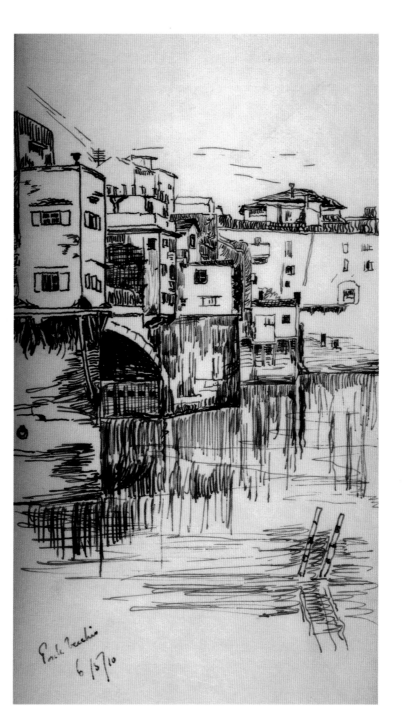

Arnold Bennett. Untitled (bridge in Florence)

1910. Pen and ink. 4–1/3 x 6–2/3 inches. From *Journals*. Berg Collection of English and American Literature, The New York Public Library, Astor, Lenox and Tilden Foundations

NICOLAS BENTLEY

Nicolas Bentley succinctly described the childhood path that led to his becoming an artist:

> Went to school at ten. Home again in tears at eleven-thirty. Odd experience with some nuns in early youth resulted in life-long antipathy to their habits. Odd experience with Latin master later on led to permanent difficulty in conjugating foreign verbs.

Bentley entered University College School in Hampstead, England, but dropped out at seventeen to enroll in Heatherley's Art School. Becoming an artist was just one idea, he admitted:

> I also thought it would be very pleasant to become a writer, though at that time, I had no clear idea of what I wanted to write about. . . . In the end, as the only gift I had that seemed likely to be worth encouraging was for drawing, it was agreed that probably the best thing would be for me to go to an art school.

Bentley soon left Heatherley's to work, briefly, as an unpaid circus clown. He worked for a while as a movie extra, then in advertising and public relations, before finally getting his first commercial work as an artist: illustrating a diary in a trade paper.

Notwithstanding his great skill at drawing—he instructed novice artists to "Leave out the shading, get the outline so true that it suggests the volume"—Bentley acknowledged "an unrequited love affair with painting" that began with visits to the National Gallery in his youth. He attributed his failure in painting at least in part to his facility with line:

> Besides drawing, I tried my hand for a while at painting. But painting involves problems of aesthetics, itself one of the most complicated branches of philosophy, of which at that time, I was only too willingly unaware. And it also involves other problems of a technical kind entirely different from those that arise in trying to transmit a visual image onto a piece of paper with a pen or pencil. This I luckily realized without much loss of time, though not without some loss of self-esteem. My immediate inclinations were towards the small aesthetic profits and quick economic returns of the illustrator's market; but in my heart, I would still like to have been a painter almost more than anything else.

Bentley was the self-described "author of three novels and numerous works of penetrating wisdom," including the thrillers *The Tongue-Tied Canary* (1949) and *The Floating Dutchman* (1950); his autobiography, *A Version of the Truth* (1960); and *Second Thoughts on First Lines, and Other Poems* (1939). He was also the illustrator of some seventy books in addition to his own—including works by **Hilaire Belloc**, T. S. Eliot, and **Lawrence Durrell**—and was a founder and director of publisher Andre Deutsch Ltd. The son of Edmund Clerihew Bentley, also a writer, Nicolas Clerihew Bentley was born in 1907 in London. He died there in 1978.

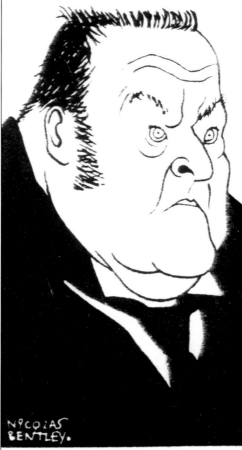

Hilaire Belloc.

Nicolas Bentley. Hilaire Belloc

From *Nicolas Bentley Drew the Pictures* (Scolar Press, 1990). With kind permission of Bella Jones

Nicolas Bentley. "Hullo—tumbled over?"

The Bystander, December 6, 1933. From *Nicolas Bentley Drew the Pictures* (Scolar Press, 1990). With kind permission of Bella Jones

Nicolas Bentley. Edgar Allan Poe

First published in *More Biography* (1929). From *Nicolas Bentley Drew the Pictures* (Scolar Press, 1990). With kind permission of Bella Jones

JOHN BERGER

An artist as well as arguably the world's most influential art critic, John Berger attended London's Central School of Arts and Crafts and the Chelsea School of Art, where he taught figure drawing from 1948 to 1955 while selling his paintings through London's Wildenstein, Redfern, and Leicester galleries. Although he gave up painting when he turned to writing in the late 1950s, he never stopped drawing. A book devoted to his drawings—*Eher ein Begehren als ein Geräusch: Zeichnungen und Texte (A Desire Rather than a Sound: Drawings and Text)*—was published in 1997. Contrasting his experience of writing with drawing over the years, Berger wrote to his daughter Katya in an unpublished letter that he provided to me in 2006:

> For me the task of writing (not letters to you but pages to be printed) is as difficult now as it was when I first began. It hasn't got any easier—and yet for fifty years I've sat down nearly every day to try to write at least a few sentences. By contrast, the act of drawing has become easier—although it's something I've done much less regularly. Maybe easier is not the right word, for drawing always demands intense, almost breathless concentration. I find today what I'm looking for more quickly than I used to. My past experience of drawing brings me more help than my past experience of writing. It helps me to have confidence in what flows, in the stream that is carrying everything I'm watching. And confidence too in how distant, unconnected points can call to one another and be heard across vast empty spaces.

Internationally renowned for his writings on visual art—*Permanent Red: Essays in Seeing* (1962), *Ways of Seeing* (1972), which was also a BBC series, *The Look of Things* (1972), and *About Looking* (1980)—Berger has utilized his own drawings as well as those of the masters in his recent works *Titian: Nymph and*

John Berger. Carp

1996. Charcoal and inkwash on paper. Collection of the artist

Shepherd (1996) and *Berger on Drawing* (2005). Denying in *Titian* that he's an art historian—"I'm too impatient, and I live too much in the present"—Berger writes:

> When I want to get closer to works from the past, I do drawings from them. (As I have done drawings from *Titian*'s paintings.) [See *The Rubbing Out of Lines* and *Magdalene, 1996,* reproduced here.] This is, however, a gestural approach, not an historical one. In drawing, you try to touch, if only for an instant—like playing tag—the master's vision.

A poet, playwright, screenwriter, and Booker Award-winning novelist, Berger began his literary career as an art critic. He was born in London in 1926, his father an army officer turned financial advisor, his mother the proprietor of a coffee shop. As a boy, Berger was sent off to a military training school where he described himself as brutalized and imprisoned, and where he began to draw and write poetry. When he quit at sixteen, his parents refused to support him or allow him to live under their roof, but with a scholarship he was able to enter art school. His studies were interrupted for service in the British army from 1944 to 1946, but resumed with the aid of a military subsidy. Spiritually aligned with the working class, and intellectually a Marxist, Berger has always seen his work as a writer, an artist, and a critic as inextricably bound up in his political views. During his early years as a critic he gave this explanation:

> Whenever I look at a work of art as a critic, I try—Ariadne-like, for the path is by no means a straight one—to follow up the threads connecting it to the early Renaissance, Pablo Picasso, the Five Year Plan of Asia, the man-eating hypocrisy and sentimentality of our establishment, and to an eventual socialist revolution in this country.

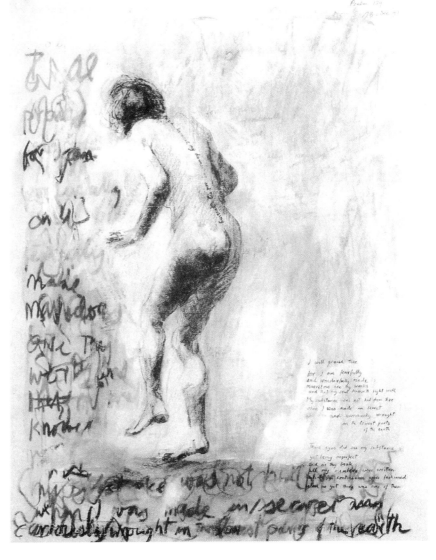

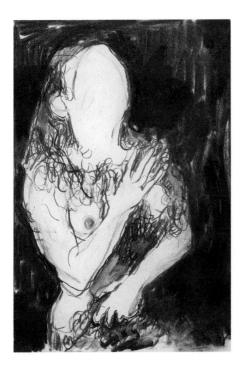

Above: John Berger.
Magdalene, 1996

Charcoal on paper. 11–3/4 x 8–1/4
inches. Collection of the artist

Left: John Berger. The
Rubbing Out of Lines

1995. Charcoal on paper. Collection
of the artist

Above: John Berger. Psalm 139

1991. Chalk and tempera on paper. 25–1/2 x 19–2/3 inches. Collection of the artist

ELIZABETH BISHOP

Considered by many of her peers to be among the greatest poets of the twentieth century despite her small output, Elizabeth Bishop drew and painted (primarily in watercolor and gouache) throughout her life and made collages and constructions. Most of her paintings were given to friends; a few were reproduced on the covers of her books, including the cover for *Complete Poems: 1927–1979* (1983) and *Collected Prose* (1984).

In *Exchanging Hats*, William Benton's 1996 volume on Bishop's visual art, he quotes her description of her own paintings: "They are Not Art—not at all." Other observations in the book include Bishop's acknowledgment that she and her Vassar classmate Margaret Miller inspired each other "to an exchange of arts"; her claim that she knew a good poem and a good painting the same way—"If after I read a poem, the world looks like that poem for 24 hours or so, I'm sure it's a good one—and the same goes for painting"; and her comparison of "primitive writing" and "primitive painting":

> Where primitive painters will spend months or years, if necessary, putting in every blade of grass and building up brick walls in low relief, the primitive writer seems in a hurry to get it over with. Another thing was the almost complete lack of detail. The primitive painter loves detail and lingers over it and emphasizes it at the expense of the picture as a whole. But if the writers put them in, the details are often impossibly or wildly inappropriate, sometimes revealing a great deal about the writer without furthering the matter in hand at all. Perhaps it all demonstrates the professional writer's frequent complaint that painting is more fun than writing.

In a letter enclosed with a painting she sent to her doctor, Bishop, with typical self-deprecation, wrote: "I'm afraid, to use an elegant expression, I bit off more than I could chew. However, it's big enough so that if you like any section of it you can cut that part out."

Bishop refused to be anthologized as a "woman poet," insisting that she should be judged by her work, not her gender, and lived to see herself become the most honored poet of her day. Among the honors she received before her death in Boston in 1979 were designation as Consultant in Poetry at the Library of Congress (1949–50), the National Institute of Arts and Letters Award (1951), the Pulitzer Prize for *Poems: North & South* (1956), and the National Book Award for *The Complete Poems*.

Bishop was born in Worcester, Massachusetts, in 1911. Her father died when she was eight months old, and her mother was permanently institutionalized for mental illness when Bishop was four, and Bishop never saw her again. Bishop lived in a succession of relatives' homes and had irregular schooling. She nonetheless absorbed great quantities of English and American poetry and published her first poems in school magazines. She also developed the severe asthma and chronic depression, which, along with the alcoholism that started when she was a college student, never left her.

In 1934 Bishop graduated from Vassar. While there, Bishop, an admirer of **Marianne Moore**'s poetry, managed to introduce herself to Moore, who became her mentor. Moore taught Bishop to write with precision and the natural diction of prose, to find meaning in the commonplace, to focus on morality before literature, and, in Bishop's words, "not to worry about what other people thought, never to publish anything until I thought I'd done my best with it, no matter how many years it took, or never to publish at all."

The landscape opposite was painted during the sixteen years Bishop lived in Brazil with her companion, Lota de Macedo Soares, who committed suicide there.

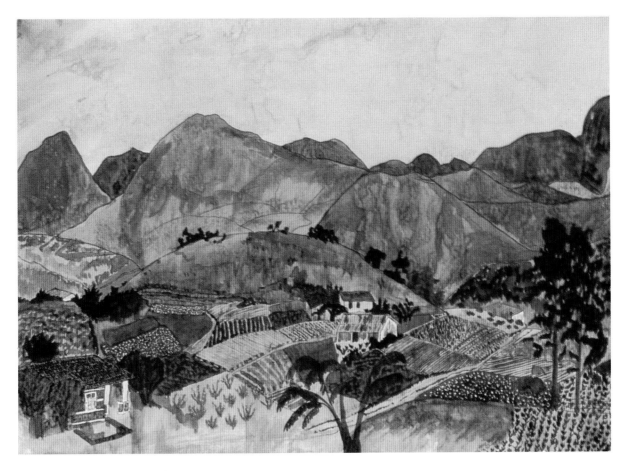

Elizabeth Bishop. Brazilian Landscape

Watercolor and gouache. From *Exchanging Hats: Paintings by Elizabeth Bishop*. Copyright © 1996 by Alice Helen Methfessel. Reprinted by permission of Farrar, Straus and Giroux, LLC

WILLIAM BLAKE

William Blake merged his poetry and painting into a single visionary expression. He saw art in all forms as prayer, art as inseparable from life, and all life as God. The mysticism that suffused his life and art originated in early childhood. Although his parents were disquieted by their child's visions (he reported seeing a tree filled with angels), they did support his artistic interests and enrolled him in drawing school at ten. At fourteen he was apprenticed to a master engraver, and at twenty-one he entered the Royal Academy in London. The brother with whom Blake was closest, Robert, died at a young age, and Blake claimed that his sibling's spirit lived in him and had, in fact, taught him how to create his "illuminated writing."

The spirit-inspired, "illuminated" books that Blake invented combined text and pictures in a relief etching from which a run of copies could be made without the need of a printer. Apart from the extraordinary artistic effects achieved with the integration of text and design, Blake felt that he was empowering the artist:

> The Labours of the Artist, the Poet, the Musician, have been proverbially attended by poverty and obscurity; this was never the fault of the Public, but was owing to a neglect of means to propagate such works as have wholly absorbed the Man of Genius. Even Milton and Shakespeare could not publish their own works. This difficulty has been obviated by the Author of the following productions now presented to the Public; who has invented a method of Printing both Letter-press and Engraving in a style more ornamental, uniform, and grand, than any before discovered, while it produces works at less than one fourth of the expense.

For Blake, the essence of art was line—"the hard and wiry line of rectitude." He detested chiaroscuro and insisted on "firm and determinate lineaments unbroken by shadows": [The] "art of losing the outlines is the art of Venice and Flanders; it loses all character, and leaves what some people call expression; expression cannot exist without character as its stamina; and neither character nor expression can exist without firm and determinate outline."

A great colorist as well as master of line, Blake believed that effective color "does not depend on where the colours are put, but where the lights and darks are put, and all depends on Form or Outline, on where that is put; where that is wrong, the colouring never can be right; and it is always wrong in Titian and Correggio, Rubens and Rembrandt."

The once neglected, now universally acclaimed Romantic poet, painter, and engraver was born in 1757 in London, where he died in 1827. Blake's father was a haberdasher, and the boy was raised in modest but respectable circumstances. He had no schooling and was never sorry to have missed out on it: "There is no use in education, I hold it wrong—it is the great Sin," he said late in life. In *The Marriage of Heaven and Hell* (1793) he wrote, "Improvement makes strait roads; but the crooked roads without Improvement are roads of Genius." For Blake, the universe is not the universe of Newton and science, a universe of mathematical abstraction; rather, it is what man perceives through his experience of it: "If the doors of perception were cleansed every thing would appear to man as it is, infinite," he famously wrote. "For man has closed himself up, till he sees all things thro' narrow chinks of his cavern." Correctly perceived, all is human, all is holy, according to Blake; for man, made in the image of God, is the microcosm: *Each grain of Sand, / Every Stone on the Land, / Each rock & each hill, / Each fountain & rill, / Each herb & each tree, / Mountain, hill, earth & sea, / Cloud, Meteor & Star / Are Men Seen Afar.*

Above: William Blake. The House of Death

1795 / c. 1805. 19–1/2 x 24 inches. Tate Gallery, London/Art Resource, New York

Opposite: William Blake. Nebuchadnezzar

1795 / c. 1805. Color print finished in ink and watercolor. 17–5/8 x 24–3/8 inches. Tate Gallery, London

ANDRÉ BRETON

André Breton rejected the notion that painting, drawing, and sculpture express the artist's inner vision. Conversely, a viewer sees more than what the eye sees "in its savage state." There is, Breton noted, what one thinks one sees and recognizes or does not, or "what others have seen, or claim to have seen . . . what I see differently from the way in which anyone else sees it, and even what I begin to see which is not visible." Moreover, he added, "To these varying degrees of sensation correspond spiritual realizations sufficiently precise and distinct to allow me to grant to plastic expression a value that on the other hand I shall never cease to refuse to musical expression, the most deeply confusing of all forms."

Breton saw the ancient process of fixing visual images as creating "a veritable language" no more artificial than spoken language. He felt, he said, that he had "the right to demand a great deal from a faculty which, more than almost all others, allows me to exercise control over the real, over what is vulgarly understood by the real." In Breton's aesthetic,

> [i]t makes no difference whether there remains a perceptible difference between beings which are evoked and beings which are present, since I dismiss such differences out of hand at every moment of my life. This is why it is impossible for me to envisage a picture as being other than a window, and why my first concern is then to know what it looks out on, in other words whether, from where I am standing, there is a "beautiful view," and nothing appeals to me so much as a vista stretching away before me and out of sight.

Breton—father of the Surrealist movement, poet, novelist, and essayist—was born in 1896 in Tinchebray, France, and died in 1966 in Paris. He studied medicine at the University of Paris during World War I, in between service in the ambulance corps, and was taken with psychiatry. His fascination with the unconscious led to what would later become the Surrealist tenet that poetry and art should tap into the nonrational part of the mind to avoid the constraints that reason imposes on expression. Breton wrote his *Manifèste du surrealisme* in 1924, taking the term he had heard years earlier from his late friend **Apollinaire** to describe one of his own plays. Breton acknowledged his literary debts to others as well—**Arthur Rimbaud**, **Alfred Jarry**, Compte de Lautréamont, and, most especially, Jacques Vaché, a close friend who killed himself at twenty-four.

In an effort to achieve thought free "of any aesthetic or moral preoccupation," in which there is no line between dream and reality, sanity and madness, Breton and the group of writers and artists he gathered around him employed techniques of automatism in both writing and painting. His *Nadja* (1928), intended as an antinovel, eschewed narrative in favor of stream-of-consciousness monologues and helped to create a novelistic form that inspired many writers who came after him.

BREYTEN BREYTENBACH

South Africa's leading Afrikaner poet, Breyten Breytenbach, has exhibited his paintings throughout Europe and the U.S., enjoying parallel recognition as a painter and writer. Breytenbach sees "a communality of purpose" in both arts: "How much must I give for the privilege of painting and poetry? Paintings and poems are contracts signed with death in terms of which you are given the lease to some more space and some more time." He asks:

> Why do you paint and write? From what urge? What lack? What surfeit? What sweet-sorrow? The simple answer must be: If I could show or say it, if I could show it my it-ness any other way, there would be no need to write and paint. . . . I also think of the answer as a need for digestion: digesting the world; digesting the self; and the need for creation, creating the world and creating the self. If this sounds like defecation, it is, because words and pigments are that as well.
>
> [. . .]
>
> What do you write and paint? I'd isolate a few intersections: memory, space, imagination, projection, transformation or even metamorphosis, which of course is movement.
>
> [. . .]
>
> How do you paint and write? By using a grammar and a syntax which are remarkably alike in the two disciplines: patterns and colors, inner rhymes and rhythms, alliteration, allusions and emptinesses, edges and borders, spacing and positioning, lines and planes, horizons and graves, and groves. Every poem is both horizon and grave, rot and resurrection, leftover and new beginning, and so is every painting.

Born in 1939 in Bonnievale, South Africa, Breytenbach is descended on his father's side from Afrikaner settlers of the seventeenth century. One brother Breytenbach described as "a trained (and enthusiastic) killer," the other "a fellow traveller of the [Security Police], with decidedly fascist sympathies."

Breytenbach attended the University of Cape Town, but dropped out to travel, settling down to paint and write in Paris in 1961. In 1964, he published his first book of poems, *Die ysterkoei moet sweet (The Iron Cow Must Sweat)*. Subsequent volumes *Die huis van die dowe (House of the Deaf,* 1967), *Kouevuur (Gangrene,* 1969), and *Lotus* (1970)—written under the pseudonym Jan Blom—received awards in South Africa, but Breytenbach could not return to claim them because his Vietnamese wife was refused entry as a "nonwhite," and he risked arrest for interracial marriage.

In 1973, a three-month visa was granted to the couple, and Breytenbach used the occasion of his visit to attack the regime, which declared him persona non grata and ordered him not to return. Breytenbach was cofounder of an antiapartheid group in Paris, on whose behalf he traveled to South Africa under an assumed name to arrange funding for black trade unionists in 1975. He was quickly arrested and convicted, and served seven years. Two he spent in solitary confinement, five in the maximum security prison that was also home to Nelson Mandela.

While in prison Breytenbach wrote an internationally praised series of sketches published as *Mouroir: Bespieeelende notas van 'n roman* (1984; *Mouroir: Mirrornotes of a Novel*), as well as *The True Confessions of an Albino Terrorist* (1983). Among his honors are the 1964 Afrikaans Press Prize, the South African Central News Agency Award (five times), and the Pier Paolo Pasolini Prize for Literature.

Breyten Breytenbach. O, The Self 2

2001. Acrylic and collage on paper. Collection of the artist

Breyten Breytenbach. De Vogelspinvrouw (The Birdspiderwoman)

1989. Gouache. 41–3/4 x 29–1/2 inches. Collection of the artist

CHARLOTTE and EMILY BRONTË

Charlotte and Emily Brontë, like all of the Brontë children, drew and painted. Alexander and Sellars' *The Art of the Brontës* (1995) includes 180 known illustrations by Charlotte, 131 by Branwell, 29 by Emily, 37 by Anne, and 22 of "dubious attribution." Only Charlotte and Branwell exhibited in their lifetime; Charlotte exhibited two drawings at the Royal Northern Society for the Encouragement of Fine Arts in Leeds in 1834. For the most part, in keeping with the social dictates of the time, the Brontë sisters produced art as part of their training to become wives and governesses. According to the influential *The Daughters of England, Their Position In Society, Character and Responsibilities* (1842), women should study painting only as a genteel accomplishment, and they were to do so only by copying existing works, primarily engravings.

The Brontë girls, however, followed their brother, Branwell, out of doors to sketch from nature. Alexander, in "The Art of Emily Brontë," writes that Emily felt there was "no good to be derived" from merely copying engravings and by adopting the practice "they should lose all originality of thought and expression." Shy, antisocial and preferring the company of dogs to people, Emily did a number of portraits of her pets.

Charlotte, whose publisher asked her to illustrate the second edition of *Jane Eyre: An Autobiography* (1847), claimed to have no illusions about the quality of her work:

> It is not enough to have the artist's eye, one must also have the artist's hand to turn the first gift to practical account. I have, in my day, wasted a certain quantity of Bristol board and drawing-paper, crayons and cakes of colour, but when I examine the contents of my portfolio now, it seems as if during the years it has been lying closed some fairy has changed what I once thought sterling coin into dry leaves, and I feel much inclined to consign the whole collection of drawings to the fire.

Charlotte and Emily, poets and novelists, are best-known for a single work each: Charlotte for *Jane Eyre* and Emily for *Wuthering Heights* (1847). They were born in Thornton, Yorkshire, England, Charlotte in 1816, Emily in 1818, two of the six children their mother had from 1813 to 1820, before she died in 1821, at the age of thirty-eight.

Their father was an Anglican priest who sent Charlotte off in 1824 to the Clergy Daughters' School at Cowan Bridge, where he'd already sent his eldest two daughters, Maria and Elizabeth. A year later, as a result of deplorable conditions at the school, Maria and Elizabeth died of tuberculosis. Their father determined to educate the other four, including Anne and Branwell, at home, in the isolated village of Haworth. There, the children entertained one another, creating fantasy worlds which they captured in plays, stories, and artwork. Branwell, who became a professional portrait painter, died in September 1848.

After caring for Branwell during his final illness, and refusing medical treatment for her own, Emily died in December, at age thirty. Anne died the following May, at twenty-nine.

Charlotte, the only Brontë child to marry—in 1854—died in Haworth. She was thirty-eight years old.

Above: Charlotte Brontë. Madonna and Child

C. 1835. Pencil on paper. 19–3/4 x 17–3/8 inches. Courtesy of the Brontë Society

Opposite: Emily Brontë. Flossy

C. 1843. Watercolor on paper. 9–1/2 x 13–1/2 inches. Courtesy of the Brontë Society

Above: Charlotte Brontë. Woman in leopard fur

1839. Watercolor and gum arabic on paper. 7–1/4 x 5–3/4 inches. Courtesy of the Brontë Society

PEARL S. BUCK

Pearl S. Buck enjoyed sculpting and always kept a set of sculpting tools within reach. She would complain to her family that her writing kept her from pursuing the avocation that she said she felt could have been her career. Her son, Edgar Walsh, remembers her assembling whimsical sculptures of driftwood at the family beach house at the New Jersey shore. One, which she thought resembled an armadillo with antlers, she mounted and titled "Armadillo Deer." Her only formal sculpture that seems to have survived are busts of her children that are preserved at the Pearl S. Buck home, Green Hills Farm, in Dublin, Pennsylvania.

Buck was the Pulitzer and Nobel Prize-winning author of novels about life in China—most famously, *The Good Earth* (1931) and its sequels, *Sons* (1932) and *A House Divided* (1935). She was born Pearl Comfort Sydenstricker in 1892 in Hillsboro, West Virginia, the fourth of seven children, four of whom died in infancy. Her parents were Presbyterian missionaries who brought her to China when she was only three months old. With her father spending months away in the countryside seeking converts, Buck was raised and educated by her mother and a Chinese tutor until she attended a school in Shanghai at fifteen.

In her Nobel acceptance speech, Buck acknowledged the Chinese novel as the shaper of her own writing: "My earliest knowledge of story, of how to tell and write stories, came to me in China." And it was the Chinese scholarly tradition's separation of art from the novel that was most influential to her: "The novel in China was never an art . . . nor did any Chinese novelist think of himself as an artist." The Chinese novel was the creation of people free from scholarly criticism, of the requirements of "art," told in the vernacular, and nurtured by popular approval.

Thus, Buck declared that her ambition was not "trained toward the beauty of letters or the grace of art." Furthermore, she insisted that the "instinct which creates the arts is not the same as that which produces art." Viewing the urge to create as a "super-energy" that consumes itself "in creating more life, in the form of music, painting, writing, or whatever is its most natural expression," she held that the secondary matter of defining art is not the concern of the creator: "[T]he sole test of his work is whether or not his energy is producing more of that life."

Buck received a degree in psychology from Randolph-Macon Women's College in Lynchburg, Virginia, and soon returned to China. She came back to the United States to earn an M.A. from Cornell University, married John Buck, and moved with him to an impoverished community in China. The couple had a severely retarded daughter and adopted a second girl. When her eighteen-year marriage ended in divorce, Buck married Richard Walsh, her publisher, and adopted six more children. She and Walsh founded three international organizations: the East and West Association to encourage cultural exchange and understanding; Welcome House, the first international, interracial adoption agency; and the Pearl S. Buck Foundation, to which she contributed the bulk of her millions in order to assist the illegitimate offspring of American GIs in Asia.

Buck wrote more than seventy books. Besides her many novels about the East, Buck wrote biographies of each of her parents, three autobiographies, a book about her eldest daughter titled *The Child Who Never Grew* (1950), children's books, and other bestselling novels under the name John Sedges. She died in Danby, Vermont, in 1973.

Opposite, left: Pearl S. Buck. Jean at seven

Terra cotta. Height, 19 inches. Courtesy of the Pearl S. Buck Family Trust and Pearl S. Buck International

Opposite, right: Pearl S. Buck. John at eight

Terra cotta. Height, 17–1/2 inches. Courtesy of the Pearl S. Buck Family Trust and Pearl S. Buck International

CHARLES BUKOWSKI

"To do a dangerous thing with style / Is what I call Art." Charles Bukowski attended Los Angeles City College between 1939 and 1941, where he enrolled in art classes and started going to galleries. However, he dropped out when his teacher dismissed a design idea of his as passé and thereafter he continued to paint for himself, without further instruction.

Bukowski's art probably would have remained personal but for the intervention of his friend and longtime publisher, John Martin of Black Sparrow Press, who realized that the value of Bukowski's poorly selling books would be enhanced if original artwork were included in them. Martin bought the art supplies and set Bukowski up on an assembly line, producing simple abstractions that could be pasted into the books or sold separately.

Bukowski biographer Howard Soanes claims that the author "had only a limited understanding of the value of his artwork." He tells how John Martin arranged the sale of about forty paintings only to be told by Bukowski that "he'd put them in the bath and pissed all over them. He wasn't quite sure why, perhaps he was crazy. And he couldn't get them back, because he'd dumped the whole mess in the garbage." Martin, however, denies that any such event took place and insists that Bukowski respected and "was very protective of his art."

Rising from skid-row alcoholic to internationally recognized author, Bukowski published more than sixty books of sardonic, anti-authoritarian poetry and prose. His novels and short stories were translated into over a dozen languages, and Bukowski acquired a loyal following through publication in small and alternative presses and magazines. He was born Henry Charles Bukowski Jr. to an American GI and his German wife in Andernach, Germany, in 1920. When he was two, Bukowski's parents immigrated to Los Angeles, where he was abused both physically and emotionally by his brutal, milkman father. As an adolescent he was afflicted with a case of acne so severe that he was forced to miss half a year of school while enduring painful treatments, and was left with severe and permanent scarring—emotional as well as facial.

Bukowski drifted from city to city, from one menial job to another, and developed into a habitual drunk. At the same time, he was writing a story a day and submitting them to major magazines, where they were rejected, until *Story* finally published one in 1944. For a decade, little of his work was published, and it was not until 1960, when he was forty, that his first, tiny volume of fourteen poems appeared. Prior to that, Bukowski led an itinerant life, earning just enough for alcohol or a room.

In the 1960s he worked as a mail carrier, while publishing ten books of poetry. He quit in 1970 to become a full-time writer. Bukowski's notable works include the short story collections *Notes of a Dirty Old Man* (1969), *Erections, Ejaculations, Exhibitions, and General Tales of Ordinary Madness* (1972), and *Hot Water Music* (1983), and the novels *Post Office* (1971), *Factotum* (1975), and the posthumous *Pulp* (1994). He also wrote the screenplay *Barfly* (1984), which was filmed by Barbet Schroeder in 1987. Bukowski died in 1994 in San Pedro, California.

Charles Bukowski. Untitled (girl with cigarette, dogs, and men)

C. 1978. Watercolor. 12 x 9 inches. By kind permission of John Martin and the estate of Charles Bukowski

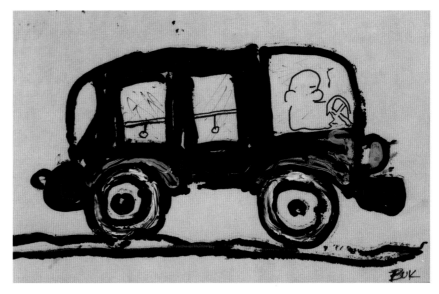

Charles Bukowski. Untitled (car)

C. 1978. Oil on paper. 6 x 9 inches. By kind permission of John Martin and the estate of Charles Bukowski

Charles Bukowski. Untitled (airplane)

C. 1978. Oil on paper. 6 x 9 inches. By kind permission of John Martin and the estate of Charles Bukowski

WILLIAM S. BURROUGHS

William S. Burroughs was a recognized artist who painted, drew, and sculpted throughout his life. Journalist Pete Hamill reports that Burroughs preceded him as an art student at Mexico City College in 1956, but Burroughs' paintings were not exhibited until 1987, at the Tony Shafrazi Gallery, in New York. They have been shown numerous times since at New York's Gagosian Gallery.

Burroughs abhorred logical structure and introduced the same notions of chance and randomness into his paintings as he had in his writings. His protean novel *Naked Lunch* (1959) was assembled from loose pages without any notion of sequential narrative, and subsequent works went further in their efforts to avoid logic or linearity, using "cut-up" and "fold-in" techniques in which pages were cut and matched or folded in half so that lines or partial lines of text would be placed in arbitrary juxtaposition. "The cut-up method," Burroughs wrote, "treats words as the painter treats his paint, raw material with rules and reasons of its own." He saw a similarity in the creative process of writer and artist:

> A writer is merely an artist with antennae tuned into certain cosmic wavelengths. They're attuned to the film—that's what life is, a film—and they bring part of it back in a form people can understand. A painter does largely the same thing.

Burroughs created with automatism, letting his unconscious dictate the expression—and, as with the example shown here, from his *Seven Deadly Sins* suite, he would use a shotgun to achieve randomness, blasting a can of paint placed before the wood panel to be splattered and pocked. When he used paper it had to be "slick" so the colors would "run around." Sometimes he painted with his hands, and once he did a series with mushrooms.

Taking a mushroom, a toadstool, sticking it in color and using it as a paintbrush. I hate the limitation that says, "You can only do it with a brush." I say, "What's this shit?" There's so many ways: spattering, marbling, strips of paper, rollers, Pollock's drip can device, the Rorschach method . . . all these randomizing techniques. I got some good mileage out of them mushrooms.

William Seward Burroughs was born in St. Louis, Missouri, in 1914. Despite a privileged background, he had an unhappy, mother-oppressed, nightmare-filled childhood before going off to Harvard, where he got an A.B. in 1936. After exploiting connections to get into the OSS, the precursor to the CIA, he cut off the end of a finger to avoid being accepted. Later, discharged on psychological grounds from the army, he worked as a bartender, exterminator, and private detective. Through Joan Vollmer, whom he would later marry, he met **Jack Kerouac**, and through him, **Allen Ginsberg**, and together they were the principal founders of the Beat generation. A morphine and heroin addict, Burroughs was harassed by law enforcement and ran from place to place, finally ending up in Mexico. There, in a drunken game of William Tell, he killed his wife with one shot through the forehead. Ruled an accident, her death was nonetheless the watershed event in his life. Burroughs wrote that it "brought me into contact with the invader, the Ugly Spirit, and maneuvered me into a lifelong struggle, in which I have had no choice but to write my way out."

Burroughs was elected a member of the American Academy of Arts and Letters in 1983, and a year later made Commandeur de l'Ordre des Arts et des Lettres of France. He died in Lawrence, Kansas, in 1997.

William S. Burroughs. Avarice (with text)

1991. Five-color silk screen. 45 x 31 inches. Copyright © Lococo Fine Art Publisher

Sloth says don't stick your neck out, go by the book, never go too far in any direction, stay in the mainstream, don't get *involved*, don't get mixed up in it. And Envy – you know the type, unfairly passed over for promotion . . . one such swine can disrupt a whole firm with his tale-bearing, lies and slander. No wonder he is passed over for promotion: he is so busy all the time with affairs and intrigues, he has no time left to do his job.

The old miser fingering his gold coins with idiot delight has given way to the deadly, disembodied Avarice of vast multinational conglomerates, with no more responsibility or consideration for the welfare of the planet than the computers that orient their maneuvers, programmed for maximum profit, humming and purring and sucking up rain forests and spewing out dividends. Avarice has ravaged the planet, cut down the rain forests, and polluted the seas and rivers.

LEWIS CARROLL

*I*ntroduced to photography in 1855, Lewis Carroll became a portraitist, mainly of children, and was praised as one of the outstanding child photographers of his century. In his own childhood, as a way to entertain his siblings, Carroll had drawn clever pictures that he gave them to paint. Later in life he continued to entertain young children with his drawings as well as his stories. One of them recalled:

> [W]e used to sit on the big sofa on each side of him, while he told us stories, illustrating them by pencil or ink drawings as he went along. When we were thoroughly happy and amused at his stories, he used to pose us, and expose the plates before the right mood had passed. He seemed to have an endless store of these fantastical tales, which he made up as he told them, drawing busily on a large sheet of paper all the time.

Although drawing pleased Carroll, he was frustrated by what he felt were his limitations. He wrote to an artist friend: "I *love* the effort to draw; but I fail utterly to please even my own eye. But I have no time now left for such things. In the next life, I do hope that we shall not only see lovely forms, such as this world does not contain, but shall also be able to *draw* them."

Consistently self-deprecating about his art, he wrote to another artist friend:

> I never made any profession of being able to draw, and have only had, as yet, four hours' teaching (from a young friend who is herself an artist, and who insisted on making me try, in black chalk, a foot of a Laocoön! The result was truly ghastly), but I have just sufficient of correct eye to see that every drawing I made—even from life—is altogether wrong anatomically; so that nearly all my attempts go into the fire as soon as they are finished.

Carroll sought **John Ruskin**'s opinion. The great art critic assured Carroll that his talent did not justify time spent sketching. As a result, even though he began illustrating his own writings—including the examples shown opposite for *Alice's Adventures Underground*—he turned ultimately to John Tenniel. In a letter seeking an introduction to the famous illustrator, Carroll wrote:

> I have written such a tale for a young friend, and illustrated it in pen and ink. It has been read and liked by so many children, and I have been so often asked to publish it, that I have decided on so doing. . . . I would send [Tenniel] the book to look over, not that he should at all follow my pictures, but simply to give him an idea of the sort of thing I want.

Carroll wrote not only those masterpieces of unreason—*Alice's Adventures in Wonderland* (1865), *Through the Looking Glass* (1872), *The Hunting of the Snark* (1876), *Sylvie and Bruno* (1889), and *Sylvie and Bruno Concluded* (1893)—but, as an Oxford professor, such studies in mathematics and logic as *An Elementary Treatise on Determinants* (1867), *The Game of Logic* (1886), and *Symbolic Logic* (1896). His Alice books are such classics, writes Kathleen Blake in the *Dictionary of Literary Biography*, they vie "with the Bible and Shakespeare as sources of quotation, and they have been translated into virtually every other language, including Pitjantjatjara, a dialect of Aborigine."

Carroll was born Charles Lutwige Dodgson in 1832, in Daresbury, Cheshire, England, one of eleven children of a poor clergyman. His mother died when he was nineteen. Like his father he went to Christ Church, Oxford, and, although he became the Reverend Charles Dodgson and a deacon of the Church of England, Carroll did not go on to become a practicing minister. He died, never married, in Guildford, Surrey, England in 1898.

"The Queen of Hearts she made some tarts
All on a summer day:
The Knave of Hearts he stole those tarts,
And took them quite away!"

"Now for the evidence," said the King, "and then the sentence."
"No!" said the Queen, first the sentence, and then the evidence!"
"Nonsense!" cried Alice, so loudly that everybody jumped, 'the idea of having the sentence first!'
'Hold your tongue!" said the Queen
"I won't!" said Alice, "you're nothing but a pack of cards! Who cares for you?"
At this the whole pack rose up into the air, and came flying down upon her: she gave a little scream of fright, and tried to beat them off, and found herself lying on the bank, with her head in the lap of her sister, who was gently brushing away some leaves that had fluttered down from the trees on to her face.

88

Above: Lewis Carroll. Large Alice. Illustration for *Alice's Adventures Underground*

1886. Berg Collection of English and American Literature, the New York Public Library, Astor, Lenox and Tilden Foundations

Left: Lewis Carroll. Queen of Hearts. Illustration with text from *Alice's Adventures Underground*

1886. Berg Collection of English and American Literature, the New York Public Library, Astor, Lenox and Tilden Foundations

JOYCE CARY

J oyce Cary once spoke of the sense of discovery common to all creative inspiration:

> It is quite true that the artist, painter, writer or composer starts always with an experience that is a kind of discovery. . . . It surprises him. This is what is usually called an intuition or an inspiration. It carries with it always the feeling of directness. For instance, you go walking in the fields and all at once they strike you in quite a new aspect: you find it extraordinary that they should be like that.

At seventeen, Cary studied art in Paris and Edinburgh. Although he went on to read law at Oxford and then to his literary career, Cary's artistic skills surfaced as illustrator of his book *The Old Strife at Plant's* (1956) and of a 1957 edition of *The Horse's Mouth,* the first of his bestselling novels. Cary described his art education in his essay "Value and Meaning":

> [T]he man who taught me most about drawing in the art school was the only one with strong prejudices. He liked only one kind of drawing, the classical. He would have loathed Picasso if he had ever heard of him. He would glance at my drawing of a model and say, "You don't know what you're doing, do you? Here, what's that mean?" Pointing, say, at a shadow on the back. I would say, "It's on the model," and he would answer fiercely, "But what is it? Muscle or dirt? What's it mean? . . . You're not trying to be a camera. You're trying to tell us something," and he'd take my pencil and do what I hated, slash in a line on top of my drawing. "Now at least she can stand up on her own legs."
>
> I don't think this man had much enthusiasm for drawing. But he had a set of principles and he was perfectly sure they were right. He taught me exactly what I needed to know about drawing, the fundamental rules, the logic, the syntax.

Cary was a novelist, short story writer, screenwriter, and essayist. He spent ten years writing books he didn't like and would not submit for publication—until he finally produced *Aissa Saved* (1932), based on his experiences in Africa, first in the Nigerian political service and then fighting until wounded with a Nigerian regiment in the Cameroon campaign of World War I. He produced dozens of books, including a collection of essays promoting artistic and political freedom called *Art and Reality: Ways of the Creative Process* (1958), *The Case for African Freedom* (1941), and *The Horse's Mouth* (1944), which was part of an art-world fiction trilogy and made into a successful film in 1958.

Arthur Joyce Lunel Cary was born in Londonderry, Ireland, in 1888. His mother died when he was ten; his stepmother, when he was sixteen. In 1912 Cary served with the Red Cross in Montenegro in two Balkan wars. The following year, after a brief stint in government in Ireland, he went to Nigeria where he was in political service and then a soldier. He died of a paralytic disease in 1957 in Oxford, England.

Above: Joyce Cary. The court-martial was held in a straw hut below the village. Illustration from *Memoir of the Bobotes*

1960. University of Texas, Austin. Courtesy AJL Cary Estate

Opposite: Joyce Cary. Gospodin Michan Plomenatz was the interpreter of Vilgar. Illustration from *Memoir of the Bobotes*

1960. University of Texas, Austin. Courtesy AJL Cary Estate

R. V. CASSILL

R. V. Cassill painted, drew, sculpted, and made woodcarvings and castings. He studied art at the University of Iowa, the Art Institute of Chicago, and, while in Paris on a Fulbright, at the Sorbonne. Although his artistic life was eclipsed by his literary career, it was his habit to sketch, paint, or sculpt whenever he was working on a novel.

Cassill painted quickly. He self-effacingly claimed that Grant Wood, under whom he had studied, had told him, "You've got more speed and less control than any student I ever had."

Cassill gained early recognition as an artist and worked for the Iowa Art Project of the W.P.A. Later in life his art was largely a matter of private expression, but he had a show of lithographs at the Pace Gallery, New York, at the time of publication of his novel *Doctor Cobb's Game* (1970).

Praised by Joyce Carol Oates as "one of the masters of the contemporary short story," and best known for his widely used text *Writing Fiction* (1963), Cassill was the author of twenty-four novels and seven short story collections, and the editor of both *The Norton Anthology of Short Fiction* (1977) and *The Norton Anthology of Contemporary Fiction* (1988; 2nd ed. 1997).

Ronald Verlin Cassill was born in Cedar Falls, Iowa, in 1919. His mother was a teacher, his father a principal and superintendent of schools who moved his family from town to town every four or five years.

Cassill received a B.A. and M.A. from the University of Iowa, his degrees separated by his service as a first lieutenant in the South Pacific, and then by studies at the Art Institute of Chicago. In his first years at college Cassill felt himself "to be fearfully alone, alienated as never before or since." He described his state then as "a para-psychotic withdrawal."

Cassill drank heavily until he met his first wife in 1940. Their marriage broke up in 1952, and he went off to write and paint in Paris. During a second trip to France in 1956 with Kay Adams, whom he married in Rome, he wrote his most successful novel *Clem Anderson* (1961).

Cassill, who taught at Iowa's Writer's Workshop, Purdue, Columbia, Harvard, and Brown universities, gave up fiction writing in 1985, saying simply "I think it's a gift I've used up." He died in Providence, Rhode Island, in 2002.

R. V. Cassill. Face of a Woman

C. 1972. Oil on paper. 4 x 5 inches. By kind permission of the estate of R. V. Cassill

R. V. Cassill. Seated Nude

C. 1972. Oil on paper, 6 x 13 inches. By kind permission of the estate of R. V. Cassill

G. K. CHESTERTON

Even as a child G. K. Chesterton was a talented artist. For him, the local art supply shop held "mysterious charm":

> [I]t was an oil and colour shop, and they sold gold paint smeared inside shells; and there was a sort of pale pointed chalks that I have been less familiar with of late. I do not think here of the strong colours of the common paint-box, like crimson-lake and Prussian-blue, much as I exulted and still exult in them. For another boy called Robert Louis Stevenson has messed about with my colours upon that sort of palette; and I have grown up to enjoy them in print as well as in paint. But when I remember that these forgotten crayons contained a stick of 'light-red,' seemingly a more commonplace colour, the point of that dull red pencil pricks me as if it could draw red blood.

Writer-artist **Hilaire Belloc** was effusive in his praise of Chesterton's skill:

> He would, with a soft pencil capable of giving every gradation in emphasis from the lightest touch to the dead black point and line, set down, in gestures that were like caresses sometimes, sometimes like commands, sometimes like rapier-thrusts, the whole of what a man or woman was; and he would get the thing down on paper with the rapidity which only comes from complete possession.

Chesterton studied at London's Slade School of Art. Of his art school experience he wrote:

> There is nothing harder to learn than painting and nothing which most people take less trouble about learning. An art school is a place where about three people work with feverish energy and everybody else idles to a degree that I should have conceived unattainable by human nature.

Chesterton declared boundaries to be symbols of "all that I happen to like in imagery and ideas," and he explained: "All my life, I have loved edges; and the boundary-line that brings one thing sharply against another. All my life I have loved frames and limits; and I will maintain that the largest wilderness looks larger seen through a window."

A towering, three-hundred-pound literary giant—author of more than one hundred volumes of poetry, novels, short stories, biography, essays, criticism, and plays—Gilbert Keith Chesterton was born into a middle-class London family in 1874. His happy childhood devolved in his teen years into "a lost experience in the land of the living" after a crisis of faith, a depression plagued with suicidal thoughts, and his departure from college without a degree.

Chesterton's journalism and nonfiction focused on social and political issues, on literary criticism, and on religious argument— all underpinned by insights gained in the childhood he described as "the real beginning of what should have been a more real life." After recovering from a nervous breakdown when he was forty, Chesterton's notion of simple pleasures led him to the social philosophy that he shared with Belloc, called Distributism, premised on the idea that all property "should be simplified to single ownership," enabling each individual family to have its own farm or business. A zealous convert to Catholicism, Chesterton found a religious imperative in opposing the Eugenics movement and in speaking up for the weak and disadvantaged.

Although he was a masterly poet, especially praised for his comic verse, Chesterton is best remembered for his novels, especially a detective series, which he illustrated, about the sleuthing priest Father Brown. He died in Beaconsfield, Buckinghamshire, in 1936.

" 'Whiskers,' he answered sternly, 'whiskers' "

"A big revolver in her hand"

" 'I tore off my accursed shawl and bonnet' "

Above: G. K. Chesterton. "A big revolver in her hand"

Illustration from *The Club of Queer Trades* (London: Harper & Brothers, 1905). Reproduced from Dover Publications, Inc., New York, reprint, 1987

Above: G. K. Chesterton. " 'I tore off my accursed shawl and bonnet' "

Illustration from *The Club of Queer Trades* (London: Harper & Brothers, 1905). Reproduced from Dover Publications, Inc., New York, reprint, 1987

Opposite: G. K. Chesterton. " 'Whiskers,' he answered sternly, 'whiskers' "

Illustration from *The Club of Queer Trades* (London: Harper & Brothers, 1905). Reproduced from Dover Publications, Inc., New York, reprint, 1987

WINSTON CHURCHILL

Sixteen-year-old Winston Churchill turned to art after his father criticized his participation in choir. "Papa said he thought singing was a waste of time, so I left the singing class and commenced drawing," the boy wrote to his mother.

It was not until he was forty that Churchill attempted the oils with which he would acquire great proficiency. He described his first try at painting the scene at the front of his house. His "empty brush," he wrote, "hung poised, heavy with destiny, irresolute in the air. My hand seemed arrested by a silent veto." Hazel Lavery, a neighbor and painter, drove up at that propitious moment and saw Churchill hesitating at his easel. Churchill recalled how Lavery demanded he give her a large brush and then:

> Splash into the turpentine, wallop into the blue and white, frantic flourish on the palette—clean no longer—then several large, fierce strokes and slashes of blue on the absolutely cowering canvas. . . . The canvas grinned in helplessness before me. The spell was broken. The sickly inhibitions rolled away. I seized the largest brush and fell upon my victim with berserk fury. I have never felt in awe of a canvas since.

In an article encouraging others who sought to take up painting late in life, he counseled that they forget training, as there was "no time for the deliberate approach." Instead, he advised: "We must not be too ambitious. We cannot aspire to masterpieces. We may content ourselves with a joy ride in a paint-box. And for this Audacity is the only ticket."

Yet Churchill never stopped taking instruction from the many fine artists he knew, including Walter Sickert, John Lavery, William Nicholson, and Paul Maze. And, except for five years during World War II, he never stopped painting. During World War I, to the amazement of those around him, Churchill set up his easel at a shelled farm that was his front-line headquarters and painted the shelling of the village, the pockmarked landscape. "I think it will be a great pleasure & resource to me if I come through all right," he told his wife. And so it was; Churchill painted and sketched wherever he went, whether he was vacationing or dealing with affairs of state. In 1920, when heading to Iraq, where he would assume his duties as Secretary of State for the Colonies, he stopped in Paris for an exhibition of the artist "Charles Morin." It was, in fact, the first show of work by Churchill himself, displayed pseudonymously in the hope of receiving an unbiased look from critics. And when, almost thirty years later, two of his paintings were accepted by the Royal Academy, they had been submitted as the work of a "Mr. Winter."

A legendary statesman and warrior, Churchill began his career as a journalist and novelist, achieving literary fame as a biographer and historian. Churchill published essays and articles on painting, along with drawings, and a book, *Painting as a Pastime* (1948). In 1953 he was awarded the Nobel Prize for Literature. Born in 1874 in Woodstock, Oxfordshire, Churchill died in London in 1965.

Right: Winston Churchill. Study of boats, South of France

Mid-1930s. Oil on canvas. 20 x 24 inches. Coombs 298. Collection: The National Trust, Chartwell. Copyright © Churchill Heritage

Opposite: Winston Churchill. The goldfish pool at Chartwell

1930s. Oil on canvas. 25 x 30 inches. Coombs 344. Collection: The Lady Soames, DBE. Copyright © Churchill Heritage

DANIEL CLOWES

*D*aniel Clowes's social satires, melancholic book-length cartoons about the lives of outsiders, are considered by many critics the best of contemporary graphic novels and remarkable for, in the words of *The New Yorker*'s Tad Friend, a "gem cutter's touch with language."

Clowes studied art at Brooklyn's Pratt Institute. The winner of numerous Harvey Awards, his first and bestselling comic book series, *Eightball,* was launched in 1989. *Eightball* is an ongoing presentation of both short and long, serialized narratives of which *Ghost World* (1998) and *David Boring* (2000) have been released as stand-alone novels. Believing that art arises from the unconscious, Clowes takes inspiration from dreams and utilizes techniques of the early Surrealists. "Stories," he says, "come from whatever your psychological state is at the time of writing."

Ideas are recorded in a notebook as they come to him. The "magical process" that turns them into art and text happens later:

> I cross out all the really stupid ones that seemed brilliant at four in the morning three months ago and now don't make any sense. Then I take all the decent ones and I try and see if there's any thematic unity to all of them. I tend to write two or three stories at once, and then often I'll realize that two of them are very similar and I can put them together and combine them into something. There's generally some kind of magical process by which they all come together at some point. . . . Then I sit

down and draw it page by page and do the writing as I go along. I usually write about two pages in advance—actual dialogue and things like that. I try to keep it relatively spontaneous, without too much advance thought.

Clowes was born in Chicago in 1961. His parents divorced when he was a year old. His mother then married a stock-car racer who was killed. Clowes was shuttled, sometimes on alternate nights, among the homes of his mother, father, and grandparents. Growing up on the South Side, his "frame of reference was decaying old buildings and water towers," and he says, "It just all seeped into my subconscious." A "shy, loner, bookworm kind of kid," Clowes, himself an outsider, learned to rely on his artistic sensibilities whenever he felt socially intimidated:

> If I felt anxious or threatened by someone, I'd look at the person and figure out the caricature that would most devastate them. . . . Later on, as an adult, I could tell from someone's affect what their emotional problem was, what made them insecure.

Today, Clowes sees his characters arising out of "a kind of marriage between the cartoonist and the reader," and his audience "as this cold, disapproving outside entity."

Ghost World became a 2001 movie directed by Terry Zwigoff, for which Clowes wrote the screenplay. In 2006, Zwigoff directed *Art School Confidential,* another Clowes screenplay, adapted from his comic story of the same name.

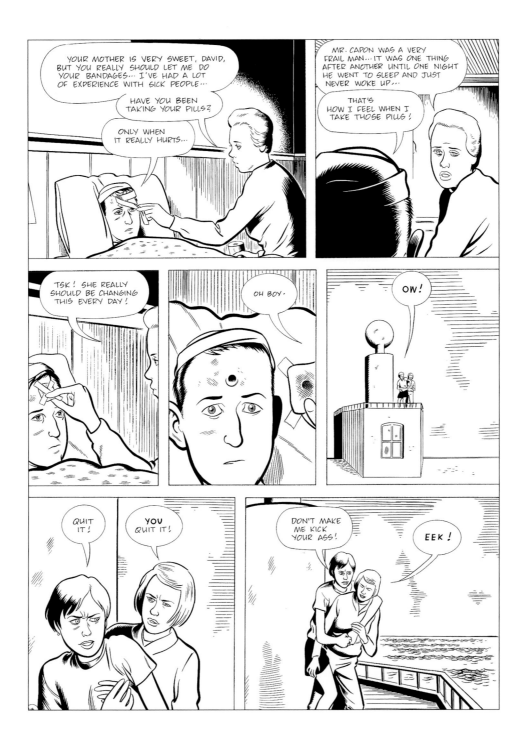

Daniel Clowes. From *David Boring* (2000)

Line art. Collection of the artist

JEAN COCTEAU

A visual artist as well as a writer throughout his life, Jean Cocteau was accused by André Gide of jumping from branch to branch like a squirrel. "Well, I have," he answered, "but always in the same tree." For Cocteau, all was poetry. Drawing, he said, was only "a different way of typing up the lines." A single method of creation was common to all of his endeavors: "All works, poems or canvases, must be created by a method of semi-sleep, that is to say, born of the nights of the conscious and unconscious."

Cocteau illustrated a number of his works, painted frescoes in the Chapel of Saint-Pierre in Villefranche-sur-Mer, the Church of Saint-Blaise-des-Simple in Milly-la-Foret, and in the City Hall of Menton, yet he insisted: "I am neither a draftsman nor a painter. My drawings are a kind of writing loosened and relooped." He described his creative process in somewhat mystical terms:

> I am able to paint because I have discovered that, in the act of painting, we bring ourselves to the point of being anesthetized, we are rendered insensible before that which is no longer the painting. Little by little, the painting pumps up our strengths that are so necessary and which we abandoned. We look at it. It looks at us. It judges us with indifference. It puts us out to sea. It does not rest until we take up another painting.

> Since I am not a painter and have no right to paint, other than considering myself free to use any expressive medium, I have had to confront certain problems and to solve them in my own fashion. Consequently, these canvases are balanced between drawing and painting, between abstract and representational forms. Above all my investigations have been concerned with light, the light proper to the picture, to the characters and places I conceive, with no other source than the imagination.

A poet, playwright, novelist, filmmaker, essayist, artist, and sculptor, Cocteau demanded that his only title be "poet"—that his works should be described as poésie de théâtre, poésie cinematographique, poésie critique, poésie graphique, and poésie plastique. Among his notable achievements are the poem "L'Ange Heurtebise" (1925), the novel *Les Enfants terribles* (1929), the play *La Machine infernale* (1934), and the films he wrote and directed *La Belle et la bête* (1946) and *Orphée* (1950).

Jean Maurice Eugène Clément Cocteau was born into a cultured family of wealth and privilege in Maisons-Laffitte, near Paris, in 1889, and died in Milly-la-Foret, also near Paris, in 1963. When Cocteau was nine, his father killed himself with a gun while at home in his bedroom. In 1909, when he was nineteen, Cocteau published his first book of poems *La Lampe d'Aladin*. That same year he told Sergey Diaghilev, the director of the Ballet Russes that he was interested in creating ballets and Diaghilev famously responded, "Etonne-moi." ("Astonish me.")

Cocteau went on to create a number of ballets for the Ballet Russes, including *Parade* (1917), a famous collaboration with Diaghilev, Massine, Picasso, and Satie; to write and illustrate with the free associative style of Surrealism his novel *Le Potomak* (1919); and to astonish sufficiently to be a leader of the avant-garde by 1920. He broke away from the movement, however, choosing to emphasize clarity and simplicity of expression.

The change of direction was inspired by Cocteau's sixteen-year-old lover, the poet and novelist Raymond Radiguet, and by a rivalry with **André Breton**, who hated Cocteau. Radiguet died at age twenty-one in 1923, and Cocteau's grief led him to opium addiction, sanitarium cures, and a temporary re-embrace of Catholicism.

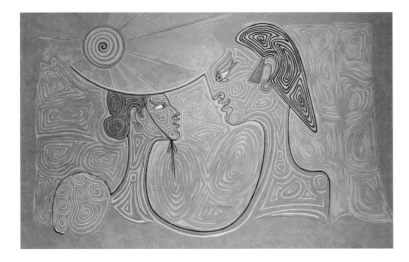

Top: Jean Cocteau. Couple

Hotel de Ville, Menton, France. Giraudon/Art Resource, New York. Copyright © 2007 Artist Rights Society (ARS) New York/ADAGP, Paris

Bottom: Jean Cocteau. Carpet with Appliqués

1958. 81–5/8 x 51–1/2 inches. Private Collection. Visual Arts Library/Art Resource, New York. Copyright © 2007 Artist Rights Society (ARS), New York/ADAGP, Paris

Above: Jean Cocteau. Souvenir de Montargis

1938. From the Artinian Collection, by courtesy of Artine Artinian. Copyright © 2007 Artist Rights Society (ARS), New York/ADAGP, Paris

WILKIE COLLINS

Wilkie Collins was the son of William Collins, a successful Royal Academy landscape painter, and godson of another Royal Academy painter, Sir David Wilkie. Immersed in the arts as a child, Collins decided at seventeen to work in the tea trade, although he continued to accompany his father on painting trips and began to write. He quit business after five years and began to read law at Lincoln's Inn. Even as a law student, however, Collins continued to paint and write—first a historical novel and then a two-volume biography of his recently deceased father. In 1848, the year the biography was published, Collins had one of his paintings exhibited at the Royal Academy—although Collins later suggested it was unworthy and was perhaps hung out of respect for his late father.

Collins gave up serious painting by 1849 when he described himself as "only painting at leisure moments, in humble amateur-fashion for my own amusement." He held on to the landscape that had appeared in the Royal Academy exhibit—displayed far above eye level—and would explain to visitors who saw it:

> Ah, you might well admire that masterpiece; it was done by that great painter Wilkie Collins, and it put him so completely at the head of landscape painters that he determined to retire from the profession in compassion for the rest. The Royal Academy were so affected by its supreme excellence and its capacity to teach, that they carefully avoided putting it where taller people in front might obscure the view, but instead placed it high up, that all the world could without difficulty survey it.

Collins was a hugely popular, much imitated novelist of Victorian England, whose income in 1862–63 exceeded that of any other writer of the nineteenth century. He wrote crime fiction of a literary quality that places it among the finest of the genre. Among his notable works are *The Woman in White* (1860) and *The Moonstone* (1868).

William Wilkie Collins was born in London on January 8, 1824. He was oddly shaped as a child, extremely nearsighted, and short. His full height would only reach five-feet, six inches. At fourteen he was sent to a boarding school where he was an uninterested student and the victim of bullying. Collins claimed he started making up stories as a way of appeasing his persecutor: "It was this brute who first awakened in me, his poor little victim, a power of which but for him I might never have been aware."

Collins passed the bar in 1851 but decided not to practice. That year he and Charles Dickens came together out of a common love for the theater, became close friends, and performed in theatricals together. They also co-wrote plays, including *The Frozen Deep* in which they both appeared. Dickens mentored and edited Collins, who contributed short stories to Dickens's magazine *All the Year Round* during the 1860s; his novels were first serialized there.

As each installment of *The Woman in White* was scheduled to appear, crowds waited eagerly outside the offices of the magazine, and its circulation exceeded that of Dickens's *Tale of Two Cities.* "Woman in White" clothes and toiletries were marketed.

Collins's financial success was propitious: he supported two women and the three illegitimate children they had borne him. Addicted to laudanum, which he took to relieve chronic pain from gout, he suffered paranoid delusions brought on by the opiate. Injured in a collision of two cabs in London, he died there in 1889. Robert Lee Wolff published sketches by Collins in 1965, in *Contemporary Collectors 42.*

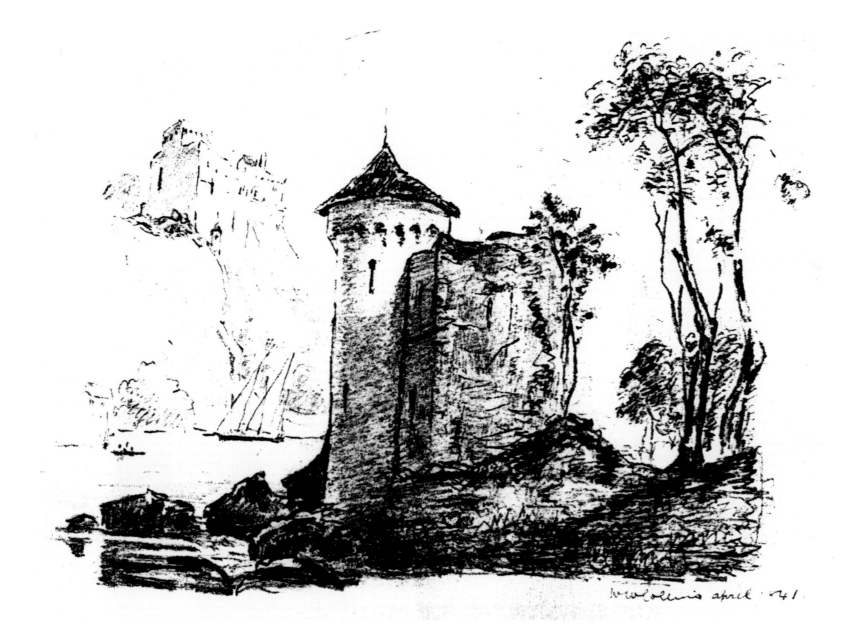

Wilkie Collins. Untitled (landscape drawing)

1841. From Catherine Peters, *The King of Inventors* (Martin Secker & Warburg Ltd, 1991)

JOSEPH CONRAD

Joseph Conrad drew, almost exclusively, pictures of women that were generally erotic in style and setting. He destroyed a number of his drawings, but his wife, Jessie, made a point of preserving those she could find and offering them for sale after he died.

The drawings were deconstructed by Bernard C. Meyer in *Joseph Conrad: A Psychoanalytic Biography* (1967). Meyer, a psychiatrist, sees in them "clear evidence of a fascination with women's legs, thighs, and nether garments, and of an interest in peeping and exhibitionism." He also detects manifestations "of the artist's fetishism [in] the streaming mass of black hair ending in a serpentine fringe." The use of bird and snake imagery in the drawings is seen as phallic expression, as "tokens of reassurance against the danger of castration that Conrad evidently shared with the fetishist."

Whether or not Meyer is right, the content of the drawings seemed to have troubled his widow. She penned explanations under each image before she sold them. Under the can-can dancers, for example, she wrote: "This little sketch was done by Joseph Conrad in his rooms in Willow Road Victoria in 1896. To show me how the girls for the ballet were engaged."

Conrad, master craftsman of the English novel and short story, only learned English later in life and after Polish, German, and French. He wrote complex and pessimistic stories of men engaged in primal struggles of morality, set at sea and in exotic places. Of these he is best remembered for *Heart of Darkness* (1899), *Lord Jim* (1900), and *Nostromo* (1904).

Conrad was born Jozef Teodor Konrad Korzeniowski in 1857 in Berdyczow, Poland (now Berdychiv, Ukraine), part of the Russian Empire. Conrad's father was a poet and leader of the Polish insurrection against Russia. He was arrested and sent into exile in northern Russia when Conrad was four. The boy and his mother followed him. She died of tuberculosis when Conrad was seven. His father died four years later. A maternal uncle who supported him financially well into adulthood assumed care of the orphaned child. At sixteen, Conrad left for Marseilles, where he

apprenticed himself on sailing ships, traveling to the West Indies and, it appears, gunrunning to right-wing conspirators in Spain. Deep in debt, and having lost his uncle's money gambling, Conrad shot himself in the chest in a failed suicide attempt.

In 1878, recovered and financially aided by his uncle, Conrad signed on a British freighter for Constantinople. For the next sixteen years he served in the British merchant marine. He received a master mariner's certificate in 1886, but got to command a vessel only when the ship's company was overcome with malaria and its captain died at sea.

Conrad started to write in 1889 and decided to adventure to Africa. The traumatic experiences of the four months he spent as a steamboat captain in the imperialistically exploited Congo Free State ultimately yielded his greatest work, the exploration of human corruption that is *Heart of Darkness*.

At thirty-seven, Conrad decided to give up his sea life and remake himself into a novelist, as a way of assuring himself a steady income and more settled existence. Nearly forty when he married quiet, twenty-two-year-old Jessie George, he struggled to support her and their two sons for years. Before finally achieving commercial success, he was burdened with debt and physical and psychological illnesses. He died in Canterbury, Kent, England, in 1924.

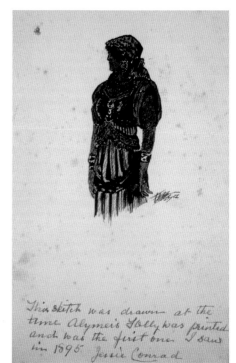

This sketch was drawn at the time Almayer's Folly was printed and was the first one I saw in 1895. Jessie Conrad

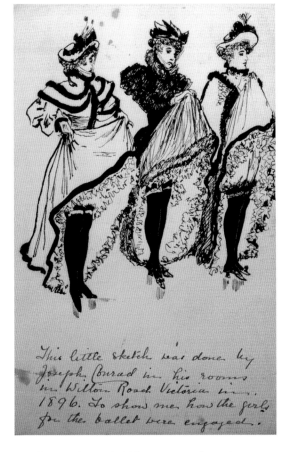

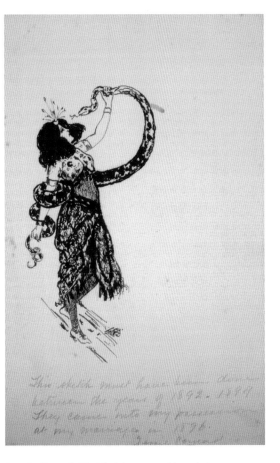

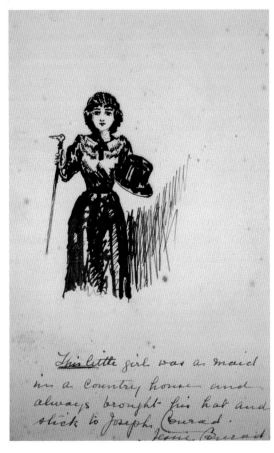

Joseph Conrad. Untitled (three can-can dancers)

"This little sketch was done by Joseph Conrad in his rooms in Willow Road Victoria in 1896. To show me how the girls for the ballet were engaged." Notation by Jessie Conrad. Berg Collection of English and American Literature, The New York Public Library, Astor, Lenox and Tilden Foundations

Joseph Conrad. Untitled (woman with snake)

"This sketch must have been done between the years of 1892–1894. They came into my possession at my marriage in 1896." Notation by Jessie Conrad. Berg Collection of English and American Literature, The New York Public Library, Astor, Lenox and Tilden Foundations

Joseph Conrad. Untitled (servant girl)

"This little girl was a maid in a country house and always brought his hat and stick to Joseph Conrad." Notation by Jessie Conrad. Berg Collection of English and American Literature, The New York Public Library, Astor, Lenox and Tilden Foundations

Opposite: Joseph Conrad. Untitled (woman)

"This sketch was drawn at the time Alymer's Folly was printed and was the first one I saw in 1895." Notation by Jessie Conrad. Berg Collection of English and American Literature, The New York Public Library, Astor, Lenox and Tilden Foundations

CATHERINE COOKSON

D ame Catherine Cookson unexpectedly discovered her talent for drawing during a visit to St. Albans Abbey in Hertfordshire, England: "I remember standing open-mouthed, while the poetry of stone and brick was revealed to me for the first time."

She bought materials, spent days making sketches of both the exterior and interior of the building. After continuing to hone her skills without any formal training, she took a drawing of a cathedral to a printer who published it on postcards, which were successfully marketed in the town's stores. Her work was exhibited locally. She then illustrated for magazines, copying small photographs into scaled up drawings. Cookson studied textbooks on art, sought out an elderly painter who allowed her to observe him, and then, under his guidance, drew and painted in oil.

Cookson was born Catherine McMullen in 1906 in Tyne Dock, South Shields, England, the illegitimate daughter of an alcoholic mother, Catherine Fawcett, and a father she never knew. Sexually molested at seven, the girl spent much of her childhood running to the pawnshop and the pub for her mother. She dropped out of school at thirteen to work in a laundry. In 1943 she married Tom Cookson, a teacher and one of the boarders in a rooming house she had opened with earnings from the laundry. Catherine suffered three miscarriages, a stillborn birth, and a period of voluntary institutionalization at a psychiatric hospital. Her husband encouraged her to write her way out of a deep depression.

She followed her first book, *Kate Hannigan* (1950), with two books a year thereafter. Under her own name and as Catherine Marchant, Cookson was the bestselling author of almost one hundred volumes of romance, autobiography and autobiographical fiction, historical novels, family sagas, juvenile novels, children's books, essays, and poetry. Over one hundred million copies of her books have been sold in more than thirty countries. The year before she died she had written nine of the ten most circulated books in English libraries.

Her childhood—and how she overcame it—is chronicled in her autobiography, *Our Kate* (1969). She received an O.B.E. in 1985 and a D.B.E. in 1993. After a long hiatus from her art, she began to paint again later in life as a way of relaxing, she said, "when my mind is going dizzy" from writing. "If I hadn't made it as a writer," she boasted, "I'd have made it as an artist."

In *Let Me Make Myself Plain* (1988) she included a selection of her paintings along with her essays and poems. When she died in 1998 in Jesmond Dene, England, Catherine Cookson was the seventeenth-richest woman in Britain. Since her death, there has been a strong market for her artworks at auction.

The South Transept

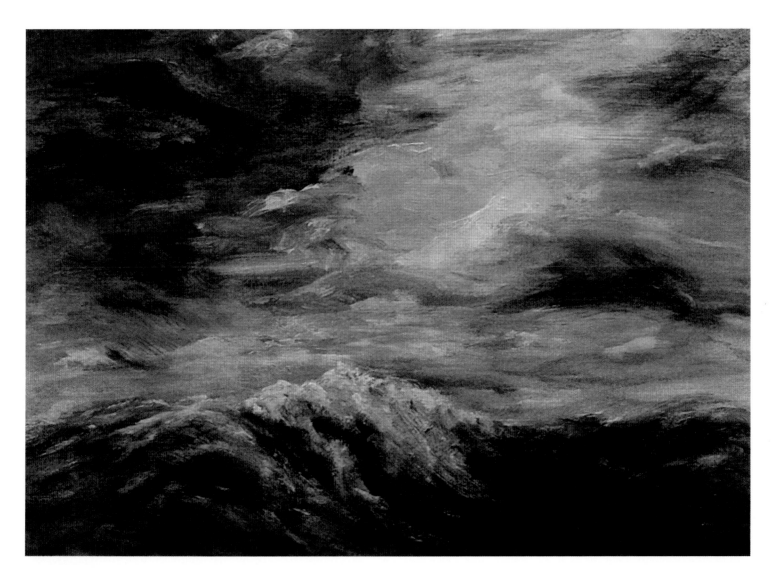

Above: Catherine Cookson. Untitled (seascape)

Oil on canvas. From *Let Me Make Myself Plain* (London: Guild Publishing, 1988). Appears over the caption "Here would I lie / For ever even / If the sun remained still. . . ." Courtesy of the Catherine Cookson Charitable Trust

Opposite: Catherine Cookson. The South Transept

Drawing. From *Let Me Make Myself Plain* (London: Guild Publishing, 1988). Courtesy of the Catherine Cookson Charitable Trust

GREGORY CORSO

*L*et me lightdrench the saddest of men."

Gregory Corso's friend and publisher **Lawrence Ferlinghetti** once called him "the last great voice of the original Beat rebellion" and "the true American primitive, made of mouthfuls of mad language, his poetry cast on the world like a roll of loaded dice."

Like many of his fellow Beats, Corso drew and painted. Like them, he saw art and life as inseparable. The Beats made art anywhere—brought jazz, art, poetry, plays, film, photography, and dance into common venues, collaborating with one another and freely crossing over into each other's fields. Corso made his first artistic efforts, as much a form of therapy as art, during a prison stint in his late teens. Living and traveling in Europe in the early 1960s, he worked in oil-based crayons and also made collages, sometimes collaboratively with Takis, a prominent Greek sculptor and artist he met in Paris.

Corso, who embellished his poems with decorative drawings, did many portraits and self-portraits, including the self-portrait in line opposite. He emphasized the importance of faces to him in "Dialogues from Children's Observation Ward":

> —You don't paint nice. You paint faces on
> window shades
> and you don't make them look nice—
> Window shades is all I got,
> and faces is all I got—

Corso's drawings were shown in the 1995–1996 exhibition "Beat Culture and the New America 1950–1965" at the Whitney Museum of American Art, New York, at the Walker Art Center in Minneapolis, and at the M. H. de Young Memorial Museum, San Francisco. His drawings and paintings are held in private collections as well as at the Columbia University Rare Book and Manuscript Library.

Artist and scholar Ed Adler praised "the deadly, head-on earnestness of Corso's work," adding, "it is evident on first happening upon a Corso painting: there is joy and there is a solid take on reality." Adler also described Corso's work in color:

> Brilliant, and owing maybe a bit to Matisse and Dufy, Gregory takes it his own way and into his own ever-Beat territory. . . . In the nineties, he was using pastels, studying the work of Redon, with an eye on Paris where this kind of romantic visionary art finds space readily in the small galleries of the Left Bank.

Gregory Nunzio Corso was born in 1930 in New York and died in 2001 in Robbinsdale, Minnesota. Abandoned by his sixteen-year-old mother, who returned to Italy before he was a year old, Corso spent most of his childhood in orphanages and foster homes. As an early adolescent he was held for five months in the Tombs—the worst of New York City's jails—and, after being abused there by the inmates, was placed in the observation ward of Bellevue Hospital for three months. At thirteen Corso was living on the streets: "I slept on the rooftops and in the subways of the city." At seventeen, convicted of robbery, he was sent to Clinton State Prison in upstate New York for three years, and with only six years of formal schooling behind him, began to read classical literature, to write poetry, and to draw.

In 1950, shortly after Corso's release from prison, **Allen Ginsberg** met him in a Greenwich Village bar and, learning he was a poet, began to teach him. Later, Ginsberg introduced him to **William Burroughs**, **Jack Kerouac**, and other Beat writers and artists. After working as a laborer, cub reporter, and merchant seaman, among other jobs, Corso became an unofficial student at Harvard, where he had a play produced by the Harvard Dramatic Workshop and where the students paid for the publication of the first of his nineteen books of poetry, *The Vestal Lady on Brattle and Other Poems* (1955).

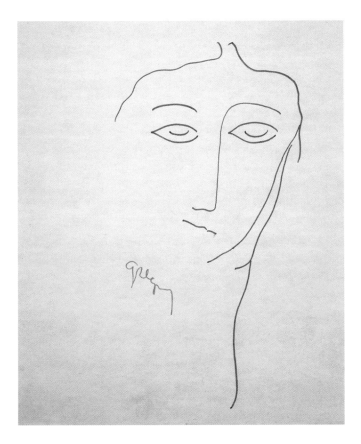

Above: Gregory Corso. Self-portrait

Ink on paper. 11 x 8–1/2 inches. Gregory Corso Papers, Rare Book and Manuscript Library,
Columbia University. With kind permission of the estate of Gregory Corso

Right, top: Gregory Corso. Untitled (landscape)

1972. Watercolor on paper, 9–3/4 x 13 inches. Gregory Corso Papers, Rare Book and
Manuscript Library, Columbia University. With kind permission of the estate of Gregory
Corso

Right, bottom: Gregory Corso. Untitled (cityscape)

Oil on wood. Gregory Corso Papers, Rare Book and Manuscript Library, Columbia
University. With kind permission of the estate of Gregory Corso

DOUGLAS COUPLAND

*D*ouglas Coupland, who became the voice of Generation X—a term he coined—upon publication of his first novel, *Generation X: Tales for an Accelerated Culture* (1991), writes plays, essays, and short stories and is an artist, sculptor, and industrial designer. He attended the Emily Carr College of Art and Design, Vancouver, the Hokkaido College of Art and Design in Sapporo, Japan, and the Instituto Europeo di Design, Milan. Coupland has twice been honored with the Canadian Award for Good Design. His shows include solo exhibits of sculpture at the Totem Gallery, New York, and the Monte Clark Gallery, Vancouver. His work has been part of group exhibitions at the Vancouver Art Gallery and Monte Clark.

In a 2002 letter to me, he wrote:

> I entered writing via Jenny Holzer. Some friends went on "the pilgrimage" to New York in 1983 and brought back sheets of her truisms, which had been wheat-pasted onto construction site walls. So to me, words have always been art supplies more than words.

Although Coupland insists that writing and art have a social purpose, a way "of taking something intensely personal and rendering it universal," he considers the literary and plastic arts as "opposites"—with writing "lost in the past":

> Ask writers in 2002 who they like and they'll feel bound to say Henry James or Proust. Can you imagine? The big deal in writing is "rendering," which is fine, but that's all it seems to be about most of the time. It's like paintings of wolves and eagles. No one's disputing that it might be good rendering, but it says nothing about our culture and has no transformative capacity. It seems disengaged from the process of trying to inhabit its own era. . . .
>
> Visual art derived from critical practise is the opposite of this. It's always trying to find new boundaries and new forms through experimentation.

Coupland says he's glad to be doing both, that "the two acts enhance each other," the visual work utilizing "a different part of the soul." Besides, he adds, "the most you can ever sit down and write is two hours. What are you going to do with the remaining 22?"

Coupland was born in 1961 on a Canadian military base in Baden-Soellingen, Germany. After a few years his surgeon-father "went civilian," and the family moved to a suburb in Vancouver, where "if we walked 100 feet and cut through the chain-link fence there was nothing between us and the North Pole or, equally, nothing between us and prehistory."

> There's a saying for men that what they do in life they get from their mothers; the way they go about doing it they get from their fathers. This is pretty much the case with me. My mother had a degree in comparative theology and lived pretty much in her mind. My father and I have no meeting point save that we can always ask each other what we're doing and have lots to say then.

Besides *Generation X*, Coupland has published ten novels which have been translated into twenty-two languages. Among his works are *jPod* (2006), *Eleanor Rigby* (2004), *Shampoo Planet* (1992), *Microserfs* (1995), *Girlfriend in a Coma* (1998), *Miss Wyoming* (2000), and short fiction in *Life after God* (1994) and essays in *Polaroids from the Dead* (1996).

Douglas Coupland. Spike

2001. Fiberglass. Human forms approximately 7 feet, 6 inches. Bottle forms 48 inches. Collection of the artist

HART CRANE

hen Hart Crane sent a collage as a thank-you for a favorable review in *Poetry*, he confessed that he had been "drawing and puppet-ing" since age five. Crane was very interested in the visual arts, and in aesthetic theory, but had not disclosed his own artistic efforts even to his many artist friends. One such friend, Peter Blume, surmised that Crane was perhaps "embarrassed about revealing a secret vice of that sort to a professional painter."

Eventually Crane's work did become public, and Blume reported being surprised to discover a Hart Crane oil painting in a New York gallery in the late 1960s, a work now in the Rare Book and Manuscript Library of Columbia University and reproduced opposite. A number of portraits and caricatures Crane drew of his contemporaries appeared in such magazines as *The Little Review, The Dial,* and *S4N,* and he was praised for his graphic talents. His sketch of editor Susan Jenkins Brown—who later published *Robber Rocks* (1969), a book of her letters from and memories of Crane—is reproduced here.

Crane is best remembered for his epic *The Bridge,* a landmark of twentieth-century poetry. Harold Hart Crane was born in 1899 in Garrettsville, Ohio, the only child of two miserably unhappy parents. His father was a wealthy candy manufacturer who couldn't relate to his sensitive, homosexual son. His mother—a study in psychopathology who had gone into a sanitarium after a nervous breakdown when Crane was four, and spent much of her time bedridden with "nerves"—smothered her son and, even in his adulthood, demanded of him daily letters and expressions of love.

At seventeen, when his parents finally separated, Crane, who had spent his childhood immersed in the arts and in an autodidactic literary education, went to New York to make his name as a poet. There, he worked for the *Little Review,* which promoted European modernists, and associated with writers and promoters of the American school. Crane's poetry came to incorporate both traditions.

After a difficult period during which his mother and maternal grandmother moved into his one-bedroom apartment, and his father threatened to cut off his allowance, Crane spent the next years shuttling between New York and Cleveland, employed in a variety of jobs in which he had no interest, and publishing his poems in small magazines. His first book, *White Buildings,* appeared in 1926. *The Bridge* took Crane seven years to write. He had conceived it in monumental terms, acknowledging, *"At worst, the poem will be a huge failure!"*

Published in 1930, *The Bridge* received frequently hostile critical notices. Crane's father died that year, Crane had broken off relations with his mother two years earlier, and he had spent much of his time in drunkenness and sexual debauchery, frequently with sailors he picked up.

The next year Crane was awarded a Guggenheim Fellowship to study European culture, but went off instead to Mexico, where he produced his last poem, "The Broken Tower." In 1932, sailing back to New York with his only heterosexual love, after a night of partying, he leapt to his death from the back of the ship.

Above: Hart Crane. Pencil sketch of Susan Jenkins Brown

1923. 5–1/2 x 5–1/8 inches. Hart Crane Papers, Rare Book and Manuscript Library, Columbia University. By kind permission of the estate of Hart Crane

Right: Hart Crane. Untitled (landscape)

Oil on canvas. 9–1/2 x 5 inches. Hart Crane Papers, Rare Book and Manuscript Library, Columbia University. By kind permission of the estate of Hart Crane

E. E. CUMMINGS

E. Cummings' father, a Harvard professor and an ordained minister of the Congregational Church, was also an amateur artist and his son's first art teacher. From early youth, Cummings was immersed in his art. **John dos Passos** described his friend's art habits and the importance of the visual in their lives:

Cummings never tired of drawing sea lions. As he walked he would be noting down groups of words or little scribbly sketches on bits of paper. Both of us lived as much for the sights we saw as for the sound of words.

Cummings sketched the scenes around him—dancers and circus animals, landscapes, friends or strangers on the street. He studied art in Paris, spent time with Picasso, but was influenced by **Cocteau** and wrote about his drawings. In the early 1920s, Cummings' work reflected the Vorticism movement. His first major show of paintings was in 1931 at the Painters and Sculptors Gallery, New York. That same year he published a collection of ninety-nine of his drawings and paintings, titled CIOPW—an acronym for C(harcoal), I(nk),O(il), P(encil), and W(atercolors). Cummings never worried about reconciling the painter and the poet within himself. In a mock self-interview he asked, "Why do you paint?" and answered:

For exactly the same reason I breathe. / That's not an answer. / There isn't any answer. / How long hasn't there been any answer? / As long as I can remember. / I mean poetry. / So do I. / Tell me, doesn't your painting interfere with your writing? / Quite the contrary: they love each other dearly. / They're very different. / Very: one is painting and one is writing. / But your poems are rather hard to understand, / whereas your paintings are so easy. / Easy? / Of course—you paint flowers and girls and sunsets;

things that everybody understands. / I never met him. / Who? / Everybody.

In a more serious tone he wrote:

Let us not forget that every authentic "work of art" is in and of itself alive and that however "the arts" may differ among themselves, their common function is the expression of that supreme alive-ness which is known as "beauty."

Edward Estlin Cummings was born in 1894 in Cambridge, Massachusetts. He attended Harvard, where his majors were English and classics and where he and his friends founded the Harvard Poetry Society. Cummings was a novelist, playwright, essayist, and artist. But, first and foremost, he was the poet who dropped punctuation but kept the sonnet; who railed bitterly and sarcastically against the impersonal, institutional, and governmental but was exuberant about sex and lyrical about love and living an engaged life.

In 1917 Cummings went to France to serve in the ambulance corps. After a few months he and a friend were arrested for supposed pro-German sympathies and held in an internment camp. His notes while imprisoned became the basis of his novel *The Enormous Room* (1922).

Cummings published *Tulips and Chimneys,* his first collection of poems, in 1923, *Collected Poems* in 1938, and *Poems 1923–1954* in 1954. Before his death in Silver Lake, New Hampshire, in 1962, Cummings garnered, among other literary honors, the Shelley Memorial Award (1945), the Academy of American Poets Fellowship (1950), the National Book Award for *Poems 1923–1954,* and the Bollingen Prize in 1958.

Above: E. E.
Cummings.
Strip Joint

Oil on canvas. 10 x 8–3/8
inches. Courtesy of Gotham
Book Mart, Inc., New York
City. Copyright © by the
trustees of the
E. E. Cummings Trust. Photo
by Jason Brownrigg

Right: E. E.
Cummings.
Bois de Bologne

C. 1920s. Pencil. 10 x 8–3/8
inches. Private collection,
New York City. Copyright ©
by the trustees of the E. E.
Cummings Trust. Photo by
Jason Brownrigg

Above: E. E. Cummings. Portrait of Marian Moorehouse Cummings

1940. Oil on wood. 10 x 14 inches. Private collection, Pennsylvania. Copyright © by the trustees of the E. E.
Cummings Trust. Photo by Don Simon

HENRY DARGER

Henry Darger, the current poster child of "outsider art," lived for forty years in a single room without a kitchen or bathroom. A pathway through floor-to-ceiling detritus, much of it picked out of neighborhood garbage, led from the door to the desk where he wrote and slept. Also in the room, found and preserved by his photographer landlord after Darger's death, were hundreds of paintings—some on double-sided scrolls four feet high and ten feet long—illustrations for his novels. Employing images copied from or cut out of magazines and children's books, his paintings presented scenes of great violence, torture, and naked girls with boy's genitals.

Although created in secret, for himself, the discovery of Darger's art led to numerous museum and gallery exhibits worldwide, as well as permanent collection in the American Folk Art Museum, New York, and the Art Brut Museum, Lausanne. He was the subject of a 2004 documentary by Jessica Yu, *In the Realms of the Unreal.* His paintings are sold for upwards of $100,000.

An effort to construct a world that gave meaning and purpose to his life, Darger's art was not intended for the museum audiences that flock to see it—and certainly not for critics' analyses. Nonetheless, the art world has taken him up and praised his work as much more than private obsession. *Time*'s Robert Hughes has written of Darger's "genuine talent . . . particularly in his power of formal arrangement and his sense of color," and sees his representations of the maimed and tortured as less psychopathology than a part of the Catholic iconography in which Darger "was marinated" throughout his life, adding:

> At their best, his friezes of androgynous Shirley Temploids hold
> the long scroll format beautifully, with a fine sense of interval and
> grouping. With the big, delicate flowers and butterflies alternating
> with weird, cavernous landscapes, searchlight rays and puffs of rifle
> smoke, they are like a skewed version of **Kate Greenaway**'s
> Victorian illustration. The pale booming color is rarely less than
> inventive, and it can break out into a startling decorative richness.

Darger authored several still-unpublished tomes, including the longest novel ever written in English, the 15,000 single-spaced pages that are "The Story of the Vivian Girls, in What is Known as the Realms of the Unreal of the Glandico-Angelinian Wars as Caused by the Child Slave Rebellion," and an 8,500-page sequel, "Further Adventures in Chicago." The novels recount the stories of wars on another planet, between a good Christian nation of Abbiennia and the evil Glandolinians, who enslave children.

Born in Chicago in 1892, Darger died in a pauper's nursing home there in 1973. After his mother died giving birth to his sister, the baby girl was placed for adoption. Darger, then four, spent several more years with his father until the boy was sent to a Catholic mission, where he was thrown out for masturbating and put in the Asylum for Feeble-Minded Children in Lincoln, Illinois. He ran away at sixteen and spent the rest of his life working as a janitor, dishwasher, or bandage roller. Alone in his packed room, he was often overheard engaged in conversations, assuming the voices of different speakers, male and female. He attended Mass daily, sometimes five times a day. Display of his art is claimed to have saved Darger from obscurity; but, given that he was an outsider by nature and design, he may have been more intruded upon than rescued.

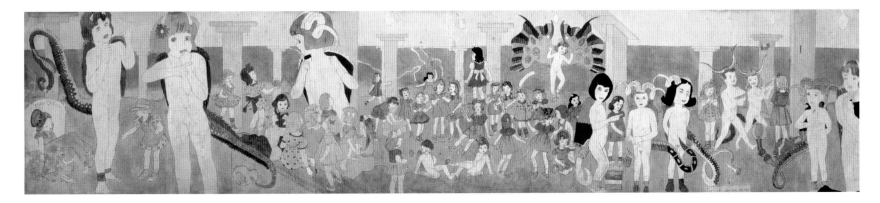

Above: Henry Darger. At Jennie Richee. Hard pressed and harassed by the storm

Watercolor, pencil, and carbon tracing on pieced paper. 24 x 107-3/4 inches. Collection of the American Folk Art Museum, New York. Museum purchase and gift. Copyright © Kiyoko Lerner. Photo by James Prinz

Right: Henry Darger. Detail from At Jennie Richee. Hard pressed and harassed by the storm

Opposite: The complete writings of Henry Darger

Collection of the American Folk Art Museum, New York. Museum purchase and gift. Copyright © Kiyoko Lerner. Photo by Gavin Ashworth

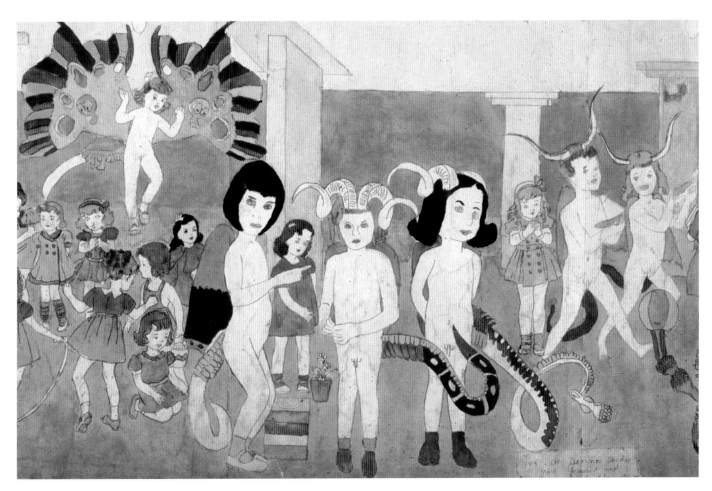

GUY DAVENPORT

*A*n internationally esteemed man of letters, Guy Davenport illustrated a number of his stories and the covers of several of his books. In 1996 his paintings and drawings were collected in Erik Anderson Reece's *A Balance of Quinces* and in the privately printed *50 Drawings*. In his introduction to *50 Drawings*, Davenport mused on his twin passions:

> Writing and drawing, distinct as they are, must converge in their root-system in the brain. By the time they are being done they retain their origin. They are both making, the creation of something out of nothing. Writing is done with words (bringing all the senses, together with memory, into play), dictionaries, notebooks, pencils, a typewriter. The ground is silence, or what silence there is in this world.
>
> Drawing, or painting, requires hours of continuous work. A square inch an hour if I'm cross-hatching or stippling. But it is a strangely free work. I can have a conversation while painting, can listen to music or the radio while drawing. I am incapable of sitting still and listening; over the years I have watercolored a Kelmscott Chaucer, a Parkinson's garden of pleasant flowers, and many another book, while hearing the five-o'clock news.
>
> Writing must be done in small amounts. I draft passages in notebooks, revise them, and make the final drafts on the typewriter. My speed is about a paragraph a day.
>
> Drawing, or painting, however, is a continuous activity. It goes on for hours and hours. I am reluctant to complete any picture. Writing I am anxious to finish, impatient; it is not my medium, and I doubt it at every turn. Drawing, however, is comfortable; I know what I'm doing. I am also more protective of it, and sensitive to its neglect. I am almost enured to my graphic work's eliciting no response whatsoever. I tell myself that seeing has become what the psychologists call flat affect in our time. . . .
>
> I believe in absolute values, and am not deluded about my drawing. Meister Baldung would have admitted me to his studio but would not have signed a certificate for my membership in the guild. As the splendid poet Guy Clark sings in "Picasso's Mandolin,"
>
>> In coloring books and drinking wine,
>> It's hard to stay inside the line.
>
> Well, I can stay inside the line. Hokusai and Tao Chi would consider me a barbarian. But as someone said, it's not the text but the texture of experience that counts. I cannot see my work any more than I can read my writing; what I see in either is the sweet time spent making them, the transforming, line by line, of blank paper into an image.

Davenport was born in 1927 in Anderson, South Carolina. He quit high school to study art at Duke University, where he received a B.A. in English in 1948, and pursued further studies at Merton College, Oxford (Rhodes Scholar 1948–50, B.Litt. 1950), and Harvard (Ph.D. 1961). The multifaceted Davenport made his mark as the author of eight collections of short stories, two collections of poetry, eleven highly acclaimed collections of essays and criticism, seven volumes of translations of Heracleitus, Diogenes, Sappho, and other Greek lyric poets. A MacArthur Fellow, he received the Morton Dauwen Zabel Award from the American Academy and Institute of Arts and Letters, and translation awards from PEN and the Academy of American Poets. A legendary teacher at the University of Kentucky in Lexington for almost thirty years, Davenport died there in 2005.

Right: Guy
Davenport. Portrait
of Ezra Pound
(Rapallo, 1963)

1970. Acrylic. 24 x 31 inches.
Collection of the artist

Opposite: Guy
Davenport. Mr. W.
B. Yeats's Aspiration
toward Mechanical
Birdhood Collides
with the Present State
of Vaucanson's Duck

Pen and ink. Illustration for
Hugh Kenner's *The
Counterfeiters* (1968).
Collection of Hugh Kenner
and courtesy of the artist

FERNANDO DEL PASO

Fernando del Paso is an internationally exhibited painter as well as an acclaimed novelist whose works have been translated into many languages, including Chinese. To this Surrealist-influenced artist "[a] successful painting is a dream that crosses over / into being . . . or nightmare." Painting is a process that consumes the artist's entire being. A painting not only reproduces the exterior reality of the artist but the interior also. "I dream that I paint, and I paint the dream," says del Paso, "when I wake up, On what side of reality will I be?"

The nature and quality of light, and the tension between light and dark, preoccupy del Paso:

> A painting, in the first and last instance, is an endless struggle between darkness and light from which light always emerges triumphant: even if we paint a completely black picture, in order to see it we have to surround it with light.

Del Paso has considered combining the literary with the visual—by illustrating his text as other writers have, for example—but he has always chosen to keep these worlds separate:

> My view of literature is still based on its oral tradition. A good page is one that can be read and enjoyed aloud. Its sound is what really matters—one really shouldn't mess around with easy tricks.

In a 2003 letter to me, del Paso observed:

> Literature and music exist in time: they have a beginning and an end. Painting and sculpture exist in space. . . . Where does the Venus de Milo begin: in her navel, in her breasts, or in her head? Where does an abstract painting begin: in the lower left corner, or in the center?
>
> A temptation: to paint a picture, show it to no one, take no photo of it, and paint another picture on top. The same, and paint another on top, and another, and another to infinity. So each painting, in order to exist, would have to kill the former, and be contemplated by only one person in all the universe.

Fernando del Paso was born in Mexico City, Mexico, in 1935 and achieved critical success with his nine-hundred-page first novel, *José Trigo* (1966), the story of a region of Mexico beginning with its prehistory. Among his other notable novels are *Palinuro de México* (1977) and *Noticias del Imperio* (1987). His widely translated, award-winning fictions have been described as difficult, encyclopedic, linguistically obsessive, semi-magical, and humorous. Del Paso himself has accused them of having "excess in style, excess in references."

Del Paso studied biology and economics at the National University of Mexico. He took pre-med courses but concluded that medicine "is nothing but a science of failure." He began a simultaneous career as an artist and writer. He is an essayist and poet as well as a novelist, and has written two children's books. He was a participant at University of Iowa's International Writing Program, and for fourteen years worked as a writer for the BBC in London and Radio France Internationale in Paris, as well as serving in France as the cultural attaché and general consul of Mexico.

Above: Fernando del Paso. From the series *Tartarin Jumping over the Rainbow*

India ink and gouache on paper. Collection of the artist

Above: Fernando del Paso. From the series *The Rainbow's Labyrinth*

India ink and gouache on paper. Collection of the artist

Opposite: Fernando del Paso. From the series *Castles in the Air*

India ink on paper. Collection of the artist

J. P. DONLEAVY

J. P. Donleavy began a career as a painter in Dublin in the late 1940s, at the same time that he was writing his best-known novel, *The Ginger Man*. As a young artist Donleavy worked in oil and watercolor, with a reputation for delivering work to galleries before the paint had dried. Art from that period is reproduced in his autobiographical works *J. P. Donleavy's Ireland: In All Her Sins and in Some of Her Graces* (1986) and *The History of the Ginger Man* (1994). *The Unexpurgated Code: A Complete Manual of Survival and Manners* (1975), his mock book of etiquette, was illustrated with his pen-and-ink drawings. He claims that being rejected as an unknown by London's prestigious Redfern Gallery motivated him to achieve fame as a writer.

There have been a number of shows of Donleavy's art over the years, including a major exhibit of 138 of his oils and watercolors at Dublin's Golophin Art Gallery in 1986. His brother T. J. Donleavy is a sculptor, and his daughter Karen Donleavy is a ceramicist who showed her works alongside her father's at London's Anna-Mei Chadwick Gallery in 1991. A 2006 exhibit of 87 works by Donleavy at Dublin's Molesworth Gallery was sold out.

A ribald, tragicomic novelist, playwright, short story writer, and essayist, Donleavy is an expatriate American who became an Irish citizen in 1967. He was born James Patrick Donleavy to Irish immigrant parents in Brooklyn in 1926, and now lives the life of a country squire in an eighteenth-century mansion on 180 acres in Mullingar, Ireland.

Donleavy was expelled from Fordham Prep in the Bronx, graduated from Manhattan Prep, joined the Navy in 1944, and attended the Naval Academy Prep School. After the war, he attended Trinity College, Dublin, on the GI Bill.

The Ginger Man was finished in 1950, but he was unable to find a publisher for it. Olympia Press in Paris, notorious for its controversial and banned works, brought it out in 1955 as part of a pornographic series. Expurgated editions were published in England and the United States (in 1956 and 1958, respectively) before an unexpurgated American edition was produced in 1965.

Other notable works of Donleavy include *A Singular Man* (1965), *The Beastly Beatitudes of Balthazar B* (1968), and the Darcy Dancer trilogy (1977, 1983, and 1990).

In *J. P. Donleavy's Ireland* he wrote:

> The animal wants its back protected and to eat. Man is that animal and when he has eaten, he deals in art and artifice, and it becomes lie and compromise; a soft, ingrate murmur of accents and incomes.

Above: J. P. Donleavy. Still Life

Watercolor. 30 x 40 inches. Courtesy of the artist and the Walton Gallery

Opposite: J. P. Donleavy. I Dare Say

Watercolor. 33 x 35 inches. Courtesy of the artist and the Walton Gallery

JOHN DOS PASSOS

John Dos Passos had aspired to become an architect after his graduation from Harvard in 1916. His plan was interrupted when he went to serve as an ambulance driver in France. He wrote in *The Best of Times* (1966), his self-illustrated "informal memoir," that he had begun drawing seriously while he and a fellow soldier were serving in Italy during World War I:

> Dudley [Poore] and I immediately started giving each other a course in drawing during our free time. Whenever it stopped raining we roamed about sketching the bridge and the church towers and the wop soldiery and the washerwomen on the riverbank.

The son of a Portuguese-immigrant father who was a successful lawyer, Dos Passos was born in Chicago in 1896. Although his mother raised him in Virginia, he spent part of his childhood in Europe and Mexico. When he returned as a soldier, the sight of Europe was a sensual experience for Dos Passos:

> In those days I had a fair head for liquor but architecture intoxicated me. The blues and the purples and reds, like the colors of greenhouse anemones, of the stained glass windows in the apse of the Tours creamy gothic cathedral went straight to my head.

Dos Passos sketched everything, but disparaged his work, saying his sketches were "like the penciled notes you jot down in your notebook and forget to do anything with." Nonetheless, he acknowledged having aspirations:

> For the first time my drawing is emerging from primal chaos a little and a few of the crayon things I've done seem to exhibit a faint hope—faint as unheard ditties!—of improvement. Après la guerre . . . I shall take a whack at the graphic arts—poor dears.

Dos Passos studied art after the war, at the Art Students League in New York, and he had an exhibit of his paintings at the Whitney Studio Club, but admitted, "I had come back from the war and the Near East not quite sure whether I wanted most to paint or write but with no idea of making a career of either one."

Dos Passos and his Harvard pal **E. E. Cummings** hung out together in New York and shared the love of painting and drawing. Suffering in his youth from what he called "a multiplicity of desires," before making his choice for literature, Dos Passos declared:

> I want to swallow the oyster of the world. I want to peel the rind of the orange. I want to drink the cup to the dregs—no—I want to swallow it and still have it to look at. I want to peel off the rind in patterns of my own making. I want to paint with the dregs pictures of gods and demons on the great white curtains of eternity.

Dos Passos wrote antiwar novels, most notably *Three Soldiers* (1922). Innovative and influential, his "newsreel" novels encapsulated America between the two world wars. His reputation-making *Manhattan Transfer* (1925), a panoramic view of New York that first utilized the newsreel or camera-eye technique—incorporating headlines, song lyrics, and other artifacts of the culture—was expanded in the U.S.A. trilogy: *The 42nd Parallel* (1930), *1919* (1932), and *The Big Money* (1936).

Dos Passos died in Baltimore, Maryland, in 1970.

Above: John Dos Passos. Manhattan Skyscraper

Tempera. 25–1/2 x 22 inches. YCAL at The Beineke Rare Book and Manuscript Library, Yale University, by kind permission of the estate of John Dos Passos

Right: John Dos Passos. Processional

1926. Gouache and pencil. 29–3/4 x 21–7/8 inches. University of Virginia Library, Charlottesville, Manuscripts Department, by kind permission of the estate of John Dos Passos

FYODOR DOSTOEVSKY

Dostoevsky, among the greatest of Russian writers and one of the most influential of nineteenth-century novelists, drew, in his manuscripts, church cupolas, various gothic architectural details, and calligraphy exercises; but primarily he drew portraits, including self-portraits, images of old and young monks, a copy of a wax figure of Peter the Great, and the faces of characters from his novels—most notably, several sketches of the main character of *The Idiot.* Some of the drawings relate to the text, others do not.

A collection of such manuscript drawings, *Risunki Fedora Dostoevskogo,* was published with an accompanying text by K. A. Barsht, in 1998, and many of those drawings, with Russian captions, may be found online. The portrait sketch, architectural details, and calligraphy shown here were inscribed on a manuscript page of his novel *The Devils,* composed between 1870 and 1872.

The author of *Notes from the Underground* (1864), *Crime and Punishment* (1866), *The Idiot* (1870), and *The Brothers Karamazov* (1879) was born Fyodor Mikhaylovich Dostoevsky in 1821 in Moscow, in a hospital for indigents at which his father was a staff doctor.

Dostoevsky described his childhood as joyless. His mother died when he was sixteen, at which time he was sent to St. Petersburg to attend a military engineering school. His father, who had acquired an estate, died two years later and was rumored to have been murdered by his serfs.

Upon graduation in 1843, Dostoevsky served one year as a draftsman in the St. Petersburg department of engineering before turning to writing full time. In 1849 he was arrested for antigovernment political activities and, with other members of his group, condemned to death.

Although their death sentences were commuted, they were brought before a firing squad, tied to stakes, and only at the last minute informed of the reprieve. Dostoevsky served out his sentence, four years at hard labor, in chains, in Siberia, followed by six years of army service as a common soldier. At the time of his death in St. Petersburg in 1881, he was hailed as the prophet of Russia. Fifty thousand people attended his funeral.

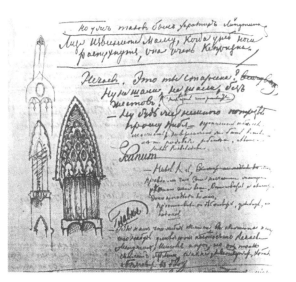
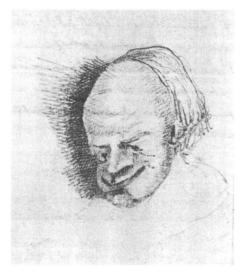

Above: Fyodor Dostoevsky. Architectonic details, calligraphic records, and sketch portrait

1870–1871. Graphical composition from the second notebook for the novel *The Devils*. sov

Opposite, center and right: Fyodor Dostoevsky. Prince Myshkin, protagonist of *The Idiot*

1867. Two ink manuscript sketches with calligraphy exercises, including the calligraphied name "Caligula"

Opposite, left: Fyodor Dostoevsky. Gothic architectural details

From 1870–1871 notebook for *The Devils*

GEORGE DU MAURIER

After losing the sight in his left eye, George du Maurier gave up painting and devoted himself exclusively to black-and-white drawing. In 1860 he began cartooning for *Punch* and became a successful illustrator of magazines and books. His work was praised by **John Ruskin**, who put du Maurier's work in the same league as Hans Holbein's.

Henry James saw literature in du Maurier's drawings, asserting they reproduced "every possible situation that is likely to be encountered in the English novel of manners; he has interpreted pictorially innumerable flirtations, wooings, philanderings, raptures."

At the urging of James, du Maurier turned to writing fiction, publishing his first novel, *Peter Ibbetson* (1891), when he was fifty-six. His novels explored the influences of unconscious mental processes before Freud did. Du Maurier's *Trilby* (1894), in which Svengali seduces and defiles the heroine, was one of the most popular books of the nineteenth century. His demonic creation, the manipulating hypnotist, brought a new word into our language. The novel inspired a rash of merchandising and brought du Maurier fame and wealth. He produced one more book, the psychological fantasy *The Martian* (1897), before dying in London in 1896.

George Louis Palmella Busson du Maurier was born in Paris, in 1834. Half English, he was lifted from a happy early childhood in Passy, France, and dropped into Pentonville, England, a dismal place notorious for its convict prison. Eventually he escaped to London and matriculated in chemistry at University College. He then left to study art in Paris.

Reflecting in a letter on his versatility as an artist—drawing, cutting blocks, and etching—and on the view that versatility was dangerous, du Maurier wrote: "I have so many ideas one way or another, that they must fructify in the end." He likened himself to "a man beginning to drive 6 or 8 horses in hand," and presciently concluded, "I think my real life will in the end be this, simply to write and illustrate myself." Years later, he summed up the life in illustration he had foreseen:

> To have pleased one's own generation—to have lived by pleasing it, honestly and without charlatanism, of course—this is already no mean achievement, even if the next generation should forget our very name. . . . We may, if we try find comfort in the thought that, for all we know to the contrary, our unsophisticated little black scratchings may still have power to charm and amuse, by mere virtue of the literal truth that is in them, when some, at least, of the Rembrandts, the Titians, Raphaels and Veroneses of our "so-called nineteenth century" shall have passed out of fashion, and lost their hold on all but the educated future few—and the wiseacres who find their opinions for them.

Du Maurier's sketches and drawings are located primarily in the collections of the British Museum, the Victoria and Albert Museum, and Harvard University.

George du Maurier. An Incubus.
Illustration from *Trilby* (1894)

ALEXANDRE DUMAS *fils*

A skilled caricaturist, draftsman, and painter, Alexandre Dumas *fils* was firmly in the tradition of the French writer-artist and saw his writing in terms of the visual arts. Describing his methods in writing for the theater, he said:

> I write my play as if the characters were alive, and I give them the language of familiar life. Or, to put it into other terms, I mould in plastic clay, and I thus obtain backgrounds of great strength and points of emphasis of great vigor.

A play, for Dumas, was a matter of "painting truth in public." But he asserted that presenting what is, however laudable, was an objective with limitations that should be transcended:

> The artist, the true artist, has a higher and more difficult mission than that of reproducing that which exists; he has to discover and to reveal to us what we do not see in all that which we observe about us every day. . . . The artist does not truly deserve that name unless he give a soul to material things, a form to the things of the soul, unless, in a word, he idealizes the real and attains the ideal which he feels.

Dumas, who gave us *Camille* and brought social realism into French theater, was also a novelist, poet, and essayist, as well as a playwright. He was born in 1824 in Paris, the illegitimate son of Alexandre Dumas, the renowned author of *The Three Musketeers*. His mother was a seamstress who raised him alone until he was seven years old. At that time, his father succeeded, over his mother's objections—and an attempt to flee with her child—in gaining custody of the boy as the law then allowed. He gave the boy his name and placed him in schools where he was tormented mercilessly for his illegitimacy.

At sixteen, the son dropped out of school to follow his father into a life of extravagant debauchery in the underworld of Paris. By age twenty-four, Dumas *fils* had run up enormous debts, which he turned to writing to satisfy. A moralist focused on exposing the hypocrisies of polite society and its indulgences in the pleasures of the demimonde, he infused his stories with the theme of illicit love.

His first and most famous novel, *La Dame aux camilias* (1852; *Camille*), was extremely popular, and the profits Dumas realized from it cleared most of his debts. The novel was based on the life of his mistress, Marie Du Plessis, a courtesan from the age of fifteen, who died of consumption at twenty-three. In the story, a young man's father forbids his son's love affair, and she breaks it off under the pretext of returning to a rich patron. As her health and circumstances deteriorate, she is abandoned by lovers and friends. When, finally, the son receives word from his father of her misfortune, he returns, only to have her die in his arms. Dramatized by Dumas, it became a successful play (at least sixteen versions have appeared on Broadway, featuring such prominent actresses as Sarah Bernhardt, Ethel Barrymore, and Tallulah Bankhead) and film (some twenty versions, most notably the 1936 George Cukor movie, starring Greta Garbo), and was the basis of Verdi's opera *La Traviata*.

When he died in 1895, a member of the Académie Française, Alexandre Dumas *fils* had produced sixteen plays that had made French theater a place of controversy and discussion.

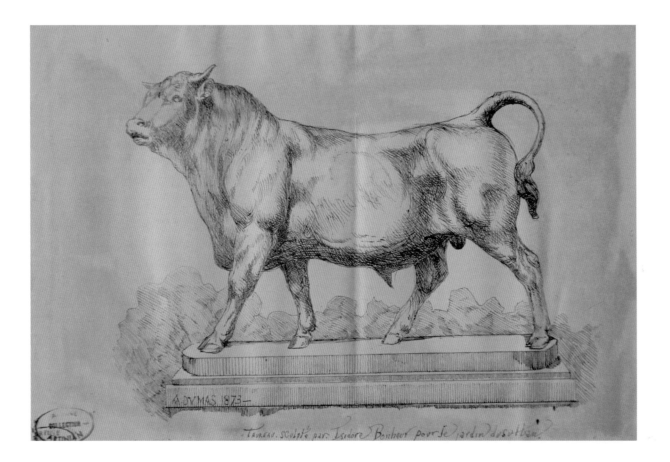

Alexandre Dumas *fils*. Untitled (statue of bull)

1873. Ink. Signed lower left: "A. Dumas." Inscribed at bottom center: "Taurus sculpté par Isadore Bonheur pour le jardin du sultan." From the Artinian Collection, courtesy of Artine Artinian

ROBERT DUNCAN

Poet Robert Duncan drew in pen and ink, in pencil, and most frequently in crayon. As a student at the University of California, Berkeley, he published a magazine to which he contributed poetry and drawings. Duncan had begun using children's crayons in his senior year of high school, and he continued at Berkeley after a fellow student, Lillian Fabilli, introduced him to her work with crayons on cloth. He came to prize the medium, not only for the thick Rouault-like surfaces he could create, but because it was not associated with serious art. However, when he was made aware of how impermanent the colors were he began using crayons made of beeswax and oil that were created for him by a friend.

Inspired by **William Morris**, Louis Tiffany, and other craftsmen, Duncan made stained glass windows, a bookplate, and a rug. He papered his walls with handcrafted panels. Artist Jess Collins, Duncan's life-partner, encouraged and sometimes collaborated with him. The collaborations were informal—crayoning as entertainment after dinner with guests or making "household art scrapbooks" in which they created surprising juxtapositions of artworks and images cut out of magazines and books.

Over several decades beginning in 1952, Duncan, deeply valuing what he called "the dearness of nearness," produced dozens of individually decorated, hand-sewn books of poems for friends. He did a series of drawings he called "The Ideal Reader," five of which were published in the book *Letters* (1958). In 1970 *A Selection of 65 Drawings from One Drawing-Book 1952–1956* was published by Black Sparrow Press.

What Duncan prized in both poetry and art was the appearance of "the interior light," that is, what was spiritual and transformative, the force that brought about connection. He wrote:

The experience of "meaning" is the experience of interrelationships. The "language" of painting in which we read the meaning of the process of art itself, analogous to the meaning of the oral/aural processes of literary poetry, presents itself in the way of painting. . . . The "language" of picture arises, as if there were a tongue in the mouth of what we see, and the eye were an ear, in which visual elements—light and dark, opacity and translucence, color and mass, and, then, lines and rhythms—lead into boundaries and the syntax of a world and the lexicon of its things and beings.

Edward Robert Duncan was born in Oakland, California, in 1919. His mother died shortly after giving birth, and his father, a laborer, placed him for adoption. Renamed Robert Edward Symmes by his adoptive family, theosophists and spiritualists who searched for hidden meanings in the events of life, Duncan published early poems under that name. He spent some time in the army, but received a psychiatric discharge in 1946.

Outspoken about his homosexuality, Duncan suggested it might have "underlay and led to the poetic." He became one of the principal Black Mountain poets and taught there with Charles Olson in 1956. His major works include *Heavenly City, Earthly City* (1947), *The Opening of the Field* (1960), *Bending the Bow* (1968), and *Derivations* (1970). After a deliberate fifteen-year hiatus, he published two final collections, *Ground Work: Before the War* (1984) and *Ground Work II: In the Dark* (1987), the latter of which was released two months before his death in San Francisco in 1988.

Robert Duncan. Head of a Woman

C. 1953–54. Wax crayon on paper. 23–5/8 x 18–1/2 inches. YCAL at the Beineke Rare Book and Manuscript Library, Yale University, with the kind permission of the estate of Robert Duncan

Robert Duncan. Untitled

Crayon on paper. 14–1/4 x 17–1/4 inches. Private collection, New York City, with the kind permission of the estate of Robert Duncan. Photo by Jason Brownrigg

WILLIAM DUNLAP

*I*n 1778, at age twelve, William Dunlap lost an eye while playing. Despite this injury, he began portrait painting. Dunlap was introduced to George Washington through mutual friends. At eighteen, with his father's backing and bringing his full-length portrait of Washington as his admission ticket, Dunlap went to England to study at London's Royal Academy with the expatriate Benjamin West.

In order to prepare for the trip Dunlap enrolled in dancing school and practiced billiards. When he arrived in London he found it "full of delight to my empty mind," and he pursued, not art studies, but "every dissipation suggested by my companions or myself."

His father called him home. Dunlap sobered up, worked in the family business, and began writing plays. By the time he was thirty he had written about thirty original plays, translated about an equal number, and with his inheritance became the half-owner and manager of a New York theater. It failed nine years later.

Bankrupt, Dunlap went on the road as a portrait painter and ivory miniaturist. In 1814, through his friend Washington Irving, he got a job in the New York militia that required travel and provided the opportunity for doing scenic watercolors. He was elected to the American National Academy of Fine Arts in 1816, and exhibited portraits and Bible paintings in its shows and galleries. One of those biblical paintings was a twelve-by-eighty-foot panorama featuring several hundred figures. Dunlap, the entrepreneur, moved it to a second-floor room on Broadway that he called the Museum of Paintings, where he showed it and lectured—until the landlord leased the first floor to a man exhibiting a screaming orangutan. Eventually Dunlap sent his huge scriptural canvases on tour with an agent where they were exhibited at a quarter a head.

In his diary Dunlap reflected on "the Sister Arts (both divine)" of painting and poetry, observing that painting is the older art:

> [E]re Letters were invented men had no other way of communicating knowledge to each other at different periods of time, but by figures of Men & Animals representing the event they wished to hand down to posterity, and this kind of Historic painting was in use among the Mexicans, when invaded by the Spaniards under Cortez. The Egyptian Hieroglyphics was but a species of Painting. Then, if any Man would pay Court to Poetry, He must first gain the favour of her Sister, without whose aid all his attempts must be vain: Then, ev'ry Poet was a painter. Now, tis not necessary for the poet to be a painter, but tis absolutely necessary that ev'ry true painter, should be a Poet.

Dunlap, who would become "the father of the American theater," was born in 1766 in Perth Amboy, New Jersey, into a middle-class Tory family. His father was an importer of china.

In addition to his work in the theater and the visual arts, Dunlap was a historian, translator, and diarist. Known as "the American Vasari," he spent his life convincing the citizens of the fledgling republic that the arts were central to the democracy, advocating a national subsidy for theater.

Dunlap died in New York City in 1839. His *History of the American Theatre* (1832) and *History of the Rise and Progress of the Arts of Design in the United States* (1834) are primary sources for our understanding of the arts in early America.

Opposite: William Dunlap. The Artist Showing a Picture From Hamlet to His Parents

1788. Oil on canvas. 42–1/4 x 49 inches. Collection of The New York Historical Society, negative #6244

DOROTHY DUNNETT

Dorothy Dunnett was an established portrait painter and sculptor before she wrote historical novels. Art filled Dunnett's life: her home was decorated with family portraits and murals she had painted. The murals contained illustrative depictions of her writings or such classic themes as a unicorn hunt. Her paintings have been exhibited in the Glasgow Institute of the Fine Arts, and hang in the Royal Scottish Academy and the University of New Brunswick, as well as other institutions, and in private collections.

In addition to having a painter's eye for detail, Dunnett created precise word portraits of her characters and made expert references to paintings of the period she wrote about. Critic Stewart Sanderson wrote of her:

> This artistic versatility in itself offers clues to her literary achievement. As a painter she has a remarkable ability to create instantly recognizable likenesses. Her sitters are portrayed with nicely calculated chiaroscuro, their faces and figures standing out against closely observed and romantically ordered backgrounds. As a sculptress she controls the modeling of her subjects with skill, shaping her material into volumes that satisfy from whatever angle they are viewed.

A highly praised, internationally popular, and prolific author of meticulously researched historical fiction, Dunnett did not publish her first novel, *The Game of Kings* (1961), until she was thirty-eight. It was written, she said, when "I ran out of historical novels that I liked reading" and her husband suggested she write her own, adding "Make it a series. They're popular at the moment."

The Game of Kings was the first of The Lymond Saga, a series of six novels of sixteenth-century feudal Scotland. Her second series, which began with *Niccolo Rising* (1986), was set in the Mediterranean countries of the fifteenth century. Dunnett also wrote a series of seven thrillers in which the main protagonist is a portrait painter named Johnson Johnson.

Born Dorothy Halliday in Dunfermiline, Scotland, in 1923, Dunnett was educated at James Gillespie's High School, Edinburgh, where she took the higher Latin that "has been an enormous help in translating the mediaeval documents I use in my research." She also studied at the Edinburgh College of Art and the Glasgow School of Art, and trained as an opera singer. For fifteen years Dunnett worked as a press officer in the Civil Service, where she met and married her husband, who later became editor of *The Scotsman* and then Chairman of Thomson North Sea Oil.

While pursuing her art and literary careers Dunnett also served as a Trustee of the National Library of Scotland, Trustee of the Scottish National War Memorial, Director of the Edinburgh Book Festival, and a Director of Scottish Television. Elected a Fellow of the Royal Society of Arts in 1992, Dunnett was awarded the Order of the British Empire for services to literature that same year. She died in 2001 in Edinburgh.

Dorothy Dunnett. Portrait of
David Sinclair Dunnett
(Dunnett's father-in-law)

1951. 27–1/2 x 36 inches. Signed
"Halliday," Dunnett's maiden name.
With the kind permission of the
estate of Dorothy Dunnett

LAWRENCE DURRELL

*I*t was while living and writing in Paris during the 1930s that Lawrence Durrell began painting with his friend **Henry Miller**. According to Durrell, the two of them developed artistically "at the same time—and with the same set of influences and preoccupations." Crediting his wife with giving him an "involuntary eye education" in his youth, Durrell described the difficulty of determining to be a painter in the shadow of Picasso, Braque, and Matisse, acknowledging that he and Miller were not about to devote themselves to the work necessary to become more than Sunday dabblers. They were in what they considered a dangerous stage, he wrote, "for serious painting might have swallowed the writers that we hoped to become."

Durrell credited Miller with the solution that allowed them to keep painting without sacrificing their writing careers:

> What was to be done? There was some sort of Rubicon to be crossed. In the first place it was necessary to realize that one was not Picasso and could never be. This was some help. Then it was necessary to try and find a shortcut that might help to supplement this obvious gap in our practice. It was at this point that the technique Miller christened The New Instinctivism was born—a technique that I was afterwards able to carry to superhuman heights (depths?) in the paintings of Oscar Epfs, my double and spirit guide! Miller allowed me to change the name to Epfsistentialism in honour of the great man. His system was based upon equal parts of faith and hope; even so, it did not always succeed. It operated as follows.

If you wished to draw an arm of a chair or an airplane, you closed your eyes and wished for it to form under your brush; also, of course, you used whatever resources you had of memory or drawing skill. But the main effort was just to will the image, and quite often (though not always) this image would actually form itself under your brush.

A British poet and novelist, best known for his Alexandria Quartet—*Justine* (1957), *Balthazar* (1958), *Mountolive* (1959) and *Clea* (1960), which tell the same story from different points of view—Durrell was born in 1912, in Darjeeling, India. An idyllic childhood in India ended abruptly when he was sent to England at age eleven. There the boy endured a dreary, alienated time that he called the "English death." After failing to pass university exams, Durrell determined to be a writer and moved with his wife, painter Nancy Meyers, and his mother and siblings to Greece.

When the Germans invaded in 1941, Durrell and his wife fled to Egypt. During the war he served with the British Foreign Office in the embassies in Cairo, Alexandria, Athens, and Belgrade. After the war, he lived in Yugoslavia, Rhodes, Cyprus, and the south of France. Durrell would marry three more times. Sappho-Jane, his daughter by his second wife, Eve Cohen, committed suicide in 1985. Durrell died in Sommieres, France, in 1990.

Opposite, left: Lawrence Durrell. C'est LUI! (self-portrait)

From the Artinian Collection, by courtesy of Artine Artinian. Reproduced with permission of Curtis Brown Ltd., London, on behalf of the Executor of the Estate of Lawrence Durrell. Copyright © The Estate of Lawrence Durrell

Opposite, right: Lawrence Durrell. Music

From the Artinian Collection, by courtesy of Artine Artinian. Reproduced with permission of Curtis Brown Ltd., London, on behalf of the Executor of the Estate of Lawrence Durrell. Copyright © The Estate of Lawrence Durrell

FRIEDRICH DÜRRENMATT

As a young man, Switzerland's legendarily pessimistic author Friedrich Dürrenmatt planned a life as a painter, but his pictures were so filled with expressionistic fantasy that the jury reviewing his application at the Art Academy in Berne told him to go learn how to draw apples. Instead, Dürrenmatt continued to paint as he wanted throughout his life, but, prompted by conflict with his father over religion, he gave up art study in favor of literature and philosophy at the Universities of Berne and Zurich. Dürrenmatt painted the walls of his student quarters, and, decades later, after the landlord's covering paint was removed, the paintings were transferred to the Swiss Archives in Berne, where the room has been reconstructed.

Dürrenmatt's pictorial works were created in parallel to his literary works. He described his visual expressions as "the drawn and painted battlefields on which my literary struggles, adventures, experiments, and defeats took place." Word and text surfaced in him almost simultaneously: when telling a story, he was frequently observed to interrupt himself to start drawing what he was describing verbally. As in the painting of the Minotaur opposite—one of his many Minotaur paintings and drawings—Dürrenmatt presented his subjects to his audience in both word and image. The mythical Minotaur, half man and half bull, was placed in a maze despite having done nothing wrong. Dürrenmatt explained:

> The guilt of the Minotaur consists in being the Minotaur, a monster, an innocently guilty being; and that is why the labyrinth is more than a prison, it is something incomprehensible

that keeps us a prisoner precisely by being incomprehensible; that is why it needs no locked doors; the innumerable doors of the labyrinth stand open, anyone can lose his way in it.

By identifying himself with the Minotaur, Dürrenmatt said, "I made the primeval protest; I protested against having been born . . . [into] a mythic world I could not understand, that pronounces innocent people guilty and whose law is unknown."

A major exhibition of Dürrenmatt's paintings, "Friedrich Dürrenmatt: The Happy Pessimist," was curated by The Swiss Literary Archives in 1997 and was shown in New York at The Swiss Institute. *Friedrich Dürrenmatt: Schrift-steller und Maler,* a catalog of his collected paintings and drawings, was published in 1994.

One of the leading German-language playwrights of the twentieth century, Dürrenmatt was born in Konolfingen, Canton Berne, Switzerland, in 1921. He said that as a boy he had been distrusted by his peers for having a pastor father, and he grew up in a village he considered ugly and labyrinthine—the first of the labyrinths in which Dürrenmatt, the Minotaur, was entrapped. He died in Neuchâtel in 1990.

Saul Bellow observed that Dürrenmatt fulfilled Oscar Wilde's dictum that "a writer should be able to write anything." Among several dozen published works—including criticism, detective stories, and scripts for movies, television, and radio—are two plays that brought Dürrenmatt worldwide fame, *Der Besuch der alten Dame* (1956; *The Visit*) and *Die Physiker* (1962; *The Physicists*), and his bestselling novel, *Der Richter und sein Henker* (1952; *The Judge and His Hangman*).

Friedrich Dürrenmatt.
Minotaurus

1975. Mixed media. 8–5/8 x
7–1/2 inches. Copyright ©
1986 Diogenes Verlag AG
Zurich. Swiss Literary
Archives, Berne

RUSSELL EDSON

ussell Edson, America's happily irrational poet and playwright, frequently accompanies his writings with drawings and woodcuts that relate to and comment upon the text. "It's as if King Lear had been written and illustrated by Edward Lear," wrote the poet Denise Levertov. Edson designed, set by hand, illustrated, and printed his first collection of poems, *A Stone is Nobody's* (1961). Other hand-set, illustrated works include *Appearances* (1961), *The Very Thing That Happens* (1964), and *The Brain Kitchen* (1965). Edson is, in Levertov's words, "one of those originals who appear out of the lonesomeness of a vast, thronged country to create a peculiar and defined world."

In a 2004 interview with editor Mark Tursi, Edson said:

> Early on I had thought to be a painter, but found the whole thing just too messy. Writing is physically less bothersome. Of course preparing a book for publication is hardly worth the trip. It's even worse than homework from school. Somehow life manages to find difficulties no matter how clear the path may seem.

Asked by Tursi what affinities he saw between painting and poetry, Edson responded:

> All the arts have a strong affinity with poetry. But the difference is that all the other arts are attached to sensory organs like eyes and ears. Poetry can be heard, read, or tapped out on one's back in Morse code; it can be read as Braille through the fingertips. In other words, all other arts have a physical presence which writing has always to earn. Poetry, which, paradoxically, is not really a language art as we know fiction to be, is perhaps, as you suggest, more related to painting. But even more, perhaps silent film, because dreams, if not completely, are mainly wordless. The babyish subconscious doesn't know how to speak. It is the land of physical understandings. Its language is a language of images. Poetry is a physical art without a physical presence, so that it often finds itself in cadence to the heartbeat, the thud of days, and in the childish grasp of the reality of rhymes.

Edson insists on keeping all biographical details private, even the date and place of his birth. Of this insistence on privacy, Edson has said:

> Take it or leave it, I make it a point not to be a celebrity, most of whom are uncreative scum feeding on the public attention; if I have any public value, it is in my published works, not in my secret dreams. Information as to how I scratched, and where, will make interesting twitterings after I'm dead; not while I still live, and still scratch.

Contemporary Authors reveals that Edson is married, lives in Stamford, Connecticut, and completed tenth grade. In a 1999 National Public Radio segment about him, Edson was said to have been born in Connecticut sixty-four years earlier. His "public value" is to be found in such works as *What a Man Can See* (1969), *The Childhood of an Equestrian* (1973), *The Clam Theater* (1973), *The Falling Sickness* (1975), *The Wounded Breakfast* (1985), and *The Tunnel: Selected Poems* (1999). He was awarded a Guggenheim Fellowship in 1974.

FIRE IS NOT A NICE GUEST

I HAD CHARGE of an insane asylum, as I was insane.

A fire came, which got hungry; so I said, you may eat a log, but do not go upstairs and eat a dementia praecox.

Above: Russell Edson. Fire is not a nice guest . . .

Drawing from *A Stone is Nobody's*, 1961. Courtesy of the artist

Right: Russell Edson. Love: Dog, love me, said a man to a dog. A dog said nothing.

Drawing from *Appearances: Fables and Drawings* (1961). Courtesy of the artist

LOVE

Dog, love me, said a man to a dog.
A dog said nothing.

WILL EISNER

A legendary cartoonist and the namesake of comics' most prestigious award, Will Eisner has been credited with coining the term "graphic novel" and with having created the first example of that genre, *A Contract with God* (1978). His one-time assistant **Jules Feiffer** described Eisner as

> an early master of the German expressionist approach in comic books—the Fritz Lang school. "Muss 'Em Up" was full of dark shadows, creepy angle shots, graphic close-ups of violence and terror. Eisner's world seemed more real than the world of other comic book men because it looked that much more like a movie.

In his preface to *A Contract with God,* Eisner discussed the relationship between the stories he was telling and the visuals with which they were being told. His fully realized, character-driven plots required a new approach to his art:

> In the telling of these stories, I tried to adhere to a rule of realism which requires that caricature or exaggeration accept the limitations of actuality. To accomplish a sense of dimension . . . each story was written without regard to space, and each was allowed to develop its format from itself; that is, to evolve from the narration.

In order to achieve this goal, the usual panel-formatting restrictions were eschewed in favor of allowing the narrative to dictate the visual, so that a full page, for example, might consist of one panel. The text and balloons were treated as part of the art. "I see all these as threads of a single fabric," said Eisner, "and exploit them as a language." His objective was to have "no interruption in the flow of narrative because the picture and the text are so totally dependent on each other as to be inseparable for even a moment."

Eisner achieved fame in 1940 with his innovative and dark comic *The Spirit,* in which a hero returns from the dead to solve crimes. Eisner "did just about all of his own writing—a rarity in comic book men," Feiffer observed. "His stories carried the same weight as his line, involving a reader, setting the terms, making the most unlikely of plot twists credible." And in *The Spirit* Eisner "developed story lines that are perhaps best described as documentary fables—seemingly authentic when one reads them, but impossible after the fact. . . . Alone among comic book men, Eisner was a cartoonist other cartoonists swiped from."

Born in Brooklyn in 1917, Eisner spent his formative years in New York's tenements, which he later incorporated into the five stories that comprise *A Contract with God.* His first commercial publication came when he was still a teen. After founding a comics studio with Jerry Iger, Eisner left in 1939 to join Quality Comics, where he created the newspaper supplement containing *The Spirit.* *A Contract with God* was followed by other graphic novels, ranging from the autobiographical to science-fiction parable.

Eisner died in 2005 in Fort Lauderdale, Florida. Exploring an infamous and enduring calumny against the Jews, his final work, *The Plot: The Secret Story of the Protocols of the Elders of Zion* (2005), was published posthumously, with an introduction by Umberto Eco.

Will Eisner. "Hey! Y'want I should become Jewish?"

ODYSSEUS ELYTIS

"After poetry, painting was my greatest passion," wrote the young Odysseus Elytis. While studying in Paris in the 1930s, he spent time with Picasso and Matisse, and his poems of this period were highly imagistic; he illustrated his books with his own gouache paintings and collages. For Elytis, the artist and the poet produce "a contemporary kind of magic whose mechanism leads to the discovery of our true reality." The artist's method of self-expression,

> which represents the reactions of its creator toward the surrounding world, can be transposed on a scale of spiritual values which will furnish us through analogy a table of multiple equivalences. Whether out-of-doors or in a studio, the artist is called upon to enact the same drama, always face-to-face with his destiny and with grand gestures ranging from triumph to despair.

Elytis saw Cubism as "the most beneficent movement ever in visual arts," and its effects as far-reaching:

> It cast them from a bed of sin; it restored geometry's clean base to expression and the Spirit's supreme order to matter. . . . [W]hatever good our days had produced—Matisse, Braque, Mondrian, Proust, Joyce, Schoenberg, Stravinsky, electronic music, St. John Perse—was secured by the Cubist lines depicting the meaning of this cleanliness.

Elytis was introduced to Surrealism in 1935, and immediately began assembling collages in the style of Max Ernst. He also produced thirty-odd gouaches that, according to scholar Kimon Friar, "in their freshness and translucency, their clear colors and purity, reflected the poems he had been writing about the apotheosis of youth amid a dazzlement of Aegean seascape." After showing his work at the First International Surrealist Exhibition in Athens that year, Elytis refocused his energies entirely on poetry.

It was not until 1966 that Elytis returned to painting. When Greece fell under a military junta in 1967, and in the years of censorship that followed, he expressed himself in image rather than text. He produced about forty collages, primarily using magazine illustrations. "Elytis came to realize," wrote Friar, "that it had become too late for him to attain to anything that might satisfy him technically as a painter . . . [but he] could now use the fully perfected images of painters and photographers and rearrange them to parallel the imagery of his poetry."

A poet, essayist, and translator, Elytis was born Odysseus Alepoudhelis in Iráklion, Crete, in 1911. He studied law at Athens University and literature at the Sorbonne. He took the name Elytis when he decided to leave his family's prosperous soap business and become a writer. He first published his Surrealist-influenced poetry in the 1930s. Believing in poetry as a force for revolution, he considered it his "mission to direct those forces against a world my conscience cannot accept, precisely so as to bring that world through continual metamorphoses more in harmony with my dreams." During the German occupation of Greece in 1941, he joined the resistance in Albania. In addition to the Nobel Prize for Literature (1979), his honors include the National Poetry Prize in 1960 for *To Axion Esti,* published in English as *The Axion Esti.* He died in Athens in 1996. *The Collected Poems of Odysseus Elytis* was published in 1997.

Odysseus Elytis. Embroidery and Bird

1974. Collage. Courtesy of the estate of Odysseus Elytis

Odysseus Elytis. Free Movement

1986. Collage. Courtesy of the estate of Odysseus Elytis

CAROL EMSHWILLER

Science-fiction and fantasy author Carol Emshwiller spent her early life drawing. She explained in a 2003 letter to me:

I drew all the time. Even in kindergarten the teacher put my drawings all along the walls. Just mine. Nobody else's. Almost all through grade school the teachers did that.

Originally a music major at the University of Michigan, Emshwiller transferred to the art program, where she studied printmaking. After receiving her B.A. (1945) and B. Design (1949) degrees, she won a scholarship to the École Nationale Supérieure des Beaux-Arts in Paris. For two years she studied figurative and abstract painting, but eventually abandoned those styles in favor of line drawing.

Her interest, she wrote,

in line . . . in pencil and ink lines, shows in my writing as an interest in structures and in a kind of clarity. I don't write lush. I think an artist interested in paint, as opposed to line, would write luxuriantly.

Emshwiller was born in 1921 in Ann Arbor, Michigan. Her childhood was divided between Europe and the U.S. ("I was eight years old in France, nine and ten here, then eleven in France, twelve back here . . . etc."), and she was unsuccessful in school: "I was hopelessly confused. . . . I remember the exact word where I decided I couldn't learn and so gave up: address/adresse." After failing freshman English, and almost failing it a second time, she reached a point where "I hated anything to do with writing."

All changed when her husband, Ed, a science-fiction illustrator turned expressionist painter and experimental filmmaker, introduced her to his science-fiction writer friends. They "talked about writing as if it could be learned," says Emshwiller, and her husband encouraged her to join their world. She began to sell stories almost immediately and only later studied—with Anatole Broyard, Kay Boyle, and Kenneth Koch.

Her critically acclaimed novels and stories frequently articulate a feminist perspective. She once explained:

I had three brothers and they were the only children that counted. Not unusual for most women. There was one good thing about being a girl in my family: if you were a boy you had three choices in life. You could be a lawyer, a doctor, or a professor. My middle brother was the black sheep because he became a musician. If you were female, nobody cared what you did. You didn't matter.

Emshwiller's notable works include the novels *Carmen Dog* (1988), *Ledoyt* (1995), and *Leaping Man Hill* (1999) and the short story collections *Joy in Our Cause* (1974) and *The Start of the End of It All* (1990).

Carol Emshwiller. Two figures

Pen and ink on paper. 11 x 8–1/2 inches.
Collection of the artist

WILLIAM FAULKNER

Novelist William Faulkner's drawings were mainly decorative art, used as illustrations for his Ole Miss yearbooks, as cartoons for a humor magazine, *The Scream,* and as occasional spot drawings in a text. They were generally influenced by Art Nouveau, particularly in his youthful work, and imitative of Aubrey Beardsley and John Held. Faulkner produced handmade, hand-illustrated books as gifts for his girlfriend Helen Baird, books that at least one scholar believes reflect the larger influence of the Arts and Crafts Movement. Faulkner's calligraphic manuscripts were in the tradition of **William Morris** and **John Ruskin**, who saw the fulfillment of the individual in labor that was an expression of craftsmanship combined with art. There are echoes of that view in a 1955 comment of Faulkner's: "It's that single voice that's the important thing. . . . Man has got to be, if he's got to be a collection, or a gang, a party or something, he's got to be a party of individual men."

For Faulkner, artistic creation was at the very core of man's relationship with God:

> To me, a proof of man's immortality, that his conception that there could be a God, that the idea of a God is valuable, is in the fact that he writes the books and composes the music and paints the pictures. They are the firmament of mankind. They are the proof that if there is a God and he wants us to see something that proves to him that mankind exists, that would be proof.

In his *Paris Review* interview in 1956, which included a pen-and-ink self-portrait, Faulkner suggested that art was the means to transcend mortal life:

> The aim of every artist is to arrest motion which is life, by artificial means and hold it fixed so that 100 years later when a stranger looks at it, it moves again since it is life. Since man is mortal, the only immortality possible for him is to leave something behind him that is immortal since it will always move.

Although he showed an early interest in poetry, Faulkner was an erratic student who dropped out of high school, returned to play quarterback, and then left again. After working at a succession of odd jobs, he became a pilot in the Canadian air force and later attended the University of Mississippi as a special student. Over the years, he worked as a bank clerk, house painter, postmaster, and bootlegger. Running raw liquor on a powerboat from Cuba into New Orleans in 1925, he met author **Sherwood Anderson** and moved into his house. Faulkner claimed that Anderson suggested he write a novel: "As I did not show any inclination to go to work, that might be a good way to avoid it—turn writer." When he finished six weeks later, Anderson recommended the novel—*Soldiers' Pay* (1926)—to a publisher on condition that he didn't have to read it.

Revered for his dark, lyrical novels set in the South, Faulkner won the 1949 Nobel Prize for Literature and a Pulitzer Prize in 1955. He was born in 1897 in New Albany, Mississippi, the eldest son of an old Oxford family, and died in Byhalia, Mississippi in 1962. Among his best-known works are *The Sound and the Fury* (1929), *As I Lay Dying* (1930), *Light in August* (1932), *Absalom, Absalom* (1936), *The Hamlet* (1940), and *Go Down, Moses* (1942).

Red and Blue Club

Above: William Faulkner. Social Activities

Drawing from page 111, 1918 *Ole Miss*, Archives and Special Collections, The University of Mississippi

Opposite: William Faulkner. Red and Blue Club

Drawing from page 137, 1921 *Ole Miss*, Archives and Special Collections, The University of Mississippi

Above: William Faulkner. Social Activities

Drawing from page 155, 1920 *Ole Miss*, Archives and Special Collections, University of Mississippi

JULES FEIFFER

ocial satirist Jules Feiffer disliked his early education, and as soon as he was able, he took classes at the Art Students League of New York and Brooklyn's Pratt Institute. He worked as an assistant to cartoon great **Will Eisner**, and when writing entered his life, a juggling act began:

> I balanced two or three careers—cartoons, plays, children's books. I wrote plays and screenplays . . . switching forms of work in what I called my system of avoidance. When I had a deadline on Job No. 1 and didn't want to do it, I switched to Job No. 2. I found that one form energized the other. As soon as I moved into theater, my cartoons improved.

Feiffer modestly denies being an artist at all: "Artists can color the sky red because they know it's blue. Those of us who aren't artists must color things the way they really are or people might think we're stupid." As for being a writer, he demurs again: "I never saw myself as a writer. I'm not a natural prose writer. Just as I can't draw backgrounds to my cartoons, I can't describe anything. I don't know what anything looks like."

Feiffer has always been aware that his work says "difficult" things—about government, relationships, work—and that he has to simplify in order to be effective. "You don't overthrow the government by making the art difficult." The idea, he explains,

> is to take difficult things and make them seem simple so that the reader would not know what he or she was in for. You just

dum-de-dum-de-dum—whack. And that's also not just politics and propaganda; that's also fun in sleight of hand. . . . If all this work would get done just for educative purposes and I wasn't having a ball, the hell with it.

Despite the cynicism that permeates all his work, Feiffer says,

> I have faith in art, music, Monet and Matisse, Samuel Beckett, Mary Tyler Moore reruns and Fred Astaire. I loved Fred Astaire. He took very hard work and made it look effortless and seamless, as if anybody could do it. That's what I wanted to be able to do in my work.

Feiffer has worked brilliantly in several mediums. His plays have won a New York Drama Critics Award, a London Theatre Critics Award, Outer Circle Critics Awards, and two Obies, for *Little Murders* (1969) and *The White House Murder Case* (1970). He is a novelist—*Harry, the Rat with Women* (1963), *Akroyd* (1977); a screenwriter—*Carnal Knowledge* (1970), *Popeye* (1980); an Academy Award-winning short filmmaker—*Munro* (1961); a children's book author and a Pulitzer Prize-winning cartoonist whose strip appeared in the *Village Voice*, the London *Observer*, and *Playboy*. Born in 1929 in the Bronx, Feiffer was the son of a dental technician father and a fashion designer mother. His parents were Jewish refugees from Poland who were "terrified of politics or too much talk in the wrong direction about personal beliefs," and who didn't believe in free speech for them; rather, "the thing you always did, as an American, was never to take advantage of being an American."

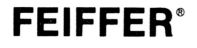

Jules Feiffer. I Dance My Fool Head Off

1999. Collection of the artist

LAWRENCE FERLINGHETTI

Lawrence Ferlinghetti is in that minority of writers who achieved separate recognition as a visual artist. His work has appeared in many group exhibitions and solo shows at galleries, museums, and universities, including the University of California at Santa Cruz (1990) and the Palazzo delle Esposizioni in Rome (1996). Although his early painting was nonobjective, influenced by the Abstract Expressionism of Franz Kline and Willem de Kooning, over time it became figurative, and generally focused on either political or lyrical subjects. "Painting," he said, "starts out nonobjectively because you have a blank canvas. That's a nonobjective painting right there, the blank canvas. So your painting always goes from nonobjective to figurative. It all depends at what point you arrest it."

The connection between the visual and the literary is often touched upon in Ferlinghetti's poetry, especially in *A Far Rockaway of the Heart* (1997). There, in poem #43, he reminds us:

> In the Beginning / wasn't the Word / since we name an image /
> after we see it. . . . When Adam one morning / went out
> wordless. . . . And speechless saw / for the first time/ the sun
> rise radiant. . . . And he had no word for it / until much later
> he bit / into the big apple of knowledge / with its wondrous /
> pips of words.

Credited as a co-founder of the Beat movement, Ferlinghetti prefers the label Fluxist. The author of one of the most widely read books of poetry of the twentieth century, the lucid, funny, and anarchic *A Coney Island of the Mind* (1958), he was born into Dickensian poverty in Yonkers, New York, in 1919. His Italian immigrant father died before Ferlinghetti was born and his Portuguese-Jewish mother was institutionalized in a state hospital. Taken by his mother's sister to France for five years, he was left in an orphanage for seven months on her return. Eventually he was placed with a family in Bronxville and educated first in public schools and then in a private school.

Ferlinghetti received a B.A. from the University of North Carolina, an M.A. from Columbia, and a doctorate from the Sorbonne, which he attended on the GI Bill after serving as an officer on a submarine chaser from 1941 to 1945. In addition to *A Coney Island of the Mind,* he has published more than a dozen books of poetry, including *Pictures of the Gone World* (1955), *The Secret Meaning of Things* (1969), *Landscapes of Living and Dying* (1979), and *How to Paint Sunlight* (2001); five books of prose, including *Tyrannus Nix* (1969) and *Her* (1960); two plays; translations of **Jacques Prévert** and Pier Paolo Pasolini; and a two-volume collection of his drawings. The Poet Laureate of San Francisco, where a street is named after him, Ferlinghetti settled there in 1951, taught briefly at San Francisco State College, wrote art criticism and book reviews, and set up his own studio to continue the painting career he had begun in Paris. In 1953 he made literary history by opening City Lights Books, the first all-paperback bookstore. Two years later he founded City Lights Press, which became famous as the publisher of **Allen Ginsberg**'s *Howl and Other Poems* and as the subject of one of the most celebrated anti-censorship victories in United States history, as well as for publishing works by Ferlinghetti's fellow Beats **Jack Kerouac**, **Gregory Corso**, and **William S. Burroughs**.

Above: Lawrence Ferlinghetti. Unfinished Flag of the United States

1988. Oil on canvas. 51–1/2 x 38 inches. Collection of the artist

Opposite: Lawrence Ferlinghetti. The Woman Who Wouldn't Lie Down

1999. Acrylic on paper. 30 x 22–3/8 inches. Collection of the author and courtesy of the artist

DONALD FINKEL

After cutting objects out of soap as a child, the poet Donald Finkel studied stone-carving at the Art Students League of New York, and it is to sculpture he has recently returned—this time to soapstone and the lighthearted assembly of scraps on hand. He acknowledges that a point came when he had to choose between sculpture and poetry:

> It seemed to me that there were equally demanding challenges awaiting me at the beginning of two paths. In the case of sculpture, I knew I needed to learn the various techniques of casting as well as carving. And, in the case of poetry, the mysteries of prosody, since, though I was composing entirely in free verse, it could easily have been because I wasn't capable of mastering form. I finally decided on the latter. And, as the ol' boy said, that's made all the difference.

In his later years Finkel was pulled back to stone-carving—and to something stranger. He felt what he describes as "an uncontrollable urge to assemble some of the scrap material in the kitchen and in the john—pill bottles, spray bottles, bottle caps, wine corks, etc." into what he calls "critters."

> "Uncontrollable" is the word. I bought myself a glue gun and opened a studio in the john. I started out calling the process "bricolage," after the French for "whatever comes to hand." I was happy enough with that term until I came across an article about some installation-type sculptor who had the gall to call his crap "haute bricolage." Now I call it "dreckolage." What fascinates me about this impulse is that it shares many of the characteristics of my writing process. I find myself doing a good deal of obsessive revising, just the same as with my poems. I've decided that the impulses lie side by side in the same area of my right lobe.

Born in New York in 1929, Finkel was the son of an attorney who had for years been maintaining a second, concealed, family. Traumatized by this revelation, Finkel ran away at fifteen with his friend Elliot Adnopoz, who later became known as the folk singer Ramblin' Jack Elliot. Eventually he returned home and earned a B.S. in philosophy and an M.A. in English at Columbia.

Finkel's nine books of precise, frequently humorous free verse have won him a Guggenheim Fellowship (1967), the Theodore Roethke Memorial Award (1974), the Morton Dauwen Zabel Award of the Academy and Institute of Arts and Letters (1980), nomination for the National Book Award (1970), two nominations for the National Book Critics Circle Award, and the position of Poet in Residence at Washington University in St. Louis, where he taught from 1960 to 1991. As founder of the Writing Program at Washington University, he instituted the requirement that student writers take at least one course in the allied arts.

Finkel's poetry examines the urge to explore (*Endurance: An Antarctic Idyll* and *Going Under,* both 1978), relationships between humans and animals (1981; *What Manner of Beast*), relationships between contemporary life and the mythological (1964; *Simeon*), and the anxieties and joys of ordinary life. His *Not So the Chairs: Selected and New Poems* was published in 2003.

Opposite, right: Donald Finkel. Critters

2001. Assemblage. Collection of the artist

Opposite, left: Donald Finkel. Untitled

2002. Black soapstone. 8 inches high. Collection of the artist

DARIO FO

*D*ario Fo considers himself an artist to the core: "When I came out of my mother's belly the first thing I said was 'Paintbrush!'" The recipient of the 1997 Nobel Prize for Literature, Fo, who began as a painter and architect, insists with some irony that "writing is just a hobby for me, my real profession is painting." He does, however, base his theatrical writings on visual preliminaries:

> Sometimes I draw my plays before I write them, and other times, when I'm having difficulty with a play, I stop writing, so that I can draw out the action in pictures to solve the problem. It's like a comic book where one frame of movement leads to the next. If the thread of the action gets lost in the words, I use drawings to help me connect one scene to another, and then the words fall into place. Drawing helps, because for me it's almost an animal instinct. I learned to draw before I could speak.

Fo credits his training in art with his perspective on the theater:

> Even today when I conceive a play, when I write it, I think in terms of "frontal and aerial views," two dimensions that are fundamental in architecture and are often referred to in painting as well. . . . I had a passion for the Renaissance, not just in Italy—I studied the great Flemish and French painters as well. I was always attracted to figure drawing. That's where I got my interest in lighting, in designing stage lights and projecting images from the stage to the audience. I draw hundreds of sketches for each of my plays. I make sketches while I write. The sketches help me to establish the foundation of the writing, to move ahead with the development of the work.

Fo was born Leggiuno Sangiano in San Giano, Italy, in 1926. His father worked for the railroad and was a part-time actor. During World War II, helped by his son, the elder Fo smuggled escapees—Allied soldiers and Jewish scientists—to Switzerland. Fo was educated at the Brera Art Academy and studied architecture at the Polytechnic in Milan.

In 1953, Fo married actress Franca Rame. Together, they founded several theater companies and collaborated on many of his plays. They were twice refused admittance to the United States— ostensibly because of their membership in the Communist Party, although the denial of a visa in the late 1960s was ascribed to Fo's insulting President Johnson in his play *La Signorina è da buttare* (1967), which touched on Vietnam and the Kennedy assassination. His most famous work from that period, *Mistero buffo* (1969; *Comic Mystery*), is a series of related, improvisatory monologues that speak of contemporary issues in a manner inspired by medieval Christian works. His plays address such issues as political revolution in Latin America, the role of women in society, AIDS, and the rights of the Palestinians. Because of this, Fo has antagonized the Italian and American governments, the Catholic Church, and the Communist Party. As a consequence, he has at various times been jailed and beaten. In 1973, Rame was kidnapped, tortured, and raped by a group of fascists to punish the couple for their political activism. The public, however, has always appreciated Fo's satirical drama. He has written more than seventy plays and has been translated into more than thirty languages.

Dario Fo. La Crociata Santa

Drawing of the Holy Crusades from Fo's notebook for *Francis, the Holy Fool*. Collection of the artist.
Photo courtesy of Aperture Foundation

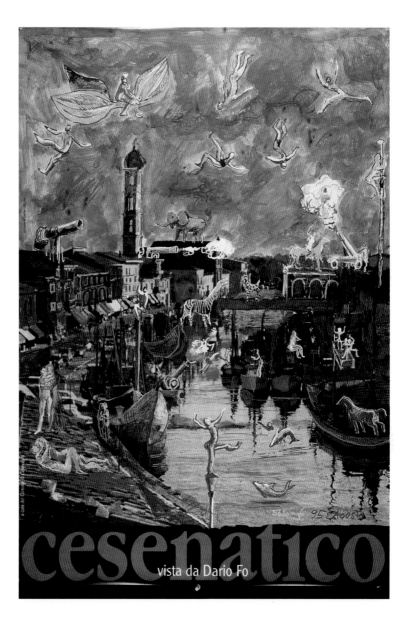

Dario Fo. Cesenatico vista da [as seen by] Dario Fo

Poster design. Collection of the artist. Photo courtesy of Aperture Foundation

CHARLES HENRI FORD

Asked which of his artistic expressions was the most satisfying, Charles Henri Ford replied, "The one I was doing at the time." Ford painted, drew, and did collage, was a photographer, and made a movie, *Johnny Minotaur* (1973), starring **Allen Ginsberg**. His photographs were first exhibited in Paris in 1954, and shown most recently in New York at the Leslie Tonkonow Gallery in 1997. Claiming, like his mentor **Jean Cocteau**, "I am a poet in everything I do," Ford added, "I'm using myself. I'm the dummy of myself. I'm the ventriloquist." In 1999, New York's Ubu Gallery showed mixed media collages with text that he had made in the 1960s, and, within weeks of his death, an exhibit of his collages opened at the Scene Gallery in New York. "I picked up on the way Matisse worked in his last phase—cutouts. . . . They turned me around completely," he said.

Ford, who published his first poetry in *The New Yorker* as a teenager, authored sixteen books of poetry and was still producing hundreds of haikus in his nineties. He was perhaps best known for *The Young and the Evil* (1933), the banned, overtly gay novel he co-wrote with Parker Tyler about his Greenwich Village life of "vice." Ford was an editor of two influential literary and art magazines. One was the short-lived *Blues: A Magazine of New Rhythms;* the other, *View*, was credited as America's first Surrealist magazine. Among *View*'s renowned contributors were Marcel Duchamp, **André Breton**, Max Ernst, Joseph Cornell, Man Ray, Meyer Shapiro, and Paul Bowles.

Charles Henry Ford (he later changed the *y* to *i* in order to avoid confusion with the auto magnate) was born in Hazelhurst, Mississippi, in 1908. His family owned a number of hotels in the south, and Ford moved frequently in his early years: "I must have stayed in hotels in Louisiana, Arkansas, Kentucky, Tennessee, Alabama." He attended private parochial schools and, as a consistent discipline problem, was expelled from two of them: "I remember when my mother was taking me away, the nun said about me, 'A rotten apple spoils the whole barrel.'"

Ford's mother, who ran off for a time with another man and whom he described as "Madame Bovary," was an artist. His sister, Ruth Ford, was an actor who appeared in productions by Orson Welles, in plays by **Tennessee Williams** and Jean-Paul Sartre, and co-wrote, with **William Faulkner**, the theatrical adaptation of his *Requiem for a Nun*. Ford described his father as a "distant" man who would carry on with waitresses during his mother's absence. When Ford was twenty-four he met and fell in love with the Russian painter Pavlik Tchelitchew, with whom he lived for the next twenty-three years. Ford's diary, published as *Water From A Bucket* (2001), ends in 1957, shortly after Tchelitchew's death.

Throughout his life, Ford traveled widely, living for extended periods in Paris, Tangiers (with **Djuna Barnes**, whose *Nightwood* manuscript he typed while they were staying with Paul and Jane Bowles), and Katmandu. He died in New York in 2002.

Charles Henri Ford. Minotaur

2000. Collage. 14 x 17 inches. Collection of the
author. With the kind permission of the estate
of Charles Henri Ford. Photo by Jason
Brownrigg

EUGÈNE FROMENTIN

From 1839 to 1844, Eugène Fromentin studied law in Paris, while he continued to write and to dabble in painting. In a poem from that period, "Peinture et poésie," he expressed a pull toward both arts. After Fromentin qualified as a lawyer, his father arranged a position in a firm for him, which he entered half-heartedly.

Fromentin felt he was an artist, and he is said to have drawn on everything, from legal documents to doors and walls. His father, on whom he was to remain financially dependent for years, reluctantly allowed him to study painting, insisting on a conventional teacher whom Fromentin left after a few months. In 1845 he entered the studio of Louis Cabat, who became his mentor and launched his career. Fromentin wrote to his mother that same year: "I am a painter, I believe it, I feel it, people tell me so; why for Heaven's sake! should I be prevented from being what I can be."

It was when he traveled to Algeria to paint the people and the landscape that Fromentin discovered that his skills were not up to the task. He wrote that "the difficulty of representation with a brush made me try the pen." Despite that crisis of insecurity, his paintings met with great success, especially after the loosening influence of Delacroix. He participated in the annual Paris Salons, and was reviewed favorably by **Théophile Gautier**, **George Sand**, and **Charles Baudelaire**. By the early 1860s Fromentin was well established as writer and painter; his novel *Dominique* (1863) was selling well, and the government of France had paid a large sum for one of his paintings. Today, his work is in the collections of the Louvre and the Metropolitan Museum of Art.

After Fromentin had become a recognized artist, the publisher of his Algerian books asked for an edition with his illustrations. Fromentin refused, insisting that his art and writing be kept separate. Although he believed the two forms of expression were complementary in his imagination, he felt they were incompatible as manifested. Following a long period of painting, Fromentin confided in George Sand and the Brothers **Goncourt** that he was bored and wanted to write again, but feared that he was no longer able: "Literature is at the bottom of the well: Will it come out? And when?"

Fromentin's words did re-emerge, and shared with his images the depiction of life as seen through the filter of memory. Fromentin did not sketch or take notes when he traveled; he only observed. He then painted, or wrote, what he recollected. He discussed his use of creative memory with the Goncourts, emphasizing again that he refrained from drawing in order to force himself to really observe.

Fromentin wrote poetry in his youth, brilliant art criticism in later life, and established his literary talent in travel books about Algeria. But he achieved fame as a writer with *Dominique*, the classic story of the lost love of his youth, recounted through the eyes of middle age. Eugène Samuel Auguste Fromentin was born in 1820 in La Rochelle, France, and died there in 1876.

Eugène Fromentin. Arab Skirmish

Black and white chalk. 6–1/2 x 11–7/8 inches. The Metropolitan Museum of Art, Gift of Albert Gallatin, 1920 (20.166.1)

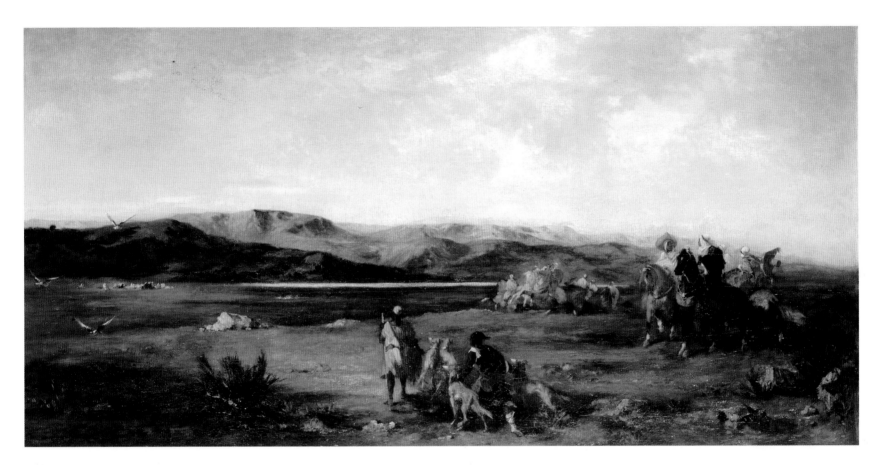

Eugène Fromentin. Gazelle hunt in Hodna, Algeria

1856. Oil on canvas. 38–1/2 x 76–3/4 inches. Musée des Beaux-Artes, Nantes, France. Giraudon/Art Resource

GAO XINGJIAN

Painting starts where words fail or are inadequate in expressing what one wants to express," says Gao Xingjian. "Painting is purely visual. When I'm painting I try to dismiss all language. I just listen to music, I avoid all verbal associations."

The avant-garde author of novels, plays, and short stories, Gao earned his living primarily as an artist until recognition as a writer came with major literary awards in the 1990s. He has had more than thirty international exhibitions of his paintings and is represented in museum collections in France, Germany, Sweden, and Taiwan. After receiving the Chevalier de l'Ordre des Arts et des Lettres from France in 1992 and the Prix Communauté Française de Belgique in 1994, Gao became in 2000 the first Chinese writer to win the Nobel Prize for Literature. His best-known book, *Soul Mountain* (1999), is an impressionistic work based on a walking tour he took along the Yangtze River.

Gao studied violin, and writes and paints to music. He lays great emphasis on the musicality of language: "Sometimes I find intonation, melody, to be more important than meaning." Writers, he says, are trying to express "the human consciousness behind language," but are limited in that effort because they are required to express consciousness "through language."

Though he initially used colors in his visual work, after a government command to take black-and-white photographs of peasants during the Cultural Revolution, Gao was inspired to make ink paintings. Composed in the traditional Chinese medium of black ink on rice paper, his paintings, executed in carefully considered strokes, are highly atmospheric, evocative, nonfigurative landscapes. Painting, in Gao's words, "means returning to the artist's instinct; returning to feeling; returning to life; returning to vitality; returning to the present, eternal moment in time."

Gao was born in Ganzhou, China, in 1940, the son of a bank official and an amateur actress. He studied French literature at the Beijing Foreign Languages Institute, but in the early 1960s he was ordered to perform farm labor. At the same time, his mother was sent to the country, where she drowned in an accident. During the Cultural Revolution, Gao was ordered to a re-education camp where, fearing recriminations, he burned a suitcase full of manuscripts of his novels, plays, and essays and endured six years of hard labor in the fields.

Eventually, Gao became a translator in the Chinese Writers Association—he has translated and been influenced by the works of Beckett, **Ionesco**, **Artaud**, and Brecht—and then was made resident playwright at the Beijing People's Art Theatre. His plays were condemned by the Communist Party as "intellectual pollution" and banned from performance. In 1987 Gao left China and settled in France. Shortly after the Tiananmen Square massacre, he dropped his membership in the party and began writing in French. In his Nobel acceptance speech, Gao said that he saw writing as basically a self-validating act and that the transformative goals of the writer are of no consequence in the process: "Whether it has any impact on society comes after the completion of a work, and that impact certainly is not determined by the wishes of the writer." He told Harvard students in 2001, "Not only do I not write to change society, but I feel an individual person could not do so anyway."

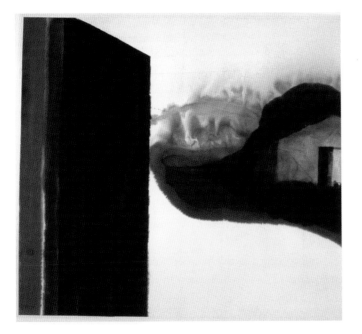

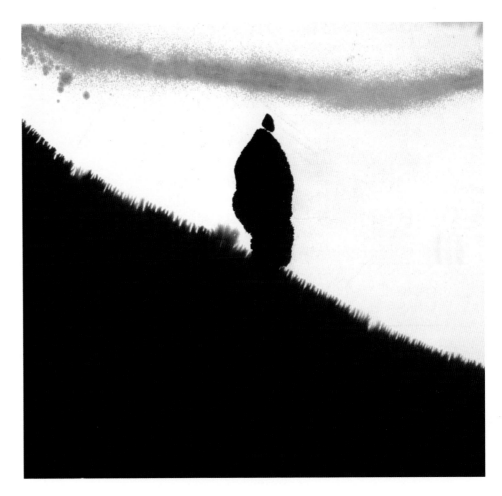

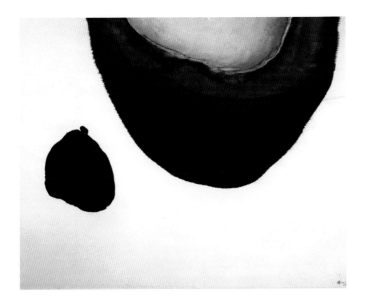

Above: Gao Xingjian. Recueillement (Meditation)
1997. Ink on paper. 15–1/4 x 15–1/2 inches. Courtesy of the artist and Goedhuis Contemporary

Left, top: Gao Xingjian. L'Oubli (Oblivion)
1997. Ink on paper. 42–1/2 x 39 inches. Courtesy of the artist and Goedhuis Contemporary

Left, bottom: Gao Xingjian. Fugue III
1998. Ink on paper. 38–1/4 x 27 inches. Courtesy of the artist and Goedhuis Contemporary

FEDERICO GARCÍA LORCA

n 1927, having given up a promising career as a classical pianist and established himself as a poet and playwright, twenty-eight-year-old Federico García Lorca began drawing. He already had a habit of sketching casually in pencil, ink, and crayon, and of illustrating his letters; but at the urging of his friends and an art critic he started to focus on producing stand-alone works. Within the year he had a show at the Dalmau Gallery in Barcelona. No exhibits followed, however, and Lorca's untutored art, which he continued to pursue, became essentially a private matter.

Lacking in technique that he might have acquired with study, Lorca's drawings are appealing in their simplicity. His friend, the artist Gregorio Prieto, observed that Lorca's art, like his poems, showed "the influence of all the movements that followed fast on one another in the between-war period to which his poetry belongs." Those influences included Modernism and especially Surrealism. In Prieto's view, however,

> The best drawings are those in which he forgets about schools and puts down, with child-like innocence, whatever comes into his fancy, as if he were secretly escaping into the world of his dreams.

Lorca, who illustrated the poems that became the posthumous collection *Poeta en Nueva York* (1940; *Poet in New York*), one day told Prieto, "You know Gregorio, the poetry of your painting and the painting of my poetry spring from the same source."

Spain's greatest twentieth-century poet and playwright was born in 1899 in Fuente Vaqueros, a rural town near Granada, Spain. Lorca was a leading member of the "Generation of 1927," part of the group that included **Rafael Alberti**, Salvador Dalí, and

Luis Buñuel. Lorca's father was a well-to-do landowner who supported his son throughout his life. His mother was a gifted pianist. Lorca idolized her and inherited her gift, but at his father's insistence, he enrolled as a law student. He continued, however, to study piano, and took up art and literature.

A professor invited him and other students on art tours around Spain, resulting in Lorca's first book, *Impresiones y paisajes* (1918), published with funds from his father. When composer Manuel de Falla visited Granada the following year, they met and began to collaborate. Lorca then left school and, dividing his time between Granada and Madrid, devoted himself to poetry and playwriting, staging his first play, *El maleficio de la mariposa (Butterfly's Evil Spell)* in 1920.

Fame came to Lorca with the poetry collection *Primer Romancero Gitano (The Gypsy Ballads)* in 1928. The following year, he enrolled in a summer course in English at Columbia University. He engrossed himself in city life and witnessed the stock market crash that marked the start of the Great Depression. Those experiences generated his *Poeta en Nueva York*. In 1930 Lorca returned to Spain after a brief stay in Cuba.

When the Spanish Civil War broke out in 1936, Lorca was a prominent figure in the arts, liberal, homosexual, and part of a family connected to the leftist government. He was arrested by the fascist Franquists. After being pummeled with rifle butts, he was killed in a mass execution. His body was thrown into an unmarked common grave. Lorca's books were publicly burned in Granada and banned throughout Spain. Among his best-known works are the plays *Bodas de sangre* (1933; *Blood Wedding*) and *La casa de Bernarda Alba* (1936; *The House of Bernarda Alba*).

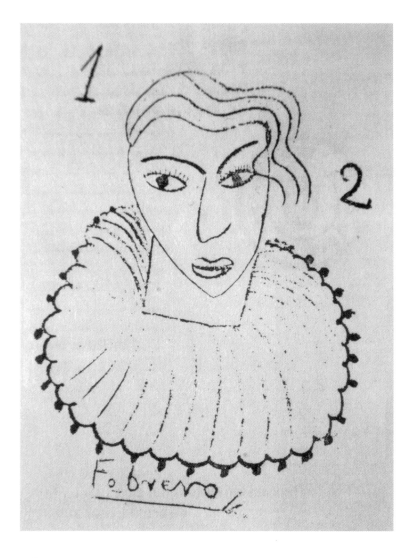

Federico García Lorca. 12 Febrero (12 February)

1929–30. Pen and ink on paper. Index/Bridgeman Art Library. Copyright © 2007 Artist Rights Society (ARS), New York/VEGAP, Madrid

Federico García Lorca. Untitled (two-headed figure)

1919. Pen and ink on paper. Index/Bridgeman Art Library. Copyright © 2007 Artist Rights Society (ARS), New York/VEGAP, Madrid

THÉOPHILE GAUTIER

*I*magination is the one weapon in the war against reality."

Poet, short story and travel writer, theater and art critic, playwright, and novelist, Théophile Gautier began art studies during his last two years of high school, which he described as spent mainly at "Monsieur Petit's swimming school and in Louis-Edouard Rioult's studio, where I studied painting." The result, he claimed, was that he became an excellent swimmer and "decent at drawing, without doing too much harm to my later literary efforts."

Recollecting his first exposure to art studies, Gautier wrote:

> Rioult was a man of a profound and mystical ugliness, whom palsy forced, like Jouvenet, to paint left-handed, and who was not the less skillful for it. At my first lesson he found me full of vigor, an accusation at least premature. The scene so well told in *L'Affaire Clemenceau* [by **Dumas** *fils*] played out for me at the modeling table, and the first female model did not seem beautiful to me, and disappointed me most deeply, such does art add even to most perfect nature. This was nonetheless a very pretty girl, whose pure and elegant lines I appreciated later, by comparison; but, following this initial impression, I always preferred the female statue and marble to flesh.

At that time Gautier's family was living at number 8 in the Place Royale. "I do not note this detail to point out one of my dwellings for the future," he wrote. "I am not of those whose houses posterity will mark with a bust or a marble plaque. But this circumstance factored heavily in the direction of my life." The reason was that **Victor Hugo**, at the height of his glory, moved into number 6, and Gautier's introduction to "the Romantic Jupiter" had the effect that "[l]ittle by little I neglected my painting and turned toward literary ideas. . . . Drunk on his favor, I sought to deserve it." Gautier began to write poetry, publishing his first collection of poems at nineteen.

Born in Tarbes, in the Pyrennes, in 1811, Gautier was the son of a government bureaucrat who relocated to Paris when the boy was three. Gautier wryly insisted he felt such an immediate longing for his birthplace that he attempted suicide:

> Having thrown my toys out the window I intended to follow them if, fortunately or unfortunately, I hadn't been grabbed by my jacket. My parents were only able to get me to go to sleep by telling me to rest up so I could try again at the crack of dawn.

Gautier's minutely descriptive writing reflected his artist's eye. **Baudelaire** dedicated *Les Fleurs du mal* to Gautier, calling him "the impeccable poet, the perfect magician in letters" and his "revered master and friend." Owing to the financial demands of supporting his mother, sisters, two former mistresses, and three children, Gautier was forced to earn a "humiliating" living as a journalist, and calculated his writings would fill "something like 300 volumes."

Gautier did not abandon his art entirely. Among his surviving works are portraits of Carlotta Grisi, the ballerina who inspired him to write *Giselle* in 1841. Addressing her as "You before whom I burn and tremble," Gautier was mad for Carlotta, though her sister Ernesta was his partner. He died in 1872 in Paris, where he received a state funeral.

Above: Théophile Gautier. Portrait de femme

1831. Paris, Musée Balzac. Copyright © Photothèque des musées de la ville de Paris/Cliché: Joffre

Above: Théophile Gautier. Portrait de femme

Paris, Musée Balzac. Copyright © Photothèque des musées de la ville de Paris/Cliché: Joffre

Opposite: Théophile Gautier. Jeune femme nue

1831. Paris, Musée Balzac. Copyright © Photothèque des musées de la ville de Paris/Cliché: Joffre

KAHLIL GIBRAN

The author of *The Prophet* (1923), the bestselling book in the history of its publisher, Alfred A. Knopf, Kahlil Gibran had an unhappy childhood but said, "I did not know I was sad. I just knew I was longing to be alone, making things." His earliest recollections were of hoarding "hundreds of pencils," which he used, first in hurried sketching on paper, and then "when there were no more sheets . . . on the walls of the room." As an eight-year-old, he made casts of gods out of "sardine cans and sand."

Gibran also recalled writing compositions with moral lessons. In one he told of an old miserable man and "how another man came and helped him and did him good—a real Good Samaritan story."

In 1895, when Gibran was twelve, his mother took her children from their home in Lebanon to Boston and placed Gibran in a public school. A year later he appeared in a drawing class at College Settlement and impressed the teacher, who informed one Jessie Fremont Beale, who wrote in Gibran's behalf:

> I am wondering if you may happen to have an artist friend who would care to become interested in a little Assyrian boy Kahlil G. He is not connected with any society, so any one befriending the little chap would be entirely free to do with him what would seem in their judgment wise. . . . His future will certainly be that of a street fakir if something is not done for him at once. The family are horribly poor.

By 1908, Gibran was studying with August Rodin at the Academy of Fine Arts in Paris. He pursued studies in painting and sculpture, and later illustrated a number of his books.

After a long stretch of writing and not painting, Gibran wrote:

> I can't paint again now until I am free from writing. . . . When I was younger, I used to do them both together—would just draw at any time; but now I can't do that. . . . I have been learning about putting form and color together . . . I knew there was something radically wrong with my work. . . . It didn't say what I wanted it to say and that something was color. . . . When I have painted these [new] pictures, I will destroy everything else that didn't lead up to them.

But he felt a mission greater than his art:

> I want some day not to write or paint but simply to live what I would say, and talk to people. I want to be a Teacher. . . . I want to wake their consciousness to what I know it can know. Because I have been so lonely, I want to talk to those who are lonely—and so many are lonely.

In addition to *The Prophet*, Gibran is the author of dozens of other books of poetry and prose that presented, often in simple parable and epigram, his mystical approach to life's problems. Born in Bechari, Lebanon, in 1883, he died in New York in 1931, leaving all of his very considerable royalties to Bechari—provoking years of litigation by heirs and claimants. *Kahlil Gibran: Paintings and Drawings, 1905-1930* was published in 1989.

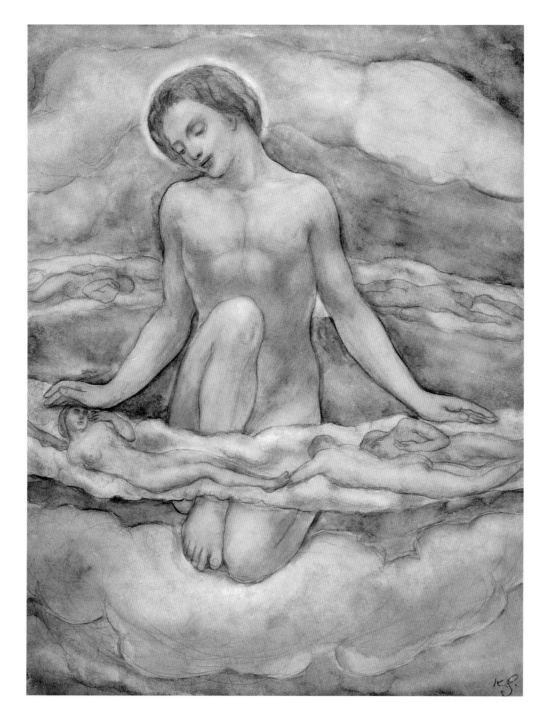

Kahlil Gibran. Nude Figure
Kneeling among Clouds

C. 1928. Graphite pencil and watercolor
on paper. 11 x 8–1/2 inches. Copyright ©
2002 Museum of Fine Arts, Boston. Gift
of Mrs. Mary Haskell Minis; 32.106

w. s. GILBERT

Besides operettas, operas, and plays, W. S. Gilbert—the writing half of the Gilbert and Sullivan team—wrote and illustrated collections of short stories, and under the name "Bab" published *The Bab Ballads* (1869) and *More Bab Ballads* (1872), collections of humorous verse and drawings, many of which had appeared in *Punch* and *Fun* magazines.

In his 1883 autobiography, Gilbert explained how he came to write an illustrated column and what he learned about his creative process:

> In 1861, *Fun* was started, under the editorship of Mr H. J. Byron. With much labour, I turned out an article three-quarters of a column long, and sent it to the editor, together with a half-page drawing on wood. A day or two later, the printer of the paper called upon me, with Mr Byron's compliments, and staggered me with a request to contribute a column of "copy" and a half-page drawing every week for the term of my natural life. I hardly knew how to treat the offer, for it seemed to me that into that short article, I had poured all I knew. I was empty. I had exhausted myself: I didn't know any more. However, the printer encouraged me (with Mr Byron's compliments), and I said I would try. I did try, and I found to my surprise that there was a little left, and enough indeed to enable me to contribute some hundreds of columns to the periodical throughout his editorship, and that of his successor, poor Tom Hood! And here I may mention, for the information and encouragement of disheartened beginners, that I never remembered having completed any drama, comedy, or operatic libretto, without feeling that into that drama, comedy, or operatic libretto, I had poured all that I had, and that there was nothing left.

Of Gilbert's journalism only *The Bab Ballads* has survived. When the pieces were collected, Gilbert claimed he decided "to publish the little pictures with them, because while they are certainly quite as bad as the ballads, I suppose they are not much worse."

In the *Bab* drawing opposite, Gilbert performed a deconstruction of his own character—unsparing in his satire, even when he was the subject. Surrounding the grumpy-looking author are eight admissions of his distemperate nature:

> "I loathe everybody"–"I love to bully"–"Everybody is an Ass"–"I am an overbearing beast"–"I hate my fellow man"–"Confound everything"–"I like pinching little babies"–"I am an ill-tempered pig, & I glory in it—W. S. Gilbert"

Author and director of the fourteen G&S operettas, including *H. M. S. Pinafore* (1878), *The Pirates of Penzance* (1879), and *The Mikado* (1885), Gilbert wrote fifty-seven other plays, operas, and musicals, some under the name F. Latour Tomline.

William Schwenk Gilbert was born in London in 1836. He attended King's College, London, practiced law for four years, and before he was twenty-four had written fifteen unproduced farces as well as unpublished poems, skits, and magazine articles. He died in 1911 after rescuing a drowning woman in a lake on his estate in Harrow Weald, Middlesex, England.

Above: W. S. Gilbert. Gilbert and Bab. Self-caricature

Right: W. S. Gilbert. General John. Illustration from *The Bab Ballads*

THE bravest names for fire and flames,
 And all that mortal durst,
Were General John and Private James,
 Of the Sixty-seventy-first.

General John was a soldier tried,
 A chief of warlike dons;
A haughty stride and a withering pride
 Were Major-General John's.

ALLEN GINSBERG

The year before he died Allen Ginsberg was asked, "What brings you joy right now?" His answer: "Making love to younger fellows. Finishing an artwork, seeing a new photograph that I've done well printed. Finishing a new drawing." When asked "What has remained for you, now at age seventy?" he replied:

> Well, a big pile of books, a big pile of records, a big pile of photographs, a big pile of drawings, a big pile of memories, of friends, imprints of their spirit on my own, imprints of their breathing and of their minds, like Kerouac.

Like his fellow Beats—**Kerouac, Burroughs, Corso,** and **Ferlinghetti**—Ginsberg drew and painted. He also had a book of his photographs published. He did not think doing art required much more than not considering how it would be received and getting "out of the commercial trap by realizing that it is only a trap, that you're not going to die":

> Art isn't art, actually. It isn't intended to be art. Art starts as sort of fucking around, experimenting with whatever you're interested in, like somebody who makes a bridge out of toothpicks. It's on that level. It has nothing to do with museums or art. Can you write a poem that says what your feelings are; can you paint a picture that will give the optical impression of space without using perspective lines?

Nonetheless, Ginsberg took a demurring, realistic view of his and his friends' skills:

> If you're famous, you can get away with anything! If you establish yourself in one field, it's possible that people then take you seriously in another. Maybe too seriously. I know lots of great photographers who are a lot better than me, who don't have a big, pretty coffee table book like I have. I'm lucky.

Ginsberg's prophetic poetry woke America up to the spiritually deadening evils of all forms of government, business, scientific, and social control, and it inspired political and ideological resistance as well as new forms and voices in poetry. Born in 1926 in Newark, New Jersey, he was the son of Louis Ginsberg, an English teacher and poet. His Communist mother, Naomi, mourned in his long poem *Kaddish* (1961), suffered from mental illness and was institutionalized for many years.

Ginsberg attended public school in Patterson, New Jersey, home of **William Carlos Williams**, his first mentor, and then Columbia University, where he received a B.A. in 1948. Ginsberg's epic poem *Howl* (1956) was published by Ferlinghetti's City Lights Press. Printed in England, it was intercepted by U.S. Customs and declared obscene. Distribution was permitted only after the famous censorship trial, and the poem became a great success. Ginsberg loved all beings and described himself as a "Buddhist Jew with attachments to Krishna, Siva, Allah, Coyote, and the Sacred Heart." When he died in New York in 1997, Ginsberg had been honored with a Guggenheim Fellowship (1965), a National Institute of Arts and Letters Award (1969), the National Book Award for *The Fall of America* (1974), and membership in the American Institute of Arts and Letters (1974).

Opposite: Allen Ginsberg. Dragon

The Allen Ginsberg Trust catalog #9927

Above: Allen Ginsberg. Buddha's Footprint

1963; 1990. Colored ink. 5 x 7–1/4 inches. Robert La Vigne Papers, Rare Book and Manuscript Library, Columbia University. (Ginsberg found this design on a wall in India in 1960 and used it on a placard he carried at demonstrations. He later commissioned a polished version from artist friend Harry Smith, which he thereafter used on covers of his books.)

12/10/96

Brooklyn College

JOHANN WOLFGANG VON GOETHE

Johann Wolfgang von Goethe was the Olympian genius, the center of an age, Germany's cultural monument. The endlessly talented poet and playwright was also an artist—painting at first, then drawing and etching. In his autobiography, *Aus meinem Leben: Dichtung und Wahrheit* (1811–33; *Out of My Life: Poetry and Truth*), Goethe acknowledged his preoccupation with the visual arts, declaring that in them "I was to find the greatest satisfaction of my life." A passion for Italy and classical art was early inspired by works in his father's home:

> I was particularly fascinated by a series of views of Rome with which my father had decorated an ante-room, and which had been engraved by some skillful predecessors of Piranesi. . . . These scenes made a deep impression on me and my normally very taciturn father would from time to time regale us with a description of the object depicted.

The visual, said Goethe, dominated his life:

> The eye was above all others, the organ with which I apprehended the world. I had lived among painters from childhood and had grown accustomed like them to look at the objects about me from the point of view of the artist.

Goethe's father, a painter, was supportive of his son's interest; Goethe took art classes in Leipzig while pursuing his academic studies. He believed there was a complementary relationship between poetry and art:

> The numerous subjects that I saw treated by the artists awakened the poetic talent in me, and just as one makes an engraving to a poem, so I made poems to the engravings and drawings by imagining to myself the state of the characters before and after their portrayal in the pictures. I sometimes even composed a little song which would have been appropriate for them, and so accustomed myself to consider the arts in combination with one another.

Goethe saw art as springing from an understanding that was deeper than the intellect:

> These sublime works of art are, at the same time, supreme works of nature produced by man in accordance with nature's laws; everything arbitrary or fanciful is eliminated. All is necessity, is God.

Goethe was a poet, artist, novelist, playwright, journalist, songwriter, historian, art and literary critic, and lawyer who wrote volumes on geology, physics, botany, and comparative anatomy and translated Hebrew, Greek, Latin, French, Italian, and English. He was also a court adviser in charge of mining, highways, finance, and military defense and acted and played the cello. Born in 1749 in Frankfurt-am-Main, Germany, his family was solidly middle-class—his father a retired lawyer and his mother the daughter of a mayor. Of eight children, only Goethe and his sister Cornelia survived. When he died in 1832 in Weimar, Saxe-Weimar, having completed his masterpiece, *Faust*, his last words were "Light—more light!"

Johann Wolfgang von Goethe. *Zür Farbenlehre (On the Theory of Colors)*, Plate 1

1810. Tübingin: J. G. Cotta, Heinemann 663, The Pierpont Morgan Library/Art Resource, New York

Above: Johann Wolfgang von Goethe. *Evoking the Spirit of the Earth. Illustration for* Faust

1810–12 or 1819. Crayon on paper. 8–5/8 x 6–3/4 inches. Weimar, Nationalen Forschungs-und Gedenkstätten der klassischen deutschen Literatur

Left: Johann Wolfgang von Goethe. *Profile portrait of Cornelia Goethe*

1773. Copyright © BPK, Berlin

NIKOLAI GOGOL

The author of such classics as *Dead Souls* and "The Overcoat" (both 1842) and *The Inspector General* (1836), Nikolai Gogol studied painting in his early twenties at the Saint Petersburg Academy of Fine Arts. Although he gave up painting, he continued to draw and designed at least one of his book covers. Scholar Gavriel Shapiro has explored Gogol's aesthetic roots in Baroque culture and found it informed his writings—poetry, stories, and plays—as well as his drawings. Gogol's education in the Baroque began with his exposure to Baroque-influenced art, architecture, and literature in his native Ukraine, and developed while he lived in Moscow, in Saint Petersburg, and finally for eleven years abroad. Gogol's father was a comic writer who also produced theater and puppet shows for a local nobleman, all in the Baroque tradition. Shapiro demonstrates that Gogol was so taken with Baroque chiaroscuro—the contrast of light and shadow—that he employed it regularly in literary portrayals of landscapes and characters:

> [T]he fickle light of the candlewick, enclosed in a misty circle, threw a pale ghost of light on his face, while the shadow from his enormous moustache was rising and covering everybody in two long bands. Only the crudely carved outline of his face was definably touched by the light and made it possible to discern a deeply insensible expression on his face.

In his drawing for the cover for *Dead Souls*, Gogol incorporated images that included serfs, musical instruments, masks of satyrs, houses, and horse-drawn carts into his finely detailed, curving, ornamented chiaroscuro design—all references to the book's themes. Fascinated with Baroque architecture and especially by the grandeur manifest in churches and cathedrals, Gogol made many drawings of church architecture, including the drawings opposite.

Nikolai Vasilievich Gogol was born in 1809 in Sorochincy, Ukraine, and died in 1852 in Saint Petersburg. Not expected to survive infancy, Gogol had a sickly childhood, and illness—most of it psychologically induced—afflicted him throughout his brief life. A withdrawn boy who did not speak until he was three, he was traumatized at age nine by the death of his younger brother. Shortly afterward he was sent away to school, where he was a poor and slovenly student nicknamed "the mysterious dwarf" by his classmates. When the boy was sixteen, his father died, and Gogol, as the eldest child, assumed responsibility for his family.

Giving up a boring job as a civil servant, he secured a position as history teacher—first at a women's school, then in 1843 at the University of Saint Petersburg. He was unqualified, however, and his comic performance during his brief tenure in the post was described by his student Ivan Turgenev. Gogol would skip two-thirds of his lectures, Turgenev wrote, and when he did appear "he did not so much speak as whisper something incoherently . . . looking terribly embarrassed all the time." When final exams arrived, "he sat with his face tied up in a handkerchief, as though suffering from a toothache," while another professor questioned the students.

In 1847, having fallen under the influence of a fanatical priest, Gogol was persuaded to stop writing, burn his unpublished work, and finally starve himself to death in what he believed would be a purifying fast. In acknowledging Gogol as the progenitor of Russian literature, **Dostoevsky** declared that he and his literary brothers "all came out from under 'The Overcoat.'"

Nikolai Gogol. Untitled (drawings of cathedrals)

C. 1843. Pencil on paper. State Library, St. Petersburg, Russia

EDMOND AND JULES DE GONCOURT

Edmond and Jules de Goncourt, known as "the Brothers Goncourt," dedicated their lives to art and literature. They lived, wrote, and shared women together, and together determined to have careers as artists. They sketched, painted, and were printmakers. They attended art school—Edmond studied under Dupois and Pouthier—and learned from the work of masters. "Whilst in Florence," wrote Edmond, "we fell seriously, conscientiously, and laboriously in love with the Pre-Raphaelites, the Giottos, the Gaddis, the Lippis, the Botticellis, Pollaiolos, and Beato Angelicos. . . . [W]e paid them assiduous courtship, and finally, through overmuch gazing, we constantly discovered an original idea in a drapery, a new school in a big toe, a system in the drawing of a cloud, and a genius in the poorest and most simple painter of the epoch." Edmond destroyed virtually all of his work, saving, notably, a pastel portrait of his brother, now owned by the Académie Goncourt and the 1857 portrait in watercolor reproduced here, which Jules later turned into an etching. Some drawings, however, are preserved, since they illustrated Paul Lacroix's *Le Moyen Age et la Renaissance.*

The brothers traveled through Algeria and France, then in Belgium and Italy, and painted as well as wrote detailed descriptions of what they saw. Jules's critically praised art—especially the eighty-six etchings that survive—secure his place in the company of **Hugo** and **Fromentin**, the best of his contemporary writer-artists. Jules was a pupil of Gavarni, a caricaturist, and exhibited at the Paris Salon from 1861 through 1865. He described the importance of art in the brothers' lives:

[N]othing in our life has taken such a hold on us as these two things: drawing formerly, and now etching . . . which makes you completely forget not only time but also the vexations of life, and everything else in the world. For whole long days together you live entirely absorbed by it. . . . Never, perhaps, in any circumstance of our lives, so much desire, impatience, or frenzy to arrive at the next day, and the success or utter failure of the printing. And to see the plate washed, see it blacken, see it grow clean, see the paper getting wet, and to set up the press and spread the coverings on it, and give the necessary two turns, this makes our hearts flutter in our breasts, and our hands tremble as we seize this dripping sheet of paper on which shimmers the misty semblance of a picture that has hardly taken shape.

Edmond was born in Nancy, France, in 1822 and died in Paris in 1896. Born in Paris in 1830, Jules contracted syphilis as a young man and died at thirty-nine in Paris in 1870. They endured a bitter childhood. "Jules's pretty face," wrote Edmond, "had the gift of arousing the hatred of his school-fellows. . . . [S]everal times they attempted to disfigure him." Edmond's own experience was of fighting "with boys who were stronger than myself, and forced me to live in that kind of quarantine which the despotism of incipient tyrants imposes on the cowardly spirit of men-children." His artistic aspirations thwarted by his mother, he was forced to endure a job as a lawyer's clerk. Miserable at work ("the temptation to suicide came very near to me"), Edmond and his brother were freed of such concerns when their widowed mother died in 1848 and left them a modest income.

JULES DE GONCOURT
From a Water Colour Sketch by Edmond de Goncourt, 1857

Above: Edmond de Goncourt. Jules de Goncourt

1857. Watercolor. From M. A. Belloc and M. Shedlock, eds., *Edmond and Jules de Goncourt*, Vol. I (1895)

Left, top: Edmond de Goncourt. La Cheminée de Jules (Jules's mantel)

1859. Etching. S. P. Avery Collection, Miriam and Ira D. Wallach Division, New York Public Library

Left, bottom: Jules de Goncourt. La Salle d'Armes (the fencing room)

Etching. S. P. Avery Collection, Miriam and Ira D. Wallach Division, New York Public Library

EDWARD GOREY

In a 1997 *Speak* magazine interview, Edward Gorey said:

> If push comes to shove I consider myself more of a writer. For the last ten years I've mainly done theater, so now there are three of me—the writer, the artist, and the theater person.

Gorey said he learned very early that his creative process required him

> to have the text completely written before I could do the drawings. . . . I mean I can start by doing the drawings, it wasn't that. It was if I started the drawings, I'd never finish the text. I had to know how it was all going to come out.

Writing was not a matter of rational construct for Gorey. "I'm a great Jungian," he said; the older he got the more he relied on his unconscious. He added that although his writing may flow without thought, "a lot of it is very concrete."

> For instance, at the beginning of my play an object falls from the sky, and throughout there are twelve different versions of what it was, and they're all Surrealist objects that bear no relation to anything at all. One is a model of the Eiffel Tower made out of toothpicks, one time it's a cast-iron bathtub, another time it's a canoe. I just kind of conjured them up out of my subconscious and put them [in order] of ascending peculiarity.

A fan of ballet, Gorey claimed George Balanchine as his greatest influence insofar as Balanchine didn't waffle, didn't let his dancers worry about meaning, but said, "Just do the steps." Gorey said he, too, tried "not to presuppose what I'm doing," but to "just do it," claiming that "I usually don't know what I've done until long after I've done it."

Gorey, who wrote—for children and adults—more than ninety books of humorous, macabre stories told in mock-Victorian prose accompanied by his elegant drawings of bleak characters and bizarre creatures, also designed sets and costumes for the theater and illustrated about sixty other books. Two collections of his stories, *Amphigorey* (1972) and *Amphigorey Too* (1975), were adapted

for the stage as *Gorey Stories* (1974–75). He won a Tony Award for costume design in 1978 for a stage adaptation of *Dracula*.

Edward St. John Gorey was born in Chicago, Illinois, in 1925; he died in Cape Cod, Massachusetts, in 2000. He said that he started drawing as a very young child, and that his first drawing

> was of the trains that used to pass by my grandparents' house, done at age three and a half. The composition was of various sausage shapes. There was a sausage for the railway car, sausages for the wheels, and little sausages for the windows.

A is for AMY who fell down the stairs

Edward Gorey. "A is for Amy who fell down the stairs"

From *Gashlycrumb Tinies* (1962). Published with permission of the Edward Gorey Charitable Trust, courtesy of Gotham Book Mart, Inc., New York City

Caviglia's revival of *Elagabalo* was cut short when the authorities had the curtain rung down on the triple-wedding scene.

Edward Gorey. "Caviglia's revival of *Elagabalo* was cut short when the authorities had the curtain rung down on the triple-wedding scene"

From *The Blue Aspic* (1975). Published with permission of the Edward Gorey Charitable Trust, courtesy of Gotham Book Mart, Inc., New York City

GÜNTER GRASS

The winner of the 1999 Nobel Prize for Literature, Günter Grass describes himself as "a studied artist and a self-made writer." Following a year as an apprentice sculptor in 1947, Grass studied sculpture and graphic art at the Academy of Art in Düsseldorf from 1948 to 1952, supporting himself by dealing in the black market and playing drums. In 1953, he moved to Berlin and continued his sculpture studies at the Hochschule für Bildende Künste.

Over the years, Grass has done drawings, paintings, several hundred etchings, engravings, and lithographs, and is internationally exhibited and collected. His art is rendered with detailed, realistic elements that are distorted or combined in a shockingly surreal fashion. He has illustrated a number of his books—and book covers—including the collections of poems *Die Vorzüge der Windhühner* (1956), *Gleisdreieck* (1960), and *Novemberland* (1993), and *Zunge zeigen* (1987; *Show Your Tongue*), a horrifying diary in words and drawings of six months spent in Calcutta. Books that especially show Grass's work as a fine artist are *Zeichnen und Schreiben* (2000; *Drawing and Writing*) and *In Kupfer, auf Stein* (1986; *In Copper, on Stone*).

Grass has said that his visual expressions underpin his literary work. Of his novel *Der Butt* (1977; *The Flounder*), he wrote, "Long before I wrote . . . the story of the flounder as a novel, I was depicting the great flatfish with a brush, a quill, charcoal and soft lead." He made the point even more emphatically in an essay written for the catalogue that accompanied a 1979 exhibit of his work at the National Museum in Stockholm. There, Grass insisted, "Not until it has been turned into a graphic image does a verbal metaphor reveal whether it is valid."

Grass sums up the relationship between word and image:

> Prints are often depictions of poems and many poems sketch outlines, work in shades of grey. . . . Look, says the image, at how few words I need. Listen, says the poem, to what you can read between the lines. . . . Our demarcation of the arts is of recent date and dictated merely by academic rulings.

Grass was born in 1927 in Danzig (now Gdansk, Poland). Before he became Germany's greatest living novelist he was variously employed as a farm worker, miner, stonecutter, jazz drummer, and speechwriter for West Berlin mayor Willy Brandt. A Hitler Youth member, Grass went into the army at sixteen; he was wounded and held as a prisoner of war. Written in Paris, his first novel, *Die Blechtrommel* (1959; *The Tin Drum*)—a fantastic exploration of the history of Germany before, during, and after World War II—made his reputation as a writer and conscience of his generation. It was followed by *Katz und Maus* (1961; *Cat and Mouse*) and *Hundejahre* (1963; *Dog Years*). Grass was elected a member of the Berlin Academy of Arts in 1963. His subsequent novels were political, challenging, and prophetic, addressing such issues as the Vietnam War, nuclear proliferation, and the desperate condition of people living in the developing world.

Above: Günter Grass. Scorpion landscape.

Lithograph. 8 x 11 inches. Collection of author. Copyright © 2007 Artist Rights Society (ARS), New York/VG Bild-Künst, Bonn.
Photo by Jason Brownrigg

Left: Günter Grass. Self-portrait with fly.

1980. Lithograph. 6 x 3–1/2 inches. Collection of author. Copyright © 2007 Artist Rights Society (ARS), New York/VG Bild-Künst, Bonn. Photo by Jason Brownrigg

KATE GREENAWAY

Kate Greenaway wrote and illustrated about 150 books, mainly for children. Her colorful, refined, childhood-idealizing art altered the concept of the picture book and spawned innumerable imitators. Her first book, *Under the Window* (1879), became an instant bestseller in Britain and the U.S., and its illustrations drew critic John Ruskin to write her and begin a close, mentoring relationship that lasted the remainder of his life. What Ruskin found so admirable in Greenaway's art was the way it romanticized childhood and its innocence, its expression of "infant divinity." More concretely, he observed that in the world she depicted, "There are no railroads in it to carry the child away . . . no tunnel or pit mouths . . . no league-long viaducts . . . no blinkered iron bridges."

Greenaway's letters to Ruskin—with occasional drawings amid the text—revealed her artistic struggles and attitudes. In 1899 she wrote him:

> I'm not doing drawings that at all interest me just now. They are just single figures of children which I always spoil by the backgrounds. I never can put a background into a painting of a single figure, while in a drawing, there isn't the least difficulty. Perhaps I don't trouble about the reality in the drawing. I put things just where I want them, not, possibly, as they ought to go.

That same year Greenaway wrote:

> How tired one would get of some paintings if one gazed upon them for a week—as tired as one often gets of one's own. I fear it is conceited but there are a very few drawings—little ones of my own—that I do not get tired of, though I do of most of them.

Constantly drawing as a child, at twelve Greenaway was enrolled at the Finsbury School of Art where she studied for six years, and at twenty-five she entered Slade School. After many years of formal study, she exhibited in London galleries and finally at the Royal Academy in 1877. She was influenced by the Pre-Raphaelites, particularly **Rossetti**. "How I should like to live always in a room with two or three Rossettis on the walls," she said in 1898.

Greenaway was born in London in 1846, her father a master wood engraver who illustrated children's books, her mother a seamstress. As a child, she endured a solitary life, inventing an imaginary garden out of the empty yard behind her house:

> I often think just for the pleasure of thinking, that a little door leads out of the garden wall into a real old flowering garden, full of deep shades and deep colours. . . . My bedroom used to look out over red roofs and chimney pots, and I made steps up into a lovely garden up there with nasturtiums growing and brilliant flowers so near to the sky.

Seeing beauty where there was none did not trouble Greenaway, who delighted in her "rose-colored spectacles," possessing a supposedly "defective art faculty that few things are ugly to me." Besides her many books, including *The Language of Flowers* (1884) and *Marigold Garden* (1885), Greenaway's work appeared in more than ninety periodicals. She died in London in 1901. The Greenaway Medal, an annual award in her honor, is bestowed on the best children's book artist in Britain.

Kate Greenaway. St. Valentine's Garden

DEBORA GREGER

Debora Greger's parents sent her to Whitman College in Walla Walla, Washington, her mother counseling her to major in art since "You love books too much to major in English." Unhappy to find that the art department "consisted of the man who taught two dimensions and the one who taught three—and one of them was on leave," Greger transferred to the University of Washington in Seattle, where she "discovered that you could be an art major without ever taking a painting course. You could have a drawing teacher who didn't want to teach drawing as much as he wanted to read poetry."

Greger says she lied to get herself into a class taught by visiting poet **Mark Strand**, the first real poet she'd ever seen. Strand, hearing that she "was about to graduate with a B.A. in art, without a clue as to what to do next," told Greger about the Iowa Writers' Workshop and his teacher there, **Donald Justice**. In the Workshop, Greger tried unsuccessfully to substitute a quilt for the essay that was one of the requirements for the M.F.A., but says, "I did leave behind a chair to which I'd attached wings that you could slip your arms into; I hear the Emily Dickinson Chair is still floating around the Workshop."

Although Greger's art was shown in galleries and group shows in the seventies and eighties, since then she's turned her hand to book-cover illustrations, "all of which are collages made of paper hand-sewn to paper. I never mastered glue." Her collages have appeared on various book jackets, from *Recitative* (1986), a collection of prose by James Merrill, to a new edition of *Poetry and the Age* (2001) by Randall Jarrell.

Born in 1949 in Walsenburg, Colorado, Greger spent her childhood in Richland, Washington. As she puts it, she grew up "in the fifties in the shadow of the Hanford Atomic Plant, in a nuclear family at the edge of a nuclear reservation, out in what historians are now calling the nuclear west."

> And yet, to a child whose father had a security clearance, just like all the other fathers, it felt like the safest place on earth. The high school team was called the Bombers, the school ring had a mushroom cloud on it—and we thought nothing of it. We were that isolated, the age was that innocent.

Greger currently teaches in the creative writing program at the University of Florida, dividing her time between Gainesville, Florida, and Cambridge, England. Her seven books of poetry— *Movable Islands* (1980), *And* (1986), *The 1002nd Night* (1990), *Off-Season at the Edge of the World* (1994), *Desert Fathers, Uranium Daughters* (1996), *God* (2001), and *Western Art* (2004)—have won numerous awards, including the Grolier Prize, the Discovery/*The Nation*, the Peter I. B. Lavan Award from the Academy of American Poets, an Award in literature from the American Academy and Institute of Arts and Letters, and the Brandeis University Award for Poetry.

Debora Greger. Lost Book I

2001. Collage on paper. 16–1/2 x 11–3/4
inches. Collection of the artist

FRANZ GRILLPARZER

Franz Grillparzer was an artist and musician as well as a writer and, like his contemporary, E. T. A. Hoffman, was afflicted with synesthesia—a confusion or intermingling of the senses. Grillparzer composed a few songs but seems to have most enjoyed improvising at the piano. In his autobiography he described the synesthetic experience of playing an engraving—of allowing music to flow out of his hands as he studied the picture before him. By contrast, Grillparzer's paintings and drawings—used as aids to memory, to sketch out or to illustrate costumes and scenes for his plays—were much more pragmatically conceived.

Poet and playwright, essayist and autobiographer, Grillparzer was the greatest of Austria's nineteenth-century writers. Compared in his day to **Goethe** and Schiller, Grillparzer was born in 1791 in Vienna, and died there in 1872. His father, a court lawyer, died deeply in debt when Grillparzer was eighteen years old, and his mentally unstable mother killed herself when he was twenty-eight. After studying law at the University of Vienna, Grillparzer became a civil servant, with his first job as director of the Imperial Archives. He later became a court playwright.

Grillparzer had an unhappy professional life, suffering greatly under a repressive regime. His poem "Campo Vacino," which he wrote in Rome in 1819, offended Catholic sensibilities, and he was censured by the Emperor in a major career setback. In 1826, he was arrested for being a member of a police-disbanded Viennese society of writers and artists (including the composer Carl Maria von Weber) that was under suspicion of encouraging subversive thinking. His private affairs were equally miserable; he never married the woman to whom he was affianced—the love of his life, Katherina Fröhlich.

Scholar Hinrich C. Seeba credits Grillparzer with having "endowed the form of classical drama with a psychological depth that anticipates the discovery of the unconscious by Sigmund Freud two generations later." Another scholar, Dagmar C. G. Lorenz, argues that Grillparzer's works reflect his disillusionment with growing German nationalism, and quotes him as characterizing post-Hegelian German education as a movement from "humanism to nationalism to bestiality." Numerous honors were bestowed on Grillparzer before his death, including membership in the Austrian Academy of Science (1847), a number of honorary doctorates, and, in 1861, appointment to the Upper House by Emperor Franz Joseph—all of which apparently left him unmoved. Grillparzer was called upon to compose the funeral oration for Beethoven; he also wrote the epitaph for the tombstone of his friend, Franz Schubert. His eightieth birthday was a celebration of state, and his funeral the following year filled the streets with tens of thousands of people.

Grillparzer's 1821 trilogy, *Das goldene Vlios (The Golden Fleece)*, a dramatization of the story of Jason and Medea, is regarded by many scholars as his greatest work. The author's sketch opposite is of a set and costumes for that play.

Franz Grillparzer. Jason and Medea beneath a Tree

Pen drawing for *Die Arqonauten*, Act 3. (CD00635) The New York Public Library, Astor, Lenox and Tilden Foundations

THOMAS HARDY

Ambitious for a life beyond trade—someday, ideally, as an Anglican priest—at sixteen Thomas Hardy was able to exploit his drawing skills and apprentice himself to a country architect. When he was nineteen, Charles Darwin's *The Origin of Species* was published, and Hardy abandoned his faith to permanent skepticism. At twenty-one, he moved to London to take a drafting job with a successful church architect. Five years later, in ill health, he returned to Dorset and hired on with another local architect.

One of Hardy's architectural assignments was to draw churches in need of restoration before work was started. He found this a disillusioning job, since no effort was made to preserve the architectural details he was drawing:

> I used to be sent round to sketch village churches as a preliminary to their restoration—which mostly meant destruction. I feel very remorseful now; but, after all, it wasn't my fault—I was only obeying orders.

In the case of St. Juliot church, drawn by Hardy in 1870, the tower and much of the exterior was demolished, as was the woodwork, despite Hardy's specific instructions for repair. In the case of the chancel screen, the builder decided as a gesture of goodwill that he'd throw in a new screen without extra charge—and burned the old one. The watercolor opposite is a Hardy rendering of St. Juliot's.

While working in London, Hardy spent much time studying and making notes on the art in the National Gallery. Scholars have uncovered connections between his visual work and the very pictorial writing of his novels. Biographer James Gibson opined that Hardy discovered a parallel between architecture and poetry, in that "each art had to carry a rational content inside its artistic form."

Hardy often sent sketches to his publishers as well as written suggestions for illustrations to accompany his fiction. He did thirty-two illustrations for his *Wessex Poems*, one of which is reproduced below. In letters to friends, however, he expressed regrets about doing so, telling one that they were "a wholly gratuitous performance." To another he wrote, "My interest lay so entirely in the novel occupation of making the drawings that I did not remove defects of form in the verses which lay quite on the surface."

Hardy, whose eighteen novels set in the imaginary county of Wessex made him one of the most widely read novelists of his day, was also a major twentieth-century poet, and it is for his poetry that he wanted to be remembered. The author of *The Return of the Native* (1878), *The Mayor of Casterbridge* (1886), *Tess of the d'Urbervilles* (1891), and *Jude the Obscure* (1895) was born in 1840 in Higher Bockhampton, Dorset, England, the eldest child of a mason-builder, and died in 1924 in Dorchester, Dorset. He spent his childhood in a lonely cottage in rural isolation. A sickly child, he did not attend school until he was eight, and he had only eight years of schooling in all. By the time of his death, Hardy had been honored with doctor of letters degrees from the universities of Cambridge, Oxford, and St. Andrews. The Order of Merit was conferred on him in 1910. He had been awarded the Medal of the Royal Institute of British Architects for "On the Application of Coloured Bricks and Terra Cotta in Modern Architecture" in 1863.

Above: Thomas Hardy. Leipzig (tailpiece)

1898. Illustration from *Wessex Poems*. Ink. Birmingham Museums and Art Gallery

Opposite: Thomas Hardy. St. Juliot (Cornwall) before restoration

1870. Watercolor and ink. Berg Collection of English and American Literature, The New York Public Library, Astor, Lenox and Tilden Foundations

S. JULIOT [BEFORE RESTORATION] 1870.

MARSDEN HARTLEY

arsden Hartley was a pioneer of American modern art. Progressing from traditional nineteenth-century Realism to Expressionism to Cubism, he returned finally to the representational, but at all times he sought to capture the spiritual essence of his subject. "My first impulses came from the mere suggestion of Kandinsky's book [*On the Spiritual in Art*]. . . . The mere title opened up the sensation for me—& from this I proceeded."

As a child Hartley lived with a variety of relatives, and his home life was unstable. Homely, homosexual, and lonely, he spent his time collecting beautiful objects, stimulating his artistic sensibilities in what he later saw as an act of pure sublimation: "I began somehow to have curiosity about art at the time when sex consciousness is fully developed and as I did not incline to concrete escapades, I of course inclined to abstract ones, and the collection of objects which is a sex expression took the upper hand." Actual involvement in art came in 1896 when he signed up for painting lessons with a local Cleveland artist, John Semon. "Semon planted the art virus in my soul," he wrote. "I had become inoculated and the virus took."

Hartley received a scholarship to the Cleveland School of Art, where a drawing teacher gave him Emerson's *Essays*, which Hartley considered, along with the work of Walt Whitman, to be the single most influential book of his life. He immersed himself in Transcendentalism, and the notion of spirit in nature imbued every aspect of his work. Hartley's impulse was religious but was entirely nondoctrinaire. In a poem addressed to God, Hartley declared: "I want nothing in the way of artificial heaven— / The earth is all I know of wonder. / I lived and was nurtured in the/ magic of dreams."

Hartley's paintings today are represented in the collections of the Metropolitan Museum of Art, the Boston Museum of Fine Arts, the National Gallery, and other major museums and institutions. There were major exhibits of his work in 2003 by The Wadsworth Atheneum Museum of Art, Hartford, and the Phillips Collection, Washington, D.C.

Born Edmund Hartley in 1877 in Lewiston, Maine, he was one of nine children of a poor cotton spinner. Only four of his siblings survived childhood. Following the death of Hartley's mother when he was eight, his father sent his sisters to their aunt in Cleveland. Hartley stayed with his father. "From the moment of my mother's death I became in psychology an orphan," he said.

When Hartley was twelve, his father remarried and moved to Cleveland, leaving the boy with a married sister in Maine. "I had," said Hartley, "a childhood vast with terror and surprise." After being forced to leave school at fifteen to support his sister's family by working in a shoe factory, Hartley moved to Cleveland to rejoin his own family. In honor of his stepmother, he took her maiden name, Marsden, as his own.

Hartley was a prolific poet, a friend of **William Carlos Williams**, **Hart Crane** (he was with him in Mexico before Crane's fatal voyage), and Gertrude Stein. His work was widely published in the important literary magazines of his day, starting with his first appearance in *Poetry* in 1918. His books include *25 Poems* (1923), *Androscoggin* (1940), *Sea Burial* (1941), *Selected Poems* (1945), and two books on art. Hartley died after a peripatetic life—he never lived in one place for more than ten months—in Ellsworth, Maine, in 1943.

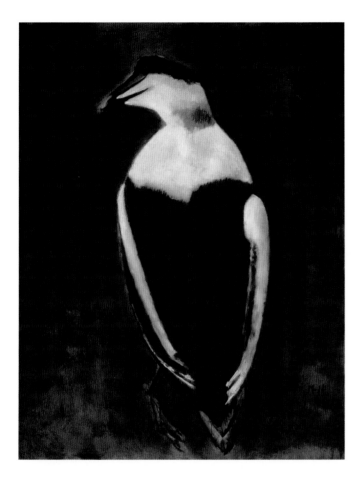

Marsden Hartley. Black Duck

1940–41. Oil on masonite. 28–1/4 x 22 inches. Museum of Fine Arts, Boston, The Hayden Collection, Charles Henry Hayden Fund, 43.32. Photograph copyright © 2005 Museum of Fine Arts, Boston

Marsden Hartley. Carnival of Autumn

1908. Oil on canvas, 30–1/8 x 30–1/8 inches. Museum of Fine Arts, Boston, The Hayden Collection, Charles Henry Hayden fund, 68.296. Photograph copyright © 2005 Museum of Fine Arts, Boston

JULIAN HAWTHORNE

*D*uring a stay with his father at the Castle of Chillon in Switzerland in 1859, Julian Hawthorne was described by Nathaniel in his journal as sketching "everything he sees, from a wild flower or a carved chair to a castle or a range of mountains." Fascinated by nature from the age of ten, Julian kept his drawings and observations in notebooks. When he was fourteen, he produced a ninety-nine-page illustrated book—in notebook form—on fifteen seashells.

Julian credited his mother, who had studied with eminent sculptors and painters, as the source of his love of art. "My aesthetic culture, began with my mother in the nursery. . . . She had a great gift in the fine arts."

> She taught me to believe in god and to see beauty. We had a folio volume of engravings of designs of classic subjects by Flaxman. . . . These I studied inexhaustibly, and she told the immortal stories which they figured and encouraged my childish copyings of the designs. But this art training also begot in me precise acquaintance with the proportions and details of the perfect human figure, which was later to be substantiated by the sculpture galleries of Rome, Paris, and London; so that before I reached my teens, I knew what the body and carriage of a man ought to be.

During the Hawthornes' long sojourn in Europe, his mother brought him a new, illuminated copy of the Book of Ruth, which inspired the young Hawthorne to search out medieval illuminated Bibles and missals and attempt the art himself:

Some of my efforts were entrusted to book shops for exhibition, at the dignified price of one hundred dollars each. Several of them were bought, and they may turn up centuries hence at auctions of bibelots, for the paints were the best of Windsor and Newtons, and the gold was pure from the mine. I spared no expense, actually using my $100 checks for the purpose—an unusual dissipation, for a husky lad in his teens.

The prolific author of popular romantic novels—as well as a short-story writer, journalist, biographer, and essayist—Julian Hawthorne was the only son of the great American writer Nathaniel Hawthorne. He suffered unfavorable comparison with his father throughout his life. Julian was born in Boston in 1846 and died in Pasadena, California, in 1934. He spent an extended part of his childhood in Europe with his family and was educated by his parents and tutors before returning to the States, where he attended Harvard. There, following his father's death his freshman year, Julian was an outstanding athlete but a poor student who failed to graduate. He studied engineering at Dresden University but again failed to earn a degree. Back in New York he worked for the Hydrographic Engineering Department of Docks—a job he detested. In 1870 he sold his first stories and determined to become a writer. Three years later, his first novel, *Bressant*, was published, followed over the next twenty years by two or three more per year.

Convicted of mail fraud in 1913, Julian served a year in the Atlanta State Penitentiary, where he edited the prison newspaper. The drawing opposite right is Julian's portrait of his father.

Julian Hawthorne. Sketch of coastline (Crystal Lake)

4–3/4 x 6–3/4 inches. Berg Collection of English and American Literature, The New York Public Library, Astor, Lenox and Tilden Foundations

Julian Hawthorne. Pencil sketch of Nathaniel Hawthorne

7 x 5–1/8 inches. Berg Collection of English and American Literature, The New York Public Library, Astor, Lenox and Tilden Foundations

LAFCADIO HEARN

*I*t was while he was living in New Orleans that Lafcadio Hearn created the first cartoons to appear in a southern newspaper. Hearn, who had drawn throughout his life, came up with the idea to help the circulation of his floundering employer. According to his publisher, he did the cartoons in woodcut, carving them into "the backs of old wooden types, which had been used for advertisement." Years later, Hearn used his art to teach his son Kazuo, who described his father discarding textbooks in favor of writing on old newspapers with Japanese brush and explicating with his drawings

Despite—or some have argued, because of—his poor vision, Hearn displayed a great sense of color and form in his art and prose. Indeed, he wrote in one essay, "Artistic Value of Myopia," that his ailment may have encouraged an aesthetic of "suggestion" and "depth." In *Re-Echo* (1957), a collection of Hearn's art put together by Kazuo, color dominates. "He could," wrote his son, "distinguish color which he associated with form, and he gained form by color."

Art, meaning "work made for the pure love of art," was immortal for Hearn, and "the sacrifice to art . . . the supreme test for admittance into the ranks of the eternal priests."

> I think art gives a new faith. I think—all jesting aside—that could I create something I felt to be sublime, I should feel also that the Unknowable had selected me for a mouthpiece, for a medium of utterance, in the holy cycling of its eternal purpose; and I should know the pride of the prophet that had seen God face to face.

Hearn was a novelist, journalist, travel writer, and translator who taught Western literature to the Japanese, brought Eastern art and literature to the West, and is prized in Japan for finding and preserving Japanese folktales. He was born Patricio Lafcadio Tessima Carlos Hearn in 1850 in Levkas, Ionian Islands, Greece, and died in 1904 in Okubo, Japan, with the name Koizumi Yakumo, having become a Japanese subject in 1895. His father was a surgeon-major who, ordered to the West Indies when Hearn was two, sent his wife and sons to live with an aunt in Dublin. When Hearn was seven, word came to his mother that his father had taken up with another woman, so she took off with another man, abandoning her sons. At thirteen, during an unhappy time at a Jesuit school, Hearn lost the sight of his left eye in an accident. From subsequent overuse his severely nearsighted right eye became repulsively enlarged and protruding, and Hearn was instilled with a lifelong shyness and morbidity.

Hearn studied briefly in Rouen, France, dropping out his first year. He returned to London and then went, at nineteen, to Cincinnati, Ohio, where he worked as a reporter, wrote prose poems and essays, and translated **Gautier** and Flaubert. In 1877 he went to New Orleans, where he found work as a reporter and short-story writer. He also did adaptations of foreign writers, publishing *Stray Leaves from Strange Literature* (1884), *Some Chinese Ghosts* (1887), and the novel that made his reputation, *Chita* (1889). Hearn went next to Martinique for *Harper's Magazine*, wrote a book about his two years there, as well as a novel, *Youma* (1890), about a slave insurrection. At forty, he traveled to Japan, where he became a teacher, married an upper-class Japanese woman, and began writing articles for *The Atlantic Monthly* that were syndicated in U.S. newspapers.

Above: Lafcadio Hearn. The Moonrise

From *Re-Echo* (1957) by Kazuo Hearn Koizumi (The Caxton Printers Ltd.)

Left: Lafcadio Hearn. The Eagle

Watercolor and ink. From *Re-Echo* (1957) by Kazuo Hearn Koizumi (The Caxton Printers Ltd.)

O. HENRY

O. Henry showed early artistic talent and regularly sketched the people he met in portrait and caricature as a boy. Then known as William Porter, he amused his classmates by caricaturing their teacher—who happened to be his aunt—and could draw with his left hand at the blackboard while doing arithmetic with his right. He left school at fifteen to work in his uncle's drugstore. There, he would occasionally be forced to identify, with drawings, strangers who had taken merchandise on credit.

Word of Porter's skills spread, and the director of a well-known military school wrote to offer him tuition and board "in order to get the use of his talent as a cartoonist for the amusement of our boys." Lacking funds for books or uniforms, Porter was forced to decline. At twenty he moved to Texas and lived on a sheep ranch, where a local writer engaged his services to provide forty illustrations for a book.

Porter left the ranch, worked as a bookkeeper, and in 1887 became a draftsman in a Texas land office, where he decorated maps and documents with little drawings of people and wildlife. Engravings for a historical work, Wilbarger's *Indian Depredations in Texas* (1889), were done entirely by Porter.

In 1894, Porter and a partner brought out a humorous weekly, *The Rolling Stone*, and during its short life Porter wrote the copy and drew all the cartoons. When the venture folded, he worked for the *Houston Post* as a columnist and cartoonist.

While publishing the weekly, Porter also worked as a bank teller. When an audit showed a $5,500 discrepancy in his accounts, he was accused of embezzlement. His in-laws offered to make up most of the loss, but Porter was indicted. With his trial pending, he ran away, first to New Orleans, then to Honduras. He came back when he got word that his wife was dying. After her death, he was tried, convicted, and given the lightest possible sentence. He served three years and three months in the penitentiary at Columbus, Ohio, where he wrote and published several stories. By the time of his release, Porter had become O. Henry.

Under that pseudonym, Porter's ironic, surprise-ending short stories—most famously "The Gift of the Magi," "The Ransom of Red Chief," and "A Municipal Report"—became among the most widely read in all American literature.

William Sydney Porter was born in 1862 in Greensboro, North Carolina. He died in 1910 in New York City. His father was an unlicensed doctor who spent his time drinking and trying to build a perpetual motion machine. His mother died when he was three, and he was raised by his father's mother and sister.

O. Henry came to New York in 1902 at the request of *Ainslee's Magazine* and sold seventeen stories in his first nine months in town. He went to work for the *Sunday World* in 1903 and wrote a story for each week's edition. He began to publish books, the first being *Cabbages and Kings* (1904), followed by *The Four Million* (1906), *The Trimmed Lamp* (1907), and *Heart of the West* (1907). Despite their great popularity and a commensurate income, O. Henry lived well beyond his means and spent his life drinking excessively and in constant financial distress.

O. Henry. Mr. Scarecrow

1892. Pencil with watercolor wash on notepad paper.
8–1/2 x 5 inches. Harry Ransom Humanities Research
Center Art Collection, University of Texas at Austin

HERMANN HESSE

In 1916 Hermann Hesse suffered an emotional breakdown precipitated by a variety of personal and social crises, and entered a sanitarium. He then underwent psychoanalysis with C. J. Jung and Jung's student Joseph Lang, who encouraged him to paint as therapy. The result was transformational. Hesse not only became an accomplished and prolific painter of more than three thousand pictures, almost all landscapes, but went on to produce his most highly regarded literary works, including *Demian* (1919), *Siddhartha* (1922), *Steppenwolf* (1927), *Narcissus and Goldmund* (1930), and *Magister Ludi or the Glass Bead Game* (1943). During World War I, Hesse sold his illustrated manuscripts in order to buy books and supplies for prisoners of war, and throughout his life used the proceeds from his art sales for the support of others in need.

The centrality of painting to Hesse's life cannot be overstated. He wrote in a 1925 letter: "I would have long since given up living if my first attempts at painting had not comforted and saved me during that most difficult time in my life."

Besides illustrating his manuscripts, Hesse did color illustrations for two of his books—*Poems of a Painter* and *Wanderings*—and decorated his letters with miniatures. Despite his success he insisted he was just a dilettante. "When I paint my little pictures," he wrote, "it is not so much a question of competence but of privilege, and probably of enormous luck, to be permitted to play with colors and sing in praise of nature." But he did not deny the pleasure he received, finding in painting an emotional satisfaction that language had not given him:

> [O]ne day I discovered an entirely new joy. Suddenly, at the age of forty, I began to paint. Not that I considered myself a painter or intended to become one. But painting is marvelous; it makes you happier and more patient. Afterwards you do not have black fingers as with writing, but blue and red ones.

Hesse saw a commonality in his literary and visual efforts, writing at the time of his first show:

> [T]he Basler Kunsthalle has a series of my watercolors. . . . You will see that there is no discrepancy between my painting and my writing; in my painting, too, I am not pursuing the naturalistic, but the poetic truth.

Many of Hesse's paintings are in the collection of the Hermann Hesse Museum in Montagnola, Switzerland. In 1998, in cooperation with his sons, the museum mounted an exhibit of his paintings at the Donahue/Sosinski Art Gallery in New York. His novels and poetry, translated into more than fifty languages, have inspired millions of young people to reconsider their lives, to appreciate the duality of our natures, and to value what is spiritual and essential.

Hesse was born in the Black Forest, in Calw, Württemberg, Germany, in 1877, and died in Montagnola in 1962. As the child of missionaries, Hesse was expected to become a minister, and he was placed in a monastic seminary. He left the seminary and school, however, and apprenticed to a mechanic; at nineteen he went to work in book and antique shops. Hesse loved music as well as painting and was a violinist in his youth. Awarded both the Goethe Prize and the Nobel Prize for Literature in 1946, he wrote in his Nobel autobiography that he could not accept "a pietistic education that aimed at subduing and breaking the individual personality."

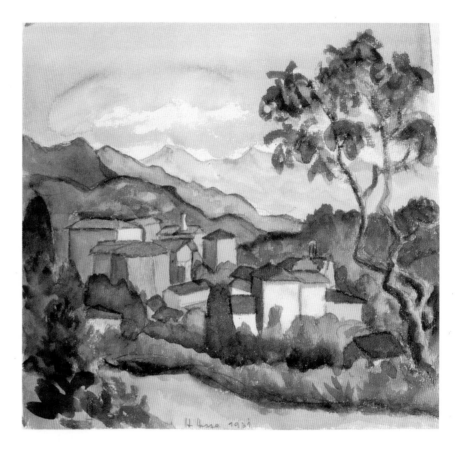

Hermann Hesse. View from Montagnola, Tessin

1931. Watercolor. 10–1/2 x 9 inches. YCAL at The Beineke Rare Book and Manuscript Library, Yale University. Copyright © Hermann Hesse Editions Archiv, Offenbach a.Main, Germany

Hermann Hesse. Verso Arasio

1931. Watercolor. 10–5/8 x 9–1/4 inches. Courtesy Hesse Museum, Montagnola, Switzerland. Copyright © Hermann Hesse Editions Archiv, Offenbach a.Main, Germany

PATRICIA HIGHSMITH

Novelist and short story writer Patricia Highsmith's mother and stepfather were commercial artists, her mother a fashion illustrator for *Women's Wear Daily* and her stepfather an advertising illustrator.

Highsmith showed artistic talent as a child and continued to draw, paint, and sculpt throughout her life. In her preface to a 1995 collection of her drawings and paintings, *Patricia Highsmith Zeichnungen*, she argued that we should not be surprised that writers like to draw and sculpt: "All arts are one and each art—even ballet—is a form of storytelling." She suggested that the impulse to tell stories is natural and that "any child who is not shy is burning to tell a story."

"I rather enjoy the lighter side of my art work," said Highsmith, "my part-time work, drawing and painting." Insisting that she didn't take her art seriously, she said she would give a painting to any "friend or girlfriend" who admired it.

For Highsmith, the writer's pleasure in painting came from being able to work in a different medium, one in which the communication with the viewer is immediate, as compared with the much greater time a book or even a short story requires. Moreover, it was not only painting, drawing, and sculpting in which she could lose herself ("live for a time in a different element"), but carpentry ("tables or something else you can make out of wood"). Expressing great admiration for the skills of the painter and composer, she disparaged the writer's talents, asserting that "anybody, or nearly everybody, can write a short story."

A master of the crime/suspense novel, Highsmith is best known for *Strangers on a Train* (1950) and *The Talented Mr. Ripley* (1955). She was born Mary Patricia Plangman in Fort Worth, Texas,

in 1921, the unwanted, only child of parents who separated before she was born. Highsmith (her stepfather's name) was twelve before she met her father. Her mother told her she'd made an unsuccessful attempt to abort her by drinking turpentine: "She said, 'It's funny you adore the smell of turpentine, Pat.'"

Until she was six years old, Highsmith was primarily cared for by her maternal grandmother, whom she identified as her only source of affection. She was then taken against her wishes by her remarried mother to New York: "Something went to pieces in me when I left my grandmother. I totally withdrew into myself." Highsmith denied loving her mother: "First, because she made my childhood a little hell. Second, because she herself never loved anyone, neither my father, stepfather, nor me." Growing up in New York, she endured frequent moves of the family and three separations of her mother and stepfather during her adolescence. She earned a B.A. at Barnard College, where she studied English, Latin, and Greek.

Because she elected to write genre fiction, some believe Highsmith has not received her due as a writer. "For some obscure reason," wrote Gore Vidal, "one of our greatest modernist writers, Patricia Highsmith, has been thought of in her own land as a writer of thrillers. She is both." Terrence Rafferty, in *The New Yorker*, called her novels "peerlessly disturbing." Her awards included a Mystery Writers of America Scroll (1957) and the Grand Prix de Littérature Policière (1957) for *The Talented Mr. Ripley*, a 1964 Silver Dagger Award from the Crime Writers Association of England for *The Two Faces of January*, and the French Officier, l'Ordre des Arts et des Lettres in 1990. She died in Locarno, Switzerland, in 1995.

Above: Patricia Highsmith. Untitled self-portrait

C. 1940. Ink on paper. From *Patricia Highsmith Zeichnungen.* Copyright © 1995 Diogenes Verlag AG Zurich

Opposite: Patricia Highsmith. Yaddo, Saratoga Springs

Undated. Ink on paper. 12 x 8–7/8 inches. From *Patricia Highsmith Zeichnungen.* Copyright © 1995 Diogenes Verlag AG Zurich

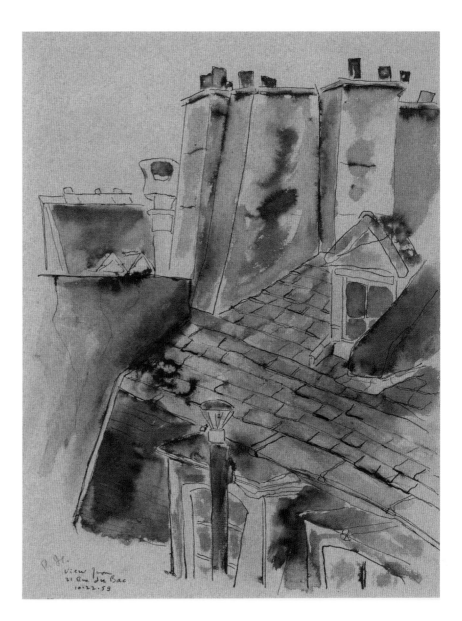

Above: Patricia Highsmith. View from 21 Rue du Bac 10.22.59

Ink and watercolor on paper. 13–3/4 x 10–3/4 inches. From *Patricia Highsmith Zeichnungen.* Copyright © 1995 Diogenes Verlag AG Zurich

RALPH HODGSON

The man everyone wanted to know, as T. S. Eliot described him in "Lines to Ralph Hodgson Esqre.," did not want everyone to know about him—Hodgson was famously reticent about the facts of his life, insisting a "poet should live in his poetry." Virtually nothing is known of his childhood and youth, but it is certain that he was an artist before he was a poet, and it appears that relatives were artisans. He started drawing in school, and in his twenties designed scenery for a touring theater.

Hodgson cartooned for newspapers and magazines including the *London Evening News, Punch,* and *Fry's Magazine* (using the pseudonym "Yorick"). The *Dictionary of British Comic Artists, Writers and Editors* also credits him as the art editor of C. Arthur Pearson's *Big Budget* from 1897 to 1909, and as contributor of occasional front-page art and comic strips to that and other Pearson publications. Hodgson also contributed comic strips to the magazine *Illustrated Bits* from 1885 until 1909. A cartoon he drew of Oscar Wilde's 1895 criminal trial appeared in the *London Evening News.* Cofounder of At the Sign of Flying Fame, a small press that produced broadsides and chapbooks, Hodgson not only contributed poetry but assisted the illustrator in hand-coloring the copies.

Hodgson was born in either 1871 or 1873—he would not even correct such basic biographical errors as date of birth—in Darlington, Durham, England. He was one of ten children born to his coal merchant father and mother. A touring theater company took him to America for a time in the early 1890s. While editing and contributing to *Fry's Magazine* (1909–1911), he was recognized as an authority on dogs and an advocate for their humane treatment. He would bring his bull terrier to the restaurant where he met poet friends for tea, and was said to prefer talk of dogs and prizefighters to that of poetry.

Publication of his *Poems* (1917) brought Hodgson critical acclaim, but he published little after that. He enlisted during World War I and served in the Royal Navy, the Royal Garrison Artillery, and the Labour Corps. His wife, reputedly anxious about the war and their separation, had a severe mental breakdown, and died in 1920. Hodgson remarried in 1921 and, a few years later, moved to Japan, having taken a position teaching English literature at Imperial University in Sendai. His new wife left him within a year of their arrival, however, and Hodgson complained that the responsibilities of teaching made creative effort impossible.

Inspiration was revived with another marriage in 1933. Hodgson began a long dramatic poem, *The Muse and the Mastiff* (selections of which appeared in 1942), and assisted in translating one thousand Japanese poems into English (*The Manyoshu*, published in 1940), for which he was made a member of the Order of the Rising Sun (1938). He left Japan that same year, settled near his wife's birthplace in Minerva, Ohio, and after some years returned to England, where he retired to a farm. Hodgson had finished *The Muse and the Mastiff* in Ohio. Back in England, he wrote a small number of short poems and broadsides. Despite his small output, Hodgson's poems garnered him an award from the National Institute of Arts and Letters (1946) and the Queen's Gold Medal for Poetry (1954). He died in 1962, the year after publication of his *Collected Poems*, which established him as one of the most original of the Georgian poets.

Ralph Hodgson. How the Waters Came Down at Lodore . . .

Watercolor on paper. 11 x 8–1/2 inches. Canaday Library, Byrn Mawr College

Ralph Hodgson. Self-portrait, smoking a pipe

1945. Watercolor and ink on paper. Canaday Library, Bryn Mawr College

E. T. A. HOFFMANN

As a child, Ernst Hoffmann loved to draw, showing early on what was to become a lifelong talent for caricature. He also studied music theory and a number of instruments, was a skilled pianist by twelve, and when in his twenties, in the midst of a love affair with a married older woman, began writing, which gave him enduring fame.

Hoffmann's parents divorced when he was three, his older brother going with their father, while Ernst and his mother moved in with a bachelor uncle, who raised the boy when his mother became a recluse. Hoffmann's uncle was a judge, and his life in the law seemed predetermined. After a series of self-sabotaging career moves brought about by his caricatures of persons of power, Hoffmann secured a post with the Supreme Court of Germany. He achieved his judicial success at the same time that he wrote, painted, and pursued a musical career in which he composed nine operas, ballets, a symphony, and other works. When his compositions failed to earn money, he tried work as an illustrator and portrait painter, and when that proved insufficient, he turned to writing. During his first political exile, to a Polish village in 1803, Hoffmann described how he coped:

> The legal documents are thrown into the next room, and then I draw, compose and write poetry as the spirit moves me; everything badly to be sure, but all the more pleasurable to me. It is a psychological phenomenon that bad artists and poets rejoice the most in their monstrosities, while great poets take not nearly so much pleasure in the amorini they bring into the world.

By 1805, Hoffmann was in Warsaw, where he headed its newly founded musical society, not only conducting the orchestra, but renovating new quarters in the Mniszek palace—painting frescoes on its walls and ceilings while conducting legal business from the scaffolding.

Hoffmann was a Romantic and prized the emotional content and the arousal of sense perceptions foremost in any work of art. The Romantics explored the phenomenon of synesthesia—the confusion of senses, or the simultaneous interchange of sensations from different sources—and Hoffmann, writer-artist-musician, articulated his own experience:

> Not so much in dreams as in the condition of delirium which precedes falling asleep—particularly when I have been hearing a good deal of music—I find a blending of colors, tones, and odors. It seems to me as if they were all produced through the beam of light in the same mysterious way and then were obliged to combine together into a wonderful harmony. The perfume of the dark-red carnation has a strange, magical effect upon me; involuntarily I sink into a dreamy condition and hear then as if from far distance the deep tones of a tenor clarinet swelling in force and then dying away.

Ernst Theodor Wilhelm (he changed Wilhelm to Amadeus in homage to Mozart) Hoffmann was born in Königsberg, Germany, in 1776. He died in Berlin in 1822 after enduring the depredations of war, poverty, alcoholism, and syphilis. The inspiration for Offenbach's opera *The Tales of Hoffmann*, his stories include "The Nutcracker," the source of Tchaikovsky's ballet; "The Sandman," on which Delibes's ballet *Coppelia* was based; and "Das Fräulein von Scuderi," which Paul Hindemith appropriated for his opera *Cardillac*. Hoffmann also produced novels, plays, essays, and musical criticism. His collections of fantasy and horror stories virtually created those genres and influenced such writers as **Andersen**, Hawthorne, Irving, **Poe**, **Gogol**, and **Kafka**.

Above: E. T. A. Hoffmann. Doktor Bertolo aus dem Singspiel Figaros Hochzeit nach Herrn Kaselitzens Darstellung (Dr. Bertolo from the musical *The Marriage of Figaro,* after Kaselitzen's illustration)

1808. Color drawing by Hoffman from the collection *Grotesque Figures* after illustrations for a production at the Royal National Theater. Copyright © BPK, Berlin

MAXINE HONG KINGSTON

An artist since childhood, Maxine Hong Kingston, smarting at early sexism, wrote in her journal at sixteen:

> I just won two honor award ribbons for my printing and silk screening at the San Joaquin County California Industrial Education Association Festival. They were both won under [her brother] Norman's name however. ([Her teacher] Mr. Britt's idea) because girls just don't enter industrial art shop festivals.

Hong Kingston says she creates images rather than words when she is starting a book or recording her dreams. Asked in a *Contemporary Authors* interview if she used a plan or outline to blend the diverse sources that inform her writing, she responded:

> What I have at the beginning of a book is not an outline. I have no idea of how stories will end or where the beginning will lead. Sometimes I draw pictures. I draw a blob and then I have a little arrow and it goes to this other blob and then I have a little arrow and it goes to this other blob, if you want to call that an outline.

She maintains two sketchbooks, one of dreams and one of summers at the Grand Canyon (where her husband "does a one-man John Wesley Powell show"):

> I have learned that dreams are more accurately set down in drawings (with color pens if dreaming in color) than in words. I divide the page into three sections because dreams are often in three acts, and do have beginning-middle-end. . . . When you put dreams into words you bring them into the reasoning logical world. I used to write my dreams; now I only draw them. . . . Speechless before the canyon, I sketch it. No matter how large the canvas, a picture of the canyon is miniature. So, I've been drawing it on extra-small pages, which I use as postcards to friends.

Hong Kingston, whose Chinese name is Ting Ting, was born in 1940 in Stockton, California, the child of a quiet scholar, gambling house manager, and laundry worker father, and a garrulous midwife, medical practitioner, field hand, laundry worker mother. She graduated in 1962 from the University of California, Berkeley, returned to get a teaching certificate in 1965, and taught locally and then for seventeen years in Hawaii, where she was named a "Living Treasure" in 1980, before returning to California. With her two most famous works, *The Woman Warrior: Memoirs of a Girlhood Among Ghosts* (1976) and *China Men* (1980), Hong Kingston created a genre of her own, blending myth and memoir, history and fiction, poetry and polemics. A member of the American Academy and Institute of Arts and Letters (1990) and the American Academy of Arts and Sciences (1992), she won the 1976 National Book Critics Circle Award for *The Woman Warrior. China Men* was named to the 1980 American Library Association Notable Books List, and *Tripmaster Monkey: His Fake Book* received the PEN West Award in Fiction in 1989. She also won the American Book Award for general nonfiction in 1981, and has twice received a National Endowment for the Arts Writers Award (1980 and 1982).

Maxine Hong Kingston. Grand Canyon sketch

1991. Ink postcard to artist Judy Foosaner, Point Richmond, California. Courtesy of the artist, Judy Foosaner, and ZYZZYVA

GERARD MANLEY HOPKINS

There were artists and musicians on both sides of poet Gerard Manley Hopkins's family. When he was five, one of his father's sisters, a musician and a portrait painter, lived with them and began to train Hopkins in both arts. He went on to study music theory, and throughout his life composed songs and melodies. His writing skills became apparent when he won his grammar school's poetry prize. At thirteen, he was painting on a trip through Belgium, and, at seventeen, he impressed friends with drawings of peasants he sent home from a trip to Germany. At Oxford in 1864, Hopkins met Christina and **Dante Rossetti** and other Pre-Raphaelites, and, after examining their poetry and paintings, wrote, "I have now a more rational hope than before of doing something—in poetry and painting." In another letter from the same period, he described his efforts:

> I am sketching (in pencil chiefly) a good deal. I venture to hope you will approve some of my sketches in a Ruskinese point of view—if you do not, who will, my sole congenial thinker on art? . . . I think I have told you that I have particular periods of admiration of particular things in Nature; for a certain time, I am astonished at the beauty of a tree, shape, effect, etc., then when the passion, so to speak, has subsided, it is consigned to my treasury of explored beauty, and acknowledged with admiration and interest ever after, while something new takes its place in my enthusiasm. The present fury is the ash, and perhaps barley and two shapes of growth in leaves and one in tree boughs and also a conformation of fine-weather cloud.

After studying classics at Oxford, Hopkins decided to leave the Anglican Church and become a Roman Catholic. Received into the church by John (later, Cardinal) Newman, he became a Jesuit priest. Burning all of his poetry as he entered the novitiate, he declared poetry to be outside his profession. Later, it was painting, with its "passions," that threatened his religious calling. As he explained to a friend, Mowbray Baillie, in an 1868 letter:

You know I once wanted to be a painter. But even if I could I wd. not I think, now, for the fact is that the higher and more attractive parts of the art put a strain upon the passions which I shd. think it unsafe to encounter. I want to write still and as a priest I very likely can do that too, not so freely as I shd. have liked.

Encouraged by a superior, Hopkins returned to poetry—and to art as well. He illustrated his journals with detailed drawings from nature, such as the examples reproduced here.

One of the most original and influential of English poets, Hopkins published only three poems during his lifetime. His intense, vivid works were "inscapes," to use the coinage of a man who wished to show how all things are "charged with love," with God, and if touched properly, "give off sparks and take fire." He was born in 1844, in Stratford, Essex, England, the eldest of nine children. His father was a former British consul general and a poet. Hopkins died of typhoid fever in Dublin in 1889.

Above: Gerard Manley Hopkins. Beech, Godshill Church Behind

Pencil on drawing pad paper. 11 x 8–1/2 inches. Harry Ransom Humanities Research Center Manuscripts Collection, The University of Texas at Austin. Copyright © The Society of Jesus. Reprinted from *The Journals and Papers of Gerard Manley Hopkins*, 2nd ed., Humphrey House and Graham Storey, eds. (1959). By permission of Oxford University Press

Opposite: Gerard Manley Hopkins. The Hare and the Tortoise

Harry Ransom Humanities Research Center Manuscripts Collection, The University of Texas at Austin. Copyright © The Society of Jesus. Reprinted from *The Journals and Papers of Gerard Manley Hopkins*, 2nd ed., Humphrey House and Graham Storey, eds. (1959). By permission of Oxford University Press

Above: Gerard Manley Hopkins. Dear Arthur

Reprinted from *The Journals and Papers of Gerard Manley Hopkins*, 2nd ed., Humphrey House and Graham Storey, eds. (1959). By permission of Oxford University Press

PAUL HORGAN

Two years after the death of his father, having been active in theater, music, and art, twenty-year-old Paul Horgan enrolled in the Eastman School of Music in Rochester, New York, to study voice. There he also acted, worked as a set designer, and fell under the influence of artist N. C. Wyeth, who eventually arranged for the publication of Horgan's first book of drawings, *Men of Arms* (1931).

Drawing with a sense of urgency enabled Horgan to preserve the excitement and feeling of discovery he experienced when he came upon the scene he wanted to memorialize. He'd leave the engine running to prevent any sense of "cool control." With deliberate haste, he wrote,

> I went at the paper with my India ink fountain pen, establishing the observed facts in outline; and then with watercolors I tried to capture light, form, atmosphere, harmony, and the scheme of values in the near and far. Excitement attended the process, and something of that excitement returned when I looked at the drawings later; and when I treated the same subjects in words, perhaps the words were more true and evocative as a result.

Considering his development as a writer the result of his multiple talents, Horgan said:

> I think that . . . because of my "accursed versatility" the influences all derived from observing and feeling for all the forms of the arts as they are not imitable but analogous for the writer. . . . You cannot imitate musical form on the page. But certainly there are great analogies in musical structure, musical form which the writer can learn from.

While music taught a writer the rhythms necessary to create readable prose and a sense of form, painting provided the visual sense essential to fiction:

> Now as to painting, every novelist, every writer of fiction must have a strong visual sense, must have a pictorial knack and a differentiation between matters of volume and composition and color and perspective even, and all the details that make up a scene. They've got to be S-E-E-N!

In addition to painting, singing, and acting, Horgan wrote more than forty books, including poetry, short stories, novels, plays, essays, and librettos. Among his biographies was the Pulitzer Prize-winning *Lamy of Santa Fe* (1975); among his histories the two-volume *Great River: The Rio Grande in North American History* (1954), which won both the Pulitzer Prize and the Bancroft Prize. Born Paul George Vincent O'Shaughnessy Horgan in Buffalo, New York, in 1903, he died in 1995 in Middletown, Connecticut.

Opposite: Paul Horgan. Prospect of Mexico: Antigua Vera Cruz

1962. Transparent watercolor, pen and black ink, with white lead. YCAL at The Beineke Rare Book and Manuscript Library, Yale University

VICTOR HUGO

French literary giant Victor Hugo left behind paintings and some 3000 drawings. He not only drew and painted with traditional materials but, a century before it was fashionable, incorporated random stains and ink blots—as well as such found materials as coffee, soot, and greasepaint—into his works, using rags, wood sticks, and stones to create effects. George Hugo described how his grandfather drew on any scrap of paper at hand:

> He scattered the ink haphazardly, crushing the goose quill which grated and spattered trails of ink. Then he sort of kneaded the black blot which became a castle, a forest, a deep lake or a stormy sky; he delicately wet the barb of his pen with his lips and with it burst a cloud from which rain fell down onto the wet paper; or he used it to indicate precisely the mists blurring the horizon.

Hugo illustrated his letters—a beautiful example of the many ways in which his text frames a drawing of monuments or architecture is found in de Ayala and Guéno's *Illustrated Letters* (1999). As the authors observe, Hugo "left at his death dozens of albums and notebooks containing more than 1,300 drawings that were inseparable from the accompanying text." Although Hugo's art was created for himself or his family and friends—to caricature, to record places visited, and occasionally as a note for a work in progress—it was inevitably published. Hugo, in a preface, asked his readers to pity him for "being an artist in spite of himself." He was similarly self-deprecating in an 1860 letter to **Baudelaire**:

> I'm very happy and very proud that you should choose to think kindly of what I call my pen-and-ink drawings. I've ended up mixing in pencil, charcoal, sepia, coal dust, soot and all sorts of bizarre concoctions which manage to convey more or less what I have in view, and above all in mind. It keeps me amused between two verses.

Victor Hugo, said **Jean Cocteau**, "was a madman who thought he was Victor Hugo." The hugely egotistical, self-aggrandizing, politically inconsistent, sexually insatiable, larger-than-life Hugo authored plays—one of which became the opera *Rigoletto*—dozens of books of poetry, and monumental novels, including *Notre-Dame de Paris* (1831; *The Hunchback of Notre Dame*) and *Les Misérables* (1862).

Hugo was born in Besançon, France, in 1802. His parents were estranged in his childhood. His mother took up with one of Napoleon's enemies while his father was one of Napoleon's generals. Hugo changed political sides throughout his life: first a royalist, then a republican; supported the revolution, then sided with the government against the rebels. After Napoleon's nephew staged a coup, Hugo went into an almost twenty-year exile, during which he achieved great popularity by attacking the dictatorship. When it fell, he returned and was elected to the National Assembly and the Senate. On his seventy-ninth birthday, a half-million people marched in his honor, and Avenue Victor Hugo was christened. Hugo died in Paris in 1885, arguably the best-known man in the world. More than a million people gathered for his funeral.

Victor Hugo. Souvenir d'une vielle maison de Blois (Memory of an old house in Blois)

1864. Given to Philippe Burty, Paris, Maison de Victor Hugo (0128)

Victor Hugo. Ville au bord d'un lac (Town beside a lake)

C. 1850 Pen and brown-ink wash over graphite, watercolor, gouache, and stencil foldings on vellum paper with the watermark "J. Whatman" partially scraped. 19–1/16 x 24–15/16 inches. Paris, Maison de Victor Hugo (0035)

EVAN HUNTER (ED McBAIN)

Evan Hunter/Ed McBain, the widely-imitated creator of the police procedural and Mystery Writers of America Grand Master, said that his art career began "when I was a kid, eight years old, nine years old," drawing the figures from *Snow White and the Seven Dwarfs.* "I remembered I copied all those, drew all the dwarfs, and Snow White herself." His father, a letter carrier who had his own band, also had an artistic bent—"he had been in the crochet beading business, would design the beading for the dresses, and did the posters for his band"—and encouraged his son's artwork. As Hunter explained to me in a 2002 interview:

> In elementary school I was considered someone with talent that the teachers had an eye on. And then when I got onto junior high and high school I really began exploring it more fully. In high school I was the art editor of the art-literary magazine and I was a cartoonist for the school paper. I took all the art courses and entered a citywide competition for scholarships to the Art Students League, and a friend of mine at the high school and I won them, and we went to the Art Students League. This was before the school term had started at Cooper Union where I also applied and was accepted.

Hunter interrupted his art studies, which included private instruction from sculptor Richard Miller, to enlist in the navy during World War II. During a tour on a destroyer in the Pacific, he occupied himself drawing officers and enlisted men:

> Eventually I ran out of subjects—there were no more guys to draw or who were interested in having their portraits done. So I drew all the smokestacks, the torpedo tubes, the depth charge racks . . . and a ship is a small thing, especially a destroyer. And there was nothing left to draw so I borrowed a typewriter from the radioman's shack. And I began typing and I wrote several stories and I found I liked it a lot.

He found the transition from artist to writer creatively expanding:

> I was trained to see things with a frame around it. I wasn't trained to free the imagination the way it is in writing. There is no frame in writing. You just go . . . I had a lot of fun.

Hunter's books have sold more than 100 million copies around the world. The man who authored novels (as Ed McBain, the fifty-volume *87th Precinct* series), short story collections, children's books, and screenplays (most notably Alfred Hitchcock's *The Birds*), also credited his work to the names Curt Cannon, Hunt Collins, Ezra Hannon, and Richard Marston. And none of them was his own: He was, in fact, born Salvatore Lombino in Brooklyn, New York, in 1926. After graduating from Hunter College, he taught briefly at vocational high schools in the Bronx and used the experience in writing *The Blackboard Jungle* (1954), his first bestseller. He employed his graphic talent in his novel *The Paper Dragon* (1966), presenting drawings ostensibly from the diary of an artist character. Hunter died in 2005 in Weston, Connecticut.

Evan Hunter (Ed McBain). Bronze nude

Collection of the artist

Evan Hunter (Ed McBain). Eye of the Tiger (detail)

Oil on canvas. Collection of the artist

ALDOUS HUXLEY

"Of Aldous Huxley's many marvelous gifts, the most surprising was the gift of sight," wrote Sir Kenneth Clark about the nearly blind Huxley. What Huxley wrote about painting, said Clark, "proves him to have been one of the most discerning lookers of our time":

> Nothing could show more clearly the difference between two divisions of sight—if I may be excused such amateur physiology—the efficient functioning of the physical organ in carrying messages to the brain, and the reception of those messages by a prepared intelligence.

At sixteen Huxley suffered "a violent attack of Keratitis punctato," which, he wrote, "left me (after 18 months of near-blindness, during which I had to depend on Braille for my reading and a guide for my walking) with one eye just capable of light perception." Despite his visual handicap, Huxley painted throughout his life, and maintained a studio where friends and family would pose for him. Indeed, perhaps because of his injured sight, color and sight became central to his life and writing. Biographer Sally Paulsell wrote that in his life and art Huxley developed "a consciousness-expanding search for ultimate reality revealed to him through the mystical qualities of color and light."

Huxley, also an accomplished pianist, wrote of the three mediums in which he worked:

> Music can say four or five different things at the same time, and can say them in such a way that the different things will combine into one thing. The nearest approach to a demonstration of the doctrine of the Trinity is a fugue or a good piece of counterpoint.
>
> Painting too can exhibit the simultaneity of incompatibilities—serene composition along with agonized brushwork and the most passionate violence of color, as in so many of Van Gogh's landscapes; neurotically restless drapery, as in one of Cosimo Tura's saints or Virgins, combined with an image of beatitude or love; the final inwardness of mystical feeling expressed in the nonhuman otherness and outwardness of a Sung landscape.

We can see more than one thing at a time, and we can hear more than one thing at a time. But unfortunately, we cannot read more than one thing at a time. In any good metaphor, it is true, there is a blending, almost at a point and almost in one instant, of differences harmonized into a single expressive whole. But metaphors cannot be drawn out, and there is no equivalent in literature of sustained counterpoint or the spatial unity of diverse elements brought together so that they can be perceived at one glance as a significant whole.

Huxley was a novelist, essayist, and short story writer, whose most famous novel, the protean *Brave New World* (1932), foretold a Utopia in which happiness is submission to authority. He was born in 1894 in Godalming, Surrey, England, and died in Los Angeles in 1963. Among his other major works are *Crome Yellow* (1921), *Point Counter Point* (1928), *Ape and Essence* (1948), *Time Must Have a Stop* (1944), and *The Doors of Perception* (1954).

Opposite: Aldous Huxley. Maria Nys Huxley at Siesta

Collection of Franziska Huxley. Courtesy of the estate of Aldous Huxley

Right: Aldous Huxley. The Living Room at Sonary

Oil on canvas. 27 x 21 inches. Collection of Franziska Huxley. Courtesy of the estate of Aldous Huxley

HENRIK IBSEN

As a child, the Norwegian playwright Henrik Ibsen entertained himself by painting figures on pasteboard and wood which he would use as characters in a doll theater. The youthful Ibsen spent most of his spare time drawing and painting. He painted quickly, and his paintings filled the house. A contemporary from those early years recalled him contributing a painting with text to a gravesite. He did drawings of virtually everyone he came in contact with—family, friends, working men and women. Caricatures of his siblings as different animals, which he painted on door panels in the family home, have been preserved and are displayed in Norway's Folk Museum in Skien.

As a young man, Ibsen studied with the painter Mikkel Mandt. His subjects were generally local scenes and images based on book illustrations. Serious art training required travel to cities where the leading artists had their studios, but this was impossible for Ibsen, given the financial circumstances of his family. Instead of studying art, he was apprenticed to a pharmacist in an apothecary.

Ibsen continued to paint throughout his writing career, and did some costume designs for his plays. Six drawings have survived of characters in medieval dress from his play *Olaf Liljekrans,* including the one reproduced here. While living in Christiania on a limited income, Ibsen had scraped together the money for lessons from painter Magnus Bagge. After some local travel, he had four landscapes published in *Illustreret Nyhedsblad,* accompanied by text about the places where they had been done—the only known sale of his art.

Born in 1828 in Skien to a wealthy family that went bankrupt while he was a boy, Ibsen grew up in scarring poverty. At sixteen, he left home and, with the exception of a brief visit or two, never saw his family again. The youthful Ibsen drank heavily, gambled, was sexually promiscuous, and, at eighteen, fathered an illegitimate child. He attended the University of Christiania, started to write, and, at twenty-one, gained a position as director first of the theater in Bergen and then of the Norwegian Theater. By thirty-one, Ibsen had directed more than 150 plays. When the theater went under,

he was unemployed, most of the plays he'd written had failed, and he had begun drinking again. He left Norway with a government stipend for the next twenty-seven years and, having written his best works in self-imposed exile, ultimately returned as a hero.

Ibsen was a pioneer of modern drama, authoring plays that addressed with realism individual psychological concerns, as well as the hypocrisy and injustice of social conventions surrounding such issues as women's rights and venereal disease. His major works include *Peer Gynt* (1876), *A Doll's House* (1879), *Ghosts* (1881), *An Enemy of the People* (1882), *The Wild Duck* (1884), *Hedda Gabler* (1891), and *The Master Builder* (1892). By the time he died in Christiania (now Oslo) in 1906, he was successful and renowned throughout Europe.

Henrik Ibsen. Åshammeren ved Jønnevald og Fossum Jernverk, nær Skien (By the Iron Factory, Fossum, near Skien)

1845. 30 x 24 inches. Hvitt hus i landskap. Oljemaleri på blikkplate. Ibsenhuset og Grimstad Bymuseum, Grimstad, Norway

Top: Henrik Ibsen. Waterfall

1856. Watercolor. Ibsen-museet. Oslo, Norway

Bottom: Henrik Ibsen. Grimstad Landscape

1849. Pastel. 15–3/4 x 19–5/8 inches. Ibsenhuset, Grimstad Bymuseum, Grimstad, Norway

Above: Henrik Ibsen. Title figure of the play "Olaf Liljekrans" in his wedding gown

1856. Watercolor. Nasjonalbiblioteket i Oslo, Norway

EUGÈNE IONESCO

Playwright Eugène Ionesco drew and painted throughout his life and, at the request of his publisher, illustrated with color drawings an essay in his 1986 work *Les Sentiers de la création* (*The Paths of Creation*). Ionesco's originals were shown in the Galerie Iolas in Geneva, and garnered some critical praise, but in the ensuing years, he did no further artwork. Then, unable to write, he decided, "I needed at least to be able to express myself in some other way. I drew (badly) for two years, day and night, and I made hundreds of scribblings." Ionesco's art was intentionally naïve:

> I tell myself once again, after having said it so many times, that one cannot write anything, one cannot draw anything either, without total, naïve sincerity, but it is very difficult to attain this sincerity. In drawing, I try to clear my mind of all that encumbers it, of all worries, of all vanities, whether what I am doing is good or bad has no importance.

What he made, he proudly wrote, were "child's drawings." "I had neither master nor manuals, I teach myself to draw, I try to teach myself. I will never again be at the point of having to learn, because I am not learning."

Images for Ionesco were a substitute for the words he had lost: "I no longer have my language. The more I speak, the less I say. The more I say, the less I speak. . . . It tires me more and more to speak, but I will never tire of painting." Painting, he believed, was "the art of silence": "One can say more with forms and colors than with words. The image is immediate, and all is shown simultaneously." Yet he insisted that "Literature and painting have nothing to do with one another [even as] they express the same anguish, the same games, the same questions." The language of painting should not be confused with the language of words, he said: "The title of a picture should be another picture."

Ionesco, with Beckett and Genet, is credited with creating the Theater of the Absurd. He was born in Slatina, Romania, in 1909. His father moved his family to Paris, but abandoned them there after returning to Romania to fight in World War I. Already traumatized by witnessing his mother's attempted suicide following humiliation by his father, the boy saw her struggle to survive with factory work. When he was twelve, his mother took her children to Romania to reconcile with their father. A man of wealth, he obtained custody of the children but kept just the boy, sending mother and daughter to Paris without paying the support he owed them. Ionesco's mother died when he was twenty-four, the age at which he ceased all contact with his father.

Refusing the labels of Surrealist or Absurdist, Ionesco said he followed **Alfred Jarry**'s pataphysics. By this he meant "the science of imaginary solutions" popularized by the French playwright, a philosophy that does not seek distinction between sense and nonsense, that rejects the idea of a moral life, or a life with meaning.

Ionesco was elected to the Académie Française in 1970. Among his well-known works are *The Bald Soprano* (1949), *The Lesson* (1950), *The Chairs* (1951), *The Killer* (1957), and *Rhinoceros* (1958). He died, a French citizen, in Paris in 1994.

Eugène Ionesco. *Essai d'une composition decorative* (Sketch for a decorative composition)

From *Le Blanc et Le Noir* (St. Gallen: Erker-Verlag, 1981). By permission of Erker-Verlag, St. Gallen, Switzerland

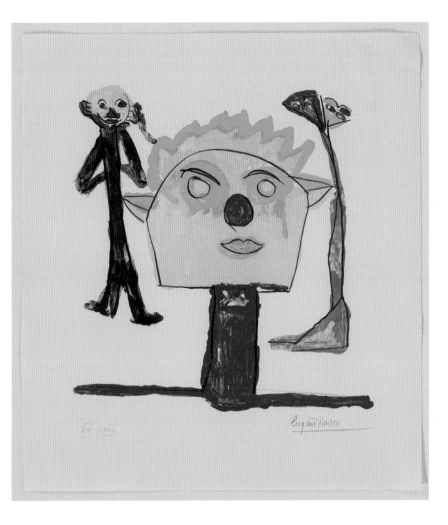

Eugène Ionesco. Le portrait et ses fils (The portrait and his sons)

1984. Lithograph. 18–3/4 x 17 inches. Printed and published by Erker-Presse St. Gallen (Switzerland). Copyright © Erker-Verlag CH-9000 St. Gallen / Switzerland (www.erker-galerie.ch)

Eugène Ionesco. Le mordant (The punch)

1983. Lithograph. 29–1/8 x 21–1/2 inches. Printed and published by Erker-Presse St. Gallen (Switzerland). Copyright © Erker-Verlag CH-9000 St. Gallen / Switzerland (www.erker-galerie.ch)

MAX JACOB

On the fiftieth anniversary of his death, in 1994, seventy-five of Max Jacob's gouaches and drawings were exhibited with seventy-five works by his friend Pablo Picasso at the Quimper Museum of Arts, Quimper, France. A section of that museum is now dedicated to Jacob's work. The influence of the Cubist art of Picasso, Braque, and Gris—all friends of Jacob's—undoubtedly influenced his poetry, which, like that of **Apollinaire**, another friend, sought to present its subjects from multiple perspectives.

Jacob was born to shopkeeper parents in 1894 in Quimper. Depressed as a child, he made three suicide attempts. Small and weak, he was frequently beaten by his mother and brothers, bullied by schoolmates, and reputedly was last slapped by his mother for a spelling error—at the age of twenty-four. At eighteen, Jacob moved to Paris, where he lived in extreme poverty. He earned, he said, "four sous of bread per day"—as a piano teacher, journalist, janitor, art critic, etc. After studying law at the École Coloniale, in Paris, he dropped out to pursue a career as a writer and artist.

In 1901, Jacob met Picasso, and not only encouraged his foray into Cubism but shared his studio with him—Picasso using Jacob's bed by day, Jacob sleeping there at night. Remaining close friends for many years, they maintained homes only three doors apart.

During his penurious years in Paris, most of Jacob's earnings came from his writings as an art critic for the *Moniteur des Arts* and the *Gazette des Beaux-Arts*. But after meeting Picasso, he refocused himself and painted rather than critiqued. Like **Victor Hugo** before him, Jacob created images out of found materials such as coffee grounds, cigarette ash, stove soot, and ink—although for him it was less a matter of choice than want of better materials. Jacob's early paintings were theater scenes. Later, working mainly in gouache and pastel, he rendered images from the streets and city settings of Paris. His first show was held in 1913 at a Paris gallery, but real recognition came only years later, when his work was exhibited at the Petit Palace.

A Jew by birth, Jacob had a vision of Christ in 1909 and converted to Catholicism. In 1915, he was baptized, with Picasso serving as godfather, and in 1921, he moved into the monastery at Saint-Benoît-sur-Loire. Despite his conversion, during the Occupation the Germans forced him to wear the Star of David, and arrested him as he was leaving Mass one morning in 1944. Neither Picasso nor any of Jacob's Parisian circle, except Sacha Guitry, made any effort to save him. He died in the Drancy concentration camp in 1944.

Remembered today primarily for his prose poems, especially those in *Le Cornet a dés* (1917; *The Dice Cup*), Jacob left a body of novels, dramas, children's books, essays, and religious meditations. His declaration that in the creation of art, emotion is to be preferred to intellect, and his use of associations from the unconscious, were an important influence on the Surrealists and a number of French poets, especially **Jean Cocteau**. In Jacob's aesthetics:

> Will plays the leading role in creation, the rest is only the bait in front of the trap. Will can only be exercised on the choice of means, because the work of art is only a collection of means and we arrive at the same definition for art as the one I gave for style: art is the will to exteriorize oneself by one's chosen means.

Right: Max Jacob. Untitled (The Virgin)

The Artinian Collection. Courtesy of Artine Artinian. Copyright © 2007 Artist Rights Society (ARS), New York/ADAGP, Paris

Opposite: Max Jacob. Saules au Bord de la Loire (Willows on the Loire)

1938. Musée des Beaux-Arts d'Orleans. Copyright © 2007 Artist Rights Society (ARS), New York/ADAGP, Paris

Saules
au bord de la [...]
Max Jacob
15 janv. 38

ALFRED JARRY

Playwright Alfred Jarry's aesthetics were much inspired by Paul Gauguin, with whom he briefly stayed in 1894—by his paintings, which generated at least three Jarry poems, and especially by the woodcuts that preoccupied Gauguin at the time of Jarry's visit.

With the Nabis—artists and critics who adopted Gauguin's self-descriptive Hebrew word for prophet—and the Symbolists, Jarry rejected classical and Impressionist art insofar as it attempted to reproduce reality. The aim of art was to express the imagination. The quality of the paint on the canvas, rather than the subject of the painting, was the point of interest.

Jarry was an artist and illustrator who worked in oils, woodcuts, lithography, and pen and pencil drawings. The majority of his surviving works are woodcuts and drawings, many used to illustrate his literary works, like the example from *César-Antechrist* (1895) reproduced here. His artworks, including drawings from manuscripts and letters, are reproduced in *Peintures, Gravures et Dessins d'Alfred Jarry* (1968) by Michel Arrivé.

The man who, more than any other, altered the concept of theater in the twentieth century, whose influence—especially through his philosophy of Pataphysics (the science of imaginary solutions)—was felt by the Symbolists, Surrealists, and Absurdists, was born in Laval, France, in 1873. His father was a successful businessman, his mother an eccentric from a wealthy family notorious for its history of insanity. His father's business failed shortly after Jarry was born, and when he was six, his mother left her husband, taking her children to Saint-Brieuc. In 1888, he entered the lycée in Rennes. Small and squat, Jarry was called "Quasimodo" by his classmates, after **Victor Hugo**'s infamous hunchback. He achieved stature among his classmates, however, by leading the harassment of a much-despised physics teacher. He and another student collaborated on a play that lampooned the man by transforming him into a grotesquely exaggerated glutton with a huge belly—the prototype of Ubu in Jarry's revolutionary play *Ubu Roi* (1896).

Jarry moved to Paris in 1891, and he became a favorite of the leading artists, writers, and composers of his day—including **Paul Valéry**, André Gide, Henri de Toulouse-Lautrec, Gauguin, Henri Rousseau, and Maurice Ravel. Jarry assumed a role—suggestive of the repulsive Ubu himself—that in time usurped his own personality. Gide described him as "plastered white," in a clown's face, "playing a fantastic, fabricated, resolutely artificial role outside of which no human characteristics could any longer be seen" and exercising "a kind of weird fascination" on others. Following the traumatizing death of his mother when he was twenty, Jarry became an alcoholic and ether-addict. Plagued by poverty and bad health, he died in 1907 at the age of thirty-four.

Although Jarry produced eight volumes of work, including Symbolist poetry and a Surrealistic novel, it is *Ubu Roi* for which he is remembered. The vulgar, greedy, and murderous Ubu is presented in a play filled with obscenities in a context devoid of logic or even coherence. The premiere incited violent reactions in an audience that included Edmond Rostand, Stéphane Mallarmé, and **William Butler Yeats**. A shaken Yeats wondered, "[W]hat more is possible? After us the Savage God."

Opposite, left: Alfred Jarry. Véritable portrait de Monsieur Ubu (True portrait of Monsieur Ubu)

Woodcut frontispiece for *Ubu Roi* (Paris: Éditions du Mercure de France, 1896). Courtesy of Department of Special Collections, Kenneth Spencer Library, University of Kansas

Opposite, right: Alfred Jarry. Illustration for *César-Antechrist*

1895. Courtesy of Department of Special Collections, Kenneth Spencer Library, University of Kansas

CHARLES JOHNSON

I n the title essay of *I Call Myself an Artist* (1999), novelist Charles Johnson thanks his mother

> for seducing me with the beauty of blank pages. . . . As with books, it was into drawing that I regularly retreated as a child. There was something magical to me about bringing forth images that hitherto existed only in my head where no one could see them.

This early passion led him to study the work of such masters as Cruikshank, Daumier, and Nast, and to consider a career in art, which his father discouraged on the grounds that "They don't let black people do that." Refusing to accept that judgment, teenaged Johnson wrote to Lawrence Lariar, a prolific mystery writer and cartoonist:

> "My dad tells me I won't be able to have a future as a cartoonist because I'm black, and I just want to know what you think." Lariar, a liberal Jewish man, fired back a letter to me within a week: "Your father is wrong," he said. "You can do whatever you want with your life. All you need is a good drawing teacher."

Johnson drew, and did strip and panel cartoons for his high school and college papers; while still a student at the Southern Illinois University, he became a political cartoonist. When the writer and activist **Amiri Baraka** visited the campus in 1968 and told black students, "Take your talent back to the black community," it was an epiphany for Johnson:

> I wondered: What if I directed my drawing and everything I knew about comic art to exploring the history and culture of black America? In 1968, we had only a handful of black cartoonists at work—Ollie Harrington, who was then living in East Berlin; Morrie Turner, who did "Wee Pals"; and Walt Carr, a staff artist at Johnson Publishing Company in Chicago. But no one was generating books about black cultural nationalism, slavery, or African-American history. I walked home from Baraka's lecture in a daze. . . . I started to sketch. . . . After seven days I had a book, *Black Humor.*

Johnson published more than 1000 drawings in newspapers and magazines, two books of comic art—*Black Humor* (1970) and *Half-Past Nation-Time* (1972)—and hosted and co-produced *Charlie's Pad,* a PBS series on drawing. An award-winning short-story writer, essayist, journalist, and novelist, Johnson had one goal when he began writing fiction: "opening up black literature to the same ethical, ontological, and epistemological questions—Western and Eastern—that I wrestled with as a student of philosophy."

Born in 1948 in Evanston, Illinois, Johnson, a professor at the University of Washington, Seattle, received a National Book Award for his novel *Middle Passage* (1990), and was a MacArthur Award winner in 1998. He wrote in *I Call Myself an Artist,* "It occurs to me sometimes when I'm writing literary criticism, as in *Being and Race,* or discussing aesthetics, that I often cross genres in the language I use for analyzing fiction, borrowing certain terminology from the world of drawing."

Charles Johnson.
"Gee, I'll bet you're glad to be out of the ghetto."

Collection of the artist

Gee, I'll bet you're glad to be out of the ghetto.

Charles Johnson. "All I know is that too much one-pointedness can make you really tired."

Collection of the artist

Charles Johnson. "What's wrong with you? Dorothy's son reached enlightenment; Janice's son reached enlightenment; Sophia's son . . ."

Collection of the artist

Charles Johnson. "Pleased to meet you. I'm being treated for a Toussaint L'Ouverture complex."

Collection of the artist

DAVID JONES

P oet David Jones was employed throughout his life as an engraver, book illustrator, and painter. He was educated at Camberwell School of Art and Westminster Art School. After leaving art school, Jones became a Roman Catholic, and was introduced by his priest to Eric Gill, who headed a community of Catholic artists and under whom Jones became a skilled wood engraver. Jones was elected into the Society of Wood-Engravers in 1925. Later, he was made an honorary member of the Royal Society of Painters in Watercolours. Jones's paintings were exhibited around the world and are part of the collections of the Tate Gallery, the Victoria and Albert Museum, the National Museum of Wales, the Sydney Art Gallery, and the Toronto Art Gallery, among others. Books of his paintings were published in 1949 by Penguin and in 1989 by John Taylor/Lund Humphries, London.

"At the time of my birth," said Jones in a *Contemporary Authors* interview,

> my father was a printer's overseer and that meant that I was brought up in a home that took the printed page and its illustration for granted. I began drawing when I was aged five and regarded it as a natural activity which I would pursue as I grew older.

The writing came when Jones had the first of two nervous breakdowns, and the neurologist he'd consulted told him to stop painting since it made him ill. When his symptoms recurred some fourteen years later, Jones declined inactivity, opting for a psychiatrist who theorized that since painting and writing made him ill, that was what he *must* do.

Although many have commented on the mystery and spirituality of his work, Jones had a more pragmatic view:

> Well, Christ almighty! What else is there in a bunch of flowers or a tree . . . or a girl or the sky, but these qualities . . . the blasted stuff is there plain as a pikestaff—the bugger of it is how to 'transubstantiate' these qualities into whatever medium one is using.

Born 1895 in Kent, England, Jones is considered one of the most important British poets of the twentieth century. He was praised and published by T. S. Eliot, honored by **W. B. Yeats** for his epic poem *In Parenthesis,* and called "one of literature's saints" by Stephen Spender. His poem *The Anathemata* was heralded by W. H. Auden as "one of the most important poems of our time." Yet when he died in Harrow outside London in 1974, Jones was virtually unread outside literary circles. *In Parenthesis,* a fictionalized account of Jones's experiences from 1915 to 1918 while an infantryman during World War I, is a novel-length poem that incorporates elements of an ancient Welsh heroic epic, Shakespeare's history plays, and Arthurian legend to express the idea that the soldiers of his day shared the experiences of soldiers throughout history. Among the literary awards Jones received were the Hawthornden Prize (1938); the Russell Loines Memorial Award for poetry, National Institute and American Academy of Arts and Letters (1954); Commander, Order of the British Empire (1955); the Harriet Monroe Memorial Prize from *Poetry* magazine (1956); and a D.Litt., University of Wales (1960).

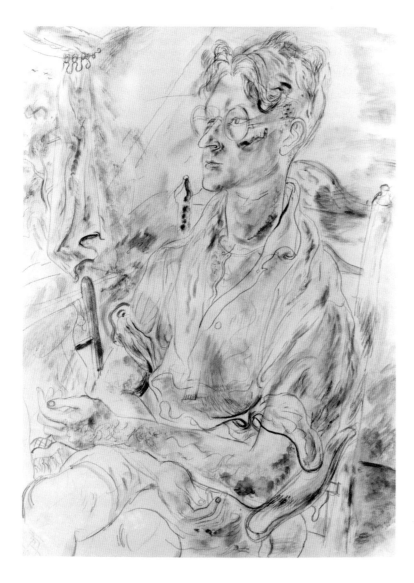

David Jones. The Translator of the Chanson de Roland

1932. Watercolor. 30 x 22 inches. National Museum of Wales. By kind permission of the David Jones Trust

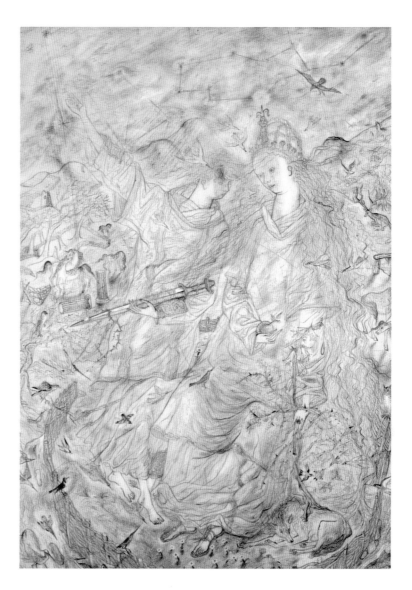

David Jones. Y Cyfarchiad i Fair (The Greeting to Mary)

1963. Watercolor. 30 x 23 inches. National Museum of Wales. By kind permission of the David Jones Trust

DONALD JUSTICE

*D*onald Justice studied music composition before becoming a writer. He denied any direct link between his music and poetry, but in a 1987 *Contemporary Authors* interview explained:

> I have a general theory that anybody with a love of one art and some practice in it may have a natural inclination to love and practice one of the other arts. In that way, I think, the arts may all be connected by way of the sensibility.

It was perhaps that love and inclination that led Justice to ask his wife, the writer Jean Ross, for a set of watercolors as a Christmas present in 1984 and to the discovery that he had another gift. In a 2001 letter to me, Justice wrote:

> When I am sketching, painting, or cutting linoleum blocks, I seem always to be happy. Even when the work is not going well, this is true. This is not at all my feeling when working on poems or stories. Then the work has to be going well for me to have anything but a rather raw anxiety and doubt. I attribute this to the fact that in painting I remain strictly an amateur, while as a poet I at least know how to do certain things, whether I am at the moment managing to do them or not. A continual sense of imperfection hovers over the writing; in art any success for me, however small, is almost completely luck. And hence a joy.

Justice confessed he was uncertain whether there was a connection between his artwork and his poems, "except that both come from the same sensibility," emphasizing that to him, that was "of supreme importance." He added that he would say the same of his compositional gift: "The music turns out—not from any conscious desire—to be more 'romantic' in spirit than my writing; the art more 'realist'; and the writing whatever may be left at bottom or perhaps the top."

Born in Miami, Florida, in 1925, Justice was a Chancellor of the Academy of American Poets and a Pulitzer Prize winner whose extraordinary craftsmanship earned him the designation of poet's poet. He was also a short story writer, essayist, translator, and librettist. The son of a carpenter, Justice suffered a childhood of near poverty, osteomyelitis, the death of a close young friend, and mistreatment by adults. Writing, for Justice, was a way of dealing with an event of pain or loss. He explained in his essay "Meters and Memory":

> The terror or beauty or, for that matter, the plain ordinariness of the original event, being transformed, is fixed and thereby made more tolerable. That the event can recur only in its new context, the context of art, sheers it of some risks, the chief of which may anyhow have been its transitory character.

Justice's writings include his National Book Award-nominated *Departures* (1973) and O. Henry Prize-winning short stories, as well as his other poetry, which received the Academy of American Poets Lamont Poetry Selection for 1959, the Bollingen Prize in 1991, and the Pulitzer, for *Selected Poems,* in 1979. He died in 2004 in Iowa City, Iowa.

Right: Donald Justice.
Courtyard of the Biltmore Hotel,
Coral Gables

Acrylic. Collection of the artist

Opposite: Donald Justice.
Back Street, Boston, Georgia

Acrylic. Collection of the artist

FRANZ KAFKA

y drawing," wrote Franz Kafka, "is a perpetually renewed and unsuccessful attempt at primitive magic." Kafka drew throughout his life, primarily in his diaries and letters, describing the images he produced as "purely personal, and therefore illegible, hieroglyphs." Kafka responded positively to a request that he illustrate his great friend Max Brod's first book of poems. Although the drawings were rejected by the publisher, Brod promoted Kafka to his painter friends as "a very great artist" and showed around a portfolio of Kafka's expressionistic drawings, supposedly reminiscent of early Paul Klee and **Alfred Kubin**. Those in the portfolio were lost, but others have come down to us. The reproductions shown here are taken from *The Drawings of Franz Kafka* (1949), a collection preserved and edited by Brod, who famously disobeyed Kafka's dying request to burn his works.

Biographer Ronald Hayman sees in Kafka's "emaciated linear figures . . . some affinity with Giacometti's" and believes they "show that Kafka's imagination was already working its way into the territory that his later novels have made famous. . . . The desperate isolated figures seek refuge or perform onerous tasks against spare backgrounds. . . . [T]here is a strong suggestion of empty space and silence."

Kafka, whose name has come to evoke the grotesque, absurd, isolated, and anxious in life, as well as in the literature his writings have so enormously influenced, was born in 1883 in Prague, Bohemia (now the Czech Republic), and died in 1924 in Kierling, Austria. As a Jew alienated from his Jewish heritage, and a German by language and culture, he felt estranged from Czech life and the German gentile community as well. A shy child, he described himself, after avoiding being outfitted for a tuxedo, as "under the reproaches of my mother, [left] warily behind, barred forever—everything happened to me forever—from girls, an elegant appearance, and dances." The boy hid in his room, drawing enthusiastically, his goal "to see, and to hold fast to what was seen." He took some formal art classes, but claimed they destroyed his skill as "a great draftsman."

After receiving a law degree at the University of Prague in 1906, Kafka went to work for insurance companies. He continued this career until he had to stop working, due to his recurring tuberculosis, two years before he died. Among his major works are *The Metamorphosis* (1912), *The Trial* (1925), and *The Castle* (1926). He was clear about the importance of what his parable-like stories sought to achieve, writing in his diary:

> What will be my fate as a writer is very simple. My talent for portraying my dreamlike inner life has thrust all other matters into the background; my life has dwindled dreadfully, nor will it cease to dwindle. Nothing else will ever satisfy me. But the strength I can muster for the portrayal is not to be counted upon: perhaps it has already vanished forever, perhaps it will come back to me again, although the circumstances of my life don't favor its return. Thus I waver, continually fly to the summit of the mountain, but then fall back in a moment. Others waver too, but in lower regions, with greater strength; if they are in danger of falling, they are caught up by the kinsman who walks beside them for that very purpose. But I waver on the heights; it is not death, alas, but the eternal torments of dying.

Above, right, and opposite: Franz Kafka. Three drawings

From *The Drawings of Franz Kafka 1914–1923,* Max Brod, ed. (New York: Schocken, 1949). Courtesy
Archiv Klaus Wagenbach

WELDON KEES

Modern society pushes people in the groove," insisted the category-resistant Weldon Kees. "Although I was always interested in music and painting as well as poetry, at first I thought I had to concentrate on writing . . . one thing only. But then the urge to paint was so strong I just went ahead and started oils. And I didn't give up my writing—one did not exclude the other."

In fact, Kees found "that painting and writing complement one another. Shifting from one to the other I don't get into periods of absolute sterility that are often experienced by writers who just write, or painters who just paint." Kees believed that the capacity to express oneself in multiple creative disciplines existed in many writers and painters:

> No doubt the majority of painters and writers could turn to either medium if they liked. Most of them, I think, are forced by society to do one thing and, consequently, in some cases, they become narrower and narrower.

Kees began painting in 1943. Attracted to artists whose paintings were "simply about paint," he moved increasingly away from the figurative. His method was to start painting with nothing more than an emotion, or "a particular range of colors, or of textures."

Eventually, Kees became a prominent abstract expressionist, was shown with Willem de Kooning and Hans Hoffman, exhibited regularly in the Palace of the Legion of Honor, San Francisco, and was included in the Whitney Annuals of 1949 and 1950. Late in his career he began to make paint-and-paper collages, which he described in evocative terms:

> It might be something you glimpsed somewhere . . . like the nostalgia of a peeled billboard . . . or it might be a dream— something you would like to have glimpsed somewhere.

Kees devoted his life to art, accepting no limitation on the directions his creative force would take him. A poet, short story writer, novelist, screenwriter, and playwright, he also played the piano and composed, notably writing the score for James Broughton's film *Adventures of Jimmy* (1950). He worked as a photographer, and with Jurgen Ruesch produced a work of cultural anthropology, *Nonverbal Communication: Notes on the Visual Perception of Human Relations* (1953). In 2000, the University of Iowa and the Steven Vail Galleries in Des Moines held exhibits of Kees's paintings.

Born in Beatrice, Nebraska, in 1914, Kees graduated in 1935 from the University of Nebraska, Lincoln. He wrote poems with the Federal Writers' Project, fiction for little magazines, and a novel, *Fall Quarter*—which was completed in 1941 but not published for nearly fifty years. After several years of separation from his mentally ill wife, a period consumed by work and marked by declarations of despair, he disappeared, a presumed suicide, on July 18, 1955, his car found parked, keys in the ignition, by the Golden Gate Bridge. Despite his great versatility, Kees was little known at the time of his death. He achieved his ever-increasing stature as a writer only posthumously: *The Collected Poems of Weldon Kees* was first published in 1960. His work has been included in major anthologies of twentieth-century American poetry and in Harold Bloom's *The Western Canon: The Books and School of the Ages* (1994).

Above: Weldon Kees. The Studio

C. 1940s. Oil on canvas. 41–1/2 x 31–1/2 inches. Courtesy Gallery: Gertrude Stein

Weldon Kees. Seated Woman

C. 1940s. Oil on canvas. 41–1/2 x 32 inches. Courtesy Gallery: Gertrude Stein

Opposite: Weldon Kees. Raffle #2

C. 1940s. Oil on canvas. 36–1/2 x 42–1/2 inches. Courtesy Gallery: Gertrude Stein

GOTTFRIED KELLER

As a child in Zurich, Gottfried Keller—recognized today as Switzerland's greatest fiction writer—put on puppet shows and demonstrated skill at caricature. After his expulsion from school at fourteen, he occupied himself reading and painting in the attic of his mother's house.

At fifteen, he made a summer visit to an uncle who lived amid beautiful scenery, and decided, over the protestations of his mother and uncle, to become a landscape painter. He studied with two local artists, the second of whom, Rudolf Meyer, trained him to notice detail and imitate nature with exactitude.

The twenty-year-old Keller decided to follow friends to Munich to study art. Although enrolled in the art academy, Keller squandered his time and a small bequest drinking and in pursuit of pleasures. Once his funds were exhausted, he demanded more and more money from his mother. Drained, distressed, and—because of the mortgage he convinced her to take out—in debt, she asked him to return home. "I have started out on my way and will pursue it to the end," Keller replied, "even if it were to mean eating cats in Munich."

Keller produced a number of paintings during his stay in Munich, but by the end of 1842, he had decided to give up on a career as a landscape artist. "[O]nly an ass would want to be a martyr to painting," he wrote. Having liquidated everything he owned, including all the paintings he'd produced, he was forced to take a job decorating flagstaffs for a royal wedding, yet still found it necessary to ask his mother for money to get back home. Although he rented an unheated studio in Zurich in 1876—a final gesture toward an art career—he spent his time reading and making his first real efforts as poet and novelist.

Scholars have remarked on Keller's ability as a writer to draw his fictional characters with an artist's eye: to show, as a painter would, rather than tell. Paul Schaffner believes that Keller's development as a writer parallels his experience as a painter, away from the Romantic (as reflected in his Ossianic landscapes) to the realistic.

Lauded in his lifetime by the governments of Germany and Switzerland as the finest writer in the German language, Keller was born in Zurich in 1819, one of six children, four of whom died in childhood. His father died when Keller was five, and he claimed he never recovered from the loss. His mother took in boarders to support the family. Keller considered his humiliating expulsion from school, as the result of a minor protest, to have been the second major trauma in his life. His selfish behavior in Munich and the pain he caused his mother also seem to have weighed heavily on him: he made use of them in his fiction in what would appear to be an effort at expiation.

Keller was small, unattractive, and unsuccessful with women. His first love, a girl who lived with her family in the Keller house, died of tuberculosis when he was twenty. When he finally got engaged, at forty-seven, to a twenty-three-year-old, she drowned herself to get out of the engagement. His sister, who had devoted her earnings as a seamstress and clerk to Keller's support, took over as his caretaker after their mother's death, and neither of them ever married. Keller's writings, especially the autobiographical novel *Der grüne Heinrich* (1854–1855; *Green Henry*), emphasize the effects of childhood experience in forming the adult, which led to his being approvingly cited by Freud. The collected works of this poet, critic, and novelist fill ten volumes. He died in Zurich in 1890.

Right, top: Gottfried Keller. Heroische Landschaft (Heroic Landscape)

1842. Oil on canvas. 34–1/2 x 45–3/4 inches. Zentralbibliothek Zürich GKN 68

Right, bottom: Gottfried Keller. Waldlichtung (Clearing)

1843. Pencil and gouache. 12 x 16–1/2 inches. Zentralbibliothek Zürich

Opposite: Gottfried Keller. Sommerlandschaft am Zürichsee (Summer landscape near Zurich Lake)

1849. Pencil and watercolor. 7–3/8 x 10–7/8 inches. Zentralbibliothek Zürich GKN 64

JACK KEROUAC

The Shadow, legendary avenger of evil in the comics and on radio in the 1930s and 1940s, seems to have aroused literary and artistic efforts in eleven-year-old Jack Kerouac. The title character of Kerouac's *Doctor Sax* (1959) was "like The Shadow when I was young," he wrote, and the novel's sinister drawings were appropriated from The Shadow's illustrations.

Kerouac's older brother, Gerard, died when Jack was four. He was an artist, Kerouac recalled, and "As he neared his death a tremendous drawing technique began to come to him." It was Gerard who taught his brother cartooning. After Gerard's death, Kerouac withdrew, finding consolation in his own imagination. He would act out stories to music on the record player, then turn them into comic books.

"Sketching," Kerouac wrote his friend **Allen Ginsberg** in 1951, was his term for the new writing technique he had taken up after an architect friend, Ed White, urged him to be more like a painter, only using words instead of paint. The idea was to be spontaneous, to achieve a rhythmic flow, and to be improvisatory in the style of jazz.

A letter Kerouac wrote to White in 1957 is reproduced in Ed Adler's *Departed Angels: The Lost Paintings* (2004). After telling White how he'd begun to paint in Mexico City the prior October and gone to the Louvre to study the masters, Kerouac offhandedly concluded:

> By the way, you started whole new movement of American literature (spontaneous prose & poetry) when (1951) in that Chinese restaurant on 125th street one night you told me to start SKETCHING. . . . And how in Dickens did you know always I wd. become painter somehow?

Kerouac was a friend of artists Willem de Kooning, Franz Kline, Larry Rivers, and Stanley Twardowicz, in whose studios he would sometimes paint or carve a woodcut. In *Departed Angels,* Twardowicz remembered

Kerouac's dislike of abstraction at that time, although he liked the abstract painters personally—Kline in particular.

In a 1959 notebook, Kerouac listed his five-point "theory of painting":

> 1. USE ONLY BRUSH 2. USE BRUSH SPONTANEOUSLY 3. FIGURE MEETS BACKGROUND OR VISA VERSA [sic] BY THE BRUSH 4. PAINT WHAT YOU SEE IN FRONT OF YOU, NO "FICTION" 5. STOP WHEN YOU WANT TO IMPROVE IT—IT'S DONE.

Kerouac's work has been in exhibitions of Beat art, notably at the 80 Washington Square East Gallery, New York, in 1994, and the Whitney Museum in 1995. His art is reproduced in *Departed Angels,* accompanied by Adler's detailed analysis.

A novelist and poet, most famous for his free-form *On The Road* (1957), Kerouac was the Beat who gave the movement its name. Born Jean-Louis Kerouac in Lowell, Massachusetts, in 1922 to French-Canadian parents, he learned English as a second language. He died in 1969 in Saint Petersburg, Florida.

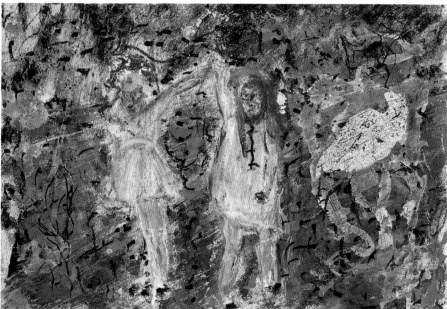

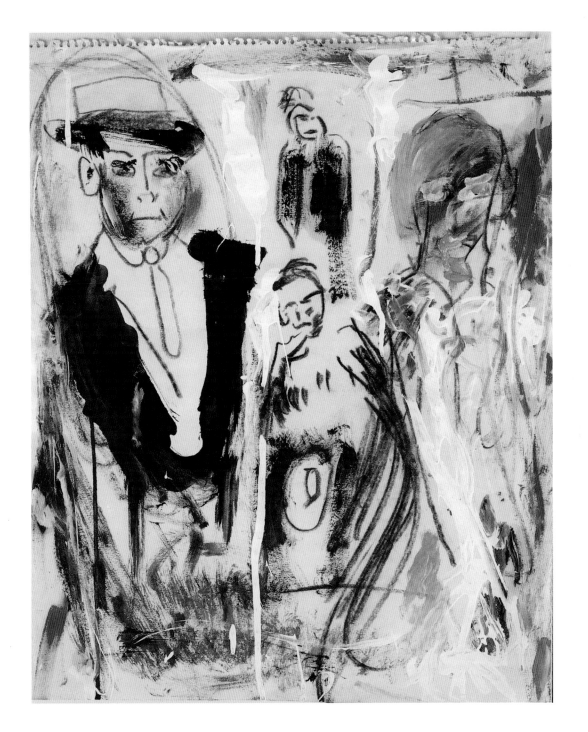

Right: Jack Kerouac. The Slouch Hat

Oil and charcoal. 14 x 17 inches. Copyright © 2004 John
Sampas, Literary Representative of the estate of Jack Kerouac

Opposite: Jack Kerouac. Two Figures in the Woods

Oil, crayon, and ink. 9 x 13 inches. Copyright © 2004 John
Sampas, Literary Representative of the estate of Jack Kerouac

CHARLES KINGSLEY

Who would have thought that Charles Kingsley—Church of England parson, chaplain to Queen Victoria, tutor to the Prince of Wales, and author of *Westward Ho!* (1855)—was a sensualist at his core? Yet, that was the judgment of Kingsley's Oxford contemporaries after viewing the series of illustrations he did for *The Saint's Tragedy; or, The True Story of Elizabeth of Hungary* (1848). Frustrated by separation from his beloved Fanny Grenfell, Kingsley had produced unabashedly sexual drawings of naked women being tortured. He was clear about the connection:

> St Elizabeth is my Fanny not as she is but as she will be. I feel I draw worse and worse. If my baby will be my model I will be able to draw such lovely pictures for her.

Kingsley seems to have inherited his talent from his father, a landscape artist, but he declared his lack of interest in "trees" as a subject, preferring the human figure, which he felt uniquely evoked "the broad natural childish emotions." Human emotion and sexuality were essential to Kingsley, along with faith: "Without faith there can be no real art, for art is the outward expression of firm, coherent belief."

While at Cambridge, Kingsley was known for his interest in the work of the masters and a proclivity for constant drawing. A fellow student said that he would provide Kingsley with pencil and paper whenever he came by, "for I knew his wont to go on sketching all sorts of fanciful things while we worried our young heads over other dreams as fanciful." Kingsley used his artistic skill to finesse a final exam in mechanics when, unable to describe a common pump, he drew a church scene around a village pump, with a notice indicating it was "locked during divine service."

An atypical Victorian moralist, Kingsley did not argue for separation of spirit and body, but saw a divine expression in married love, which became so central to his religious teaching that he was viewed as an "apostle of the flesh." He even drew himself and Fanny coupled in the act of sex on a (horizontal) cross, their bodies intertwined as one crucified figure.

Kingsley was born in 1819 in Devon, England. His father was forced to earn his living as a clergyman after wasting all of his inherited monies as a young man. The family moved from parish to parish, and Kingsley saw two of his four younger brothers die in their youth. He and Fanny were married in 1844. Four years later, Kingsley cofounded the Christian Socialist movement and addressed the plight of the working classes in articles and in *Yeast,* his first novel, concerning the hardships of agricultural workers. His collected works—essays and sermons, children's books, poetry, writings on geology and marine biology, as well as his anti-Catholic attacks, including famous conflicts with the future Cardinal Newman—fill twenty-eight volumes. He is best remembered, however, for his historical novels, particularly *Westward Ho!* He died in 1875 in Eversley, England.

Above: Charles Kingsley. Ascension of Charles and Fanny

1843. Ink on paper. From Susan Chitty's *The Beast and the Monk: A Life of Charles Kingsley* (1975)

Above: Charles Kingsley. "The Thorn!"

1843. Ink on paper. From Susan Chitty's *The Beast and the Monk: A Life of Charles Kingsley* (1975)

Opposite: Charles Kingsley. The Harvest Truly Is Plenteous But the Laborers Are Few

1843. Ink on paper. From Susan Chitty's *The Beast and the Monk: A Life of Charles Kingsley* (1975)

RUDYARD KIPLING

Rudyard Kipling's legendary mistreatment in childhood made him the central argument for Edmund Wilson's thesis in *The Wound and the Bow* (1941) about how trauma informs the creative soul. Joseph Rudyard Kipling was born in Bombay (now known as Mumbai), India, in 1865. His father, a painter and sculptor who taught architectural sculpture in the Bombay School of Art, sent the five-year-old Kipling and his younger sister to a sadistic aunt's home in England to be Anglicized. There, in what he referred to as the "House of Desolation," Kipling was subjected to unremitting physical and emotional abuse. He said that his aunt told the brutalized children "she had taken us in out of pity."

As a child Kipling had bad eyesight that prevented him from doing his schoolwork, a failure for which he was made to perform humiliating penance. When he suffered a serious emotional breakdown and partial blindness, he was punished by being isolated from his sister.

Viewing his artistry as the result of craftsmanship—he believed a writer or artist mastered a trade in the same way stonecutters, seamen, or cabinetmakers did theirs—Kipling saw his childhood abuse, in very pragmatic terms, as helpful:

> Nor was my life an unsuitable preparation for my future, in that it demanded constant wariness, the habit of observation, and attendance on moods and tempers; the noting of discrepancies between speech and action; a certain reserve of demeanour; and automatic suspicion of sudden favours.

Respite came only during Kipling's annual Christmas visits to another, more sympathetic aunt, who was married to the artist Edward Burne-Jones (whom he called "Uncle Ned"). It was while visiting this aunt that Kipling met the multiply gifted **William Morris**, founder of the Arts and Crafts Movement (whom he called "Uncle Topsy"). In that light-hearted household Kipling's pleasure was bound up in the elemental sights, sounds, and smells of creativity:

> There were the most wonderful smells of paints and turpentine whiffing down from the big studio on the first floor where my uncle worked. . . . There were pictures finished or half finished of lovely colours; and in the rooms chairs and cupboards such as the world had not yet seen, for William Morris . . . was just beginning to fabricate these things.

It was in this setting that Kipling began drawing and writing stories, and that he and the Burne-Jones and Morris children produced a magazine in which his first story appeared. Kipling illustrated many of his famous stories, including the fables in his *Just So Stories* (1902).

Best remembered for "The Man Who Would Be King" (1888), "Gunga Din" (1892), and *Kim* (1901), Kipling wrote stories, poems, novels, and essays. He was awarded the Nobel Prize for Literature in 1907. An unabashed imperialist, he nonetheless declined all honors proffered by the British government. He died in London in 1936, his ashes buried in Westminster Abbey.

Right: Rudyard Kipling. The Birthday of
Madame Cigale

Pen and ink. 7–1/2 x 6 inches. Berg Collection of English and
American Literature, The New York Public Library, Astor,
Lenox and Tilden Foundations

Opposite: Rudyard Kipling. From "How the
Whale Got His Throat"

Pen and ink. From *Just So Stories* (1902)

ERIC KNIGHT

Before the creator of *Lassie Come-Home* launched his career as a novelist, newspaperman, short story writer, and screenwriter, Eric Knight studied at the Boston Museum of Fine Arts School, and in New York at the National Academy of Design, the Art Students League of New York, and the Beaux-Arts Institute of Design. Painting and drawing, as well as reading and watching movies, had been a consolation for Knight as a child. His father, a diamond merchant, died in South Africa when the boy was three. The instantly impoverished family was split apart: Knight's mother took a job as a governess and sent each of her five sons to live with a different relative.

Knight was born in 1897 in Menston, Yorkshire, England. At thirteen he dropped out of school to work in a textile mill but continued to stimulate his imagination with his art. His family was reunited after twelve years, when the boys joined their remarried mother in the United States. Knight embarked on formal art studies, only to leave them to enlist in Canada's Princess Patricia Light Infantry Brigade—renowned for its courage and high mortality—at the start of World War I. Knight sketched throughout his service as an artillery expert. After the war, he wrote theater and film criticism for newspapers, as well as feature articles for a syndicate bureau. According to biographer Geoff Gehman, Knight, a visual writer who frequently used artist characters in his fiction, had many artist friends, including Grant Wood, N. C. Wyeth, and Peter Hurd, whose painting of Knight hangs in the National Portrait Gallery in Washington, D.C.

His interest in the visual found a new and startling creative application when Knight was hired by RCA Victor in the early 1930s to collaborate with Leopold Stokowski, legendary conductor of the RCA orchestra, on films in which Debussy was set to images of blowing grass and moving clouds. Stokowski pursued with great success this innovation of cinematically imagined classical music in Walt Disney's animated movie *Fantasia* (1940).

Knight left journalism and film criticism in 1934, moving to Hollywood to write his own screenplays. He worked unhappily for Fox on unproduced films for Shirley Temple and Spencer Tracy, and when he'd had enough, left Hollywood. His first novel, the autobiographical *Invitation to Life* (1934), was followed by *The Flying Yorkshireman* (1936) and *Song on Your Bugles* (1937). After *Lassie Come-Home* (1938), Knight wrote the bestselling novel *This Above All* (1941), which was adapted as a motion picture, starring Tyrone Power and Joan Fontaine.

In 1942, Frank Capra recruited Knight, who was a Quaker, to help him write and produce indoctrination-propaganda films for the army. Knight died in 1943 when his army transport plane crashed on route to Cairo. His widely popular story of a loyal collie and his young master has been adapted into countless movies and television series.

Although his publisher decided to use another, more tested illustrator, Knight had illustrated his manuscript for *Lassie Come-Home*. It was an unfortunate choice, biographer Gehman wrote, "for Knight's drawings are much more interesting." Knight's portrait sculpture of Lassie, shown here, is part of the permanent collection of the National Portrait Gallery.

Right: Eric Knight. Bust of Jere Knight (his wife)

C. 1941. Cedar. 18 x 9 inches. Private collection, Pennsylvania. Photo by Don Simon. Courtesy of the estate of Eric Knight

Opposite: Eric Knight. Lassie

1938. Wood. 6 x 13 x 5 inches. National Portrait Gallery, Smithsonian Institution. Gift of Mrs. Jere Knight. Courtesy of the estate of Eric Knight

OSKAR KOKOSCHKA

Modern master Oskar Kokoschka's 485 oil paintings, 567 prints, and more than 5000 drawings equal or surpass his important literary work, including his six plays. Word and image were conjoined in his early creations. His first play, performed when he was twenty-one, was a shadow play that utilized puppets he made of paper and metal sheeting. He illustrated his first book, and it was displayed in his school's art show in 1908. In his notorious *Morder, Hoffnung der Frauen* (1908; *Murder, the Hope of Women*), considered the first German Expressionist play, Kokoschka painted the actors' bodies to suggest their underlying anatomy. Line drawings were included in its published version.

Kokoschka's training as an artist had begun in Vienna when, at eighteen, he enrolled in the School of Arts and Crafts. There he was taught, to his dissatisfaction, mainly decorative arts. But he also learned drawing, lithography, bookbinding, and other crafts. By 1910, he had achieved recognition as a portrait artist and acquired commissions from Viennese notables. He soon moved to Berlin, where he began doing pen-and-ink illustrations for the magazine *Der Sturm*. He directed and designed sets for the plays he mounted and, in 1920, created a portrait series that was published to great praise for Kokoschka's expressive depiction of his subjects.

Having been appointed professor at the Dresden Art Academy in 1919, Kokoschka took a sabbatical four years later, from which he never returned. He traveled and painted the cities he visited, each landscape shown from an elevated, distant, panoramic perspective. Returning to Vienna in 1934, he encountered the rising tide of Nazism, and moved to Prague, where the President of Czechoslovakia, Tomás G. Masaryk, had Kokoschka paint his portrait, and invited him to become a Czech citizen. At the time, Kokoschka's paintings were being removed by the Germans from museums in Austria. Czechoslovakia was shortly overrun, and Kokoschka fled to London with his future wife. His art took on political overtones: he painted a self-portrait as a "Degenerate Artist" (1937); he made lithographs and drawings with antifascist themes. He became a British citizen in 1947, only to move in 1953 to Villeneuve, Switzerland, and then to Salzburg, where he founded his "School of Seeing," which attracted artists internationally.

Kokoschka was born in 1886 in Pochlarn, Austria. His father, a former goldsmith, had lost his business, and needed his son's help, throughout Kokoschka's life, to support their impoverished family. At twenty-five, Kokoschka met and fell in love with Alma Mahler, widow of composer Gustav Mahler. They had a tempestuous relationship for three years. When World War I broke out, Kokoschka joined the cavalry of the Austro-Hungarian army. Bayonetted and shot in the head, he learned from a letter in the hospital that Alma had aborted their child and married the architect Walter Gropius.

Kokoschka returned to the battlefield, suffered shell shock, and was released from service. He remained obsessed with Alma and in 1919 had a life-size doll of her made. He dressed it, did portraits of it (as he had done of Alma), and had it accompany him in public. It is Alma who appears with him in the painting opposite right.

Of his dozens of published works, Kokoschka's plays are what earned him literary recognition. He died in 1980 in Villeneuve.

Oskar Kokoschka. Marquis Joseph de Montesquiou-Fezensac

1910. Oil on canvas. 31–1/2 x 24–3/4 inches. Moderna Museet, Stockholm. Copyright © 2007 Artist Rights Society (ARS), New York/ProLitteris, Zürich

Oskar Kokoschka. Die Windsbraut (The Tempest aka The Bride of the Wind)

1914. Oil on wood. 71–1/4 x 87 inches. Kunstmuseum, Basel, Switzerland. Copyright © 2007 Artist Rights Society (ARS), New York/ProLitteris, Zürich

ALFRED KUBIN

*A*lfred Kubin, now considered a precursor of the Surrealists in art and literature, was ten when his mother died:

> Her death throes made a permanent impression on me, but much stronger were the terror and confusion inspired in me by my father's complete despair; he lifted his wife's long, emaciated body from the bed and ran weeping with it through the whole house as though crying out for help.

Life got worse for the young Kubin:

> When my stepmother died in childbed at the end of a single year of marriage, and I soon thereafter returned home miserably as a failed scholar who had not yet completed primary school, I experienced for the first time a period of real hell. My father, himself deeply unhappy and confused, had lost all confidence in me. I was no longer permitted to come into his presence and had to live completely alone.

The imposed isolation, however, greatly stimulated Kubin's fantasies: "From the start, I had found keen pleasure in dwelling in imagination on catastrophe and the upsurge of primeval forces; it was like an intoxication, accompanied by a prickly feeling along my spine." The unhappy child found additional satisfaction in sadistically mistreating animals: "Lying on the ground in a hidden corner of the garden, I would stage ingenious scenes of torture with any wretched creatures unlucky enough to come into my power." More importantly for his future career in art, he said,

> I covered countless sheets of paper with pencil sketches and paintings. From the beginning, I had a natural tendency toward exaggeration and fantasy; a cow with four horns always seemed to me more interesting than those with two.

In school, Kubin described himself as wanting to rise "above nature," and the experience of examining the world through a microscope inspired him to reject "every memory of the given organization of nature, and I created compositions out of veils or bundles of beams, out of fragments of crystals or parts of seashells, from layers of flesh and skin, from the patterns of leaves and a thousand other things, and these compositions, bathed in a warm or cold light."

At twenty-one, after years of academic failure, Kubin joined the army and was discharged in three months. At twenty-five, he went to Munich to study art. There he entered an art gallery for the first time. It was, he said,

> a turning point in my life. . . . I was completely overcome by such an immense accomplishment and such a radiant outburst of the human spirit; without eating or growing tired, I stayed from nine in the morning until closing time at six in those rooms that seemed to me heaven itself.

Kubin studied privately for two years, then took a class at the Academy in Munich, he explained, "only to please my father, who wanted me to have some connection with a government institution." At twenty-nine, he had a one-man show in Berlin.

Born in 1877 in Leitmeritz, Bohemia (now the Czech Republic), Kubin died in 1959 in Zwickledt, Austria. The illustrator of the books of more than 140 writers, including **Edgar Allan Poe**, **E. T. A. Hoffmann**, and **Fyodor Dostoevsky**, he authored and illustrated dozens of books of his own, most notably *Die andere Seite* (1908; *The Other Side*), a novel that takes the reader into a dystopic dream world, where reason and logic do not apply, and which has been compared to **Kafka**'s works.

Alfred Kubin. Der Sauger (The Bloodsucker)

1903–1904. Photo copyright © Städtische Galerie im Lenbachhaus, München

Alfred Kubin. Der Sauger (The Bloodsucker)

1901. Photo copyright © Städtische Galerie im Lenbachhaus, München

ELSE LASKER-SCHÜLER

Poet and playwright Else Lasker-Schüler began drawing in early childhood. Her uncle and eldest brother were both painters, and beginning in 1894, she spent at least three years at art study in Berlin with the painter and rabbi Simson Goldberg. There, she was also directly influenced by many members of the avant-garde German Expressionists, including **Oskar Kokoschka**, Franz Marc, George Grosz, and Peter Hille.

Lasker-Schüler's art has been exhibited around the world, and comprehensive catalogues of shows honoring the fiftieth anniversary of her death were published by August Macke Haus, Bonn; the Deutsche Schillergesellschaft Marbach am Neckar, Zurich; and Jerusalem's Israel Museum and Anna Ticho House. Curator Irit Salmon observes that Lasker-Schüler

> exemplified the principle of total art (*Gesamtkunst*), creating her own illustrations and bindings for her books of poetry, writing poems the same way she drew pictures, the same way she lived: in cafes, wandering from place to place.

Salmon quotes Lasker-Schüler to the effect that her art was simply another form of her poetry: "I have been drawing since I was a child. . . . I [also] wrote many poems as a girl, but then I wanted to use force to write everything in with the brush."

Elisabeth Schüler was born in 1869 in Elberfeld, in the Rhineland section of Germany. (As Schüler told it, "I was born in Thebes although I came into the world in Elberfeld.") German Jews had been granted rights of citizenship by the Emancipation Law that year, and Schüler's parents were so assimilated that they enrolled her brothers in Catholic schools. Unfortunately for Else, legal rights did not affect German anti-Semitism: she was subjected to such vicious assaults at school that she became ill and, at eleven, had to be withdrawn and tutored at home. When her mother—whom Schüler called "the great angel who walked by my side"—died, the loss affected her deeply, and maternal yearning was a recurrent theme in her work.

In 1894, Schüler married her first husband, Berthold Lasker, a doctor (and older brother of chess champion Emanuel Lasker). She moved with him to Berlin, where she led a bohemian life and became deeply enmeshed in the German Expressionist movement. Although her genius was apparent, so were her great swings in mood and bizarre, visionary, hallucinatory expressions. In a letter to Walter Benjamin, their mutual friend Gershom Sholem described Lasker-Schüler as "bordering on madness . . . an amazing phenomenon; she had a half-hour long talk with King David, and now she is asking me for kabbalistic references to him."

One of the greatest German language poets of the twentieth century, Lasker-Schüler also wrote plays. Her work, which mined Jewish, Christian, and Islamic traditions, is difficult and hermetic, not least because of her extensive neologisms—she actually created a language of her own that she called "Mystic Asiatic, or Ur-language."

The year after Germany's highest literary honor, the Kleist Prize, was bestowed on her in 1932, she was beaten by Nazis on a Berlin street. She moved to Zurich. After the Swiss refused her a new visa in 1939, Lasker-Schüler settled permanently in Palestine. Destitute, in part from trying to save her tubercular son, she died in Jerusalem in 1945.

Above: Else Lasker-Schüler. Fear of Loneliness

The Jewish National and University Library, Jerusalem

Left: Else Lasker-Schüler. To My Dear Mrs. Wormser and Her Two Boys

The Jewish National and University Library, Jerusalem

D. H. LAWRENCE

Although he had been instructed in art as a child, and had drawn and watercolored over the years, it was not until he was forty, just four years before his death, that D. H. Lawrence found himself, to his astonishment, "bursting into paint." He would not have started, he wrote, if

Maria Huxley [wife of **Aldous Huxley**] hadn't come rolling up to our house near Florence with four rather large canvases, one of which she had busted, and presented them to me because they had been abandoned in her house.

Painting was a physical pleasure for Lawrence:

It is to me the most exciting moment when you have the blank canvas and a big brush full of wet colour, and you plunge. It is just like diving in a pond—there you start frantically to swim.

But it was also a spiritual act, and to create required some sense of God's presence:

One may see the divine in natural objects: I saw it today, in the frail, lovely little camellia flowers on long stems, here on the bushy and splendid flower-stalls of the Rambla in Barcelona . . . and I saw them like a vision. So now, I can paint them. But if I had bought a handful, and started in to paint them 'from nature', then I should have lost them. By staring at them I should have lost them. I have learnt by experience.

In 1929, Lawrence showed twenty-five of his recent paintings at the Warren Gallery in London. Thirteen were removed to police court to be tried under the obscenity laws; if found to be obscene, the paintings would have been burned. Lawrence wrote from Florence, instructing the gallery owner to compromise with the police by agreeing that the works would never be shown in England again:

I do not want my pictures to be burned, under any circumstances or for any cause. . . . There is something sacred to me about my pictures and I will not have them burnt, for all the liberty of England.

Nine of the seized paintings were acquired in 1956 by the La Fonda Hotel, Taos, New Mexico, and they have been on continuous display there since.

Lawrence saw art as "a form of religion, minus the Ten Commandment business, which is sociological." It meant "being at one with the object." But most of all it was a source of bliss:

All my life, I have from time to time gone back to paint because it gave me a form of delight that words can never give. Perhaps the joy in words goes deeper and it is for that reason more unconscious. The conscious delight is certainly stronger in paint.

The author of *Sons and Lovers* (1913), *The Rainbow* (1915), *Women in Love* (1920), and *Lady Chatterley's Lover* (1928), D. H. (David Herbert) Lawrence was venerated as a prophet and defamed as a pornographer. Despite the brevity of his life, he left an enormous body of work—novels, novellas, short stories, poems, plays, travel sketches, essays, translations, and criticism—which established him among the most influential and controversial of twentieth-century writers.

Lawrence was born in 1885 in Nottinghamshire, England, and grew up in the conflict-filled home of his coal miner father and schoolteacher mother. He earned a teaching certificate at Nottingham University College in 1908. A few years later, he ran off with Frieda Weekley, the wife of a former professor and the sister of the legendary German flying ace Baron von Richthofen. Stricken with tuberculosis, Lawrence traveled in constant search of a healthful climate, living for extended periods in Italy, Mexico, and Taos, New Mexico. He died in a sanitarium in Vence, France, in 1930.

D. H. Lawrence. Rape of the Sabine Women

1928. Oil. 16 x 12 inches. Collection of La Fonda Hotel, Taos. Photo courtesy of Barry Norris Studio, Taos. Reproduced by permission of Pollinger Ltd. and the proprietor

D. H. Lawrence. Lerici

1913–14. Watercolor. 19 x 14 inches. Private collection, New York City. Photo by Jason Brownrigg. Reproduced by permission of Pollinger Ltd. and the proprietor

EDWARD LEAR

Edward Lear was the twentieth of twenty-one children. When he was four years old, after his father had suffered financial losses, Lear's mother sent him to be raised by his eldest sister, Ann. It engendered a lifelong hurt. Lear apparently received no education beyond his sister's tutoring at home, but it nurtured his incipient talent for art.

The boy was stricken with epilepsy at five, and when the shame associated with the seizures increased his sense of isolation, he sought to hide from those around him. Yet at sixteen, Lear was supporting Ann and himself with his drawings. His work was so exceptional that he was hired by the London Zoological Society to illustrate *The Family of the Psittacidae* (1832), a book about parrots; the series of lithographic prints he produced are esteemed as among the best of all ornithological renderings. The work led to his engagement by the Earl of Derby to draw the animals in his personal menagerie—published in *Gleanings from the Menagerie and Aviary at Knowsley Hall* (1846)—and then to full patronage by the Earl throughout Lear's career.

Lear suffered from poor eyesight and chronic lung disease. When he was twenty-five, seeking a better climate and less detailed art, he moved, with the Earl's support, to Rome. There he began a career as a traveling landscape painter, wandering throughout Europe and the Near East. The works Lear painted on his travels were published in a series of journals, including *Illustrated Excursions in Italy* (1846), *Journals of a Landscape Painter in Albania and Greece* (1851), *Views in the Seven Ionian Islands* (1863), and *Journals of a Landscape Painter in Corsica* (1870). He also produced *Tortoises, Terrapins and Turtles Drawn from Life* (1872), another nature book.

In 1846 Lear decided to illustrate his *Book of Nonsense,* a collection of the limericks he had used, along with piano improvisations, in order to entertain children and adults at the Earl's estate. Following its appearance under a pseudonym, Lear waited fifteen years before publishing more limericks, this time under his own name. Three more volumes followed—*Nonsense Songs* (1871),

More Nonsense (1872), and *Laughable Lyrics* (1877)—all so popular that Lear must have realized his reputation as a serious artist was doomed to be overshadowed by such immortal verse as "The Owl and the Pussy-Cat." Other illustrated books, including *The Lear Coloured Bird Book for Children* (1912) and *Indian Journal: Watercolours and Extracts from the Diary of Edward Lear 1873–1875* (1953), appeared posthumously.

Lear was born in 1812 in London and, after a lonely, wandering life, died alone in San Remo, Italy, in 1880. Although he had a number of close friendships, he appears never to have experienced an intimate relationship beyond a painfully unrequited love for one of his longtime male friends.

Manypeeplia Upsidownia.

Above: Edward Lear. Mt. Sinai, Egypt

Oil on canvas. Copyright © Fine Art Photographic Library/Corbis

Right: Edward Lear. Sunrise at Civitella di Subiaco

Oil on canvas. 37 x 59 cm. Worcester Art Museum, Worcester, Massachusetts, Charlotte E. W. Buffington Fund

Opposite: Edward Lear. Manypeeplia Upsidownia

Harvard College Library, Department of Printing and Graphic Arts, Gift of Philip Hofer

MIKHAIL LERMONTOV

The Russian poet and novelist Mikhail Lermontov's creative energies found an early outlet in drawing, painting, and music. He entered a boarding school for children of nobility at thirteen and studied painting and poetry. Throughout his life he illustrated his work, the first example of which is believed to be the frontispiece for "Prisoner of the Caucasus," a Byronesque poem he wrote at fourteen depicting its subject being dragged behind his captor's horse. He also did portraits of people he encountered and made visual records of the places he visited as a young officer:

> Since I left Russia, I have lived a roaming life, sometimes by coach, sometimes on horseback. I have travelled the whole length of the battle line from Kislyar to Taman. I have crossed the mountains, seen Shusha, Kuba, Shemakha and Kakhetia, always dressed as a Circassian with my gun slung over my shoulder. I have camped in open country, fallen asleep to the cry of jackals, eaten flat round loaves and drunk Caucasian wine. . . . I have made sketches of all the noteworthy places and I shall bring back a large collection of them in my luggage.

The Russian Museum and the Institute of Russian Literature, both in Saint Petersburg, and Moscow's State Literary Museum hold most of Lermontov's drawings and paintings, although a few, including the painting reproduced here, are in the collection of the Rare Book and Manuscript Library of Columbia University. The watercolor is of Varvara Lopukhina, an early love who rejected him for a wealthier older man and who was immortalized in Lermontov's poetry.

Inheritor of **Pushkin**'s mantle, Lermontov was not only a great lyric poet in the Romantic tradition, but the author of the first Russian psychological novel, *A Hero of Our Time* (1840). He was born in Moscow in 1814. His mother died before he was three, and her mother, who had never approved of her daughter's marriage, drove his father away. The bereft, widowed grandmother lavished her attention on Lermontov and secured the finest tutors she could for his education. The conflict between his father and grandmother engendered a profound unhappiness in the boy, which deepened when he developed a disease that left him stooped and his schoolmates began to call him "the frog."

Lermontov lived a self-consciously romantic life he appropriated for his literary work. "I no longer merely write novels," he told a friend, "I make them happen." In the text of his own life he managed to include two duels. The first, with the son of the French ambassador, was ostensibly over whether Lermontov had slandered France in a poem about Pushkin's death in a duel with a Frenchman, but was probably because they were courting the same woman. It concluded with no deaths, but with Lermontov's arrest, imprisonment, and transfer to a regiment being sent into combat.

The second duel, with an old friend provoked by an offensive comment from the poet, took place with pistols at ten paces in Pyatigorsk in 1841. "I will not fire on this fool," Lermontov is said to have told the witnesses, whereupon he was shot dead through the chest. Just days prior he had written these words: "With a bullet in my chest, I lay unmoving / the deep wound still steamed, / Drop by drop my blood oozed out." He was twenty-seven.

Mikhail Lermontov. Varvara Lopukhina

From Album 2, belonging to Alexandra Vereshchagina von Hugel (Baroness Karl) 1831–33. Watercolor. 3–1/2 x 5–1/2 inches. Lermontov Papers, Bakhmateff Archives, Rare Book and Manuscript Library, Columbia University

JONATHAN LETHEM

Jonathan Lethem, wrote the critic John Leonard, is "a young writer as clever as they come and as crafty as they get, who skinwalked and shape-changed from **Kurt Vonnegut** into Saul Bellow before our starry eyes." Prior to his literary morphing, however, there had been an equally dramatic transformation from artist to writer. According to Lethem's terse summary,

> I studied to be an artist from age twelve to nineteen, intensively, in the home of a working and exhibiting painter—my father [Richard Lethem]—and at the High School of Music and Art and at Bennington College. I mostly painted. Once I began writing novels seriously—at nineteen—I quit art completely, apart from writing about it, which I've done a number of times.

Lethem's mother stimulated the verbal side of his sensibility. She gave him a typewriter when he was fourteen, and died of a brain tumor the next year. Her death informs her son's creative self:

> If writing's a beard on loss, then, like some character drawn by Dr. Seuss, I live in my own beard. . . . Mine has been a paltry beard, anyway, the peach-fuzzy kind a fifteen-year-old grows, so you still see the childish face beneath. Each of my novels, antic as they sometimes are, is fuelled by loss. I find myself speaking about my mother's death everywhere I go in this world.

At the same time he was trying to follow in his artist father's footsteps, Lethem began writing on the typewriter bestowed by his mother. He immersed himself in the science fiction she had introduced him to and in the countercultural world she had inhabited. He says, "I seized on comic books and science fiction as a solution to the need to disappoint my father's expectation that I become an artist like himself."

Lethem had actually been on parallel creative tracks and made a choice for the literary. The decision could not have been easy—the pull toward visual art was strong for the teenager: "In the years following my mother's death, when I was fourteen, then fifteen, then sixteen, I forged a series of friendships with grown men, all of them teachers or artists or bohemians or seekers of one kind or another." Lethem illustrated one's book, another made him "a prodigy at marble carving."

Lethem was born in 1964 in Brooklyn, New York. "I grew up in a very borderline Brooklyn neighborhood," he explains:

> My parents were part of the first wave: bohemians, radicals and artists. . . . So I definitely grew up in a world where my parents and their friends were living in the counterculture in the '70s. I think it is detectable in my work in a lot of different ways.

The youngest of this book's subjects, Lethem appears destined to take his place among the most prolific and best-regarded writers. Of Lethem's eight novels, *Motherless Brooklyn* (1999) won the National Book Critics Circle Award and the Salon Book Award. A collection of his stories was published as *Men and Cartoons* (2004), and a collection of essays as *The Disappointment Artist* (2005). The paintings reproduced here are from his college days.

Jonathan Lethem. Notebook Painting No. 1

Oil on canvas. 46 x 42 inches. Collection of the artist. Photograph by Sandy Azrafiotis

Jonathan Lethem. Notebook Painting No. 2

Oil on canvas. 52 x 46 inches. Collection of the artist. Photograph by Sandy Azrafiotis

CARLO LEVI

arlo Levi, a painter and sculptor as well as a novelist, journalist, politician, and physician, began his art career in his last years of medical school. He contributed a portrait of his father (himself a painter) to the Quadrennial Exhibition of Turin in 1923, his first show. In 1929, Levi exhibited as one of Turin's Group of Six, and continued to show with them in subsequent years in Milan, Geneva, Rome, and London. During the 1920s, Levi spent a good deal of time in Paris painting and associating with leaders of the avant-garde movement, including Giorgio de Chirico. His first one-man shows were held in Paris, at Galerie Jeune Europe in 1932 and Galerie Bonjean the following year. When, in 1934, he was barred by the Fascists from participating in the Venice Biennale, in which he had regularly shown for a decade, protests were raised by Chagall, Léger, Derain, and Signac.

Arrested in 1934 for antifascist activities, Levi was exiled to Gagliano, Lucania, Italy. There he practiced medicine, and the close relationship he developed with the area and the people he treated inspired his most famous literary work, *Cristo si è fermato a Eboli* (1945; *Christ Stopped at Eboli*), as well as dozens of landscapes, still lifes, self-portraits, and portraits of the locals. Levi was a vocal opponent of nonfigurative art, and his paintings reflected the same commitment manifested in his neorealist writing.

Throughout his life and since his death, Levi has had numerous one-man shows in European and American museums and galleries—his first in New York was mounted in 1947 at the Wildenstein Gallery. Thirty paintings from Levi's exile received an exhibit at Montreal's Bonsecour's Market in 2000, and in 2003 the Jewish Museum of Berlin and the Jewish Museum of Frankfurt displayed selected works. He has been compared to his contemporaries Soutine and the Fauves, and has been said by some critics to show the influences of Modigliani and German Expressionism.

Graziadio Carlo Levi was born in Turin, Italy, in 1902, into a progressive, Jewish, financially secure, and cultured family. His maternal uncle was a leader of the Italian Socialist Party. Levi received his M.D. from the University of Turin in 1924. In his twenties, he joined the social reform movement "Giustizia e Liberta" (Justice and Liberty), whose members included Primo Levi (no relation). In the 1930s, Levi pursued an anti-Mussolini agenda, founding the Italian Action Party and an antifascist periodical. He emigrated to France in 1939, but returned to Italy in 1941 to join the resistance. He was arrested again in 1943, but was released a few months later. After the war, he moved to Rome, and edited antifascist and left-wing journals. He was elected to the Italian Senate as a Communist in 1963 and served two terms (until 1972).

Christ Stopped at Eboli was an early work of Italian social realism, and it was successfully adapted for the screen by Francesco Rosi in 1979. Among Levi's other works are the novel *L'orologio* (1950; *The Watch*) and an extended essay on the importance of intellectual freedom, *Paura della libertá* (1946; *Of Fear and Freedom*). He died in Rome in 1975.

Carlo Levi. A Portrait of
Leone Ginzburg

1933. Copyright © 2007 Artist
Rights Society (ARS), New
York/SIAE, Rome

WYNDHAM LEWIS

*L*ong before he became a prolific writer, Wyndham Lewis was an artist who went on to become one of England's greatest painters, renowned for modernist work both abstract and figurative. He was a founder of Vorticism, an English avant-garde movement influenced by the Cubists and Futurists. Ezra Pound called Lewis "a more significant artist than Kandinsky," and believed his friend's work contained "certain elements not to be found in Picasso." In 1915, Pound wrote,

> If you are a Cubist, or an Expressionist, or a Imagist, you may believe in one thing for painting and a very different thing for poetry. You may talk about volumes, or about colour that "moves in," or about a certain form of verse, without having a correlated aesthetic which carries you through all of the arts. Vorticism means that one is interested in the creative faculty as opposed to the mimetic.

Discussing a painting of a beggar he did as a student, Lewis explained the relationship between his writing and art: To keep the painting a "pure" visual expression, he suppressed the "literary," which he defined as "the crystallization *of what I had to keep out of my consciousness while painting.*"

Having devoted his life to the literary and visual arts, and to extensive critical analysis of both, in 1934 Lewis wrote a dismissive summation of human creativity that has been variously interpreted as ironic, nihilistic, or Nietzschean:

> Singing, dancing, acting and building are all indulged in by animals of one kind or another. The pretensions of art, I take it, do not point to anything beyond the thresholds of life, or aspire to transcend the well-defined limits of man's animal status. . . . [M]an, except for what the behaviorist terms his word-habit, is that and no more, except for his paradoxical "reason" . . . regarded in that manner our tricks—and our "fine arts" are only part of our repertoire of tricks, not necessarily our finest tricks, even—are indeed too unimportant a matter to detain us for so much as the twinkling of an eye.

Percy Wyndham Lewis was born in 1882 to a Civil War-veteran father and an English mother, on a yacht moored near Amherst, Nova Scotia. Lewis kept his Canadian citizenship throughout life. When he was six, his parents moved to England. A few years later, his father abandoned the family, leaving them limited resources. Lewis won a scholarship to the Slade School of Art at sixteen, but dropped out to travel the continent and paint in Paris. In 1909, he returned to London, and began to write and show his art. He published about fifty books in his long career, including novels—notably *Tarr* (1918), *The Apes of God* (1930), which he illustrated, and *Self Condemned* (1954)—short stories, long poems, and memoirs, as well as volumes on art, literature, and political theory.

Lewis's literary career was ruined in the 1930s as a result of his vociferous anti-Semitism, two successful libel actions against him, and his support of Fascism, including his sympathetic *Hitler* (1931). Although he recanted in his 1939 works *The Jews, Are They Human?* and *The Hitler Cult,* his reputation was gone. In 1951, his art career was ended by blindness, but he managed to write six more books (on a board with a wire to guide his pen) before he died in 1957 in London.

Opposite, left: Wyndham Lewis. Bagdad

1927. Oil on plywood. 72 x 31 inches. Tate Gallery, London/Art Resource. Courtesy of the estate of Mrs. G. A. Wyndham Lewis

Opposite, right: Wyndham Lewis. Praxitella

1920–21. Oil on canvas. Bridgeman Art Library. Courtesy of the estate of Mrs. G. A. Wyndham Lewis

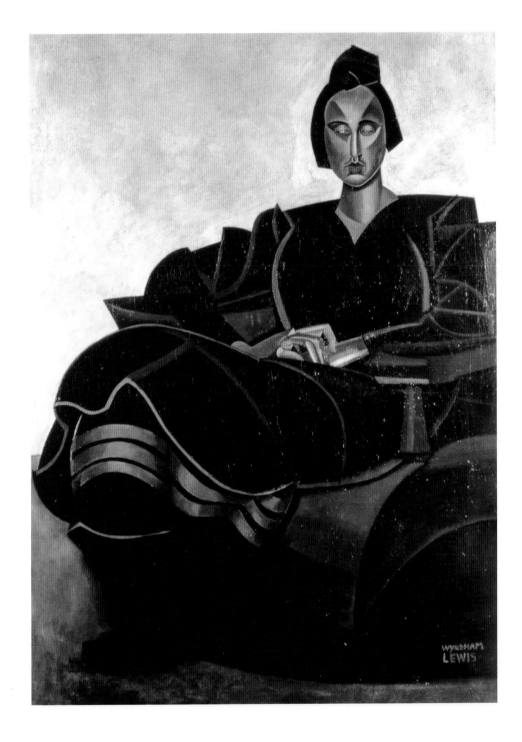

VACHEL LINDSAY

Drawing and painting were the paramount means of expression for Vachel Lindsay; his poetry, he insisted, was written to accompany the art. It wasn't until his senior year of high school that Lindsay wrote a poem unrelated to a drawing, and he described it as his "first picture drawn in words." As a successful poet, he demanded that his publishers include his drawings in his collections.

Lindsay won acquiescence to a career as an artist from his disapproving parents by declaring it was how he could best preach Christ's teachings. Specifically, he would do "Christian cartooning." Having enrolled at the Art Institute of Chicago in 1901, Lindsay brought some nude studies home, and encountered such moral condemnation from his father that he was forced to leave and draft a desperate apology. After declaring he was "very, very sorry," he swore that he was "not going to the bad" and that he didn't like the nude any better than his father did. He concluded:

> I am going to neglect it all I possibly can. I am going to study hard on draperies and conceal my ignorance all I can by them.

Lindsay studied next at the New York School of Art, where the emphasis was on realistic rendering. While there, in 1904, he had his first poems published, and they appeared with accompanying drawings—although a nude figure in one drawing was deleted by the censoring publisher. That same year, Lindsay began to have visions which became the basis for a personal religious mythology he represented in a drawing titled "The Map of the Universe." So important was that image that he claimed it informed all of his poetry for decades. As part of a long explication, he said that "it was by a leaping of the flame from the Harp of the great singer Lucifer that the angels fell in love with suffering, and went forth to the stars to be forsaken of God." Lindsay's friend the poet Edgar Lee Masters considered the drawing

> a picture as wild and incoherent as any given in Revelation, the Koran, or the Mormon Bible; and it is a compound of these,

together with the Arabian Nights. Altogether this is rather a map of Lindsay's mind, his theology, and theodicy, and cosmology, than of any rationalized conception of the world of mind and matter in which we live.

Nicholas Vachel Lindsay was born in 1879 in Springfield, Illinois, in the same house where he would drink a lethal potion of lye in 1939. His parents held deeply divided views about their expectations for their son. Lindsay's father was a doctor, and had wanted his son to follow suit, while his mother encouraged the boy to a life in art, the career to which he was inclined. He was a sickly child, and for a time was home-schooled by his mother who, he said, "filled me full of the Brownings and the Pre-Raphaelites." When he was seventeen, however, in what Lindsay considered an act of betrayal equivalent to his father's flogging him, his mother aligned with his father in demanding that their son take up medicine. He told a teacher, "If I were an orphan, I'd be an artist."

Enormously popular and praised in his day as the greatest American poet since Whitman, Lindsay went on recital tours performing before large crowds that he complained didn't buy his books. Those books included *General William Booth Enters into Heaven and Other Poems* (1913), *The Congo and Other Poems* (1914), *Every Soul is a Circus* (1929), and a seminal work of film criticism, *The Art of the Moving Picture* (1915).

Vachel Lindsay. Lotus and Rose

Watercolor and ink. 21 x 38 inches. Abraham Lincoln Presidential Library, Springfield, Illinois. With kind permission of the estate of Vachel Lindsay

Vachel Lindsay. The Dream of King David in Heaven

1908. Watercolor. 29 x 22 inches. YCAL at The Beineke Rare Book and Manuscript Library, Yale University. With kind permission of the estate of Vachel Lindsay

Vachel Lindsay. Machinery.

Watercolor and ink. 26–1/2 x 40 inches. Abraham Lincoln Presidential Library, Springfield, Illinois. With the kind permission of the estate of Vachel Lindsay.

HUGH LOFTING

Hugh Lofting's beloved Dr. Doolittle stories have entertained generations of children, and are credited by primatologist Jane Goodall with instilling her desire to go to Africa. The first were written in letters to his children from the trenches of World War I. Surrounded everywhere by horror, Lofting was particularly appalled at the violence done to the defenseless, uncomprehending animals, especially the horses. He wrote about his feelings years later in *The Junior Book of Authors* (1951):

> One thing, however, that kept forcing itself more and more on my attention was the very considerable part the animals were playing in the World War and that as time went on they, too, seemed to become Fatalists. They took their chances with the rest of us. But their fate was far different from the men's. However seriously a soldier was wounded, his life was not despaired of; all the resources of a surgery highly developed by the war were brought to his aid. A seriously wounded horse was put out by a timely bullet. This did not seem quite fair. If we made the animals take the same chances as we did ourselves, why did we not give them similar attention when wounded? But obviously to develop a horse-surgery . . . would necessitate a knowledge of horse language.

The notion of a gentle, loving doctor who would speak with and care for those horses arose from Lofting's need to communicate with his children in the midst of wartime pain: "[M]y children at home wanted letters from me—and they wanted them with illustrations rather than without."

Thus, they were illustrated, and when the stories became books, Lofting's charming, untutored drawings were included. There's no evidence he had any formal training, although he had an interest in architecture during his schooling as a civil engineer. Despite the utopian vision of his dozen Doolittle books—the world of the good doctor was kindly, moral, peaceful, honest, and filled with compassion for all peoples, animals, and nature—some stereotypical expressions were expurgated because they could be read as racist or imperialistic. Lofting's wonderful illustrations fell victim as well.

Born in Maidenhead, Berkshire, England, in 1886, one of six children, Lofting was sent to a Jesuit boarding school at eight and endured an isolated upbringing, instructed by staff that "had very little interest besides the good of the boys spiritually, morally and educationally." At eighteen, Lofting sailed to America and matriculated at M.I.T. in civil engineering—his father's choice of a career for him. He returned to England and received his engineering degree from London Polytechnic. He then began to travel widely, working on railroads in Africa and Cuba, abandoning engineering to prospect for gold in Canada, and working as an architect. In 1912, he emigrated to New York, where he married and began a career as a journalist and writer of burlesques and comedies. He joined the British Army at the outbreak of the war and served as a captain of the Irish Guards on the front lines of Flanders and France, where he was wounded by shrapnel and discharged as an invalid. His first wife died in 1927, and his second wife died of flu shortly after their marriage. Besides his children's books, Lofting wrote adult fiction and a long poem, *Victory for the Slain* (1942). He died, a naturalized United States citizen, in Santa Monica, California, in 1947.

THE FAREWELL FEAST

"After they had all finished eating the Doctor got up"

Hugh Lofting. The Farewell Feast

1920. Frontispiece to *The Story of Doctor Doolittle* (Frederick A. Stokes Company)

"Cheering and waving leaves and swinging out of the branches to greet him"

Hugh Lofting. "Cheering and waving leaves and swinging out of the branches to greet him"

1920. Illustration from *The Story of Doctor Doolitle* (Frederick A. Stokes Company)

PIERRE LOTI

One of the most popular writers of his day, Pierre Loti began painting and drawing in childhood. His father and older sister were painters, and art was the only subject he excelled at during his five years of schooling. Loti's illustrations supplemented his diaries, journals, and travel writings. They included idealized, eroticized portraits of his fellow shipmates and documentation of his travels, like the waterfall and the map reproduced here. With drawings published in *Le Courier,* which he made during an 1872 trip to the Easter Islands, he introduced the famous statuary to France. Loti extolled the freedom that his talent bestowed on him as a young sailor in the navy, when his captain would send him off to wander freely and record the sights of the strange, very distant places they visited. Some of those images, including the Easter Island heads and his portrait of the Queen of Tahiti, are still reproduced on popular posters today. An artist's eye is also manifest in Loti's famously descriptive, sensuous prose. No less a figure than Marcel Proust claimed Loti as his favorite author.

Loti was born Louis Marie Julien Viaud in Rochefort, France, in 1850. The unexpected child of elder, Protestant parents, Loti was raised in a highly feminized atmosphere, indulged and overprotected by his mother, older sister, and aunts. His sensitivity as a child was so extreme that his friends described him as "écorché vif" ("skinned alive"). Raised in isolation, he was not sent to school until age eleven. He hated the experience, was a social misfit ridiculed for being escorted to and from home, and was academically unmotivated except in painting and music.

Loti's older brother, a surgeon in the navy, died at sea when Loti was fifteen. That and the proximate death of a close childhood friend were traumatizing experiences for the boy. Compounding the injury, his father, who is virtually unmentioned in Loti's autobiographical writings, was charged with embezzlement less than a year later. The father was imprisoned for a time, a situation that impoverished as well as dishonored the family. Loti assumed partial responsibility for support of the family, which became fully his when his father died in 1870.

Always preoccupied with death, Loti was suicidally depressed in his mid-twenties—partly because of a crisis of faith experienced in a Trappist monastery, and partly because of conflict over his homosexuality. He enrolled in the naval academy, and ran off to a life at sea to escape what he described as his "hothouse upbringing."

Loti is remembered for highly descriptive, politely sexualized, exotic novels based on his wide travels. His works include *Aziyadé* (1879), *Le Mariage de Loti* (1880), *Mon frère Yves* (1883), and *Pêcheur d'Islande* (1886), considered his best. He was aboard ship in Algiers when he learned of his election to the Académie Française in 1891, and continued his active naval career until retirement with a captain's rank in 1910. He died in Hendaye, on the Basque coast, in 1923, writing and drawing to the end.

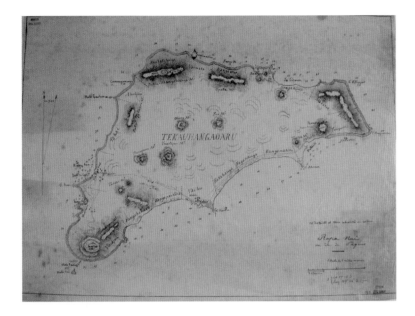

Above: Pierre Loti. Carte de l'Ile de Paques (Map of Easter Island)

1872. Ink on oiled paper. 14–1/2 x 20 inches. Maison de Pierre Loti. Copyright © Maison de Pierre Loti, Rochefort-sur-mer, France

Right: Pierre Loti. Cascade de Faata a-Tahiti

1872. Watercolor. 19–5/8 x 12–3/4 inches. Maison de Pierre Loti. Copyright © Maison de Pierre Loti, Rochefort-sur-mer, France

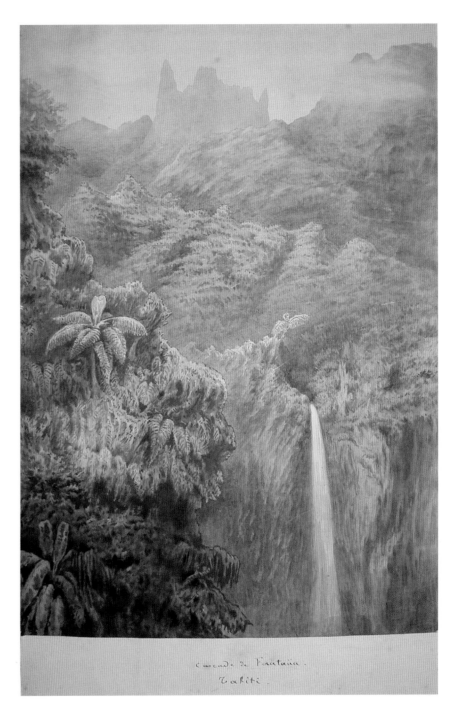

MINA LOY

The poet Mina Loy first studied art at St. John's Wood School in London in 1897. A respectable institution, it had a special entrance for ladies. Little had changed since the time of the **Brontës**, when art was simply middle-class training to prepare young women for a future as wives or governesses. Women were only to learn to copy, and never to contemplate art as a career. Biographer Carolyn Burke describes attitudes in Loy's day as mandating watercolor as the medium of choice for girls "since its misty effects etherealized everyday life and pointed the artist's thoughts toward higher spheres." All work was to be small, picturesque, and unoriginal.

When Loy first encountered her fellow art students silently copying from plaster casts, she said she saw herself among "rows of miners in the galleries of ignorance." By seventeen, she had escaped to Munich to study painting. After returning to London in 1901, she settled in Paris at the age of twenty.

Loy exhibited in Paris in 1906 with the three-year-old Salon d'Automne, which presented work by Bonnard, Matisse, Renoir, and Cézanne. Moving to New York in 1936, she lived in the Bowery, and in 1949 she began to construct art out of found materials. The constructions—of which *Marcel Duchamp, Tinman* shown here is an example—were exhibited in New York's Bodley Gallery in 1959.

A very deliberate writer, she claimed, "one must have lived ten years of life to write a poem." Loy published only two collections in her lifetime: *Lunar Baedecker* (1923), in which she sought to achieve audible effects through her arrangement of type on the page, and *Lunar Baedeker & Time-Tables* (1958). Nonetheless, she influenced poets **William Carlos Williams**, **Hart Crane**, and **E. E. Cummings** and was lauded by Ezra Pound, who created the word "logopoia" to describe the purity of her word use. The subject matter of her poetry—particularly the emotional life and sexuality of women— was considered scandalous, however, and combined with the exacting intelligence that made her work less accessible, it deprived her of popular success. By the mid-1930s, she was largely forgotten.

Loy was born Mina Lowry in 1882 in London, to a Jewish father and a Gentile mother who hated her husband's Jewishness and raged at her adolescent daughter for outgrowing her clothes and for her sexual maturation. ("Your vile flesh, you'll get no good out of it. Curse you. Curse your father.") Loy's mother denied her access to her infant sister, "to save, she said, this brown-eyed baby . . . from my 'moral contamination.'"

Highly praised at school, Loy found solace in her artwork. But her mother destroyed it as immoral: "Thereafter the lack of keys, making it impossible to protect things from her, allowed for incessant raids on the work which had for a time so comforted me. Drawings and poems became the prey of her attacks."

While in Paris in 1903, she married Stephen Haweis, another art student, but divorced him in 1918 in order to marry the poet-boxer Arthur Cravan. Cravan, a hero of the Dadaists, disappeared that same year. Asked in 1929 for the happiest moment of her life, and the unhappiest, Loy answered: "Every moment I spent with Arthur Cravan. The rest of the time." She died in 1966 in Aspen, Colorado.

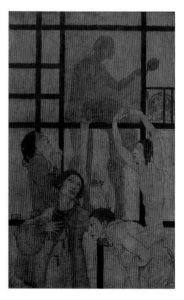

Mina Loy. La maison en papier
(The paper house)

C. 1906. Mixed mediums on paper. 19–3/4 x 12–1/2 inches. Collection of Michael Duncan

Above: Mina Loy. L'Amour dorloté par les belles dames (Also known as "The bachelor stripped bare by his brides")

C. 1913. Oil on canvas. 20 x 20 inches. Collection of Roger I. Conover

Left: Mina Loy. Marcel Duchamp, Tinman

C. 1953. Mixed mediums ("bowery construction" with tin cans and found materials). 21 x 14 inches. Collection of Roger I. Conover

LUCEBERT

Dutch poet Lucebert began drawing and painting in childhood, and at fourteen was awarded a scholarship to Amsterdam's School of Arts and Crafts, where he studied for less than a year. The scholarship came when he was discovered by a passerby, creating art on a piece of construction lumber while working for his father's painting business.

Although Lucebert's first recognition came as a poet, by 1948, after joining the Dutch Experimental Group—which later evolved into the Dutch wing of the Cobra movement (an acronym of **Co**penhagen, **Br**ussels, and **A**msterdam)—he began to be known for his art as well. Interviewed in 1959, when he was thirty-five and Cobra had been disbanded for eight years, Lucebert acknowledged he was still too little known as a painter to be able to sell, adding that there was also the problem of "the odium of two vocations." In his view, people thought "That's impossible, a painting poet." Yet the "unalterable fact," he said,

> is that I have become known as a poet. I led a wandering life without having my own studio, so my painting was pushed somewhat into the background, for myself too. But since I have a real home I can fall to work regularly and vigorously.

Lucebert's work was heavily influenced by his involvement in the three-year revolution that was Cobra. Founded by a group of writers and artists who were greatly influenced by Cubism and Surrealism, and then by Art Brut and folk art, the movement demanded art that was spontaneous and expressionistic. The catalog cover for the first Cobra exhibit, in 1948, showed a mouth sticking its tongue out. It was an attitude that Lucebert found natural, even essential. His first commission as a painter—decorating a Franciscan convent—had come the year before. He was to cover a 47-foot-long corridor "with the necessary biblical and Franciscan scenes." He began, he wrote, by

> making everything as utterly ugly as it was in my power to do. . . . [I]t is always a good thing, when painting or writing poetry, to start from something that excites dislike. Later one will be able to add some conciliating details, because the eye and the ear demand their due. But one should never begin by letting oneself be cheated by this superficial pair of twins.

In 1959, when he claimed he was still unrecognized, Lucebert won the Mediterranean Prize at the Paris Biennale, and his reputation as an artist continued to spread internationally. Today, Amsterdam's Stedelijk Museum has the largest collection of Lucebert's work—nearly 900 drawings, paintings, and prints—but his art may be found worldwide: in New York at the Museum of Modern Art and the Guggenheim; at the Tate Gallery, London; and the National Gallery of Ireland, Dublin, to name only a few.

Born Lubertus Jacobus Swaanswijk in Amsterdam in 1924, he was raised by his grandmother on a nearby farm. After leaving the Amsterdam School of Arts and Crafts, Lucebert supported himself for years with a succession of temporary jobs. When World War II started he worked for the Resistance. His iconoclastic poetry eschewed, among other conventions, rhyme, meter, and punctuation. Regularly creating neologisms, Lucebert thought of words as a physical form and employed them to suggest multiple meanings. Even his invented name implies both evil and a source of light. Translated into almost two dozen languages, Lucebert's poetry received the Amsterdam Literary Prize (1954) and, in 1983, the State Literary Prize, Holland's most prestigious literary award. He died in the village of Alkmaar in 1994.

Lucebert. The Menaced House

1962. Oil on canvas. 51–1/2 x 79 inches. Mildred Lane Kemper Art Museum, Washington University in St. Louis. Bequest of Mrs. Harry (Ruth) Franc, 1989

JOHN MASEFIELD

I must down to the seas again, to the lonely sea and the sky . . ."
Narrative is what John Masefield emphasized in his
poetry as well as his fiction; it is what he valued in art, and
what he got from music: "Sometimes in an orchestral piece,
or sonata, I would hear a strain that suggested a story or that
would suit a story-teller. I would try to make tales in verse
that would go to these strains." When he was young, Masefield
visited museums and galleries "for qualities that might help story-
telling." He recollected in his 1952 autobiography, *So Long to Learn,*

> There were many book-illustrations, from illuminated
> manuscripts to the admirable designs in the books and magazines
> of the day. In the picture galleries were the masterly presentations
> of scenes from stories, the scene alive in all essentials, exquisite in
> all detail. I perceived at once that these men were master story-
> tellers. They knew all the story and made all others feel the
> importance of their chosen incident. . . . All that I saw in the
> picture galleries and in book-illustrations seemed to proceed
> from a mighty power of narrative, much of it most helpful to a
> writer, if it made him try to know how the painter had come to
> his decision, that this or that was the significant scene.

Masefield, who identified **William Morris** and the Pre-
Raphaelites as a major influence ("we felt we owed our souls to
them"), painted and drew throughout his life and illustrated a
number of his books. He was self-taught and diligent, believing
that the impulse to art was no more than that:

> Perhaps the instinct for the arts is a part of all youth, as the
> instinct for the sea is a part of all boyhood. Boys used to run
> away to sea, to discover, at once, in the first ten minutes, that
> the sea is hard work. Youth, also, in those days, sometimes ran
> away to the arts, to discover, in the first few weeks, that they,
> too, are hard work.

Masefield was born in 1878 in Ledbury, England, into the
short-lived "paradise" of a loving, comfortable home in an idyllic
setting provided by his lawyer father and doting mother. His
mother died when he was six. The following year, both of his
surviving grandparents died—and with the death of his
grandfather came the news that the family's wealth had been
squandered. Masefield's depressed father, who would die a year
later, turned over the care of his children to a despised governess
and his indifferent, disapproving sister-in-law. Although the boy
found some respite from his misery during summer holidays with
his godmother, his life was terrible enough that he attempted
suicide and made a runaway attempt that concluded with a
flogging when he was caught. His aunt decided that he needed a
trade and sent him off at thirteen to learn seamanship.

After a seasick first voyage during which he suffered a
breakdown and hospitalization, Masefield had had enough. His
aunt, however, demanded he return to sea. He did—and deserted
once he reached New York, where he worked odd jobs until
returning to England in 1897. A member of the Order of Merit in
1935, Masefield was England's poet laureate from 1930 until his
death in 1967 in Abington, England. Of the approximate one
hundred volumes that comprise his literary legacy, twenty-one were
novels, and the rest were mainly books of poetry.

Opposite: John Masefield. Clipper Ship

Watercolor. 14 x 17–1/2 inches. YCAL at The Beineke Rare Book and Manuscript Library, Yale University;
The Society of Authors as literary representative of the estate of John Masefield

VLADIMIR MAYAKOVSKY

At twelve, Vladimir Mayakovsky was delivering his father's shotguns to the revolutionaries. By age fourteen, he was a full-fledged Bolshevik and had been elected to the party committee. The start of Russian poet Vladimir Mayakovsky's artistic life came at fifteen—with his first imprisonment. He had already evidenced a talent for drawing, but in jail he read serious literature and made his initial, unsuccessful tries at poetry, which, he said, led to his art: "I thought to myself: I can't write poetry, my attempts were pitiful. So I turned to painting." After his release he studied with established painters and learned enough to qualify for acceptance at the Moscow Institute for the Study of Painting, Sculpture, and Architecture in 1911.

Although Mayakovsky was an industrious student and acquired considerable skill as a draftsman, having been exposed to Modernism through the early paintings of Cubists and Expressionists, he was expelled for his activities as a trouble-making Futurist. The youngest, but soon the most prominent, member of this avant-garde group, he would appear at public "happenings" dressed in a yellow jacket sewn by his mother. In 1912 he moved to Saint Petersburg and signed the Futurist manifesto "A Slap in the Face to Public Taste."

Mayakovsky put his art in the service of the Revolution. At the same time he was insisting on art for its own sake, as a "free play of man's cognitive faculties." In a 1914 essay, he wrote:

> It was not so long ago, either, that nobody even dreamed of art as an end in itself. Doubled up under the load of the idea of dumb animal existence and the struggle for survival, we forced even the artists to join in our screams for bread and justice.

Later that year, he added that "while, as a Russian, I hold sacred our soldier's every effort to tear away an inch of soil from the enemy, I must also think [as an artist] that the whole war was thought up for the sole purpose of allowing someone to write one good poem."

Mayakovsky was a draftsman at the Petrograd Military Automobile School for about eighteen months beginning in 1915.

By 1919 he had seen his vision of autonomous art betrayed by the Bolsheviks, and artists such as Kandinsky and Chagall forced to leave for Europe. Co-opted from 1919 to 1922, he worked for ROSTA, the government news service, turning out propaganda posters as well as writing political plays and verse. In 1922 he traveled to Paris and visited Léger and Picasso.

The leading poet of the Russian Revolution—and, with **Pushkin**, among the most revered of Russian poets—was born Vladimir Vladimirovich Mayakovsky in 1893 in the Georgian village of Bagdadi (now renamed Mayakovsky in his honor). His father, a government forester, died of blood poisoning when the boy was thirteen. He moved with his mother and sisters to Moscow, where they lived in near starvation. As a Futurist, Mayakovsky's poetry borrowed heavily from Cubist art, using its language as well as its vision. The Futurists emphasized the "texture" of word sounds, the deformation and analysis of traditional structures, and what they called the "transrational": direct, unmediated expressions of the subconscious.

Troubled by the realities of Soviet oppression—including a boycott of a twenty-year retrospective of his art and refusal to permit him to travel abroad—and unhappy in love, Mayakovsky killed himself with a revolver in 1930. "The love boat has crashed against the everyday," he had written in a long, final note. After his death, Stalin declared indifference to his works a crime.

Opposite, left: Vladimir Mayakovsky. Let's use everything!

1921. Satirical vitrine from the Director of Political Propaganda. Mayakovsky Museum, Scala/Art Resource

Opposite, right: Vladimir Mayakovsky. Cover drawing for his novella *The Story of the Deserter*

1921. BPK, Berlin

ИСПОЛЬЗУЕМ ВСЕ!

1. Завоевания октябрьские сохраним до тех пор — пока во всем мире,

2. Не разрешится наш с буржуазией спор.

3. В этой борьбе каждая ниточка должна применяться с пользой

4. Страсть буржуев к наживе и ту для революции используем.

5. Мы раздаем аренды —

6. Заводы, вода строй!

7. Этот завод поможет расправиться

8. И с голодом и с разрухой-сестрой

9. И когда фундамент промышленности крупной будет под октябрь подведен

10. И наша буржуазия

И заграничная купно

Постепенно выкинется вон!

ГЛАВПОЛИТПРОСВЕТ № 402

Р. С. Ф. С. Р. Пролетарии всех стран, соединяйтесь!

ОТДЕЛ ВОЕННОЙ ЛИТЕРАТУРЫ
при
РЕВОЛЮЦИОННОМ ВОЕННОМ СОВЕТЕ РЕСПУБЛИКИ

РАССКАЗ О ДЕЗЕРТИРЕ

Текст и рисунки В. В. МАЯКОВСКОГО

ГОСУДАРСТВЕННОЕ ИЗДАТЕЛЬСТВО
1921

MICHAEL MᶜCLURE

Michael McClure believes that there is a fusion of mind and body in writing and art; that artistic expressions, whether in image or text, are biologically based: "What we write, or what we paint, or what we sing or do, must actually, literally, be an extension of ourselves, or it is meaningless."

The idea of a work of art as first and foremost a physical manifestation of the body came to McClure when he was introduced to the work of the Abstract Expressionists by the artist Bruce Conner, his boyhood friend. After studying art at college in Kansas and Arizona, McClure moved to San Francisco. He went there, he said,

> thinking I was going to study with painters and study gestural painting to bring the philosophy of it into my poetry. Not because I saw myself as a painter, although I was doing some painting, it was only to bring that philosophy of Jackson Pollock, Clifford Still and those painters into my work as a poet. [However] they were no longer at the art institute when I got there. The catalogue I had looked at had been old.

Undeterred, McClure continued painting. During a peyote-eating period, he did large pieces that ranged from depicted visions of serpentine spirit figures to oversize portraits to pure abstractions. These were shown at San Francisco's SPAATSA Gallery in 1960. His artwork has appeared in numerous other exhibits, including the Batman Gallery, San Francisco, and, most notably, in Beat art shows at New York's 80 Washington Square East Gallery in 1994 and the Whitney Museum in 1995.

Conceiving of the poem as an object, McClure has emphasized the visual architecture of verse, using typography to create a schematic for the spoken word:

> The poem on the page troubled me because it seemed like such a thing of beauty, I wanted to remind the reader that it was, in fact, an object, and a seductive object because it was so close to being alive. By putting lines of capital letters in the text of the poem there was a disruption of the allure of the poem and reminder that it was a made thing.

McClure was born in 1932 in Marysville, Kansas. When he was five, his parents divorced and sent him to live with his grandfather in Seattle. When he was twelve, he was sent back to Wichita to live with his remarried mother. He began writing poems at fourteen and had two villanelles published in *Poetry* in 1956. McClure took part in **Robert Duncan**'s poetry workshop and joined the San Francisco circle of poets that included **Kenneth Rexroth** as well as **Allen Ginsberg** and the Beats. The writings of **Artaud** influenced McClure to find a voice unconstrained by literary or social conventions and to the use of invented words he termed "beast language."

A playwright, essayist, novelist, and poet, McClure is a professor at the California College of Arts and Crafts. Among his awards are a Guggenheim fellowship (1973), the Magic Theatre Alfred Jarry Award (1973), an Obie Award for best play for *Josephine, the Mouse Singer* (1979), and the Award for Lifetime Achievement in Poetry from the National Poetry Association (1993). Since the early 1990s McClure has collaborated with keyboard player Ray Manzarek (formerly of the Doors), reading his poetry to improvised music.

Opposite, left: Michael McClure. Blacksilver Waterfall

1964. 11 x 11–1/4 inches. Collection of Emprise Bank, Wichita, Kansas, USA. Courtesy of the artist. Photo courtesy of Steve Brown

Opposite, right: Michael McClure. Ghost Mother Poet Vision

20 x 20 inches. Collection of Emprise Bank, Wichita, Kansas, USA. Courtesy of the artist. Photo courtesy of Steve Brown

COLLEEN McCULLOUGH

*U*nfortunately I got married and lost the free time to paint," the Australian novelist Colleen McCullough wrote me in April 2003, continuing:

> So I haven't picked up a brush in donkey's years. Did they say that nude was acrylic? It wasn't, it was in oils. I always painted in two mediums—oils and gouache. Never watercolor, which seemed so anemic. Whereas gouache, at which I excel, is strong, vivid, vital. One day I hope to get back to the oils, but when is on the lap of the gods.
>
> My old paintings have all disappeared, where to, I don't know. The only things I have are rather bizarre—four horoscopes. I had to do some research into astrology for a book that's never been published—MRS. DELVECCHIO SCHWARTZ—though I hope it will be. Candidly, I found astrology very boring and unscientific, but I had to sustain my interest in it, so I turned doing horoscopes into an art form. One of my horoscope, one of my husband's, one of his son, and one of his daughter.

Wanting historical exactitude and "fed up with people thinking that Cleopatra looked like Elizabeth Taylor," McCullough located busts of her characters to use as models for her drawings. Her art has been used to illustrate her writing, beginning with a series of historical novels set during the decline of the Roman Republic.

McCullough was born in 1937 in Wellington, in the western part of New South Wales, Australia. *The Thorn Birds* (1977) was loosely based on her family history there, where her working-class parents moved her from place to place until she was twelve, when they settled in Sydney. She described her father as mean-spirited, but her mother was very supportive of her education. McCullough

suffered the loss of her only sibling in 1965, when her brother drowned while rescuing some women in the sea near Crete.

Displaying early talent in art, and writing poetry and stories before she was five, McCullough was also gifted in math and science. After studies at Sydney's Holy Cross College and the University of Sydney, she settled on a career in neurophysiology. For five years she headed the Department of Neurophysiology at Sydney's Royal North Shore Hospital, then went to England for additional work in her field. There, she met a colleague who asked her to manage the Yale research laboratories. McCullough did so beginning in 1967, teaching, running experiments, and supervising medical students. She also did artwork for the department and showed her paintings locally to good reviews. McCullough decided to write a novel during her evenings to supplement her income. *Tim* (1974) earned her $50,000, and it was followed by *The Thorn Birds,* which achieved record sales and international popularity.

As a famous multimillionaire, McCullough decided "it was unsafe for me to live on my own on any major landmass" and picked one of the most remote spots on earth to settle—Norfolk Island, a three-by-five mile spot in the South Pacific, more than a thousand miles from Australia, inhabited by descendants of the *HMS Bounty* mutineers. Besides her prolific writing, McCullough draws and does cartography, keeps up with scientific and medical journals, and has for a number of years been collaborating as lyricist on musical adaptations of her works, including "Mrs. Delvecchio Schwartz." She announced in 2004 that she was going blind from hemorrhagic macular degeneration and had already lost the sight in one eye.

Colleen McCullough.
Horoscopes of the
artist, her husband, and
his son and daughter

Gouache. 20 x 30 inches each.
Collection of the artist

PROSPER MÉRIMÉE

Prosper Mérimée's artistic skills may have been inherited from his parents. His father was an established painter, and his mother did portraits and wrote stories for children. Young Mérimée painted and drew, but must have displayed insufficient talent, since he was pushed by his father toward a career in law. Although law was displaced by literature, his life as a writer competed with his careers as archeologist, historian, translator, and public bureaucrat. For a time Mérimée ran the offices of Secretary General of the Navy, of Commerce, and of the Interior and served longest as Inspector General of Historic Monuments. He had a final appointment to the senate after a close friend married Louis-Napoléon and became Empress.

Yet Mérimée continued to paint; contemporary landscapes, as well as imagined scenes from medieval history, rendered in watercolor and gouache, are held in private collections. (Scholar Alan W. Raitt acknowledged the unlocatable "Duke and Duchess of Alba" as the source of Mérimée paintings in his 1970 biography.) Drawing was apparently habitual in all Mérimée's professional incarnations, as may be seen in the sketch of trees shown here, which he did on Department of Agriculture stationery.

The author of *Carmen* (1845), the tale of jealousy that inspired Bizet's opera and the more than fifty film versions that have followed, Mérimée was born in Paris in 1803, the only child of loving parents with whom he lived until they died. He received his law degree from the University of Paris Law School in 1823. But while still in law school he began to write, completing his first play, *Cromwell,* in 1822, and to circulate in literary salons. He was especially encouraged as a writer by his close friend Stendhal.

Gifted in languages, Mérimée mastered Greek, Latin, English, Italian, Spanish, and Russian. His writing was greatly influenced by Spanish and Russian literature, especially **Alexander Pushkin**. He translated many Russian works and collaborated with Turgenev.

When he was twenty-eight, Mérimée met and fell in love with Jenny Dacquin, a young girl with whom he began a lifelong romantic correspondence, which was published a few years after his death. Mérimée's feelings for Dacquin were hardly exclusive: he was always busy with courtships, seductions, and visits to brothels. In 1833 he was added to the list of famous suitors of **George Sand**, but their flirtation culminated in a night of lovemaking that she described as an "utterly failed experiment."

Summing up Mérimée's contribution to world literature in the *Dictionary of Literary Biography* (1992), Scott D. Carpenter wrote that Mérimée, credited as the inventor of the modern short story, was also responsible for other notable literary advances: his *Théâtre de Clara Gazul* marked the start of Romantic theater; his prose poem in *Las Guzla* was a first in that form; and his historical novel *1572: Chronique du temps de Charles IX* was a refinement of that genre.

Mérimée died in Cannes in 1870.

Above: Prosper Mérimée. Untitled (trees on stationery of the Department of Agriculture)

The Artinian Collection, courtesy of Artine Artinian

Right: Prosper Mérimée. Carmen and Don José

1846. Watercolor. Bibliothèque Nationale de France

Opposite: Prosper Mérimée. De la Veille

Ink. The Artinian Collection, courtesy of Artine Artinian

LEONARD MICHAELS

Short story writer and novelist Leonard Michaels attended New York's High School for Music and Art with the intention of making a life as a painter. Although he abandoned the career, he retained his interest in art. An art critic—Max Beckman was one of his notable subjects—Michaels also collected Asian art, and worked in a number of mediums. He did drawings such as the self-portrait and the semi-abstract, ink-and-crayon fish and bird reproduced here. His diaries are filled with sketches, generally unrelated to the journal narrative. Besides the balsa wood horse's head opposite, Michaels once carved a portrait of a missing cat from a chunk of chestnut beam left from the restoration of his home in Italy. (The cat returned only when the piece was completed.) Another horse's head was chiseled from marble at the ancient Carrera, Italy, mines that supplied Michelangelo. Although years had passed since he painted, Michaels started again in the months before he died in 2003.

In contrast to Michaels' forceful style—rendering images with a line full of conviction—is the nearly faceless woman depicted in the 1961 watercolor shown here. The subject of this barely discernible portrait is Sylvia Bloch, the first of Michaels' four wives. They separated in 1963; she killed herself later that year. One could infer from his failed attempt to capture her on paper that he couldn't see her clearly. He would try again and again to capture her and their relationship in words.

Born in New York City in 1933 to immigrant Jews from Poland, Michaels said "I spoke only Yiddish until I was about five or six years old." His mother's family died in the Holocaust, the details of their violent deaths leaking out over the years to Michaels and his parents. Michaels was closer to his mother, who was only seventeen when he was born, than he was to his father.

Encouraging her son to speak English, she bought a set of Dickens to read to him. He explained:

> If you can imagine a little boy . . . listening to his mother, who can hardly speak English, reading Dickens hour after hour in the most extraordinary accent, it might help to account for my peculiar ear.

His "peculiar ear" evoked critical praise. Susan Sontag described Michaels' story collection *Going Places* (1969) as "healing, even redemptive," and declared Michaels "the most impressive new American writer to appear in years." Highly original, Michaels said that he tried to minimize "the considerations of literary art" in his novel *The Men's Club* (1981): "Everything I talk about, I try to talk about in regard to human reality, which is a much sloppier thing than art."

Michaels earned a B.A. at New York University (1953), and an M.A. (1956) and Ph.D. (1966) at the University of Michigan. Hailed by critics as a master of short fiction, he was a professor of English at the University of California, Berkeley, at the time of his death. His award-winning stories appeared in *The New Yorker, Esquire, Paris Review, Partisan Review,* and numerous other journals. They were included in a number of anthologies, and collected in *Going Places, I Would Have Saved Them if I Could* (1975), *A Girl with a Monkey* (2000), and *Collected Stories* (2007). He also wrote plays, the screenplay for the 1986 movie *The Men's Club,* essays, and "fictional memoirs."

Among other honors, Michaels received the American Academy Award in Literature of the National Institute of Arts and Letters (1971), as well as Guggenheim and National Endowment for the Humanities fellowships in 1969 and 1970, respectively.

Above, Left: Leonard Michaels. Untitled drawing of fish, birds, and flowers

With kind permission of the estate of Leonard Michaels. Photo by Ian Harper

Above, right: Leonard Michaels. Horse's Head

Balsa wood. With kind permission of the estate of Leonard Michaels. Photo by Ian Harper

Right: Leonard Michaels. Portrait of Sylvia

1961. Watercolor and pencil. With kind permission of the estate of Leonard Michaels. Photo by Ian Harper

Opposite: Leonard Michaels. Self-portrait

Ink on paper. With kind permission of the estate of Leonard Michaels. Photo by Ian Harper

HENRI MICHAUX

Henri Michaux's career as a draftsman and painter paralleled his vocation as a poet, and he achieved international recognition for each. He described his impetus to art in terms of a need to rid himself of constricting social conventions: "Born, raised, educated in a purely verbal environment and culture (and before the era of the invasion of images), I paint to decondition myself."

Both word and image reflect Michaux's vision of the subconscious: an unseen, interior world without logic or sense, a surreal world. His goal when drawing was not to create "one vision that excludes others," but

> to draw the moments that, placed side by side, go to make up a life. To expose the interior phrase for people to see, the phrase that has no words, a rope that uncoils sinuously, and intimately accompanies everything that impinges from the outside or the inside.

Many of Michaux's drawings look like pen scratchings in a pseudo-alphabet—some weird version of an ancient ideograph. The viewer feels an urge to read them (one famous image from 1927 is titled *Narration*) with the same frustration one experiences looking at undecipherable pictographs—and yet, because of the beauty with which they are rendered, the suggestiveness of their shapes, and their arrangement as language, the viewer comes away as satisfied as she is disquieted, and perhaps with some thoughts about the nature of meaning. When people, intrigued but perplexed, initially asked Michaux "what kind of 'art'" he was making, he tore up the drawings: "I had been made to doubt too much of their communicability."

Decades later, Michaux made dozens of drawings under the influence of mescalin, a drug, as he put it, "designed to violate the brain and deliver its secrets." What he produced, in the words of critic Roger Cardinal, were works "of a haunting beauty created through the scrupulous shepherding of the signs of disintegration."

During a 1961 interview with John Ashbery, Michaux denied that poetry was as satisfying to him as painting, and when asked whether he felt his poetry and painting expressed the same thing in different forms, he responded:

> Both of them try to express music. But poetry also tries to express some non-logical truth—a truth other than what you read in books. Painting is different—there is no question of truth. I make rhythms in paintings just as I would dance. This is not a verité.

The son of a lawyer, Michaux was born in Namur, Belgium, in 1899. Afflicted with a congenitally weak heart he described as having "holes," Michaux portrayed himself as a child as "subsisting in the margins, always on strike." After an adolescence under the German Occupation and abandoning medical studies, he signed on as a merchant seaman and traveled the world. Eventually settling in Paris, Michaux became a French citizen in 1955. He earned his first critical attention with his collection *Qui je fus (Who I Was)* in 1927, but it was a 1941 study of his work by André Gide that brought him to wider public awareness. He died in Paris in 1984.

Right: Henri Michaux.
La Prince de la Nuit (Prince of
the Night)

1937. Gouache on paper. 13 x 9–7/8
inches. Réunion des Musées Nationaux.
Copyright © 2007 Artist Rights Society
(ARS), New York/ADAGP Paris

Opposite: Henri Michaux.
India Ink Painting

1962. 18–1/2 x 23–5/8 inches.
CNAC/MNAM/Dist. Réunion des Musées
Nationaux/Art Resource, New York.
Copyright © 2007 Artist Rights Society
(ARS), New York/ADAGP Paris, Musée
National d'Art Moderne, Centre Georges
Pompidou, Paris. Photo by Jacqueline Hyde

JAMES A. MICHENER

I have tried all the arts," explained novelist James A. Michener, "because I think one should respond to the art of his time and should be aware of what good people are doing."

> When I am through with writing a book, I turn to music or painting. I also look at postcards of great works of art, which I have collected since I was a boy. I leaf through them at least once a week. And several museums have had shows of my paintings, most of which are now at the University of Texas.

Consent to the display and reproduction of his artwork by the institutions that held it was granted by Michener in a 1989 letter with a strong qualification: "[O]nly if they are shown in their relationship to me as writer, not in an attempt to demonstrate that I was an artist."

Michener spoke of the importance of the impressionist style to his writing, employing a painting by George McNeil, *Schwanda, The Bagpipe Player,* to make his point. The painting, he wrote "does not define the human figure but does suggest it" in its depiction of Schwanda, "as he swings around a corner playing his unseen bagpipes."

> One of the reasons why I have had good luck in writing is that I have always visualized my characters in the style of this painting and have kept them in my mind that way for a year or two before describing them in practical terms. Thus one senses the weight and movement of a character and comes to know what that character is worth in the balance of the story.

Michener had a lifelong involvement with the visual arts. He began art study in London and Siena following college graduation, and he published a critical study of Japanese prints, *The Floating World* (1954), the first of his scholarly works on art. Originally enamored of twentieth-century American figurative art, Michener underwent a change of aesthetic while living abroad in the 1950s:

> It was in Europe that I became converted to the work of our abstract expressionists, for it became obvious that here was the first corpus of American painting that merited full comparison with the very best being done anywhere in the world.

Michener was born in 1907 in New York. These facts are uncertain, however, because he was left in an orphanage in Doylestown, Pennsylvania, where, as a young child, he was adopted by Mabel Michener. At fourteen, he hitchhiked through every state—a foreshadowing of what would be a lifetime of world travel. He won a sports scholarship to Swarthmore College, from which he graduated summa cum laude in 1929. He then studied and taught at private schools and colleges, including Colorado State College and Harvard. Employed as a historian in the South Pacific by the navy, he made use of that experience in the first of his many bestsellers, the Pulitzer Prize-winning *Tales of the South Pacific* (1947), which was adapted for the 1958 musical *South Pacific,* also a Pulitzer Prize winner. At the time of his death in 1997 in Austin, Texas, Michener had turned his great wealth to philanthropic uses, contributing millions of dollars to schools, the Authors League Fund, and the funding of art collections at the Allentown Art Museum and the University of Hawaii.

James A. Michener. Symbols

1966. Mixed mediums. Jack S. Blanton Museum of Art, University of Texas, Austin, gift of Mari and James A. Michener, 1991. Photo by Rick Hall

HENRY MILLER

Over the course of his life, Henry Miller created thousands of watercolor paintings. The "real impetus" toward art, he suggested, came when his high-school art teacher considered him so inept that he was told not to bother attending class. Whatever its source, Miller's drive to paint was so great that he bought his first watercolors at a time when he was begging handouts for food. In the words of his friend and fellow writer-artist **Lawrence Durrell**,

> Henry Miller always gave the impression of enjoying a pleasant, if somewhat infantile, flirtation with paint, but in fact his love went very deep, and whatever his positive achievements as an artist may be, his random sensibility drew a great part of its richness from the world of colour—into which he had penetrated with delight long before his arrival in Paris.

Miller himself was lyrical about his passion:

> To paint is to love again. It's only when we look with eyes of love that we see as the painter sees. His is a love, moreover, which is free of possessiveness. What the painter sees he is duty bound to share. Usually he makes us see and feel what ordinarily we ignore or are immune to. His manner of approaching the world tells us, in effect, that nothing is vile or hideous, nothing is stale, flat, and unpalatable unless it be our own powers of vision.

Painting was not labor for Miller, as writing was. It came from "some other part of my being. . . . While I played, for I never looked on it as work, I whistled, hummed, danced on one foot, then the other, and talked to myself."

In a collection of his watercolors, *Paint as You Like and Die Happy* (1960), Miller explained that his routine allowed him to get to "the treat of painting" in the hour or two before dinner, only after attending to responsibilities and following his afternoon nap:

> When the dinner bell rings I drop everything, trusting to the Lord that when I invoke the spirit again the hand will be ready to do its bidding. I do the same thing when writing. I can stop in the middle of a sentence and know that I shall be able to finish it when I sit down at the desk again. . . . What's inside will out, whether one starts at the beginning, the middle, or the end.

Expatriate, iconoclast, and countercultural author of erotic, autobiographical novels that were banned for years as obscene, Miller was born in New York in 1891. His impoverished life in Paris in the 1930s was the subject of his highly influential novel *Tropic of Cancer* (1934). Although praised by luminaries from Marcel Duchamp and **Aldous Huxley** to T. S. Eliot and Ezra Pound—who declared Miller's work superior to that of James Joyce and Virginia Woolf—Miller was for many years unpublishable in America. Eventually, in 1961, with two other of his frequently smuggled books—*Black Spring* (1936) and *Tropic of Capricorn* (1939)—*Tropic of Cancer* was published by Grove Press. The result was great commercial success and a series of censorship trials culminating in a favorable 1963 decision by the U.S. Supreme Court. Miller's autobiographical, surreal style informed the work of such postwar writers as Norman Mailer, **Jack Kerouac**, **Allen Ginsberg**, **William S. Burroughs**, and Hunter S. Thompson. He was elected a member of the National Institute of Arts and Letters in 1957 and died in 1980 in Big Sur, California.

Henry Miller. Antoine the Clown

1940. Watercolor. 15 x 10 inches. Courtesy of Coast Galleries. By kind permission of Coast Galleries and Coast Galleries Publishing and the estate of Henry Miller

Henry Miller. Paris

1940. Watercolor. 14 x 11 inches. By kind permission of Coast Galleries and Coast Galleries Publishing and the estate of Henry Miller

SUSAN MINOT

W riter Susan Minot has drawn and painted throughout her life, and studied art briefly at Brown and Columbia universities. She acquired the practice of making "little pictures, whether it was painting on old postcards I found, or snapshots I took or, if nothing else, doing watercolors at the tops of pieces of paper—usually while on the phone—which I'd then use for stationery." Although her writing and art started out as private expressions, her writing became "public and subject to judgment" and the way she earned her living; and "the drawing and painting became more of the private thing I was doing for no other reason than that I loved doing it."

In a 2001 letter to me, Minot emphasized she kept her art small—in cigarette-case-sized books, at first—"to reinforce the idea that what I was doing was merely sketching, noting things down, doing studies. I was avoiding the intimidation of actually painting."

> While it requires time and attention it doesn't have other expectations hanging over it. Only my own, of making a record. So I can become lost while I paint. It is not the thing I am supposed to be doing. When I'm supposed to be doing something it tends to get my back up. I also find solace in painting because it's an alternative to writing. It doesn't involve words, and while it still requires the concentration that makes the time you are doing it disappear, it does not involve the mind the same way, or require logic in the same way. (Though of course painting has its own visual logic.) Painting allows me to convey something not from my head, but from my hand, through images. It may not be as specific—that is, it cannot express a precise notion in the way that words can, but an image can express so many other things—of mood and feeling and how people live and what the world looks like. Many of the watercolors I've done are notations of a place I'm passing through. I don't go searching for subjects, I paint what is in front of me.

Novelist, short story writer, poet, and screenwriter of Bertolucci's film *Stealing Beauty* (1995), Minot was born in Manchester, Massachusetts, in 1956, one of seven children in an upper-class family that includes a number of artists. Her mother died in a car accident while Minot was in her senior year at Brown; upon graduation she went home to care for her father and younger sister. The experience inspired Minot's first stories, which form part of her critically acclaimed first novel, *Monkeys* (1986). Published in a dozen countries and winner of France's Prix Femina, it details in a much-praised minimalist style the lives of seven children suffering with their father's alcoholism and their mother's death. Minot's stories have appeared in *The New Yorker, Grand Street, Paris Review,* and *The Atlantic Monthly* and have won O. Henry and Pushcart Prize awards. Minot received her M.F.A. from Columbia in 1983. Her other works include *Lust and Other Stories* (1989), *Folly* (1993), *Evening* (1998), *Rapture* (2002), and *Poems 4 A.M.* (2003).

Susan Minot. Tuscan Landscape

1995. 4 x 6 inches. From the set of *Stealing Beauty.* Watercolor. Collection of the author with the kind permission of the artist. Photo by Jason Brownrigg

Susan Minot. Alasai-Loliondo, Tanzania

1999. Watercolor. Collection of the artist. Photo by Roberto Guerra

MARIANNE MOORE

P oet Marianne Moore, a determined artist in her youth, was taught drawing, as well as piano and voice, at the Metzger Institute in Carlisle, Pennsylvania. By the time of her graduation from Bryn Mawr she was skilled enough to consider a career as a painter. Asked at what point in college poetry became "world-shaking" for her, Moore responded:

> Never! I believe I was interested in painting then. At least I said so. I remember Mrs. Otis Skinner asking at Commencement time, the year I was graduated, "What would you like to be?"
> "A painter," I said.
> "Well, I'm not surprised," Mrs. Skinner answered.

By her senior year, however, Moore, who was then writing stories and poetry, in addition to painting, expressed reservations about beginning an artist's life. "It's silly of me to paint," she wrote in a letter home, "when I couldn't make a cent at it and when I'd do it badly if I knew I *had* to make a cent at it."

Bryn Mawr was steeped in the philosophy of the Arts and Crafts Movement when Moore attended. Its emphasis on the (more female) practical arts and its core appreciation of the value of labor influenced her own aesthetic, which famously prized the "genuine" and the "unforced."

Moore kept drawing and painting throughout her life, and for a while after graduation earned money from the sale of her pen-and-inks of animals. She also began to teach herself about the revolution in European art—Picasso, Braque, Duchamp, and other Cubists and Futurists—cutting out and studying reproductions of their works.

More than one hundred of Moore's paintings and drawings, including the example shown here, are archived with her papers and personal effects at the Rosenbach Museum and Library in Philadelphia. "Vision into Verse," a 1987 exhibit curated by Patricia Willis, demonstrated the way Moore's careful and detailed observations of a wide variety of objects transformed their visual images into poetic ones.

Born in 1887 in Kirkwood, Missouri, Moore never knew her father, who, shortly before her birth, had a nervous breakdown after losing his fortune. She lived with her grandfather until his death, after which her mother took the seven-year-old Moore and her brother to live in Pennsylvania. They eventually settled in Carlisle, where her mother taught at Metzger, the girl's school Moore attended. After graduation from Bryn Mawr, Moore returned to Carlisle and taught at the Indian School. (Jim Thorpe was her famous pupil.) The recipient of many honors, including the National Book Award and the Pulitzer Prize (both in 1952), and the Bollingen Prize (1953), Moore was a member of the American Academy of Arts and Letters. She was lauded by her contemporaries, including **Wallace Stevens** and T. S. Eliot. **William Carlos Williams** wrote that her "magic name . . . has been among my most cherished possessions for nearly forty years, synonymous with much that I hold dearest to my heart." John Ashbery once said, "I am tempted simply to call her our greatest modern poet."

Emphasizing the naturalness of her writing, Moore went so far as to deny it was "poetry," suggesting that a better term might be "compositions. . . . Or better, still, observations." She died in 1972 in New York.

Marianne Moore.
Untitled (house)

WILLIAM MORRIS

The English designer, craftsman, poet, and painter William Morris believed that severing the "great arts" of architecture, sculpture, and painting "from those lesser, so-called Decorative Arts" is

ill for the Arts altogether: the lesser ones become trivial, mechanical, unintelligent, incapable of resisting the changes pressed upon them by fashion or dishonesty; while the greater, however they may be practiced for a while by men of great minds and wonder-working hands, unhelped by the lesser, unhelped by each other, are sure to lose their dignity of popular arts, and become nothing but dull adjuncts to unmeaning pomp, or ingenious toys for a few rich and idle men.

Morris further objected to the separation by capitalist mass production of work from the joy of creation felt by the craftsman, and to the absence of art in the lives of laboring men. Losing "an Art which was done by and for the people" meant the loss of "the natural solace of that labour; a solace which they once had, and always should have."

Morris met his lifelong friend, the painter Edward Burne-Jones, when they were students at Oxford planning careers as clergymen. **John Ruskin**'s writings on the moral basis of Gothic architecture persuaded Morris to apprentice himself to a Gothic Revivalist architect, but at the urging of **Dante Gabriel Rossetti**, he and Burne-Jones decided to become painters. In 1857, Rossetti got Morris to join a group of artists painting scenes from Malory's *Le Morte D'Arthur* on the walls of the Oxford Union, where Morris met Jane Burden. The beautiful young woman became the model for Queen Guenevere in Morris's only surviving painting, *La Belle Iseult* (1858), reproduced opposite. That same year, Morris published *The Defence of Guenevere and Other Poems*. Burden soon married Morris, and subsequently fell in love with Rossetti. The triangle, a torment for Morris, endured until Rossetti's death in 1882.

While they were still young, however, Morris and Rossetti, along with Burne-Jones and others, formed a firm of "fine-art workmen" to produce decorative art products: stained glass, furniture, embroidery, wallpaper, carpets, and tapestries. "Have nothing in your houses which you do not know to be useful or believe to be beautiful," Morris enjoined the public. Inspired by medieval illuminated manuscripts, Morris created calligraphic and illuminated manuscripts, using original translations of Icelandic sagas as texts. In 1890 he established the Kelmscott Press to publish classics and his own works in type styles and ornamental letters of his design.

Morris was born in Walthamstow, England, in 1834 to a wealthy father who died when Morris was fourteen. A precocious child, by seven he had read Sir Walter Scott's three-volume novel *Waverly*. Morris's collected works, which fill twenty-four volumes, include the lengthy narrative poems, especially *The Life and Death of Jason* (1867) and *The Earthly Paradise* (1868–70), essays on art, architecture, socialism, travel journals, and translations, as well as *The Novel on Blue Paper*, which went unpublished until 1982. Best known as a poet, Morris was privately asked and declined to be named Britain's poet laureate. He died in London in 1896, having created what would become the enduring international Arts and Crafts Movement.

LOVE FULFILLED.

HAST thou longed through weary days
For the sight of one loved face,
Hast thou cried aloud for rest,
Mid the pain of sundering hours,
Cried aloud for sleep and death
Since the sweet unhoped for best
Was a shadow and a breath —
O, long now, for no fear lowers
O'er these faint feet-kissing flowers
O, rest now; and yet in sleep
All thy longing shalt thou keep.

Thou shalt rest, and have no fear
Of a dull awaking near
Of a life for ever blind,
Uncontent and waste and wide .
Thou shalt wake, and think it sweet
That thy love is near and kind
Sweeter still for lips to meet;
Sweetest, that thine heart doth hide
Longing all unsatisfied
With all longings answering
Howsoever close ye cling

Above: William Morris. Love Fulfilled

1870. Book of verse. Victoria and Albert Museum, London/Art Resource, New York

Opposite: William Morris. *The Well at the World's End,* pp. 116-117

1896. Kelmscott Press. Victoria and Albert Museum, London/Art Resource, New York

Above: William Morris. La Belle Iseult (Queen Guenevere)

1858. Oil on canvas. 28–1/4 x 19–3/4 inches. Tate Gallery, London/Art Resource, New York

ALFRED DE MUSSET

When the young poet and playwright Alfred de Musset was still struggling to find himself, he announced despairingly, "I would not want to write unless I could be either a Shakespeare or a Schiller, and so I do nothing!" And perhaps it was an analogous fear that he lacked the skills to become one of the masters whose work he copied in the Louvre which prevented Musset from pursuing a career as a painter. He had a natural talent as a draftsman, took up drawing and painting, and was so accomplished that Delacroix, a lifelong friend, told Musset's lover **George Sand**, "Had he wished, he might have become a great artist."

Musset chose to squander his artistic talent, however, employing it merely for sketches, cartoons, and caricatures done for the amusement of himself and friends. What has survived are portrait sketches, many with captions of famous contemporaries, including Sand and her children, as well as an album of drawings dedicated to a friend's courtship and marriage. For a Musset portrait of **Alfred de Vigny** in the Bibliothéque Nationale, Sand wrote the caption: "Constipated old swan about to give birth to a proverb after laborious efforts."

Musset was born in 1810 in Paris into a life of wealth and privilege. His adoring mother indulged him completely, setting no limits on his monstrously destructive behavior, whether he was smashing the mirror in the drawing room or cutting up her draperies. When she sent him off to school with his never-cut golden tresses, in a velvet suit and lace collar, he received the predictable reaction from his peers. Not only was he ridiculed, but for a month he also faced daily beatings.

When it was time to consider a profession Musset was flummoxed: "After love, my sole treasure was my freedom." He said he felt no interest in any of the suggestions made by his father. Letting his thoughts wander, it seemed to him as if he

> suddenly felt the earth moving and that my senses could apprehend the silent, invisible power that drew it through space. . . . I stood up, stretched out my arms and cried: "It is

little enough to be a passenger for a day on a ship floating in the ether; it is little enough to be a man, a mere dark spot on that ship; I will be a man, but never any particular kind of man!"

Foregoing the life of an artist came only after Musset had abandoned a legal education for medical school, which he had also left after a year or so upon discovering that he didn't have the stomach for dissection. Study of languages, music, and drawing followed. Although he didn't foresee it, Musset became a prolific poet, novelist, and the most gifted dramatist of his day. Given the limitations of staging in his time, Musset wrote plays that evoked a dream world which could be read with a good imagination but not easily produced; as a result, they were not successfully mounted for a hundred years. These "armchair" dramas were distinguished by their rich language and psychological depth. Eight of them were turned into operas by such composers as Offenbach, Messager, and Polignac. Jean Renoir's film *The Rules of the Game* (1939) was based on two of Musset's plays.

Musset was admitted to the Académie Française in 1852. A high-living womanizer, alcoholic, and lifetime insomniac, he died in 1857 in Paris, his last words welcoming the sleep to come: "Dormir! . . . [E]nfin je vais dormir!"

Right: Alfred de Musset. George Sand

1833. Pen and ink. 9 x 7 inches. Snark/Art Resource

Opposite: Alfred de Musset. Man with Hat and Angel

From the Artinian Collection, courtesy of Artine Artinian

VLADIMIR NABOKOV

A colored spiral in a small ball of glass, this is how I see my own life."

Novelist Vladimir Nabokov had a passion—he called it a mania—for butterflies and enjoyed a successful career as a lepidopterist. Doing research at Harvard's Museum of Comparative Zoology, he labored compulsively, to the detriment of his fiction. ("I have dissected and drawn the genitalia of 360 specimens.") Nabokov's ability to capture the details of each specimen with precision in both word and image was essential to his scientific work. He valued the aesthetic quality, which for him meant accuracy, of his technical writings no less than he did the aesthetic quality and accuracy of his fiction. He described to critic Edmund Wilson his work on one of his important butterfly papers as "a wonderful bit of training in the use of our (if I may say so) wise, precise, plastic, beautiful English language." As Nabokov's dry, scientific writing still manages to capture facts with literary precision and beauty, his skilled butterfly drawings capture beauty while they record anatomy. The drawings are a meld of science and aesthetics, and consistent with Nabokov's view of nature as art and art as a reflection of nature: "There is no science without fancy, and no art without facts."

Butterflies were Nabokov's trademark. He was photographed with his butterfly book as an eight-year-old and later, as a famous adult, by magazine photographers who posed him with his net or bent over a tray of insects. Butterflies appear in his writing; they were drawn below his signature in letters and books inscribed to friends and family, and most especially to his wife Vera. The selection of butterfly drawings opposite was made by artist Barbara Bloom, who conceived of reproducing them as commemorative stamps in conjunction with the centenary exhibition of Nabokov's work by the Glen Horowitz Gallery, New York.

Nabokov was born in 1899 in Saint Petersburg, Russia, into a family of wealthy aristocrats who maintained fifty servants—not counting Nabokov's governesses, valets, and tutors. His mother painted aquarelles for him and, intending that he should be a painter, hired a succession of artists to teach him. Among these was Chagall's teacher, Mstislav Dobuzhinsky, a master of fine line who gave Nabokov the skills for precise rendering that are manifest in his fiction. Dobuzhinsky, Nabokov wrote,

> made me depict from memory, in the greatest possible detail, objects I had certainly seen thousands of times without visualizing them properly: a street lamp, a postbox, the tulip design on the stained glass of our own front door.

A synesthete who believed his "colored hearing"—the sound of a long *A* in English had for him the "tint of weathered wood," but a French *A* was "polished ebony"—and other sense confusions seemed "tedious and pretentious to those who are protected from such leakings," Nabokov discovered his affliction at seven, when he told his mother that the colors of the letters on alphabet blocks were all wrong. He learned then that they shared the condition.

Nabokov fled Russia with his family after the revolution, in 1919. He spent twenty-one years in "voluntary exile in England, Germany, and France," followed by emigration in 1940 to America, where he became a citizen in 1945. Along the way, he studied languages at Cambridge, graduating with highest honors; wrote nine Russian novels, nine plays, and many stories and poems; taught chess and tennis; and began to write in English and to translate (including *Alice in Wonderland* into Russian in 1923).

The recipient of numerous literary awards for his brilliant, intricate, and difficult writing, Nabokov achieved popular success with *Lolita* (1955), which first appeared in Paris but was not published in the United States for three years because of censorship concerns. In 1959 he moved to Montreux, Switzerland, where he died in 1977.

Above: Vladimir Nabokov. Commemorative stamps

Left: Vladimir Nabokov. "For Vera, Adorata adorata, Jan. 5, 1970"

HUGH NISSENSON

When Hugh Nissenson was doing research for his novel *The Tree of Life* (1985)—which he described as "a faux ledger-journal written by an American early 19th-century intellectual in Ohio, during the War of 1812"—he learned "that it was common at the time for writers to incorporate their drawings and poems into their diaries." In a 2001 *New York Times* interview Nissenson explained, "I became obsessed with the idea of doing the same with *The Tree of Life*." It took him seven years to complete the book.

> Although I'd no formal training as a visual artist, I'd drawn for my own pleasure—out of an inner need—all my life. I drew and painted five illustrations for the book and wrote a cycle of poems. The idea grew within me to use these disparate elements as functions of narrative: to integrate them into the themes and structure of the book. I was partially successful.
>
> My innovative notion found complete expression in my next novel, *The Song of The Earth* (2001), in which forty-seven visual images and a cycle of poems combine with my prose to contribute to the development of the plot—a fictive biography of a future visual artist, whose talents have been genetically enhanced. Each form is essential to the unity of the whole. My pictures, poems and prose, ascribed to different characters, combine to tell a story in a new way.

The child of a Jewish immigrant father from Poland and a mother who was the child of Polish Jews, Nissenson was born in 1933 in Brooklyn. Deeply affected by the Holocaust and the creation of Israel, he traveled there in 1957 to script a movie about the War of Independence and returned to cover the Eichmann trial for *Commentary*. Nissenson's youth was remarkable for its assimilative success: A secular Jew who professes a deep identification with his people and Israel, he attended the Fieldston School in Riverdale, New York, graduated from Swarthmore College with honors in 1955, and then attended Stanford as a Wallace Stegner literary fellow. Yet he has been plagued with chronic depression, and in 2002 told me of having suffered "six major breakdowns," and of recovering well into adulthood the memory of abuse at the hands of a babysitter.

The connection between trauma and art is a central subject of Nissenson's futuristic *The Song of the Earth*. Written during the "protracted, terrible experience" of his parents' deaths, when Nissenson was first addressing the ramifications of his own early sexual abuse, the novel features a protagonist who has been genetically manipulated to have a predisposition toward artistic creativity. His artistic gift is nurtured—in the most ironic sense— by deliberately inducing a postpartum depression in his mother so that he will experience the withdrawal of love at the earliest formative stage of life.

Reading Nissenson's works, writes scholar Leila Goldman, means confronting "the meaning of existence, the brutality of life, the nature of evil, God's relationship to man, man's need and search for redemption, and being Jewish in a hostile world." Cynthia Ozick has equated the "revelatory commentaries" in his writings to those of the great Jewish sages. His stories have been published in *The New Yorker, Commentary, Harper's,* and *Esquire.* His first collection, *A Pile of Stones* (1965), won the Edward Lewis Wallant Memorial Award. *The Tree of Life* was a National Book Award and PEN/Faulkner Award finalist. Other notable books by Nissenson include *Notes From the Frontier* (1968), *In the Reign of Peace* (1972), *My Own Ground* (1976), and *Days of Awe* (2005).

Hugh Nissenson. The
Ground Beneath My Feet

2001. Painted papier-mâché,
textured with architectural
modeling material, glass eyes,
mounted on canvas. 20 x 16 x 3
inches. Collection of the artist.
Photo courtesy of John Parnell

SEAN O'CASEY

*I*n addition to the financial misfortunes of his childhood, playwright Sean O'Casey endured extreme pain from a chronic ulceration of the cornea that left him with a permanent loss of vision. Possessing a natural talent for art, he found his bad eyesight too great a handicap for painting, but was able to draw, sketch scenes, do portraits, and become an accomplished caricaturist.

At a time when O'Casey's works were the core of the Abbey Theatre's repertoire, he submitted an experimental new play which **William Butler Yeats** believed unworthy of production. Yeats persuaded his fellow Abbey playwright Lennox Robinson and cofounder Lady Gregory to reject it. In the hope of mollifying O'Casey with the thoughtfulness of Yeats's criticism, Lady Gregory passed his communications along to the playwright in confidence. An outraged O'Casey wrote to Robinson:

> I am too big for this sort of mean and petty shuffling, this lousy perversion of the truth. There is going to be no damned secrecy with me surrounding the Abbey's rejection of the play. Does he think that I would practice in my life the prevarication and wretchedness that I laugh at in my plays?

In addition to publicizing the rejection in the press, O'Casey found catharsis in caricature. The caption for the example opposite reads:

> YEATS: We decree that thou art a heretic.
> ROBBIE: Cast out from the unity of the Abbey.
> YEATS: Sundered from her body.
> ROBBIE: Segregated & abandoned for evermore.
> LADY GREGORY: Amen.

Ireland's greatest playwright was born John Casey in 1880, into a miserably poor Protestant family in Catholic Dublin, the youngest of thirteen children. His father died when O'Casey was six, creating greater hardships for his burdened widow and family. O'Casey had little schooling, but he taught himself to read and write at fourteen using old primers, a dictionary, the Bible, and then Shakespeare. After a series of clerical jobs as a child, he became a manual laborer in his teens.

A wide range of talents, however, were revealed in O'Casey's adulthood. He played the bagpipes and participated in a famed band of pipers. He sang satiric songs of his own devising and entertained as a mime, comedian, and actor. He learned to speak and write the Irish language. And he took up painting and drawing.

The egalitarian O'Casey had an unexalted view of art and writing:

> The writer should not encourage the thought that his work is more important than the worker in wood, in metal or the weaver of textiles. . . . The delicate pencil and paintbrush, the sculptor's searching chisel, or the potent pen is no more than the plumb line and the spirit level, the jack-plane and saw, or the hammer beating out utilitarian shapes from metal.

An Irish nationalist who was active in the labor movement as a writer and a member of its military arm, O'Casey withdrew from the movement when he felt it had forgotten its socialist ideals. His playwriting career began with his first Abbey Theatre acceptance, *The Shadow of a Gunman* (1923). He died in Devon, England, in 1964.

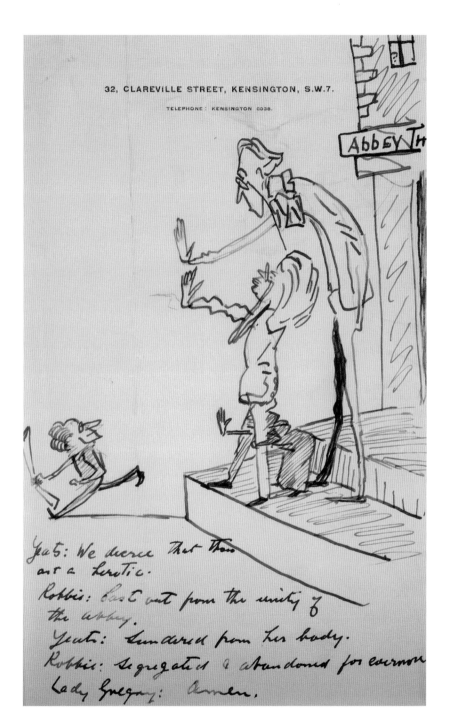

Sean O'Casey. Untitled (*The Silver Tassle*
rejected by the Abbey Theatre

Berg Collection of English and American Literature,
The New York Public Library, Astor, Lenox and
Tilden Foundations

FLANNERY O'CONNOR

Fiction writer Flannery O'Connor's father was a real-estate broker who encouraged her early efforts in art and writing. He died when she was fifteen of a hereditary form of lupus, from which she would prematurely die, after a solitary life in which she'd never held a job or had an intimate relationship. O'Connor described herself as "a pigeon-toed only child with a receding chin, and a you-leave-me-alone-or-I'll-bite-you complex."

At Georgia State College for Women in Milledgeville, Georgia, O'Connor became art editor of the student newspaper, editor of the campus literary magazine, and feature editor of the yearbook, dividing her creative efforts evenly between cartooning and fiction writing. The examples opposite are college cartoons.

O'Connor the artist considered writing as foremost an expression of the visual:

> For the writer of fiction, everything has its testing point in the eye, and the eye is an organ that eventually involves the whole personality, and as much of the world as can be got into it.

Echoing **Joseph Conrad**, she wrote in her 1957 essay, "The Nature and the Aim of Fiction":

> My task which I am trying to achieve is, by the power of the written word, to make you hear, to make you feel—it is, before all to make you see. . . . Any discipline can help your writing: logic, mathematics, theology, and of course and particularly drawing. Anything that helps you to see, anything that makes you look. The writer should never be ashamed of staring. . . . I know a good many fiction writers who paint, not because they're any good at painting, but because it helps their writing. It forces them to look at things.

O'Connor acknowledged how directly art techniques influenced her, advising a friend who was trying to salvage a novel to "[t]ry rearranging it backwards and see what you see." She credited the idea to art classes "where we always turn the picture upside down, on its two sides, to see what lines need to be added."

A darkly comic Catholic, O'Connor wrote about grotesque characters in the decaying South, with a religious vision that has been read as both conventionally Christian and demonic. She was born Mary Flannery O'Connor in 1925 in Savannah, Georgia. She attended Catholic parochial schools until the family was forced by her father's illness to move to her mother's family home, a former governor's mansion, in Milledgeville. O'Connor studied at the Iowa Writers' Workshop, wrote her first novel, and received her lupus diagnosis before it was published in 1952. Expecting to die, she returned home so her mother could care for her, and they relocated to a farm where she raised peacocks and other exotic fowl. O'Connor wrote that her job as a "novelist with Christian concerns" was to take the repugnancies of modern life and make them "appear as distortions to an audience which is used to seeing them as natural. . . . [T]o the hard of hearing you shout, and for the almost blind you draw large and startling figures."

O'Connor died in 1964 in Milledgeville, leaving, among her honored works, *A Good Man is Hard To Find* (1955), *The Violent Bear It Away* (1960), and *Everything That Rises Must Converge* (1965). *The Complete Stories of Flannery O'Connor,* published posthumously in 1971, received the National Book Award.

HAVING A WONDERFUL TIME

Above: Flannery O'Connor. Having a Wonderful Time

Woodblock on paper. From 1945 *Spectrum*, pg. 5. Special Collections, Ina Dillard Russell Library, Georgia College and State University

Right: Flannery O'Connor. "Wake Me Up In Time To Clap!"

17 April, 1943, issue of *The Colonnade*. Special Collections, Ina Dillard Russell Library, Georgia College and State University

"Wake Me Up In Time To Clap!"

CLIFFORD ODETS

When, in the 1940s, playwright Clifford Odets was blocked as a writer and, in the early 1950s, when he was persecuted by the House Un-American Activities Committee, painting became the outlet for his creative energies and for his torment. An insomniac, Odets would paint at his desk through the long nights. His work was colorful and whimsical and suggestive of the Modernists he admired and whose art he collected—including more than sixty works by Paul Klee alone.

Odets made explicit the close relationship between his life and his artistic expressions:

> All of the characters in my plays have the common activity of "a search for reality." Well, it's my activity before it's theirs. And before it was mine, it was the activity of almost any serious artist who ever lived, from the breakdown of feudalism till today. When you say an artist died still looking for his form, as, for instance, Beethoven and Cézanne did, you mean he died still looking for his reality.

Acknowledging that he was "of a lesser breed than Beethoven," Odets insisted he shared, as all artists do, "similar problems":

> I was not strong enough to stand the loneliness, the opprobrium —I could not look my Fate in the face, could not clasp it hand to hand. . . . In the creative sense, I was never being neurotic until I tried to live the "normal" life of other men.

J. B. Neumann gave Odets's paintings on paper their first showing at his New York gallery in 1946. The Philadelphia Museum of Art exhibited his work in 1952, and in 1996, a major retrospective, *Clifford Odets—In Hell + Why,* was presented by the Michael Rosenfeld Gallery, New York.

Odets was born in 1906 in Philadelphia, his father a Russian Jewish immigrant peddler, his mother a factory worker. Although his financial circumstances became solidly middle-class by the time he was an adolescent, Odets was determined to pursue a career as an actor or writer, although his father—who, in an angry moment, smashed his son's typewriter—wanted him to be a businessman. After two disastrous years in high school, during which he failed five of his major subjects (including art) and barely passed four others (English among them), the fifteen-year-old Odets dropped out to become an actor.

Famed for his socialist plays of the 1930s, Odets wrote of the individual's struggle to maintain integrity in the face of poverty and of the lure of middle-class materialism, and found himself at the end of his life writing screenplays in Hollywood. In 1931 he co-founded the Group Theatre in New York, where most of his plays were produced. They included the play that first made his reputation, *Waiting for Lefty* (1935), followed by *Awake and Sing* (1935), *Til the Day I Die* (1935), *Golden Boy* (1937), and *Night Music* (1940). Among his many screenplays were *None but the Lonely Heart* (1944), *The Story on Page One* (1959), and *Sweet Smell of Success* (1957). He died in Los Angeles in 1963.

Clifford Odets.
Coming Snow

1947. Watercolor, gouache, and ink on paper. 14–7/8 x 10–7/8 inches. Courtesy of Michael Rosenfeld Gallery, LLC, New York, New York

Clifford Odets. April Swamp

1952. Watercolor and ink on paper. 9 x 11–3/4 inches. Collection of Lucy Daniels, courtesy of Michael Rosenfeld Gallery, LLC, New York, New York

KENNETH PATCHEN

"I don't consider myself to be a painter," said the poet Kenneth Patchen. "I think of myself as someone who has used the medium of painting in an attempt to extend—give an extra dimension to—the medium of words." Frequently he would turn from his poetry to graphic work: "[I]t happens very often my writing with pen is interrupted with my writing with brush—but I think of both as writing."

It was for his painted books that Patchen achieved his first recognition as an artist. *The Dark Kingdom* (1942) was published in a limited edition of seventy-five copies, with an individual painting on each cover. Merger of word and image in picture poems followed. In 1953, with the help of an artist friend, Frank Bacher, Patchen produced silkscreen folios of his paintings.

Patchen, who suffered from a disabling spinal disease that struck him in 1937, got relief in 1956 from a spinal fusion, only to succumb to a "surgical mishap" in 1959. The few pain-free years he had enjoyed were, in the words of his wife Miriam, "replaced in even more violent and vicious form, his life of pain confined totally to bed." The receipt, wrote Miriam,

> of some hundreds-of-years-old handmade papers started him back to painting. Physically torturous for him since he cannot sit, lie on his back, or move more than slightly without incurring monstrous pain, painting little words on paper gives him air from the cramped bedroom, everything else, including the page, closes in.

"All of my life I have been lonely," said Patchen, who was born in 1911 in Niles, Ohio. Ill throughout his childhood, he drew a cartoon world inhabited with invented creatures. He didn't start school until he was eight:

> [I]t was while I was sick that I had things read to me. I lived in an imaginative world and I believe sometimes that I never really left that world. Thus starting out to school my interests were not as those around me, and I sort of withdrew into myself.

Using Paul Klee as his example, Patchen defined the quality that, for him, defined the true artist:

> I feel that every time he approached a new canvas, it was with a feeling that "well, here I am, I know nothing about painting, let's learn something, let's feel something"—and this is what distinguishes the artist of the first rank, the innovator, the man who *destroys* [emphasis added], from the man who walks in the footsteps of another.

Besides writing more than forty books of poetry, prose, and drama, Patchen pioneered the use of jazz as a backup to his spoken-word performances. His most famous jazz collaborator was Charles Mingus. Patchen also collaborated with John Cage to produce a radio play, *The City Wears a Slouch Hat,* in 1942.

A devout anarchist and pacifist who opposed United States involvement in World War II, Patchen died in 1972 in Palo Alto, California. Collections of his art are held by the University of California, Santa Cruz, and the University of Texas at Austin.

Opposite, right: Kenneth Patchen. Cover for *Sleepers Awake*

1946. Pen and ink and gouache on paper. 46 x 75 inches. Private collection, New York City. Copyright © 2007 the estate of Miriam Patchen, used by permission. Photo by Jason Brownrigg

Opposite, left: Kenneth Patchen. Untitled

1950. Watercolor on paper. 16–1/2 x 10 inches. Private collection, New York City. Copyright © 2007 the estate of Miriam Patchen, used by permission. Photo by Jason Brownrigg

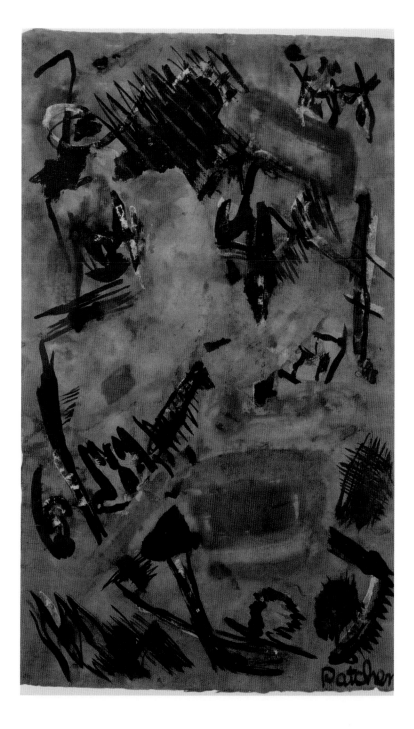

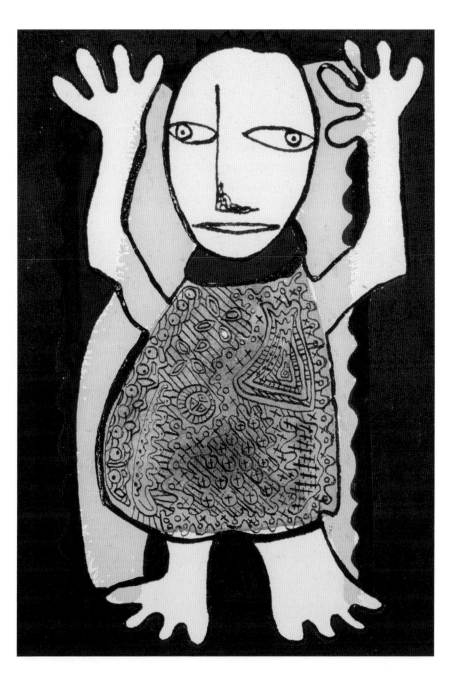

MERVYN PEAKE

Mervyn Peake's best-known novels, the allegorical gothic fantasies known as the Gormenghast books, were, according to his family, the outcome of being forced to use his artistic skills to record the horrors of World War II. Appointed a war artist, Peake was assigned to do portraits of the Bergen-Belsen concentration camp survivors. Examples of those sketches, now in the collection of the British Imperial War Museum, are reproduced here. Disturbing paintings and poems followed Peake's encounter with the unspeakable. His wife said it was "as if he had lost, during that month in Germany, his confidence in life itself."

All of the Gormenghast books are illustrated, and drawings covered the pages of the handwritten drafts of *Titus Groan* (1946), the first of the series, which Peake sent home from the front. Peake was already an accomplished artist who had achieved recognition as an outstanding illustrator of children's books, including *Treasure Island*, *Household Tales* by Brothers Grimm, and, most notably, *Alice's Adventures in Wonderland*. He had begun writing and drawing at London's Eltham School for the Sons of Missionaries, which he left to take up art studies at the Croydon School of Art and then at the Royal Academy Schools for four years beginning in 1929. Peake was twenty and still a student when he had his first exhibit. After two years of living in an artists' colony on an island in the English Channel and showing his paintings in London, he took a job teaching at Westminster School of Art. His highly regarded and uniquely styled children's book illustrations reflect the influences of Rembrandt, Goya, and Piranesi.

Peake was born in Kuling, China, in 1911. His parents were missionaries—his father was a physician, his mother a nurse—who were forced, when their son was fifteen months old, to flee when caught in the middle of a bloody revolution against the imperial powers. After relocating to Tianjin, a desert city in northern China where they lived amid a hostile population and endured sandstorms and frigid winters, they returned to England when Peake was three. With the outbreak of World War I that same year, his father left to serve as a volunteer in Belgium and France,

resulting in recurrent themes in Peake's writing involving the separation of a man or boy from his family. At age five, Peake returned to Tianjin with his family, and stayed until he was twelve. After World War II, he moved back to the channel island with his wife and children, to a house without running water or electricity, where he painted and wrote.

In the 1950s the Peakes returned to London, where he taught art and produced poetry, dramas, and essays, as well as his fiction. There, he was stricken with what was variously diagnosed as Parkinson's disease, "sleeping sickness" contracted in a 1911 epidemic in China, premature senility, and mental breakdowns caused by maladjustment to the army (he had been given sick leave, then a medical discharge) and financial pressures. Whatever the cause, Peake spent twelve years going from doctor to doctor, submitting to electroshock treatments and brain surgery, until he was finally institutionalized. He died in a hospice in Burford, England, in 1968.

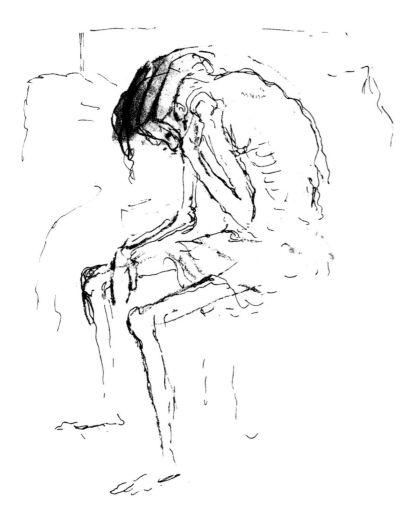

Above: Mervyn Peake. Drawing of a Girl at Belsen

1945. Ink on paper. Courtesy of the estate of Mervyn Peake

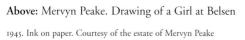

Opposite: Mervyn Peake. Girl of Seventeen Dying (Belsen)

1945. Ink on paper. Courtesy of the estate of Mervyn Peake

Above: Mervyn Peake. Girl with Cropped Hair (Belsen)

1945. Ink on paper. Courtesy of the estate of Mervyn Peake

S. J. PERELMAN

Humorist S. J. Perelman summarized his history in the arts:

> Simply stated I became interested in the life creative because I was a comic artist at college. I was more interested in working for the college humor magazine, *The Brown Jug,* than I was in trigonometry and all those necessary adjuncts. Eventually, in my senior year, I became editor of the magazine and subsequently went professional in New York as a comic artist. This lasted for six or seven years, when I drifted into writing, principally because my cartoon captions became longer and longer and longer.

With the experience of college cartooning behind him—see the examples opposite—Perelman

> tied a red bandanna to a peeled willow stick and emigrated to New York in 1924 to earn, as I believed, a sumptuous living. . . . I saw myself ensconced in a studio, with lightly draped models, wearing a Windsor tie and a beret and expertly negotiating a palette, a loaded brush and a maulstick.

The reality was that Perelman got a job with *Judge* magazine that required him to deliver two cartoons and a humor piece weekly, for which he was poorly paid. The pen-and-wash drawings he turned in, Perelman said, were produced in "four distinct manners":

> Held [John Held Jr., a popular illustrator and *Judge* cartoonist], Barton [Ralph Barton, a celebrity caricaturist], figures based on African sculpture, then I hit upon collage, which no one else was doing in cartoons then.

Sidney Joseph Perelman was born in Brooklyn in 1904, but his family moved shortly afterward to Providence, Rhode Island. His immigrant Jewish parents, secure in the belief that their son would grow up to be a doctor, encouraged his childhood urge to draw. They bought him a blackboard and chalk when he was eleven so he could imitate the vaudeville artists he'd seen doing "chalk talks." They watched as he drew cartoon characters on the board and on long strips of cardboard that wrapped cloth in his father's dry goods store. One can only imagine their disappointment when Perelman abandoned his premed studies at Brown to dedicate his life to cartooning and humor writing.

Perelman said that he "ran afoul of the Marx Brothers" in 1931 and "did a hitch or two for them"—meaning that he wrote their early zany comedies *Monkey Business* (1931) and *Horse Feathers* (1932). At Brown University, Perelman had met and married his classmate Nathanael West's sister, Laura, who cowrote a half dozen of his seventeen movie and theatrical scripts. Perelman produced twenty-six books of humor, many of them collections of pieces from *The New Yorker.* Although he described his writing as "a mixture of all the trash I read as a child, all the clichés, criminal slang, liberal doses of Yiddish, and some of what I learned in school from impatient teachers," critics see his work as having introduced an original, brilliantly crafted form of wordplay that informed virtually all American humor that followed. Besides an Academy Award for Best Screenplay that he shared for *Around the World in 80 Days* (1956), Perelman was honored with a special National Book Award in 1978 for his contribution to American letters. He died in New York in 1979.

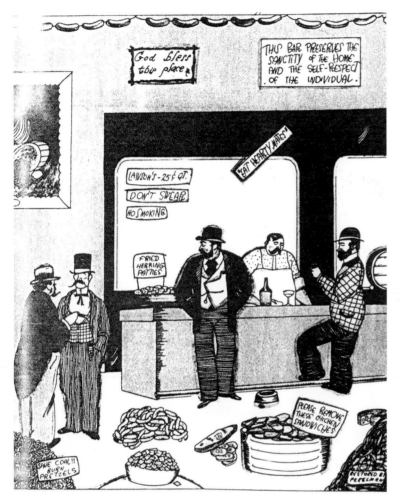

IF WE CAN BELIEVE THE OLD STORIES ABOUT THE FREE-LUNCH COUNTERS
IN THE BAR-ROOMS

S. J. Perelman. If We Can Believe the Old Stories about the Free Lunch Counters
in the Bar Rooms

Reprinted by permission of Harold Ober Associates Inc. on behalf of Abby and Adam Perelman

EARLY LAWS OF THE COLLEGE

S. J. Perelman. Early Laws of the College.

Reprinted by permission of Harold Ober Associates Inc. on behalf of Abby and Adam Perelman

SYLVIA PLATH

From early childhood until her third year of college, poet Sylvia Plath's creative trajectory was aimed as much at a career in the plastic arts as in literature. Taken at the age of four from her family, and placed in the custody of grandparents while her mother cared for her brother and her sick father, Plath lost herself in art during the next four years. At one point her mother, who communicated with the child by letter, sent her a note telling her she must learn to write as well as she drew. Plath's immigrant father, a biologist and Boston University German professor, died when she was eight. Her relationship with her parents was, unsurprisingly, conflicted. In her 1966 poem "Daddy," Plath assaulted her father as a Nazi— and identified herself as a Jew. Despite a deep attachment, Plath denied loving her mother, calling her "a walking vampire."

Throughout her school years Plath worked in a variety of mediums: she drew, painted in watercolor and tempera (and on rare occasion in oils), used pastel and crayon, did crafts (including rug weaving), and successfully competed in art shows. She also illustrated her letters, school papers, writings, and journals. At Smith College she took studio arts courses but was dissuaded from an art career by critical teachers and peers, as well as by insecurity about whether it was a financially viable choice. Although Plath refocused her energies on writing, she continued to utilize visual expressions, not only as a source of personal gratification, but to illustrate, inspire, and shape her writing.

For Plath, seeing something was a means to writing about it. Pen-and-ink drawings that she ostensibly did to illustrate her *Christian Science Monitor* reportage on her experiences abroad actually preceded her articles, which were written to accompany the drawings. Drawings also inspired poems. And drawing deepened her knowledge what she saw, moreover, transforming intellectual understanding into physical experience. In a 1956 journal entry Plath described herself sketching a scene through the Pont Neuf's arches in Paris. "It was not very good," she wrote, "too unsure & messily shaded. . . . Felt I knew that view though, through the fiber of my hand."

Plath was born in 1932 in Boston. At thirty, following a life of depression, breakdowns, hospitalizations, and shock therapy while in college, Plath committed suicide in London, on February 11, 1963. Her poetry is described by Ellmann and O'Clair in *The Norton Anthology of Modern Poetry* (1973) as "a holy scream, a splendid agony—beyond sex, beyond delicacy, beyond all but art."

The surface of Plath's biography suggests a normal and successful young life. She was raised in the upper-middle-class suburb of Wellesley, and sold stories and poems to national publications before she was out of high school. Attending Smith on a scholarship, she was Phi Beta Kappa and an editor of *The Smith Review*. She graduated summa cum laude and went to Cambridge on a Fulbright. In 1956, Plath married fellow poet Ted Hughes, later a poet laureate of Britain, who left her and their two children in 1962.

Plath's works include her autobiographical novel, *The Bell Jar* (1960); poetry collections *The Colossus* (1960), *Ariel* (1965), *Winter Trees* (1973), and *Collected Poems* (1981); and her *Unabridged Journals* (2000). Many of Plath's ink drawings have been published with her literary work. Kathleen D. Connors organized a show of Plath's art, *Eye Rhymes: Visual Art and Manuscripts of Sylvia Plath,* for the Indiana University School of Fine Arts Gallery, in conjunction with the Lilly Library in 2002.

Right: Sylvia Plath. Two Women Reading

C. 1950–51. Tempera, 18 x 24 inches. Courtesy of the Lilly Library, Indiana University, Bloomington, Indiana. Reproduced with the kind permission of the Sylvia Plath Estate 2007

Bottom, left and right: Sylvia Plath. Illustrations accompanying articles in *The Christian Science Monitor* (March 1956)

Courtesy of the Mortimer Rare Book Room, William Annan Neilson Library, Smith College. Reproduced with the kind permission of the Sylvia Plath Estate 2007

Opposite: Sylvia Plath. Self-portrait

1951. Pastel. 24 x 18 inches. Courtesy of the Lilly Library, Indiana University, Bloomington, Indiana. Reproduced with the kind permission of the Sylvia Plath Estate 2007

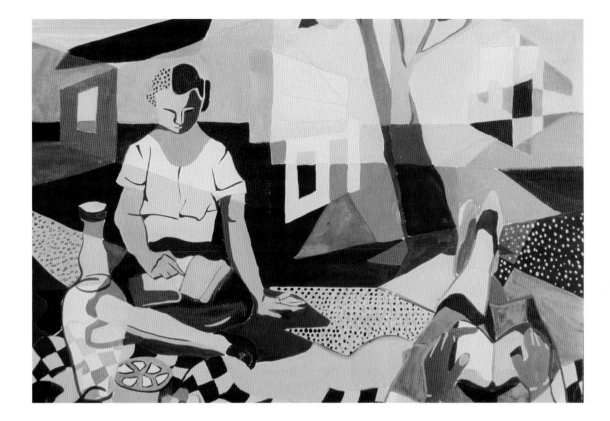

Drawings by the author

A colorful pattern of rounds and oblongs, knobs and wheels, legs and handles

"Each object has a line, a tint, a character of its own—the older and odder the better"

EDGAR ALLAN POE

Edgar Allan Poe seems to have been a natural artist: his skillfully rendered portraits survive—including the self-portrait and the drawing of his young wife shown here—although there is apparently no record of his having attended art classes. Poe drew as a student—indeed, he is reported to have covered the walls of his room at the University of Virginia with charcoal drawings. He did caricatures of professors and copied illustrations from a collection of Lord Byron, his romantic model at the time.

Poe also evidenced an aesthetic sensibility that presaged **William Morris**'s movement to bring art back into the everyday. In a light-hearted 1840 essay entitled "The Philosophy of Furniture," Poe took his countrymen to task for seeing the cost of an article as "the sole test of its merit":

> There is reason, it is said, in the roasting of eggs, and there is philosophy even in furniture—a philosophy nevertheless which seems to be more imperfectly understood by Americans than by any civilized nation upon the face of the earth. . . . There could be scarcely any thing more directly offensive to the eye of an artist than the interior of what is termed in the United States, a well-furnished apartment.

Poe was born in Boston in 1809 to a pair of itinerant actors. When the two-year-old boy's mother died he was in Richmond, Virginia, his alcoholic father's whereabouts unknown. While his two siblings were left in the care of others, Edgar was informally adopted by the childless, ailing Frances Allan and her husband, John. The Allans provided Poe with quality schooling, sending the six-year-old off to boarding school in England while the family was living there, and enrolling him in Richmond academies on their return when Poe was eleven. There, his fellow classmates scorned him as a social inferior, and taunted him for being the offspring of actors and a foster child. When he was fifteen, a friend's mother, to whom he had become attached, died, and the bereft Poe became a frequent visitor at her grave.

At the time of his adoptive mother's death, the twenty-year-old Poe was in the army, having run off and enlisted under an assumed name two years before; he had achieved the rank of sergeant major, the highest noncommissioned officer in the army. He had by then also published his first book, *Tamerlane and Other Poems* (1827). After a series of estrangements over Poe's drinking and huge gambling debts, his foster father arranged for his admission to West Point. Another altercation between them led to Poe's deliberate misbehavior and dismissal after court-martial, and to the permanent severing of their relationship.

Poe was twenty-six when he asked his aunt for the hand of her thirteen-year-old daughter, Virginia Clemm. They were soon wed—the date is uncertain—but Poe later denied ever having consummated their childless marriage. Virginia, twenty-five, died in 1847. Poe died two years later, a few days after being found unconscious on a street in Baltimore. His prototypical detective stories and tales of horror, and his lyrical, visionary poetry influenced, most notably, **Baudelaire**, Mallarmé, and **Valéry** in France, and **Dostoevsky** in Russia.

Edgar Allan Poe. Portrait of Virginia Clemm Poe (his wife)

1845. Crayon. Courtesy of the Lilly Library, Indiana University, Bloomington, Indiana

Edgar Allan Poe. Self-portrait

1845. Crayon. Courtesy of the Lilly Library, Indiana University, Bloomington, Indiana

BEATRIX POTTER

Beatrix Potter was a neglected, effectively abandoned child, who was denied schooling outside her home, consigned under the care of governesses to the third floor of the house, and deprived of her parents' love as well as their presence, even at meals, which she took separately. Potter's companions consisted of her pets—including mice and frogs—and her sole source of entertainment was the writings and drawings she generated herself. Her parents used their isolated child's near-desperate need for art supplies to control her, offering them as reward and withholding them to punish. Until she was grown, the only outside world she knew was the countryside of England's Lake District, where her family vacationed, and the museums in London—both of which became important to her art. It was the close study of creatures in the countryside, including their skeletons, that helped Potter to render her animal subjects faithfully; and it was the study of museum art that taught her composition and perspective.

At twenty-four, in an effort to create an independent life for herself, Potter successfully promoted her art for Christmas cards to a German company with a London office. A little older and deeply lonely, Potter would visit the children of her last governess, apparently the only children with whom Potter had a relationship. In 1893, when one of them became ill, Potter sent the child an illustrated letter with what was to become the first of her twenty-three exactingly illustrated Peter Rabbit stories. Seven years later she retrieved the letter, turned it into a book, and when it was rejected by Warne Publishing, had it printed privately in 1902. Potter sent a copy to Warne, who reprinted it and became her publisher. Like *The Tale of Peter Rabbit*, Potter's second classic, called *The Tailor of Gloucester* (1902), grew out of her relationship with her former governess's family—the original manuscript was a Christmas present for her governess's daughter. Twelve watercolors accompanied the manuscript, including the one reproduced opposite right.

Helen Beatrix Potter was born in South Kensington, now Greater London, in 1866. Her parents, having inherited a fortune made in textiles, lived in idleness, and beyond a desire to ensure their only daughter's total dependence, had no apparent interest in her. At fifteen, Potter began a ten-year journal she wrote in code, in a minute script, which undoubtedly provided a safe emotional outlet, although she suffered in her twenties from undiagnosed periods of incapacitation.

Potter pursued her childhood passion for natural history into adulthood, doing detailed paintings and drawings of plants and animals from multiple points of view, and in the late 1880s, began serious studies of mushrooms. An article she published in 1897 on sprouting mushroom spores was presented to the Linnaean Society by a male friend, since women were not permitted to appear before scientific bodies. An extensive collection of her mushroom drawings and paintings—unconventionally beautiful scientific illustrations—are held by the Armitt Library and Museum in England.

In 1905, the nearly forty-year-old Potter became engaged to Norman Warne, her editor and her publisher's son. Her parents fiercely objected because his family was in trade, but Potter made plans for a country life with him, buying Hill Top, a cottage in her beloved Lake District. When Warne died of undisclosed leukemia a few months later, her parents wouldn't acknowledge his death. After years alone at Hill Top, in 1913 Potter married again, spending her last thirty years breeding sheep and helping preserve the surrounding countryside.

Over the course of her life, Potter acquired—on occasion by doing watercolors of her characters, which she would sell to raise the needed capital—more than four thousand acres of Lake District land, including half the village of Sawrey, Lancashire, where she died in 1943. Potter turned the property over to the National Trust to be kept as farmland and for public use.

Above: Beatrix Potter. Hunca Munca the Mouse and Her Baby

1904. Illustration from *The Tale of Two Bad Mice*. Copyright © Blue Lantern Studio/CORBIS

Below: Beatrix Potter. Hygrophous laetus (now Hygrocybe laeta)

1895. Watercolor. Courtesy of the Armitt Trust, Ambleside, UK. Copyright © the Armitt Trust

Above: Beatrix Potter. Watercolor of a mouse

Copyright © Adam Woolfitt/CORBIS

JACQUES PRÉVERT

Poet Jacques Prévert began making collages when he was about forty-three, two years before he produced *Paroles* (1945; *Words*), his enormously successful debut collection of poems. The poetry of *Paroles* is extremely visual and, like the collages, elevates everyday images and language to art. Prévert's orientation was visual: he wrote for the theater, authored fourteen produced screenplays, directed experimental movies, and collaborated with photographer Izis Bidermanas on books about Paris and London in which Prévert's poems appeared next to Bidermanas's photographs. The French Bibliothèque Nationale owns many of Prévert's collages, including those reproduced opposite, and a collection of them was published in *A la rencontre de Jacques Prévert* (1987; *Meeting Jacques Prévert*).

The collages are surreal in their re-employment of the common objects and images that surround us to make larger, generally satiric points about our world. At twenty-four, Prévert lived with the painter Yves Tanguy, their house a gathering place for other painters and poets, including the founder of the Surrealist movement, **André Breton**. The descriptions of Prévert's poetry one finds in critical studies that allude to its Surrealist qualities apply as well to his art. In her *Jacques Prévert's Word Games,* Anne Hyde Greet observes that "the lyric, the grotesque, and the comic spring simultaneously from a wild assemblage of sound effects and verbal relationships." Of course, in the collages, it is an assemblage of objects, rather than words or sounds, but Greet perceives the same interest in the concrete in Prévert's poetry and his links to such "lovers of objects" as Francis Ponge and Alain Robbe-Grillet.

Prévert's success in "exposing clichés," and affirming "life's essential value by creating new meanings for words or by renewing old ones," is manifest in his collages as well as his poetry.

In a poem from *Paroles*, "Promenade de Picasso," Prévert depicts a confrontation between a painter of reality—of real objects—and the reality that defeats him:

> On a nicely round plate of real porcelain / an apple poses / face to face with it / a painter of reality / tries in vain to paint the apple as it is / but / it does not give itself up / the apple / it has its piece to say . . .

Like his poetry, Prévert's collages express a profound antagonism toward religion (especially the Catholic Church), bourgeois complacency and indifference to injustice, all things militaristic, and right-wing ideology in general. "Our Father who art in heaven, stay there," he wrote.

An immensely popular poet, Prévert was born in Neuilly-sur-Seine, France, in 1900 and raised in financially straitened circumstances by a father who worked for a charity and early on exposed his son to the needs of the poor. When Prévert was fifteen, his older brother died of typhus. Prévert dropped out of school and was drafted into the military, which did nothing to reduce his ingrained antipathy to militarism. In 1932, he joined the October Group, performers advancing a leftist ideology.

Prévert's poems from *Paroles* were set to music and sung by such notables as Marlene Dietrich, Edith Piaf, Yves Montand, and Joan Baez. He died in 1977 in Omonville-la-Petite, France.

Above: Jacques Prévert. L'Empereur

Collage. 10–1/4 x 7–1/2 inches. Bibliotèque Nationale de France. Copyright © 2007 Artist Rights Society (ARS), New York/ADAGP, Paris

Right: Jacques Prévert. Visage-papillon (Butterfly face)

1968. Collage. 13 x 7–1/2 inches. Bibliotèque Nationale de France. Copyright © 2007 Artist Rights Society (ARS), New York/ADAGP, Paris

MARCEL PROUST

Marcel Proust had no artistic skills: his drawings are crude and often little more than scribblings. But he left about a hundred of them, and since they were made by the greatest French author of the twentieth century, they have generated a wealth of scholarly commentary, including books specifically devoted to their analysis.

Sketched in the margins, on blank interleaved pages, on the text itself, and on papers attached to pages with a fold, Proust's drawings were part of his manuscripts, but they do not relate to or interpret the writing. He generally depicted men and women, their faces and full length in frontal view or profile. Scholar Claude Gandelman made a list of the features that characterize the drawings:

> Absence of arms, or arms set into the torso. Hands folded over the genitals, from which sometimes issue linear vectors, arrow, parasols, umbrellas, straps of bags. Absence of legs or legs concealed by dresses or togas. Stiff and inordinately elongated necks. General stiffness of the body and the silhouette. Extreme elongation of the contours. Prominent hips and rumps in the drawings of clothed women. Impassive faces. Caricatural deformation of the noses, often into beak-noses or pecking noses. Deformed masculine skulls. Presence of numerous phalluses in erection, represented in a stylized manner or concealed in the lines of the drawing.

Gandelman interprets the drawings from the perspective of Proust's psychopathology, as well as seeing in them reflections of his system of aesthetics. He concludes that they "are marionettes of the theatre of society." Their stiffness is the "rigidity . . . of dreams . . . also the rigidity of Cubism not yet clearly detached from Art Nouveau. . . . [T]he stiff elongation of the neck may be related to asthma and the respiratory difficulties it involves." Their armlessness suggests "solipsism, the impossibility of embracing another (whatever the sex)." And, he claims, "the absence of members, signifies the literal 'dismemberment' of the homosexual."

Proust was born in Paris in 1871. His Catholic father was an eminent physician, author of medical texts, and professor at the University of Paris Medical School, and his Jewish mother, a beautiful, wealthy child of a distinguished family. Such conflicts as were engendered in Catholic Proust by virtue of his Jewishness appear in the scholarship concerning his treatment of his Jewish characters. He lived through the anti-Semitism of the Dreyfus trials, which he attended, and organized pro-Dreyfus petitions. It was Proust's homosexuality, however, that was the greatest source of conflict for him. He suffered the repulsion of his fellow students when he made advances; at twenty-six he fought a duel when dishonored by a public outing. An unhealthy child, Proust struggled from the age of nine with asthma debilitating enough to keep him out of school for extended periods, and later from such awful nocturnal attacks that, among other destructive products, he took to consuming enough coffee to forego sleeping at night altogether.

The author of *A la recherche du temps perdu*, the seven-volume masterpiece known in English as *Remembrance of Things Past* and *In Search of Lost Time*, Proust was bedridden for ten years in a cork-lined room, which shielded his nerves from noise. He died in Paris in 1922, his final hours devoted to touching up his writing.

Marcel Proust. Faud Pasha

Ink on paper. 7 x 4-1/2 inches. YCAL at The Beineke Rare Book and Manuscript Library, Yale University

Marcel Proust. A l'ombre des jeunes filles en fleurs (In the shade of young girls in flowers)

Ink on paper. From manuscript of *A la recherche du temps perdu*. Copyright © Erich Lessing/Art Resource, New York

ALEXANDER PUSHKIN

Perhaps because Alexander Pushkin is revered as Russia's greatest literary figure, his modest drawings receive inordinate attention. *A. Pushkin: The Complete Collection of Drawings,* was published in 1999 by the Russian Literature Institute of the Russian Academy of Sciences, with a preface that boasts of Russian experts who see in "the expressive outlines of his drawings . . . [the] sharp and powerful strokes of Picasso and Matisse." The scholarly commentary in the same book insists that Pushkin's drawings "are primarily unalienable elements of his manuscripts and, therefore, components of his overall creative endeavour."

Like that of **Proust**, **Kafka**, and **Dostoevsky**, Pushkin's surviving art consists for the most part of drawings done in the margins of his manuscripts. In Pushkin's case, scholars divine in them graphic anticipations of the text that follows. A sketch of a bearded muzhik's profile, for example, is followed by a line about "a bearded village elder." And although the description is changed to just "village elder," and finally to "neighbor," the inference is made that the illustration of some imagined personality inspired the literary process. Similarly, Pushkin, who had virtually no experience of the sea yet wrote lyrically about it, made regular drawings in his manuscripts of boats and sails that presumably influenced his text. A drawing of a galloping knight in armor could have served, say critics, as an "excellent illustration" for Pushkin's poem "There Lived a Poor Knight" done a year later.

Pushkin received his first art instruction at the Lyceum, the palace school established by Alexander I near Saint Petersburg for the children of the nobility. Using drawing manuals of the day, Pushkin was taught to draw the figure and render a landscape following the rules of composition and perspective, and he continued to obey them as an adult, even to maintaining the sample style of representing foliage. It appears that he rarely drew from life, however, preferring to render images, including other works of art, from memory.

The author of *Boris Gudonov* (1831) and *Eugene Onegin* (1832) was born Alexander Sergevich Pushkin in 1799, into an aristocratic Moscow family whose influence in Russian history extended back, on his father's side, six hundred years. His mother was descended from an African slave bought as a gift for Peter the Great. She did not care for her son and would go months without speaking to him. When, at twelve, he was sent away to board, his mother did not visit him for two years. Short, with a dark, homely face, Pushkin was dubbed "monkey" by his classmates. He referred to himself as "an ugly offspring of Negroes, brought up in savage simplicity." Despairing at his prospects of attracting a beautiful girl, he said he thought it possible only if she fell into a "wild frenzy of desire," as he imagined a "young nymph, stealthily and without realizing it, sometimes gazes at a fawn, her cheeks aflame in spite of herself." Those fears proved unfounded as Pushkin fell into a life of dissolution and licentiousness, having multiple affairs, at least two of them with married women.

Finally married, Pushkin was killed in 1837, in a duel in Saint Petersburg, defending the honor of his beautiful wife, who was being openly pursued by one Georges d'Anthés. D'Anthés borrowed a pistol for the duel from the son of the French Ambassador, who would use it to kill **Lermontov**, Pushkin's literary successor, in a duel four years later.

Alexander Pushkin. Three untitled drawings (clockwise from upper left: man on a horse, woman on a bed, man with a pen)

From *After Pushkin: Versions of the Poems of Alexander Sergeevich Pushkin by Contemporary Poets*, Elaine Feinstein, ed. (1999)

KENNETH REXROTH

Poet Kenneth Rexroth asked his friend and publisher James Laughlin in 1953 to help correct what he felt were poor representations of him and his work in some recent essays. Foremost, he wrote:

I would like it mentioned that I was one of the first abstract painters in the USA. That I am now a Romantic painter. That I have exhibited in Chicago, New York, Los Angeles, Santa Monica, and several times in San Francisco, always one man shows. I do not believe in art juries & never submit my paintings to group shows. I have paintings in many collections around the country and abroad.

Rexroth had begun formal art study as an adolescent in Chicago—at Chicago's New School, at the Art Institute, and with local abstract expressionists. During a sojourn in New York City a few years later, he studied at the Art Students League.

At twenty-one, Rexroth fell in love with the artist Andrée Dutcher, whom he soon married. The two were so enmeshed that they jointly created collages and even painted together on single canvases—part figurative, part geometric abstracts—which they signed "KRAR." Traveling throughout the West—on foot, hitchhiking, or riding freight trains—the couple supported themselves, among many other means, by painting furniture and murals.

Rexroth was born in 1905 in South Bend, Indiana. His mother, an early feminist, was also his teacher, instilling in him a love of art, a strong social conscience, and a sense of the value of self-discovery. She was stricken with tuberculosis when he was seven, and died when he was ten, the young boy having previously accompanied her to select her coffin. She might have lived longer had it not been for the strain of Rexroth's father's bankruptcy and descent into alcoholism, and the family's dispossession from their home. Rexroth was left in the care of a senile grandmother who abused him. After his father's death, when Rexroth was thirteen, he was shuffled among relatives until he acquired a permanent home with an aunt in Chicago's tough South Side neighborhood.

At a Hyde Park synagogue that invited teenagers of any faith to participate in cultural activities, Rexroth met Esther Czerny, who introduced him to Jacob Loeb and his salon. There Rexroth met such prominent figures as Clarence Darrow, **Sherwood Anderson**, Carl Sandburg, **Vachel Lindsay**, Eugene V. Debs, and Frank Lloyd Wright. And it was in Chicago that the adolescent Rexroth began writing poetry and studying art. After serving time for a marijuana possession in the early 1920s, he fell in love with his social worker, Lesley Smith, and followed her across the country, ending up in New York. A literary omnivore, Rexroth wrote two volumes of essays on world classics. Besides fourteen volumes of poetry, he published translations of Chinese, Japanese, Greek, Spanish, and French poets.

Rexroth died in 1982 in Montecito, California. Author Bradford Morrow summed him up as an "American original—a polymath, a crank, a solitary singer."

Kenneth Rexroth. Sailor with Hornpipe

1928. Oil on board. 15–1/2 x 19–3/4 inches. Courtesy of the Kenneth Rexroth Trust, Santa Barbara, California. Photo by Jason Brownrigg

Kenneth Rexroth. Self-portrait

1937. Oil on paper. 11–1/2 x 12–3/4 inches. Courtesy of the Kenneth Rexroth Trust, Santa Barbara, California. Photo by Jason Brownrigg

JAMES WHITCOMB RILEY

F ed up with his son's neglect of his schoolwork and concerned that he become self-sufficient, the father of poet James Whitcomb Riley apprenticed him to a local sign painter. As the fourteen-year-old's self-portrait reveals, the young Riley must have demonstrated talent. After learning the fine points of sign-lettering and ornamental painting, he opened his own shop with a shingle reading "Fancy Painter, Delineator and Caricaturist." Conjoining his rhyming and visual talents, Riley made signs of advertising jingles. (One began, "Fine! FINE!! SUPERFINE!!! / Paints and oils and turpentine," and concluded, "Painted by a friend of mine / who boasts the name of Riley.")

He formed a partnership with several other young men, the Graphic Advertisers, and went on the road. They would attract attention in the towns they visited by wearing loud clothes and providing musical entertainment. "One fellow could whistle like a nightingale," wrote a troupe member, "another sang like an angel, and another played the banjo. . . . [Riley] scuffled along with the violin and guitar." Reputedly the first to introduce commercial billboards into the American countryside, they would paint advertising for the local businesses on fence posts and the sides of barns.

Riley was also employed in his early twenties by two charlatan doctors who sold patent medicines—"McCrillus' Tonic Blood Purifier" (see Riley's posters opposite) and Townsend's "Cholera Balm" and "Magic Oil." When Townsend pitched to the crowds from his wagon, Riley's job was to accompany the talk with blackboard illustrations:

> I have two boards about 3 ft. by four, which—during the street concert—I fasten on the sides of the wagon and letter and illustrate during the performance and throughout the lecture. There are dozens in the crowd that stay to watch the work going

on that otherwise would drift from the fold during the dryer portions of the Doctor's harangue.

The beneficent effects of the blood purifier, for example, were depicted by drawing a bedridden woman who would, at the climax of the pitch, be sitting up and looking at her healthy self in a mirror. The bottle of cholera balm was sketched with legs and a smile, driving away the Grim Reaper.

Riley authored more than fifty volumes of small-town, sentimental, humorous poetry that was widely popular in his day—both as adult and children's literature—and earned him admission to the American Academy of Arts and Letters in 1911.

He was born in 1849 in Greenfield, Indiana, and died in Indianapolis in 1916. A poor student who disliked school, he was scorned by his lawyer father who, Riley wrote, "had little use for a boy who could not learn arithmetic." Riley added that his father's low opinion was shared by "half the town" and that "Again and again I was told I would have to be supported by the family." His resentment only deepened as his contemptuous father lost their home and the family was forced to relocate into ever more squalid houses, eventually ending up with his father's unwelcoming mother. Riley's own mother was the comfort of his life, and he blamed his father for her untimely death when he was twenty—in an "inhospitable place" and, lacking money for a coffin, "buried in a shroud." After his careers as a sign painter and huckster, Riley began working at a succession of newspapers in 1873, with a brief interruption for an unsuccessful law clerkship with his father. He credited his time in "the reportorial rooms" (through which the "world with its excellence and follies flows") with any wisdom he acquired.

Above: James Whitcomb Riley. Self-portrait of the poet at fourteen

Dickey manuscript. Courtesy of the Lilly Library, Indiana University, Bloomington, Indiana

James Whitcomb Riley. McCrillus' Tonic Blood Purifier

1873. Original sign. 17 x 12 inches. Courtesy of the Lilly Library, Indiana University, Bloomington, Indiana

James Whitcomb Riley. My Medicine Is McCrillus' Tonic Blood Purifier

Original sign. 17 x 12 inches. Courtesy of the Lilly Library, Indiana University, Bloomington, Indiana

ARTHUR RIMBAUD

Poet Arthur Rimbaud struggled throughout his life to escape his oppressive, religiously obsessed mother and her Christianity—only to call her to his hospital bed when his leg was to be amputated, confess, and receive the last sacraments before dying a few months later. Likewise, the quintessential youth in revolt—whose rejection of any traditional notion of art led him, while visiting a Paris café, to compose a tabletop painting out of his own excrement—seems, from what little has survived, to have produced only such ordinary drawings as are reproduced opposite. His roommate and Louvre-exploring pal, the artist Jean-Louis Forain, quoted Rimbaud as predicting with astonishing prescience that the future of art would

> tear painting away from its old copying habits. . . . The material world will be nothing but a means for evoking aesthetic impressions. Painters will no longer replicate objects. Emotions will be created with lines, colours and patterns taken from the physical world, simplified and tamed.

Yet maybe it was ordinariness that Rimbaud aimed at in his sketches. Eschewing the celebrated art and artists of the museums and galleries, he declaimed, "I liked idiotic pictures, decorative lintels, theatre sets, fairground backdrops, shop-signs, popular prints." And he found it necessary to interpret the figures he caricatured, as he did when he drew old men in a copybook and labeled them "senile, senile, senile."

Rimbaud was born in 1854 in Charleville, France. His father, an army captain, abandoned the family when Rimbaud was six.

His affectionless mother held great ambitions for her son, whom she made memorize hundreds of lines of Latin verse and disciplined with slaps. She enrolled him in a school for priests that became the crucible for Rimbaud's anti-Christian views. Rimbaud excelled academically but was ridiculed by his classmates because his mother dressed him in homemade clothes—all cut from a single blue fabric that she had bought on sale—and because she would not allow him to socialize with them, escorting him to and from school until he was fifteen.

By sixteen, Rimbaud had won a list of academic prizes and had his first poems published. He made three unsuccessful runaway attempts before settling in Paris, where he engaged in a legendary display of teenage acting out. The personal filth that the absinthe-guzzling Rimbaud maintained in order to ensure social outrage was truly prodigious. He didn't bathe or cut his hair for months, supported colonies of lice, and ate out of garbage cans. Yet his entire, influential poetic work was completed before he turned twenty-one. *Une Saison en enfer* (1873; *A Season in Hell*) was inspired by his tempestuous relationship with the poet **Verlaine**. Printed in a five-hundred-copy edition, it was left to languish at the printers, and Rimbaud began a life of world travel. He hiked over the Alps, joined the Dutch foreign legion and deserted in Indonesia, traveled with a French circus, ran guns, and explored Africa, doing construction work and writing journalism in Cairo. At thirty-seven, afflicted with syphilis and cancer of the knee, Rimbaud died after the amputation of his leg in Marseille in 1891.

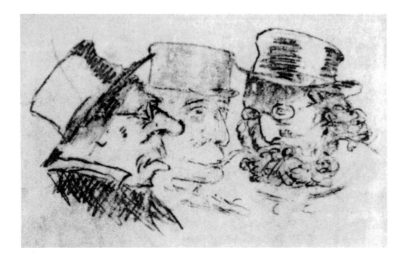

Above: Arthur Rimbaud. Three men's faces

Rimbaud Museum, Ardennes, France

Right: Arthur Rimbaud. Man with cane and top hat

Rimbaud Museum, Ardennes, France

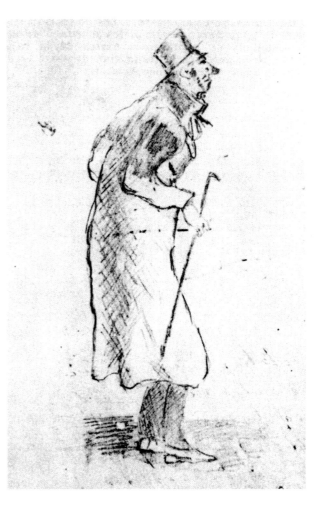

ISAAC ROSENBERG

When the poet Isaac Rosenberg was fourteen and living with his immigrant Jewish parents in a London slum, and it was time for him to leave school and get a job, he proposed the financially unthinkable career of artist. His parents had him bring his drawings for appraisal to John Henry Amschewitz, the son of an acquaintance, who was studying at the Royal Academy. "I advised him as best I could," Amschewitz wrote, "and awkwardly purchased a drawing with a poem attached for half a crown whereat he burst into tears and rushed from my presence."

Because Rosenberg had talent and needed a trade, it was decided he should learn platemaking and engraving from an art publisher. Notwithstanding the **Blake**-like apprenticeship and Rosenberg's interest in poetry and art, he came to detest the work:

> It is horrible to think that all these hours, when my days are full of vigour and my hands and soul craving for self-expression, I am bound, chained to this fiendish mangling-machine, without hope and almost desire of deliverance, and the days of youth go by.

Through a chance encounter at the National Gallery, Rosenberg acquired three Jewish women as benefactors and was able to enroll at the Slade School of Art in 1911. There he set forth his standards for good painting, strikingly like those for good writing:

> Can I read it? Is it clear, concise, definite? It cannot be too harsh for me. The lines must cut into my consciousness, the waves of life must be disturbed, sharp, and unhesitating. It is nature's consent, her agreement that what we can wrest from her we keep. Truth, structural veracity, clearness of thought and utterance, the intelligent understanding of what is essential.

Following his art studies, Rosenberg suffered a crisis of confidence, writing, "Art is not a plaything, it is blood and tears, it must grow up with one; and I believe I have begun too late." Nonetheless, he entered the Prix de Rome competition in 1913 and exhibited in London's Imperial Institute Galleries. Today, his art is held in the collections of Britain's Tate Gallery, the Imperial War Museum, and the National Portrait Gallery, as well as in numerous private collections. Reproductions appear in *The Collected Works of Isaac Rosenberg: Poetry, Prose, Letters, Paintings, and Drawings* (1979).

Rosenberg was born in Bristol, England, in 1890 to Lithuanian/Russian Jews. His father was a peddler and the family lived in poverty. In 1912, while studying at Slade, Rosenberg submitted to literary reviews and published privately his first collection, *Night and Day*. Editor Edward Marsh became Rosenberg's patron in 1913, buying his art and introducing him to artists and writers, including Ezra Pound. Small and in poor health, with a chronic cough, Rosenberg enlisted in the army in 1915. In the months prior he was able to finance the publication of *Youth,* a second small collection of poems, by selling paintings. He endured onslaughts of anti-Semitism in the army, as well as humiliation for his frailty, but was able to provide some income for his family. The poetry he sent home from the trenches has been favorably compared to the work of the war poets Wilfred Owen and Rupert Brooke.

Rosenberg was twenty-seven when he was killed while on patrol near Arras, France, in 1918.

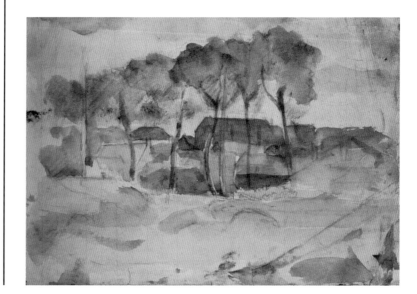

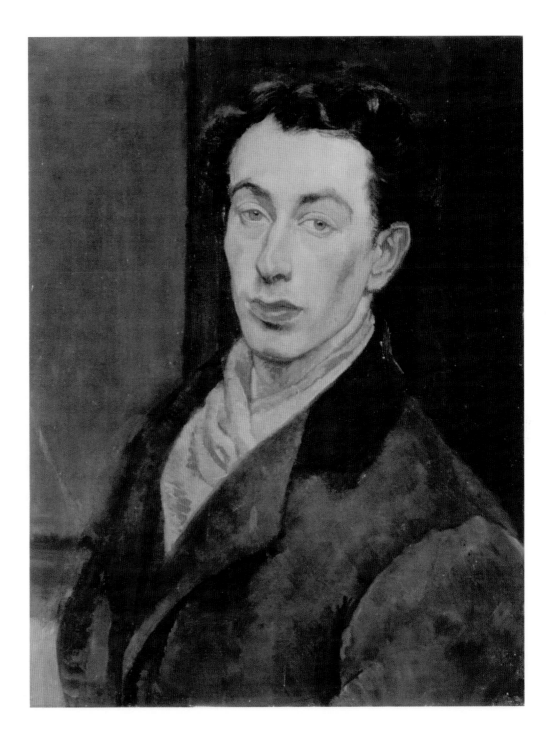

Right: Isaac Rosenberg. Self-portrait

1911. Oil on canvas. 19–1/2 x 15–1/4 inches. Tate Gallery, London/Art Resource, New York

Opposite: Isaac Rosenberg. Untitled

Watercolor. 6–3/4 x 5 inches. Berg Collection of English and American Literature, The New York Public Library, Astor, Lenox and Tilden Foundations

DANTE GABRIEL ROSSETTI

The poet and artist Dante Gabriel Rossetti once proclaimed to his friend Edward Burne-Jones, "If any man has any poetry in him he should paint it, for it has all been said and written, and they have hardly begun to paint it." Nonetheless, Rossetti considered himself more poet than artist.

Rossetti made poems for pictures and pictures to accompany poems. Still, he rejected the idea of a poem as no more than a careful description that could give the effect of a painting:

> I should particularly hope it might be thought . . . that my poems are in no way the result of a painter's tendencies—and indeed no poetry could be freer than mine from the trick of what is called "word painting."

The connection between the two mediums, Rossetti believed, lay in the common vision of poet and artist—when "a poet or a painter has caught the music . . . snatches of an enchanted harmony, and the glimpses of Eden."

Poems about pictures were never to be "merely picturesque" but to provide clarification and insight. Each was to maintain its separate form:

> Picture and poem bear the same relationship to each other as beauty does in man and woman: the point of meeting where the two are most identical is the supreme perfection.

Rejecting the then-fashionable, dark, artificial painting style that claimed its roots in Raphael, in 1848 Rossetti founded the Pre-Raphaelite Brotherhood. Using bright colors and selecting subjects from biblical, Shakespearean, and medieval sources, including the

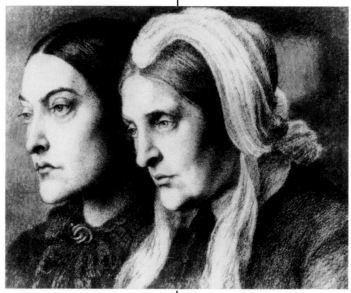

Arthurian legend, the group produced beautiful, morally serious works they signed PRB, and inspired others to continue in their style.

Rossetti's work possessed a distinctly erotic element that took inspiration from the women who modeled for him. His wife was the first whose beauty obsessed him, and when she died young, his mistress became his muse. Later, Jane Burden, **William Morris**'s wife and model, became Rossetti's model and lover. The series of paintings he did of her is among his best work. *La Pia*, opposite, is one of that series.

Gabriel Charles Dante Rossetti was born in 1828 in London, his father an Italian political refugee and Dante scholar. Because Rossetti was always drawing as a child, the family assumed he would become an artist and earn a living that would assist them. Since tuition was free, he was pressured by his father to enter the Royal Academy Schools. Years later, as a successful artist, Rossetti would insist that he was a poet, that it was "my poetic tendencies that chiefly give value to my pictures," and that "painting being—what poetry is not—a livelihood—I have put my poetry chiefly in that form." He added more bitterly, "I have often said that to be an artist is just the same thing as to be a whore."

After living for years with a depression that settled on him after the death of his young wife, a scathing attack on his poetic style, and his subsequent addiction to the sedative chloral hydrate, Rossetti died in 1882 in Birchington, England.

Dante Gabriel Rossetti. Crayon drawing of Christina Rossetti and mother

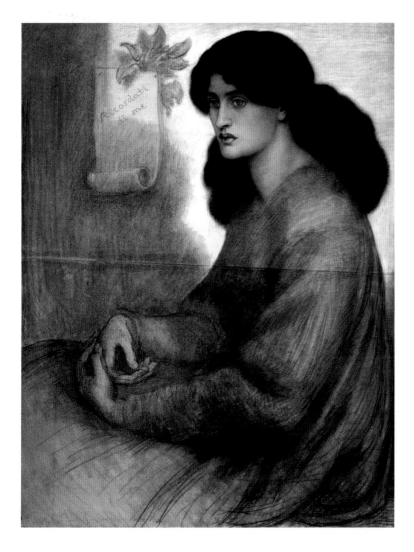

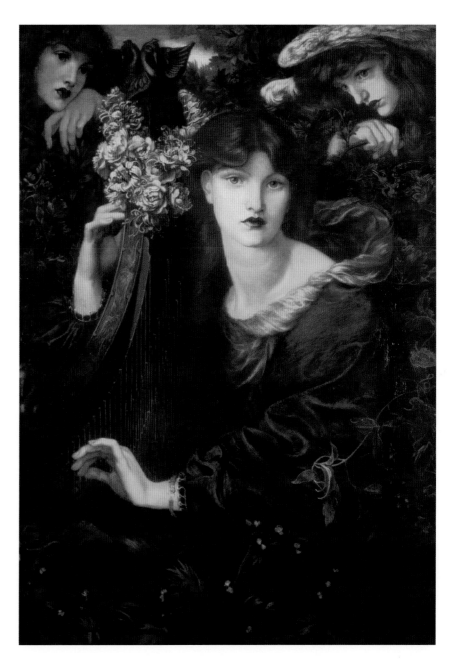

Above: Dante Gabriel Rossetti. La Pia

C. 1870–75. Pastel on paper. 38 x 30 inches. Harry Ransom Humanities Research Center, University of Texas at Austin

Right: Dante Gabriel Rossetti. La Ghirlandata

1873. Oil on canvas. 46–1/4 x 35–1/4 inches. London, Guildhall Art Gallery

JOHN RUSKIN

John Ruskin's mother was an evangelical Christian whose beliefs were inculcated in her son and informed all his thinking, especially his conflation of the moral and the spiritual with art and architecture—until 1859, when Charles Darwin's *The Origin of Species* brought about a terminal disaffection with his faith. Ruskin's father, a wealthy wine merchant and amateur painter, started his son drawing and, when the boy was twelve, arranged for private, formal training from some of the leading artists of his day. In 1834 Ruskin studied with Copley Fielding, president of the Society of Painters in Water-Colours, but he later repudiated Fielding's work as aiming for the picturesque at the sacrifice of truth. Samuel Prout taught Ruskin his outlining technique which, after study with J. D. Harding from 1841 to 1844, Ruskin also rejected as lacking expression, in favor of Harding's emphasis on texture and tonal values. The influence of Harding is apparent in the 1843 landscape opposite.

Ruskin began illustrating his notebooks as a boy, and he never ceased the practice, his illustrations an integral and essential part of his writings on painting, drawing, and architecture. Thus, most of Ruskin's drawings and paintings, like the drawing of the Ducal Palace reproduced here, served a didactic function. Ruskin's goal as a proselytizer of art among the general populace was similarly pragmatic: "My efforts are directed not to making a carpenter an artist, but to making him happier as a carpenter." People of Ruskin's era relied on their own hands to capture the landscapes they wanted to remember, and his books on how to draw were widely popular. It was Ruskin's arguments for a spiritually infused, socialized art that inspired **William Morris** and the Arts and Crafts movement.

The scores of books Ruskin produced include the foremost art and architecture criticism of his century, poetry, for which he received the Newdigate Prize in 1839, the enduring children's book *The King of the Golden River* (1851), essays on social theory which inspired Shaw and Gandhi, and his unfinished autobiography, *Praeterita* (1885–89), written during bouts of madness. In addition to his paintings and drawings, he sculpted and made pottery. In the words of Victorian scholar Valentine Cunningham,

> It was Ruskin's great achievement to teach a whole nation to see and cherish buildings, paintings, clouds, water, rocks, vegetation, and to put a low value on "the insanity of avarice," the money-greed of Victorian capitalism.

Born in 1819 in London, Ruskin was an only child, raised in isolation. He attended Christ Church, Oxford, where he was an uninterested student with a social life burdened by his mother's living close by. *The King of the Golden River* was written for the nine-year-old daughter of family friends, Euphemia (Effie) Gray, whom he married when she was seventeen. Effie had their unconsummated marriage annulled five years later and reported her husband's sexual phobias to a circle of acquaintances.

Ruskin seems to have been attracted to young girls: he spent time with **Kate Greenaway** and **Lewis Carroll**'s little models (convincing Alice Liddell's father to make her his drawing student). The love of his life was Rose La Touche, another drawing student, to whom he proposed on her eighteenth birthday, when he was thirty years her senior. Her rejection became a lifetime nemesis, incorporated into the dementia that appeared first in 1870 and plagued the last part of Ruskin's life. He died in Lancashire in 1900.

Left: John Ruskin. Exterior of the Ducal Palace, Venice

1845 or 1852. 14–1/4 x 19–3/4 inches. Pencil and wash on paper. Ashmolean Museum, University of Oxford, UK. AM0110740 Bridgeman Art Library

Right: John Ruskin. Study of rocks and ferns in a woods at Crossmount, Perthshire

1847. Watercolor and pen on paper. 12–3/4 x 18–3/4 inches. Abbot Hall Art Gallery, Kendal, Cumbria, UK. ABT143902 Bridgeman Art Library

PETER SACKS

*I*t was watching a lunar eclipse that led poet and Harvard literature professor Peter Sacks out of words and into paint: "As that gradual diminution and then re-emergence of light occurred in complete silence, it was as if the materiality of what I was witnessing was more palpable because of the silence." He explained to me in a 2002 interview that he wanted "to be there as if I weren't there." He realized that "speech is a way of presenting oneself through voice, immediately," so

> by not speaking I think one can entertain the imagining of what it might be like to not be there. So somehow I came back and just started doing the most minute little sequence of sketches of this experience because I wanted to capture duration. And because the visual world doesn't score its tempo, you stand in front of a painting and you could stand there for three years if you wanted to or three minutes. There's nothing in the painting saying this is a five-minute experience.

Sacks started making small works, ink drawings and pastels in notebooks and sketchbooks, but within a few years he was painting museum-scale canvases in oils and acrylics that are now sold through Paris's Galerie Piece Unique. The breakthrough, he says, occurred when he had made a simple rectangle and was painting within its borders:

> What happened was that I came in one evening I think and added two tabs on the left-hand side of this rectangle and

realized that I had created what looked liked hinges, so that the rectangle just by virtue of that abstract addition became also now a door. . . . And then the whole notion of what a door was, opened, literally like a door. Then the question was, well, are you looking at the surface of a door, or are you looking at a doorway, or what does this door open into?

Exploring the answer to that question, he began to produce

> door after door after door and I did about thirty-three doors and they're all thirty-six by sixty inches so they are pretty isomorphic. . . . One of the things that I was doing was finding that this was a way to allow parts of my life to get into the work that hadn't been given the same kind of expression in the poems.

Sacks was born in 1950 in Port Elizabeth, South Africa. Like his physician father, he planned a medical career, but a "mind-opening" visit to racially torn Detroit in the 1960s resulted in his returning home to study political science and philosophy and becoming involved in the antiapartheid movement. He fell in love with poetry while a scholarship student at Princeton. After graduating in 1973, Sacks was a Rhodes Scholar at Oxford. He received his M.Phil. there in 1976 and a Ph.D. from Yale in 1980. Sacks is married to poet Jorie Graham. His books of poetry include *In These Mountains* (1986), *Promised Lands* (1990), *Natal Command* (1997), *O Wheel* (2000), and *Necessity* (2002).

Peter Sacks. Africa

2002. Oil on canvas. 60 x 180 inches. Collection of the artist

Peter Sacks. Des Zeugnis (The Witnesses)

2002–2003. Triptych. Oil and acrylic on canvas. 51–1/8 x 112–1/4 inches. Collection of the artist. Courtesy Galerie Pièce Unique, Paris

ANTOINE DE SAINT-EXUPÉRY

Antoine de Saint-Exupéry wrote his most famous work, the allegorical *Le Petit Prince* (1943; *The Little Prince*), which he also illustrated, during a sojourn in America. According to biographer Curtis Cate, the idea for the book came from his publisher over lunch at a New York restaurant after he asked what Saint-Exupéry was drawing on the tablecloth: "Oh nothing much," explained Saint-Exupéry, "just a little fellow I carry around in my heart."

Saint-Exupéry began the project by buying colored pencils and making some preliminary drawings. He then asked Bernard Lamotte, the illustrator of Saint-Exupéry's novel *Pilote de Guerre* (1942; *Flight to Arras*) for help. According to Cate,

> Lamotte, responded with a few sample sketches which left Saint-Ex dissatisfied: they were insufficiently naïve and dream-like for the effect he wanted to convey. As the days passed and he became more absorbed by his tale, he began to realize that he would have to illustrate as well as write it himself. He continued to solicit his friend's advice, but his own ideas had now begun to jell, and one day, after a sleepless night spent painting a baobab tree uprooting a tiny planet, he refused to make the slightest alteration.
>
> "You should straighten it up a bit here, darken it a bit there," began Lamotte. "Impossible, mon vieux," answered Saint-Ex. "If this were a written text, all right—I would agree to modify it, for after all I'm a writer. That's my job. But I can't do better than this drawing. It's quite simply a miracle. . . ." And that was that.

Not really. The Morgan Library displayed, in 2000, Saint-Exupéry's recently unearthed first efforts alongside the finished illustrations for *The Little Prince*, revealing the extraordinary amount of revision that had gone into the creation of seemingly effortless drawing. It was an unsurprising truth about the man who admitted that he often rewrote a phrase twenty-five or thirty times and who declared it was a writer's responsibility to exercise his craft "as if it were essential to the earth's rotation."

Revered for his heroism as much as his writing, Saint-Exupéry was born in Lyon, France, in 1900, to a count who had fallen on hard times and who died when his son was three. A poor student, Saint-Exupéry entered the military and trained as a pilot. Thereafter, he worked to establish commercial airmail routes in various parts of the world. His novels and memoirs, inspired by the perils of early aviation, exalt heroic action. They include *Courriers-sud* (1929; *Southern Mail*), *Vol de nuit* (1931; *Night Flight*), and *Terre des hommes* (1939; *Wind, Sand and Stars*). Despite his age, and serious disabilities suffered in plane crashes, Saint-Exupéry became a reconnaissance pilot in World War II, first for the French and later for American forces. He disappeared on a reconnaissance flight over the Mediterranean in 1944, his plane discovered sixty years later. There was no indication he had been shot down. Although the cause of the crash may have been technical failure, Saint-Exupéry's last words, contained in a letter left in his barracks room on the day he disappeared, suggest the possibility of suicide. Insisting that there was "only one problem in the whole world"—to restore spiritual meaning to people's lives—he concluded:

> It is impossible to survive on refrigerators, politics, balance sheets, and crossword puzzles, you see! It is impossible! It is impossible to live without poetry and color and love.

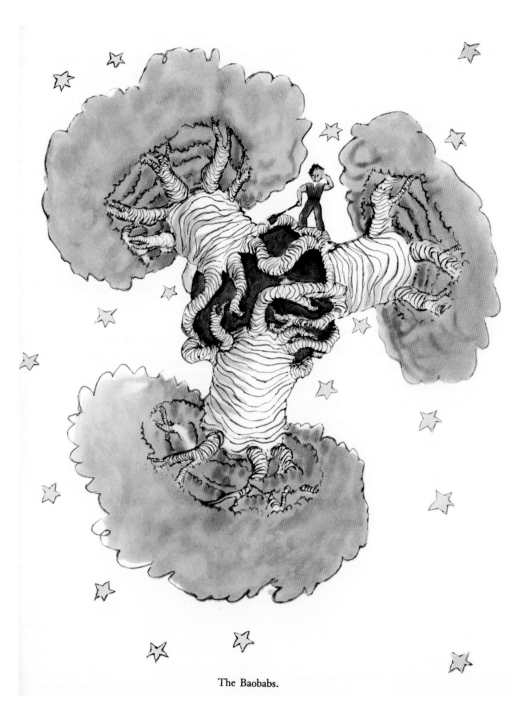

Antoine de Saint-Exupéry.
The Baobabs

1943. Watercolor. Illustration from *Le Petit Prince* by Antoine de Saint-Exupéry, Harcourt, Inc. Copyright © Editions Gallimard

The Baobabs.

GEORGE SAND

French novelist George Sand was a conscientious art student who began by doing copies in the styles of the masters, especially Goya. A feminist before anyone conceived of the term, she was influenced by her friend the painter Eugène Delacroix—and to an extent by one of her lovers, the playwright and sometime artist **Alfred de Musset**—but her work was first and foremost the product of her unique vision. Many of her paintings depicted pastoral scenes she had conjured during childhood:

> There were woods, prairies, rivers, towns with strange gigantic architecture, such as I still see often in a daydream; enchanted palaces with gardens the like of which do not exist, with thousands of birds.

When an early marriage ended, Sand was obliged to support herself. With income from her writing unreliable, it was her art that bought her financial independence. She did commissioned portraits, and paintings on unvarnished cigar boxes known as boîtes de Spa, for the Belgian seaside resort where that decorative art originated. These, however, were only a fraction of her visual output. The range of her expressions was astounding. Besides portraits and traditional landscapes, she depicted crystalline forms in stones and geodes as rugged mountains she called "dendritage," a fantastic geography aimed at reflecting nature's hidden structures. Some of her paintings seemed to presage the Impressionists several decades in advance.

Contrasting writing and art, she wrote:

> Painters who understand the real are happy (or fortunate) poets. They grasp everything at once, the whole and the details, and produce in five minutes a summary that the writer would say in many pages, that the naturalist can only penetrate after many days of observation and fatigue.
>
> I was totally surprised and delighted to find in painting a joy as great as the one I had tasted in music. . . . I contemplated, I was overtaken, I was transported to a new world. . . . It is in beautiful painting that one may feel what life is.

And in an 1874 letter to her friend Flaubert, she described the role that painting played in her literary productions:

> The ease [of writing] increases with age, and thus I do not allow myself to work at this more than two or three months of each year. I would become a machine and I believe that my products would lack the necessary conscience. Indeed I only write two or three hours per day, and the interior work is done while I scribble away at my watercolors.

Born Amantine-Aurore-Lucile Dupin in Paris in 1804, Sand was the illegitimate child of an officer father and milliner mother. Before she died in 1876, she had written one hundred volumes, in every literary genre, and had been the scandalous, cigar-smoking, cross-dressing lover of many illustrious men, including Musset and Chopin. "Morally," Balzac remarked of her, "she is a man of twenty."

Left: George Sand. Landscape with a Lake

Gouache and watercolor on paper. 60–1/2 x 92–1/2 inches. Louvre, Paris.
Bridgeman Art Library

Right: George Sand. The Black Town

Watercolor on paper. 44–7/8 x 59 inches. Paris, private collection.
Bridgeman Art Library

WILLIAM SANSOM

Author William Sansom grew up surrounded by his father's oils. An "accomplished copyist," his father hung the walls of their home with his renditions of masterpieces from the Tate. Sansom, a jazz pianist who wrote cabaret music (and had a waltz accepted by the Folies Bergère), claimed that he spent his early years "studying Bix Beiderbecke and Co. under the eyes of 'The Laughing Cavalier.'"

Raised middle-class, and pushed by his father into banking, Sansom acknowledged he had "no *practical* reason to leave a comfortable Philistine entourage for a completely unknown world of what one may call Art." But, at twenty-three, he deserted banking for an advertising agency where a coworker, poet Norman Cameron, introduced him to the works of great writers and, in a life-altering moment, to Surrealist art.

Sansom saw Surrealist paintings as "at last blowing the old, old story sky-high!"

> I was immediately addicted forever. I was under no delusion that they painted the subconscious: theirs was a plain statement of reality: the umbrella and the sewing machine on the dissecting table was no strange association, what it did was dissociate these objects, which you then saw clearly in their own right for the first time.

As for his own art, little survives. Sansom drew regularly in sketchbooks—examples are reproduced here—and his illustrations for two children's books, *The Get-well-quick Colouring Book* and

Who's Zoo, were exhibited at the 1971 Arts Club of Chicago show *A Second Talent: An Exhibition of Drawings and Painting by Writers.*

Sansom was born in London in 1912. His father was a naval architect who took his son on trips to Europe and encouraged him to learn languages. Although Sansom's childhood was happy on the surface, his experience of it was not. He described himself as "always [having] been shy and self-conscious." At seventeen, he lost control of his voice:

> For about three years, I could either shout or speak in a whisper. . . . This embarrassment was complicated by a fairly fictitious fear of a poor physique—narrow-chested, buck-toothed. . . . Even today with these qualms somewhat settled, disguised by beard and embonpoint, I feel more like a bag of artificial gestures moving about than a body.

Past the age of enlistment when World War II broke out, Sansom joined the British National Fire Service. His first published story, when he was twenty-nine, came out of the experience of fighting bombing fires. A short story writer, he also wrote novels, screenplays, and travel books, leaving two dozen volumes at the time of his death in London in 1976.

Praised for its great attention to detail, Sansom's writing reflects his artist's vision, love of Surrealism, and childhood wounds. Speaking about a childhood bout with scarlet fever, he wrote, "I became . . . a snail—great eyes peering out on stalks but ramming back into my shell at any sign of interference. I have remained a snail ever since."

William Sansom. Fork supper

From the second volume of Sansom's sketchbooks. Berg Collection of English and American Literature,
The New York Public Library, Astor, Lenox and Tilden Foundations

William Sansom. Man with top hat

From the second volume of Sansom's sketchbooks. Berg Collection of English and American Literature,
The New York Public Library, Astor, Lenox and Tilden Foundations

WILLIAM SAROYAN

Putting words to pictures may seem a funny business," author William Saroyan wrote,

but that is precisely what man has done from the beginning—that is how he made everything he did in fact make, and how he came to find, measure, and try to understand everything else. New pictures impel new words, new variation of words. One picture is worth a thousand words. Yes, but only if you look at the picture and say or think the thousand words.

To a request from the Arts Club of Chicago curator Rue Winterbotham Shaw for a sample of his art for its 1971 show of writer-art, Saroyan replied:

I have never had an exhibition of drawings or paintings, although for longer than 40 years I have made drawings and paintings. A book entitled *Not Dying*, published four or five or six years ago by Harcourt, Brace has a line drawing at the top of each of its two dozen or so chapters. Nobody noticed them officially, although a number of people spoke to me about them: a ballet choreographer in Paris said he studied them for ideas. I myself regard these drawings as (also) hieroglyphics, maps, blueprints, divisions of space and mass, but ten times as many other things than I know. But I do learn from both making these drawings, and from beholding them—ten or more years later, whereupon I do actually read each drawing. Words from ten years ago do not tell me the same order of thing that the drawings tell me. It has to do with the changes passing time makes that we have no way of otherwise noticing.

In a moment I shall make a drawing or two and send them along with this note—by comparing them with the drawings sent to Gertrude Stein you will gather how informative I find all of the drawings, which I took to dating and placing a few years after I noticed that I was using the drawings and paintings for ideas and for methods and techniques in writing.

"I hope your show is fun for everybody," he concluded, "because if it isn't, we've not got the thing quite right."

Saroyan did not get his solo exhibition until twenty-one years after his death, when California's Fresno Art Museum curated a show from the extensive collection of Saroyan art and literary works held by Stanford University. His enormous literary output was inspired by his practice of drawing. His musician friend Artie Shaw described journals Saroyan showed him containing drawings the author said manifested the chance nature of creation and suggested a play in which would be projected "the imagined interiors of such things as fire, water, clouds, rocks, grapes, figs, roses, fish eyes."

The prolific short story writer and Pulitzer Prize-winning playwright was born in 1908 to Armenian immigrants in Fresno, and he died there in 1981. When Saroyan was three, his father died, and his mother put Saroyan and his three siblings in an orphanage for four years while she went off to San Francisco to work as a maid. An indifferent student, Saroyan quit school at fifteen to help support the family. His career—launched with his first story collection, *The Daring Young Man on the Flying Trapeze* (1934)—skyrocketed after he won an Oscar for the screenplay of his 1943 autobiographical novel *The Human Comedy*. At one time he had as many as four plays running simultaneously, although his dramas fell into obscurity in the decades before his death. His reputation as an artist, however, continues to grow, and examples of his work are now in the permanent collections of, among other institutions, Yale University, the Boston Museum of Fine Arts, and the Birmingham Museum of Art.

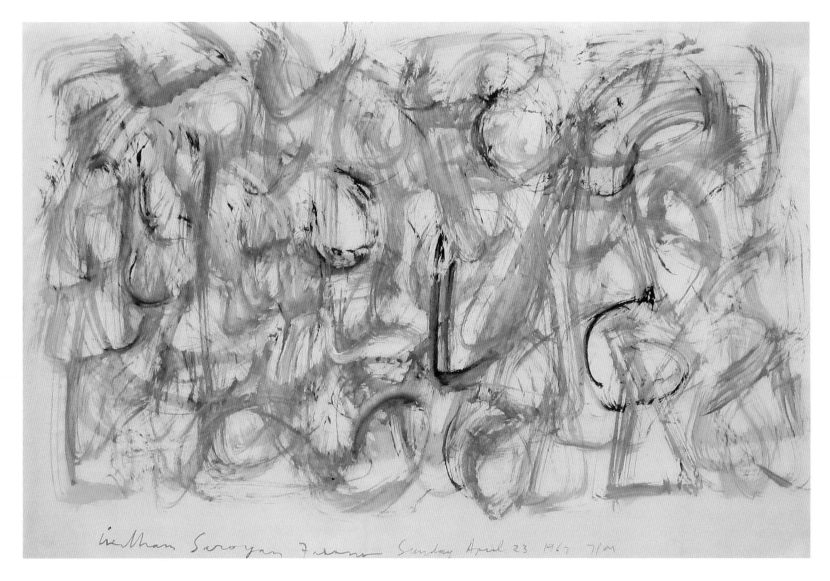

william Saroyan Fresno Sunday April 23 1967 7/M

Above: William Saroyan. Fresno, Sunday, April 23, 1967

Watercolor on paper. 29 x 40 inches. Courtesy of the Anita Shapolsky Gallery, New York City. William Saroyan Foundation. Photo by Petra Valentova

Opposite: William Saroyan. Circus

C. 1934. Graphite on paper. 11 x 8–1/2 inches. YCAL at the Beineke Rare Book and Manuscript Library, Yale University, William Saroyan Foundation

BRUNO SCHULZ

"The beginnings of my graphic work," wrote Bruno Schulz, "are lost in mythological twilight":

> Before I could even talk, I was already covering every scrap of paper and the margins of newspapers with scribbles that attracted the attention of those around me. At first they were all horses and wagons. . . . I don't know how we manage to acquire certain images in childhood that carry decisive meanings for us. They function like those threads in the solution around which the significance of the world crystallizes for us. . . . There are texts that are marked out, made ready for us somehow, lying in wait for us at the very entrance to life.

Schulz wanted to write but, having to earn a living, procured a position as art teacher at an all-boys high school—a job he hated. Schulz's art is highly literary:

> If I were asked, whether the same thread recurs in my drawings as in my prose, I would answer in the affirmative. The reality is the same; only the frames are different. Here material and technique operate as the criteria of selection. A drawing sets narrower limits by its material than prose does. That is why I feel I have expressed myself more fully in my writing.

Schulz's prose is highly visual, and his drawings tell stories, even when not illustrations of his works. Many, like the one opposite, are sado-masochistic, depicting scenes of groveling men expressing fetishistic adoration for feet and legs. The avant-garde playwright and artist **Witkacy** called Schulz a "star of the first magnitude," placing him in the company of his revered "demonologists," including Goya, Munch, and Beardsley, whose art addressed the "evil itself that lies at the base of the human soul."

Schulz made oil paintings that received gallery exhibitions, and his engravings were held in private collections in Warsaw—until they were obliterated with their Jewish owners during the uprising, and in other smaller towns where they were lost through theft or destruction. We know what we do of Schulz only because Jerzy Ficowsky, a Polish poet, has devoted himself to resurrecting the fragments of his life.

"One of the most remarkable writers who ever lived," as Isaac Bashevis Singer adjudged, Schulz was born in 1892 in Drogobycz, (Ukraine), which was Austrian when he was born and Polish when he died. A shy man who so revered life that he tried to revive dying flies with sugar, he was murdered on the street in 1942 by a German SS officer who identified Schulz as a Jew being protected by another SS officer he didn't like. Schulz was only one of one hundred fifty Jews killed that day.

The officer who had been protecting Schulz bragged about the Jewish artist-slave he kept alive on a slice of bread and a bowl of soup while he painted murals for his son's room. The murals, discovered in 2001, were removed by Israeli agents for the Holocaust museum Yad Vashem, to the protests of Poland, esteeming its once disposable Jew as one of its greatest writers.

Like Kafka, whose novel *The Trial* he translated into Polish in 1936, Schulz presents the everyday as bizarre, alien, and fantastic. His prose has been compared to **Proust**, Joyce, and Virginia Woolf. He was awarded the Golden Laurel of the Polish Academy of Literature in 1938 for *Sklepy Cynamonowe* (1934; *Cinnamon Shops*), published in English as *The Street of Crocodiles*. He was also the author and illustrator of *Sanatorium Pod Klepsydra* (1937; *Sanatorium under the Sign of the Hourglass*). His legendary unfinished novel, *The Messiah*, has never been found. He is buried in an unmarked grave.

Bruno Schulz. The Infanta and
Her Dwarfs

Cliché-verre. 18 x 13 inches. National
Museum, Warsaw

ANNE SEXTON

"I'm an artist at heart," said poet Anne Sexton, in a 1965 interview with Patricia Marx, "and I've found my own form, which I think is poetry." She once made even more explicit her view that word and image derive from a common artistic urge, saying that she wrote poetry with the same impulse that made people try to catch a scene in a painting or photo:

> When I was eighteen or nineteen, I wrote for half a year. One time, I tried painting, but I wasn't good. . . . I like to capture an instant. A picture is a one-second thing—it's a fragile moment in time. I try to do it with words.

Sexton continued to paint, although her work was created for personal expression rather than for public consumption. One is not surprised to learn that the obliterating self-portrait reproduced here is of a stunningly beautiful sometime model who suffered a life of depression, alcohol and pill addictions, repeated attempts to kill herself, and intermittent institutionalizations until her suicide, at forty-five, in 1974 in Weston, Massachusetts.

"My fans think I got well, but I didn't: I just became a poet," Sexton said. She had made her mental illness and therapy the subject of her writing, but she rejected the notion that the genius of poets and artists, including her own, was a product of, or an aligned force with, disease:

> Well, their genius is more important than their disease. I think there are so many people who are mentally disturbed who are not writers, or artists, or painters or whatever, that I don't think genius and insanity grow in the same bed. I think the artist must have a heightened awareness. It is only seldom this sprouts from mental illness alone.

Sexton was born Anne Gray Harvey in 1928 in Newton, Massachusetts, into an upper-middle-class family. Her father was an alcoholic, and may have sexually abused her. Sexton perceived her parents as hostile, and she feared abandonment. She couldn't adjust to school, and her parents rejected recommendations for her counseling. After being sent to boarding school, then finishing school, Sexton eloped, although engaged to another. She became a model while her husband served in Korea, and a succession of adulteries on her part led her into therapy. The birth of her second child and the death of a beloved great-aunt resulted in depression. Despite treatment, the depression worsened, and she was institutionalized; her children, whom she had abused, were taken from her.

Admission into Robert Lowell's writing seminar in the summer of 1959 and his subsequent patronage launched Sexton's career. (**Sylvia Plath** was also in the seminar, and Lowell encouraged a friendship between the two women.) She was a critically praised poet with wide popularity, giving readings that were crafted entertainments—sometimes backed by a rock band. She received the 1967 Pulitzer Prize for *Live or Die* (1966) and National Book Award nominations for her first collection, *To Bedlam and Part Way Back* (1960), and *All My Pretty Ones* (1962). *The Awful Rowing Toward God* (1975) was published posthumously.

Anne Sexton. Self-portrait

Oil on canvas board. 19–5/8 x 15–7/8
inches. Harry Ransom Humanities
Research Center Art Collection,
University of Texas at Austin and
with the kind permission of the
estate of Anne Sexton

GEORGE BERNARD SHAW

"I never felt inclined to write," said George Bernard Shaw, "any more than I ever felt inclined to breathe. I felt inclined to draw: Michelangelo was my boyish ideal." Shaw's only close school friend, Edward McNulty, described his initial overtures to the boy sitting in the desk in front of him. After pulling Shaw's hair and kicking him in the ankles, McNulty drew a caricature of him and passed it over:

> He took it, and remained quiet for some time with his head bent. I began to wonder what he was doing, when he handed me back the paper over his shoulder: then I saw that he had drawn on the other side a caricature of myself.

The two boys sketched and McNulty described Shaw as more inclined to figure-drawing than landscape; Shaw tried unsuccessfully to impress McNulty into service as a nude model. Shaw pursued his self-education in art history and his efforts in the studio simultaneously. "[T]here is in Dublin a modest National Gallery, with the usual collection of casts from the antique," he wrote. "Here, boys are permitted to prowl. I prowled." He was also able to

> borrow a volume of Duchesne's outlines of the old masters— twenty volumes of them, I think. When I had any money— which hardly ever happened, I bought volumes of the Bohn translation of Vasari, and read them with immense interest. Result, at fifteen, I knew enough about a considerable number of Italian and Flemish painters to recognize their work at sight.

Claiming he could not draw, Shaw gave up art as a career, while insisting to McNulty that it was because his people could not afford to pay for art school. Shaw nonetheless continued to draw for practical purposes, as seen here in his sketch of the costuming for his play *Saint Joan,* or for fun, as in his light-hearted self-caricature as Don Quixote.

"Dublin is my chief birthplace," Shaw replied to a biographical questionnaire. The year was 1856—with Shaw adding, "hearsay only: I do not remember the occasion." He grew up in genteel poverty, hated school, and dropped out at fifteen. His mother was one of the best singers in Dublin, but she failed to provide her son with any musical education. When he was sixteen, she took his two sisters, and left him and his father for London. Shaw taught himself music, became a capable pianist—"[B]efore I was fifteen, I knew at least one important work by Handel, Mozart, Beethoven, Mendelssohn, Rossini, Bellini, Donizetti, Verdi and Gounod right through from cover to cover"—and his first public attention came as music critic for the London *Star* and then *The World.* Major recognition came as theater critic for the *Saturday Review,* before which he spent ten years struggling to get work accepted by a magazine and wrote five novels that were rejected for publication.

Eventually he turned to drama, achieving renown for plays addressing social, moral, and political issues. For Shaw, that was the aim of creative effort: "I make no distinction between literature and art. I say that all art at the fountainhead is didactic, and that nothing can produce art except the necessity of being didactic."

Shaw won the Nobel Prize for Literature in 1925. He died in 1950 in Ayot St. Lawrence, Hertfordshire, England.

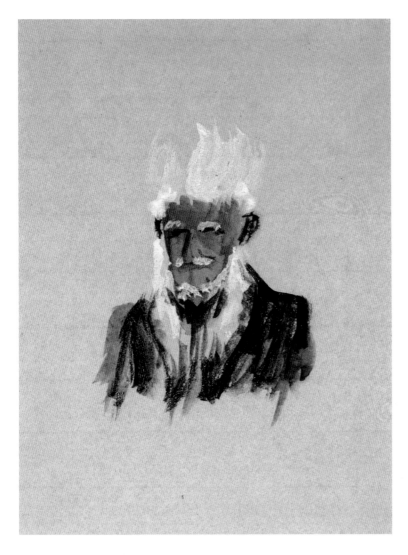

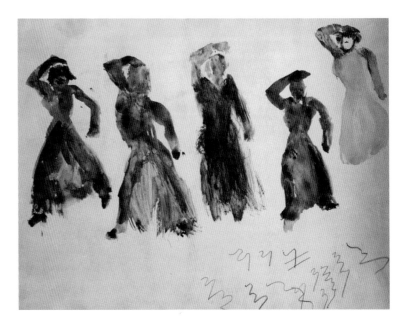

Above: George Bernard Shaw. Drawing for the costuming of *Saint Joan*

Watercolor. Berg Collection of English and American Literature, the New York Public Library, Astor, Lenox and Tilden Foundations, the Society of Authors, on behalf of the Bernard Shaw estate

Above: George Bernard Shaw. Caricature

Watercolor/drawing. Berg Collection of English and American Literature, the New York Public Library, Astor, Lenox and Tilden Foundations, the Society of Authors, on behalf of the Bernard Shaw estate

Right: George Bernard Shaw. Self-Portrait as Don Quixote

Watercolor and pencil. YCAL at the Beineke Rare Book and Manuscript Library, Yale University, the Society of Authors, on behalf of the Bernard Shaw estate

CHARLES SIMIC

The poet Charles Simic was fifteen when he started drawing and painting an occasional watercolor. Then, as he explained to me in a 2001 letter,

> after I graduated from high school [I] got very serious about painting. I looked at art books, did my first oils and visited galleries and museums in Chicago. I imagined I would be an artist since art was my primary interest until the age of 23. That was interrupted by being drafted in the Army from 1961–63. Afterwards, I painted less and wrote more. I have a memory of realizing one day that my abilities were limited, that I had little talent. Except for a few drawings, I pretty much stopped painting at the age of 27.

Born in Belgrade, Yugoslavia (now Serbia), in 1938, Simic, his mother, and brother joined his father in the U.S. in 1953. His wartime memories were vivid: "Germans and the Allies took turns dropping bombs on my head while I played with my collection of lead soldiers on the floor. I would go boom, boom, and then they would go boom, boom." Asked in a 1998 interview by J. M. Spalding how his experience of war-torn Europe had affected his writings, Simic replied:

> My travel agents were Hitler and Stalin. Being one of the millions of displaced persons made an impression on me. In addition to my own little story of bad luck, I heard plenty of others. I'm still amazed by all the vileness and stupidity I witnessed in my life.

He is able to maintain a sense of humor, because "It's not like I have much of a choice. Sobbing and biting my pillow won't do me much good." Simic has written approvingly of a critic who avoids "the trope of the artist as a wounded being whose wound becomes the source of his art." He ascribes his impulse to write to the realization that a high school friend was having success with the best-looking girls by composing "sappy love poems," and the recognition that he could do it too. Poet Anthony Hecht described Simic as "particularly gifted at revealing the derivation of joys and pleasures from the most unlikely, and even forbidding, sources." When some of his poetry was characterized by Spalding as "stunningly surreal," Simic responded:

> I'm a hard-nosed realist. Surrealism means nothing in a country like ours where supposedly millions of Americans took joyrides in UFOs. Our cities are full of homeless and mad people going around talking to themselves. Not many people seem to notice them. I watch them and eavesdrop on them.

Publishing his first poems at twenty-one, Simic, a chancellor of the Academy of American Poets, has produced a dozen books, including the Pulitzer Prize-winning *The World Doesn't End: Prose Poems* (1990); *Walking the Black Cat* (1996), a National Book Award finalist; *Selected Poems: 1963–2003* (2004), winner of the 2005 International Griffin Poetry Prize; and *A Wedding in Hell* (2006). A regular contributor to *The New Yorker* and *The New York Review of Books,* Simic has also published a memoir; translations of Serbian, Croatian, Slovenian, and Macedonian poets; and, with **Mark Strand**, *Another Republic* (1976), an anthology of European and Latin American poets.

Charles Simic. Untitled

"This was done in New York, probably in 1959–61 when I was living on East 13th Street, going to Cedar Bar, and thinking of myself as an abstract expressionist." Oil on paper. 15–1/2 x 11–1/2 inches. Collection of the artist

Charles Simic. Untitled

"The one with sun in the sky and red roofs was done circa 1957 in Chicago. I must have been thinking of Vlaminck." Oil on wood. 8 x 6 inches. Collection of the artist

PATTI SMITH

Before she was a rock star, even before she was a poet, Patti Smith was an artist. Her drawings evolved, she once explained, quite literally from the physicality of words: "Standing before large sheets of paper tacked to a wall, frustrated with the image, I'd draw words instead—rhythms that ran off the page onto the plaster." That was in 1967, after she had moved to New York to become an artist. But her love of the shape of words had originated much earlier, with a reproduction of the Declaration of Independence she received in third grade: "The audacious grace of the script intrigued me and I spent hours as a child copying it out—the image of the word, the signatures—on long paper scrolls."

Hand-rendered text may underscore, frame, or provide the shape of many of Smith's drawings, inscribed so as to suggest a butterfly, an orchid, or, in the case of the series inspired by the attack on the twin towers, a building. She credits photographer Robert Mapplethorpe, her late friend and lover, with teaching her the technique she employs:

> Inspired [after "copying out the Lord's Prayer in Aramaic"] I pulled out my pencils and pad of clay coat [and] made several small drawings in a manner I learned from Robert—a field composed of a single word—a simple phrase repeated, entwining. And then, as was my wont, more elaborate phrases snaking back to a single line.

Smith's drawings have been exhibited at the Whitney Museum in New York in 1978, the Museum Eki in Kyoto in 1998, and in a major 2003 retrospective at the Andy Warhol Museum in Pittsburgh, and are held in the collections of several museums, including the Museum of Modern Art in New York.

Smith was born in 1946 in Chicago, but raised in a working-class town in New Jersey. The daughter of an atheist factory worker and a Jehovah's Witness waitress, the "godmother of punk" discovered **Arthur Rimbaud** when, at sixteen, she found a copy of *Illuminations* and bought it because she thought the French poet looked like Bob Dylan: "The first thing I got from Rimbaud was the power of the outer image: his face." Rimbaud became a major influence, referenced in her lyrics, and the subject of a portrait she did in 1973.

Smith had "a Gorey childhood," and when she came to know **Edward Gorey** she would "tell him stories of my childhood and say that he could use them." It was an upbringing Smith describes as beset with frightening hallucinations brought on by a succession of illnesses. She endured a variety of vision problems, including a wandering eye that was treated with an eye patch and therapy. Among the effects of her bad eyesight were an inability to write except upside down and in mirror image, as well as double vision that made her clumsy: "I'd walk into a tree and get yelled at for daydreaming, but I wasn't."

After high school, she attended a community college, where she got pregnant and dropped out to have the baby, which she placed for adoption. Smith worked in a factory, her feelings reflected in the title of the 1974 recording "Piss Factory." She fled New Jersey in 1967, first to New York where she met, lived with, and supported Mapplethorpe, then to Paris where she performed with a street troupe, eventually returning to New York. There she wrote for music magazines, started to write poetry, and in 1971 moved into the Chelsea Hotel with Sam Shepard and cowrote the play *Cowboy Mouth,* which was produced that year with the two of them in the leads. Smith's eight books of poetry include *Witt* (1973), *Babel* (1978), and *Auguries of Innocence: Poems* (2005).

Patti Smith. Unfinished drawing with Sam Shepard's tattoo

Pencil on paper. Collection of Gotham Book Mart, Inc. Courtesy of the artist. Photo by Jason Brownrigg

Patti Smith. Self-portrait

Pencil on paper. Collection of Gotham Book Mart, Inc. Courtesy of the artist. Photo by
Jason Brownrigg

ART SPIEGELMAN

Art Spiegelman took the graphic novel and elevated it into the realm of literature. His *Maus: A Survivor's Tale—My Father Bleeds History* (1986) and *Maus: A Survivor's Tale II—And Here My Troubles Began* (1991) are classics of the form. The Maus stories won a Pulitzer Prize, a National Book Critics Circle Award nomination, and the *Los Angeles Times* book prize, all in 1992.

Describing the unspeakable, barely depictable horrors of the Holocaust using cartoon animals—cats for Germans, mice for Jews, and pigs for Poles—creates a unique and profound effect on the reader, the result of conscious calculation by Spiegelman:

> To use these ciphers, the cats and mice, is actually a way to allow you past the cipher at the people who are experiencing it. So it's really a much more direct way of dealing with the material.

Spiegelman discussed his methodology of presenting horror with reference to the image shown here of a German soldier smashing a Jewish child's head into a wall. He directs us first to the way the panels are drawn: "I defy you to tell me whether that's cats and mice or people." He framed his dilemma in these terms:

> I couldn't show it and I couldn't not show it. I said to myself "Spiegelman, you can't just avoid this." But I didn't want to be overly graphic. I didn't want the picture drawing the attention like "Ooh, look at that!" The panel is basically like an ideogram of a swinging motion. The head is outside the panel, although there is a splash of blood. And on the next panel, the splash of blood is covered up by a word balloon as my dad and I walk by and he says "This I didn't see with my own eyes, but somebody the next day told me." And that's important.

Born in Stockholm in 1948, Spiegelman emigrated to the United States with his parents, Vladek and Anja, Polish Jews who survived Auschwitz and Birkenau and suffered the murder of their first child by the Germans. His family's scarred lives deeply affected Spiegelman, who, at twenty, had a nervous breakdown and was briefly institutionalized. Shortly afterwards, his mother killed herself. *Maus,* which depicts the strain on a child being parented by survivors, arose, he said, from "an impulse to look dead-on at the root cause of my own deepest fears and nightmares." It was also "a meditation on my own awareness of myself as a Jew."

At sixteen, Spiegelman designed bubble gum cards and stickers, and wrote and edited underground comics. He studied art and philosophy at Harpur College in New York state. With his wife, Françoise Mouly, he copublished the avant-garde showcase *Raw*, edited the *Little Lit* comics anthologies, and wrote the libretto and created sets for *Drawn to Death: A Three Panel Opera* by composer Phillip Johnston. Recognizing Spiegelman's powerful work, and seeking to educate its citizens about the Holocaust, Hungary—which had 600,000 Jews murdered by the Germans, almost all at Auschwitz—reproduced pages of *Maus* in the subway cars of Budapest for the month of March 2005.

Art Spiegelman. Page from *Maus I: A Survivor's Tale—My Father Bleeds History*

RALPH STEADMAN

W hat I used to do with a passion," Ralph Steadman concluded in his autobiography, GONZO: The Art (1998),

foolishly and vainly imagining I would change the world for the better, I no longer tolerate in myself or anyone else. But draw, always draw—and WRITE!"

Steadman had just finished contrasting the person he had become with his younger self, who had concealed his niceness behind his scathing political caricatures:

> My apparent desire to conform was the trick. This drawing is the birth of GONZO in my work—a dispassionate statement of fact intended to elicit uncomfortable laughter—its ruthless portrayal a gentle assassination of the subject in a spat of ink. . . . I am a kind person but outwardly, I project a volatile disposition.

Steadman is the co-creator, with Hunter Thompson, of "gonzo journalism," defined by Steadman as "the essence of irony," wherein the reporters themselves, as actors (in their case, often drunken and drugged) and catalysts of others' actions, become part of the story.

Born in 1936 in Wallasey, England, to a traveling salesman and a homemaker, Steadman escaped an unhappy stint in boarding school, dropping out at sixteen to work odd jobs, and began cartooning after service in the Royal Air Force. In 2000, he told me that he had "a need to be noticed and a desire to shock." He studied at the East Ham Technical College, London, and the London College of Printing and Graphic Arts while cartooning for a chain of small-circulation papers, moving up in the 1960s to *Punch, Private Eye,* and the London *Times.* Reminiscing on his website about his first artistic efforts, Steadman found that they contained incipient text:

> I was full of strange nostalgic imagery, even then. There was also a kind of literary dimension to my work which intrigued me. I thought there was always more to an image than the image itself. Like the first sentence of a story. That's why I like to write

too, and that is why I like to write into my drawings rather than around the edge. I like the writing to belong to the drawing. Over the years, that came to be the general drift and eventually a compulsion.

Declaring "I use the writing as an excuse for not drawing, and the painting as an excuse for not writing," Steadman, in fact, is prodigious in both fields. Among his writing credits are children's books; a book he claims was authored by God, *The Big I Am* (1988); critiques of the United States, including *Scar Strangled Banger* (1988); *I, Leonardo* (1983); *The Grapes of Ralph: Wine According to Ralph Steadman* (1996); and the libretto for *Plague and the Moonflower,* a 1989 oratorio by Richard Harvey. In addition to his own books, Steadman has illustrated, most notably, Lewis Carroll's *Through the Looking Glass and What Alice Found There* (1972) and the famous collaborations with Hunter S. Thompson: *Fear and Loathing in Las Vegas* (1972), *Fear and Loathing on the Campaign Trail* (1975), and *The Curse of Lono* (1981). Receiving a D.Litt. degree from the University of Kent in 1995, Steadman has won many honors, including the Illustrator of the Year Award from the American Institute of Graphic Arts (1979) and Holland's Silver Pencil Award for children's book illustration (1982).

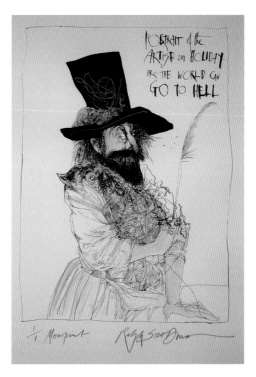

Right: Ralph Steadman.
The Sheriff

Five-color silkscreen. Edition of 77,
signed by Ralph Steadman and Hunter S.
Thompson. 44 x 30 inches. Printed by
Joe Petro III, 1995. Copyright © 1995
Ralph Steadman. Image courtesy of
www.ralphsteadman.com

Opposite: Ralph Steadman.
Artist on Holiday

One-color monotype silkscreen with
hand-applied gouache and colored
pencil. From an edition of 30 unique
prints. 44 x 30 inches. Printed by Joe
Petro III, 2004. Copyright © 2004 Ralph
Steadman. Image courtesy of
www.ralphsteadman.com

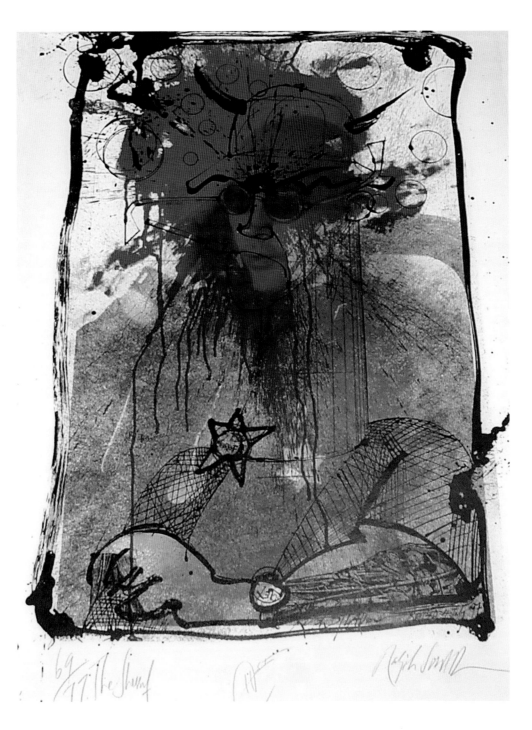

WALLACE STEVENS

*I*n 1931, poet Wallace Stevens, his wife, and their seven-year-old daughter enrolled in a course in euthenics (the science of improving life by improving environment) at Vassar. Exploring the campus, he made a series of meditative sketches he called *Vassar Viewed Veraciously.* The amateurish drawings, mainly of architectural details, are all in pencil on 8 x 10-inch paper. Published by the Windhover Press in 1995, they were edited and introduced by scholar Daniel Woodward, who says they were "apparently Stevens's only surviving exercise in the graphic arts." Woodward found in these sketches evidence that Stevens's "mature sensibility was substantially influenced by modern art." *The One-Eyed Man Below EVS' Window,* reproduced opposite, was Stevens's attempt to capture in his typically unpretentious style "one of the grotesque nineteenth-century garden statues collected by Matthew Vasser, and now lost." Woodward saw in the drawing "the dandiacal provocations of *Harmonium* (1923)."

Stevens was born in 1879 in Reading, Pennsylvania, and died in Hartford, Connecticut in 1955. He was employed as a lawyer and vice-president of the Hartford Accident and Indemnity Company even as he was recognized as an intensely imaginative, philosophical giant of twentieth-century American poetry. Seeing nothing contradictory in that, he said:

> I prefer to think I'm just a man, not a poet part time, businessman the rest. This is a fortunate thing, considering how inconsiderate the ravens are. I don't divide my life, just go on living.

Stevens did a three-year course at Harvard and received his law degree from New York Law School in 1903. In 1904, at home in Reading for the summer, he met and fell in love with Elsie Moll, the beauty who became the model for the Liberty-head dime and half-dollar. His family disapproved, and no members attended his wedding to Elsie in 1909. Stevens wrote no poetry after college until a classmate introduced him, after the Armory Show in 1913, to avant-garde artists and writers, including Marcel Duchamp and the poets **Mina Loy** and **William Carlos Williams**. Inspired, Stevens published a number of poems, but it was not until 1923, just before his forty-fourth birthday, that his first collection, *Harmonium,* appeared. He went on to publish thirteen more volumes of poetry and prose, including an expanded version of *Harmonium* in 1931, receiving the National Book Award for *The Auroras of Autumn* (1950) and the National Book Award and the Pulitzer Prize for his *Collected Poems* (1954). A Francophile heavily influenced by the symbolist poets—*Harmonium*'s poems are laden with French phrases—Stevens never visited Europe. He boasted, in fact, that the farthest he had ever traveled was Staten Island.

The author of "Anecdote of the Jar," "The Emperor of Ice-Cream," "The Idea of Order at Key West," "Not Ideas about the Thing but the Thing Itself," and other reality-transforming poems remarked without apparent irony: "Poetry and surety claims aren't as unlikely a combination as they may seem. There's nothing perfunctory about them for each case is different."

Wallace Stevens. The One-Eyed Man
Below E[lsie] V[iola] S[tevens]' Window

1931. Pencil on paper. 10 x 8 inches. By permission
of The Huntington Library, San Marino, California

ROBERT LOUIS STEVENSON

I am not but in my art: it is me; I am the body of it merely." Robert Louis Stevenson began making artwork as an invalid child who lacked the alternative of an active outdoor life:

> My health was of the most precarious description. Many winters I never crossed the threshold; but used to lie on my face on the nursery floor, chalking or painting in water-colours the pictures in the illustrated newspapers; or sit up in bed, with a little shawl pinned about my shoulders, to play with bricks or whatnot.

Although the habit of art persisted through adulthood, he reported that, growing up, his depictions were never from life:

> Although I was never done drawing and painting, and even kept on doing so until I was seventeen or eighteen, I never had any real pictorial vision, and instead of trying to represent what I saw, was merely imitating the general appearance of other people's representations. I never drew a picture of anything that was before me, but always from fancy, a sure sign of the absence of artistic eyesight; and I beautifully illustrated my lack of real feeling for art, by a very early speech, which I have had repeated to me by my mother: "Mama," said I, "I have drawed a man. Shall I draw his soul now?"

Stevenson received private drawing instruction at fifteen, along with tutoring in German (having already acquired Latin and French). Traveling ceaselessly throughout his life, hoping to find better health in a different climate, he sketched the people and scenery he encountered. After meeting and following divorcée Fanny Osbourne to America, where they married in 1882, Stevenson sought to assist her twelve-year-old son make a book with a toy press. He wrote verses for the project, titled *Moral Emblems,* and carved a series of woodcuts with a pocketknife. He sent a pair of them to his parents, noting, "they are moral emblems; one represents 'anger,' the other 'pride scorning poverty.' If my father does not enjoy these, he is no true man." He added, "Wood engraving has suddenly drave between me and the sun. I dote on wood engraving. I'm a made man for life. I've an amusement at last." Among the two dozen woodblocks he made for the book was "The Precarious Mill," reproduced here.

The author of twenty-eight volumes, including *Treasure Island* (1883), *Kidnapped* (1886), and *The Strange Case of Dr. Jekyll and Mr. Hyde* (1886), was born Robert Louis Balfour Stevenson in Edinburgh in 1850. He described the daily misery of "the terrible long nights that I lay awake, troubled continually with a hacking exhausting cough, and praying for sleep or morning from the bottom of my shaken little body." The ailment, tuberculosis, forced his family to move in the hope that the boy would find relief in other surroundings. Besides many travel sketches, he produced an account of canoeing in Belgium and France, titled *Inland Voyage* (1878), and *Travels with a Donkey* (1879), about a tour through the Cevennes. Before his travels, Stevenson studied engineering, then became a lawyer. He settled in Samoa in 1889, in a home he called Valima, where he died in 1894. His painting of Valima is reproduced opposite.

Right: Robert Louis Stevenson. The Precarious Mill

1882. Woodcut carved with a penknife. Illustration for *Moral Emblems,* toy press publication of his twelve-year-old stepson. From *Voyage to Windward* (1921)

Above: Robert Louis Stevenson. Untitled (landscape)

1864–1867. 7–1/8 x 3–1/2 inches. YCAL at the Beineke Rare Book and Manuscript Library, Yale University

Right: Robert Louis Stevenson. Valima

1893. Watercolor. 6–1/2 x 8–1/2 inches. YCAL at the Beineke Rare Book and Manuscript Library, Yale University

ADELBERT STIFTER

When Austrian novelist, poet, and educator Adelbert Stifter was twelve, his father, a flax trader and farmer, was crushed to death under a wagon, and the boy had to work the farm with his paternal grandfather. He was rescued from a laborer's life by his maternal grandmother, who took him to the Benedictine abbey of Kremsmünster, where he matriculated at thirteen. There, he received, besides a fine education in science, literature, and language, lessons in drawing and painting by Georg Rietzlmayr, who inspired Stifter to think of himself as an artist. Only a few years before he died, Stifter wrote that at Kremsmünster he

> first heard the statement that beauty is nothing but the divine presented in a beautiful form: that the divine is infinite in God but finite in man: that it is, however, the essence of his nature, striving everywhere for absolute revelation, as the good, the true and the beautiful in religion, science, art, and human conduct— a revelation which is the true source of man's happiness.

Everything he'd done in his life, wrote Stifter, had led him to the same conclusion.

Stifter became one of the most highly regarded nineteenth-century prose writers in German, yet his first career move was not toward painting or writing, but the law. He completed his legal studies at the University of Vienna, but was denied a degree for failing to take a final exam, and turned to painting and teaching for income. Even after the success of his first published story, "The Condor," in 1840 and the six volumes worth of popular stories that followed during the next decade, Stifter continued to think of himself primarily as an artist. In addition to painting throughout his life, Stifter did art and furniture restoration. The largest collection of his paintings is found in the Wein Museum, Vienna, the source of the one reproduced here. Although the quality of Stifter's writing has aroused strong literary debate, there is universal admiration for his descriptions of nature.

Besides his careers as a short story writer, novelist, poet, and artist, Stifter was renowned for the breadth of his knowledge in mathematics and science, as well as in law, literature, and art. He was employed as tutor to notable families of the Viennese aristocracy and, after moving to Linz following the 1848 revolution, was appointed supervisor of elementary schools for Upper Austria.

Stifter was born in 1805 in Oberplan, Bohemia (now part of the Czech Republic). The death of his father was the beginning of a chronicle of loss: Stifter fell in love at twenty-three, but after a five-year relationship, the young woman's family rejected him for lack of means. He entered into a childless marriage with a poor, uneducated woman, in which he repeatedly sought surrogate offspring. In 1854, a young man he thought of as a son died. The next year, he adopted his wife's niece, who ran away when she was ten, and drowned herself eight years later. Another girl he'd taken in, again a relative, was stricken with consumption, and died in 1859. During the same period, his brother's two small children died. Beset with illness, depression, anxiety, and chronic financial desperation, Stifter slit his throat in 1868. Despite a doctor's ministrations, he died two days later, in Linz.

Of his dozens of literary works, Stifter is probably best known for a two-volume collection of stories *Bunte Steine* (1853; *Colored Stones*), which contains a number of stories anthologized as German classics. His introduction to the collection has garnered attention for its philosophical assertions that rejected the prevalent science-versus-God dichotomy and insisted that universal laws of justice could be comprehended by observing nature.

Opposite: Adelbert Stifter. Seestück bei Mondbeleuchtung (Seascape under Moonlight)

C. 1840. Oil on canvas. Wein Museum, Vienna

HARRIET BEECHER STOWE

Although novelist Harriet Beecher Stowe had limited formal education in art, she saw herself as an artist, painted, and for a time taught art at her sister Catharine's Hartford Female Seminary. While working on *Uncle Tom's Cabin* (1852), Stowe wrote to the editor of the abolitionist paper *National Era,* casting her literary effort in artistic terms:

> My vocation is simply that of a painter, and my object will be to hold up in the most life like and graphic manner possible slavery, its reverses, changes, and the Negro character, which I have had ample opportunities for studying. There is no arguing with pictures, and everybody is impressed by them, whether they mean to be or not.

In a letter to her grandmother during her youthful art studies, Stowe described the intensity of her effort:

> I have been constantly employed from nine in the morning until after dark at night, in taking lessons of a painting and drawing master, with only an intermission long enough to swallow a little dinner which was sent to me in the schoolroom.

Elaborating on her motives, Stowe tied them directly to her love and feelings of respect for her late mother:

> I propose, my dear grandmamma, to send you by the first opportunity a dish of fruit of my own painting. Pray do not now devour it in anticipation, for I cannot promise that you will not find it sadly tasteless in reality. If so, please excuse it, for the sake of the poor young artist. I admire to cultivate a taste for painting, and I wish to improve it; it was what my dear mother admired and loved, and I cherish it for her sake.

Stowe wrote short stories and poetry, but it was through her novels—most famously *Uncle Tom's Cabin,* which flamed antislavery sentiment before the Civil War—that she achieved recognition. She was born Harriet Elizabeth Beecher in Litchfield, Connecticut, in 1811, and died in Hartford in 1896. Her father, Lyman Beecher, was a prominent minister whose thirteen children included at least eight notables, among them Catharine and Henry Ward Beecher, both writers.

In 1836, while living in Cincinnati, Harriet married Calvin Ellis Stowe, a minister and professor of theology. In Kentucky, and from fugitive slaves she met in Ohio, she became exposed to slavery. When her husband took a position with Bowdoin College in 1850, they moved to Brunswick, Maine, where she began to write *Uncle Tom's Cabin.* The novel initially appeared in serial form in the *National Era,* and was hugely successful when it came out as a book, selling half a million copies in its first five years in print. It was translated into more than twenty languages and successfully dramatized. In 1854 Stowe published *A Key to Uncle Tom's Cabin,* in which she assembled evidence to buttress her antislavery attack. She published a second popular polemical novel, *Dred,* in 1856. Her best-known non-abolitionist work is the novel *The Minister's Wooing* (1859).

Harriet Beecher Stowe.
Great Snowy Owl

C. 1863–1866. Oil. 26 x 20 inches.
The Harriet Beecher Stowe Center,
Hartford, Connecticut

MARK STRAND

*I*n 1959, poet Mark Strand studied painting at Yale with Josef Albers. "I had no style as either a poet or a painter," he said at a 2001 exhibit of the works of Albers and painter Neil Welliver, another Yale instructor. "I wanted my paintings to look like a cross between de Kooning and Gorky, and they ended up looking like weak Marsden Hartley":

> While painting, I had the feeling that whatever I was was diminished by my work, that visual experience could not represent or take the place of other experience. So when I turned to writing poetry it was with considerable relief. Though my poetry was not good, I felt that it offered the opportunity for intellectual growth. For me, writing was thinking.

According to Strand, it was an encounter with a painting by Welliver that was the transformative event in his life:

> I admired a painting of his in the office of the secretary of the art school at Yale, and I wondered instantly if I were in the right place. . . . Looking at that Welliver painting had a lot to do with my becoming a poet.

Strand remains engaged with the visual arts. He has written books of art criticism and poetry inspired by works of art, and has had a successful career as a printmaker. Reproduced here are prints done for Baltimore's Goya-Girl Press.

Poet Robert Pinsky sees the qualities of Strand's poetry— "plangent while amused, daring and emotional, with a kind of calm poise"— in his artwork. Strand's own view of painting and poetry is highly idiosyncratic:

> Increasingly, I have felt that I don't see a painting until I turn away from it and don't read a poem until I close the book. What

I know or retain of either depends on what I am able to invent in their place. Oh I refer to them, but mostly I draw on my own blindness and ignorance, insight and knowledge.

Strand was born in 1934 in Summerside, Prince Edward Island, Canada. He came to the United States at four and, because his salesman father was frequently relocated, lived in a number of American cities. In his teens, Strand lived in Mexico, Colombia, and Peru. Receiving a B.A. at Antioch College (1957) and his B.F.A. from Yale (1959), Strand earned his M.A. at the University of Iowa (1962), where he studied under the poet **Donald Justice**. After teaching at a number of universities, including Yale, Harvard, and Johns Hopkins, he is currently a professor at Columbia University.

Strand has received Rockefeller, Guggenheim, and National Endowment for the Arts fellowships, as well as a MacArthur award (1987). He was designated Poet Laureate of the United States in 1990. Among many other honors, he won the Bobbitt Prize for Poetry in 1992, the Bollingen Prize in 1993, and the Pulitzer Prize in 1999. He has also written short stories and several children's books, and has translated Spanish and Latin American poets.

Above: Mark Strand. Untitled

1999. Ink on paper. 22 x 30 inches. Courtesy of the artist and Goya-Girl Press, Inc.

Opposite: Mark Strand. Future Ruins

1998. Four-color lithograph. 20 x 22 inches. Courtesy of the artist and Goya-Girl Press, Inc.

AUGUST STRINDBERG

Playwright August Strindberg was also a novelist, actor, guitarist, and photographer, but it was to art that he turned for his deepest pleasure. He described the experience of doing his first oil painting at twenty-three, of seeing the transformation of paint into sky, grass, and foliage as the equivalent of a hashish high. However, it would be almost twenty years—in 1892—before he painted again. In the interim, Strindberg's visual expressions were mainly photographic and highly experimental. Believing that lenses distorted reality, he took pictures of heavenly bodies with a lensless camera, and sometimes with no camera at all—exposing the photographic plate directly to starlight. In later years, he experimented with creating images using crystallized solutions on glass: he would heat or cool the solutions and capture the effects on photographic paper, directly from the plates.

In 1894, lacking funds and hoping to earn a living as an artist, Strindberg moved to Paris, where he was set up in a studio by an art dealer and began to prepare for a show that never materialized because of a falling out with his patron. That same year he wrote an essay on "The Role of Chance in Artistic Creation." After describing the unique harmonies created by wind blown through holes drilled in bamboo stalks, the weavers who use kaleidoscopes to discover new patterns, and the practice of painters who sketch with leftover paint scraped off the palette, he declared this to be "natural art, where the artist works in the same capricious way as nature, without a goal."

> Once freed from the problem of composing the colours, the soul of the artist is inclined to concentrate all its energy on the outline. Since his hand keeps moving the palette knife at random, never losing sight of the model provided by nature, the whole reveals itself as a wonderful mixture of the conscious and unconscious.

Strindberg's maxim was "Imitate nature in an approximate way, imitate in particular nature's way of creating!" He described how that was translated into technique:

> I select a medium sized canvas or preferably a board, so that I am able to complete the picture in two or three hours, while my inspiration lasts. I am possessed by a vague desire. I imagine a shaded forest interior from which you see the sea at sunset. So: with the palette knife that I use for this purpose—I do not own any brushes!—I distribute the paints across the panel, mixing them there so as to achieve a rough sketch. The opening in the middle of the canvas represents the horizon of the sea; now the forest interior unfolds, the branches, the tree crowns in groups of colours, fourteen, fifteen, helter-skelter—but always in harmony. The canvas is covered. I step back and take a look!

The greatest writer of modern Sweden was born Johan August Strindberg in Stockholm in 1849. He suffered throughout his life from manic depression with paranoid features. Unhappily married three times, he turned to painting, particularly at times of crisis, such as the breakup of a marriage. Strindberg's plays, as well as his art, focused on inner reality and put him in the forefront of Expressionism. His novel *The Red Room* (1879) was an early landmark of the Naturalist movement. He died in Stockholm in 1912.

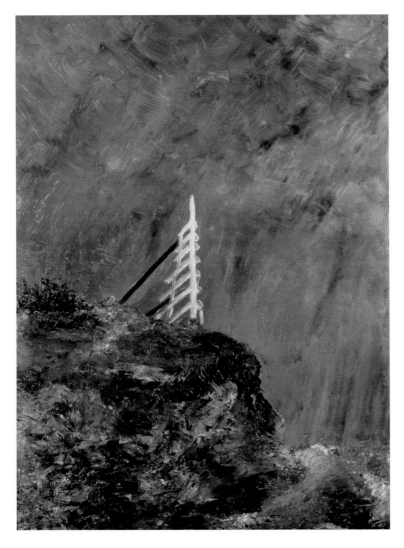

August Strindberg. The Vita Märrn Seamark II

1892. Oil on cardboard. 23–5/8 x 18–1/2 inches. The National Museum of Fine Arts, Stockholm. Photo by Asa Lundén

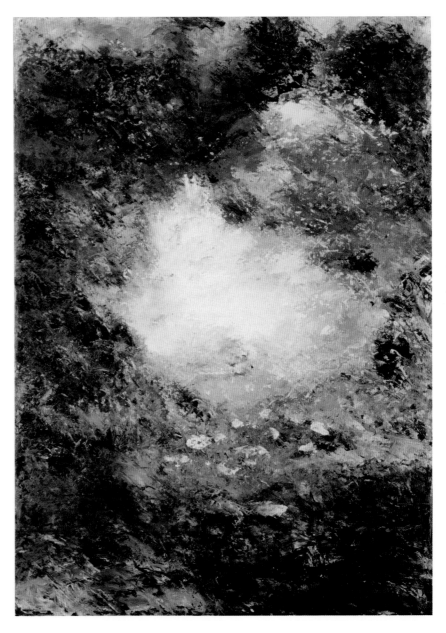

August Strindberg. Underlander (Wonderland)

1894. Oil on cardboard. 28–1/2 x 20–1/2 inches. The National Museum of Fine Arts, Stockholm. Photo by Erik Cornelius

RABINDRANATH TAGORE

F ullness of expression is fullness of life," wrote the Nobel Prize-winning novelist, playwright, and poet Rabindranath Tagore. He elaborated:

[A] large part of man can never find its expression in the mere language of words. It must, therefore, seek for its other languages—lines and colours, sounds and movements. Through our mastery of these we not only make our whole nature articulate, but also understand man in all his attempts to reveal his innermost being in every age and clime.

"Very often," he added, "men's words are not a language at all, but merely a vocal gesture of the dumb."

Tagore had painted as a hobby, but not until he was in his sixties—when he had already expressed himself in more than two hundred volumes of poetry, plays, novels, short stories, essays, and songs—did serious work begin on what would become more than two thousand works of art. Since his first solo show, at the Galerie Pigalle in Paris in 1930, his work has been exhibited by institutions worldwide, including the Boston Museum of Fine Arts (1930), the National Gallery of Australia (1947), the Academy of Fine Arts, Calcutta (1957), the Rome-New York Art Foundation, Rome (1959), the Tate (1982), the Hermitage (1982), and the Seibu Museum of Art, Tokyo (1988). One of the largest collections of his paintings is housed at the British Museum.

In a 1930 letter to the head of London's Royal College of Art, Tagore wrote modestly of his artistic skills, suggesting that his pictures merely

possess psychological interest, being products of untutored fingers and untrained mind. I am sure they do not represent what they call Indian Art, and in one sense they may be original, revealing a strangeness born of my utter inexperience and individual limitations.

Tagore believed his artwork was not graspable by average viewers who, he believed, "do not or cannot use their eyes well. They go about their little business—unobservant and listless." Yet, he insisted the artist must rise to the challenge:

The artist has a call and must answer the challenge to compel the unperceptive majority to share in his joy of the visible, concrete world—directly perceived. He sings not, nor does he moralize. He lets his work speak for itself and its message is: Look, this is what I am.

Tagore was born into a gentrified family in 1861 in Bengal, his father the head of a Hindu sect which promoted the view that all reality, mind and matter, is one. After home schooling, Tagore was sent to England for formal study, which he did not complete. Back in India, in addition to his literary and artistic pursuits, Tagore ran his family's enterprises and established a school that became a social and political force. He was a close friend of Mahatma Gandhi's and was involved in the push for Indian independence. A few years after being knighted in 1915, he protested British policy by resigning the honorific. He died in Bengal in 1941. "I know not," Tagore opened his autobiography, "who paints the pictures on memory's canvas, but whoever he may be, what he is painting are pictures."

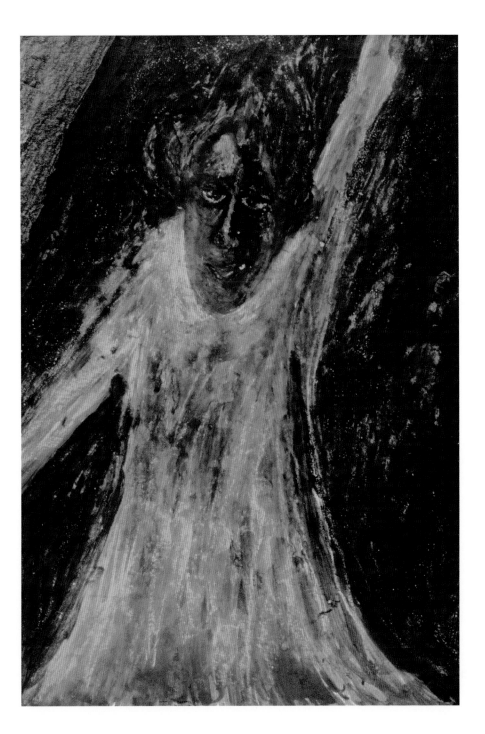

Rabindranath Tagore. Untitled

Oil. 24 x 16–3/4 inches. By permission of
Dartington Hall Trust

BOOTH TARKINGTON

A novelist, short story writer, and playwright, Booth Tarkington was only seventeen when he got his first professional work as an artist, hired by his neighbor **James Whitcomb Riley** to do the cover design for a book of Riley's fiction. A gifted illustrator, Tarkington contributed drawings to university publications—he attended, but did not graduate from Purdue and Princeton—and his art was exhibited in 1946 alongside his literary works at the Princeton Library and reproduced in the show's catalog.

By twenty-six, Tarkington had determined to be a writer rather than an artist. He explained that change of direction in a scribbled note which appeared in an 1895 issue of *Life* magazine, to which he had previously contributed a satiric story and illustration in the styles of Wilde and Beardsley: "*Life,*" he wrote,

> paid me twenty dollars for this, mentioning that it paid thirteen dollars for the text and seven dollars for the drawing. This helped me to decide upon writing rather than illustrating as a career.

Tarkington didn't stop drawing, and among the surviving examples of his art are illustrated letters he sent to his nephews during travels in Europe in 1903–1904. The letters and accompanying illustrations—several of which are reproduced here—were published as *Your Amiable Uncle: Letters to His Nephews by Booth Tarkington* (1949). His droll salutations for the boys ran from "Angelic Nephews" and "Most Pious" to "Inheritors of Sin" and "Share Awfaw," which, he explained, was how one pronounced "Cher enfants," meaning "Wicked Boys."

The letter in which the image of the overburdened donkey appears explains that it depicts "an Italian mover": "The donkeys go up and down the hills with grotesque loads: they look like rabbits hitched to houses." The sketch of the serenaders, Tarkington said, showed "Neapolitan singers and how the English listened." In another letter, containing the drawing of the gondola in which he says he saw his parents disappear into the Grand Canal, he claimed that on the Lido beach he'd seen "the toughest man in the world," whom he was representing (opposite) "without exaggeration."

Newton Booth Tarkington was born in 1869 in Indianapolis, Indiana. His father was a lawyer, his uncle a governor of California and United States senator, and Tarkington himself served a term in the Indiana legislature. An unhappy nine-year marriage that ended in divorce produced a daughter from whose early death Tarkington never recovered. Extraordinarily prolific throughout his life, even during a three-year period of blindness from cataracts, Tarkington published more than sixty books, including two Pulitzer Prize–winning novels—*The Magnificent Ambersons* (1919), which was famously adapted for a film by Orson Welles in 1941, and *Alice Adams* (1922). Other honors included the Gold Medal of the National Institute of Arts and Letters (1933) and the Howells Medal of the American Academy of Arts and Letters (1945).

Tarkington was an enormously popular writer in his lifetime, with nine bestselling novels and more than five million copies sold. Although he lived for extended periods in New York, as well as in France and Italy, he returned to the Midwest that was the inspiration for his fiction, dying in Indianapolis in 1946.

Right: Booth Tarkington.
Four sketches from letters
written to his nephews

1903. From *My Amiable Uncle:*
Recollections about Booth Tarkington by
Susanah Mayberry (Purdue University
Press, 1983)

Opposite: Booth Tarkington.
Self-portrait

Graphite. 11–1/2 x 9–1/2 inches.
Newberry Library

WILLIAM MAKEPEACE THACKERAY

William Makepeace Thackeray began drawing at the same time he made his first efforts at poetry. Both were an antidote to childhood torment, and his visual and literary creativity remained inextricably connected throughout his life. He used his comic drawings and caricatures alongside his written sketches to sell the weekly newspaper he started at twenty-two. He soon moved to Paris, where he studied painting, continuing intermittently over the next few years. In 1836, he published a volume of eight lithographs satirizing a popular ballet. It was not a financial success, nor were his efforts to find employment as an illustrator, although he included illustrations with his own, often serialized, fiction. Among other rejections, he was turned down by Charles Dickens for the job of illustrating *The Pickwick Papers* (1837).

Vanity Fair (1848), Thackeray's most enduring novel, is laden with his drawings; no mere illustrations of the text, they supplement and comment ironically upon it. Indeed, the work appeared in installments as *Vanity Fair: Pen and Pencil Sketches of English Society.* Thackeray caricatured himself there in the costume of an entertainer who holds a mask on his lap—reflecting his dual role as narrator of the story, or "manager of the performance," and a character in it. The protagonist, Becky Sharp, angling for a wealthy man, is depicted with rod in hand, a fat fish swimming below.

As "Michael Angelo Titmarsh," one of his many pseudonyms, Thackeray wrote art criticism and set forth the polestar of his aesthetics: that beautiful art must embody not just the qualities of a skilled hand but, more importantly, "a great heart." The portrait of his wife, Isabella, reproduced opposite, undoubtedly contains Thackeray's heart. Isabella fell into a depression after the birth of their third daughter and, after trying to kill herself by jumping overboard en route to Ireland, was institutionalized for the rest of her life.

Thackeray was born in Calcutta in 1811, the son of an official of the British East India Company who died when the boy was four. A year later, his mother, engaged to another man, sent Thackeray to boarding school in England. Rationalizing his early abandonment to the British-Indian social structure, Thackeray wrote of what he called its "strange pathos": "In America it is from the breast of a poor slave that a child is taken; in India it is from the wife, and from under the palace, of a splendid proconsul." He had a miserable time at a school "governed by a horrible little tyrant," and knelt in prayer each night asking God that he might dream of his mother. He was nine when his mother and stepfather finally reappeared, but he was allowed just one month with them before being sent to another boarding school, where he was emotionally and physically abused, and taught "foolish old-world superstitions," along with "misery, vice, and folly" and a "small share of Greek and Latin."

At Trinity College, Cambridge, Thackeray contributed to campus magazines before leaving in his second year. To improve his mother's poor opinion of him, he became a lawyer, but found legal studies "certainly one of the most cold blooded prejudiced pieces of invention that ever a man was slave to." In the twenty-six volumes of work Thackeray produced are found fiction, critical writings, essays, biography, and memoir. Besides *Vanity Fair*, he is best remembered for the novels *Barry Lyndon* (1844) (in part because of the 1975 Stanley Kubrick film), *Pendennis* (1850), *Henry Esmond* (1852), and *The Newcomes* (1855). He died in London in 1863.

William Makepeace Thackeray. George Makes Acquaintance with a Waterloo Man

1847. Engraving for *Vanity Fair*. 8–5/8 x 5–1/2 inches. The University of Chicago Library, The Joseph Regenstein Library

William Makepeace Thackeray. Portrait of Isabella Shaw Thackeray

Watercolor. 4–1/2 x 4 inches. Berg Collection of English and American Literature, The New York Public Library, Astor, Lenox and Tilden Foundations

DYLAN THOMAS

"My horrible self . . . would not be itself did it not possess the faults."

Even Dylan Thomas's angry wife, Caitlin—following a harsh appraisal of his flirtation with another woman by "playing ridiculous things on the piano"—acknowledged that he could not only generate a tune but had art talent as well: "He could also paint a little and draw cartoons in an amateurish kind of way; these were talents that he had never bothered to develop, although some of his watercolours were very good." As the painter Augustus John's model and lover, she presumably had had sufficient exposure to accomplished art to offer a creditable opinion.

Thomas's watercolors are lost, but, owing to a habit of self-caricature, a number of his casual drawings have been preserved, including the example opposite, executed beside an inscription inside the cover of a book of his poems one night in a bar. That Thomas was so often the subject of his art, and the somewhat comic way he chose to represent himself, reflects perhaps the legendary conflict between his interior poetic life and the external world of unpleasant adult reality, which he faced only with the help of alcohol.

Caitlin's reference to her husband's history of artistic expression is consistent with the highly visual way he said that poetry first came to him. He spoke of

> the colours the words cast on my eyes, and though what the
> words meant was, in its own way, often deliciously funny

enough, so much funnier seemed to me, at that almost forgotten time, the shape and shade and size of words as they hummed, strummed, jigged and galloped along.

Thomas was born in the seaport town of Swansea, Wales, in 1914. His father, an embittered grammar school teacher with unrealized literary aspirations, was a heavy-drinking, emotionally distant parent, feared and loved by his son. Scholar David E. Middleton, speaking of "this rather terrifying father," argues that "in some sense [Thomas's] life was an attempt to realize his father's frustrated dream of being a great poet." The twenty years Thomas spent in Swansea, and on visits to his uncle's nearby farm before moving to London for the first time, became the idyllic period that is the subject of much of his lyrical writings.

Thomas dropped out of school at seventeen, taking a job as a reporter at the South Wales *Evening Post*. In 1932, he joined a local amateur theater group in Swansea and, over several years, appeared regularly in its productions. The experience helped to train his naturally magnificent voice and was the start of a career of reading and acting, which was often the only source of steady income he had. Thomas's oratorical skills spread his fame and helped fuel demand for his poetry.

Thomas spent his life living on the financial edge, exhibiting outrageous, drunken, promiscuous, adolescent behavior. Yet he delivered brilliant performances and inspirational readings on tour and for the BBC, and produced many of the greatest poems of the twentieth century before he died of alcoholism in New York in 1953.

Dylan Thomas. Self-caricature

Pencil. 4 x 3–2/3 inches. Berg Collection of English and
American Literature, The New York Public Library,
Astor, Lenox and Tilden Foundations. Courtesy of the
estate of Dylan Thomas

JAMES THURBER

Humorist James Thurber lost the sight in his left eye at the age of six, when he was shot by the arrow of his William Tell-playing brother. Later in life, despite a series of surgeries, he gradually lost the sight in the other eye, yet continued to produce stories and drawings.

In 1927, Thurber was introduced by the writer E. B. White to Harold Ross, the founding editor of *The New Yorker*, and he was immediately appointed managing editor, a job that he left after a few years to devote himself to writing, contributing regular essays and drawings to the magazine over the years. Thurber had no art training, and although he drew constantly, even on the walls of *The New Yorker*—the walls containing his faded pencil sketches have been several times relocated, and are now preserved under glass and displayed at the magazine's new headquarters—he initially refused to submit such work for publication. It was White, Thurber's officemate, who submitted his drawings, after retrieving and inking in discards from the garbage. Thurber's first book, *Is Sex Necessary?* (1929), coauthored with White, was illustrated with forty of Thurber's drawings, all done the night before the manuscript was turned in. According to Thurber,

> Three bewildered and frightened publishers looked at them, and one man, the head publisher, said, "These I suppose are rough sketches for the guidance of some professional artist who is going to do the illustrations?" and Andy [E. B. White] said, "Those are the actual drawings that go in the book."

The book was a great success and made Thurber's reputation as a literary figure and artist. With wry pseudo detachment, he commented on his dual creativity in 1944:

Thurber's life baffles and irritates the biographer because of its lack of design. One has the disturbing feeling that the man contrived to be some place without actually having gone there. His drawings, for example, sometimes seem to have reached completion by some other route than the common one of intent. The writing is, I think, different. In his prose pieces he appears always to have started from the beginning and to have reached the end by way of the middle. It is impossible to read any of the stories from the last line to the first without experiencing a definite sensation of going backward. This seems to me to prove that the stories were written and did not, like the drawings, just suddenly materialize.

Thurber illustrated many of the more than thirty volumes he published of his own work, as well as books by three other writers. His drawings were exhibited in one-man shows in New York and London, and he counted the 1956 Silver T-Square Award of the National Cartoonists Society among his many honors.

The writer and dramatist who gave us Walter Mitty and *The Unicorn in the Garden* was born in Columbus, Ohio, in 1894 and died in New York in 1961. Thurber left Ohio State University during World War I to serve as a code clerk in the State Department.

After the war, he worked as a reporter for *The Columbus Dispatch, Paris Tribune,* and *The New York Evening Post.*

Thurber cowrote the play *The Male Animal* (1941) with Elliott Nugent, and appeared as himself in a stage production of *The Thurber Carnival* in 1960. A dozen of his stories became movies, including *The Secret Life of Walter Mitty* (1947); *The Thirteen Clocks* (1950) was adapted as an opera, and *The Last Flower* (1939) as a ballet. His memoir, *The Years with Ross* (1959), recounts his time with the legendary *New Yorker* editor.

"Perhaps *This* Will Refresh Your Memory"

Above: James Thurber. Pencil drawing on a wall at *The New Yorker*, done one afternoon in the 1930s

Courtesy of *The New Yorker*, New York City. Copyright © 2007 Rosemary A. Thurber. Photo by Raymond Adams

Right: James Thurber. Self-portrait. Detail from the wall drawings above

Opposite: James Thurber. "Perhaps *This* Will Refresh Your Memory"

Copyright © 1945 James Thurber. Copyright © 1973 Rosemary A. Thurber. From *The Thurber Carnival*, published by HarperCollins

WILLIAM TREVOR

William Trevor, novelist and master of the short story, began wood carving at age seven. The gratification he felt was visceral as well as aesthetic: The razor-sharp tool, he said, slipped pleasurably through the grain of the wood, and for an instant or two, you could control it perfectly. The grain was a pattern to make use of, a means of suggesting concavity or depth, an emphasis where you wanted it to be.

Formal instruction came at fifteen, when he impressed sculptor Oisin Kelly, who was teaching at St. Columba's College in Dublin. Trevor learned enough from his "impatient and tetchy and down-to-earth" instructor to be able to execute his first commissions by the time he was nineteen. These included a war memorial for a church, a tombstone for a friend's sister, and a wooden plaque of carved saints.

While at Dublin's Trinity College, Trevor first accepted, then, under family pressure, gave up an apprenticeship as a type designer with the brother of one of Eric Gill's colleagues. His career took off three years after graduation, when he won the Irish division of the International Unknown Political Prisoner sculpture competition, a huge event that drew thousands of entrants from around the world. Trevor then worked as an art teacher and did sculptural work for local churches, including the oak lectern carving of St. Matthew reproduced here.

Trevor had his first solo show in 1956—exhibiting works in wood, clay, and metal, as well as embroidery—and his last exhibit, a work in metal, in 1959. Working for an advertising agency at that time, he had become disillusioned with his sculpture and began writing: "A terrible thing happened. My sculpture became more and more abstract, and finally I did not like it at all. There is hardly a worse thing that could happen to an artist."

Trevor explained his distress in terms of "the absence of people": "I sometimes think all the people who were missing in my sculpture gushed out into the stories . . . the humanity that isn't in abstract art." If any of his work in the plastic mediums affected his writing, Trevor insisted it's only that he was "still obsessed by form and pattern . . . the actual shape of a novel or the shape of a short story."

Regularly and favorably compared to James Joyce, Trevor was born in Ireland, in Mitchelstown, County Cork, in 1928, and named William Trevor Cox. He attended thirteen schools, the first as a Protestant boy in a convent school for girls. At fourteen, he entered St. Columba's, and at eighteen Trinity College, where he got his degree in history in 1950. His first novel, *A Standard of Behaviour,* was published in 1958, but major recognition did not come until 1964 with *The Old Boys,* winner of that year's Hawthornden Prize. Since then, his internationally acclaimed writing, which includes plays, television scripts, and fiction, for which he is famed, has earned him a Royal Society of Literature Award (1975), the Whitbread Book of the Year Award (1994), and his 1977 designation as a Commander, Order of the British Empire, among others.

Despite crafting stories of keen insight, precise characterization, and exacting attention to the nuances of human drama, Trevor says, "I believe in not quite knowing. A writer needs to be doubtful, questioning. I write out of curiosity and bewilderment."

Above: William Trevor. Lovers

Cast metal. Courtesy of the artist

Right: William Trevor. St. Matthew

1956. Carved oak. 48 x 20 inches. For lectern at All Saints Church, Braunston. Courtesy of the artist

MARK TWAIN

Mark Twain seems to have always doodled and drawn. America's greatest humorist did playful illustrations when instructing his children, used rebuses when writing them letters, and employed pictographs as lecture notes. It appears he also did serious art study with "the best instructors in drawing and painting in Germany," although it's hard to tell with what result, given his humorous self-deprecation:

> Whatever I am in Art, I owe to these men. I have something of the manner of each and all of them; but they all said that I had also had a manner of my own, and that it was conspicuous.

In a rare moment of non-ironic expression, Twain acknowledged the deep effect his art had on him: "I am living a new and exalted life of late. It steeps me in a sacred rapture to see a portrait develop and take soul under my hand." Few examples of his work have survived, and what has consists mainly of cartoons and some self-portraits, including the copperplate etching shown here. Twain light-heartedly etched on the bottom of the engraving: "N. B. I cannot make a good mouth, therefore leave it out. There is enough without it anyway."

In *A Tramp Abroad* (1880), Twain included the drawing reproduced below. It is a purported depiction of his carriage and entourage as they were leaving Heilbronn, Germany, which he accompanied with his own dry critical commentary:

> I made a sketch of the turnout. It is not a Work, it is only what artists call a "study"—a thing to make a finished picture from. This sketch has several blemishes in it; for instance, the wagon is not traveling as fast as the horse is. This is wrong. Again, the person trying to get out of the way is too small; he is out of perspective, as we say. The two upper lines are not the horse's back, they are the reins; there seems to be a wheel missing—this would be corrected in a finished Work, of course. That thing flying out behind is not a flag; it is a curtain. That other thing up there is the sun, but I didn't get enough distance on it. I do not remember, now, what that thing is that is in front of the man who is running, but I think it is a haystack or a woman. This study was exhibited in the Paris Salon of 1879, but did not take any medal; they do not give medals for studies.

The author of *The Adventures of Huckleberry Finn* (1884), as well as *The Adventures of Tom Sawyer* (1876), *The Prince and the Pauper* (1881), *A Connecticut Yankee in King Arthur's Court* (1889), and *The Tragedy of Pudd'nhead Wilson* (1894), short stories, travel sketches, and memoirs, Twain was born Samuel Langhorne Clemens in 1835 in Florida, Missouri, and died in 1910 in Redding, Connecticut. Twain's father died when Twain was eleven, and the boy was forced to work to help support his mother and siblings. At seventeen, after four years' training, he traveled the country working as an itinerant printer. At twenty-four, after another four-year apprenticeship, he became a licensed Mississippi River pilot. Twain headed west when the Civil War stopped river traffic, first to Nevada, and then to California, where, at a mining camp, he heard the story that became "The Celebrated Jumping Frog of Calaveras County," which brought him national recognition. A successful career as a travel writer and lecturer followed. In the 1880s, after some bad investments, Twain went bankrupt but worked until he paid off every creditor. He lived to see two of his three daughters and his wife predecease him.

Right: Mark Twain. Self-portrait

From original copperplate. Berg Collection of English and American Literature, the New York Public Library, Astor, Lenox and Tilden Foundations

Opposite: Mark Twain. Leaving Heilbronn

From *A Tramp Abroad* (1880). YCAL at the Beineke Rare Book and Manuscript Library, Yale University

JOHN UPDIKE

John Updike's childhood passion was cartooning, although he admits, "I drew not for the sake of drawing, but to get into metal—to have the work of my hand be turned into zinc cuts and by this means printed." That ambition was realized at Harvard where he cartooned for, then edited, the *Lampoon*. By graduation he had "pretty well given up on becoming a cartoonist. It took too many ideas, and one walked in too many footsteps. Writing seemed, in my innocence of it, a relatively untrafficked terrain." Nonetheless, he continued with art studies following his summa cum laude graduation in 1954, and spent a year (1954–1955) as a Knox Fellow at the Ruskin School of Drawing and Fine Art at Oxford.

In his 1989 memoir, *Self-Consciousness,* Updike speaks of suffering from the social and economic failures of his father, a science teacher, as well as from feelings of shame about his chronic psoriasis. It was out of this suffering, he says, that his career choices were made. Driven to "avenge all the slights and abasements visited upon my father," and considering his skin condition to foreclose ordinary, "presentable" jobs, Updike was determined to become

> a craftsman of some sort, closeted and unseen—perhaps a cartoonist or a writer, a worker in ink who can hide himself and send out a surrogate presence, a signature that multiplies even while it conceals.

Updike's writing is distinguished, in Cynthia Ozick's words, by its "visual and painterly" style: "His effects are of sheen and shadow, color and form, spine and splay, hair and haunch." In 1997, reflecting on his life as a writer and artist, Updike wrote:

> I dislike drawing now, since it makes me face the fact that I draw no better, indeed rather worse, than I did when I was twenty-one. Drawing is sacred to me, and I don't like to see it inferiorly done. A drawing can feel perfect, in a way that prose never does, and a poem rarely. Language is intrinsically approximate, since words mean different things to different people, and there is no material retaining ground for the imagery that words conjure in one brain or another. When I drew, the line was exactly as I made it, just so, down to the tremor of excitement my hand may have communicated to the pen; and thus it was reproduced. Up to the midpoint of my writing career, most strenuously in the poem "Midpoint," I sometimes tried to bring this visual absoluteness, this two-dimensional quiddity, onto a page of print with some pictorial device. But the attempt was futile, and a disfigurement, really. Only the letters themselves, originally drawn with sticks and styluses and pens, and then cast into metal fonts, whose forms are now reproduced by electronic processes, legitimately touch the printed page with cartoon magic.

Updike was born in 1932 in Shillington, Pennsylvania. He is the author of books of poetry, novels, short stories, collections of essays and criticism (many on art and artists), children's books, a play, and memoirs. His fiction has won the Pulitzer Prize, the National Book Award, the National Book Critics Circle Award, the O. Henry Prize, and the Rosenthal Award of the National Institute of Arts and Letters. He was elected to the National Institute of Arts and Letters in 1964 and the American Academy of Arts and Letters in 1977. On the staff of *The New Yorker* from 1955 to 1957, he continues to contribute essays, short stories, poems, criticism, and book reviews to the magazine.

John Updike. John Franklin Hoyer

1952. Charcoal on back of drawing pad cover, scored by dog claws. 20–1/2 x 17–3/4 inches. Courtesy of the artist

John Updike. Untitled (cartoon of runner)

1953. Courtesy of the artist

PAUL VALÉRY

*D*rawing," wrote poet, philosopher, and mathematician Paul Valéry,

is an act of the intelligence—It shows the mark of intelligence which is SUCCESSIVE APPROXIMATION and thereby, the taking to the limit not only of Likeness, but the harmony between the parts and the whole, between local and total likeness, and above all between likeness and overall expression.

Valéry, a polymath who, in addition to his writings on art and literature, absorbed the cutting-edge mathematics and physics of de Broglie, Einstein, and Maxwell, came to the conclusion that, "The best three exercises—the only ones, perhaps, for an intelligent mind are: composing verse; cultivating mathematics; and drawing." Their common appeal was due to what he considered their completely unnecessary natures, and the fact that they involved acts which exercised the mind in ways that entailed "imposed, arbitrary and rigorous conditions."

"All arts," Valéry wrote,

have the common goal of capturing Poetry; and they have particular, less elevated goals such as likeness in painting; interest in literature (i.e. the reader's involuntary participation in some adventure or description): rhythmic stimulus, enticing combinations of timbre in music, etc.

Drawing, he believed,

teaches how you pass from the unformed to the "formed"—And how a form is an act—a uniform correspondence, an act that comes about by means of points and lines, i.e. through muscular modifications which leave a visible and permanent trace.

In both poetry and art, Valéry emphasized the distinction between the *thought*, in the case of poetry, and the *thing*, in the case of drawing, and what the writer or artist brings forth:

Poetry should produce an impression of perfected thought. It isn't genuine thought. It should be to thought what a drawing is to the thing itself—a convention which recreates what is fleetingly eternal in any thing. . . . The art of seeing (in the sense of drawing and painting) is the opposite of seeing in the sense of *recognizing* objects. Similarly with literature, form results from the opposition between recognizing—(= understanding) and *perceiving*—the thing itself.

Ambroise Paul Toussaint Jules Valéry was born in Sète, France, in 1871, the son of a customs officer. He studied law but focused on poetry, which he wrote until 1892; then he stopped writing verse for twenty years, devoting his time to philosophical and mathematical investigations. In 1917, after five years of effort on the part of André Gide, Valéry published several long works, beginning with *La Jeune Parque,* which established him as the leading French poet of his day. At his death in 1945 in Paris—his funeral a state event—Valéry left behind, besides his poetry, essays, and a play, twenty-nine volumes of notebooks containing the record of his daily thoughts.

Paul Valéry. Le Lit Défait (The rumpled bed)

Ink on paper. The Artinian Collection, courtesy of Artine Artinian, with the kind permission of the estate of Paul Valéry

Paul Valéry. *Piazza Cavour*

Ink on paper. 4–3/4 x 7–1/2 inches. YCAL at the Beineke Rare Book and Manuscript Library, Yale University, with the kind permission of the estate of Paul Valéry

JANWILLEM VANDEWETERING

After attending Delft University (1948), College for Service Abroad (1949–1950), and Cambridge University (1951), future crime novelist and Zen Buddhist Janwillem Vandewetering worked odd jobs, drifted for six years, and was married to an artist in Cape Town, South Africa, who taught him pottery making and sculpture. After decades of world travel, Vandewetering settled in Maine where, having been inspired by the art of Papua, New Guinea, he began to make constructions. In a 2003 letter he told me:

> Never thought I could be visual artist until a head on TV talked to me. It said "in art you can do anything you want" and I thought Yes I'll make a rhinoceros. That was twenty years ago. The rhino, somewhat weathered, stills stands outside my writing studio, knee deep in meadow sweet. The rhino got into the local paper. After that I did some painting and the Ellsworth (Maine) coffee shop hangs and sells them. For good money too. Amazing.

Vandewetering added that, resistant to schooling, he reads to learn how to write, and looks to learn art:

> I visit museums and studios of friends. I don't ask them anything. Don't want to intrude. If the object is big, such as the Presences and their Dog, I hire a carpenter. Dance around the project for a few days and say "hey let's do this let's do that." Pull the whole thing to pieces when it doesn't go right. Start all over. No carpenter ever minded. On the contrary, they get drawn into the thing, have good ideas. Never underestimate carpenters. Christ was one. Although I'm more into Buddha & Co. I don't know whether those guys were handy. Too busy preaching about Nothing no doubt, like Seinfeld and George Carlin. I'm into them too. Amoral, that's the right attitude. Not immoral, being immoral is a waste of good energy. Being moral is another waste of good energy. Sympathetic detachment and a pot of green tea, that's the ticket.

> When there are no carpenters around I paint. Or draw. And don't think about whether I want to sell the stuff. I don't really want to anyway, but I run out of space. And money is okay. I don't mind money. It folds and fits my back pocket and makes young women smile, calling me Sir.

> I don't know how I ever became a writer or a visual artist. All my blood relatives are regular folks, except a cousin who flies an old airplane during weekends and a great grand uncle who was an archbishop (of Utrecht). One day I'll paint a portrait of Greatgranduncle. . . . Or maybe not. I can never control my art. The rhino, for instance, has very pink balls and the eyes of the dog who goes with the Presences aren't forgiving.

Before he began writing, at forty, Vandewetering was a businessman in South Africa, studied Zen in a Kyoto monastery, and became a policeman in Amsterdam. Born in 1931 in Rotterdam, he lived through the bombing of the city and occupation by the Germans, observed the abuse and deportation of his Jewish classmates. After two years in the monastery, Vandewetering returned to business, this time in South America, where he married Juanita Levy and had a daughter before moving to Australia. Because he had dodged the draft when traveling as a young man, he was told he could avoid arrest by serving in law enforcement for four years. The four stretched to seven when he became a sergeant and an inspector. After publication of two books about his monastic experiences and the first of his "Amsterdam Cop" series, Vandewetering settled in America, then spent eight years traveling the world in a lobster boat. His many million-selling police procedural novels—as well as his short stories, children's books, memoirs, and biographies—have been translated into twenty-five languages.

Janwillem Vandewetering. The Presences and Their Dog

The Presences: 2000; varnished scallop shells, stripped cedar branches, salvaged boards, cloth, house paint, and found materials; human size (male: 5 feet, 11 inches; female: 5 feet, 5 inches). The dog: 1999; cedar, driftwood plywood, Philippine seashells, blown-down tree, and paint; Danish dog size. Collection of the artist

Janwillem Vandewetering. Rhinoceros

1982. Driftwood, cedar branches and twigs. "True size" of a rhinoceros. Collection of the artist

VERCORS (JEAN BRULLER)

Famed French Resistance author Vercors had a degree in electrical engineering but worked full time as a graphic artist—a career that paralleled the literary one launched in 1941 when he was almost forty and wrote his first fiction. Besides his own published art, Vercors illustrated children's books, works by Shakespeare, **Kipling,** and Racine, and did set and costume design for the Comédie Française. There have been numerous international exhibitions of his art.

In his 1969 biography, *Vercors: écrivain et dessinateur* (Vercors: Writer and Artist), Radivoje Konstantinovic saw a similarity between the genius of Vercors and that of **Victor Hugo**. Observing that Vercors was exposed to Hugo's work and born on the hundredth anniversary of Hugo's birth, Konstantinovic implied that Vercors's careers as writer and artist were fated. In a commentary on Konstantinovic's text, Vercors dismissed such irrationality, and suggested that the author was taking him and his work too seriously:

> As far back as I can remember any books, they were [Hugo's]: the big popular illustrated edition that never left its place of honor in my father's library, or later in mine. It is bound in fine-grained red calfskin. Numerous illustrations were done by Hugo himself. That I became a writer and artist in my own right, the astrologers will not fail to see as a proof of the exactitude of their science. They will forget that I grew up with these books.

Published in 1926, Vercors's first collection of drawings, from which the examples

opposite come, was titled *21 practical recipes for violent death, for use by persons discouraged or disgusted by life for reasons that, all in all, are none of our business. Preceded by The little manual of the perfect suicide, by Jean Bruller, rider of the Nation's railways.* Responding dismissively to Konstantinovic's straight-faced analysis of the motives behind his work, Vercors insisted that his art was produced for very mundane reasons:

> first the desire to soften the heart (by means of humor) of a beautiful but indifferent woman; and then, only much later in having it published, that of making some money from it.

Vercors was born Jean Marcel Bruller in Paris in 1902, his father a Hungarian Jew who, at fifteen, had fled the anti-Semitism of Budapest. After service as a lieutenant in the French army in Tunis in 1940, Bruller chose the name Vercors for his new role as Resistance author and publisher during the German Occupation. He founded Editions de Minuit (Midnight Press) and clandestinely issued more than twenty anti-Nazi works. The first was his own novella *Le Silence de la mer* (1941; Silence of the Sea), a patriotic story translated into more than thirty languages, and adapted for film by Jean-Pierre Melville in 1949. Vercors produced dozens more novels, wrote and adapted dramas, and published books of his collected art, histories, essays, and memoirs. At his death in Paris in 1991, among the honors that had been bestowed on him were the Council of Europe Prize (1981), Commandeur des Arts et des Lettres, Légion d'Honneur, and the Médaille de la Résistance.

Above: Vercors (Jean Bruller). Du suicide par suspension par le col (Suicide by hanging by the collar)

1926. From *21 recettes pratiques de mort violente*. Courtesy estate of Jean Bruller Vercors

Above: Vercors (Jean Bruller). Du suicide par immersion prolongée totale (Suicide by prolonged total immersion)

1926. From *21 recettes pratiques de mort violente*. Courtesy estate of Jean Bruller Vercors

Opposite: Vercors (Jean Bruller). Chatiment du scandale éternel (Punishment of eternal scandal)

From the Artinian Collection. Courtesy of Artine Artinian and the estate of Jean Bruller Vercors

PAUL VERLAINE

The French poet Paul Verlaine had an early inclination toward art, and he described a childhood spent drawing:

I was particularly observant: I gazed at everything, no outward sight escaped me. I was endlessly in search of shapes, colours and shades. The daylight charmed me, and though I was a coward in the dark, I was fascinated by the night; I sought something in it, I am not sure what: whiteness, greyness, shades perhaps. I used to scrawl in pencil and spread crimson lake, Prussian blue and gamboges on every piece of paper that came to hand, which is commonly called a vocation for painting. I drew grotesque old men and coloured them ferociously; my characters were mainly soldiers whose anatomy consisted of 8 on top of 11, and women in great furbelows which were represented by incoherent flourishes.

Verlaine's "mania for blackening the margins of my manuscripts and the main part of my private letters with formless illustrations which flatterers pretend to find amusing" stayed with him into adulthood. Such marginal illustrations include a self-portrait on a letter preserved in the Archive of American Art at the Smithsonian Institute in Washington, D.C., and others held by the Bibliothèque Municipale of Metz and the Bibliothèque Nationale, Paris. Reproduced opposite are similarly small but more attentively drawn sketches—of a little girl, a country house, and a woman at a piano—from the private collection of Artine Artinian. Despite Verlaine's small opinion of his talents, he was persuasive enough to convince English schools to hire him to teach art, French, and classics. He taught from 1875 to 1877 in Stickney, Lincolnshire, and Bournemouth.

Symbolist pioneer Paul-Marie Verlaine was born in 1844 in Metz, France. The very spoiled only child of an absent career army officer father and an indulgent mother, Verlaine turned from drawing to poetry at fourteen, when he sent a poem entitled "Death" to **Victor Hugo**. Attracted by the bohemian lifestyle of Paris, Verlaine mingled with the Parnassian poets and developed an addiction to absinthe. His first collection of poems, published when he was nineteen, was financed by a female cousin he loved who spurned him for another man and died a few years later. At twenty-six, Verlaine married a sixteen-year-old with whom he had a son—a miserable marriage that he fled when he fell in love with **Arthur Rimbaud**, also ten years his junior.

After traveling widely, the two poets had an altercation in Brussels in 1873, during which the drunken Verlaine, despairing that Rimbaud would leave him, shot him in the wrist. Rimbaud pressed charges; Verlaine was convicted and served two years. While he was incarcerated, his wife divorced him, he read Shakespeare and Dickens, and found religion. Released, he was declined entry to a Trappist monastery and rebuffed by Rimbaud. He traveled to England, where he taught and produced *Sagesse* (1881; *Wisdom*), the second of his great works, the first being *Fêtes galantes* (1869). In 1886, he helped Rimbaud achieve fame by getting *Illuminations* published.

Verlaine descended into drunkenness following the death of Lucien Létinois, a favorite pupil whom he had adopted while teaching at the Collège de Notre Dame after his return to France in 1877. The rest of Verlaine's life was passed in poverty with frequent hospital stays. He died in Paris in 1896, in the home of Eugénie Krantz, one of several aging prostitutes who cared for him. Thousands turned out for his funeral.

Above: Paul Verlaine. Country house

From the Artinian Collection, courtesy of Artine Artinian

Above: Paul Verlaine. Woman at piano

From the Artinian Collection, courtesy of Artine Artinian

Left: Paul Verlaine. Child standing

Pen and ink. 2–1/2 x 2–3/8 inches. From the Artinian Collection, courtesy of Artine Artinian

ALFRED DE VIGNY

There is no record of France's great Romantic writer Alfred de Vigny having studied art or, indeed, having produced art beyond a few singular drawings, such as "Dante and Friend," the pen-and-ink reproduced here from the collection of the late Artine Artinian. Presumably he learned from his mother, who was an accomplished artist and whose fine portrait of her son in uniform is held by the Musée Carnavalet in Paris.

Vigny biographer Arnold Whitridge recounted how one drawing was created in a moment of high drama. The incident occurred during Vigny's military service, when an adjutant was blown up by an accidentally ignited barrel of gunpowder and Louis XVIII made an appearance the next day without rendering any compensation for the dead man's family. Vigny protested the callousness of royalty by making a drawing of the corpse.

Vigny was born Alfred Victor, Comte de Vigny, in 1797 in Loches, France, into a family bearing an aristocratic name but impoverished after the revolution. The only surviving child of a sixty-year-old wounded veteran father and a forty-year-old mother, he was enrolled at the age of ten in a day boarding school, of which he retained only memories of miseries endured. His persecuting companions would ask if he was an aristocrat because of the "de" before his name. Vigny would reply, "Yes, I am. Then they would set upon me. I felt that I belonged to an accursed race, and that made me somber and pensive." At seventeen, he followed his father's example and became a second lieutenant in the army, assigned to guard the king. He received regular promotions but saw no action and, bored, retired from the military in 1827.

During a military leave in 1825, Vigny married Lydia Bunbury, the daughter of a wealthy Englishman, his mother having forbidden him to marry for love. His wife never learned French, and became an invalid without bearing him any children; worse, her father's remarriage after becoming widowed cost Vigny his inheritance. Active in the theater as a successful playwright and translator of Shakespeare, in 1831 Vigny took a prominent actress, Marie Duval, as his mistress. By the time he was forty, personally unhappy and embittered at seeing other writers achieve greater recognition, he made a retreat into a private life that was famously remarked upon by poet and critic Sainte-Beuve. In an 1837 poem, Sainte-Beuve compared **Hugo** and Vigny, applied a Song of Solomon neck-as-ivory-tower simile to Vigny, altering its meaning to suggest disengagement from the everyday—asserting that Vigny had made a discreet withdrawal to his "ivory tower"—thereby coining the now commonly used metaphor.

A poet, novelist, essayist, and dramatist, Vigny was elected to the Académie Française in 1845. Besides his poetry, he is probably best remembered for a novel containing studies of poets who suffered misfortune, *Stello* (1832), twenty-two chapters of which address the execution of poet André Chénier during the Reign of Terror; his still-performed play *Chatterton* (1835), which elaborates on themes in *Stello,* portraying the poet as without a home in industrial society; and *Servitude et grandeur militaires* (1835; *Military Service and Grandeur*), a tribute to the unquestioning obedience, sense of duty, and loyalty of the victimized common soldier.

Vigny died in Paris in 1863, after having at last found a loving relationship with a woman forty years his junior. She gave birth to their son a month after his death.

Alfred de Vigny. Dante and Friend

Ink wash. 6–5/8 x 9–1/8 inches. The Artinian Collection, courtesy of Artine Artinian

KURT VONNEGUT

You're supposed to do it all. That's what it is to be human and to dance."

Literary icon Kurt Vonnegut created images—in paint, ink, and aluminum sculpture—that shared the black-humored, understated, and fantastic sensibilities of his writing. His simple pen drawings first appeared as ironic accompaniments to text in his novels, most notably in *Breakfast of Champions* (1973). After participating in an exhibit of artwork by writers, Vonnegut produced a series of more than one hundred drawings on parchment, a portion of which appeared in a 1983 solo show at New York's Margo Fiden Gallery. In 1997, Vonnegut announced that *Timequake*, his nineteenth novel, would be his last and that painting was now his creative outlet. He began to produce prints, making images on acetate, which are then silkscreened by his collaborator, Joe Petro. In 2000, a show of Vonnegut's paper works was held at the Elaine Benson Gallery, Bridgehampton, New York, and a show of his print work and sculpture was at R. Michelson Galleries, Northampton, Massachusetts.

Vonnegut played down his talent—"What I am is a picture designer"—but he did not dismiss the value of his creations:

> I asked the famously effective satiric draftsman Saul Steinberg if he was gifted. He said he was not, but that the appeal of many graphic works of art was the evident struggle of their creators with their obvious limitations.

Vonnegut insisted in a 2000 interview with me that

> It's just perfectly ordinary for writers to do this—I mean, I might have been a writer and a golfer, too! Imagine being two things at once!

Never having taken a formal art class, he implied that he inherited his skills from others:

> I hung out with artists enough and I had enough friends who were artists, and my father was an artist, and my grandfather was an artist, and my sister was a gifted artist. . . . So it's

nothing radical. It's as if I took over the family gas station—this is what we do.

Moreover, he added, the "utterly irresponsible" pleasure of creating visual art comes with its making—as compared with the satisfaction of the novelist, which comes when he hands the book off to the publisher:

> I asked many people more committed than I am to the making of pictures by hand when it was that their art gave them the most satisfaction. . . . All replied without hesitation that they were at one with the universe when making a picture in perfect solitude.

The author of novels, plays, short stories, and essays, Vonnegut was born in 1922 in Indianapolis, Indiana, his father and grandfather both architects. His mother committed suicide on Mother's Day in 1942, when Vonnegut was home on leave from the air force. Taken prisoner by the Germans, he lived through the firebombing of Dresden. His sister, Alice, died of cancer hours after her husband was killed in a train crash, and Vonnegut adopted their children.

Vonnegut died in New York City in 2007.

SOME OF THESE ARE GALAXIES.

27/65

Right: Kurt Vonnegut. Smerdyakoff.

Two-color silkscreen. Edition of 99. 8–1/2 x
11–3/4 inches. Printed by Joe Petro III, 1996.
Copyright © 1996 Kurt Vonnegut. Image
courtesy of www.vonnegut.com

Opposite: Kurt Vonnegut. Some of
These Are Galaxies

Two-color silkscreen. Edition of 65. 11 x 15
inches. Printed by Joe Petro III, 2006. Copyright
© 2006 Kurt Vonnegut. Image courtesy of
www.vonnegut.com

DEREK WALCOTT

A legacy of watercolors and oils, left by the father Derek Walcott never knew, imbued in the 1992 Nobel Prize-winning poet and playwright an early desire to "continue what he was doing." A related impulse, Walcott suggested to me in 2000, may have led to his life as a poet: Perhaps he wanted to be a writer "because my father died when I was one year old and my mother adored him."

Walcott was mentored by Harold Simmons, a professional painter who had been taught by Walcott's father. Simmons' studio was exciting to the young Walcott because Simmons "was a real artist and he was an example. . . . You saw paintings framed; you saw pictures of black women; you saw the landscape—what was around you—represented brightly and well by Harry."

Walcott was born in 1930 in Castries, St. Lucia. As a boy, he painted landscapes with a friend who became a church muralist. "It was a tremendous feeling," Walcott said, "nothing happier than going out together to go painting, especially if you had a bottle of very cheap muscatel, you know?"

Artistry is not a matter of inspiration for Walcott, but of craftsmanship:

> No seasoned artist ever expects trumpets and a visionary light saying, "Go now to the studio." You just get up and you do your work as if you are a mason or a carpenter. . . . You get an immense kick out of painting for ten minutes, and then you realize it's hard. You can fake a poem for a long time, because you're just talking to the surf.

In a 1997 lecture, Walcott hypothesized that "all art has to do with light":

> Whatever the art, it's based on light. I think plays are based on light—not on lighting, but on light. And that the real thing is—the back of every artist's intention, I think, is an intention towards representation of light. . . . The greatest writers have that quality of light and so do the painters. It's there in Milton, in the Greek poets, in the Romantics.

Walcott believes the goal of writing and painting is to create art "without a cloud of identity." Dante's writing is an ideal, he says, with "nouns so simple and so radiant, that he becomes an invisible writer."

> I think there's something missing in me as a painter and that may simply be a gestural thing. . . . I may approach painting too meticulously. The joke that we share between my friend and me is that I paint like a Methodist. He paints like a Catholic.

By which Walcott says he means that he's given to "a logical Protestant approach to things," and not the "wilder, semi-blasphemous swipe at things." Walcott's paintings are held in the collection of the National Trust of St. Lucia and were shown in a joint exhibition with Donald Hinkson's at the University of New York, Albany, in 1998 and a solo show at the June Kelly Gallery, New York, in 2005.

Derek Walcott. Seascape of St. Lucia

1983. Watercolor. 9 x 12 inches. Collection of the author. Courtesy of the artist

Derek Walcott. Boats on St. Lucia

1983. Watercolor. 9 x 12 inches. Collection of the author. Courtesy of the artist

EVELYN WAUGH

Satirist Evelyn Waugh's youthful ambition "was to draw, decorate, design and illustrate." Images were a source of pleasure to him in a way that words were not: "I worked with the brush and was entirely happy in my employment of it, as I was not when reading or writing." Early on Waugh showed talent, to some extent familial—an uncle and grandmother were accomplished watercolorists—and by the time he was eighteen, he saw drawing and painting as a metaphor for life. In a 1921 diary entry, he wrote:

> We are all painting or drawing our lives. Some with pencil, weakly and timidly. . . . Some use ink and draw firmly and irrevocably with strong, broad lines. Some of us use colour, rich and lurid, layed on in full glowing brushfuls, with big sweeps of the wrist. Some draw a straggling haphazard design, the motive being eternally confused with unnecessary and meaningless parts. . . . But some, and these are the elect, draw their design cleanly and fully. No part is unnecessary. . . . Each part works into the whole and there is no climax or end to it.

Waugh was one of the elect, drawing (and living his life) with "strong, broad lines." His skills were in constant demand during his years at Oxford. He designed covers for school magazines, book jackets for a publisher, and engraved bookplates for friends. Besides taking private courses in woodprints, Waugh studied figure drawing at Oxford's Ruskin School of Drawing and twice exhibited at the Oxford Arts Club. He did caricatures of the undergraduates, and his prints appeared in the *London Mercury* and the *Golden Hind.*

Thinking to make art his career after Oxford, Waugh enrolled in 1924 in Heatherley's School of Fine Art in London. He became disillusioned, however, first by the school, which aimed at turning out commercial rather than fine artists, and then by himself. "I had neither the talent nor the application—," he wrote, "I didn't have the moral qualities."

Waugh did not stop drawing, and he did illustrations and covers for his books. The dust jackets for *Decline and Fall* and *Vile Bodies* were his, as were the illustrations for a limited edition of *Black Mischief* reproduced here. Based on Waugh's experiences as a journalist in Abyssinia, the 1932 novel satirized colonialism.

Arthur Evelyn St. John Waugh was born in Hampstead, England, in 1903, his father a prominent literary critic and publisher. Waugh had a happy childhood, marred only by jealousy of his older brother Alec (later a bestselling writer himself), whom he thought was better loved. Waugh, a prodigy, wrote a short story at seven, which was published with a collection of his adult work. At Oxford, he contributed both art and text to university publications, but an uninterested student, he left after his third year, burdened with debt. After quitting art school, he found teaching positions, but was fired from three of them in two years. He began drinking heavily, attempted suicide, and eventually started writing. His stories were first published when he was twenty-four and, after writings about **Rossetti** and the Pre-Raphaelites, he published at twenty-five his highly regarded premier novel, *Decline and Fall.*

The author of thirty-six largely black-humorous and satiric books, Waugh is best remembered for *Vile Bodies* (1930), *Brideshead Revisited* (1945), and *The Loved One* (1948). He died in 1966 in Combe Florey, Somerset, England.

Evelyn Waugh. Viscount Boaz and Mme Fifi Fatima Bey at the Victory Ball at the Perroquet

C. 1932. Ink. 11 x 6–1/4 inches. Reproduced from the original edition of *Black Mischief,* copyright © 1932 Evelyn Waugh. Rare Book and Manuscript Library, Columbia University. By permission of PFD on behalf of the estate of Laura Waugh

Evelyn Waugh. Basel rode to Gulu

C. 1932. Ink. 11 x 6–1/4 inches. Reproduced from the original edition of *Black Mischief*, copyright © 1932 Evelyn Waugh. Rare Book and Manuscript Library, Columbia University. By permission of PFD on behalf of the estate of Laura Waugh

Evelyn Waugh. Destination unknown

C. 1932. Ink. 11 x 6–1/4 inches. Reproduced from the original edition of *Black Mischief*, copyright © 1932 Evelyn Waugh. Rare Book and Manuscript Library, Columbia University. By permission of PFD on behalf of the estate of Laura Waugh

PETER WEISS

*B*esides writing and painting, Peter Weiss illustrated books and dust jackets, designed stage sets, and made films. His first creative successes came as an artist, but he was encouraged to pursue literature, as well as art, by **Hermann Hesse**, the hero of his adolescence, to whom he sent examples of his work in both disciplines. Weiss was twenty-one when he made his first long journey from Czechoslovakia to Switzerland to visit Hesse, and later, after Weiss had completed a year at the Art Academy in Prague, the older writer bought several of Weiss's paintings and hired him to hand-copy and illustrate two of Hesse's stories.

Although he received at least one award at the art academy, Weiss's painting—influenced by the sixteenth-century Flemish masters—was not of great interest to a Prague art circle in the grip of the Surrealists, Expressionists, and Dadaists. Nonetheless, by 1941 he was exhibited in Stockholm (where he had settled, taught art at the university, and did art therapy with prison inmates), and for the next five years in shows throughout Sweden. Dissatisfied with the static nature of the painted image, Weiss turned to filmmaking in experimental, Surrealistic styles. In his autobiographical *Abschied von den Eltern* (1961; *Leavetaking*), Weiss described how his writing was affected by his visual orientation:

> [W]hen the words had passed, shapes would appear, first as patches on the retina consisting of coloured dots, then gradually expanding into shapes, objects, figures. Before the images faded I often examined the activity in the photographic dark-room of my eyes, directed my pupils to the window so that its brightness and spars of shadow penetrated the lenses, then closed my eyelids and laid my hand in front of them. The negative appeared and changed into various tints according to the colour of the sky. By briefly blending new images I could vary the reproduction in the interior of my eye or develop it into a clear positive.

Weiss was born in 1916 in Nowawes, near Potsdam, Germany. Although his Jewish father converted, and Weiss was raised a Lutheran, German anti-Semitism forced the family to flee to London in 1934. Seventeen-year-old Weiss was left bereft that year by the death of his younger sister Margit, an event that deeply influenced his writing and art. In 1936, his family relocated to Czechoslovakia. Over the strenuous objection of his parents, Weiss left his father's factory to study art in Prague. An alien to the culture, he lived an isolated life, with no knowledge of the language. In 1938, the invading Germans forced another relocation, this time to Sweden, where his father had preceded him. Weiss's non-Jewish mother, less threatened, stayed to pack up, in the process destroying what Weiss considered to be his most important paintings. He was devastated by her actions, which deepened an already longstanding estrangement between them. Of his highly philosophical and political literary works—plays, novels, essays, translations, journalism, and the three-volume *Die Ästhetik des Widerstands (The Aesthetics of Resistance)* published between 1975 and 1981—the best-known are his dramas *Marat/Sade* (1964) and *Die Ermittlung* (1965; *The Investigation*). Among his many awards were Tony and Drama Critics' Circle awards for *Marat/Sade* in 1966, the Heinrich Mann Prize of the East German Academy of Art for *Die Ermittlung* in 1966, and a posthumous Büchner Prize from the German Academy of Language and Literature in 1982. Weiss died that year in Stockholm.

Peter Weiss. Town Life

1942. Oil on board. Private Collection/Phillips, the International Fine Art Auctioneers/Bridgeman Art Library. Copyright © 2007 Artist Rights Society (ARS), New York/BONO, Stockholm

DENTON WELCH

Novelist Denton Welch was seventeen, and had just returned to England from a year of travel through China, when he enrolled at Goldsmith's School of Art in suburban London. The school, he wrote, had been chosen for him "by my aunt, because she had once bought a print from the man who taught wood engraving there. The journey out to it was long." And his experience when he finally arrived, was disappointing:

> The main part was devoted to the training of school teachers, so I would run down a long, dark passage till I reached the stairs which led to the art school. I would climb up as quietly as possible, for I was usually late, get my drawing-board and pencil, and glide silently into the antique room. Students already astride their 'donkeys' would glance up at me, then down again. They seemed both curious and uninterested. I was too new to have any friends. I thought that they would talk about me, but not to me. Sometimes, there were only two or three girls in the room, and then they would talk about men, as if I were just another plaster cast. I was left to get down on my paper something that looked a little like the Hermes of Praxiteles.

Welch became an accomplished artist, and contributed illustrations to *Vogue* magazine. Although most of his paintings are in private collections, his writings, notably his second novel, *In Youth Is Pleasure* (1945), contain his illustrations. He also did the cover of his first novel, *Maiden Voyage* (1943)—shown opposite with its frontispiece—and his story collection, *Brave and Cruel and Other Stories* (1948).

Maurice Denton Welch was born in 1915 in Shanghai, where his grandparents—English on his father's side, American on his mother's—had established shipping and trading businesses. Welch's father was emotionally distant, but his adoring mother kept her son always by her side during extensive travels. She failed to consider his education until he was nine, however, when, unable to read, he was enrolled in a girls' school. At eleven, Welch suffered the death of his mother, who had recently put him in a school aligned with her Christian Scientist beliefs. At fourteen, he entered Derbyshire's Repton School, which his brother attended, but found it unendurable and ran away. He later spent a year of travel in China with his father and brother, which became the source of much of the material in *Maiden Voyage*. Struck down on his bicycle by an auto when he was twenty, Welch suffered major injuries, including a seriously fractured spine, which led to chronic health problems that would plague him until he died in 1948, at thirty-three, in Middle Orchard, Kent, England.

During his post-accident recuperation, when he turned from painting to writing because he could no longer stand for extended periods, Welch met the artist Walter Sickert; Welch's 1942 article about their encounter was his first publication. *In Youth Is Pleasure* was a groundbreaking novel in the genre of gay autobiographical literature, and Welch was acknowledged "without hesitation" by **William S. Burroughs** to be the writer who "most directly influenced my own work."

Opposite, left: Denton Welch. Frontispiece for *Maiden Voyage* (1943)

Berg Collection of English and American Literature, The New York Public Library, Astor, Lenox and Tilden Foundations

Opposite, right: Denton Welch. Front jacket cover for *Maiden Voyage* (1943)

Berg Collection of English and American Literature, The New York Public Library, Astor, Lenox and Tilden Foundations

T. H. WHITE

Novelist, poet, essayist, and translator T. H. White thought his painterly skills had arisen as a counterbalance to his feelings of inadequacy:

Compensating for my sense of inferiority, my sense of danger, my sense of disaster, I had to learn to paint even, and not only to paint—oils, art and all that sort of thing—but to build and mix concrete and to be a carpenter and to saw and screw and put in a nail without bending it.

Near the end of his life, he explained his entire extraordinary history of creative, scholarly, and physical achievements as motivated by childhood trauma, or, to be precise, by the feelings of insecurity and anxiety engendered by the end of his parents' marriage, when he was fourteen: "This meant that my home and education collapsed about my ears, and ever since I have been arming myself against disaster. This is why I learn."

Piloting airplanes, deep water diving, riding show jumpers, driving fast cars, proficiency at games, shooting with guns and bows and arrows—these were some of the physical things his "compulsive sense of disaster" inspired. He clearly felt the same impulsion toward intellectual achievement: "I had to get first-class honours with distinction at the University. I had to be a scholar. I had to learn Medieval Latin shorthand so as to translate bestiaries."

He was born Terence Hanbury White in Bombay in 1906, the only child of a violent, alcoholic father who was serving in the Raj as a district superintendent of police. Taken ill, White was brought to England by his parents to live with his maternal grandmother, while his father returned to India. At fourteen, with his mother back in India as well, White was sent to a military school. He later studied at Cheltenham College, Gloucestershire, and Queens' College, Cambridge, and worked as a tutor and teacher. Unable to cope with his homosexuality, White resigned his position as head of the English department of Stowe School, Buckingham, exiling himself to a cottage, where he wrote in seclusion and poured his energies into a wide range of physical and mental challenges, not least of which was farming his land. He lavished his affections on an assortment of pets that included dogs, badgers, owls, falcons, and snakes.

In a 1944 letter to his friend L. J. Potts, White declared that, "If I had the courage to switch over, I would stop writing books and try to earn a living as a painter." He wrote of a year of "painting pictures without pausing for breath," depicting his artwork in fantastic terms:

I have got to a stage when I stick glass eyes on them with putty, and silver tinsel for eyelashes, and they look horrible. They are oils. . . . One of them is an OVIPAROUS CREEPER. It crawls about on its hands, in a poisonous Prussian blue light and has laid an egg. It has leaves like a castor oil plant. The other is a NEVERGREEN. It flies about on mercurial feet, with red leaves straying between flamingo and beetroot, and its flowers have feathered wing.

Of White's dozens of books—stories, novels, poems, essays, histories, and translations—it is his novel *The Once and Future King* (1958) and his children's book *The Sword in the Stone* (1938) for which he is remembered. *The Once and Future King* was adapted as the musical and the movie *Camelot*. White died in Piraeus, Greece, in 1964.

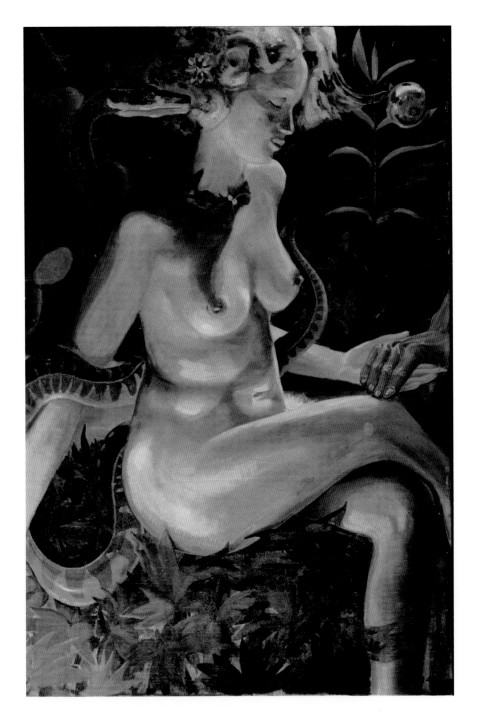

T. H. White. Eve

1949. Oil on canvas. 35–3/8 x 23–5/8 inches.
Harry Ransom Humanities Research Center Art
Collection, The University of Texas at Austin,
with permission of David Higham Associates for
the estate of T. H. White

RICHARD WILBUR

Poet Richard Wilbur's gift for drawing was an inherited talent and began early in life. In a 2001 letter to me, he wrote:

My father was a portrait artist, and my mother came from a family of journalists. It's not surprising that, all through my younger years, I drew pictures, and imagined that I might end as a newspaper cartoonist—doing a strip like *Krazy Kat,* or political cartoons like those of Fitzpatrick, Duffy or Art Young. I was also drawn to writing from an early age, and ultimately put my main energies into poetry, because it was poems that I did best, and poems in which I could give my sense of things most fully.

The best thing about my drawings had been their representation of bodily motion—I had a certain knack for making figures run or throw or dive—and there is in my poems a like taste for the strong expression of movement, whether it be physical movement or the movements of thought and feeling. Anthony Hecht once wrote a fine little essay on that aspect of my work.

A chancellor of the American Academy and Institute of Arts and Letters and of the American Academy of Arts and Sciences, Wilbur is not only a poet, critic, and translator—most notably of Voltaire, Molière, and Racine—he is a lyricist for composers such as Leonard Bernstein (*Candide* in 1956) and William Schuman (1958's "On Freedom's Ground" cantata), and an award-winning author and illustrator of children's books. The drawing opposite is taken from *Opposites, More Opposites, and a Few Differences* (2000),

a compilation of his children's books. Wilbur believes that pictures are the essence of poetry:

In most poetry, phanopoeia or picture-making is the primary means, though expressive sound and rhythm are essential. Whether or not one has had an artist father, or drawn pictures, the visual will be dominant in one's poems.

The second poet laureate of the United States (1987–88), Wilbur was born in 1921 in New York City. When he was two, his father moved the family to rural life in North Caldwell, New Jersey, and Wilbur attended Montclair High School, where he wrote for the school paper. At Amherst College, he edited the school newspaper and contributed to the student magazine. Wilbur began writing poetry while serving in the army in Europe during World War II, primarily, he says, to relieve boredom. His poems—spiritual, philosophical, and tightly controlled—are also emotionally evocative, being grounded in, to use the title of his third book of verse, the "things of this world." Wilbur earned a master's degree in English at Harvard after the war, and began a long career as a teacher—at Harvard, Wellesley, Wesleyan, and Smith.

Among the many honors he has received are the Pulitzer Prize and the National Book Award for *Things of This World* (1957), the Pulitzer Prize for *New and Collected Poems* (1989), Bollingen prizes for his translation of *Tartuffe* (1963) and his poetry collection *Walking to Sleep* (1971), a 1983 Drama Desk Award for *The Misanthrope* (1983), and the Chevalier L'Ordre des Palmes Académiques (1983).

A DIFFERENCE

How is a room unlike a moor?
They're not the same, you may be sure.
A room has walls, a moor does not.
Inquire of any honest Scot
And he will say, I have no doubt,
That one's indoors and one is out.
A room, then, fits inside a dwelling;
A moor is its reverse in spelling,
And has such wild outdoorish weather,
Such rocks, such miles and miles of heather
All full of flocks of drumming grouse,
You wouldn't have one in the house.

Richard Wilbur. A Difference

Drawing and poem. Collection of the artist

TENNESSEE WILLIAMS

Arguably America's finest playwright, Tennessee Williams painted throughout his life, and told his friend Robert Hines that he'd taken "art instruction with his 'childhood sweetheart' in St. Louis, when they were teenagers." By the 1970s, Williams was exhibiting his works in the galleries of Key West, Florida, selling some for as much as $2,500. In later life, he turned from writing and expressed himself exclusively in artwork. At least one of his paintings was used as cover art, for his book of poems *Androgyne, Mon Amour* (1977). In *Tennessee Williams: An Intimate Biography,* his brother Dakin Williams and Shepherd Mead describe his art:

> A Williams could be, for instance, in "pencil and oil" or "pencil and acrylic." They often have a pale, almost etiolated look. One of them for sale (price $2,000) at the time the authors were in Key West, was a 1978 portrait of Robert Carroll, titled *Esprit de Robert;* another, with an almost Gauguin-look and lots of tropical foliage, was called *Au Jardin des Palmes,* and another was a self-portrait of Tennessee with Robert Carroll.

Although most of Williams's work is in private hands, the Harry Ransom Center at the University of Texas, Austin, and the Rare Book and Manuscript Library at Columbia University hold large collections of his paintings.

Among Williams's enduring dramas are *The Glass Menagerie* (1944), the Pulitzer Prize-winning *A Streetcar Named Desire* (1947) and *Cat on a Hot Tin Roof* (1955), *The Night of the Iguana* (1961), *Suddenly, Last Summer* (1958), and *Sweet Bird of Youth* (1959), for which he won four Drama Critics' Circle Awards. Williams also authored the novels *The Roman Spring of Mrs. Stone* (1950) and *Moise and the World of Reason* (1975), as well as poetry, essays, three volumes of short stories, his memoirs, and seven screenplays.

Williams was born Thomas Lanier Williams in 1911 in Columbus, Missouri. His father, a traveling salesman, was largely absent, and provided no home for his family until Williams was seven. He then moved his wife and children to St. Louis, where he'd taken a job with a shoe company. Williams's emotionally unstable mother later wrote that her husband was a crude drunk. While Tennessee and Rose, his sister and closest friend, were still in their teens, she suffered a mental collapse, and was institutionalized for life. It was then, he later wrote, "that I began to find life unsatisfactory as an explanation of itself and was forced to adopt the method of the artist of not explaining but putting the blocks together in some other way that seems more significant to him." His father taunted his homosexual son for being a "sissy," and forced him to drop out of the University of Missouri to work in a shoe factory. Williams endured three years of misery until he had a physical breakdown. He later attended Washington University in St. Louis, and received a degree from the University of Iowa in 1938.

After decades of dependence on alcohol and drugs, Williams died in New York City in 1983, when he accidentally inhaled a bottle cap and was asphyxiated.

Tennessee Williams.
Le Voyageur Des Reves
(The Dream Traveler)

Oil on canvas. 29–1/2 x 23–3/4
inches. Tennessee Williams Papers,
Rare Book and Manuscript Library,
Columbia University. Copyright ©
2003 the University of the South.
Printed by permission of the
University of the South, Sewanee,
Tennessee

WILLIAM CARLOS WILLIAMS

William Carlos Williams began painting as the unanticipated consequence of showing up on Sundays to visit a friend from his medical school days, an older painter "who had a daughter, Dorothy, of marriageable age":

> My delight was in going down to the old boy's second floor, north-light studio and sitting there all Sunday afternoon while he'd work putting in his trees and cows with a low-toned sky in the background, over and over the same thing. At first I used to sit and hear him talk until one day he said, "How about trying it yourself? Here, I'll set you up a canvas," which he did. "Here are some clean brushes, here are the colors"—at which he jammed a handful of other brushes, hairs in the air, into a small jar and placed it before me—"There, paint that!"

Although he was a physician and head of pediatrics at Paterson General Hospital in New Jersey, Williams believed medicine was not an interference with his writing, but his "very food and drink, the very thing which made it possible for me to write." The occupations of doctor and writer were "two parts of a whole," complementing each other:

> The physician enjoys a wonderful opportunity actually to witness the words being born. Their actual colors and shapes are laid before him carrying their tiny burdens which he is privileged to take into his care with their unspoiled newness.

"Colors and shapes," were of central importance to his aesthetic. Critic M. L. Rosenthal observed that "Williams had far more of a painter's eye than do most poets," and Williams himself, looking back at his early efforts as a poet, saw his struggle as closely allied with the painters. Impressionism, dadaism, surrealism applied to both painting and the poem. What a battle we made of it merely getting rid of capitals at the beginning of every line!

The turning point for Williams came when a friend, working at an art gallery, responded to an important customer who asked what was in the corner of a painting she was about to buy. After inspecting the area he answered, "That, Madam, is paint." Art was no longer to be appreciated "as a copying of nature," Williams said, but "as the imitation of nature, spoken of by Aristotle in his *Poetics,* which has since governed our conceptions." The poem was an object which, "like a symphony or a cubist painting" and "every other form of art," makes "its case and its meaning by the very form it assumes."

Williams was born in 1883, and died in 1963. Apart from European travels, he lived his entire life in Rutherford, New Jersey. While studying at the University of Pennsylvania School of Medicine, he met poets H. D. (Hilda Doolittle) and Ezra Pound, who became his enduring friend and mentor. A poet, novelist, short story writer, playwright, and essayist, Williams created a distinctly American poetic, using colloquial speech and rhythms, and focusing not on themes or symbols but on seeing the world as it is—"no ideas but in things," as he wrote in his five-book poem, *Paterson* (published serially between 1946 and 1958).

Among the many awards bestowed on Williams were the National Book Award for *Selected Poems and Paterson III* (1950), the Bollingen Prize (1953), and a posthumous Pulitzer Prize (1963). He was also named Consultant in Poetry to the Library of Congress in 1951, but lost the coveted honor because of supposed Communist associations and his friendship with the pro-Fascist Pound.

William Carlos Williams. Passaic River

Oil. 14–1/2 x 19 inches. YCAL at the Beineke Rare Book and Manuscript Library, Yale University. Copyright © 2007 Paul H. Williams and the Estate of William Eric Williams. By permission of New Directions Publishing Corporation

WITKACY (STANISLAW I. WITKIEWICZ)

The father of Stanislaw Ignacy Witkiewicz (Witkacy) was a painter in the naturalist style who insisted his son paint the same way, and the boy's early works were traditional landscapes. But as the young Witkiewicz was becoming Witkacy, the merged name he gave himself to mark his independent life, he began to paint in a grotesque form, exaggerating and distorting his figures. Eventually he arrived at a theory of Pure Form that argued for images completely divorced from representation as the way to achieve art's objective of awakening its viewers to a sense of wonder and spirituality. The practical need to support himself and his wife, however, led him in 1925 to abandon such artistry for a business of commissioned portraiture he named the S. I. Witkiewicz Portrait-Painting Firm. Some of those portraits, done only of friends and for free, like Helena Bircula-Bialynicka's reproduced here, were created under the influence of hallucinatory drugs and signed "Witkacy." ("Witkiewicz" was reserved for the more conventional works.)

Witkacy published a sardonic, somewhat tongue-in-cheek set of "Rules" for the firm in 1928, which established five categories of portraits. These ranged from the "'spruced up' type . . . with a certain loss of character in the interests of beautification" to those "executed with the aid of C2H5OH [alcohol] and narcotics of a superior grade." In the latter style,

> Subjective characterization of the model, caricatural intensification, both formal and psychological [i.e., that approach "abstract composition, otherwise known as 'Pure Form'"] are not ruled out.

In a series of essays on his use of nicotine, alcohol, cocaine, peyote, morphine, and ether to release his creative powers, Witkacy insisted that his plays and novels were drug- and alcohol-free, but he acknowledged doing portraits—which he considered merely "a psychological pastime"—under the influence:

> [A]lthough I do not favor drug-induced states for their own sake, in the portraits I painted in just such states I accomplished on a very small scale what I never would have been able to do without that stimulus. I simply point out that I do not consider these compositions finished works of art but as belonging to a completely distinct genre.

Witkacy wrote art theory, philosophy, metaphysics, novels, and plays. Along with **Jarry**, **Mayakovsky**, and **Artaud**, he was one of the leading figures of avant-garde theater in the twentieth century. He was born in Russian-controlled Warsaw in 1885 to Stanislaw Witkiewicz, a painter and writer who was a major cultural figure in Poland, and Maria Pietrzkiewicz, a music teacher. Educated at home, Witkiewicz was painting, playing the piano, and writing comedies at seven. His father attempted to control the boy's life, insisting that he eschew companions not worthy of him and focus on a life of spirit, intellect, and transcendence of his base nature. Witkacy seems to have lived his life and produced art in negative reaction to his father's influence. Suicidal ideation began to thread through Witkacy's life and works after his fiancée killed herself, with his gun, in 1914. Caught between the invading Germans and Soviets in Jeziory in 1939, Witkacy killed himself by slashing his wrists and throat.

Above: Witkacy (Stanislaw I. Witkiewicz). The Creation of the World

1921–22. Oil on canvas. 45–1/4 x 67 inches. Lodz, Muzeum Sztuki

Left: Witkacy (Stanislaw I. Witkiewicz). Portrait of Helena Bircula-Bialynicka

1927. Pastel on paper. 24–7/8 x 18–7/8 inches. Lodz, Muzeum Sztuki

TOM WOLFE

Tom Wolfe's determination "to be a writer or an artist when I grew up" came, he said in a 2002 interview with me, by the age of six or seven, from watching his agronomist father write a regular column for industry and from what he admits was a "desire for the attention." At eight, he received the only art instruction of his life. It was "during the Depression," he recalls, "at a WPA art class in Richmond, Va., taught for twenty-five cents a week by some excellent artists, I would realize years later." One of Wolfe's paintings from the school's annual show, "a scene of naval warfare at night," was printed in the local newspaper "and compared, tongue in cheek, I assure you, to the work of Matisse, probably because the contours of my boats meandered." The success inspired further effort: "I drew and painted a great deal after that and learned anatomy using boxers from *The Ring* magazine as my models."

As a journalist, Wolfe found a way to exploit his talents as an artist:

> My first journalistic appearance came when I covered a murder trial as a reporter for the *Springfield* (Mass) *Union* and also did courtroom drawings. I continued reporting and illustrating against daily deadlines for the *Union* and, in due course, *The Washington Post* and the *New York Herald Tribune*. Incidentally, I can assure you that drawing and writing have very little to do with each other. In court, for example, you can't listen to testimony while you're drawing, and you can't draw while you're listening. It's maddening.

In addition to his illustrated journalism and his illustrated collections of essays, Wolfe's drawings were collected under the title *In Our Time* (1980). He has had one-man shows at the Maynard Walker Gallery, the Tunnel Gallery, and the Forbes Gallery, all in New York City, and at Hillsdale College in Michigan.

Born Thomas Kennerly Wolfe, Jr. in 1931 in Richmond, Virginia, Wolfe is a journalist, novelist, essayist, artist, and, at all times, scathing social critic. He uses the techniques of fiction to make his New Journalism vivid, and journalistic truths to create realistic fiction. His bestselling works include *The Right Stuff* (1980); the novels *Bonfire of the Vanities* (1987), *A Man in Full* (1998), and *I am Charlotte Simmons* (2004); and his essay collections *The Kandy-Kolored Tangerine-Flake Streamline Baby* (1965), *The Painted Word* (1975), *Mauve Gloves & Madmen, Clutter & Vine, and Other Short Stories* (1976), and *The Purple Decades: A Reader* (1982). He has written for *The Washington Post*, the *New York Herald Tribune, New York, Esquire, Rolling Stone*, and *Harper's*.

A cum laude graduate of Washington and Lee, with a Ph.D. in American Studies from Yale, Wolfe has won many awards and honors, including the Washington Newspaper Guild Awards for foreign news reporting and for humor, the American Book Award and the National Book Critics Circle Award, the Harold D. Vursell Memorial Award for excellence in literature from the American Institute of Arts and Letters, the Columbia Journalism Award, a D.F.A. from the Minneapolis College of Art (1971), a citation for art history from the National Sculpture Society (1980), a D.F.A. from the School of Visual Arts (1987), and honorary doctorates from Johns Hopkins, Washington and Lee, St. Andrews Presbyterian College, and the University of Richmond.

Tom Wolfe. Melting Pot

1980. From *In Our Time* ("New York"). Courtesy of the artist

Tom Wolfe. Ted Kennedy

1980. From *In Our Time* ("Portraits"). Courtesy of the artist

WILLIAM BUTLER YEATS

William Butler Yeats's father, a lawyer turned portrait painter, trained his children as artists. Yeats described his first experience of death, sitting with his sister after their younger brother had died: "[V]ery happy, drawing ships with their flags at half-mast high." The senior Yeats achieved real success, however, only with his younger son, Jack Butler Yeats, who became one of Ireland's greatest painters. William Butler wrote in his autobiography of his father's role:

> I was at the Art schools in Kildare Street, but my father, who came to the school now and then, was my teacher. The masters left me alone, for they liked a very smooth surface and a very neat outline, and indeed understood nothing but neatness and smoothness. A drawing of the Discobolus, after my father had touched it, making the shoulder stand out with swift and broken lines, had no meaning for them; and for the most part I exaggerated all that my father did.

Yeats did not, however, care for his father's emphasis on realism:

> When alone and uninfluenced, I longed for pattern, for pre-Raphaelitism, for an art allied to poetry, and returned again and again to our National Gallery to gaze at Turner's "Golden Bough."

But his father was insistent:

> [M]y father would say: "I must paint what I see in front of me. Of course I shall really paint something different because my nature will come in unconsciously." Sometimes I would try to argue with him, for I had come to think the philosophy of his fellow-artists and himself a misunderstanding created by Victorian science, and science I had grown to hate with a monkish hate; but no good came of it, and in a moment I would unsay what I had said and pretend that I did not really believe it. . . . In my heart I thought that only beautiful things should be painted, and that only ancient things and the stuff of dreams were beautiful.

A mere handful of Yeats's artworks have survived, and most are to be found in the collection of the National Gallery of Ireland. Two that are not—a pastel of the lake at Lady Gregory's home Coole Park, and an invitation—are reproduced here.

Born in Dublin, Ireland, in 1865, Yeats dominated the verse of the twentieth century, wrote Ellmann and O'Clair in *The Norton Anthology of Modern Poetry* (1973), "as Wordsworth dominated that of the prior." Active in promoting an Irish literary revival, Yeats and Lady Gregory founded the Irish (later the Abbey) Theatre, where he was its first main playwright. Rejecting the Protestantism of his parents and the Catholicism of Ireland's majority, he cultivated a faith based on the pagan beliefs and legends of Irish folklore. He received the Nobel Prize for Literature in 1923, when the majority of his work was as a playwright, and his greatest work as a poet was still before him. Yeats died in Roquebrune-Cap-Martin, France, in 1939.

William Butler Yeats.
My Dear Moirae

Drawing/invitation. Courtesy of Special Collections, Northwestern University Library. By permission of A. P. Watt Ltd. on behalf of Gráinne Yeats, Executrix of the Estate of Michael Butler Yeats

William Butler Yeats. Lake at Coole

Pastel. 6–¾ x 9 inches. Private collection, Massachusetts. Photo by Vince Guadazno. By permission of A. P. Watt Ltd. on behalf of Gráinne Yeats, Executrix of the Estate of Michael Butler Yeats

Among the Missing

The following is a list of writer-artists not included in the main body of this book. Some were excluded because examples of their art could not be located; several because permission for reproductions could not be obtained; a few because there was insufficient evidence to determine if visual art was a significant part of their creative output. Also, some cartoonists and children's book authors were excluded simply because their genre was overrepresented. My hope is that a future, expanded edition may remedy these and other omissions. Any reader having information concerning artwork or a writer-artist I have overlooked is kindly requested to contact the author at www.donaldfriedman.com.

Jean Anouilh, the French playwright, did illustrations for an advertising agency early in his career and, later in life, painted watercolors. "For me," he said, "colour and shape are more agreeable than paper for bringing my demon to life. It is, anyhow, a less somber and happier activity."

Clive Barker, a popular fantasy and science fiction author, and creator of a series of slasher movies, is also a prolific artist whose paintings and drawings have been collected in *Visions of Heaven and Hell* (2005) and widely exhibited. Oil paintings of images from his subconscious inspired and illustrate a series of children's novels. "Abarat," the fantasy world Barker based on these paintings, has been purchased by Disney for prospective films.

Lynda Barry, an established cartoonist with a broad range of satirized subjects, achieved recognition as a writer with the novels *The Good Times Are Killing Me* (1999) and *Cruddy: An Illustrated Novel* (2000). She said the writing that had been going slowly "got faster when I figured out to write it very slow and very large and very neat. By hand. I made it so neatness counts."

William Rose Benét, a Pulitzer Prize-winning poet, studied painting and made one otherwise inconsequential drawing which inspired the first major assembly of writer art—the collection by Norman Holmes Pearson that Pearson dubbed "Art for the Wrong Reason," now housed at Yale's Beinecke Library. In a letter to Rue Winterbotham Shaw, curator of the 1971 Arts Club of Chicago show of writer art, *A Second Talent,* Pearson explained: "I suppose my collection began, as such, by chance. Bill Benét, when I was working with him on *The Oxford Anthology of American Literature,* gave me his picture of a strutting whale as a joke and something our daughters might enjoy."

Oswell Blakeston was as talented a visual artist as he was a novelist, short story writer, poet, and author of nonfiction books on cooking, travel, photography, and filmmaking. His paintings, created with a unique method involving materials that crystallized on the painting surface, are represented in public collections. Blakeston was also a filmmaker, who, with photographer Francis Bruguière, created the significant early abstract film *Light Rhythms* (1930).

Elizabeth Bowen studied at the London County Council School of Art, but withdrew after concluding that her ability was limited. The novelist and short story writer later said, "It seems to me that often when I write I am trying to make words do the work of line and colour. I have the painter's sensitivity to light. Much (and perhaps the best) of my writing is verbal painting."

Paul Bowles, before he became a composer, novelist, translator, and photographer, aspired to be a painter: "When I had completed secondary school at sixteen, I enrolled in an art school. At the end of the first term, painting seemed silly, so I went to the University of Virginia because Poe had gone there." But he wrote from college to a friend: "I have painted four things since I came. The first was called 'Sacrifice' and was done in black and white. I sold it to a student. The second was a portrait of Virgin Mary, which shocked everyone. The third was 'Nausea,' and the fourth 'The Poet.' You will undoubtedly be amazed at my new style, which is almost monochromatic and extremely heavy." He later insisted that none of his youthful artwork had survived.

Elizabeth Barrett Browning, the Victorian poet, has no known history as an artist, but a couple of her drawings—most notably of her spaniel, Flush, who is the titular subject of a Virginia Woolf "biography"—are in the Berg Collection of the New York Public Library. Her poet husband, **Robert Browning,** began as an artist and musician, but no example of his art could be located.

Karel and Josef Capek were brilliantly collaborative brothers who painted and wrote poetry, novels, and plays. They left their native Czechoslovakia in 1910, Josef for Paris to study art and Karel for Berlin University. On their return to Czechoslovakia, the brothers, through their painting and writings, introduced Cubism to Czech literary and art circles.

Colette, who mined her scandalous life to produce the fifty-two books that made her one of the greatest French writers of the twentieth century, turned to painting toward the end of her life: "For half a century, I wrote in black on white, and now for nearly ten years, I have been writing in color on canvas." Despite photographs of her at her easel, and the record of a missing self-portrait in the collection of Artine Artinian, no works of hers could be located.

Dave Eggers, the author of *A Heartbreaking Work of Staggering Genius* (2000) and founder/editor/designer of the online zine *McSweeney's,* began as an artist: "When I was studying art, my paintings were representational and usually political. A lot of the paintings I did in high school, for instance, were about class, and I trained myself for ten years to be able to draw photorealistically. I wanted to be able to get there, and then distort, if need be. I wanted to do [Diego] Rivera-like murals, huge tableaus of the state of the country, etc. Somewhere along the way, I found that I was better able to make things look the way I envisioned with words—more so than with paint."

Louise Erdrich, the novelist and short story writer, has illustrated her children's books, most recently *The Game of Silence* (2005).

T. S. Eliot, at eleven, wrote and illustrated in pencil fourteen numbers of *The Fireside,* "A Weekly Magazine" containing "Fiction, Gossip, Theatre, Jokes and all interesting." While studying art at Harvard, he made graphite copies of museum pieces; the copies are preserved at the Fogg Art Museum.

Ronald Firbank, the eccentric impressionist novelist of the English decadents, sketched in the notebook he used for *Valmouth* (1918) and *The Princess Zoubaroff* (1920), and painted at least one seascape watercolor. The notebook and painting are in the Berg Collection of the New York Public Library, but no other art and or biographical references to it were found.

Zelda Fitzgerald, the beautiful flapper but mentally ill wife of F. Scott Fitzgerald, wrote stories, articles, and a novel—*Save Me the Waltz* (1932)—which are reprinted in *The Collected Works of Zelda Fitzgerald,* edited by Matthew J. Bruccoli (1991). Her paintings, exhibited in 1933 and 1934 in the Baltimore Museum of Fine Arts and in a Manhattan gallery, are reproduced in Peter Kurth's *Zelda: An Illustrated Life* (1996). Some of her art is also held by the Scott and Zelda Fitzgerald Museum, Montgomery, Alabama.

María Irene Fornés was a painter before she became a playwright and director. She studied with the abstract expressionist Hans Hofmann, who shaped her sense of character as well as informing the visual skills needed to direct: "So much of his class had to do with dynamic. The dynamic of two shapes. Two colors. Hofmann would call it 'push and pull.' Two colors next to each other have a certain dynamic. They affect each other. That kind of observation helped me a lot in playwriting. I was much more interested in dynamic than anything analytical the actor would say." Fornés did not preserve her paintings and cannot recall to whom she gave them.

Frederick Franck authored more than thirty books that, like his artwork, reflected a profound and abiding interest in human spirituality. His sculptures—of steel, glass, and wood—are displayed in public places around the country, and his paintings and drawings are in the collections of the Museum of Modern Art and the Whitney Museum of American Art in New York. He also created a six-acre sculpture park and meditation space, Pacem in Terris, which is open to the public near his home, about fifty miles north of New York City. A dentist by trade, Franck worked with Albert Schweitzer

in Gabon, and his experiences, captured in words and drawings, became the book *My Days with Albert Schweitzer* (1958).

Gabriel García Márquez has said that he started writing "by drawing cartoons. Before I could read or write I used to draw comics at school and at home. . . . My earliest recollection is of drawing comics and I realize now that this may have been because I couldn't yet write. I've always tried to find ways of telling stories and I've stuck to literature as the most accessible." The visual still informs his writing: "I suppose that some writers begin with a phrase, an idea, or a concept. I always begin with an image."

Judith Gautier, the eldest daughter of Théophile Gautier, emulated her father by pursuing a career as a writer while exhibiting great artistic talent, primarily as a watercolorist.

Eric Gill's religious and social thinking led him to conclude that everyone is inherently an artist insofar as he desires to create something and in so doing shows his love for God. After a couple of years of art school, Gill apprenticed to an architect, but, influenced by Carlyle, Ruskin, and the Fabian Society, he decided he preferred the less abstract life of a craftsman. He became a stonemason, sculptor, engraver, and designer of elegant typefaces.

Phoebe Glockner, arguably the best of a group of cartoonists who fictionalize their lives in their art, wrote the edgy roman à clef *The Diary of a Teenage Girl* (2002), and has published a critically praised collection of her art, *A Child's Life and Other Stories* (1998). Integrated into the *Diary* narrative are illustrations and cartoons.

Gail Godwin draws for herself—to assist her memory and her writing. The novelist wrote, "I keep a jar of colored pencils by my bed and often draw before I go to sleep or when I can't get to sleep. Little pictures of things I remember, or am trying to remember. . . . Or the prevailing mood of the day. Or my dreams—and nightmares. Or a fantasy or concept. . . . I also draw when I am baffled about some aspect of a character. Making a visual image of that character in action (such as evangelist Grace Munger getting her instructions from God in *Evensong*) almost always reveals something new."

Jorie Graham develops a poem with "almost always a sense perception of some kind"—frequently an image she's drawn herself: "I draw to make myself try to keep the act of looking physical—bodily. So you're not looking with your brain, you're looking with your body, to get it."

Louis Grudin was not only an acclaimed poet—his "Dust on Spring Street" was praised by William Carlos Williams as "the best poem written in my language in this generation"—but studied art at New York's Art Students League and the National Academy of Design; he earned his living as a freelance artist and editor.

Alan Gurganus, a childhood cartoonist, painted and drew into adulthood, stopping, he told me, because he was "afraid the writing would go into the art."

Ramon Guthrie, poet, novelist, and Dartmouth scholar, best remembered for *Maximum Security Ward* (1970), made Paris his second home when he arrived from New York at twenty-one. There he began to paint and write in the company of Modigliani, Giacometti, and Tristan Tzara.

Pete Hamill, enthralled with comics as a child, began studying at the Cartoonists and Illustrators School in New York when he was fifteen, but quit a year later to help support his family. After military service, he resumed art study on the G.I. Bill at Brooklyn's Pratt Institute and at Mexico City College, where Jack Kerouac and William S. Burroughs had just preceded him. After encountering the work of artist José Clemente Orozco, Hamill said, "it seemed an act of self-delusion to try and be a painter." He shifted his focus to writing, but still employs his skills as an artist in his fiction, frequently drawing characters before he writes about them.

A. M. Homes includes artwork, purportedly by her troubled protagonist, in *Appendix A* (1996), an elaboration on her controversial novel *The End of Alice* (1996). Besides painting, she writes on art, and has her Columbia writing students draw stories: "I wouldn't say there's a connection between making art and writing. But I have found that there are times when one can't find words and the act of painting, the use of gesture, color, abstraction, can

be quite liberating. The unfortunate thing is that I often don't allow myself the time to paint—it's become a luxury. I've known many artists, writers, and musicians who also work or play in other forms. Creativity seems best served when it isn't limited to a single expression."

Washington Irving left some inept, perhaps humorously intended, pencil sketches, which can be found in his manuscripts at the New York Public Library Manuscripts and Archives Division, and an amateurish self-portrait in the library's Berg Collection.

Shelley Jackson, best known for her hypertext novel *The Patchwork Girl* (1995), also writes and illustrates books on paper: "I have always drawn whatever I'm writing, the writing's the most important part of course, but when I'm trying to visualize a character, just spending an hour trying to construct their faces with a pencil, suddenly I can see where the writing's gone wrong."

Rona Jaffe, the author of *The Best of Everything* (1958), drew and painted in her youth, including cartoons for school publications and a U.N. newsletter. In the beginning of her writing career, she sold drawings to *The New York Times Book Review* and *The Saturday Review.* Jaffe, at thirteen, and artist Helen Frankenthaler were two of three students of Mexican painter Rufino Tamayo. In a 2005 letter, she told me: "His first words to me were: 'Make eet big!' So I made big oil paintings. One time he asked me how I was able to make so many disparate colors go together, since he had always found it difficult, and I said it was because I didn't clean my brush in between. (I didn't tell him that I didn't clean my brush because I was too lazy.) He said that was interesting, and he would try it. His next exhibit was the famous and much praised *Watermelons*, where critics said it was the first time he had used different, brighter colors. Draw your own conclusions." In recent years, Jaffe's work has been exhibited by Baird Jones, a curator of "celebrity art."

Henry James grew up in a family closely acquainted with many prominent New York artists, and the milieu seems to have inspired him and his older brother, William, to paint. As a child, Henry began illustrating scenes that he would write in a notebook—one page of illustration for every three pages of text: "I was capable of learning . . . to express ideas in scenes, and was not capable, with whatever patience, of making proper pictures; yet I aspired to this form of design to the prejudice of any other, and long after those primitive hours was still wasting time in attempts at it." The brothers studied with the same art instructor in New York, but William continued with Léon Cogniet in Paris and William Morris Hunt in Newport. When Henry attempted unofficial study with Hunt as well, he was consigned to copying casts in a separate room. Nothing remains of that experience, beyond what was translated into Henry's prose, yet he placed great value on it: "Frankly, intensely— that was the great thing—these were hours of Art, art definitely named, looking me full in the face and accepting my stare in return—no longer a tacit implication or a shy subterfuge, but a flagrant unattenuated aim." William's art survives, along with his monumental works in philosophy and psychology, but he wrote no fiction or poetry, and thus was excluded from this book.

Ted Joans, a Beat poet greatly influenced by progressive jazz, was born on a riverboat in Cairo, Illinois. His entertainer father put his twelve-year-old son off the boat in Memphis and gave him a trumpet. Joans stopped playing and started painting, earning a degree in fine arts from Indiana University. In 1951, he became part of the coffeehouse scene in Greenwich Village, and claimed he originated the "Bird Lives" graffiti that flourished after Charlie Parker's death.

Ben Katchor is a cartoonist whose talent is manifest in his bare-bones prose and artwork, combining to great effect in such New York-based graphic novels as *Julius Knipl, Real Estate Photographer* (1996).

Ken Kesey, an artist from his youth, combined art and text in his posthumously published *Kesey's Jail Journal* (2003).

Lawrence Lariar, editor and author of more than one hundred books, including mystery novels under the pseudonyms Adam Knight and Michael Lawrence, was a popular cartoonist, and for twenty years, cartoon editor of *Parade* magazine. Writer and cartoonist Charles Johnson credits Lariar with telling him as a boy that he could be anything he wanted and that Johnson's father was wrong to tell him he couldn't be a cartoonist because he was black.

Robert Lax created posters as well as poems. His work, shown at Kunsthaus Zürich, has been described as more a color-filled extension of his poetry than stand-alone art. His two closest friends were writer-artist-monk Thomas Merton and artist Ad Reinhardt.

Norman Mailer published cartoon faces with captions in *The New York Observer* and, despite denying any background or other involvement in art, published more than one hundred drawings in a collection titled *Modest Gifts: Poems and Drawings* (2003), whose avowed goal, in contrast to his "serious work," is "to offer the reader an easy pleasure." Admitting that "shading is beyond my means," Mailer described his art as "in a no-man's-land between caricatures and comic drawings."

André Malraux was an enthusiastic artist in his youth, drawing, painting in watercolor and oil, and modeling in clay. But when he ceased to head his class in art studies, his interest waned, and he directed his energies solely into writing. He once told an interviewer that he and his adolescent friends "were persuaded that a great writer, like a great painter, had to be 'maudit'—i.e., 'damned' in the eyes of a scandalized society."

Heinrich Mann was a far better artist than his kid brother, Thomas and, before World War II, was a more popular author. Discovered at his death was an archive of sexually oriented drawings now owned by the Feuchtwanger Memorial Library at the University of Southern California, Los Angeles. A catalog of an exhibition of those drawings was published by Steidl Verlag.

Thomas Mann, when twenty-one, collaborated with his older brother, Heinrich, on a hand-lettered, hand-drawn book as a confirmation present for their fifteen-year-old sister, Carla. They called the book "Bilderbuch für artige Kinder" (A Picture Book for Good Children). The future Nobel laureate did an ink drawing for the cover, as well as twenty-eight color pictures and forty-eight engravings. The illustrations, and the sixteen poems in the book, were intended as social satire, especially on the moral instruction given to children. The illustrations included *Das Leben* (Life), represented as a crass drunk, and *Mutter Natur* (Mother Nature), represented as a rapacious-looking slattern. The originals of these drawings were destroyed in the bombing of Munich, but H. E. Jacob, a longtime friend of Mann's and a student of his work, published several reproductions in *The New York Times Book Review* in 1950. There are no other known examples of Mann's artwork.

Robert Marshall says that writing and art were his means of escape from a misfit childhood he fictionalized in his novel *A Separate Reality* (2006). At Wesleyan, "not ready to say what I needed to . . . I studied art." After graduation in New York, he painted under the influence of Neo-Expressionism—"the idea that you could tell stories through paintings." "The story I told myself," Marshall says, "was that I would be the queer Eric Fischl." Frustrated by the interpretations placed on his images, he found greater control "over how my work was read" by using text: "Sometimes in the paintings, sometimes on the wall alongside them. So I was writing very, very short stories." More elaborated writing began with a fiction class at the New School in 1995, and Marshall's stories, poems, and essays appeared in a variety of publications thereafter. Pursuing parallel careers as writer and artist, he has experimented with the idea of "self-consciousness" in both forms. Using mirrors and reflective surfaces as the base for paintings, he creates shifting images that bring the viewer into the space of the visual narrative. In this, he says, "they share a certain quality with my writing: in both, I'm interested in uncertainty."

Guy de Maupassant decorated a least one letter with amateurish cartoons, and did a tightly rendered drawing of a well-dressed couple out for a stroll. Both are reproduced in de Ayala and Guéno's *Illustrated Letters* (1998).

Thomas Merton, a Trappist Monk best known for his autobiography, *The Seven Storey Mountain* (1948), and essays on the contemplative life, wrote poetry that was published posthumously, and left some eight hundred drawings now held by Bellarmine College, Louisville, Kentucky. Some of Merton's drawings were reproduced in his *Dialogues with Silence: Prayers and Drawings* (2001), edited by Jonathan Montaldo.

George Moore, the Irish novelist and art critic, studied art in Paris, where he became an intimate of many of the great Impressionists.

Although he loved art, his painterly aspirations had as much to do with youthful romanticism as with the desire for a career. He described his studio in Paris as essentially "tapestries, smoke, models and conversations." The visual arts quite consciously informed his literary efforts: he would ask his painter friends to illustrate a scene that he would then describe in words.

César Moro was a Peruvian by birth, but after emigrating to France in 1924, he encountered the Surrealist movement, which influenced his poetry—written largely in French—and his painting. In 1938, after a brief return to Peru, Moro moved to Mexico, where he was an organizer of the Surrealist Exposition of 1940. Although he ultimately moved back to Peru and remained there until his death, the perception that he had betrayed his native culture by writing in French, coupled with his open homosexuality, prevented his being published during his lifetime. Virtually all of his paintings were acquired by the Getty Museum in 2002.

Harold Norse, in his *Memoirs of a Bastard Angel,* describes starting to paint by throwing "colored Pelican inks at random on Bristol paper," which he then washed off in the bidet. He says the result was "a series of maplike drawings of outer and inner space in the most vivid colors and minutely precise details, as if they had been drawn by a master hand. . . . I allowed everything to happen, letting the laws of chance take over, acting as a medium through whom these colors, shapes, and designs could flow, dictated by whatever forces reside in the unconscious. With the feeling that I was charting new territory in the visual arts, I worked compulsively, calling the results 'Cosmographs'—cosmic writings." The Beat poet and novelist had his first one-man show in Paris, in 1961, at the Librairie Anglaise. Years later, when he learned that some Parisian painters were founding a school of Cosmograph art based on his methods, Norse christened it "Bidet Art."

Frank O'Hara, a New York School poet, wrote art criticism, curated for the Museum of Modern Art, and lived surrounded by artists—Willem de Kooning, Fairfield Porter, Larry Rivers, Phillip Guston, Alice Neel and others—for whom he sat or with whom he collaborated, contributing text to images they created. Their collaborations and a couple of O'Hara's own efforts are reproduced in the catalogue for the 1999 MOCA exhibition *In Memory of My Feelings: Frank O'Hara and American Art.*

Georges Perec, the Oulipo member who wrote lipogrammatic novels—*La disparition* (1969; *A Void*) was written without using the letter "e," and *Les revenentes* (1972) used only the vowel "e"—said he wanted to work in all fields of literature, including cartoons and comic strips. He covered his manuscript drafts with cartoons, sketches, and doodles, and did collages and typographical art.

Raymond Queneau, a founding member of Oulipo, mathematician, and self-proclaimed Pataphysician, drew and painted in addition to writing novels, poetry, and philosophy. A collection of his art, *Queneau: dessins, gouaches et aquarelles,* was published in 2003.

Katherine Anne Porter had a multiplicity of talents as a child—poetry and story writing (starting at six), dance, vocals, piano, and drawing. "It wasn't really dabbling," she wrote later. "I was investigating everything, experimenting in everything." There is no record of formal art study by Porter, during or after a desperately impoverished upbringing, but in 1921, she went to Mexico to catalog some eighty thousand pieces of folk art for a U.S. traveling show. That Porter drew well is apparent from her gracefully rendered ink portrait of poet Elinor Wylie, wife of William Rose Benét, who began the collection of writer art at Yale, where the drawing is held.

Carl Sandberg, influenced by the Arts and Crafts movement as a young man, designed, printed, bound, and decorated his books. *The Plaint of a Rose* (1908), an early handcrafted poetry collection, has a Sandberg cover that depicts a flower in the elegant Art Nouveau style—apparently a singular example of his artwork.

Siegfried Sassoon, the war poet, filled almost six hundred pages of notebooks with poetry, stories, watercolors, and crayon and pencil drawings before he was twenty-two. He was most gifted as a cartoonist, although at school he was taken with calligraphy, and throughout his life produced elaborate, handwritten books he also illustrated. Sassoon was also an accomplished pianist.

Marjane Satrapi wrote and illustrated the bestselling, four-volume autobiography *Persepolis* (2000–2003), which is presented as a graphic novel. Satrapi was sent away by her parents at fourteen to Vienna to escape the oppression of her native Iran. She writes and illustrates an op-ed column in the *New York Times*. Her most recent illustrated memoir, *Chicken with Plums* (2006), tells of her great uncle, a revered Iranian lute player.

Victor Segalen, a poet, writer, physician in the French navy, and archaeologist, was also an artist who illustrated, as well as wrote about, what he encountered in his travels to remote locales.

Maurice Sendak's bestselling books—especially the international classic *Where the Wild Things Are* (1963)—have a dark and serious psychological undercurrent, which touches so directly on the reality of the childhood experience that early reviewers worried about their appropriateness for the children. Sendak's view of childhood as a time of "disrupting emotions . . . fear and anxiety" was informed by his own self-described "miserable" childhood as a fat, overprotected, alienated kid, living in constant fear of death. His parents—immigrant Jews from Polish shtetls—raised him with a consciousness of their Old World lives, including the terror of the pogroms, and imbued him with their pessimistic outlook. According to his assistant, Sendak is indifferent to "further reproductions of his artwork," and so is not represented here.

Anthony Sher, a highly regarded actor, is also a novelist, screenwriter, memoirist, and artist. He routinely does drawings of the characters in the dramas in which he performs; a collection of them, titled *Characters: Paintings, Drawings and Sketches,* was published in 1989. Sher's inclination to art came early, his skill providing "some compensation for my failure with the rugby ball." After writing and illustrating *Year of the King* (1983), Sher at first felt he had broken a taboo by doing both. Then, he recognized how much the creative arts mix: "The theatre director without a painter's eye for composition will be the poorer for it, as will the playwright without a composer's ear for poorer for it, as will the playwright without a composer's ear for rhythm and melody."

Leslie Marmon Silko, the prominent female Native American novelist, is also a poet and a 1981 MacArthur Fellowship-winner, who has not stopped painting since she was a child. "Painting helps me when I hit a rough spot in my writing," she explained in a 2006 interview with the University of New Mexico's *Mirage* magazine, "and that's why I'm doing these big paintings right now. I'm having a big fight with it." Referring to a work in progress, "Blue Sevens," she added, "It's personal between the book and me. It's a very misbehaving novel, and until it can straighten itself up, I'm not going to waste my time on it." Silko told an *Alt-X* interviewer that, in 1986, she was so outraged over the election of a racist governor in her home state of Arizona she was unable to write, and only found relief by painting a graffiti snake on the wall of prominent building in downtown Tucson. "I kept painting and painting, and I decided, if I could make it work and look right, I could finish the novel. I worked for about six months, and the snake came, and a message came, and it was in Spanish: 'The people are cold, the people are hungry, the rich have stolen the land, the rich have stolen freedom.'"

Shel Silverstein was not only the brilliant cartoonist and illustrator of such popular children's books as *The Giving Tree* (1964) and *Where the Sidewalk Ends* (1974), but also a poet, composer, songwriter, musician, playwright, and screenwriter. He began writing and drawing as a teenager—it occupied him, he said, when girls ignored him—and cartooned in the military for *Pacific Stars and Stripes.*

Peter Sis is the MacArthur Fellowship-winning author-illustrator of children's books, honored with both the Newbery and Caldecott Medals. The Czech-born Sis is also an award-winning filmmaker, whose films are in the permanent collection of the Museum of Modern Art in New York.

Stephen Spender, a lonely, orphaned adolescent, was preoccupied with painting and writing in his childhood. Then, at twenty-nine, it occurred to him that he "might still become a poet and a painter, as others had done." He wrote: "I envied the painter's life—the way in which he is surrounded by the material of his art. A writer does not have a visible palette of words laid out before him into which he dips his pen, mixes them, and lays them on the

page. The painter can immerse himself in his work more than a writer, because painting is largely a craft, a sensuous activity with tangible material, whereas writing is largely cerebral." So he bought paint and canvas and tried: "The experience of painting brought home to me two lessons. One was that it is possible entirely to lack talent in an art where one believes oneself to have creative feeling. Banal as this may seem, it is difficult to realize that one can think a picture which one will never be able to paint. Even today I find myself thinking that if I had my materials I could paint some picture which is real in my mind's eye." Nonetheless, Spender continued to draw, and a very accomplished double portrait from one of his journals is held by the New York Public Library.

Carmen Sylva was the pseudonym of Elisabeth, Queen of Rumania. She wrote in German, French, English, and Rumanian, and was an accomplished pianist, singer, and painter.

Dorothea Tanning, the famous surrealist painter, has had a late-life career as poet and writer; she published her first novel at ninety-four.

J. R. R. Tolkien was an artist as well as writer, and a fine collection of his illustrations for *The Hobbit* and *The Lord of the Rings* was published in 1995 as *J. R. R. Tolkien: Artist and Illustrator*. In a lecture on fantasy fiction, Tolkien took the position that fantasy should not be illustrated but rather "left to words, to true literature." Given the obvious inconsistency with his own practice, one might infer the remark was tongue in cheek. "The radical distinction between all art (including drama) that offers a *visible* presentation and true literature," he said, "is that it imposes one visible form." For Tolkien, literature is "progenitive." It is also, paradoxically, universal and particular at the same time. "If it speaks of *bread* or *wine* or *stone* or *tree*, it appeals to the whole of these things, to their ideas; yet each hearer will give to them a peculiar personal embodiment in his imagination."

Leo Tolstoy was well known for his illustrated alphabet, which was widely used as a primer. For his own children, he would illustrate each evening's bedtime story. He also made for them a private edition of Jules Verne's *Around the World in 80 Days,* which he illustrated with amateurish line drawings. This artwork and other drawings, including a series of untitled portraits of old men, is housed in the Tolstoy Museum in Moscow.

Miguel de Unamuno studied with the painter Antonio María Lecuona and rendered portraits of family members, as well as local scenes in Salamanca. He also was skilled at origami, and drawings of his paper fabrications were given to friends and used in his novel *Amor y pedagogía* (1902).

Tomi (Jean Thomas) Ungerer has published adult and children's books and has produced, by his estimate, thirty to forty thousand drawings. Their subject matter includes social criticism, the macabre, and the erotic, and has brought him international renown.

Chris Ware is among the brightest lights of the new generation of graphic novelists, employing elegant and precise drawings, which he describes as "ideograms—drawn words, if that makes any sense." Ware's equally gifted writing led poet J. D. McClatchey to dub him the "Emily Dickinson of comics." *Jimmy Corrigan: The Smartest Kid on Earth* (2000) is a 380-page, nonlinear, illustrated narrative that utilizes the familiar cruelties of childhood and the special pain Ware experienced over his absent father. His father's poignant reappearance when the author was halfway through the book was incorporated into the story.

Diane Wakoski did artwork tipped into a book of her poems, but insisted she is not an artist and declined to allow reproduction here.

Philip Whalen, whose poetry and fiction were influenced by Eastern art and ideas, produced art in forms suggested by Chinese calligraphy.

Oscar Wilde, primarily a photographer, left behind at least one drawing, now held by the Harry Ransom Center in Austin, Texas: a well-executed pencil portrait of Florence Balcombe, a beautiful young woman Wilde courted as a student. "My photographs," Wilde said, "are now so good that in my moments of mental depression (alas! Not rare) I think that I was intended to be a photographer. But I shake off the mood, and know that I was made for more terrible things of which colour is an element."

La maison d'en face or That Other Art / WILLIAM H. GASS

Once upon a time, it was customary for educated persons to include both literature and painting in their studies, and to consider writing and drawing to be desirable skills. Some familiarity with a musical instrument was also expected. People communicated by letter, entertained at home with amateur recitals, and when traveling abroad recorded memorable moments in their diaries, or rendered notable sights through pencil, ink, and watercolor sketches. Music, painting, and poetry were graces expected of men and women of refined taste everywhere. The same hand might employ a pen or pencil to figure accounts, confess love, or depict a scene, and in most cases the hand's skills would have been learned in school as a matter of course. The hand was the carrier of music to the ear; it brought a thought out from the mind; it formed a figure for the eye. The pen and the brush resembled one another, paper and canvas were as twins, and each were worked upon or directed by educated fingers no less than the flute, the recorder, or the piano were.

A man might prepare his quill as carefully as he reamed and packed his pipe. Ready for his writing, like an artist in his atelier, he would have his knees soon under a desk's smooth resilient surface, and over his shoulder as good a light as might be managed. He'd have a bit of soft wax handy to him, a signet ring, a well of dark ink, sheets of heavy paper, dusting powder, dictionary (preferably on a stand), notable addresses, and often the letter which had provoked him into taking up his pen.

Characters would be formed with elegance and clarity, but the originality of the writer would not be neglected either. Words would not be thought, they would be made—made each time in a unique way, so that when Rainer Maria Rilke, for example, completed a poem, he sent copies to his friends in his own hand, for it was in that hand the poem was embodied, not in the impress of any indifferently repetitive machine. When Michelangelo Buonarroti writes to Giorgio Vasari to complain that a mistake has been made by Sebastiano Malenotti, the Clerk of Works, in the construction of the vault for the Chapel of the King of France and

to apologize for his absence from the site, which permitted the error ("if one could die of shame and grief I should not be alive"),[1] the drawing of the vault he includes in his letter, and the calligraphy of the text, will be equal in visual importance and refinement.

If one wrote words, one drew the letters which spelled them, and it was one of the most natural moves imaginable that the line should shape, sometimes, a face or a trouser leg, a barking dog or a fountain in a square, usually to amuse the recipient, as Thackeray liked to, with a satirical figure meant to underscore a wry remark: a man hung in the air by a nail through his pants (labeled suspense), or a grinning figure chasing another with a table fork. In Jean Cocteau's case, Pierre Chanel observed, drawing was the child of handwriting. "Poets don't draw," Cocteau wrote in his album, *Dessins,* "they unravel their handwriting and then tie it up again, but differently."[2]

Learning our letters was like looking into a crowd of strange faces. And then dreaming their meaning. "In Caïn, the diaeresis marking the *i* corresponds to a sort of rictus, a curling up of the chops revealing two pointed canines that jut out over the other teeth," Michel Leiris writes in that wonderful chapter on "Alphabet" in his memoir *Scratches.*

> Besides the letters with diaereses—which seem to represent vowels endowed with such a special stridency—there is the letter people call the "*c* cedilla" when they spell a word . . . ç . . . with its lower appendage (a little pig's tail or a crank like the one used by the owner of the store at the corner of Rue Michel-Ange and Rue d'Auteuil to maneuver the awning that protected his stall) . . .[3]

Wallace Stevens sees the Z as a kneeling man peering over a cliff, perhaps into the abyss. When I was a boy, if an 8 resembled a snowman's innocent shape, a fallen B drew a pair of boobs. An inverted Q was also obscene.

In a genteel educational atmosphere, pupils as errant as Edgar Poe or George Sand could be trained to produce polished sketches of loved ones, themselves not excluded. Poe used a crayon, and his portrait of his young wife, Virginia Clemm, is as soft as

swansdown. When George Sand's country house at Nohant was full of visitors, reading, writing, and drawing were among their principal amusements. In *Autour de la Table*, she vividly depicts the occupations of her guests:

> So much lunatic and ingenious scribbling—charming drawings or mad caricatures, painting in water-colour or tempera, the making of models of all kinds, flower studies from nature by lamplight, sketches dashed off from imagination or impressions of the morning walk, the preparation of entomological specimens, building of cardboard models, copying of music, somebody writing letters, somebody else writing comic verses, piles of wool or silk for embroidery, construction of scenes for the puppets, costume making for the same, games of chess or piquet—a hundred and one things. Everything that people do in a family party in the country, with talking going on all round, during the long autumn and winter evenings. . . .4

One can easily imagine Prosper Mérimée, with whom she had what's called a "fling," or Alfred de Musset, lover for longer, in such an environment, although their sketches have a bit more vibrancy than the academically rounded drawings of Poe (surprising for an orphan), or the quietly correct and rurally raised Charlotte Brontë. Along with the madcap pieces, like Alexandre Dumas fils at the easel, turning out canvases for eager customers (as if there were any), or the reverent portraits of friends (like that of Charlotte's of Lady Jersey, as delicate as tissue), there will be customarily found literal "studies" of flowers and leaves, animals and birds, where the accuracy of minute detail is clearly important to the writer who, in this moment, is a diligent student. Emily Brontë's watercolor of her mastiff is both loving and close, whereas her watercolor of a merlin hawk is only the latter. The tradition is continued by Harriet Beecher Stowe with her quite astonishing oil, *Snowy Owl,* which sits in a tree like a ghost in a thunder storm. In her "scientific" notebooks, Marianne Moore did a number of such drawings, among them a kingfisher, very carefully observed.

Thackeray's caricatures are particularly charming. Of course he was as surrounded by gifted cartoonists as a picnic by gnats, but his wit was never idle. There is one I particularly like, of a potato-nosed runt in a cocked hat seated in front of a mirror drawing, on a pad held in his lap, an image of his reflected self wearing a

satisfied smile. One might call it, anachronistically, the Escher effect, since the regress here begins with Thackeray's drawing on the page, proceeds to potato nose's image in the glass, and then to the sketch on the pad, since he was, of course, as surrounded by gifted cartoonists as . . .

Another simply gives crutches and an accountant's visor to a gouty cupid, or shows two swordsmen, already with lost limbs, simultaneously skewering one another.

Writers drew for study, sheer relief, or amusement, but also to make a kind of visual diary. They consequently produced many landscapes, and in Ruskin's case, for example, the architectural studies we might expect. Victor Hugo did weddings as though he had been hired, most of them in dark tones reminiscent of Goya. Goethe, who loved painting and "lived among painters," as he said, did an enormous number, but they are, for the most part, technically weak, formally conventional, and emotionally banal. Mediocrity is rarely daring, although incompetence may now and then do something which seems so. He founded two magazines to promote his views about art but neither of them had many subscribers or any significant impact. In addition, Goethe offered, for a while, an annual prize in painting which nobodies competed for and nobodies won. He favored the kind of high finish he could not achieve himself, and argued honestly though perversely that "it is really only possible to speak usefully of works of art in their presence"5 (he of course could never overhear what docents say, in front of no doubt embarrassed paintings, to fuddle the minds of art club members), a remark I call perverse because he stayed in Weimar most of the time where there weren't a lot of works to chat at, and had to rely on reproductions or upon his own—it's true—rather extensive collection.

Goethe had an exceptional mind, so that what he writes about art is always stimulating (although he is too relentlessly didactic for my taste), and he raises an issue we should take to heart in our considerations of "the dual muse."

> One of the most striking signs of the decay of art is when we see its separate forms jumbled together. The arts themselves, in all their varieties, are closely related to each other, and have a great tendency to unite, and even lose themselves in each other. But herein lies the duty, the merit and the dignity of the artist: that

he knows how to separate his own branch from the others, and to isolate it as far as may be.[6]

Unity, interaction, mingling, were fine when they took place in the mind of the artist, for Goethe had a vision of "the whole man" always before him, someone as universal in interests and accomplishments as he was. In the single soul let the winds of influence play, but not in order to produce a kind of mixed-media mush. Despite Goethe's disposition to encourage each art to seek its own kind of excellence, his novels were criticized for being too visual. "Time has turned him into a spectator," Mme de Staël wrote.[7] Still, of the three lives the Pythagoreans spoke about in their example of the Olympic Games—the participant, the hawker who sold refreshments and souvenirs, and the observer in the seats—it was the latter who received praise. The spectator knows because he sees, and he sees because he is not lost in participation, profiting, or talk, because you can't see and speak at the same time. Goethe, whose own powers as a conversationalist may have worn him out, admires paintings for their silence, since Nature is mute, too, and is content simply to be.

"The eye was the organ, *par excellence,* through which I apprehended the world."[8] It operates at the safest, greatest distance, and it does no material harm to its object. Scientists, as well as philosophers, have always favored the eye as the organ best designed to feed reason, but when it came to recording the results, language always won out. It was the scientific mind, I think, which led Goethe to produce his most striking image. While engaged in his studies on color, Goethe drew a woman's head, breasts, and shoulders, but inverted the colors which he normally would have used so that black replaced white, and so on, creating an image two hundred years would make modern: a black demoisellish face with blue cheeks, white eyes and nipples, straw colored hair, all ovalled in a black square big as night.

The drawing hand has not yet suffered the fate of its writing twin, although the computer is presently making threats. The quill was replaced by the pen, the pen by typewriters of increasing sophistication, and these, in turn, by word processors (as if meat were being made into Spam), undergoing upgrades so continuous and steep as to call for a new gear.

Books that once were copied in rooms full of scribes, who listened intently to a reader in order to write down what was recited, could not fail to possess, like birthmarks, errors of ear and understanding, idiosyncrasies of execution, and, in their scarcity, to be as prized as persons. It is still claimed that a writer's inner nature can be seen in the shape of her hand's "o"s and "e"s, the loops of her "y"s, the height of her "t"s. Nor, in English, was the difference, between the "letter" formed by the quill, and the "letter" put in the post, marked by a change in the sound of their nouns. Again and again, the writer, impatient with the abstractness of language, would pen a picture to a friend along with his verbal account, as Goethe, for example, did, when describing his workroom to a correspondent, or, in a letter to his mother, Henry James might include a quick sketch of his sister, Alice, knowing how much the likeness would please its recipient. When a gifted professional cartoonist like Winsor McCay includes images in his letters, as he does when writing to his soldiering son about the birth of his son's nephew, the arrangement of the drawings on the page, their dominance and casual capability, indicate that they are being executed by a different side of the dual muse.

When type and the typewriter arrive, they put an end to penmanship's expression of personality and emotion, to the effect of an impatient ink blot, the enlargement of a letter like "I", the darkening of the ink in a line, and all the rest of the singularities of formation Saul Steinberg has so wittily explored. The portable still permitted different levels of striking, and therefore a few of fury's symptoms could be given to the page, as well as the hesitations signified by X'd out words and other strikeovers. Games could still be played on the keyboard, and many were, but now there is a note of willed cleverness about them. More and more, they resembled advertising strategies.

Z...ipper.

Detectives were soon able to identify the very machine on which a ransom note had been typed, although the word had lost most of its individuality to the uniformities of type faces and to the mechanics of printing. The electrified model even eliminated hammering; words no longer fainted as the ribbons wore; and new methods of erasure left not a trace of one's first thoughts behind. Early versions disappeared as though they were political dissidents under Speed,

Ease, and Utility's tyranny. The poet lost the page. The materiality of the word might be heard like a distant bird, but the singer would never be seen. Now the Processor hums impatiently . . . waiting . . . waiting. Out of sight of our staring eye, fingers move like automatons, so that any sense of "making" is forgotten. Letters in fixed and often fancy fonts appear in front of our gaze as if they had simply been thought, to be erased by a change of mind, and to pop back into nothingness, as immaterial as spirit.

The hum of the machine, like a fan in a room, is meant to be ignored, but it nevertheless competes and often hides the music of our language. An E-mail message is as silent as a corpse. The single purpose of this computational invention is the safe and speedy management of complexity. One paradoxical result of the arrival of the Processor (there may be many) is that it reminds the poet that language is conceptual at its core; that it lives in neither space nor time; that it has no more materiality than a dit among dahs, or the flicker of energy in a proverbial wink, or spit through a telephone cable.

And so the poet is pushed into the realm of Forms, where language glows as ghosts glow, as insubstantial as the worm's light; and there the poet grows desperate, because the poet knows what Wallace Stevens wrote: that "beauty is momentary in the mind—the fitful tracing of a portal; but in the flesh it is immortal."9 This is the longing of the line: to feel "made," so that the word "paw" might leave a print in the snow that the hunting fox might follow: for which should provoke the greater fear? the hunger of the fox for its imagined prey, or the steady emaciations of the machine, a wasting away of the paw's print in the melting of the snow, and the disappearance, even—no longer under anything—of the field itself, the space of the page.

Before the hand made them, the mouth did; and before the eye saw, the ear heard. Books bulked like boxes; they contained their words: the handmade word was in a handmade world. Such a dream, as both Blake and Morris had, was not simply one of charming or silly idiosyncrasy. It was as spiritual as the Shakers were, as political as dissenters. When a culture is mechanically manufactured, as ours is, we become that curiously passive element in it called "a consumer." Objects come in multiples, are tailored to no particular taste, resist individuation, are created to be destroyed in the course of their use, and pass through the digestive tract of the collective population like the dung they resemble to the landfill they deserve. However, when one constructs—fashions—composes—weaves—shapes a thing the way a true artisan must, then a knowledge of the method of its making must be understood, the nature of the material appreciated and respected, a sense for standards developed, and one's own character improved, because no exercise of taste, skill, and intelligence is lost on either mind or body, but muscles our minds up as certainly as sawing wood strengthens our shoulders.

Sloppy characters signified a sloppy character, once, back when calligraphy mattered. A Japanese wood carver's relation to his tools, or the Chinese painter to his ink stick, was spiritual. Years of concentrated effort, study, meditation, preceded Qi Bai-Shi's magically translucent shrimp or his graceful depiction of the humble rake, accomplished in a few flicks. "I can look at a knot of wood till I am frightened at it," Blake once said.10

Inner discipline, individual mastery, have been transferred to the machine. The computer has done for the hacker what the motor car did for the adolescent: made them feel powerful and at least equal to anyone on the road or on the net.

God's word was written with reverence and art. The prophet's truth might be spelled out in a textile, adorn a dome, encircle a dish, be inked on parchment or carved in stone; and that impulse—to join beauty and truth in one realization—was occasionally retained by artists like Blake whose works aspired to a sacred status. Thuluth and Nasta'liq, two cursive forms of Arabic writing, are so lovely in themselves, it is hard to imagine their sensuous glyphs wasted on vulgarities. A page of the Koran can look so elegant, its message must be true. Inscriptions became decorations, and under them entire walls dematerialized.

William Morris's fine eye saw that the dignity of objects lay equally in their beauty and their use (not slaves but companions to one another); and the width of his genius was so vast, and his sense for the inner worth of all things so democratic, that he could without a qualm devote himself to wallpaper as well as poetry, to textiles as well as texts, to glass and rugs and lamps and tables, ensuring the eventual reduction of his reputation by realizing his masterpieces in the so-called lesser arts—in tile and stained glass, the design of fonts, the beauty of a binding—while achieving more modest goals in the grander ones. He understood

that a book is like a building, one of our sacred sort (cathedral, courthouse, museum, school, laboratory, library), and that to put ill-argued and uninformed texts into ugly containers may be a case of just deserts, to disgrace a fine text so is an instance of moral malfeasance.

If the poem is beautiful, shouldn't the page be? and a stanza as well appointed as the room the word refers to? and each line look as lovely as its song? Little poem, who made you? dost thou know who made you? gave you vowels—'o's all in a row—dost thou know? Bye and bye, O, was it I?

How well Jean Cocteau understood and loved the line. Elegant always, it traveled about its chosen nose as continuously as the nose actually was—like a cat or a dancer—gracefully balanced about some invisible point; for a curve is not like a slash which divides itself from its neighbors and ignores its past, but a curve constantly remembers where it was and celebrates the space which will arise when "where it will be" looks back at "where it's been." The skater at her compulsory figures must do the same: write a line on the ice with the poised penmanship of her body.

Like the word "nose," the drawn nose has a nose for its referent, and as much as the line which limns Colette's (a nose equivalent to her chin), may love its own path and do its duty by the writer, as it famously does, it must remain in Cocteau's hand, as if it were signing a check. "What is line?" Cocteau exclaims. "It is life. A line must live at each point along its course in such a way that the artist's presence makes itself felt above that of the model." The line must be itself, yet it must be Cocteau's line, and Cocteau's line must be Colette's nose.

> With the writer, line takes precedence over form and content. It runs through the words he assembles. It strikes a continuous note unperceived by ear or eye. It is, in a way, the soul's style, and if the line ceases to have a life of its own, if it only describes an arabesque, the soul is missing and the writing dies.[11]

Hugh Kenner, in his wise discussion of the art of Wyndham Lewis, points out that Lewis's "way commenced with the will and with the hand, not with an idea or an aesthetic or an effect; the will and the hand, he thought, were answerable to no one's notions of congeniality or of taste."[12] Milorad said, about Cocteau, that "his hand, somehow, drew by itself, without conscious direction.

Long before the Surrealists' famous "automatic writing," Cocteau had invented automatic drawing."[13]

The doodle may seem the closest thing we ordinarily understand to be automatic drawing. The treasurer's report drones on, a friend groans through the mouthpiece about his rough-tongued boss, a cabaret singer moans out a song about unrequited love, and our fingers fill our boredom with back talk—a geometric maze, a grimacing face, a scared cat, a blighted tree—but I think we tend to doodle away at the same designs—always bushy kitties, interlaced rectangles, grimacing gargoyles—the unconscious creating and repeating and refining the same symbol over and over again. These doodles are hardly examples (if there are any) of "free association." And sometimes an author will doodle back at his own text, as Dostoevsky does on pages of his novel, *The Devils.*

The hand is either its fist of fingers, or it is a paw pivoting at a joint, or the brush at the swinging end of a rod; so that one must distinguish among the sweeping strokes of the arm, the tighter turns of the wrist, and the hatches and scratches of the fingers. The unconfident artist may be reduced to small moves since, with short strokes, only small errors can be committed, and control is presumably under closer scrutiny than when the arm is in a generous wave. How far from caution are the sureties of the ink stick, or the arrogances of flicked or dribbled or flung paint?

The hand, however, needs more training than a dog, if it is—thoughtlessly—to do the right thing, and many writers, drawn to art in their early years (Théophile Gautier is a good case), found themselves no more willing to discipline their facility than most owners of animals are. Henry James, who had followed his brother, William, to the Newport studio of the fortuitously well-named William Morris Hunt, had his artistic inadequacies revealed to him one day when, after scratching away at a resemblance of a plaster cast of Michelangelo's *The Captive,* he wandered, for a break, into his brother's workplace to discover Willy sketching a naked cousin (fortunately one of the male ones) perched upon a pedestal. "I might niggle for months over plaster casts," he later wrote, "and not come within miles of any such point of attack" as his brother's drawing displayed. "The bravery of my brother's own in especial dazzled me out of every presumption."[14] If the pinnacled cousin had been wearing a proper coat and tie, perhaps the thought of an artistic career would not have seemed so daunting. James preferred

to remain on the hall side of the bedroom door, as Beerbohm's clever caricature depicts him, in puzzlement about a couple of pairs of shoes. Many years later, a witty little story, "The Tree of Knowledge," about a sculptor who never experiences such a revelation, but who goes on in ignorance of his ineptitude, reflects James' relief at no longer having to run after his older brother.

A decent education, a smidgen of talent, an indulgent parent, a sniff of sibling rivalry which was not removed by sneezing: these drew Henry along in William's wake, but it wasn't long before their true vocations found the brothers, and, as opposite as their directions seemed, they both spent their different lives in authorship. John La Farge, William's fellow student in the studio, consoled Henry by insisting that both painting and writing were forms of language, a position held by more than a few, mostly on account of the comfort of its vagueness.

The number of writers who considered or desired a career in art is a generous one. Some, like Gautier or Baudelaire, Mérimée or the Goncourt brothers, drifted from drawing to its criticism, went from painting to its press, and in that fresh arena found more monetary success than any art would grant them. The Goncourts were skilled copiers, doing for art what scribes had once done for books. They issued a series of reproductions, *L'Art du Dix-Huitième Siècle,* in 1875. It was a many-volumed collection of technically impeccable and highly-praised etchings representing the work of Watteau, Boucher, Greuze, Chardin, Fragonard, and their like, almost entirely engraved by Jules de Goncourt, of whom his biographer, André Billy, said "As a black-and-white artist, a water-colour painter and an etcher," Jules was "superior to most of those writers of his time, except Hugo and Fromentin, who like himself handled a pencil, a brush, or an etcher's needle."[15]

The Goncourts were writing a series of novels about "real" life (which meant whores, of course, and which got them into trouble with the bluenoses). Jules, upon the printing of his first etching, strikes three notes about our subject which will be recurrent:

> nothing in our life has taken such a hold on us as these two things: drawing formerly, and now etching . . . which makes you completely forget not only time but also the vexations of life, and everything else in the world.

The busy brothers are on "vacation." They are happy with their hobby. They are living for a moment in *la maison d'en face,* in a room which isn't lined with writing desks but has a window opening onto a garden.

> Never, perhaps, in any circumstances of our lives, [has there been] so much desire, impatience, or frenzy to arrive at the next day, and the success or the utter failure of the printing.

The process of making is like a new lover, never before encountered naked, nor so enjoyed.

> And to see the plate washed, see it blacken, see it grow clean, see the paper getting wet, and to set up the press and spread the coverings on it, and give the necessary two turns, this makes our hearts flutter in our breasts, and our hands tremble as we seize this dripping sheet of paper on which shimmers the misty semblance of a picture that has hardly taken shape.[16]

To have created a concrete image of the world, one which needs no translation, to watch it swell as though it were in your belly: to see born an interlace of markings—mean, you thought, and miserable—which nevertheless throws lines like those used to net fish around the actual objects of daily life; and not to have made with the mind's ineffable signs an invisible lady or an intangible city street or an imperceptible domestic tragedy—Hamlet's "words, words, words,"—but to see emerge "it"—"it"—so much itself a universal semblance that a native of Nigeria might in a moment's inspection say: "What funny clothes on this girl."

The exhilaration, the stimulation, the relaxation of the "other" activity, this new neighborhood: that's the first feeling. Old pros like Cézanne or Degas may agonize over every crayon slash or brush dab (as authors do over every word), but writers are only happy tourists here. "Did I do that?" authors repeatedly cry, in the high of a happiness the real artists of the art lost long ago, as long ago as innocence in the garden.

No one has ever made the two houses seem more duplexical or even whole and single than William Blake, who was unlike other men in so many ways as to raise doubts about his lineage. Blake was visited, not by oracular angels but by the figure of his dead brother, Robert, who offered him some very practical advice: how to publish his illustrated *Songs* without having to suffer the expense of letter-press. Instead of cutting into the copper plate, the line is

raised above it, in *relief,* as the process is called. Blake "painted" both words and images on the plate, and in so doing supported a supposition I have always enjoyed: that the medium *is* the muse, and that the deepest unities in the arts are achieved when the media are fused in a single skillful consciousness.

Peter Ackroyd's description of the process, in his recent biography of William Blake, shows how dexterity and craft and knowledge, employed upon materials lovingly appreciated, permit eye and mind and imagination to unite in the production of a work of art.

> He worked directly upon the copper plate as if it were a sketch pad. It is likely that his first purpose had been to execute engravings with the same freedom and inventiveness as drawings; the deployment of actual words upon the surface of the plate may have marked a second and decisive stage. His first step was to cut out plates from a large sheet of copper, using a hammer and chisel, and to prepare the surface for his labours upon it. Then he made out a rough design with white or red chalk and, with that as his guide, he used a camel-hair brush to paint the words and images upon the plate with a mixture of salad oil and candle-grease. This mixture resisted the aqua fortis (of vinegar, salt armoniack, baysalt and vert de griz purchased from the local druggist), which bit into the surrounding plate for three or four hours—this was normally achieved in two stages, so Blake could check upon the progress of the operation. After that time the words and images stood up, and stood out, as part of one coherent design. There were technical compli- cations that Blake, a very practical and intelligent craftsman, managed to overcome—the most important being that he wrote the words backwards with his quill, so that when the image was printed in reverse they would be the correct way round. He used various instruments to lend variety to his designs—among them quills, brushes of various thickness, as well as his own stock of engraving tools. After the plate was "bitten in," to a depth of approximately one-tenth of a millimetre, he used a conventional printer's ball of cloth to ink or black the plate with burnt walnut oil or burnt linseed oil; the plate was then gently printed on Whatman paper. Once the design had been produced Blake gave the paper a preliminary "wash" with glue and water, before

hand-painting the words and images with a "size colour" or "distemper" made out of water, colour pigment and carpenter's glue. As a result of the hand-colouring, too, every page of every "illuminated book" is unique.[17]

An easy facility is a doubtful gift. The hard-won wins. The two talents are rarely found in the same strength. Nor is a writer likely to take the time or expend the energy necessary to master another art. One alone gives enough grief. So language is likely to be penetrated by an author to a far greater depth than that which is constituted by color, line, and canvas. We remain satisfied, in the other house, with modest furnishings, and appreciate not having to suffer the cruelties of comparison, criticism, or our failure to reach perfection's always alluring, always illusory goal.

Chalk and copper, camel's hair, salad oil and candle-grease, the aqua fortis: each prepare the plate and disappear upon the paper where painted words and written images will rise, a vision of a vision on account of a vision—"all the gardens of delight swam like a dream before my eyes," Blake writes.[18] He waits to do the bidding of his angels. "[And] the moment I have written I see the words fly about the room in all directions."[19]

The painted word has now another space. It is as much an image as a muscle, for these words are not captions or balloons full of cartoon talk, or signs simply to be read the way we read inscriptions on buildings, they are the speech of the spirit, just as the frequently up-flung arms of Blake's figures are elements in a mystic rhetoric. I see the poem. I read the image. And although the dog a man may be walking can, on account of its character or kind, comment on its owner; man, dog, and leash live at the same level of being, and in the same land, and feel the pull of the leash as the leash does, though the leash, like the connection it creates and the control it exercises, is tugged upon from both its ends.

We might not have to learn a language in order to recognize a representation or grasp a piece of music, but learning to draw, especially to do caricatures, cartoons, or architectural renderings (as Hardy, Dos Passos, and Voznesensky did), is much like learning a lot of little squiggles which variously stand for eyes or feet or hats or walking sticks or wheels, or bricks, or trees, or bushes. If one turns out to have a little gift for it, then these conventional marks

can begin to speak with some wit, some insight, some suavity. It is nevertheless easy for neophytes to feel that they have simply added to their stock another language.

And it is cartoons or caricatures which we find most writers producing: satirical extensions of their satirical works, as in Thackeray's case, visual jokes like Eduard Mörike's church steeple as seen through a keyhole, or the several that demonstrate his fondness for designing leaves Adam might wear, or quick impressions of people or places in the decorative style of the time, like Djuna Barnes's drawings to accompany her newspaper interviews, sketches which keep one eye on her model, another on the vocabulary of the drawing book, while her nose remains appreciatively attentive to the fashionable scented figures pictured in contemporary magazines. Her smeared charcoal "impression" of Flo Ziegfeld is uncharacteristic of Barnes's early work, which tends to be done with broad stuttery ink strokes suggesting haste and improvisation, possibly to cover up a lack of skill and confidence. Drawing and writing about the actor Charles Rann Kennedy for the New York *Press,* the prose description of her subject is shaped, witty, and succinct: "He succumbed to fate, which gave him the eyes of a dreamer, the hair of a cave man, the smile of a humorist, and the hands and feet of a woman."[20]

Many writers, like William Faulkner (Henrik Ibsen is a signal instance), after an early fling with ink or watercolor, let their art interests pass like other early loves into a scarcely remembered past, possibly and perversely because his mother hoped he'd be a painter (it was in her kitchen, at her easel, he daubed his first daubs); but during his collegiate years at the University of Mississippi Faulkner did a significant amount of graphic work for the school yearbook and for a theater group called The Marionettes, as well as illustrating a series of hand-crafted booklets containing a one-act play and some of his early prose. These drawings show *fin de siècle* influences similar to those which affected Djuna Barnes. Oscar Wilde wit, Beardsley decadence and the insouciance of art nouveau were appealingly exotic not only to Faulkner but to his classmates, some of whom contributed images of their own to *Ole Miss*—a peacock, kimono, sphinx, a dandy or a *femme fatale*—things and creatures commonly encountered on the streets of Oxford, Miss.

As Lothar Hönnighausen has pointed out, aims more serious than adolescent pleasures of effrontery are involved here, and their reach is as far as their sharing is wide.[21] The obvious link is the handmade book—its printing, its illustration, its calligraphy—and in this case the principal influence has to be William Morris and the Arts and Crafts movement. Carl Sandburg, in Chicago certainly closer to its American heart than Oxford was, is writing and designing his first poetry books in Morris's manual spirit: seeking a unity of text and illustration on the field of the page, exploiting what were believed to be organic forms with all their luxuriance and individuality, employing stylized figures which won't try to tell their own story, thus competing with that of the text, and by bursting across borders, frames, or anything else which might suggest the settled, the mechanically assembled and repetitious, in order to lay claim to the uncontained, the asymmetrical, the infinite.

Faulkner's inklings are those of a very clever amateur with a facility for mimicry, but they differ from those of Aubrey Beardsley in more than quality. Faulkner's drawings possess an innocence Beardsley avoids as if it would be embarrassing. His figures simply dance the Charleston with energy and delight. He unbalances his designs, often turning a figure, as Beardsley does, into a pedimentless caryatid; he plays black masses against white vacancies with an eagerness lacking in allusion, and his thin black lines loop and swoop appropriately, though not with Beardsley's rhythms; but Faulkner's lines cautiously follow contours, and do not slip back as Beardsley's do into the dark wells they appear to have run from, nor does he pick up Beardsley's habit of allowing them to whiten, threadlike, when they enter a patch of darkness, or to become broken, as if black and white dots were dancing. The lidded eyes, the smirk of Ali Baba would be quite beyond him, and he never stops suddenly in a design of swirling simplicity for a length of beautiful detail like Ali Baba's sash or bejeweled hat and wrist. Space outside any contour simply disappears into no distance, whereas, for Beardsley, it is often a malevolent darkness or a boudoir wall or the water and sky of a widening world.

Faulkner's poems at this time are appropriately about no one real: Pierrots and Columbines emerging from candle flames to fling—somehow—a paper rose. They are a part of a copied exoticism he will later pretend never happened, however Beardsley's other muse haunts him his whole brief life. Beardsley

liked to think of himself as a man of letters, yet his "letters," when we look at them, are pictures too. Here is his Venus, from *Under the Hill,* at her toilette, as so many of his drawings depict, preparing for her rendezvous with Tannhäuser:

> Venus slipped away the dressing-gown, and rose before the mirror in a flutter of frilled things. She was adorably tall and slender. Her neck and shoulders were wonderfully drawn, and the little malicious breasts were full of the irritation of loveliness that can never be entirely comprehended, or ever enjoyed to the utmost. Her arms and hands were loosely but delicately articulated, and her legs were divinely long. From the hip to the knee, twenty-two inches; from the knee to the heel, twenty-two inches, as befitted a goddess.[22]

Passage after passage offers evidence for the principles of production behind this prose. Beardsley would dream drawings and then describe the drawings he'd dreamed. The exotic objects he liked to depict are replaced by exotic names: "pantoufles," "sarcenet," "maréchale," "maroquin," "fardeuse," "chevelure," and the like; and his cosmetized settings find their equivalents in color and cloth words, in buttons and perfumes and silken stuffs, in fancy foods. His characters, whether drawn or written down, are equally artificial, and their eroticism seems as harmless as a daydream's. The dandy is a desperate man. Substance disappears into decoration as though the artist's thin black lines were slipping back into the dark wells they appear to have come from. For Beardsley, one's hairdo renders the brow harmless, the cuff's lacy flounce replaces the wrist, the mirror overcomes the face. Fashion covers his corpse before it has reached the grave to which TB is coughing him.

Beardsley's writing style embodies the weariness of the roué who is always seeking some fresh sensation. However, having tasted every pleasure many times, he is bored by their necessary gestures, nor is he any longer delighted by the shock his behavior gave others; and for all his diligent debauchery, he has managed to remain ignorant of the true nature of the organs and actors which have participated in his game.

Beardsley's line runs like a hand over the bodies it is creating, its fingers palp a chemise into existence, dimple a breast. Of *The Coiffing,* Max Beerbohm writes that "it is a drawing of pure outline mostly, built up obliquely across the page; utterly simple; utterly exquisite; a decoration for which I have no words."[23] It is an extraordinary "artist with his art work" picture. Proudly the coiffeur contemplates . . . what? . . . only a head of hair . . . above a vapidly pretty face.

"B is for Beardsley, the idol supreme," Gelett Burgess wrote, "whose drawings are not half so bad as they seem."[24]

Unlike Faulkner, Djuna Barnes had an economic use for her drawings which accompanied newspaper accounts of little forays "on the town," or her brief interviews with people of the theater and other arts; consequently she continued to develop her skills, finally producing images drawn from her plays, and then incorporating them into her fictions. We can watch Barnes's style change over time, for a while resembling her *Yellow Book* master by so much that she was called the American Beardsley, but eventually adopting a mock "woodcut" mode for *Ladies Almanack,* which she took from some early albums she found in the stalls along the Seine and began to employ in her novel, *Ryder.* The medievalized toy-like figures were ideally suited to the *Almanack*'s material. Now the graphic work no longer simply stood beside her texts like an iconic decoration, but fully participated in the structural conception of the book, which uses the signs of the Zodiac to stand for the various melancholies ladies suffer, and the mannerisms of the drawings mirror perfectly the Robert Burton embellishments of the prose—a prose which frequently reaches poetry despite its parodistic intentions. In the section on September, the tides and moons of what Barnes calls woman's "pick-thank existence" is concluded this way:

> We shake the Tree till there be no Leaves, and cry
> out at the Sticks; we trouble the Earth awhile with our
> Fury; our Sorrow is flesh thick, and we shall not cease
> to eat of it until the easing Bone. Our Peace is not
> skin deep, but to the Marrow, we are not wise this side
> of *rigor mortis;* we go down to no River of Wisdom, but
> swim alone in Jordan. We have few Philosophers
> among us, for our Blood was stewed too thick
> to bear up Wisdom, which is a little
> Craft, and floats only when

the way is prepared, and
the Winds are calm.[25]

It sometimes seems that Barnes is looking at the world through other people's drawings, and, while in her Beardsley period, not looking at the world at all; but she could occasionally achieve an expression which caught the soul of its subject in its teeth, as she did in her luminous sketch of Paul Claudel, in whose poetic drama, *The Tidings Brought to Mary,* Djuna Barnes played a nun—no doubt without a wimple of irony.

Barnes was a borrower both as a writer and an illustrator, but she became so skillful that what she borrowed is in better shape when she returns it. Elizabeth Bishop, in contrast, though she longed to be a painter, let her judgment restrain her ambitions. Although she did the customary walk about in Europe to gawk at masterpieces, she retained her Nova Scotian eyes and let them be her muses.

Regarde! Colette commanded. Elizabeth Bishop obeyed by writing poetry that is descriptive in the best way. Her watercolors are "artless" in the sense that they seem free of affectation and esthetic ideology, a freedom we cannot claim for Wyndham Lewis, at least at first, or for Faulkner or Cummings or Barnes, or Morris or Rossetti either. Ibsen had some early instruction in pencil work and oil; however, his luminous and startling watercolor, *Grimstad Landscape,* with its two horizontal streaks of water and sky blue separated by another of boats and houses, and dawn's white light in a swath across the center of the composition, is painted with the meticulousness of an amateur interested in nothing more than Grimstad harbor.

When a writer like Bishop paints, she is learning to see, even to touch. Poems like "The Bight," "Sandpiper," "Cape Breton," "The Fish," or "A Cold Spring" were written with a brush.

> The next day
> was much warmer.
> Greenish-white dogwood infiltrated the wood,
> each petal burned, apparently, by a cigarette-butt;
> and the blurred redbud stood
> beside it, motionless, but almost more
> like movement than any placeable color.[26]

The hand has to teach the eye how to abstract, refine, depict. The ear participates, moving music through the line: "burned"

"by" "-ette" "butt" "blurred" "bud" "beside" "but" again or "wood" "stood" "more" "color" and so on; yet it is the sense of watercolor rendering that spots the red and makes it move through the field of the forest like something twinkling.

Elizabeth Bishop's poems are full of dark undertones; she was not, by and large, a happy person; yet her watercolors, for the most part, take undiluted pleasure in their scenes. Even when, in the work, there are tombstones for sale, or, in perhaps my favorite, we are facing a graveyard of fenced graves, the paintings exist to pay joyous tribute to their subject. The petals of the dogwood have not, in her painted world, infiltrated a woods or been burned by a burning butt.

Coming from northern Maine and Nova Scotia she welcomed the warmth of Key West and her homes in Brazil, and she liked to live at the edge of the sea, as islanded as Derek Walcott, her sensuousness, like his, coloring the water with images.

Watercolor is not particularly friendly to the line. It prefers patches, and the nature of the brush puts the line at risk, placing its making more and more in the wrist, shortening the stroke, while often broadening the swath with a tip too soft to suggest it's cut a path. Henry Miller, Kenneth Patchen, Oscar Kokoschka, D. H. Lawrence—let us say a certain kind of man—tend to work with wide strokes and bold slashes; virile and vigorous marks are the only ones allowed. Lawrence painted himself as a blackbearded Christ in an oil he called *Resurrection.* But even a blob is never just a blob; there are as many sorts as gumdrops. Blobs can have quite opposed character traits, differing the way Dickens's and Thackeray's attitudes toward money did, for example. Dickens never hesitated to break a contract, if he thought his fame had increased since he signed it, and Thackeray tended to think he was always being overpaid. In one of the latter's drawings our spud-nosed friend is bowing as low as bowing gets before a blobby lady with blobbed hair seated on what appears to be a canopied throne. I venture that the groveler is Benjamin Disraeli and the grovelee is Victoria, his Queen.

There are, of course, all kinds of lines, too: there are Beardsley's delicate dots, or the ink that flows like a gown down the page; there are Cocteau's continuous contours and his furious little scratches; there are the tentative doubled and troubled lines of preliminary sketches, such as those Wyndham Lewis made for his

portrait of T. S. Eliot, or some of Thackeray's, which go about in dashes; there are the softly smeared lines G. K. Chesterton fancies, natural to soft pencil and charcoal, ones which are ruled, and rule as Davenport's do; others, like Thurber's which try to look awkward, or, as Agee's do, strive to seem casual—Dylan Thomas's are soft and droopy, Lorca's hate straight; there are lines that thicken at the waist and thin at each end in the manner of Max Beerbohm's, or hatchings designed to create a tormented darkness out of which creep Bruno Schulz's little worshippers of women as well as their high-heeled feet, then Baudelaire's, another crosshatcher, who uses them to put his mistress, Jeanne Duval, in a snood, or shape her breasts, or gather darkness like a wad of cloth up under her arm; there are highlight lines like those Elizabeth Bishop employs to ink in fences over patches of gouache, or draw a shack's warped boards; and Guy Davenport's rigid grids, lines which seem to frame the body they delimit, or Kipling's whirligigs, following the path of furiously spinning leaves, and Verlaine's similar eddies; then out at the edge of the type, Tagore's white lights, the outlines of lines, or Lermontov's, so cautious about themselves they gather in thread-thin groups to indicate the drape of a skirt or the fold in a trouser.

Each kind, when added to others, furnishes a face, a skirt, a tree, a road, with a feeling: this tree is nervous, its leaves are gales, its bark is jagged; or a cobbled road is as gay as the bubbles which make its stones; or a mountainside is mysterious, and look: here's a hand that has given up the ghost.

In most cases, when the dual muse is present, one shows itself as a gift, the other as an aptitude, but Bruno Schulz was favored by both arts equally, although apparently in quite different ways. His childhood scrawls quickly turned into horses and carriages, and soon swarms of little images appeared on every ready paper, in any available space. His father, though a merchant, did not frown upon his son's art, but seems to have been proud of it, thus it was in drawing, painting, and engraving that his future was seen. Schulz had a knack for mathematics in addition to these other talents, so his enrollment in the Department of Architecture at Lvov Polytechnic must have been accounted both sensible and appropriate, although poor health, economic uncertainties, and war soon put an end to any hopes for a profession. His writing, Jerzy Ficowski tells us, he kept rather secret, while his graphic art was sufficiently known that he was able to get a position as a teacher of it in a local school. Later, this situation reversed itself, since the neurotic nature of the subject matter compelled him to put his graphic art in drawers. It had always been discounted anyway, when it was seen by professionals, and judged the work of a dilettante.[27]

Left pretty much to his own creative devices, Schulz would purchase used glass photographic plates from a drugstore, cover them with a black gelatin (the darkness of his drawings begins symbolically early in their manufacture), and scratch about in this with a needle to produce a kind of negative which could be exposed to photosensitive paper and developed as any photograph might. Then he glued the finished prints onto cardboard sheets and put them into portfolios where they formed a collection of . . . what? Goya-like Disasters of Lust?

We can examine first a cover which, in its unsewn state can only lid. This "cover" depicts, beneath its title "Xiega" (archaic Polish for "book"), a slightly pouty young lady in a filmy, flung-up dress, her hands behind her head, sitting on a throne-sized chair whose back is formed by the leaves of an open book. She has two dwarfs in surplices at her feet, one literally a tongue length from a toe. When we turn to the Dedication we confront Bruno Schulz (for it is plainly he) presenting to us . . . what are we?—we onlookers—we overseers . . . he is holding toward us a tray bearing a crown from which, like mist or steam, a dimly devilish figure rises. Then *The Book of Idolatry* begins. It appears, like one of Max Ernst's collage novels, to tell a tale, an eternal one indeed (the title of the first drawing): that of the domination of man by woman through the sex they bear and the disdain for men they share, and the power they have, like Circe, to turn men into animals. When we lift out more sheets, that's where we find them, these animalmen, these freaks: wizened, dwarfish, bowing if not crouching, crawling on the carpet, cringing, peering lewdly up skirts and parted legs, lowering their noses, too, toward large saucers which turn out to be footbasins, kissing or caressing a sole just laved, large-eyed, huge-headed, like the starving; or, if out in the street, walking a pace behind, hat in hand, or even on callused hands and knees, rear ends furry and tailed, sometimes on a short leash. That's what the whips are for . . . for the mananimals.

The drawing style is more than scratchy, as if the plate itched. Every line is several: there is one that will perhaps do; there are a

number that have been tried out. And frequently there will be the thin image of a man in heat that's been drawn over so that it seems to be where—a moment ago—his fawning was. This gives an eerie motion to the drawing.

No one is having any fun. The men are miserable. They can't help themselves. The women are indifferent, untouched, like the golden calf, the just-shed slipper, though once in a while a woman will wear a smile of triumph, her foot resting on an admirer's neck. If alone, they are reclining on a couch; if in company, they are sitting in a naked row with other women like whores in a bawdy house. This is not a celebration of masochism. It is the allegorical use of such images to complain about the condition of mankind, and to create an unholy, a truly black book, an underside to those Schulz composed in a prose of rare and jubilant beauty. When *Sanitorium under the Sign of the Hourglass* begins, we are told of a volume quite different from *The Book of Idolatry*:

> Sometimes my father would wander off and leave me alone with The Book; the wind would rustle through its pages and the pictures would rise. And as the windswept pages were turned, merging the colors and shapes, a shiver ran through the columns of text, freeing from among the letters flocks of swallows and larks. Page after page floated in the air and gently saturated the landscape with brightness. At other times, The Book lay still and the wind opened it softly like a huge cabbage rose; the petals, one by one, eyelid under eyelid, all blind, velvety, and dreamy, slowly disclosed a blue pupil, a colored peacock's heart, or a chattering nest of hummingbirds.[28]

My hunch is that Schulz's dark paintings permitted him his radiant prose.

Sometimes a writer's art gets no nearer his books than their covers; occasionally drawings are used to illustrate a story the way Sunday School leaflets illuminate the life of Jesus or show Daniel surrounded by a pride of milling lions; yet often they do no more for the text than lighten the page and interrupt the journey. In a life like that of Giorgio de Chirico, a novel (*Hebdomeros*) functions like a period put at the end of a length of the past. De Chirico put his early paintings behind him almost as abruptly and decisively as Rimbaud did his poems, but instead of running guns and selling sewing machines, he wrote a strange surreal philosophical novel,

not in his natal tongue, Greek, or in his native Italian either, but in French, the language of his Parisian companions, the language of his mind. A novel written by a painter is not unique, Jennifer Bartlett with her *History of the Universe* reduced that statistic, but it is nevertheless rare indeed. De Chirico's novel is almost as motionless as a canvas, and, although it is crowded with characters, unlike his paintings which depict notoriously depeopled spaces, it is made of mysterious metamorphoses, of sudden, almost transparent visions, as if thoughts were being seen, or seen through. The movement that occurs is (as in Max Ernst's collage novel, *Une semaine de bonté*) largely symbolic and thematic. Here is a sample, and an example of De Chirico's love of strange wild esoteric words as well:

> An aged and taciturn servant, whom Hebdomeros [a name which I understand to be Hebdom/eros, meaning "week of love"] called the Eumenis, was sweeping the ruins which still strewed the floor and, facing this new life, facing this grandiose and mappemondial spectacle, he suddenly *saw* the oceans. Like the Colossus of Rhodes, like a Colossus of Rhodes infinitely enlarged in dream, his legs apart and his feet touching different regions; between his left toes Mexican bandits pursued each other like famished wild beasts around rocks overheated by the canicule, while his right foot, up there, trod the immaculate regions, among white bears, obese old men with weasel-like profiles shaking their heads in front of glaciers that were slashed, crenellated and jagged, like ruins of famous cathedrals, destroyed by cannon-fire, and on the threshold of stinking huts, woven from sealskin, Eskimos trussed up in furs politely offered their wives to excited explorers.[29]

In a moment, the nightmare shifts gears. De Chirico remains De Chirico, paint or prose.

> Then, young man [Hebdomeros says], one sees this inexplicable sight: strange chickens, entirely stripped of their plumage, frantic with fear, like tiny ostriches, running on their long legs round the dining-room table. Funereal violinists hastily put away their instruments in boxes similar to coffins for new-born babies; portraits move in their frames and pictures fastened to the wall fall to the ground; phantom cooks, who are prototype assassins,

go up with catlike tread to the first floor, to the bedrooms of those distinguished and bald old men who, armed with ivory-handled canes, are preparing to die in dignified fashion so that their nephews need never blush when speaking of them.[30]

John Ashbery believes that this 1929 novel is the high point of surrealist fiction, and I am inclined to agree with him. His odd novel completed, De Chirico appears to have taken no continued interest in it, but after the fashion of the prodigal son (whose story is, like *Ulysses* and *The Notebooks of Malte Laurids Brigge*, the novel's principal theme), brings his brush back home to the dubious lawns and hillsides of classical allegory.

As we've seen, a number of writers began with careers in art in mind, even William James, as well as Wyndham Lewis, Gautier and the Goncourts, Bruno Schulz, and so on. One of these was E. E. Cummings who regarded himself as much a painter as a poet his entire life. But history—viciously linear—hates to entertain two very different thoughts about the same thing, event, or person simultaneously. So Blake and Lewis and Cummings are forced into literature's circle, while Morris, for instance, is jammed into a designer's square. Breyten Breytenbach is known as a writer in the United States whereas in Europe his paintings are widely shown and admired. Tom Phillips is an entire artistic orchestra. The description "book artist" hardly does him justice. The activity that gets in the first blow often wears the champion's belt, which may be what happened in Cummings's case, though certainly not in Blake's or Schulz's. Readers who had forgotten Apollinaire's "calligrammes," not to mention George Herbert's shaped poem, "Easter Wings," or the medieval tradition from which it springs, or Besantinus's first century "Altar," about which they'd no doubt have never heard, might have found Cummings's poempictures to be original and revolutionary; however, for art critics up on the modern movements, Cummings's work, though excellent to a degree, seemed fickle and derivative, now reminding the viewer of Kandinsky, then of Léger or Delauney, Picabia, Cézanne, or John Marin. Cummings's charming pencil drawings of dancers, done, like Faulkner's in the early '20s, are responsive to the style of time rather than to anyone else's sketches; nevertheless, there they are, like the rest of his art, not his as his poems seem to be, but belonging in style and therefore spirit to someone else.

Cummings's painting style became more "realistic" as well as more "spontaneous" as his character grew less rebellious, and his tastes turned, like unrefrigerated milk, a more conservative color. Writers who leave their painterly impulses unfulfilled can't have "a development." Nor can one art see its reflection in another. In a 1925 painting, *Noise Number 13*, Delauney spirals are broken into arc-like bits, centers of energy are unable to hold anything together, colors ribbon away in an unfelt wind. There's been a pastel explosion. "The man who has witnessed an explosion does not stop to connect his sentences grammatically," said Marinetti.[31]

> spiral acres of bloated rose
> coiled within cobalt miles of sky
> yield to and heed
> the mauve
> of twilight[32]

Frequently in the poetry, too, thoughts and feelings which might be appropriate on valentines of both the loving and the nasty kind, are hidden behind lexical and syntactical dislocations which confer on them an importance they would otherwise not have. If Apollinaire's calligrams more often than not are molded to resemble objects, Cummings's poems are designed to mimic motions.

Wyndham Lewis was also concerned to render motion, but in an entirely different way—by turning it into stillness. With Lewis we have another example, like Blake and Morris, of equivalent skills of a major sort in the two arts. His extraordinary early painting (in the so-called "Vortex" phase of his career) does not frantically overlap images in an attempt to vibrate like a functioning engine. If the futurists loved machines, they did not love the physics of their operation. They admired only the future they missaw coming in them. They admired mechanical forms and the force these forms exemplified as the machines that owned them did their work, but they did not care about the forces that molded those machines from inside. The laws of motion, Plato might have said, are motionless. The structure of a function produces a different feeling than the function.

The vocabulary of Wyndham Lewis's visual forms is largely organic. The oncoming list is in the words of Hugh Kenner and is borrowed from his characteristically brilliant essay, "The Visual World of Wyndham Lewis":

leaf-forms, grass-forms, the curve that defines the glassy plane of a breaking wave, cranial and ocular shapes, stances of intricate line like paraphrased skeletons, but emptied of all suggestion of the macabre; lines like the contours of twigs and like the curl of horns; forms like stones polished by an eternity of persistent water; forms derived from the architectural details that sculptors in turn derived from the forms of trees and leaves.[33]

With this vocabulary Lewis created his "visually logical" beings, as, with his recondite English, Lewis constructed the odd logical worlds of his fictions in a prose which is impressive in its muscularity, intriguing in its extravagant mannerisms, and astonishing in its originality. Let me parade past you part of one paragraph from Lewis's prose masterpiece, *The Childermas*. The Festival of Childermas Day remembers the Holy Innocents who were massacred by Herod. According to tradition these are the souls who are assembled in camps on the other side of death, awaiting judgment before entering Heaven. Here some come:

> One figure is fainter than any of the rest, he is a thin and shabby mustard yellow, in colouring a flat daguerreotype or one of the personnel of a pre-war film, split tarnished and transparent from travel and barter. He comes and goes; sometimes he is there, then he flickers out. He is a tall man of no occupation, in the foreground. He falls like a yellow smear upon one much firmer than himself behind, or invades him like a rusty putrefaction, but never blots out the stronger person.[34]

The visual intensity of this prose should be evident. It is like steam from a kettle:

> the monotonous breathing of the group turns into a heave that with a person would be a sigh; all this collection are inflated with a breath of unexpected sadness; a darker shade rushes into the pigments, as it were, of them, like a wind springing up in their immaterial passionless trances, whistling upon their lips, at some order, denying them more repose—since they have a life after their fashion, however faded.[35]

Wyndham Lewis would eventually execute, in pencil, pen, and paint, some of the finest portraits in this century, especially of other writers, even though this is a century which disdains both writers and portraits. Those of Pound, Sitwell, and Eliot are especially penetrating.

Freud asked the question some time back, and since then we've had answers aplenty, so we are supposed to know by now what women want, but what does the word—even the word "woman"—want? "In the flesh it is eternal. . . ." . . . to be material, it turns out; to be noisy, singular, well-connected, splendidly performed, quirkily personal. Words want what they are not. Not an unusual desire. The child is eager to become a grown-up, the adult pines for former times and an innocence regained. That is most dear that can't be had: to make music when you haven't any instrument and don't know how to play; to color the eye, outline objects, create sea, mountains, meadows with a swish of ink, to watercolor sky; it wants to be the periwinkle or the pink that has no need to speak, to rest in the world like a dog before the fire, to sit on a sofa and sink in its cushions, occupy a seat, fill a box, cover a wall, dance the tango, copulate in the foam, beat as strongly as a healthy heart. The word, like so many of its referents, wants to be a thing one day . . . then an object in action like a thrown stone . . . on still another, it wants to be a song.

The practitioner of any art soon grows familiar with the limitations inherent in the medium: in painting it begins with the tyranny of the rectangle, the relative absence of time, movement, thought in the materials of composition, the fundamental flatness of stretched canvas or appointed wall, consequently the work's precarious, adjectival attachment to solids, its fragile nature and dependency upon site, yet its insistent particularity wherever it's placed. So we should not be surprised at the appearance of impasto, the presence of wax melted into slow flows, collage, bullet holes and slashes, to witness the image break out of its frame and grow into an environment, nor should it shock us to see the icon of today become the word itself, like the word "mustache" spelled across the Mona Lisa's upper lip.

Paintings have wanted to be a thousand words from the beginning, but if one had to read them to see them, then they could not cross seas, countrysides, and cultures in order to—for instance—propagandize for Christ. And if they were replicable as easily as a sonnet is reprintable, they wouldn't have any commercial value, and their makers would never become rich. They'd not be national treasures and live in museums. If I burn a

book it's only a gesture. If I slash a canvas, it's a crime. Paintings are social and draw crowds. Reading is a silent isolating exercise in mind-your-own-business. But the writer can have a thought to utter and utter it, have a silence in which to say his piece, whereas the painter painting is given two looks and one get-a-move-on through chitty chatty crowds, the drones of docents, and the snooze of guards. Barring quiet days and dedicated eyes, almost the only chance a painting has to be really looked at is to get its picture into a book. Yes. Wherever I am, I want to live across the street. But . . .

East/West, home is best. The illusory, remember, is loved by the illiterate. Let them listen to rock and go to the movies. Plato does not approve of having his eye deceived and consequently his mind muddled. The introduction of perspective, any realism, is a lie. Paintings are flat and should remain unpadded; they are mute and therefore should be quiet; they are fixed, and therefore should be still; paint should be paint, then, not fish on a plate; and why fish on a plate? why bistro cloth? glasses and bottles? all so commonplace. Lewis complained of the bourgeois character of cubist subjects. They are as bad as the Flemish who made chapels out of kitchens, and holy relics out of pots, pans, and dress lace. If you want to put words in pictures, enroll in a workshop and learn to type. Imitation is a limitation. Once the painter frees himself from bourgeois or plebeian requirements, he can explore his own holy spirit. But . . .

There is something about a mark on a page that makes a space and prefigures a concept. Moreover, the word wants to hear itself sung by a contralto with quivering breasts. Andrei Bely and Stéphane Mallarmé worried about the placement of words on the page because they were struggling to find a more adequate musical notation. Yet once out there . . .

Certain words would require larger print, this or that font, wider fields. Margins had real presence: they were silent surrounds, death strips, frames, moats. Above and beyond grammar, the page worked to unify the words the way a case can unify a collection. Now it is sky—this expanse—the void, an ocean, earth. *Un coup de dés* and there is a roll of words across a baize-covered table, quiet on account of the felt. Every throw turns up a different number. Watch for the word which once ricocheted from a rail, though it's now at rest.

In Mallarmé's room on the Rue de Rome, the manuscript laid out on a square bow-legged table, in a low and even voice, Mallarmé read the poem to Paul Valéry, and then added astonishment to Valéry's admiration by showing him the configuration of the words. Valéry saw, he said, the outline of a thought which had found, for the first time, its place in our universe,

> . . . here on the very paper shone an indefinable, infinitely pure light from the farthest stars, in the same half-conscious void where, like a new kind of matter scattered in heaps, in tracks, in systems, coexisted Language.[36]

Star struck indeed, the metaphor followed the young poet like a stray. Later, at Valvins, the master shows Valéry proof-sheets of the poem. That evening, as Mallarmé accompanied Valéry to the train station, under the constellations "of the Serpent, the Swan, the Eagle and the Lyre," Valéry wrote, Mallarmé

> seemed to me to be now involved in the very meaning of the silent universe: a text full of clarity and enigma; as tragic or as unimportant as one wants to make it; which speaks and does not speak; which embraces order and disorder; which proclaims a God as loudly as it denies one; which contains in its inconceivable entirety every period of time, each one associated with the distance of a heavenly body; which recalls the most evident and incontestable success of man, the fulfillment of his predications—to the seventh decimal place; and which crushes the living witness, the wise contemplator, beneath the futility of his triumphs. . . . He had tried, I thought, to raise writing, at last, to the level of the starry heavens.[37]

Regardless of the character and personality and intentions of any author or artist, a thought is a ghost without even gauze, and knows its real fate and habitation: to have a face without features, and a place without rooms; nevertheless, it desires an address, seeks solidity, courts the singular, while the singular image, knowing the body it is married too, wanting to be honest, trying to be faithful, nevertheless dreams it is mated to a mind.

Which is a more punishable form of hubris: in Mallarmé to want to raise writing to the level of the spangled heavens, or for the night sky, itself, to let fall the figures of the stars upon the pages of *Un coup de dés?*

Notes

1. Facsimile of Letter 437, in *The Letters of Michelangelo*, Vol. II, translated, edited, and annotated by E.H. Ramsden. Stanford, California: Stanford Univ. Press, 1963, 178–9. (Casa Vasari, Arezzo).

2. Pierre Chanel. "A Thousand Flashes of Genius," translated by Arthur King Peters, in *Jean Cocteau and the French Scene*, edited by Alexandra Anderson and Carol Saltus. New York: Abbeville Press: 1984, 107.

3. Michel Leiris. *Rules of the Game, I: Scratches.* Translated by Lydia Davis. New York: Paragon House, 1991, 43, 47.

4. George Sand. *Autour de la table.* Quoted by André Maurois in *Lélia: The Life of George Sand.* New York: Harpers, 1954, 371.

5. J. W. von Goethe in *Goethe on Art*, selected, edited, and translated by John Gage. Berkeley: Univ. of California Press, 1980, 13.

6. Ibid., 11.

7. Quoted by John Gage, ibid., ix.

8. Ibid., ix.

9. Wallace Stevens. "Peter Quince at the Clavier," iv, from *Harmonium.* New York: Alfred Knopf, 1950, 156.

10. Peter Ackroyd. *Blake.* New York: Alfred Knopf, 1995, 340.

11. Pierre Chanel, op. cit., 107–8.

12. Hugh Kenner, "The Visual World of Wyndham Lewis," in *Wyndham Lewis: Paintings and Drawings*, by Walter Michel. Berkeley: Univ. of California Press, 1971, 11.

13. Quoted by Pierre Chanel, op. cit., 114.

14. Henry James in *Henry James: Autobiography*, edited by Frederick W. Dupee. New York: Criterion Books, 1956, 293.

15. André Billy. *The Goncourt Brothers*, translated by Margaret Shaw. New York: Horizon Press, 1960, 73.

16. Ibid., 73–4.

17. Peter Ackroyd, op. cit, 112–113.

18. Ibid., 282.

19. Ibid., 342.

20. Djuna Barnes. *Poe's Mother: Selected Drawings of Djuna Barnes*, edited by Douglas Messerli. Los Angeles: Sun and Moon Press, 1995, 52.

21. Lothar Hönnighausen, "Faulkner's Graphic Work in Historical Context," in *Faulkner: International Perspectives*, ed. by Fowler and Abadie. Jackson, Miss.: Univ. Press of Mississippi, 1984, 139–173.

22. Aubrey Beardsley and John Glassco. *Under the Hill.* New York: Grove Press, 1959, 29–30.

23. Max Beerbohm in an appendix to Stanley Weintraub's *Beardsley.* New York: George Braziller, 1967, 263.

24. Gelett Burgess, quoted by Weintraub, ibid., 186.

25. Djuna Barnes. *Ladies Almanack.* New York: Harper and Row, 1972, 58–9.

26. Elizabeth Bishop, "A Cold Spring," in *The Complete Poems 1927–1979.* New York: Farrar, Straus and Giroux, 1983, 55.

27. Bruno Schulz. *The Drawings of Bruno Schulz*, edited by Jerzy Ficowski. Evanston, Ill.: Northwestern Univ. Press, 1990, 2.

28. Bruno Schulz. *Sanatorium under the Sign of the Hourglass.* Trans. by Celina Wieniewska. New York: Walker, 1978, 1–2.

29. Giorgio de Chirico. *Hebdomeros*, trans. by Margaret Crosland. New York: PAJ Publications, 1988, 68.

30. Ibid., 69.

31. Quoted by Milton Cohen in *PoetandPainter: The Aesthetics of E. E. Cummings's Early Work.* Detroit: Wayne State Univ. Press, 1987, 159.

32. From "Paris, this April sunset completely utters," quoted in Cohen, ibid., 176.

33. Hugh Kenner, op. cit., 21.

34. Wyndham Lewis. *The Childermas.* Section I. London: Chatto & Windus, 1928, 15.

35. Ibid., 15.

36. Paul Valéry. "Mallarmé's 'Coup de Dés'" translated by Anthony Bower in *Selected Writings of Paul Valéry.* New York: New Directions, 1950, 218.

37. Ibid., 219.

Writers and Artists / JOHN UPDIKE

The itch to make dark marks on white paper is shared by writers and artists. Before the advent of the typewriter and now the word processor, pen and ink were what one drew pictures and word pictures with; James Joyce, who let others do his typing, said he liked to feel the words flow through his wrist. There is a graphic beauty to old manuscripts, and to the signatures whose flourishes and curlicues were meant to discourage forgery. The manuscripts of Ouida, dashed off with, it seems, an ostrich quill, and the strenuously hatched and interlineated manuscripts of Pope and Boswell are as much pictorial events as a diploma by Steinberg. An old fashioned gentleman's skills often included the ability to limn a likeness or a landscape, much as middle-class men now can all operate a camera; such writers as Pushkin and Goethe startle us with the competence of their sketches.

Thackeray, of course, was a professional illustrator, as were Beerbohm and Evelyn Waugh. Edward Lear was a serious painter and a frivolous writer, and he might be surprised to know that the writing has won him posterity's ticket. On the other hand, Wyndham Lewis now seems to be valued more for his edgy portraits of his fellow-modernists than for his once much-admired prose. Thurber was thought of as a writer who, comically and touchingly (since he was half-blind), could not draw but did anyway, whereas Ludwig Bemelmans is remembered, if he is remembered at all, as an artist who could write; in truth, both men were bold minimalists in an era when cartoons were executed in sometimes suffocating detail. A number of writers began as cartoonists: of S. J. Perelman we might have suspected this, and even of Gabriel García Márquez; but Flannery O'Connor? Yes, when we think of her vivid outrageousness, the definiteness of her every stroke.

Alphabets begin in pictographs, and, though words are spoken things, to write and read we must see. The line between picture and symbol is a fine one. In the days of mass illiteracy, imagery—hung on cathedral walls, scattered in woodcuts—was the chief non-oral narrative means. Most paintings "tell a story," and even

departures from representation carry a literary residue; e.g., the labels and bits of newspaper worked into Cubist collages, and the effect of a monumental calligraphy in the canvases of Pollock and Kline. The art of the comic strip exists as if to show how small the bridge need be between the two forms of showing, of telling. Music, perhaps the most ancient of the fine arts, is simultaneously more visceral and abstract, and though some musicians become writers (John Barth, Anthony Burgess) the leap is rarer. Music is a world of its own; writing and drawing are relatively parasitic upon the world that is in place.

As those who have both drawn and written know, the problems of definition differ radically. A table or a person becomes in graphic representation a maze of angles, of half-hidden bulges, of second and third and fourth looks adding up to an illusion of thereness. When color is added to line, the decisions and discriminations freighted into each square inch approach the infinite; one's eyes begin to hurt, to water, and the colors on the palette converge toward gray mud. Whereas the writer only has to say "table" to put it there, on the page. Everything in the way of adjectival adjustment doesn't so much add as carve away at the vague shape the word, all by itself, has conjured up. To make the table convincing, a specified color, wood, or number of legs might be helpful; or it might be too much, an overparticularized clot in the flow of the prose. The reader, encountering the word "table," has, hastily and hazily, supplied one from his experience, and particularization risks diminishing, rather than adding to, the reality of the table in his mind. Further, the table takes meaning and mass from its context of moral adventure, from what it tells us about the human being who owns it, his or her financial or social or moral condition; otherwise this piece of furniture exists outside the movement of the story and is merely "painterly."

The painter's media are palpable. The more he tells us, the more we know. What he tells us, goes: his strokes are here and not there, this and not that. Although I rarely have cause in my adult life to open the India ink bottle, when I do, and take the feather-light nib and holder again in hand, and begin to trace wet

marks over my pencil sketch on the pristine Bristol board, the old excitement returns—the glistening quick precision, the possibility of smudging, the tremor and swoop that impart life to the lines. Drawing, we dip directly into physical reality. The child discovers that a few dots and a curved line will do for a face, which smiles back out at him. Something has been generated from nothing. Or the pose of a moment has been set down forever; back in my mother's attic, old sketchpads of mine hold pets long dead, infants now grown to adulthood, grandparents whose voices I will not hear again.

Years before written words become pliant and expressive to their young user, creative magic can be grasped through pen and ink, brush and paint. The subtleties of form and color, the distinctions of texture, the balances of volume, the principles of perspective and composition—all these are good for a future writer to explore and will help him to visualize his scenes, even to construct his personalities and to shape the invisible contentions and branchings of plot. A novel, like a cartoon, arranges stylized versions of people within a certain space; the graphic artist learns to organize and emphasize, and this knowledge serves the writer. The volumes, cloven by line and patched by color, which confront the outer eye—the most vulnerable of body parts, where our brain interfaces with the world—are imitated by those dramatic spaces the inner eye creates, as theaters for thoughts and fantasies. Unconscious, we dream within vivid spaces; when we read a book, we dream in a slightly different way, again slightly different from the way in which the writer dreamed.

Joseph Conrad, introducing his third novel, the novel that committed him to the writer's vocation, made the visual component central: "Art itself may be defined as a single-minded attempt to render the highest kind of justice to the visible universe. . . . It is an attempt to find in its forms, in its colors, in its light, in its shadows, in the aspects of matter and in the facts of life, what of each is fundamental, what is enduring and essential. . . . My task which I am trying to achieve is, by the power of the written word, to make you hear, to make you feel—it is, before all, to make you *see*."

"The highest kind of justice to the visible universe"—the phrase, expanded to include "psychological" and "social" along with "visible," nobly sums up what the writer hopes to render. As training to render such justice, no better school exists than graphic representation, with its striving for vivacity, accuracy, and economy. No wonder writers, so many of them, have drawn and painted; the tools are allied, the impulse is one.

SELECTED BIBLIOGRAPHY

KATHY ACKER

"Acker, Kathy." Contemporary Authors. New Revisions Series 55:1–5.

Friedman, Ellen. "A Conversation with Kathy Acker." *Review of Contemporary Fiction* 9, no. 3 (Fall 1989).

Junker, Howard. *The Writer's Notebook.* San Francisco: Harper Collins West, 1995.

Klavan, Andrew. "All the Rage." *Voice* 22 (November 1988): 54.

Sinclair, Mick. "Kathy Acker." The Mick Sinclair Archive. http://micksinclair.com/stiletto/ackerst.html (accessed January 7, 2002).

Stone, Judi. "Kathy Acker: From Mascot to Doyenne of the Avant-Garde." *Publishers Weekly,* December 11, 1995.

Æ (GEORGE RUSSELL)

"Æ and His Paintings." *Oriel Gallery Catalogue.* Dublin. http://www.colin-smythe.com/authors/ae.htm#ae (accessed September 24, 2001).

Summerfield, Henry. "Æ, George William Russell." Dictionary of Literary Biography 19:9–16.

Yeats, William Butler. *The Autobiography of William Butler Yeats.* New York: Macmillan, 1938.

JAMES AGEE

Armistead, Jack. "The Agee Legacy: A Conference at the University of Tennessee at Knoxville." Dictionary of Literary Biography. Yearbook 1989. Edited by S. M. Brook. Detroit: Gale, 1989, 153–54.

Cassidy, Judy, and Ross Spears, eds. *Agee: His Life Remembered.* New York: Holt, Rinehart and Winston, 1985.

Doty, Mark A. *Tell Me Who I Am: James Agee's Search for Selfhood.* Baton Rouge and London: Louisiana State University Press, 1981.

Kramer, Victor A. "James Agee." Dictionary of Literary Biography 152:3–13.

Moreau, Genevieve. *The Restless Journey of James Agee.* New York: Morrow, 1977.

Ohlin, Peter H. *Agee.* New York: Obolensky, 1966.

Rosenwein, Andrea. "James Agee." Dictionary of Literary Biography 26:3–8.

RAFAEL ALBERTI

Alberti, Rafael. *To Painting.* Evanston, IL: Northwestern University Press, 1997.

Karmel, Terese. "A Spanish Artist of the Highest Distinction." *Chronicle,* June 24, 1999, 9–10.

Lorenzo-Rivero, Luis. "Rafael Alberti." Dictionary of Literary Biography 108:3–17.

Manteiga, Robert C. *The Poetry of Rafael Alberti: A Visual Approach.* London: Tamesis, 1978.

"Rafael Alberti." Adapted from *Dictionary of Iberian Literature.* http://www.lib.uconn.edu/Exhibits/alberti/albertibio2.htm (accessed October 13, 2001).

"Rafael Alberti, Painter." Fundación Rafael Alberti. http://www.rafaelalberti.es/asp/en/albertipintor.asp (accessed July 31, 2002).

"Tribute to Raphael Alberti." http://www.lib.uconn.edu/Exhibits/alberti/alberfpg1.htm (accessed October 15, 2001).

HANS CHRISTIAN ANDERSEN

"Hans Christian Andersen." Literature Resource Center. New York Public Library. http://www.galenet.com (accessed March 6, 2002).

Mylius, Johan de. *H. C. Andersen: Papirklip, Paper Clip Cuts.* Copenhagen: Komma and Clausen, 1992.

SHERWOOD ANDERSON

Anderson, Sherwood, Thornton Wilder, Roger Sessions, and William Lescaze. *The Intent of the Artist.* Princeton, NJ: Princeton University Press, 1941.

Rideout, Walter B. "Sherwood Anderson." Dictionary of Literary Biography 9:19–35.

Schevill, James. *Sherwood Anderson: His Life and Work.* Denver: University of Denver Press, 1951.

Townsend, Kim. *Sherwood Anderson.* Boston: Houghton Mifflin, 1987.

GUILLAUME APOLLINAIRE

"Apollinaire, Guillaume." Contemporary Authors 152:27–29.

Breunig, Leroy C., ed. *Apollinaire on Art: Essays and Reviews 1902–1918.* New York: Viking, 1972.

Davies, Margaret. *Apollinaire.* New York: St. Martin's, 1964.

JEAN (HANS) ARP

"Jean Arp." Literature Resource Center. New York Public Library. http://www.galenet.com (accessed June 12, 2001).

Watts, Harriett. "Jean Arp." *European Writers: The Twentieth Century* 10. Edited by George Stade. New York: Scribner, 1990.

ANTONIN ARTAUD

Artaud, Antonin. "Manifesto in a Clear Language." *Manifesto by Antonin Artaud Art Minimal and Conceptual Only.* http://members.aol.com/mindwebart2/page101.htm (accessed September 10, 2000).

"Artaud, Antonin (Marie Joseph)." Contemporary Authors 149:11–14.

Charbonnier, Georges. "Essai Sur Antonin Artaud." *Poètes d'Aujourd'Hui.* Paris: Pierre Seghers, 1959.

Derrida, Jacques, and Paule Thévenin. *The Secret Art of Antonin Artaud.* Cambridge and London: MIT Press, 1998.

Rowell, Margit, ed. *Antonin Artaud Works on Paper.* New York: Abrams, 1996.

Sante, Luc. "Mad as Hell: Antonin Artaud's Pictures from a Psychiatric Institution," October 16, 1996. http://slate.msn.com (accessed November 10, 2000).

Sontag, Susan, "Antonin Artaud." http://art-slab.ucsd.edu/ARTSLAB/VA131ProjFall95/laura/artaudref.html (accessed September 10, 2000).

ENID BAGNOLD

"Bagnold, Enid." Contemporary Authors. New Revisions Series 40:6–8.

Bagnold, Enid, and R. P. Lister, eds. "Extract from Journal, April 4, 1914." *Letters to Frank Harris and Other Friends.* London: Heinemann, 1980

"Enid Bagnold." Literature Resource Center. New York Public Library. http://www.galenet.com (accessed September 10, 2000).

Friedman, Lenemaja. "Enid Bagnold." Dictionary of Literary Biography 191:3–9.

Sebba, Anne. *Enid Bagnold.* London: Weidenfeld and Nicolson, 1986.

R. M. BALLANTYNE

Marks, Chris. "Why the King of Coral Island Walked the 400 Miles Home." *Evening News* (Edinburgh), July 13, 1999.

Quale, Eric. *Ballantyne the Brave: A Victorian Writer and His Family.* London: Rubert Hart-Davis, 1967.

"R. M. Ballantyne." Literature Resource Center. New York Public Library. http://www.galenet.com (accessed March 8, 2002).

AMIRI BARAKA

"Amiri Baraka." Academy of American Poets. http://www.poets.org (accessed June 30, 2002).

Baraka, Amiri, and Michael Scasserra. "Jazz Age." *Performing Arts Magazine,* February 1998, 6–8.

Bischoff, Dan. "Inventive Perspective on Black History and Culture." *Star Ledger,* January 31, 1999, 1–2.

Hester, Tom. "The Anger Still Burns." *Star Ledger,* February 25, 2002, 45, 49.

Kaimann, Frederick. "Preserving Newark's Mixed Musical Roots." *Home News Tribune,* May 27, 1998, C5.

Miller, James A. "Amiri Baraka (Le Roi Jones)." Dictionary of Literary Biography 16:3-24.

ERNST BARLACH

"Barlach, Ernst." Contemporary Authors 178:24–26.

Mahlendorf, Ursula R. "Ernst Barlach." Dictionary of Literary Biography 56:3–11.

DJUNA BARNES

Barnes, Djuna. *The Book of Repulsive Women.* Los Angeles: Sun & Moon, 1994.

Barry, Alyce, ed. *Interviews.* Washington, DC: Sun and Moon, 1985.

Broe, Mary Lynn. *Silence and Power: A Reevaluation of Djuna Barnes.* Carbondale and Edwardsville: Southern Illinois University Press, 1991.

Field, Andrew. *Djuna: The Life and Times of Djuna Barnes.* New York: Putnam, 1983.

Kannentine, Louis F. *The Art of Djuna Barnes: Duality and Damnation.* New York: New York University Press, 1977.

Messerli, Douglas, ed. *Poe's Mother: Selected Drawings of Djuna Barnes.* Los Angeles: Sun and Moon, 1995.

Parsons, Deborah. "Djuna Barnes." The Literary Encyclopedia. http://www.litencyc.com/php/speople.php?rec=true&UID=266 (accessed July 7, 2001).

CHARLES BAUDELAIRE

Baudelaire, Charles. *Baudelaire: Selected Writings on Art and Artists.* Translated by P. E. Charvet. Cambridge: Cambridge University Press, 1972.

———. *Eugene Delacroix: His Life and Work.* Translated by Joseph M. Berstein. New York: Lear, 1947.

Haskell, Francis, Anthony Levi, and Robert Shackleton, eds. *The Artist and the Writer in France.* Oxford: Clarendon, 1974.

Hyslop, Lois Boe, and Francis E. Hyslop Jr. *Baudelaire: A Self-Portrait.* London: Oxford University Press, 1957.

Quennell, Peter, ed. *My Heart Laid Bare and Other Prose Writings.* New York: Vanguard, 1951.

Raser, Timothy. *Poetics of Art Criticism.* Chapel Hill: North Carolina Press, 1989.

Turnell, Martin. *Baudelaire: A Study of His Poetry.* New York: New Directions, 1972.

JULIAN BECK

"Beck, Julian." Contemporary Authors 102:43; 117:44.

Beck, Julian. *The Life of the Theater.* New York: Limelight Editions (Distributed by Harper and Row), 1986

"Julian Beck." *Spress Beatland Authors.* http://www.txt.de/spress/beatland/homes_of_the_beat/margin/livinghe/ (accessed May 8, 2001).

Bilder, Erica, ed. *Theandric: Julian Beck's Last Notebook.* Philadelphia: Harwood Academic, 1992.

MAX BEERBOHM

Cleary, Ann Adams. "Max Beerbohm." Dictionary of Literary Biography 34:9–16.

Epstein, Joseph. "Portraits by Max." *New Yorker*, December 8, 1997, 108–10.

HILAIRE BELLOC

Belloc, Hilaire. *Diary and Sketchbooks: 1889–1912.* Notre Dame, IN: University of Notre Dame Archives, 1912.

Crooks, Monica Hemstock. "Hilaire Belloc." Dictionary of Literary Biography 19:17–25.

Morton, J. B. "Portrait of Hilaire Belloc." *Hilaire Belloc: A Memoir.* http://www.angelfire.com/va/belloc/morton.html (accessed April 3, 2002).

Speaight, Robert. *The Life of Hilaire Belloc.* New York: Farrar, Straus and Cudahy, 1957.

LUDWIG BEMELMANS

Bemelmans, Madeleine, ed. *Tell Them It Was Wonderful.* New York: Viking Penguin, 1985.

Jennerich, Edward J. "Ludwig Bemelmans." Dictionary of Literary Biography 22:37–42.

Marciano, John Bemelmans. *Bemelmans: The Life and Art of Madeleine's Creator.* New York: Viking Penguin, 1999.

ARNOLD BENNETT

Bennett, Arnold, and Marguerite Soulie. *Arnold Bennett in Love.* Edited and translated by George and Jean Beardmore. London: Bruce and Watson, 1972.

Drabble, Margaret. *Arnold Bennett: A Biography.* New York: Knopf, 1974.

Hepburn, James. "Arnold Bennett." Dictionary of Literary Biography 98:8–20.

———, ed. *Sketches for Autobiography.* London: Allen and Unwin, 1979.

Miller, Anita. "Arnold Bennett." Dictionary of Literary Biography 34:17–28.

NICHOLAS BENTLEY

"Bentley, Nicholas." Contemporary Authors. New Revision Series 11:53.

McLean, Ruari. *Nicolas Bentley Drew the Pictures.* Brookfield, VT: Scolar Press, 1990.

JOHN BERGER

Berger, John. *Berger on Drawing.* Aghabullogue, UK: Occasional, 2005.

———. *John Berger: Eher ein Begehren als ein Geräusch: Zeichnungen und Texte.* Ostfildern vor Stuttgart: Edition Tertium, 1997.

———. Telephone interview with author, January 6, 2006.

———. Excerpts of an unpublished letter exchanged between Berger and daughter Katya. Supplied by Berger to author January 2006.

Berger, John, and Katya Berger Andreadakis. *Titian: Nymph and*

Shepherd. Munich: Prestel-Verlag, 1996.

Hertel, Ralf. "John Berger." Dictionary of Literary Biography 319:25–33.

ELIZABETH BISHOP

Benton, William, ed. *Exchanging Hats.* New York: Farrar, Straus, and Giroux, 1996.

Brown, Ashley. "An Interview with Elizabeth Bishop." *Shenandoah,* Winter 1966, 3–19.

Millier, Brett C. "Elizabeth Bishop." Dictionary of Literary Biography 169:35–53.

Rohter, Larry. "Brazilian Renaissance for an American Poet: Embracing Elizabeth Bishop's Legacy." *New York Times,* August 6, 2001, E1, E5.

WILLIAM BLAKE

Bentley, G. E., Jr., *The Blake Collection of Mrs. Landon K. Thorne.* New York: Pierpont Morgan Library, 1971.

Blake, William. *The Complete Illuminated Books.* New York: Thames and Hudson, 2000.

Hamlyn, Robin, and Michael Phillips, eds. *William Blake.* New York: Abrams, 2000.

Raine, Kathleen. *William Blake.* London: Thames and Hudson, 1970.

Reinhart, Charles. "William Blake." Dictionary of Literary Biography 93:16.

ANDRÉ BRETON

Balakian, Anna. "André Breton." Dictionary of Literary Biography 65:20–28.

Breton, André. *Surrealism and Painting.* New York: Harper and Row, 1965.

Caws, Mary Ann. André Breton. New York: Twayne, 1971.

Masheck, Joseph. *Beat Art.* New York: Butler Library, Columbia University, 1977.

Polizzotti, Mark. *Revolution of the Mind: The Life of André Breton.* New York: Farrar, Straus and Giroux, 1995.

Rosemont, Franklin, ed. *What Is Surrealism: Selected Writings by André Breton.* New York: Monad, 1978.

BREYTEN BREYTENBACH

"Breytenbach, Breyten." Contemporary Authors. New Revisions Series 61:108–13.

Breytenbach, Breyten. "Cadavre Exquis." *The Dual Muse: The Writer as Artist, the Artist as Writer* (Papers from the International Writers Center Symposium, 7-9 Nov. 1997). Edited and introduced by Lorin Cuoco. Amsterdam: Benjamins, 1999.

CHARLOTTE BRONTË

Alexander, Christine, and Jane Sellars. *The Art of Brontës.* Cambridge: Cambridge University Press, 1995.

"The Art of the Brontës." *New Yorker.* February 5, 1996, 48–50.

Rosengarten, Herbert J. "Charlotte Brontë." Dictionary of Literary Biography 21:25–54.

EMILY BRONTË

Alexander, Christine, and Jane Sellars. *The Art of Brontës.* Cambridge: Cambridge University Press, 1995.

Winnifrith, Tom. "Emily Brontë." Dictionary of Literary Biography 21:55–67.

PEARL S. BUCK

Buck, Pearl S. Nobel Lecture, December 12, 1938. http://nobelprize.org/nobel_prizes/literature/laureates/1938/buck_lecture.html (accessed March 28, 2007).

"Pearl Sydenstricker Buck." Pearl S. Buck International. http://www.pearlsbuck.org (accessed July 25, 2002).

CHARLES BUKOWSKI

Basinski, Michael. "Charles Bukowski." Dictionary of Literary Biography 130:56–64.

Glazier, Loss Pequeño, ed. *All's Normal Here: A Charles Bukowski Primer.* Fremont, CA: Ruddy Duck, 1998.

Sounes, Howard. *Charles Bukowski: Locked in the Arms of a Crazy Life.* New York: Grove, 1991.

WILLIAM S. BURROUGHS

Kerouac, Jack. *Departed Angels: The Lost Paintings of Jack Kerouac.* Text by Ed Adler. New York: Thunder's Mouth, 2004.

Severo, Richard. "William S. Burroughs, the Beat Writer Who Distilled His Raw Nightmare Life, Dies at 83." *New York Times,* August 4, 1997, B5.

Sobieszek, Robert A. *Ports of Entry: William S. Burroughs and the Arts.* Los

Angeles: County Museum of Art. New York: Thames and Hudson, 1996.

LEWIS CARROLL

All in the Golden Afternoon: The Inventions of Lewis Carroll. An Exhibition from the Joseph Brabant Collection. Toronto: Thomas Fisher Rare Book Library, 1999.

Blake, Kathleen. "Lewis Carroll." Dictionary of Literary Biography 18:43–61.

Cohen, Morton. *Lewis Carroll: A Biography.* New York: Knopf, 1995.

———, ed. *Lewis Carroll: Interviews and Recollections.* New York: Macmillan, 1989.

Cotter, Holland. "Notable Notes, Drawings by Writers and Composers." *New York Times,* January 9, 1998, late edition, 39.

Gopnik, Adam. "Wonderland." *New Yorker,* October 9, 1995, 82–90.

Shute, Mrs. E. L. "The Walks Were Well Worth the Cricks! Lewis Carroll as Artist." *Cornhill Magazine,* November 1932, 559–62.

JOYCE CARY

Anshen, Ruth Nanda. *Art and Reality.* New York: Doubleday Anchor Books.

Ayling, Ronald. "Joyce Cary." Dictionary of Literary Biography 100:73–82.

Bishop, Alan. *Gentleman Rider: A Life of Joyce Cary.* London: Michael Joseph, 1988.

Foster, Malcom. *Joyce Cary: A Biography.* Boston: Houghton Mifflin, 1968.

Friedman, Warren. "Joyce Cary." Dictionary of Literary Biography 15:55–65.

R. V. CASSILL

Balmer, Stephen. "R. V. Cassill." Dictionary of Literary Biography 218:98–107.

Lehmann-Haupt, Christopher. "R. V. Cassill, Novelist and Writing Teacher, Dies at 82." *New York Times,* April 1, 2002, late edition, B7.

G. K. CHESTERTON

Boyd, Ian. "G. K. Chesterton." Dictionary of Literary Biography 19:62–76.

Chesterton, G. K. *The Autobiography of G. K. Chesterton.* North

Yorkshire, UK: House of Stratus, 2001.

Cotter, Holland. "Notable Notes, Drawings by Writers and Composers." *New York Times,* January 9, 1998, late edition, 39.

Finch, Michael. *G. K. Chesterton.* New York: Harper Collins, 1987.

Furlong, William B. "G. K. Chesterton." Dictionary of Literary Biography 10:101–6.

WINSTON CHURCHILL

Keegan, John. "His Finest Hour." *US News & World Report,* May 29, 2000, 50–57.

Kitzen, Laurence. "Sir Winston Churchill." Dictionary of Literary Biography 100:83–90.

Manchester, William. *The Last Lion.* New York: Dell, 1983.

Simertz, S. "The Nobel Prize for Literature." Nobel Prize for Literature 1953 Presentation Speech. http://www.nobel.se/literature/laureates/1953/press.html (accessed October 30, 2000).

Soames, Mary. *Winston Churchill: His Life as a Painter.* London: Collins, 1990.

"Winston Churchill." http://www.winstonchurchill.org/ffhartist.htm.

DANIEL CLOWES

Chocano, Carina. "Daniel Clowes." Salon.Com People. http://www.salon.com/people/bc/2000/12/05/clowes/ (accessed August 1, 2001).

Friend, Tad. "Comics from Underground." *New Yorker,* July 30, 2001, 28–31.

JEAN COCTEAU

Emboden, William. *The Visual Art of Jean Cocteau.* New York: International Archive of Art, 1989.

McNab, James P. "Jean Cocteau." Dictionary of Literary Biography 65:29–41.

Steegmuller, Francis. *Cocteau: A Biography.* Boston and Toronto: Atlantic, Little, Brown, 1970.

WILKIE COLLINS

Breton, André. *Surrealism and Painting.* New York: Harper and Row, 1965.

Davis, Nuel Pharr. *The Life of Wilkie Collins.* Urbana: University of Illinois Press, 1956.

Gasson, Andrew. *Wilkie Collins: An Illustrated Guide.* Oxford University Press, 1998.

Nadel, Ira B. "Wilkie Collins." Dictionary of Literary Biography 18:61–77.

Peters, Catherine. *The King of Inventors.* London: Martin Secker and Warburg, 1991.

JOSEPH CONRAD

Conradiana: A Journal of Joseph Conrad Studies 27 (Spring 1995).

"Joseph Conrad." OhioLink Research Databases for MLA International Bibliography. http://olc7.ohiolink.edu (accessed March 4, 1999).

Meyer, Bernard C., M.D. *Joseph Conrad: A Psychoanalytic Biography.* Princeton, NJ: Princeton University Press, 1967.

Widmer, Kingsley. "Joseph Conrad." Dictionary of Literary Biography 34:43–82.

CATHERINE COOKSON

"Cookson." Contemporary Authors. New Revision Series 68:113–16.

Cookson, Catherine. *Our Kate.* London and Sydney: MacDonald, 1969.

"Cookson's Best Sellers." *International Express,* December 1, 1998, 22.

Goodwin, Cliff. *To Be a Lady: The Story of Catherine Cookson.* London: Century, 1994.

Jones, Kathleen. *Catherine Cookson: The Biography.* London: Constable, 1999.

GREGORY CORSO

Corso, Gregory. "Dialogues from Children's Observation Ward." Cited in The Allen Ginsberg Papers, 1937-1994. Box 54, Reel-to-reel Tape 56A4/005. Stanford University Libraries. Department of Special Collections and University Archives.

Creeley, Robert. "Gregory Corso: 1930–2001." http://wings, buffalo.edu/epc/authors/creeley/corso.html (accessed January 18, 2001).

Honan, William H. "Gregory Corso, a Candid-Voiced Beat Poet, Dies at 70." *New York Times,* January 19, 2001, late edition, 10.

Kerouac, Jack. *Departed Angels: The Lost Paintings of Jack Kerouac.* Text by Ed Adler. New York: Thunder's Mouth, 2004.

"(Nunzio) Gregory Corso." Contemporary Authors. New Revisions Series 76:71–74.

Sanders, Edward. "A Salute to Gregory Corso, Poet among Poets."

Woodstock Journal. http://www.woodstockjournal.com/corso6-18.html#ferlinghetti (accessed May 9, 2001).

Schwartz, Marilyn. "Gregory Corso." Dictionary of Literary Biography 16:117–40.

Selerie, Gavin, ed. *The Riverside Interviews* 3*: Gregory Corso.* London: Binnacle, 1982.

Skau, Michael. "Gregory Corso: Biographical Note." Modern American Poetry (University of Illinois at Urbana). http://www.english.uiuc.edu (accessed May 9, 2001).

DOUGLAS COUPLAND

"Coupland, Douglas." Contemporary Authors. New Revisions Series 90:82–85.

"Douglas Coupland." Monte Clark Gallery Web Page. http://www.monteclarkgallery.com/pages/toronto/toronto.htm (accessed July 16, 2002).

HART CRANE

Bennett, Maria F. *Unfractioned Idiom: Hart Crane and Modernism.* New York: Peter Lang, 1987.

Epstein, Daniel Mark. "Condensing Eternity: A New Biography of Hart Crane Reads the Poems in the Context of the Life." *New York Times,* July 14, 2002, late edition, 12.

Herendeen, Warren, and Donald G. Parker, eds. *Hart Crane Newsletter.* Vol. 1. New York: Waldon, 1977.

Miller, Joseph. "Hart Crane." Dictionary of Literary Biography 48:78–96.

Socin, Jay, and Kirby Congdon, eds. *Hart Crane: A Conversation with Samuel Loveman.* New York: Interim, 1964.

Unterecker, John. *Voyager: A Life of Hart Crane.* New York: Farrar, Straus and Giroux, 1969.

E. E. CUMMINGS

Cotter, Holland. "Notable Notes: Drawings by Writers and Composers." *New York Times,* January 9, 1998, late edition, 39.

Firmage, George J. *E. E. Cummings: A Biography.* Middletown, CT: Wesleyan University Press.

Kennedy, Richard S. *Dreams in the Mirrors: A Biography of E. E. Cummings.* New York: W. W. Norton, 1994.

Martin, Robert K. "E. E. Cummings." Dictionary of Literary Biography 4:105–11.

Mattson, Francis O. *E. E. Cummings @ 100.* New York: New York Public Library, 1994.

Walrath, Jean. "A Cummings Exhibit." *People,* April 21, 1972, sec. C.

HENRY DARGER

Anderson, Brooke Davis. *Darger: The Henry Darger Collection at the American Folk Museum.* New York: Abrams, 2001.

Boxer, Sarah. "He Was Crazy Like a . . . Genius?" *New York Times,* September 16, 2000, late edition, 7.

Homes, A. M. "Hidden Treasures: Henry Darger's Unearthed Fairy Tales." *Vanity Fair,* December 2001, 138.

Hughes, Robert. "A Life of Bizarre Obsession." *Time,* February 24, 1997.

In the Realms of the Unreal: A Documentary about Artist Henry Darger. Directed by Jessica Yu; produced by Susan West. Diorama Films LLC, 2004.

GUY DAVENPORT

Davenport, Guy. *50 Drawings.* New York: Dim Gray Bar Press, 1996.

"Davenport, Guy." *Contemporary Novelists.* 5th ed. London: St. James, 1991.

Meanor, Patrick. "Guy Davenport." Dictionary of Literary Biography 130:89–103.

Reece, Erik Anderson. *A Balance of Quinces: The Paintings and Drawings of Guy Davenport.* New York: New Directions, 1996.

FERNANDO DEL PASO

Del Paso, Fernando. Interview with author, December 16, 2003.

Stavans, Ilan. "Interview with Fernando del Paso." Dalkey Archive Press. http://www.centerforbookculture.org/interviews/interview_delpasso.html (accessed July 18, 2001).

J. P. DONLEAVY

Nelles, William. "J. P. Donleavy." Dictionary of Literary Biography 173:73–83.

"Yah, He's Still the Man." *Irish Times,* July 24, 1999. http://www.ireland.com/newspaper/features/1999/0724/fea3.htm (accessed April 2, 2002).

JOHN DOS PASSOS

Dos Passos, John. *The Best Times: An Informal Memoir.* New York: New American Library, 1966.

"John Dos Passos." Bentley Publishers. http://www.rb.com/author/htm?who=john_Dos_Passos (accessed July 21, 2002).

"John Dos Passos." OhioLink Research Databases for MLA International Bibliography. http://olc7.ohiolink.edu (accessed March 8, 1999).

"John Dos Passos." Spartacus Educational. http://www.spartacus.schoolnet.co.uk/Jpassos.htm (accessed July 21, 2002).

Ludington, Townsend, ed. *The Fourteenth Chronicle: Letters and Diaries of John Dos Passos.* Boston: Gambit, 1973.

FYODOR DOSTOEVSKY

Dostoevsky, Fyodor. *The Notebooks for Crime and Punishment.* Edited and translated by Edward Wasiolek. Chicago and London: University of Chicago Press, 1967.

———. *Fedora Dostoevskogo.* Text by K. A. Barscht. Moscow: Voskresene, 1998.

"Fyodor Dostoevsky." http://www.kirjasto.sci.fi/dosto.htm (accessed July 21, 2002).

Murav, Harriet. "Fyodor Dostoevsky." Dictionary of Literary Biography 238:42–70.

Terras, Victor. *The Young Dostoevsky, 1846–1849: A Critical Study.* Slavic Printings and Reprintings, no. 69. The Hague: Mouton, 1969.

GEORGE DU MAURIER

Du Maurier, Daphne, ed. *The Young George du Maurier: A Selection of His Letters 1860-1867.* New York: Doubleday, 1952.

Du Maurier, George. "The Illustrating of Books from the Serious Artist's Point of View." The Magazine of Art, 1890, 371–375.

Kelly, Richard Michael. *The Art of George du Maurier.* England and Vermont: Scolar and Ashgate, 1996.

———. "George du Maurier." Dictionary of Literary Biography 153:76–83.

ALEXANDRE DUMAS *FILS*

Degen, John A. "Alexandre Dumas Fils." Dictionary of Literary Biography 192:103–16.

Schwartz, Stanley. *Alexandre Dumas Fils, Dramatist.* New York: New York University Press, 1927.

ROBERT DUNCAN

Butterick, Robert J. "Robert Duncan." *Dictionary of Literary Biography* 193:95–113.

Duncan, Robert. *Drawings and Decorated Books.* Berkeley: University of California at Berkeley, Rose, 1992.

Mills, Ralph J., Jr. "Three Established Poets and a New One." *Sun-Times,* October 19, 1969.

WILLIAM DUNLAP

Canary, Robert H. *William Dunlap.* New York: Twayne, 1970.

Coad, Oral S. "William Dunlap: New Jersey Artist." *Proceedings from the New Jersey Historical Society: A Magazine of New Jersey History,* October 1965.

Dunlap, William. Diary of William Dunlap: *The Memoirs of a Dramatist, Theatrical Manager, Painter, Critic, Novelist, and Historian.* Vol. 1. New York: New York Historical Society, 1930.

Harvey, Robert D. "William Dunlap." *Dictionary of Literary Biography* 59:101–7.

Henkels, Stan V., compiler. *Collection of Ivory Miniatures and Water Color Views in New York by W. M. Dunlap.* Catalogue no. 927. Philadelphia: Davis and Harvey, 1905.

William Dunlap, Painter and Critic: *Reflections on American Painting of a Century Ago.* Andover, MA: Addison Gallery of American Art, 1939.

Woolsey, Theodore S. "William Dunlap, Painter and Critic or the American Vasari." *Yale Review,* July 1914, 4–5.

DOROTHY DUNNETT

Casciani, Elizabeth. "The Full Life of Dorothy Dunnett," *Scots Magazine,* August 1986, 512–19.

"Dorothy Dunnett." http://www.jthin.co.uk/dunnett.htm (accessed December 29, 2000).

"Dorothy Dunnett." Contemporary Authors Online. Gale. http://www.galenet.com (accessed January 17, 2001).

Dunnett, Alastair. *Among Friends: An Autobiography.* London: Century, 1984.

Malcolm, Anne. "Dorothy Dunnett's Excellent Adventures." *New York Times,* December 24, 2000, book review, 11–12.

Mor, Ruairidh. "Meet Dorothy Dunnett." http:// www.his.com/~rory/dntbio.html (accessed December 29, 2000).

Richardson, Jean. "Dorothy Dunnett: An Historical Pageant." *Publishers Weekly,* May 11, 1998, 46.

Verongos, Helen. "Dorothy Dunnett, Novelist of Scotland, Is Dead at 78." *New York Times on the Web,* November 13, 2001. http://www.nytimes.com (accessed July 23, 2002).

LAWRENCE DURRELL

Wickes, George, ed. *Lawrence Durrell, Henry Miller: A Private Correspondence.* New York: E. P. Dutton, 1963.

Young, Noel, ed. *The Paintings of Henry Miller: Paint as You Like and Die Happy.* San Francisco: Chronicle, 1973.

FRIEDRICH DÜRRENMATT

Crockett, Roger A. "Friedrich Dürrenmatt." Dictionary of Literary Biography 69:61–84.

———. *Understanding Friedrich Dürrenmatt.* Columbia: University of South Carolina Press, 1998.

Dürrenmatt, Friedrich. *The Happy Pessimist.* New York: Swiss Institute, 1997.

———. *Schrift-steller und Maler.* Berne and Zurich: Bundesamt für Kultur, 1994.

"Friedrich Dürrenmatt." Contemporary Authors Online. Gale. http://www.galenet.com (accessed January 17, 2001).

"Friedrich Dürrenmatt." OhioLink Research Databases for MLA International Bibliography. http://olc7.ohiolink.edu (accessed March 3, 1999).

RUSSELL EDSON

"Edson, Russell." Contemporary Authors 33–36:270–71.

"Edson, Russell." Contemporary Literary Criticism 13:190–91.

Siegel, Robert, and Noah Adams, anchors. "Poetry from a Man Who Says His Writing Is Not Poetry." *All Things Considered.* National Public Radio, July 20, 1999.

Upton, Lee. *The Muse of Abandonment.* London: Associated University Press, 1998.

WILL EISNER

Boxer, Sarah. "Will Eisner, a Pioneer of Comic Books, Is Dead at 87." *New York Times,* January 5, 2005.

Eisner, Will. *A Contract with God and Other Tenement Stories.* New York: Titan, 1996.

Feiffer, Jules. *The Great Comic Book Heroes.* New York: Bonanza/Crown, 1965.

"Will Eisner." http://willeisner.tripod.com/bio/index.html (accessed January 14, 2005).

ODYSSEUS ELYTIS

Elytis, Odysseus. *Open Papers.* Translated by Olga Broumas and T. Begley. Port Townsend, WA: Copper Canyon, 1995.

———. "Picasso's Equivalences." *Books Abroad: An International Literary Quarterly* 49, no. 4 (Autumn 1975).

Friar, Kimon. "The Imagery and Collages of Odysseus Elytis." *Books Abroad: An International Literary Quarterly* 49, no. 4 (Autumn 1975).

"Odysseus Elytis." http://www.kirjasto.sci.fi/elitis.htm (accessed April 2, 2002).

"Odysseus Elytis." Contemporary Authors Online. Gale. http://www.galenet.com (accessed March 8, 2002).

"Odysseus Elytis." Nobel Foundation. http://www.nobel.se/literature/laureates/1979/elytis-bio.html (accessed April 2, 2002).

CAROL EMSHWILLER

"Carol Emshwiller." Contemporary Authors Online. Gale. http://www.galenet.com (accessed January 15, 2003).

Emshwiller, Carol. Autobiography. http://www.sfwa.org/members/emshwiller/CE_Info.

———. Interview with author, February 23, 2003.

———. Letter to author, undated, received in March 2003.

WILLIAM FAULKNER

Fowler, Doreen, and Ann J. Abadie, eds. *Faulkner: International Perspectives.* Jackson: University Press of Mississippi, 1984.

Meriwether, James B., and Michael Millgate, eds. *Lion in the Garden: Interviews with William Faulkner.* New York: Random House, 1968.

Taylor, Henry. "Sanctuary: Literature and Architecture Merge in This Study of Faulkner's Mississippi." *New York Times,* February 9, 1997, book review, 7.

"William Faulkner." Little Blue Light. http://www.littlebluelight.com/faulknermain.html (accessed March 18, 2001).

"William Faulkner." OhioLink Research Databases for MLA International Bibliography. http://olc7.ohiolink.edu (accessed March 4, 1999).

JULES FEIFFER

Feiffer, Jules. Interview with author, May 22, 2001.

"Feiffer Biography." http://www.julesfeiffer.com (accessed June 14, 2001).

Hajdu, David, "The Spirit of the Spirit." *New York Review,* June 21, 2001, 48–49.

"Jules Ralph Feiffer." *Contemporary Literary Criticism Online.* Gale. http://web.lexis-nexis.com (accessed July 24, 2000).

Memran, Michelle A. "From Cary Grant to 'Carnal Knowledge.'" *The Daily Northwestern,* 1966.

Ruddick, Thomas Edward. "Jules Feiffer." Dictionary of Literary Biography 7:172–78.

Russo, Francine. "A Matter of Medium: Writer Jules Feiffer Recalls the Forces That Redirected His Career." *Time,* May 21, 2001, G8. (Special section, not available in all editions.)

LAWRENCE FERLINGHETTI

Ashely, Beth. "This Poet Can Also Paint." Marin *Independent Journal,* July 13, 1999, Lifestyles, C1ff.

Ferlinghetti, Lawrence. Interview with author, October 22, 2000.

Finkel, Jori. "Over There: A Critical Guide to San Francisco Events." *Express,* March 13, 1998.

"Lawrence Ferlinghetti: Pure Art vs. Agit-Prop." *The Journal of Prints, Drawings, and Photography,* May–June 1998.

"Pure Art vs. Agit-Prop." *San Francisco Examiner Magazine,* March 15, 1998.

Rodriguez, Juan. "A Conversation with Lawrence Ferlinghetti." *Artweek,* September 1999, 19–20.

Shaboy, Benny. "Lawrence Ferlinghetti." *Studio Notes,* August–October 1999.

Smith, Larry. "Lawrence Ferlinghetti." Dictionary of Literary Biography 16:199–213.

DONALD FINKEL

Finkel, Donald. Emails to author, September 19, 2000 and October 24, 2000.

———. Letter to author March 28, 2000.

DARIO FO

"Dario Fo." American Repertory Theater. http://www.fas/harvard.edu/~art/fo/html (accessed October 21, 2001).

"Dario Fo." http://www.kirjasto.sci.fi/dariofo.htm (accessed September 15, 2001).

"Dario Fo." Nobel Foundation.
http://www.nobel.se/literature/laureates/1997/fo-bio.html. (accessed September 15, 2001).

Jenkins, Ron. "Comedy That Starts in the Muscles." *New York Times,* September 16, 2001, late edition, 5, 21.

———. *Dario Fo and Franca Rame: Artful Laughter.* New York: Aperture Foundation, 2001.

CHARLES HENRI FORD

Hoare, Philip. "Charles Henri Ford: Enigmatic Survivor of New York's Bohemian Surrealists," *The Independent,* October 1, 2002, obituaries.

Rood, Karen L. "Charles Henri Ford." Dictionary of Literary Biography 48:199–210.

Smith, Roberta. "Charles Henri Ford, 94, Prolific Poet, Artist and Editor." *New York Times,* September 30, 2002, obituaries.

EUGÈNE FROMENTIN

Fleming, John A. "Eugène Fromentin." Dictionary of Literary Biography 123:90–100.

Wright, Barbara. *Eugène Fromentin: A Life in Art and Letters.* Berlin: Peter Lang, 2000.

GAO XINGJIAN

"Gao Xingjian." *Books and Writers.* http://www.kirjasto.sci.fi/gao.htm (accessed January 31, 2002).

"Gao Xingjian." Cerle-blue.fr. http://www/cercle-blue-fr/Gao (accessed November 1, 2000).

"Gao Xingjian." *Contemporary Authors Online.* Gale. http://www.galenet.com. (accessed February 4, 2002).

"Gao Xingjian." The Swedish Academy. http://www.nobel.se/announcements/2000/litbibl_en00.html (accessed October 30, 2000).

"Gao Xingjian." Alisan Fine Arts. http://www.alisan.com.hk/ali_newsletter_mid.html (January 31, 2002).

Lee, Mabel. *Walking Out of Other People's Prisons: Liu Zaifu and Gao Xianjian on Chinese Literature in the 1990s.* Sydney: University of Sydney, School of Asian Studies. 1996.

Lee, Vico. "A Literary Master Sheds New Light." *Online Taipei Times,* October 7, 2001. http://www.taipeitimes.com/news/2001/10/07/print/0000106151 (accessed January 31, 2002).

Shen, Andrea. "Nobel Winner Affirms the 'Self.' " *Harvard University Gazette,* March 8, 2001. http://www.nes.harvard.edu/gazette/2001/03.08/03-xingjian.html.31 (accessed January 2002).

FEDERICO GARCÍA LORCA

Anderson, Andrew A. "Federico García Lorca." Dictionary of Literary Biography 108:134–60.

Gebser, Jean. *Lorca: Poète-Dessinateur.* Paris: GLM (Guy Lèvis Mano), 1949.

Lorca, Federico García. *Dibujos.* Barcelona: Ministerio de Cultura, 1996.

"Lorca, Federico García." OhioLink Research Databases for MLA International Bibliography. http://olc7.ohiolink.edu (accessed March 4, 1999).

Preito, Gregorio. *García Lorca: As a Painter.* London: De La More, 1946.

THÉOPHILE GAUTIER

Breunig, LeRoy C. Barzun. "Théophile Gautier." *European Writers: The Romantic Century* 6. Edited by Jacques and George Stade. New York: Scribner, 1985.

Théophile Gautier. "Théophile Gautier par lui-même," *L'Illustration,* March 9, 1867.

Théophile Gautier, la critique en liberté. Les Dossiers du musée d'Orsay, no. 62. Paris: Editions de la Réunion des musées nationaux, 1997.

Smith, Albert B. "Théophile Gautier." Dictionary of Literary Biography 119:151–64.

KAHLIL GIBRAN

Ferris, Anthony. *Kahlil Gibran: A Self-Portrait.* Secaucus, NJ: Citadel, 1959.

"Gibran, Kahlil." Contemporary Authors 150:163–66.

Gibran, Jean, and Kahlil Gibran. *Kahlil Gibran: His Life and World.* New York: Avenel, 1981.

W. S. GILBERT

Browne, Edith A. *W. S. Gilbert.* London: John Lane, the Bodley Head, 1926.

Bush Jones, John. *W. S. Gilbert: A Century of Scholarship and Commentary.* New York: New York University Press, 1970.

"Gilbert, William." Contemporary Authors 173:162–67.

Gilbert, William Schwenk. *An Autobiography.* 1883.

Pearson, Hesketh. *Gilbert: His Life and Strife.* London: Methuen, 1957.

ALLEN GINSBERG

Carter, David, ed. *Ginsberg, Allen: Spontaneous Mind: Selected Interviews 1958–1996.* New York: HarperCollins, 2001.

Christensen, Paul. "Allan Ginsberg." Dictionary of Literary Biography 16:214–40.

Masheck, Joseph. *Beat Art.* New York: Columbia University Press, 1977.

JOHANN WOLFGANG VON GOETHE

Adler, Jeremy. "Midlife Strum und Drang." *New York Times Book Review* (Nicholas Boyle's *Goethe: The Poet and The Age: Volume II: Revolution and Renunciation (1790-1803)*), May 28, 2000, 17.

Brown, Jane K. "Johann Wolfgang von Goethe." Dictionary of Literary Biography 94:46–67.

Goethe, Johann Wolfgang. *The Autobiography of Goethe, Truth and Poetry from My Life.* New York: Wiley and Putnam, 1846.

"Goethe, Johann Wolfgang von." OhioLink Research Databases for MLA International Bibliography. http://olc7.ohiolink.edu (accessed March 8, 1999).

Robson-Scott, W. D. *The Younger Goethe and the Visual Arts.* Cambridge: Cambridge University Press, 1981.

NIKOLAI GOGOL

Adams, Amy Singleton. "Nikolai Vasilevich Gogol." Dictionary of Literary Biography 198:137–66.

Matlaw, Ralph E. "Nikolay Vasilevich Gogol." *European Writers: The Romantic Century* 6. Edited by Jacques and George Stade. New York: Scribner, 1985.

Shapiro, Gavriel. *Nikolai Gogol and the Baroque Cultural Heritage.* University Park: Pennsylvania State University Press, 1993.

EDMOND DE GONCOURT

Baldick, Robert, ed. *Pages from the Goncourt Journal.* London: Folio Society, 1980.

Bart, B. F. "Edmond de Goncourt and Jules de Goncourt." Dictionary of Literary Biography 123:117–38.

Belloc, M. A., and M. Shedlock. *Edmond and Jules De Goncourt.* Vol. 1. New York: Dodd, Mead, 1895.

JULES DE GONCOURT

Bart, B. F. "Edmond de Goncourt and Jules de Goncourt." Dictionary of Literary Biography 123:117–38.

Belloc, M. A., and M. Shedlock. *Edmond and Jules De Goncourt.* Vol. 1. New York: Dodd, Mead, 1895.

Billy, Andre. *The Goncourt Brothers.* Translated by Margaret Shaw. London: André Deutsch, 1960.

EDWARD GOREY

"Edward Gorey: Artist-Author Dies at 75." Yahoo! News. April 17, 2000. http://www/fullcoverage.yahoo.com/fc/Breaking/Edward_Gorey.

Gorey, Edward. *Ascending Peculiarity.* Edited by Karen Wilkin. New York: Harcourt, 2001.

Street, Douglas. "Edward Gorey." Dictionary of Literary Biography 61:99–107.

GÜNTER GRASS

Grass, Günter. *In Kupfer, auf Stein: Das grafische Werk Herausgege ben von G. Fritze Margull.* Gottingen: Steidl, 1994 (1st ed. 1986).

"Günter Grass." The Swedish Academy: The Nobel Prize for Literature. http://www.nobel.se/literature/laureates/1999/press.html (accessed October 30, 2000).

Günter Grass the Artist. An Exhibition. Stockholm, Sweden: Nobel Library of the Swedish Academy. December 6–17, 1999.

Russell, John. "Art View; Günter Grass as Printmaker, Poet, Storyteller and Fabulist." *New York Times on the Web,* March 6, 1983. http://www.nytimes.com (accessed August 2, 2001).

KATE GREENAWAY

Holme, Bryan. *The Kate Greenaway Book.* New York: Penguin, 1977.

Lundin, Anne H. "Kate Greenaway." Dictionary of Literary Biography 141:103–17.

Spielmann, M. H., and G. S. Layard. *Kate Greenaway.* London: Adam and Charles Black, 1905.

DEBORA GREGER

Greger, Debora. Telephone interview with author, November 5, 2001.

———. Letter to author, undated, but received in December 2001.

FRANZ GRILLPARZER

Seeba, Hinrich C. "Franz Grillparzer." Dictionary of Literary Biography 133:123–33.

THOMAS HARDY

Brennecke, Ernest, Jr. *The Life of Thomas Hardy.* New York: Haskell, 1973.

Draper, Jo. *Thomas Hardy: A Life in Pictures.* Edited by Richard Ellman and Robert O'Clair. Dorset, UK: Dovecote, 1989.

Gibson, James. *A Literary Life.* New York: St. Martin's, 1996.

———. Thomas Hardy: Interviews and Recollections. New York: St. Martin's, 1999.

Jackson, Arlene M. *Illustration and the Novels of Thomas Hardy.* Totowa, NJ: Rowman and Littlefield, 1981.

Page, Norman. "Thomas Hardy." Dictionary of Literary Biography 18:119–42.

MARSDEN HARTLEY

Haskell, Barbara. *Marsden Hartley.* New York: New York University Press, 1980.

Innes, William, ed. *Heart's Gate: Letters between Marsden Hartley and Horace Traubel.* Highlands, NC: Jargon Society, 1982.

Ludington, Townsend. *The Biography of an American Artist.* New York: Little, Brown, 1992.

———. *Seeking the Spiritual: The Paintings of Marsden Hartley.* Ithaca, NY, and London: Cornell University Press, 1998.

Martin, Robert K. "Marsden Hartley." Dictionary of Literary Biography 54:147–53.

Ryan, Susan Elizabeth. *The Autobiography of Marsden Hartley.* Boston: MIT Press, 1996.

JULIAN HAWTHORNE

Bassan, Maurice. *Hawthorne's Son: The Life and Literary Career of Julian Hawthorne.* Columbus: Ohio State University Press, 1970.

Hawthorne, Edith Garrigues, ed. *The Memoirs of Julian Hawthorne.* New York: Macmillan, 1938.

"Hawthorne, Julian." Contemporary Authors 165:149–53.

Salmonson, Jessica Amanda. "Nathaniel Hawthorne's Son: Julian Hawthorne's Beginnings and Beliefs." Violet Books. http://www.violetbooks.com/julianhawthorne.html (accessed July 30, 2002).

LAFCADIO HEARN

Cott, Jonathan. *Wandering Ghost.* New York: Knopf, 1991.

Frost, O. W. *Young Hearn.* Tokyo: Hokuseido, 1958.

Koizumi, Kazuo. *Father and I: Memories of Lafcadio Hearn.* Boston and New York: Houghton Mifflin, 1935.

———. *Re-Echo.* Edited by Nancy Jane Fellers. Caldwell, ID: Caxton, 1957.

Kreyling, Michael. "Lafcadio Hearn." Dictionary of Literary Biography 12:245–53.

Stevenson, Elizabeth. *The Grass Lark.* Somerset, NJ: Transaction, 1999.

Yu, Beongcheon. *An Ape of God's.* Detroit: Wayne State University Press, 1964.

O. HENRY

Langford, Gerald. Alias *O. Henry: A Biography of William Sidney Porter.* New York: Macmillan, 1957.

Leudtke, Luther S., and Keith Lawrence. "William Sydney Porter (O. Henry)." Dictionary of Literary Biography 78:288–307.

Olaniszyn, Jean, and Karin Adrian von Roques, eds. *Hermann Hesse: Poet and Painter.* New York: Donahue/Sosinki Art, 1998.

O'Quinn, Trueman E., and Jenny Lind Porter. *Time to Write: How William Sidney Porter Became O. Henry.* Austin, TX: Eakin, 1986.

Porter, William Sydney, Robert H. Davis, and Arthur B. Maurice. *The Caliph of Bagdad.* New York and London: Appleton, 1931.

"A Rewrite by the Fans Any Author Would Like." *New York Times,* February 22, 1998, late edition, 24.

HERMANN HESSE

"Hermann Hesse—Autobiography." The Swedish Academy: The Nobel Prize for Literature. http://www.nobel.se/literature/laureates/1999/press.html (accessed July 20, 2002).

PATRICIA HIGHSMITH

Highsmith, Patricia. *Zeichnungen.* Zürich: Diogenes Verlag Ag, 1995. [Highsmith's original preface was lost, and the quoted text is from a retranslation of the German version.]

"(Mary) Patricia Highsmith." *Contemporary Authors Online.* Gale. http://www.galenet.com (accessed March 8, 2002).

"Patricia Highsmith." http://www.kirjasto.sci.fi/highsm/htm (accessed March 26, 2002).

RALPH HODGSON

Clark, Alan. S.v. Hodgson, Ralph. *Dictionary of British Comic Artists, Writers and Editors.* London: British Library, 1998.

D'Amico, Diane. "Ralph Hodgson." Dictionary of Literary Biography 19:210–14.

Kershner, Ammon George, Jr. "Ralph Hodgson: A Biographical and Critical Study." Ph.D. dissertation. University of Pennsylvania, 1952.

Pelkey, Kim. "The Ralph Hodgson Collection." http://www.brynmawr.edu/Library/Docs/hodgson.html (accessed March 22, 2002).

Sweetser, Wesley D. *Ralph Hodgson: A Biography.* New York and Oswego, NY: privately printed for the author, 1974.

E. T. A. HOFFMANN

"Ernst Theodor Amadeus Hoffmann." Scandinavian Studies. http://scandinavian.wisc.edu/hca/glossary/hoffmann.html (accessed March 18, 2001).

"Ernst Theodor Amadeus Wilhem Hoffman." *Book and Writers.* http://www.kirjasto.sco.fi/hoffman.htm (accessed March 18, 2001).

"E. T. A. Hoffmann." Little Blue Light. http://www.littlebluelight.com/hoffmannframe.html (accessed March 18, 2001).

Hewett-Thayer, Harvey W. *Hoffmann: Author of the Tales.* Princeton, NJ: Princeton University Press, 1948.

Sahlin, Johanna, ed. and trans. *Selected Letters of E. T. A. Hoffmann.* Chicago and London: University of Chicago Press, 1977.

"Weird Tales of the Weird Man." German Culture. http://www.german-culture.com. (accessed March 18, 2001).

MAXINE HONG KINGSTON

Feng, Patricia. "Maxine Hong Kingston." Dictionary of Literary Biography 173:84–97.

Kingston, Maxine Hong. Emails to author, September 22 and 27, 2000.

"Kingston, Maxine (Ting Ting) Hong." Contemporary Authors. New Revisions Series 13:292; 74:191–95.

GERARD MANLEY HOPKINS

Bump, Jerome. "Gerard Manley Hopkins." Dictionary of Literary Biography 35:82–105.

Lahey, G. F. *Gerard Manley Hopkins.* New York: Octagon, 1970.

Martin, Robert Bernard. *Gerard Manley Hopkins: A Very Private Life.* New York: Harper Collins, 1991.

Phillips, Catherine. *Gerard Manley Hopkins: Selected Letters.* Oxford: Clarendon, 1990.

Ruggles, Eleanor. *Gerard Manley Hopkins: A Life.* Port Washington, NY: Kennikat, 1969.

PAUL HORGAN

Day, James M. *Paul Horgan.* Austin, TX: Steck-Vaughn, 1967.

Gish, Robert Franklin. *Nueva Granada: Paul Horgan and the Southwest.* College Station: Texas A&M University Press.

Horgan, Paul. *A Writer's Eye.* New York: Abrams, 1988.

Morrison, Robert W. "Paul Horgan." Dictionary of Literary Biography 102:171–76.

VICTOR HUGO

Berman, Paul. "Hugomania: For Victor Hugo, Nothing Succeeds Like Excess." *New Yorker,* January 26, 1998, 76–81.

Hugo, Victor. *Shadows of a Hand: The Drawings of Victor Hugo.* London: Merrell Holberton, 1998.

Philbin, Ann, and Florian Rodari, eds. *Shadows of a Hand: The Drawings of Victor Hugo.* New York: Drawing Center, 1998.

Rothstein, Edward. "Victor Hugo: A Theme of Good and Evil? Not So Fast." *New York Times,* May 11, 1998, late edition, 2.

"Victor Hugo." Scribner Writers Series, New York Public Library. http://www.galenet.com (accessed February 4, 2002).

EVAN HUNTER (ED MCBAIN)

Schleier, Curt. "The Many Faces of Evan Hunter." *Ironminds.* http://www.ironminds.com (accessed May 18, 2002).

ALDOUS HUXLEY

"Aldous Huxley." OhioLink Research Databases for MLA International Bibliography. http://olc7.ohiolink.edu (accessed March 5, 1999).

Huxley, Aldous. *Complete Essays.* Chicago: Ivan R. Dee, 2000.

———. On Art and Artists. New York: Harper Brothers, 1960.

Huxley, Julian. *Aldous Huxley: 1894–1963.* London: Chatto and Windus, 1965.

Loos, Anita. "Aldous Huxley in California." *Harper's Magazine,* May 1964.

Marovitz, Sanford E. "Aldous Huxley and the Visual Arts." *Papers on Language and Literature,* Spring 1979.

Paulsell, Sally. "Color and Light: Huxley's Pathway to Spiritual Reality." *Twentieth Century Literature* 41 (Spring 1995).

HENRIK IBSEN

Ferguson, Robert. *Henrik Ibsen: A New Biography.* London: Richard Cohen, 1996.

"Henrik Ibsen." *Contemporary Authors Online.* Gale. http://www.galenet.com (February 19, 2002).

"Henrik Ibsen, Playwright." Little Blue Light. http://www.littlebluelight.com (accessed March 18, 2001).

Jorgenson, Theodore. *Henrik Ibsen: Life and Drama.* Minnesota: St. Olaf Norwegian Institute, 1965.

Koht, Halvdan. *The Life of Ibsen.* New York: Norton, 1931.

Meyer, Michael. *The Making of a Dramatist.* London: Rupert Hart-Davis, 1967.

EUGÈNE IONESCO

"Ionesco, Eugène." Contemporary Authors. New Revisions Series 55:237–44.

Ionesco, Eugène. "Black and White." *Radical Shadows, Conjunctions* (New York: Bard College) 31 (1998).

———. *Le Blanc et le Noir.* Paris: Gallimard, 1981.

Kimmerle, Robert. Email to author, October 1, 2000.

Olsen, Soren. Email to author, September 1, 2000.

MAX JACOB

"Cyprien Max Jacob." *Twentieth-Century Literary Criticism* 6. Detroit: Gale, 1984, 189–204.

"Max Jacob." *The Jacobs' Saga Biography.* http://www.bagadoo.tm.fr/maxjacob/uk/saga3.html (accessed June 21, 2001).

"Max Jacob." *Some Poems from* Le Cornet à dés. http://translate.google.com/translate_c?hl=en&u=http://www.jbeilharz.de/jacob/cornet.html&prev=/ (accessed June 7, 2001).

ALFRED JARRY

Beaumont, Keith. *Alfred Jarry: A Critical and Biographical Study.* Leicester, UK: Leicester University Press, 1984.

Harvey, Sir Paul, and J. E. Heseltine, eds. "Jarry, Alfred." *Oxford Companion to French Literature.* Oxford: Clarendon, 1986.

Justice-Malloy, Rhona. "Alfred Jarry." Dictionary of Literary Biography 192:195–205.

Goddard, Stephen H., and Brian Parshall. *Ubu's Almanac: Alfred Jarry and the Graphic Arts* (University of Kansas: Spencer Museum of Art, 1998).

CHARLES JOHNSON

Boccia, Michael. "An Interview with Charles Johnson." *African American Review* (Indiana State University), 1996, 611–18.

Byrd, Rudolph P., ed. *I Call Myself Artist.* Bloomington and Indianapolis: Indiana University Press, 1999.

Graham, Maryemma. "Charles R. Johnson." Dictionary of Literary Biography 33:124–27.

"Johnson, Charles Richard." Contemporary Authors. New Revisions Series 82:206–8.

Johnson, Charles. "The Gift of Osuo." *African American Review* (Indiana State University), 1996, 519–26.

———. Emails to author, September 27 and October 24, 2000.

———. Letters to author, September 8 and October 27, 2000.

DAVID JONES

Gray, Nicolete. *The Paintings of David Jones.* London: John Taylor/Lund Humphries, 1989.

"Jones, David." Contemporary Authors. New Revisions Series 28:261–66.

"Mapping the Labyrinth: The Ur-Anathemata of David Jones." *Renascence: Essays on Values in Literature* 51 (1999): 253ff.

"Mythological References in Two Painted Inscriptions of David Jones." *Journal of Modern Literature* 23 (1999): 173ff.

Ross, Ian. "David Jones." Dictionary of Literary Biography 100:139–49.

DONALD JUSTICE

"Donald Justice." The Academy of American Poets. http://www.poets.org (accessed October 28, 2001).

"Justice, Donald (Rodney)." Contemporary Authors. New Revisions Series 26:192–97.

Justice, Donald. Letter to author, November 2, 2001.

Kazin, Catherael. "Donald Justice." Dictionary of Literary Biography. *Yearbook 1984.* Edited by M. Bruccoli and R. Ziegteld. Detroit: Gale, 1984, 266–71.

FRANZ KAFKA

Brod, Max von, ed. *The Diaries of Franz Kafka: 1910–1913*. Vol. 1. New York: Schocken, 1948.

———, ed. *The Diaries of Franz Kafka: 1914–1923*. Vol. 2. New York: Schocken, 1949.

"Franz Kafka." Little Blue Light. http://www.littlebluelight.com (accessed March 18, 2001).

Hayman, Ronald. *A Biography of Kafka*. Phoenix, AZ: Giant, 1981.

Mailloux, Peter. *A Hesitation before Birth: The Life of Franz Kafka*. London and Toronto: Associated University Press, 1989.

WELDON KEES

Elledge, Jim. *Weldon Kees: A Critical Introduction*. Metuchen, NJ, and London: Scarecrow, 1985.

Gioia, Dana. "The Cult of Weldon Kees." Dana Gioia Online. http://www.dangioia.net/essays/ekees.htm (accessed May 4, 2001).

Justice, Donald, ed. *The Collected Poems of Weldon Kees*. Lincoln and London: University of Nebraska Press, 1975.

"Weldon Kees." Nebraska Center for Writers. http://mockingbird.creighton.edu/NCW/kees.htm (accessed May 4, 2001).

"Weldon Kees: Biographical Note." Modern American Poetry (University of Illinois at Urbana). http://www.english.uiuc.edu (accessed May 4, 2001).

GOTTFRIED KELLER

Hart, Gail K. "Gottfried Keller." Dictionary of Literary Biography 12:159–73.

Lindsay, J. M. *Gottfried Keller: Life and Works*. London: Oswald Wolff, 1968.

Ruppel, Richard R. *Gottfried Keller and His Critics: A Case Study in Scholarly Criticism*. Columbia, SC: Camden House, 1998.

JACK KEROUAC

Cassady, Carolyn. *Heart Beat: My Life with Jack and Neal*. Berkeley, CA: Creative Arts, 1976.

Charters, Ann. *Kerouac: A Biography*. San Francisco: Straight Arrow, 1973.

Dardess, George. "Jack Kerouac." Dictionary of Literary Biography 16:278–303.

Kerouac, Jack. *Departed Angels: The Lost Paintings of Jack Kerouac*. Text by Ed Adler. New York: Thunder's Mouth, 2004.

Nicosia, Gerald. *Memory Babe: A Critical Biography of Jack Kerouac*. New York: Grove, 1983.

Turner, Steve. *Angelheaded Hipster*. London: Bloomsbury, 1996.

CHARLES KINGSLEY

Chitty, Susan. *The Beast and the Monk: A Life of Charles Kingsley*. New York: Hodder and Stoughton, 1974.

Coles, Nicholas. "Charles Kingsley." Dictionary of Literary Biography 32:182–90.

Uffelman, Larry K. "Charles Kingsley: A Biography." The Victorian Web. http://65.107.211.206/authors/kingsley/skbio/html (accessed September 19, 2001).

RUDYARD KIPLING

Gorra, Michael. "When the Sun Never Sets: A Biography of the Poet and Author Who Chronicled the Glories of the British Empire and Prophesied Its End." *New York Times,* May 5, 2002, late edition, 13.

Kipling, Rudyard. *Something of Myself and Other Autobiographical Writings*. Edited by Thomas Pinney. Cambridge: Cambridge University Press, 1990.

Lycett, Andrew. *Rudyard Kipling*. London: Weidenfeld and Nicolson, 1999.

O'Toole, Mary A. "Rudyard Kipling." Dictionary of Literary Biography 34:208–20.

Wilson, Angus. *The Strange Ride of Rudyard Kipling: His Life and Works*. London: Secker and Warburg, 1977.

ERIC KNIGHT

"Eric (Mowbray) Knight," Contemporary Authors 137:252–54.

Gehman, Geoff. "Capturing Eric Knight Is a Group Effort," *Morning Call* (Allentown, PA), July 5, 1998, F1.

———. *Down but Not Quite Out in Hollow-Weird*. Metuchen, NJ, and London: Scarecrow, 1998.

———. Email to author, December 4, 2002.

OSCAR KOKOSCHKA

Bryant-Bertail, Sarah, and Susan Russell. "Oskar Kokoschka." Dictionary of Literary Biography 124:288–300.

Faerna, José María, ed. *Kokoschka*. New York: Abrams, 1995.

Homage to Kokoschka. Marlborough-Gerson Gallery, Inc. London, New York, and Rome, March–April 1966.

"Kokoschka, Oscar." Grove Art. http://www.groveart.com (accessed January 22, 2002).

Kokoschka, Oscar. *Kokoschka Portraits and Figure Drawings.* New York: Dover, 1996.

ALFRED KUBIN

Kallir, Jane. *Alfred Kubin: Visions from the Other Side.* New York: Crown, 1967.

Lindley, Denver. *Alfred Kubin's Autobiography.* New York: Crown, 1967.

Rhein, Phillip H. "Alfred Kubin." Dictionary of Literary Biography 81:169–76.

———. *The Verbal and Visual Art of Alfred Kubin.* Riverside, CA: Ariadne, 1989.

ELSE LASKER-SCHÜLER

Berman, Nina. "Else Lasker-Schüler." The Literary Encyclopedia. http://www.litencyc.com/php/speople.php?rec=true&UID=5758 (accessed March 11, 2005).

Jochimsen, Margarethe, ed. *Else Lasker-Schüler: Schrift, Bild, Schrift.* Bonn: Verein August Macke Haus, 2000.

Salmon, Irit, curator. *I and I: Drawings by Else Lasker-Schüler.* Translated by Judith Levy. Jerusalem: Israel Museum, 1997.

Zohn, Harry. "Else Lasker-Schüler." *Encyclopedia of World Literature in the Twentieth Century.* Vol. 3. Edited by Steven R. Serafin. London: St. James, 1999, 17.

D. H. LAWRENCE

Levy, Mervyn, ed. *Paintings of D. H. Lawrence.* New York: Viking, 1964.

Widmer, Kingsley. "D. H. Lawrence." Dictionary of Literary Biography 36:115–49.

EDWARD LEAR

Dehejia, Vidya. *Impossible Picturesqueness: Edward Lear's Indian Watercolours, 1873–1975.* New York: Columbia University Press, 1989.

Hark, Ina Rae. "Edward Lear." Dictionary of Literary Biography 32:190–97.

MIKHAIL LERMONTOV

Davis, Jessie. *The Fey Hussar.* Liverpool: Print Origination Ltd., 1989.

Kelly, Laurence. *Lermontov: Tragedy in Caucasus.* London: Constable, 1977.

Mersereau, John, Jr. Mikhail Lermontov. Carbondale: Southern Illinois University Press, 1962.

Powelstock, David. "Mikhail Iurevich Lermontov." Dictionary of Literary Biography 205:179–205.

CARLO LEVI

"Carlo Levi." http://www.kirjasto.sci.fi/clevi.htm (accessed March 26, 2002).

"Levi, Carlo." Contemporary Authors. New Revisions Series 10:289–91.

Levi, Carlo. *The Watch.* Vermont: Steerforth, 2000.

WYNDHAM LEWIS

Edwards, Paul. *Wyndham Lewis, Painter and Writer.* New Haven and London: Yale University Press, 2000.

Meyers, Jeffrey. "Wyndham Lewis." Dictionary of Literary Biography 15:306–22.

VACHEL LINDSAY

Camp, Dennis. "Vachel Lindsay." Dictionary of Literary Biography 54:207–45.

Masters, Edgar Lee. *Vachel Lindsay: A Poet in America.* New York: Biblo and Tannen, 1969.

Ruggles, Eleanor. *The West-Going Heart: A Life of Vachel Lindsay.* New York: Norton, 1959.

West, Herbert F. *The George Matthew Adams Vachel Lindsay Collection.* Hanover, NH: Dartmouth College Library, 1945.

HUGH LOFTING

"Hugh Lofting." *Contemporary Authors Online.* Gale. http://www.galenet.com (accessed January 17, 2001).

"Hugh Lofting." *Online Catalog of the New York Public Library.* http://catnyp.nypl.org/search (accessed January 19, 2001).

Molson, Francis J. "Hugh Lofting." Dictionary of Literary Biography 160:150–59.

Schmidt, Gary D. *Hugh Lofting.* New York: Twayne, 1992.

PIERRE LOTI

D'Auvergne, Edward B. *Pierre Loti: Romance of a Great Writer.* London
 and New York: Kegan Paul Ltd., 2002.
Blanch, Lesley. *Pierre Loti: Portrait of an Escapist.* London: Collins, 1983.
Hargreaves, Alec G. "Pierre Loti." Dictionary of Literary Biography
 123:158-172.
"Proust Questionnaire." *Vanity Fair,* April 4, 2005, 284.
Szyliowicz, Irene L. *Pierre Loti and the Oriental Woman.* New York: St.
 Martins, 1988.

MINA LOY

Burke, Carolyn. *Becoming Modern: The Life of Mina Loy.* New York:
 Farrar, Straus and Giroux, 1996.
———. "Mina Loy." Dictionary of Literary Biography 4:259–61.
Loy, Mina. *The Last Lunar Baedeker.* Edited by Roger L. Conover.
 Highlands, NC: Jargon Society, 1982.
MacFarquhar, Larissa. "Surrealist Siren." *Bazaar,* August 1996, 92.
Mallarmé, Stéphane. *A Painter's Poet.* The Bertha and Karl Leubsdorf Art
 Gallery in conjunction with Bibliothèque Littéraire. Paris: Jacques
 Doucet, 1998.

LUCEBERT

Demets, Paul. "A Walk on the Wild Square: Poetry of the 1980s and 1990s."
 Knack 31 (January 2002). http://www.nlpvf.nl/essays/demets/htm.
Eijkelboom, J. *Lucebert.* Translated by C. de Dood. Amsterdam: J. M.
 Meulenhoff, 1964.
"Lubertus Jabous Swaanswijk." *Contemporary Authors Online.* Gale.
 http://www.galenet.com. (accessed January 31, 2002).
Van der Keuken, Johann. "Lucebert, Time and Farewell." Red Diaper
 Productions. http://www.reddiaper.com/lucebert.htm (accessed
 March 23, 2001).

JOHN MASEFIELD

The Centenary of John Masefield's Birth. An Exhibition. New York:
 Columbia University Libraries, 1978.
"Masefield, John." OhioLink Research Databases for MLA International
 Bibliography. http://olc7.ohiolink.edu (accessed March 8, 1999).
Masefield, John. *So Long to Learn.* New York: Macmillan, 1952.
Skierka, Volker. *Love Affairs and Tales of Atrocity: Heinrich Mann's
 Unknown Drawings.* Gottingen: Steidl, 2001.

Whited, Stephen R. "John Masefield." Dictionary of Literary Biography
 153:186–94.

VLADIMIR MAYAKOVSKY

Gray, Francine Du Plessix. "Mayakovsky's Last Loves." *New Yorker,*
 January 7, 2002, 38–55.
"Mayakovsky, Vladimir." Contemporary Authors 158:269–72.
Terras, Victor. *Vladimir Mayakovsky.* Boston: G. K. Hall, 1983.
Thompson, Patricia J. *Mayakovsky in Manhattan: A Love Story.* New York:
 City University of New York, 1993.
"Vladimir Majakovski." *Books and Writers.*
 http://222.kirjasto.sci.fi/majakovs.htm. (accessed April 29, 2001).

COLLEEN MCCULLOUGH

Steinberg, Sybil. "Colleen McCullough: The Indefatigable Author Has
 Embarked on a Five-Volume Series Set in Ancient Rome." *Publishers
 Weekly,* September 14, 1990, 109–10.

PROSPER MÉRIMÉE

Carpenter, Scott D. "Prosper Mérimée." Dictionary of Literary Biography
 119:193–205.
Pater, Walter. "Prosper Mérimée." *Miscellaneous Studies.* London:
 Macmillan, 1895.

LEONARD MICHAELS

"Leonard Michaels." *Contemporary Authors Online.* Gale.
 http://www.galenet.com (accessed February 12, 2005).
Martin, Douglas. "Leonard Michaels Obituary." *New York Times,* May 13,
 2003, A29.

HENRI MICHAUX

Ball, David. *Darkness Moves.* Berkeley, Los Angeles, and London:
 University of California Press, 1994.
Cardinal, Roger. "The Sage of Disintegration." *Times Literary Supplement*
 March 26, 1999.
"Henri Michaux." Little Blue Light. http://www.littlebluelight.com
 (accessed March 18, 2001).
Michaux, Henri. *Untitled Passages.* New York: Drawing Center, 2000.
Sieburth, Richard, trans. *Emergences-Resurgences.* New York: Drawing
 Center, 2000.

JAMES A. MICHENER

Grobel, Lawrence. *Talking with Michener.* Jackson: University Press of
Mississippi, 1999.

Michener, James. *The James A. Michener Foundation Collection.*
Allentown, PA: Allentown Art Museum, 1963, foreword.

HENRY MILLER

Brown, J. D. "Henry Miller." Dictionary of Literary Biography 4:282–94.

Wickes, George. *Lawrence Durrell, Henry Miller: A Private
Correspondence.* New York: Dutton, 1963.

Young, Noel, ed. *The Paintings of Henry Miller: Paint as You Like and Die
Happy.* San Francisco: Chronicle, 1973.

SUSAN MINOT

"Minot, Susan." Contemporary Authors 134:353–54.

Minot, Susan. Emails to author, January 18 and 21, and February 2, 2002.

———. Interview with author, January 25, 2002.

"Susan Minot Interview." The Book Report, Inc. http://www.bookre-
porter.com (accessed August 2, 2001).

MARIANNE MOORE

Cotter, Holland. "Notable Notes: Drawings by Writers and Composers."
New York Times, January 9, 1998, late edition, 39.

Driver, Clive E., executor. *Marianne Moore Newsletter.* Fall 1980.

Leavell, Linda. *Marianne Moore and the Visual Arts: Prismatic Color.* Baton
Rouge and London: Louisiana State University Press, 1995.

"Marianne (Craig) Moore." *Contemporary Authors Online.* Gale.
http://www.galenet.com (accessed January 17, 2001).

"Marianne Moore." Literature Resource Center. New York Public
Library. http://www.galenet.com (accessed January 17, 2001).

"Paying Attention: The Rosenbach Museum's Marianne Moore Archive
and the New York Moderns." *Journal of Modern Literature* (Indiana
University Press), February 19, 2002. http://www.iupjournals.org
(accessed February 19, 2002).

Willis, Patricia C. "Marianne Moore." Dictionary of Literary Biography
7:253–328.

WILLIAM MORRIS

Dunlop, Joseph R. "William Morris." Dictionary of Literary Biography
18:204–25.

ALFRED DE MUSSET

Haldane, Charlotte. *Alfred: The Passionate Life of Alfred de Musset.* New
York: Roy, 1961.

Lestringant, Frank. *Alfred de Musset.* Paris: Flammarion, 1999.

Sedgwick, Henry Dwight. *Alfred de Musset: A Biography.* Indianapolis:
Bobbs-Merrill, 1931.

Sices, David. "Alfred de Musset." Dictionary of Literary Biography
192:263–77.

VLADIMIR NABOKOV

Boyd, Brian. *Vladimir Nabokov: The Russian Years.* Princeton, NJ:
Princeton University Press, 1993.

Funke, Sarah. *Véra's Butterflies.* New York: Horowitz, 1999.

Hagopian, John V. "Vladimir Nabokov." Dictionary of Literary
Biography 2:350–64.

Nabokov under Glass. A Centennial Exhibition at the New York Public
Library. April 23–August 21, 1999.

Wood, Michael. "Nabokov on the Wing." *New York Review of Books,* June
21, 2001, 39–41.

Zimmer, Dieter E. *A Guide to Nabokov's Butterflies and Moths.* Hamburg:
Zimmer, 1998.

HUGH NISSENSON

Goldman, Leila H. "Hugh Nissenson." Dictionary of Literary Biography
28:189–95.

"Hugh Nissenson." *Publishers Weekly,* November 1, 1985, 67–68.

Nissenson, Hugh. *The Song of the Earth: A Novel.* Chapel Hill, NC:
Algonquin, 2001.

———. *The Tree of Life.* New York: Harper and Row, 1985.

———. Email to author, December 5, 2002.

———. Telephone interview with author, December 18, 2002.

Smith, Dinitia. "Depression His Linchpin: A Novelist Keeps Going."
New York Times, July 26, 2001, late edition, 1.

SEAN O'CASEY

Ayling, Ronald. "Sean O'Casey." Dictionary of Literary Biography
10:71–90.

DaRin, Doris. *Sean O'Casey.* New York: Unger, 1976.

Kraus, David. *Sean O'Casey and His World.* London: Thames and
Hudson, 1976.

———. *Sean O'Casey: The Man and His Work.* New York: Macmillan, 1960.

O'Casey, Eileen. *Sean.* Edited and introduced by J.C. Trewin. London: Macmillan, 1971.

O'Casey, Sean. *The Green Crow.* New York: Braziller, 1956.

O'Connor, Garry. *Sean O'Casey: A Life.* London: Hodder and Stoughton, 1988.

FLANNERY O'CONNOR

Butterworth, Nancy K. "Flannery O'Connor." Dictionary of Literary Biography 152:158–81.

"Flannery O'Connor." Little Blue Light. http://www.littlebluelight.com (accessed March 18, 2001).

The Flannery O'Connor Bulletin (Georgia College) 14 (1985).

Gerald, Kelly S. Email to author, October 24, 2000.

Gordon, Sarah, ed. *Flannery O'Connor: In Celebration of Genius.* Athens, GA: Hill Street, 2000.

O'Connor, Flannery. *Collected Works.* Edited by Sally Fitzgerald. New York: Library of America, 1988, 39:1237–57.

CLIFFORD ODETS

Brenman-Gibson, Margaret. *Clifford Odets: American Playwright.* New York: Atheneum, 1981.

Fleichman, Beth. "Clifford Odets." Dictionary of Literary Biography 7:126–39.

Odets, Nicholas. *The Time Is Ripe: The 1940 Journal of Clifford Odets.* New York: Grove, 1988.

KENNETH PATCHEN

Holmes, John. "A Wild World of His Own." *New York Times Book Review,* February 2, 1958, sec. 7.

Kenneth Patchen: Painter of Poems. Washington, DC: Corcoran Gallery of Art, December 12, 1969–January 18, 1970.

"Kenneth Patchen: Selected Poems." *Alameda County Weekender,* September 16, 1967, 2–12.

Laughlin, James. *What Shall We Do without Us? The Voice and Vision of Kenneth Patchen.* San Francisco: Sierra Club, 1966.

Nelson, Raymond. *Kenneth Patchen and American Mysticism.* Chapel Hill and London: University of North Carolina Press, 1984.

Smith, Larry. "Kenneth Patchen." Dictionary of Literary Biography 16:440–45.

———. *Kenneth Patchen: Rebel Poet in America.* Bottom Dog, 2000.

MERVYN PEAKE

Hartston, William. "Peake Performance." *International Express.* November 13, 2001.

"Mervyn Peake." *Gormengshast.* http://www.pbs.org/wgbh/gormenshast/novel/peake.html (accessed August 23, 2001).

Mills, Alice. "Mervyn Laurence Peake." Dictionary of Literary Biography 160:207–16.

S. J. PERELMAN

Adcock, Christopher. "S. J. Perelman." Dictionary of Literary Biography 44:283–88.

Herrmann, Dorothy. *S. J. Perelman: A Life.* New York: Putnam, 1986.

"S. J. Perelman." OhioLink Research Databases for MLA International Bibliography. http://olc7.ohiolink.edu (accessed February 25, 1999).

Teicholz, Tom, ed. *Conversations with S. J. Perelman.* Jackson: University Press of Mississippi, 1995.

SYLVIA PLATH

Ames, Lois. "Sylvia Plath: A Biographical Note." *The Walking Man Presents: Sylvia Plath.* http://www.thewalkingman.net/unhappygirl/Articles/bioplath2.htm (accessed March 1, 2002).

Connors, Kathleen D. "Introduction to the 'Eye Rhymes' Exhibition Works." January 2002. Unpublished. (Exhibition held September 3–November 23, 2002, at Indiana University's School of Fine Arts Gallery.) http://www.indiana.edu/~plath70.

———. "Sylvia Plath's Art of the Visual." *Ryder Magazine,* September 2003.

Locke, Richard. "The Last Word: Beside the Bell Jar." *New York Times on the Web,* June 20, 1971. http://www.nytimes.com (accessed March 1, 2002).

Plath, Sylvia. "Journals." *New Yorker,* March 27, 2000, 104–15.

EDGAR ALLAN POE

Thompson, G. R. "Edgar Allan Poe." Dictionary of Literary Biography 3:249–97.

BEATRIX POTTER

Beatrix Potter: A Centennial Exhibition. Logan Square: Free Library of Philadelphia, October 16–November 27, 1966.

"Beatrix Potter Light of Foot." *Town and Country,* January 21, 1971, 124.

MacDonald, Ruth K. "Beatrix Potter." Dictionary of Literary Biography 141:230–48.

JACQUES PRÉVERT

A la rencontre de Jacques Prévert. Paris: Fondation Maeght, 1987.

Greet, Anne Hyde. *Jacques Prévert's Word Games.* Berkeley and Los Angeles: University of California Press, 1968.

McGoldrick, Malcolm. "Jacques Prévert." Dictionary of Literary Biography 256:338–53.

MARCEL PROUST

Alden, Douglas W. "Marcel Proust." Dictionary of Literary Biography 65:218–54.

Chernowitz, Maurice E., Ph.D. *Proust and Painting.* New York: International University Press, 1945.

Freudenheim, Milt. "Lively Remembrances of Things Proust upon His Centennial." *Chicago Daily News.* Panorama. July 10–11, 1971.

Gandelman, Claude. "The Drawings of Marcel Proust." *ADAM International Review,* nos. 394–96, 1976.

Sollers, Phillipe. *L'oeil de Proust: Les dessins de Marcel Proust.* Paris: Stock, 1999.

ALEXANDER PUSHKIN

Binyon, T. J. *Pushkin: A Biography.* New York: Knopf, 2003.

Bobrova, Olga. "A Tribute to Pushkin." Russian Culture Navigator. http://www.vor.ru/culture/cultrach74_eng.html (accessed July 17, 2001).

Feinstein, Elaine, ed. *After Pushkin.* Manchester, UK: Carcanet and the Folio Society, 1999.

Gutsche, George J. "Alexander Sergeevich Pushkin." Dictionary of Literary Biography 205:243–80.

Magarshack, David. *Pushkin: A Biography.* London: Chapman and Hall, 1967.

Pushkin, A. *The Complete Collection of Drawings.* Moscow: Voskresene, 1999.

Simmons, Ernest J. *Pushkin.* Cambridge: Harvard University Press, 1937.

Shaw, J. Thomas. *The Letters of Alexander Pushkin.* Vol. 1. http://falcon.jmu.edu (accessed June 11, 2001).

Vernadsky, George V. *Centennial Essays for Pushkin.* Edited by Samuel H. Cross and Ernest I. Simmons. Cambridge, MA: Harvard University Press, 1937.

KENNETH REXROTH

Bartlett, Lee ed. *Kenneth Rexroth and James Laughlin: Selected Letters.* New York: Norton, 1991.

Bureau of Public Secrets: Rexroth Archive. http://www.bopsecrets.org/rexroth/index.html (accessed September 27, 2002).

Hamalian, Linda. *A Life of Kenneth Rexroth.* New York: Norton, 1992.

Smith, Larry R. "Kenneth Rexroth." Dictionary of Literary Biography 48:250-367.

JAMES WHITCOMB RILEY

Johnson, Benjamin F. Contemporary Authors 137:385–88.

Ridgeway, Major. *Early Collections of James Whitcomb Riley.* Harrison, OH: 1902.

Van Allen, Elizabeth J. *James Whitcomb Riley: A Life.* Bloomington and Indianapolis: Indiana University Press, 1999.

ARTHUR RIMBAUD

Arthur Rimbaud: Portraits, Dessins, Manuscrits. Exhibition at the Musée D'Orsay. Paris, 1991.

Delhaye, Ernest. *Rimbaud.* Monaco: Editions Sauret, 1993.

Hanson, Elisabeth. *My Poor Arthur: A Biography of Arthur Rimbaud.* New York: Holt.

Ivry, Benjamin. *Arthur Rimbaud.* England: Absolute, 1998.

Levi, Anthony. *Guide to French Literature 1789–Present.* London: St. James, 1992.

Robb, Graham. *Rimbaud.* New York: Norton, 2000.

Starkie, Enid. *Arthur Rimbaud.* New York: Norton, 1968.

ISAAC ROSENBERG

Bottomly, Gordon, ed. *Poems by Isaac Rosenberg.* London: Heinemann, 1922.

"Isaac Rosenberg." *Contemporary Authors Online.* Gale. http://www.galenet.com (accessed April 19, 2001).

Liddiard, Jean. *Isaac Rosenberg: The Half-Used Life.* London: Gollancz, 1975.

Staley, Thomas F. "Isaac Rosenberg." Dictionary of Literary Biography 20:318–21.

Wilson, Jean Moorcroft. *Isaac Rosenberg: Poet and Painter.* London: Cecil Woolf, 1975.

DANTE GABRIEL ROSSETTI

Bass, Eben E. *Dante Gabriel Rossetti: Poet and Painter.* New York: Peter Lang, 1990.

Fredeman, William. "Dante Gabriel Rossetti." Dictionary of Literary Biography 35:212–36.

Dante Gabriel Rossetti: Painter and Poet. Exhibition at the Royal Academy of Arts, London, January 13–March 11, 1973.

Dobbs, Brian and Judy. *Dante Gabriel Rossetti: An Alien Victorian.* London: MacDonald and Jane's, 1977.

Marsh, Jan. *Dante Gabriel Rossetti: Painter and Poet.* London: Orion, 1999.

McGann, Jerome J. The Rossetti Hypermedia Archive (University of Virginia). http://www.rossettiarchive.org.

Mégroz, R. L. *Dante Gabriel Rossetti: Painter Poet of Heaven in Earth.* London: Faber and Gwyer, 1972.

JOHN RUSKIN

Bell, Quentin. *Ruskin.* London: Hogarth, 1978.

Cunningham, Valentine. "A Victorian Renaissance Man." *New York Times Book Review,* May 14, 2000.

The Drawings and Watercolours of John Ruskin. University of Manchester, Department of History of Art, Whitworth Art Gallery, March 5–May 3, 1982.

Hilton, Tim. *John Ruskin: The Later Years.* New Haven, CT, and London: Yale University Press, 2000.

Olsen, Marilynn Strasser. "John Ruskin." Dictionary of Literary Biography 163:247–58.

Penny, Nicholas. *Ruskin's Drawings.* Oxford: Phaidon, 1989.

Walton, Paul H. *The Drawings of John Ruskin.* Oxford: Clarendon, 1972.

———. John Ruskin: *Watercolors and Drawings.* New York: Salander-O'Reilly Galleries, 1996.

Wheeler, Michael, ed. *Time and Tide: Ruskin and Science.* London: Pilkington, 1996.

Whitehouse, J. Howard. *Ruskin the Painter and His Works at Bembridge.* London: Oxford University Press, 1932.

PETER SACKS

"Peter Sacks." Dia Center for the Arts. http://www.diacenter.org (accessed November 30, 2001).

Peter Sacks. Interview by author, December 1, 2001.

Powell, Alvin. "Swimming in Words." *Harvard University Gazette,* April 15, 1999. http://www.news.harvard.edu/gazette/1999/04.15/sacks/profile.html (accessed October 30, 2001).

Sacks, Peter. Letter to author, February 20, 2002.

ANTOINE DE SAINT-EXUPÉRY

Cate, Curtis. *Antoine de Saint-Exupéry.* New York: Putnam, 1970.

Mitgang, Herbert. "Books of the Times," *New York Times,* July 30, 1986.

GEORGE SAND

Bernadac, Christian. *George Sand, Dessins et aquarelles.* Paris: Pierre Belfond, 1992.

Cate, Curtis. *George Sand: A Biography.* Boston: Houghton Mifflin, 1975.

McKenzie, Aimee L., trans. *The George Sand–Gustave Flaubert Letters.* New York: Liveright, 1921.

Powell, David A. "George Sand." Dictionary of Literary Biography 119:238–54.

"Sand, George." Ohio Link Research Databases for MLA International Bibliography. http://olc7.ohiolink.edu (accessed March 3, 1999).

WILLIAM SANSOM

Chalpin, Lila. *William Sansom.* Boston: Twayne, 1980.

Kleeberg, Michael. "William Sansom." Dictionary of Literary Biography 139:199–202.

Michel-Michot, Paulette. *William Sansom: A Critical Assessment.* Paris: Société d'Édition "Les Belles Lettres," 1971.

"William Sansom." Literature Resource Center. New York Public Library. Gale. http://www.galenet.com (accessed April 19, 2001).

WILLIAM SAROYAN

Lee, Lawrence, and Barry Gifford. *Saroyan: A Biography.* New York: Harper and Row, 1984.

Matalene, H. W. "William Saroyan." Dictionary of Literary Biography 7:204–27.

Saroyan, William. *Who Is Varaz?* Fresno, CA: Panorama West Books, 1985.

Saroyan on Paper: Drawings, Watercolors and Words. Fresno Art Museum, 2002.

BRUNO SCHULZ

Bohlen, Celestine. "Artwork by Holocaust Victim Is Focus of Dispute." *New York Times,* June 20, 2001, A1.

Ficowski, Jerzy, ed. *The Drawings of Bruno Schulz.* Evanston, IL: Northwestern University Press, 1990.

———, ed. *Letters and Drawings of Bruno Schulz.* New York: Fromm International, 1990.

"Schulz, Bruno." Contemporary Authors 123:355–57.

"Schulz, Bruno." OhioLink Research Databases for MLA International Bibliography. http://olc7.ohiolink.edu (accessed March 3, 1999).

ANNE SEXTON

McClatchy, J. D., ed. *Anne Sexton: The Artist and Her Critics.* Bloomington: Indiana University Press, 1978.

Middlebrook, Diane Wood. "Anne Sexton." Dictionary of Literary Biography 169:244–52.

Sexton, Linda Gray. *Anne Sexton: A Self-Portrait in Letters.* Boston: Houghton Mifflin, 1977.

Wagner-Martin, Linda. "Anne Sexton's Life." Modern American Poetry (University of Illinois at Urbana). http://www.english.uiuc.edu/maps/poets/s_z/sexton/sexton_life.htm (accessed March 21, 2005).

GEORGE BERNARD SHAW

Ervine, St. John. *Bernard Shaw: His Life, Work and Friends.* New York: Morrow, 1956.

Gibbs, A. M., ed. *Shaw: Interviews and Recollections.* Iowa City: University of Iowa Press, 1990.

Henderson, Archibald. *George Bernard Shaw: Man of the Century.* New York: Appleton-Century-Crofts, 1956.

Holroyd, Michael. *Bernard Shaw.* New York: Random House, 1988.

Winsten, S., ed. *G. B. S. 90: Aspects of Bernard Shaw's Life and Work.* London: Hutchinson, 1946.

CHARLES SIMIC

"Charles Simic." *Poetry Exhibits.* Academy of American Poets. http://www.poets.org/poets/Poets.cfm?prmID=28 (accessed September 29, 2001).

"Seeing Things." *The Atlantic Online,* January 10, 2001. http://www.theatlantic.com/unbound/interviews/ba2001-01-10.htm (accessed September 29, 2001).

Simic, Charles. "The Secret Doctrine." *New Yorker,* January 7, 2002, 59.

PATTI SMITH

Delano, Sharon. "The Torch Singer." *New Yorker,* March 11, 2002, 48–63.

Greenberg, David, and John W. Smith. *Strange Messenger: The Work of Patti Smith.* Pittsburgh: Andy Warhol Museum, 2002.

"Smith, Patti." Contemporary Authors. New Revisions Series 93–96:492–94.

ART SPIEGELMAN

Leventhal, Robert S. "Art Spiegelman's MAUS: Working Through the Trauma of the Holocaust." http://jefferson.village.virginia.edu/holocaust/spiegelman.html (accessed March 5, 2005).

"Speigelman, Art." Contemporary Authors. New Revisions Series 74:419–22.

"Speigelman, Art." Steven Barclay Agency. http://www.barclayagency.com/spiegelman.html (March 5, 2005).

"Speigelman, Art." Interview by Christopher Monte Smith. Book Sense.com. http://www.booksense.com/people/archive/spiegel-manart.jsp (accessed March 5, 2005).

RALPH STEADMAN

Jesher, Art. "For Steadman, Gonzo Still a Crazy Art." *Lexington Herald Leader,* December 30, 1996.

"Ralph Steadman." Ralph Steadman. http://www.raplhsteadman.com (accessed September 13, 2000).

Rayner, Richard. "Ralph Steadman: If There Is a God, He Certainly Is Indifferent and an Underachiever." *Vogue,* April 1985, 180, 193–94.

Steadman, Ralph. Interview with author, September 25, 2000.

"Steadman, Ralph." Contemporary Authors. New Revisions Series 29:404–6.

WALLACE STEVENS

Stevens, Wallace. *Vassar Viewed Veraciously.* Iowa City: Windhover, 1995.

"Wallace Stevens." *Literature Online.*
 http://longman.awl.com/kennedy/stevens/bibliography.html
 (accessed December 16, 2000).

"Wallace Stevens." *Poetry Exhibits.* Academy of American Poets.
 http://www.poets.org/poets/poets.cfm?prmID=125 (accessed
 December 16, 2000).

ROBERT LOUIS STEVENSON

Balfour, Graham. *The Life of Robert Louis Stevenson.* New York: Scribner,
 1907.

Furnas, J. C. *Voyage to the Windward: The Life of Robert Louis Stevenson.*
 New York: William Sloane Associates, 1951.

"Robert Louis Stevenson." *Nineteenth-Century Literature.* Literature
 Resource Center. http://www.galenet.com (accessed January 17,
 2001).

"Stevenson, Robert Louis." OhioLink Research Databases for MLA
 International Bibliography. http://olc7.ohiolink.edu (accessed March
 5, 1999).

ADALBERT STIFTER

Gump, Margaret. *Adalbert Stifter.* New York: Twayne, 1974.

Smith, Duncan. "Adalbert Stifter." Dictionary of Literary Biography
 133:257–69.

HARRIET BEECHER STOWE

Fields, Annie, ed. *Life and Letters of Harriet Beecher Stowe.* Detroit: Gale,
 1970 (reprint of 1897 Houghton Mifflin edition).

Ricklin, Leslie P. Letter to Mrs. Alfred P. Shaw, April 12, 1971.

"Stowe, Harriet Beecher." OhioLink Research Databases for MLA
 International Bibliography. http://olc7.ohiolink.edu (accessed March
 4, 1999).

MARK STRAND

"Mark Strand: Artist Biography." Goya-Girl Press, Inc.
 http://www.goyagirl.com/msbio.htm (accessed November 7, 2001).

"Mark Strand." Modern American Poetry (University of Illinois at
 Urbana).
 http://www.english.uiuc.edu/maps/poets/s_z/strand/strand.htm

(accessed October 9, 2001).

"Strand, Mark." Contemporary Authors. New Revisions Series 65:332–36.

AUGUST STRINDBERG

Granath, Olle. *Strindberg: Painter and Photographer.* New Haven, CT, and
 London: Yale University Press, 2001, foreword.

Jenkins, Alan. "Strindberg's Savage Satisfactions." *Times Literary
 Supplement,* March 23, 2005.

Lagercrantz, Olof. *August Strindberg.* New York: Farrar, Straus, and
 Giroux, 1984.

RABINDRANATH TAGORE

Bhatia, Shyam. "Tagore Painting for Sale in London." *India Abroad.*
 November 24, 2000.
 http://www.indiaabroadonline.com/PublicAccess/ia-
 11242000/Arts/Tagore.html (accessed June 8, 2001).

Frenz, Horst, ed. "Rabindranath Tagore—Biography." In *Nobel Lectures,
 Literature 1901–1967.* Amsterdam: Elsevier, 1969.

"Rabindranath Tagore." National Gallery of Art. http://www.ngma-
 india.com/rabindranath.html (accessed June 11, 2001).

Robinson, Andrew. *The Art of Rabindranath Tagore.* London: André
 Deutsch, 1989.

Sen, Amartya. *Tagore and His India.* Nobel Prize.org.
 http://nobelprize.org/literature/articles/sen/index.html (accessed
 March 9, 2005).

BOOTH TARKINGTON

An Exhibition of Booth Tarkington's Works. Treasure Room of the Princeton
 University Library, March–April 1946.

Mayberry, Susanah. *My Amiable Uncle: Recollections about Booth
 Tarkington.* West Lafayette, IN: Purdue University Press, 1983.

Sorkin, Adam J. "Booth Tarkington." Dictionary of Literary Biography
 9:90–96.

WILLIAM MAKEPEACE THACKERAY

Cotter, Holland. "Notable Notes: Drawings by Writers and Composers."
 New York Times, January 9, 1998, first edition late, 39.

Harden, Edgar F. "William Makepeace Thackeray." Dictionary of
 Literary Biography 21:258–93.

DYLAN THOMAS

Ackerman, John. *Dylan Thomas: His Life and Work.* New York:
 Macmillan, 1996.

Ferris, Paul. *Dylan Thomas.* London: Hodder and Stoughton, 1977.

Middleton, David E. "Dylan Thomas." Dictionary of Literary Biography
 20:365–94.

Perkins, Derek. *Dylan Thomas and His World.* Swansea, Wales: Domino,
 1995.

Thomas, Dylan. OhioLink Research Databases for MLA International
 Bibliography. http://olc7.ohiolink.edu (accessed March 3, 1999).

JAMES THURBER

"Thurber, James." Contemporary Authors. New Revisions Series
 39:420–26.

Thurber, James. *The Thurber Carnival.* New York and London: Harper
 and Brothers, 1945.

WILLIAM TREVOR

Bruckner, D. J. R. "Stories Keep Coming to a Late-Blooming Writer."
 New York Times on the Web, May 21, 1990. http://www.nytimes.com
 (accessed January 18, 2002).

Halio, Jay L. "William Trevor." Dictionary of Literary Biography 14:723–30.

MARK TWAIN

Rice, Stephen. Letter to author, December 30, 1998.

Twain, Mark. *A Tramp Abroad.* New York and London: Harper and
 Brothers, 1921.

JOHN UPDIKE

Klinkowitz, Jerome. "John Updike." Dictionary of Literary Biography
 227.:484–92.

Updike, John. "Lost Art." *New Yorker,* December 15, 1997, 75–80.

———. *Self-Consciousness.* New York: Fawcett Crest, 1989.

PAUL VALÉRY

Mackay, Agnes Ethel. *The Universal Self: A Study of Paul Valéry.* Toronto:
 University of Toronto Press, 1961.

"Valéry, Paul." Contemporary Authors 122:455–63.

Valéry, Paul. *Cahiers/Notebooks, I.* New York: Peter Lang, 2000.

———. *Cahiers/Notebooks, II.* New York: Peter Lang, 2000.

JANWILLEM VANDEWETERING

Davis, William A. "Janwillem van de Wetering and His Amsterdam
 Detectives Are Back on the Job in Maine." *Boston Globe,* October 24,
 1994, 35.

"Janwillem van de Wetering Biography."
 http://www.dpbooks.com/vandewe5.htm (accessed March 24, 2001).

"Van de Wetering, Janwillem." Contemporary Authors. New Revisions
 Series 90:418–21.

Vandewetering, Janwillen. Email to author, November 30, 2002.

———. Letter to author, November 19, 2002.

JEAN BRULLER VERCORS

"Bruller, Jean (Marcel)." Contemporary Authors. New Revisions Series
 47:37–39.

Kidd, William. *'Le Silence de la Mer' et autres récits.* Glasgow, UK:
 University of Glasgow French and German Publications, 1991.

Konstantinovic, Radivoje D. *Vercors: Ecrivain et Dessinateur.* Paris:
 Librarie C. Klincksieck, 1969.

PAUL VERLAINE

Adam, Antoine. *The Art of Paul Verlaine.* New York: New York University
 Press, 1963.

"Paul Verlaine." Little Blue Light. http://littlebluelight.com (accessed
 March 18, 2000).

Richardson, Joanna. *Verlaine.* London: Weidenfeld and Nicolson, 1971.

Verlaine, Paul. *Confessions of a Past.* New York: Philosophical Library,
 1950.

ALFRED DE VIGNY

Denommé, Robert T. "Alfred de Vigny." Dictionary of Literary
 Biography 119:312–33.

Whitridge, Arnold. *Alfred de Vigny.* London: Oxford University Press,
 1933.

KURT VONNEGUT

"Kurt's Back and Writing Too." *New York Post,* October 22, 2001, 8.

Stone, Brad. "Vonnegut's Last Stand." *Newsweek,* September 29, 1997, 78.

"Vonnegut Exhibitions." Kurt Vonnegut Home Page.
 http://www.kutvonnegut.com (accessed September 9, 2000).

"Vonnegut, Kurt." Contemporary Authors. New Revisions Series

75:431–38.

Vonnegut, Kurt. Interview by author, October 5, 2000.

DEREK WALCOTT

"Derek Walcott." *Nobel E-Museum.* http://www.nobel.se (accessed
 November 26, 2001).

Hamner, Robert D. "Derek Walcott." Dictionary of Literary Biography
 117:290–312.

Taylor, Robert. "The Bounty and the Beauty." *Bostonian,* Spring 1999,
 23–25.

Walcott, Derek. Interview with author, November 27, 2001.

EVELYN WAUGH

Doyle, Paul A. "Evelyn Waugh." Dictionary of Literary Biography
 15:570–86.

Hastings, Selina. *Evelyn Waugh: A Biography.* New York: Houghton
 Mifflin, 1994.

Patey, Douglas Lane. *The Life of Evelyn Waugh.* Oxford: Blackwell, 1998.

Stannard, Martin. *Evelyn Waugh: The Early Years, 1903–1939.* London:
 Dent, 1986.

PETER WEISS

Bahr, Ehrhard. "Peter Weiss." Dictionary of Literary Biography
 124:420–28.

Cohen, Robert. *Understanding Peter Weiss.* Columbia: University of South
 Carolina Press, 1993.

Hilton, Ian. *Peter Weiss: A Search for Affinities.* London: Oswald Wolff,
 1970.

"Peter Weiss." http://members.aol.com/emmybca/PeterWeiss.html
 (accessed March 24, 2001).

Peter Weiss als Maler. Kunsthall Bremen, January 16–February 20, 1983.

Wager, Walter, ed. *The Playwrights Speak.* New York: Delacorte, 1967.

"Weiss, Peter." Contemporary Authors. New Revisions Series 3:580–83.

DENTON WELCH

De-La-Noy, Michael. *The Journals of Denton Welch.* New York: Dutton,
 1984.

"Welch, D. Don, Jr." Contemporary Authors 148:472–74.

Welch, Denton. *A Last Sheath.* London: John Lehmann, 1951.

T. H. WHITE

Gallix, François, ed. *Letters to a Friend: The Correspondence between T. H.
 White and L. J. Potts.* New York: Putnam, 1982.

Nelson, Marie. "T. H. White." Dictionary of Literary Biography
 255:265–75.

Warner, Sylvia Townsend. *T. H White: A Biography.* London: Jonathan
 Cape with Chatto and Windus, 1967.

RICHARD WILBUR

"Richard Wilbur." *Poetry Exhibits.* Academy of American Poets.
 http://www.poets.org (accessed October 28, 2001).

"Wilbur, Richard." Contemporary Authors. New Revisions Series
 29:450–56.

Wilbur, Richard. Letter to author, November 2, 2001.

TENNESSEE WILLIAMS

Haley, Darryl Erwin. "Certain Moral Values": A Rhetoric of Outcasts in
 the Plays of Tennessee Williams. Dissertation, 1999.
 http://www.etsu.edu/haleyd/DissHome.html (accessed ???).

"Tennessee Williams." Literature Resource Center. New York Public
 Library. http://www.galenet.com (accessed February 4, 2002).

Williams, Dakin, and Shepherd Mead. *Tennessee Williams: An Intimate
 Biography.* New York: Arbor House, 1976.

Williams, Tennessee. *Androgyne, Mon Amour.* New York: New Directions,
 1944.

WILLIAM CARLOS WILLIAMS

Breslin, James E. *William Carlos Williams: An American Artist.* New York:
 Oxford University Press, 1970.

Dijkstra, Bram, ed. *A Recognizable Image: William Carlos Williams on Art
 and Artists.* New York: New Directions, 1978.

Mariani, Paul. *William Carlos Williams: A New World Naked.* New York:
 McGraw-Hill, 1981.

Marling, William. *William Carlos Williams and the Painters.* Athens, OH:
 Ohio University Press.

Rosenthal, M. L. "William's Life and Career." *Modern American Poetry.*
 http://www.english.uiuc.edu/maps/poets/s_z/williams/bio.htm
 (accessed July 8, 2002).

Wallace, Emily Mitchell. *A Biography of William Carlos Williams.*
 Middletown, CT: Wesleyan University Press, 1968.

"William Carlos Williams." Literary Kicks.

http://www.charm.net/~brooklyn/People/WilliamCarlosWilliams.html (accessed July 8, 2002).

"William Carlos Williams." *Poetry Exhibits*. Academy of American Poets. http://www.poets.org/poets/poets.cfm?prmID=120 (accessed July 8, 2002).

Williams, William Carlos. *The Autobiography of William Carlos Williams*. New York: New Directions, 1951.

WITKACY (STANISLAW I. WITKIEWICZ)

Gerould, Daniel. "Stanislaw Ignacy Witkiewicz (Witkacy)." *European Writers: The Twentieth Century*. Edited by George Stade. Vol. 10. New York: Scribner, 1990.

———, ed. and trans. *The Witkiewicz Reader*. Evanston, IL: Northwestern University Press, 1992.

TOM WOLFE

McKeen, William. *Tom Wolfe*. New York: Twayne, 1995.

Scura, Dorothy, ed. *Conversations with Tom Wolfe*. Jackson and London: University Press of Mississippi, 1983.

"Thomas Kennerly Wolfe, Jr." *Contemporary Authors Online*. Gale. http://www.galenet.com (accessed January 17, 2001).

"Tom Wolfe." *Tom Wolfe Biography*. http://www.tomwolfe.com (accessed September 10, 2000).

Wolfe, Tom. *In Our Time*. New York: Farrar, Straus and Giroux, 1980.

———. Interview with author, May 20, 2002.

———. Letters to author, April 2, May 10, and May 28, 2002.

"Wolfe, Tom." OhioLink Research Databases for MLA International Bibliography. http://olc7.ohiolink.edu (accessed March 5, 1999).

WILLIAM BUTLER YEATS

Brown, Terence. *The Life of W. B. Yeats: A Critical Biography*. London: Gill and Macmillan, 2001.

Frank, Michael. "Yeats, a Poet Who Kept Trying On Different Identities." *New York Times*, August 6, 1999, E44.

Loizeaux, Elizabeth Bergmann. *Yeats and the Visual Arts*. New Brunswick, NJ, and London: Rutgers University Press.

Trevor, William. *A Writer's Ireland: Landscape in Literature*. London: Thames and Hudson, 1984.

"William Butler Yeats." The Nobel Prize for Literature. http://www.nobel.se/literature/laureates/1923/press.html (accessed October 30, 2000).

Yeats, William Butler. *The Autobiography of William Butler Yeats*. New York: Macmillan, 1938.

General Sources

Aberbach, David. *Surviving Trauma: Loss, Literature and Psychoanalysis*. New Haven, CT, and London: Yale University Press, 1989.

Arieti, Silvano. *Creativity, the Magic Synthesis*. New York: Basic Books, 1996.

Ayala, Roselyne de, and Jean-Pierre Guéno, eds. *Illustrated Letters: Artists and Writers Correspond*. New York: Abrams, 1999.

Auerbach, Erich. *Mimesis*. Princeton, NJ: Princeton University Press, 1953.

Bachelard, Gaston. *The Poetics of Space*. Boston: Beacon, 1969.

Berger, John. *About Looking*. New York: Vintage, 1980.

Boden, Margaret A., ed. *Dimensions of Creativity*. Cambridge and London: MIT Press, 1994.

Csikszentmihalyi, Mihaly. *Creativity: Flow and the Psychology of Discovery and Invention*. New York: HarperCollins, 1996.

Cuoco, Lorin, ed. *The Dual Muse: The Writer as Artist, the Artist as Writer*. Amsterdam: John Benjamins, 1999.

Damasio, Antonio. *The Feeling of What Happens*. New York, San Diego, and London: Harcourt Brace, 1999.

Ellmann, Richard, and Robert O'Clair, eds. *The Norton Anthology of Modern Poetry*. New York: Norton, 1973.

Felman, Shoshana, and Dori Laub, M.D. *Testimony*. New York and London: Routledge, 1992.

Foster, Tonya, and Kristin Prevallet. *Third Mind, Creative Writing through Visual Art*. New York: Teachers and Writers Collaborative, 2002.

Gardner, Howard. *The Arts and Human Development*. New York: Basic Books, 1994.

———. *Creating Minds*. New York: Basic Books, 1993.

Ghiselin, Brewster. *The Creative Process*. Berkeley, Los Angeles and London: University of California Press, 1952.

Gombrich, E. H. *The Story of Art*. London: Phaidon, 1995.

Grudin, Robert. *The Grace of Great Things*. New York: Ticknor and Fields, 1990.

Harrison, Charles. *Conceptual Art and Painting*. Cambridge and London: MIT Press, 2001.

Hjerter, Kathleen G. *Doubly Gifted: The Author as Visual Artist.* New York: Abrams, 1986.

Koestler, Arthur. *The Act of Creation.* London: Arkana Penguin, 1964.

Mandelbaum, Paul, ed. *First Words.* Chapel Hill, NC: Algonquin, 1993.

McClatchy, J. D., ed. *Poets on Painters: Essays on the Art of Painting by Twentieth-Century Poets.* Berkeley: University of California Press, 1988.

Miller, Alice. *Pictures of a Childhood: Sixty-six Watercolors and an Essay.* New York: Plume, 1986.

Phillips, Lisa. "Beat Culture and the New American: 1950–1965." *Whitney Museum of American Art, New York.* Paris and New York: Flammarion, 1995.

Schapiro, Meyer. *Theory and Philosophy of Art: Style, Artist, and Society.* New York: George Braziller, 1994.

Shaw, Rue Winterbotham. *A Second Talent: An Exhibition of Drawings and Paintings by Writers.* Chicago: Arts Club of Chicago, 1971.

Sorell, Walter. *The Duality of Vision: Genius and Versatility in the Arts.* New York and Indianapolis: Bobbs-Merrill, 1970.

Sternberg, Robert J., ed. *Handbook of Creativity.* Cambridge: Cambridge University Press, 1999.

Szladits, Lola L., and Harvey Simmonds. *Pen and Brush: The Author as Artist.* New York Public Library: Astor, Lenox, and Tilden Foundations, 1969.

"Une Grade Enquête: Pentures et Dessins des Grands Ecrivans." *Le Courier* 8 (August 1957).

Waldman, Diane. *Notable Notes: Drawings by Writers and Composers.* New York: Joseph Helman Gallery, 1998.

Wilson, Edmund. *The Wound and the Bow: Seven Studies in Literature.* New York: Oxford University Press, 1965.

Woodfield, Richard, ed. *The Essential Gombrich.* London: Phaidon, 1996.